DIABLO®

BOOK OF LORATH

Written by Matthew J. Kirby

BLIZZARD
ENTERTAINMENT

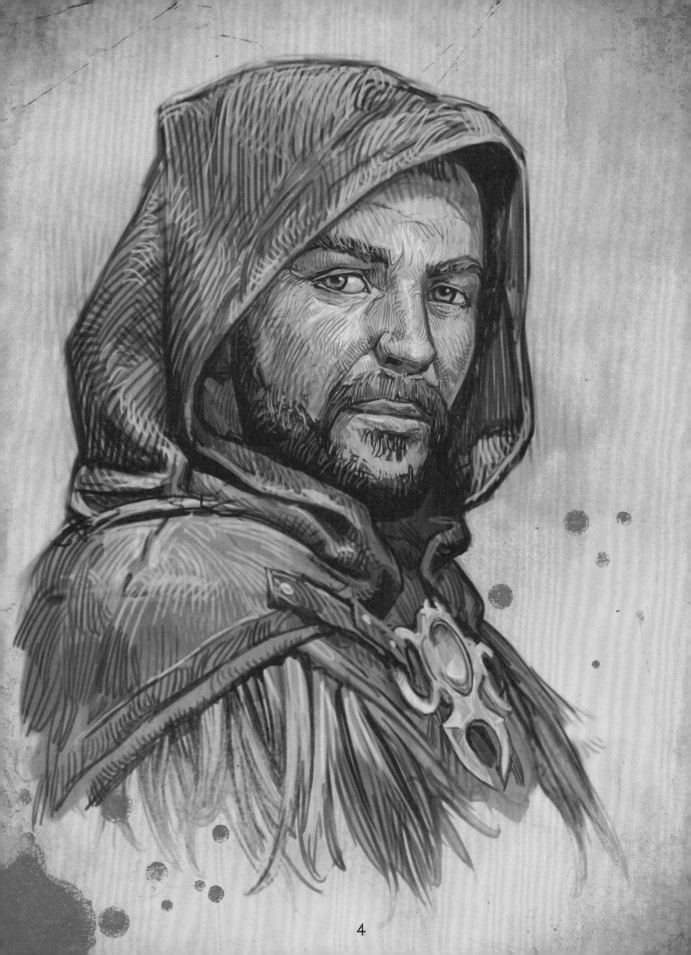

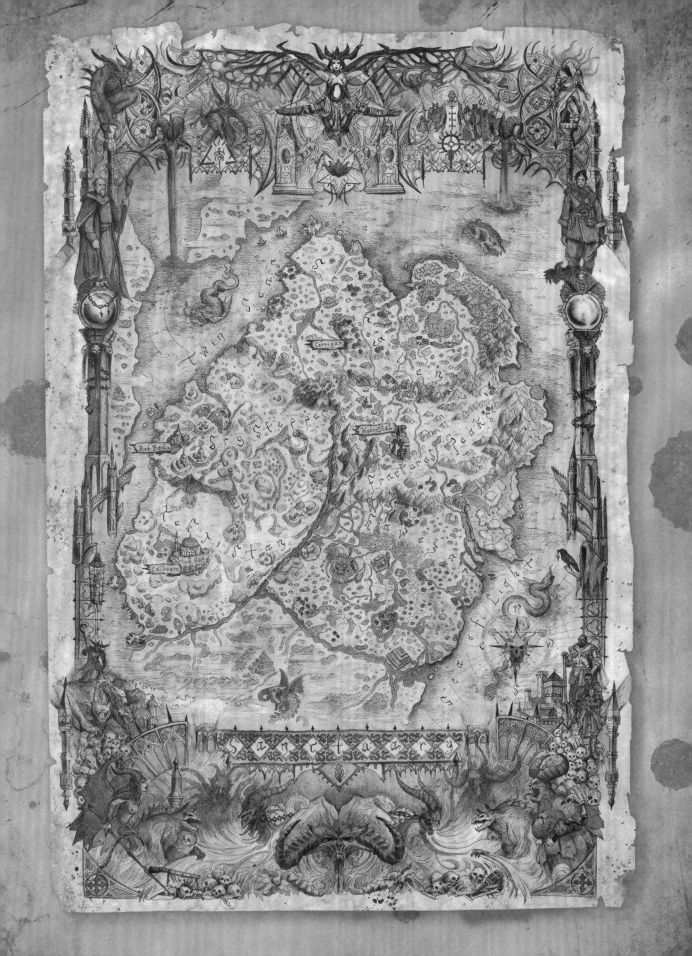

Take Heed

This book should not exist.
And yet, this book __must__ exist.

When I, Lorath Nahr, consider the history of the Horadric Order to which I have belonged, I feel both pride and shame. As a younger man, I dreamed of joining them, even against my father's wishes. He was a soldier and a blacksmith who worked with the hard material of the world at hand. He had little use for ancient knowledge and scholarly tomes. But I admired the Horadrim for their courage, their power, and for what I believed to be wisdom. I trusted in their goodness.

That was a long time ago, and I am now an old man with more scars than I can count. Each one aches from my many years, yet it is the invisible scars that bend my back the most. In the darkest moments of my despair, I have sometimes thought of my father hammering away in the red heat of his forge and wished that I had taken the path he wanted for me. For the Horadrim have not always been wise. Some even turned toward the very evil they had sworn to fight. Nor have I always been wise. ~~I have made mistakes, terrible mistakes that~~

It is possible that my name will be remembered in infamy and I will be spoken of in whispers reserved for the damned. If that should be the case, I cannot object to it. Had I been more observant, had I been stronger, had I seen the betrayal to come, Donan might still be alive. Instead, I sit here in his study, surrounded by his possessions, writing this book.

Some might rightly question how I can risk creating such a volume, knowing as I do now that not even my fellow Horadrim can be trusted with the knowledge I intend to write in its pages. But I see no other way. The Cathedral of Light has seized the Vault, and I don't know what will be left when they are through. The need for this record, therefore, outweighs the danger it represents, even if it were to fall into the wrong hands.

So I write this book for your sake, you who are reading my words. In these pages, you will find a catalog of the many powerful relics scattered and hidden throughout Sanctuary, from the seemingly mundane to the extraordinary. Some objects described herein are imbued with the light of angels, while others burn with the hellfire of demons. Some are weapons, and some are symbols of peace. Some no longer exist, except as memories and ideas. But never forget that all are perilous, each in its own way. I give you this knowledge to arm you for the fight that is undoubtedly before you. That way, when evil finds a foothold and flourishes once again, at least I can say it will not be due to ignorance. That is why this book must exist.

It will be up to those who come after me to decide what the Horadric Order might yet become, broken as it is, or if it is to go on existing at all. Perhaps it will rise once more to its former stature and be again what I admired in my youth. Alas, I will leave such dreams to more hopeful souls than mine. The events of my life have taught me well that evil is inevitable and can never be truly destroyed. It can be banished. It can be thwarted. It can be driven back, but only for a time. I have come to accept that we humans are merely battlefield fodder, trapped between the High Heavens and the Burning Hells in their Eternal Conflict.

There is no escaping this fate.

But I am not a fool, and I will not leave the knowledge in this book unguarded. Recent events have shown me that Horadric codes and ciphers are insufficient when the enemy might come from within our ranks. I have therefore devised new protections. My plan will require a lengthy journey, which I shall undertake as I write, trusting that I will see its conclusion before I die. But I am old, and the road is long.

So let us begin.

Neyrelle,

Fate willing, this book has found its way into your hands, and I hope to be the one who put it there. I write it for you more than anyone else, despite the terrible burden you carry. I know why you have chosen your dark path, and you must follow it where it leads. That is true for all of us. Once, I might have tried to choose your path for you, but no more. You are as aware of my failures in that as anyone, and we both know you wouldn't have listened to me. But I have faith in your goodness, and I pray your strength will prevail against the evil you hold. May our paths cross at least once more. Take care, child.

Lorath

Elias's Finger & Tattoo Chisel

As I sit here in Donan's study, I suppose it is only right that the first relic in this book should be a reminder of my greatest failure. It is one of Elias's fingers (or what remains of it). He severed it during a blasphemous ritual in the Sunken Temple of the Deathspeaker in Hawezar.

Elias was a brilliant pupil, a mage of great talent and promise, and in him I once believed I glimpsed the future of the Horadrim. I did not see the darkness that lurked behind his ambition. I was blind to the signs of his capacity for treachery and evil. But I <u>should</u> have seen these things. If I had been a better, wiser teacher, perhaps he would have found a different path. If I had offered him the great purpose he craved, perhaps I would not be here now, holding these charred bones.

Elias exchanged this piece of his body for immortality. Had we not discovered it, at great personal cost, he would have been unstoppable in his service to the demon Lilith, Daughter of Hatred, an outcome I shudder to contemplate. In the end, he was defeated, and I am left with this relic of his sins *and mine*. I do not know what purpose these bone fragments could be put to. I fear they hold a residue of evil and could yet be the cause of future mischief and suffering.

we will come to that in subsequent pages

This cruel implement now tortures my mind as it once did flesh. Of the many depravities committed by Elias, I am perhaps most haunted by the ritual he attempted to perform on a witch named Taissa, a profane sacrifice that would have allowed Andariel, Maiden of Anguish, to return to Sanctuary. I sometimes hear Taissa's screaming in my dreams, only this time I cannot save her as I did in the waking world. I cannot stop Elias from carving into her, and I must listen to her agony as I frantically search in vain. The chisel is made of heavy iron, and its cutting edge is still gleaming and sharp. Though its shape is simple, there is no grace in its line or form. I have cleaned it, and yet it retains a stain that is not rust. Its bloody inquest imprinted it with the very substance it sought, and this chisel drank deep from the blood of those it violated.

Clear skies today, so went walking with Braega and Yorin up in the hills above the house. Wildflowers grew all around, which delighted B. She gathered a bouquet as we went—some for fragrance, others for cooking and medicine.

Yorin's mind was only half with us, the other part riding high on imagined adventures and triumphs. Like many his age, he desires to be tested, and that is what worries me. I would keep him with me forever if I could, protected and safe, but he is almost a grown man, with his own life to lead. I cannot hold him back much longer.

We passed the day in leisure and joy in each other's company. Finished the evening with a meal and songs. B and Y are in bed now, and their sleep is peaceful. Mine is not. No matter how clear the skies, a cloud hangs over the back of my mind at all times. I cannot forget the evil that lies imprisoned beneath the keep, and I fear what will happen if it is ever set free. This dread has come to torment both my waking hours and my dreams of late. The only rest I find comes from my faith in the Light. Inarius will protect us. After all, I would do anything for my child. I would gladly lay down my life to save his. And are we not the children of Inarius?

Donan's Journals

I did not know Donan well. He was a fellow Horadrim, but other than that commonality, we shared few similarities, either in temperament or philosophy. Though we respected each other as colleagues, I cannot claim to have called him a friend for most of the years I knew him, nor would he have described me as such, until perhaps at the end.

Now he is gone, slain in the depths of Hell, and I sit here in his study, reading from his journals. They are bound in tooled leather worn smooth and almost glossy from frequent handling, and they smell faintly of dried herbs, woodsmoke, and the damp heath that covers much of Scosglen. Some of his writings are of a personal nature, rendered poignant and haunting by his death.

Much of his work, however, is scholarly and quite brilliant. These pages remind me of the reasons for the intellectual distance between us, though I am no longer as irritated by our familiar disagreements. In fact, I rather wish that he were here to tell me once again how my ideas are utter bollocks, and then we could go on bickering over his blind and unwavering faith.

Two things are clear from his journals: Firstly, he possessed a keen and observant mind, and I will gratefully make use of the rich lore his journals contain to fill the gaps in my own recollections. Secondly, he loved his wife and son dearly. ~~I have never married, but I did once love~~ As I read about Donan's life with Braega, I confess to twinges of envy, the wistful regret of an old man revisiting missed opportunities, wondering what might have been.

Grimoire of Ash

In Donan's study, locked away in a small corner chest, I found something unusual. It is a book, notable not only for the fact that someone apparently tried to hide it but also because it seems that someone tried to <u>burn</u> it. The leather binding and many of its pages are caked with soot that I cannot brush or wipe away. I cannot say with certainty what might be written beneath the ash on these pages. The few markings that remain legible unsettle me, for they describe certain places in the Burning Hells as if by one who has seen them and yearns to return.

I am troubled by the fact that someone tried to destroy this book with fire. That it survived the flames intact causes me dread. There is magic upon it, and I cannot discern whether it is blessed or cursed. I suspect the latter. Its unremarkable size and weight and lack of decoration somehow only add to its sinister qualities.

The Realm of Hatred, the glory of Mephisto, touches every grain of sand and drop of blood. Sublime hymns of loathing are carried on the wind there, and at its center stands the Citadel of Hatred, the bastion of its lord. All who stand before its gates cower, overcome by its terrible majesty.

Light a candle,
Cast a
 shadow.
Kindle a fire,
 Darken the
 night.

A common saying in the Western Kingdoms and elsewhere,
which I have heard repeated many times. I see the
Eternal Conflict raging behind these few words.

Eternal Conflict

To the south of where I now sit lie the Fractured Peaks, a mountainous region I recently called home. Even souls who choose to live there know it to be a forbidding and lonely place. To those seeking solitude and privacy, it can be a refuge. It is also a haunted land, scattered with ruins of a distant past forgotten by all save a few. Beneath the icy crags and misty vales, deep underground near the very roots of Sanctuary, there is a road paved with ancient mosaic tile. It is called the Path of the Firstborn, and its imagery depicts the history of our world, which you must know if you are to understand the nature of powerful relics.

For untold eons, an Eternal Conflict has raged between the demonic hordes of the Burning Hells and the angelic host of the High Heavens. Scholars have spilled gallons of ink and spent their eyesight in dim scriptoriums writing and debating how these two factions began and what came before them. Perhaps the tale of the great warrior Anu and its battle with the seven-headed dragon Tathamet is a metaphor. Or perhaps it contains literal truth. Donan believed it to be true, according to his journals, whereas I suspect it is a story crafted to keep angels in a position of eternal primacy over humanity. *Even Tyrael, who was once an angel, described this story as legend.*

Regardless of how the Eternal Conflict came to be, the angelic forces led by the Angiris Council had successfully fought countless battles against the armies of the seven demon lords who sought to conquer all of creation. Though the High Heavens always defeated their adversaries, they also failed to destroy them, allowing evil to return again and again and again. This endless cycle is the reason one archangel, Inarius, eventually concluded that the war could never be won, and he resolved to abandon it. His path eventually brought him before the demon Lilith, Daughter of Hatred, a meeting to which humanity owes its existence.

Inarius and Lilith. Angel and demon.

I wonder if the cosmos had ever contemplated such an unholy alliance and divine union. I wonder if creation shuddered in horror and awe as Inarius and Lilith swayed others to their cause.

Because of this, I have often thought the Eternal Conflict would be better named the Eternal Stalemate.

As they plotted and stole the Worldstone, the Heart of Creation, and used its unimaginable power to shape a new world for themselves, a Sanctuary hidden from their former realms and rulers. As they produced offspring.

The joining of opposing natures within their Firstborn made their children into beings unlike any before—beautiful abominations called Nephalem, from which humanity would one day descend as inheritors of both lineages. The birthrights of the Firstborn graced them with power to resist the evil of the Burning Hells and to defy the dominion of the High Heavens. Because of this, many feared what these children might become.

Surely, Inarius and Lilith could not have foreseen the cosmic consequences of their actions. Nor was their love to last, if their bond could ever be described using such a word. Perhaps what followed simply proved that the Eternal Conflict was and forever shall be inescapable, for even Inarius and Lilith inevitably fought against each other over the fate of their children. In doing so, they ignored one of the plainest and simplest of truths that every human parent knows: children grow up. *Something Donan learned all too painfully.*

Perhaps it was unavoidable that Rathma, eldest of the Firstborn, would refuse the rule of both angel and demon. He led a rebellion that became a war, after which Sanctuary could no longer remain hidden from either Heaven or Hell. That is when the battlefield of the Eternal Conflict shifted to the terrain of the human soul. Since then, we have been caught up in a fight that is not ours, forced to endure incalculable pain and suffering we do not deserve. ~~This knowledge fills me with rage~~ Anger is useless in matters of fate. We are what we are and must deal with what is. That is what the Horadrim were meant to do.

The history of our order begins with Tyrael, who assembled a group of powerful mages. He called these first Horadrim to stand for justice and light, and he tasked them with the defense of humanity against the Prime Evils—Mephisto, Baal, and Diablo—demon lords who were banished to Sanctuary. Many Horadrim have died in service to this cause. Some fell to corruption, such as Elias and others before him. Let their failures stand as a warning that to confront evil is often to be tempted by it.

Soulstones

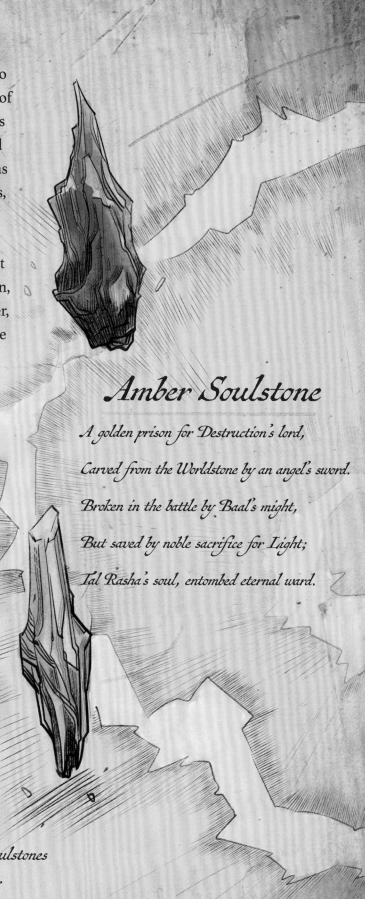

It is said that the Worldstone used to create Sanctuary was once the eye of the great warrior Anu. It was from this mountain-size gem that Tyrael carved the first Soulstones, crystalline prisons for binding and restraining evil spirits, including demons. Donan's journals reflect his curiosity about Soulstones, but ~~I think he showed foolish~~ Without wishing to impugn Donan's reputation, I do believe he was naive in this matter, as he himself learned. Whether we are discussing the first Soulstones given to the Horadrim by Tyrael or later examples fashioned by mortal hands, I believe they are all <u>dangerous</u>.

Tyrael once had a lieutenant, an angel named Izual, who fell to Hell's corruption. Izual claimed to have revealed the nature of the Soulstones to the Prime Evils, a betrayal that essentially handed over the keys of the prison to the prisoners. That is why I cannot put my faith or trust in Soulstones. They will never offer more than the temporary illusion of control over the powers of Hell. And Hell should never be underestimated.

including the latest innovation of the Helliquary

Amber Soulstone

A golden prison for Destruction's lord,

Carved from the Worldstone by an angel's sword.

Broken in the battle by Baal's might,

But saved by noble sacrifice for Light;

Tal Rasha's soul, entombed eternal ward.

I admit that much of my hatred of Soulstones comes from my fears for you, Neyrelle.

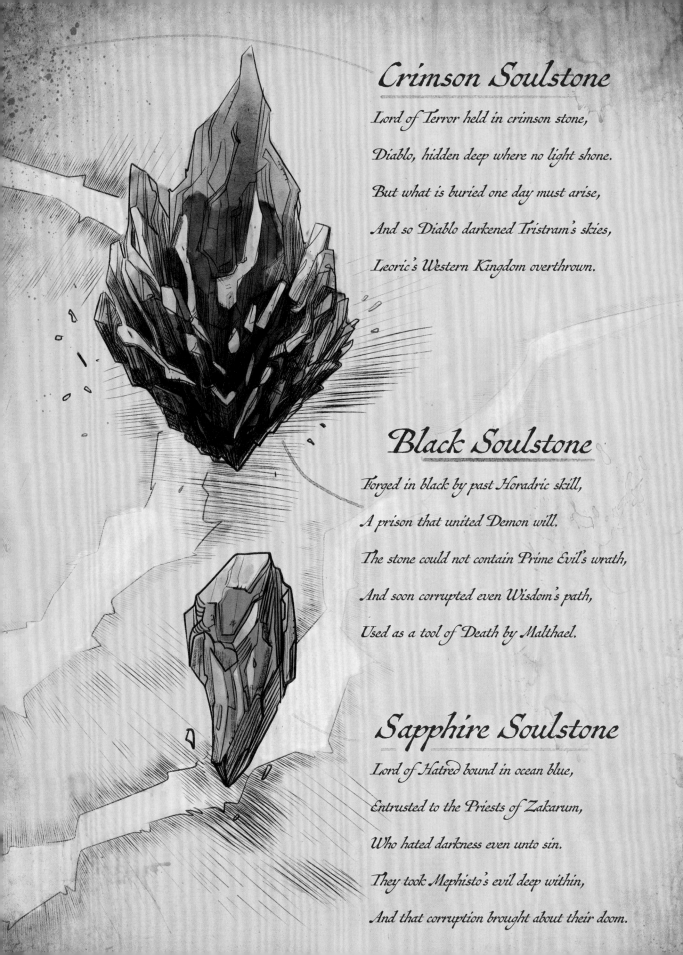

Crimson Soulstone

Lord of Terror held in crimson stone,

Diablo, hidden deep where no light shone.

But what is buried one day must arise,

And so Diablo darkened Tristram's skies,

Leoric's Western Kingdom overthrown.

Black Soulstone

Forged in black by past Horadric skill,

A prison that united Demon will.

The stone could not contain Prime Evil's wrath,

And soon corrupted even Wisdom's path,

Used as a tool of Death by Malthael.

Sapphire Soulstone

Lord of Hatred bound in ocean blue,

Entrusted to the Priests of Zakarum,

Who hated darkness even unto sin.

They took Mephisto's evil deep within,

And that corruption brought about their doom.

WORLDSTONE

Afew more words are needed on the subject of the Worldstone, even though I doubt its nature will ever be fully understood. It has been called the Eye of Anu, and it embodied the endless cycles of birth and death, destruction and creation. Desire to control its infinite power fueled the Eternal Conflict until Inarius and Lilith stole it and brought it to Sanctuary, where the stone eventually became corrupted.

That is why Tyrael used his sword, El'druin, to shatter it.

SHARDS & SPLINTERS

The Worldstone was nearly as large as the mountain that housed it, Mount Arreat, and the cataclysm that followed its destruction left that high peak a crater. The blast also scattered dangerous shards of the Worldstone across Sanctuary.

Some of those shards fell to earth imbued with the power of death, and death followed them. The corruption of the Worldstone tainted even those small fragments, and there were some who attempted to use the shards for evil purposes. A witch named Eskara attempted to summon a powerful demon named Skarn. The Necromancer Lethes sought to wield the power of a shard for herself to gain mastery over life and death. The power of another shard even helped revive an ancient evil known as the Countess, who once bathed in the blood of the innocent and had been defeated before. Brave heroes retrieved these three shards and brought them to Deckard Cain. Even he was unable to destroy them, despite his vast knowledge, without the aid of an angelic dagger. *— I have read that his attempt unleashed demons in his home in Westmarch.*

It is possible there are many of these shards left in Sanctuary, and that is what troubles me. Splinters of the Worldstone might appear in a farmer's field as the earth is tilled, or in a riverbed beneath a swimming child, or in the garden of a cruel lord. Wherever a shard is found, suffering will surely follow. I think it will be the task of any future Horadrim to follow rumors of these shards and splinters and collect them. If these fragments cannot be destroyed, they must at least be contained and hidden by those who understand the true dangers they pose.

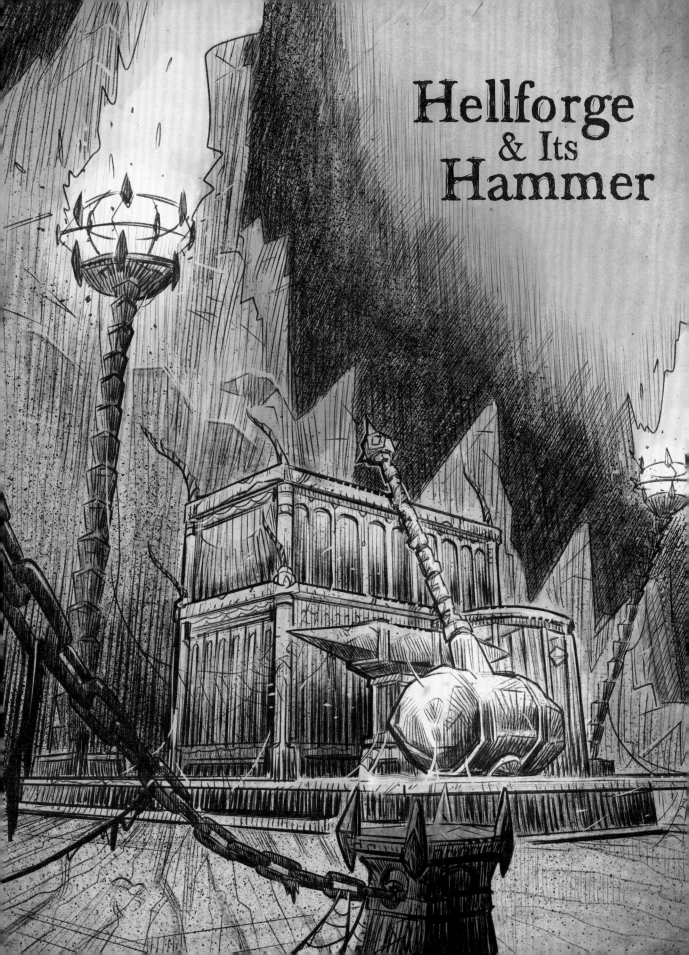

Hellforge & Its Hammer

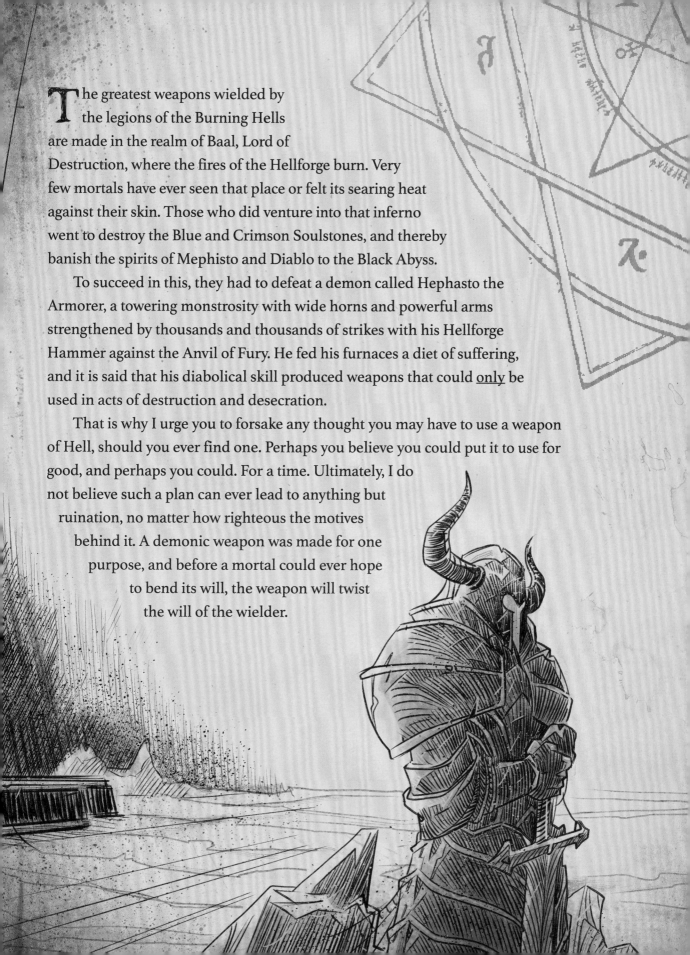

The greatest weapons wielded by the legions of the Burning Hells are made in the realm of Baal, Lord of Destruction, where the fires of the Hellforge burn. Very few mortals have ever seen that place or felt its searing heat against their skin. Those who did venture into that inferno went to destroy the Blue and Crimson Soulstones, and thereby banish the spirits of Mephisto and Diablo to the Black Abyss.

To succeed in this, they had to defeat a demon called Hephasto the Armorer, a towering monstrosity with wide horns and powerful arms strengthened by thousands and thousands of strikes with his Hellforge Hammer against the Anvil of Fury. He fed his furnaces a diet of suffering, and it is said that his diabolical skill produced weapons that could <u>only</u> be used in acts of destruction and desecration.

That is why I urge you to forsake any thought you may have to use a weapon of Hell, should you ever find one. Perhaps you believe you could put it to use for good, and perhaps you could. For a time. Ultimately, I do not believe such a plan can ever lead to anything but ruination, no matter how righteous the motives behind it. A demonic weapon was made for one purpose, and before a mortal could ever hope to bend its will, the weapon will twist the will of the wielder.

MALTHAEL'S CHALICE

According to most texts, Malthael was the oldest member of the Angiris Council of Archangels and was once entrusted as its leader. Within the borders of his domain in the High Heavens lay the Pools of Wisdom. Their waters flow with the sum of all emotion and passion in creation, and it is from those wells that Malthael filled Chalad'ar, his Chalice of Wisdom. I have often wondered what happened to his mind in the countless hours he spent gazing into its basin. What did he see that convinced him to forsake his Aspect of Wisdom for the Aspect of Death? What caused him to embrace destruction as his purpose?

I do not wish to believe that any true wisdom led him down the path he chose. Nor do I need to look into a bowl of water to scry my own mortality. I know that death is inevitable, but that knowledge leads me to merely accept death, not to embrace it. Death may be the end, but it is not the answer. Or as it is written in <u>The Gospel of Death</u>, our mortality isn't earned—it simply <u>is</u>.

I have never looked into Malthael's Chalice. If it is like other vessels, the water's surface will function as a mirror as well as a window. As the ravages of the Eternal Conflict took their toll on Malthael's mind, as they must have, it is natural that his pain and doubt would be reflected back at him when he stared into Chalad'ar. I believe he poisoned the source of his wisdom with his own despair.

Beware the fortune teller who knows your fears. Avoid chalices. Live as if you will die.

OF WISDOM & SCYTHES

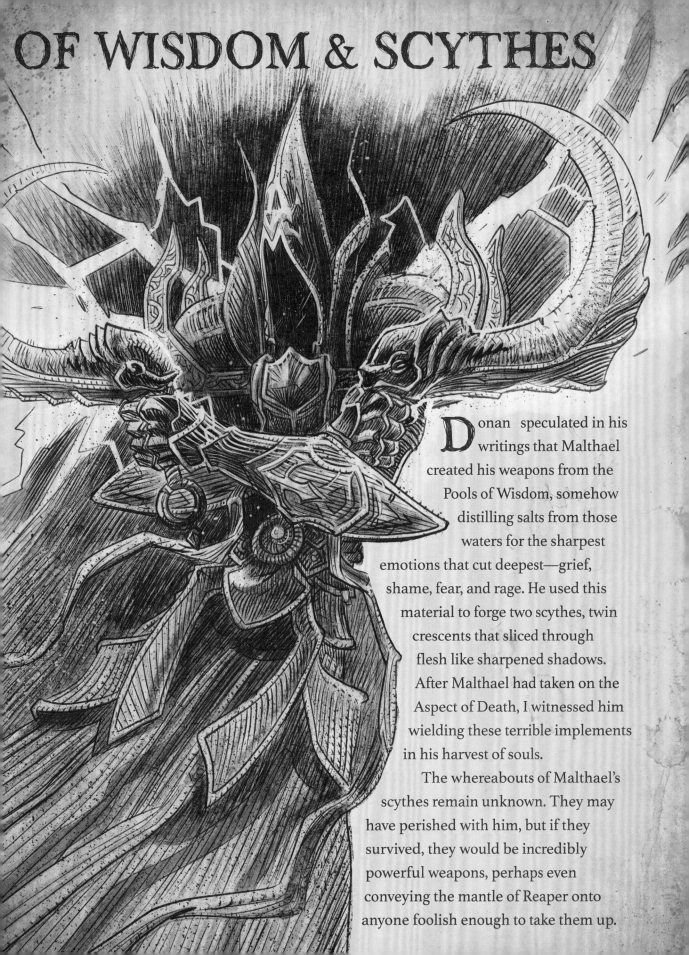

Donan speculated in his writings that Malthael created his weapons from the Pools of Wisdom, somehow distilling salts from those waters for the sharpest emotions that cut deepest—grief, shame, fear, and rage. He used this material to forge two scythes, twin crescents that sliced through flesh like sharpened shadows. After Malthael had taken on the Aspect of Death, I witnessed him wielding these terrible implements in his harvest of souls.

The whereabouts of Malthael's scythes remain unknown. They may have perished with him, but if they survived, they would be incredibly powerful weapons, perhaps even conveying the mantle of Reaper onto anyone foolish enough to take them up.

Tyrael's Sword

Standing in opposition to weapons of darkness are weapons of light. Tyrael's sword, El'druin, Sword of Justice, is one such blade. The shape of its golden hilt evokes the image of an archangel's wings spread wide, or perhaps the rays of the rising sun over the horizon. A crystal shines at its center, glowing with the radiance of the heavens. Some writings claim that its edge can cut through any substance or barrier but will not harm the righteous. *I never asked Tyrael if this is true.*

When Tyrael renounced his angelic nature and fell to earth as a mortal, El'druin fell with him, breaking into three lost pieces. The quest to recover those fragments cost the life of the venerable Deckard Cain—in his final living act, that aged Horadric mage repaired the sword. For this deed and for many, many more, I believe history will judge Cain as standing among the greatest Horadrim, representing the best of what the Horadric Order can be. *I am certain Cain would rebuff such a description of himself.*

It must be said that I likely owe my life to El'druin. In that first confrontation with Malthael, as others fell and died, I was spared behind a magical shield that Tyrael raised using his sword. Therefore, let it be known that what I write next is not intended as an expression of ingratitude.

A wealthy man once came to my father and asked him to forge a sword. He paid well for a blade of the strongest steel, with the sharpest edge, and a wicked gleam. Something about the man's demeanor unsettled my father, which I had rarely seen. He asked the stranger who he intended to kill with the sword, and the wealthy man replied that he only wanted the weapon to defend himself.

"Friend," my father said, "no one carries a sword unless they expect to use it."

I have never forgotten those words, and at times that memory leads me to wonder why the Heavens carry a sword. Do eternal blades defend against Eternal Conflict, or do they bring it about?

Yl'nira

Yl'nira, the Edge of Temperance, was a dagger, and according to one account, it originally belonged to an archangel who followed Inarius to Sanctuary. It was later given to that angel's Nephalem child and eventually came to be hidden in the Temple of Namari, on a jungle island south of Aranoch known as the Bilefen. It was an elegant blade, decorated with delicate inlay and filigree. In the midst of its ornamentation stood a golden hooded figure, peaceful and mysterious, bearing a glittering jewel of pale blue in its arms.

A dagger and a sword are very different things. A sword has but one purpose, whereas a dagger is much more than a weapon. It is a <u>tool</u>.

Yl'nira wasn't known for the demons it slew, nor for the glorious battles it won. It was put to different uses. Its light was carried into Hell to destroy the ghastly Pits of Anguish in which demons spawned. Deckard Cain wielded its power to shatter the dangerous Shards of the Worldstone. As a weapon, some might say that Yl'nira accomplished little. As a tool, that dagger may have saved Sanctuary. Let it therefore serve as a reminder that there are many ways to defeat evil. Do not be too quick in dismissing the humblest of tools or the smallest of allies, even the ones that seem the least deadly. Seek only to be useful.

Itherael's Scroll

Talus'ar. The Scroll of Fate.

This relic is used by the archangel Itherael, the keeper of lore in the High Heavens. His domain contains the Library of Fate, and the tomes housed therein contain histories upon histories, and knowledge within knowledge. The Scroll of Fate is reportedly a manifestation of the whole library, the sum of Heaven's vast intelligence. And yet, it failed to mention the Nephalem, a startling omission of fateful significance.

It seems that even the Scroll of Fate could only reveal what the angels already knew and understood. They did not anticipate the Nephalem, so neither did the scroll. I do not doubt the extraordinary power of Talus'ar. But it is not infallible.

In writing this book, I have thus far referred to the writings of Cain and Donan and other texts as sources. Perhaps that gives my words added weight or makes them seem more trustworthy. However, what if Cain and Donan were wrong in what they wrote? Worse yet, what if they intended to deceive? We would be wise to remember that the map is not the territory. Books and scrolls are not the same as knowledge.

Including <u>this</u> book!

GATES OF HELL

While a gateway is often built to protect against invaders, there are few mortals to whom the Gates of Hell would be closed. The evil that lies beyond will welcome almost any soul who voluntarily enters. If that soul is still clothed in a physical form, the flesh of that body will be stripped and rendered to adorn the walls, which are strung with the dismantled remains of innumerable victims. Cracks and fissures in the uneven ground around the gates exhale a poisonous miasma, the rank effluvia of unspeakable filth and degradations. The deafening wails, screams, and roars that stab the ears can cause madness in the same moment they are first heard. The ramparts seem to rise to the height of mountains, built of stones on which are carved repulsive and forbidden runes, as though each rock received its own curse as it was laid. The gates of iron were built to withstand the onslaught of angels and to cause the heavens to quake. They stand with cruel defiance that would gladly see the entire world destroyed before suffering defeat.

But they are not the only gates to the only hell. Many of us walk through more subtle portals into our own personal hells, often without realizing it until it is too late. Once there, we do not need demons to torture us, for we do that to ourselves with implements such as shame and self-hatred. None can free us, and those who love us can often only stand by and watch as we suffer, as though we have dragged them with us into the hells of our making. I would like to believe that if all the gates to all the hells were as terrible and obvious as the Gates of the Burning Hells, no one would walk through them. Yet I know there will always be souls so lost they feel unworthy of any other place.

& HELL RIFTS

There is a verdant Garden of Hope in the High Heavens, the domain of the archangel Auriel. Flowers bloom there eternally, scenting the air with soft perfume while music fills the soul with celestial harmonies. Mortals who have experienced the beauty of this garden describe an almost intoxicating tranquility, one in which the mind can become lost, forgetful, and complacent. Perhaps that is why Diablo, empowered as the Prime Evil, chose the Garden of Hope as an entry point during a siege against the High Heavens. By opening Hell Rifts there, he used our hope against us.

I wonder, can a demon's mind see hope as anything but a weakness? It seems Diablo thought our hope would be our undoing, and it almost was, so perhaps the Prime Evil was not entirely wrong in his strategy. It was only by the strength of the Nephalem that the Hell Rifts were closed and Diablo was defeated, saving creation once again. But what if the Nephalem had failed?

~~It is best not to hope~~

~~You must always have hope~~

I will say only this: take hope as nourishment when needed, but do not subsist on it alone, lest you become drunk on its reassurance and made vulnerable by its promises. To hope for salvation while doing nothing to attain it brings only ruin.

Demonic Relics

The rebellion in Hell that saw the Prime Evils exiled to the mortal plane also left them incorporeal. For any of the three to take physical form now requires a body for their spirit to possess. Over time, the presence of the demonic entity will corrupt the victim's human flesh, twisting it into a grotesque simulacrum of the Prime Evil's physical form. When this abomination is defeated or destroyed, the entity is banished once again from the material world, leaving behind whatever remains of its dead and mangled shell. Just as some venerate and utilize the teeth or finger or femur of a sanctified corpse, so others make use of the profane leavings of demons.

When I consider these relics and their uses, I cannot help wondering if anything of the human hosts does remain, hidden deep within them. When the Horadrim exploited the magical properties of an object like the horn of Diablo, did its power come from the demon's essence? Or did it arise from a lingering residue of the host's righteousness, however faint? Or is it perhaps the combination that matters, the synthesis of natures that once granted the Firstborn their tremendous power?

Brain of Mephisto

The Lord of Hatred left this gelatinous relic behind. Many think hatred sits in the heart, but it begins in the mind, with thoughts and stories whispered into our ears, like worms that wriggle and gnaw their way inward and leave us infested. Mephisto's Brain reminds us that all are vulnerable to the corrupting influence of hatred, even those who believe they are engaged in righteous work.

Eye of Baal

The Eye of Baal was a ghastly reminder of what the Lord of Destruction saw when he looked at our human world—and what he wanted to do to it. I was not at the Barbarian city of Sescheron when Baal laid siege with his armies, though I have read accounts by the few survivors of that assault. They describe the Prime Evil atop his litter, surveying the city with ravenous malice and an insatiable lust for destruction. His vision for Sanctuary was of a wasteland stained with blood.

Horn of Diablo

Diablo's horns are sharp enough to pierce and gore, though anyone so injured would be wise to pray the wound is swiftly fatal. If not, the tainted gash will fester and rot from the inside out, giving the body of the injured over to maggots and hellish parasites long before death ends the feverish agony. Diablo's whole body bristles with vicious, bony spikes. Even a relic of one of his lesser horns would be enough to cause terror.

Cursed Pillar

I have put off talking about this subject long enough, and I should know better. I have enough experience with pain to have learned that suffering is made worse by attempts to avoid it. In this moment, it is the memory of Donan's death that I resist.

In our quest to stop Lilith, we traveled through a gateway in the ancient city of Caldeum, into the Burning Hells. The darkness there can be as difficult to describe as the blinding light of the High Heavens. The mind can scarcely comprehend the gruesome blasphemies encountered, and I hope no other mortal will ever be called to venture there again. But if that should be your path, I urge you to remember that the very walls are alive with malice.

We had taken shelter in a small cavern. The dank air in that chamber clung to us with the smells of a charnel house and a fetid swamp. Ranks of tall columns surrounded us. At one point, Donan heard wet, squelching movement in the shadows, and he recklessly, foolishly went to investigate alone. He discovered that the pillars standing over us had been sculpted from demonic tissues and animated by foul magic. They uncoiled tendrils lined with teeth and jagged barbs. One of these feral claws ripped into Donan's belly, a mortal wound, but he lived long enough to warn us of the danger. Had he not found the strength to endure until then, we might have perished with him. All would have been lost. As it was, the fight cost us dearly.

I wish now I had paid more attention to what Donan was doing. I wish I had urged him to be more cautious. Such thoughts are the self-torture of memory, and I suspect he would have ignored me. I have come to believe that Donan's grief at being preceded to the grave by his wife and son may have led some part of him to seek his own death.

Against the cruel
and lashing wind,
against the howling
winter hounds,
the Druid college
towers stand
upon the hard and
bitter ground.

A stanza from a Scosglen folksong. This land is haunted in a way I have not felt in other regions of Sanctuary. In the middle of the night, unearthly wailing can be heard off in the cold mists that shroud the moors. Werewolves stalk the gloom beneath the dense forests. Khazra goatmen gather to waylay travelers and raid unprotected settlements. Amidst these threats, the Druid colleges hold fast, bulwarks against the encroaching wilds. At Túr Dúlra, the greatest of the colleges, there is an ancient oak tree named Glór-an-Fháidha. The Druid reverence of this tree speaks to their deep connection with the other-than-human world. Were it not for the influence of Hell, perhaps those who call Scosglen home could live in greater harmony with the other beings who share this land.

Painting of Donan, Airidah, & Nafain

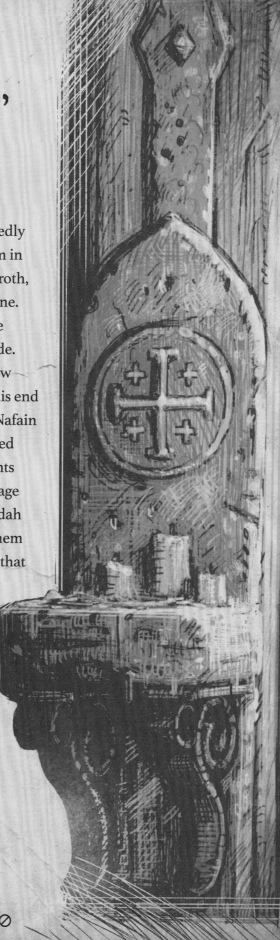

There is a painting hanging near me in Donan's study. It depicts him with two Druids, Airidah and Nafain. It was undoubtedly commissioned to recognize the trio's heroism in defending Scosglen against the demon Astaroth, whose essence they imprisoned in a Soulstone. Donan was a humble man, but I imagine the painting gave him joy, and possibly even pride.

All three of the painting's subjects are now dead and gone. Tragically, only Donan met his end with his honor and soul intact. Airidah and Nafain both succumbed to temptations that unraveled their legacies and undid the very achievements commemorated by the painting. Now the image only serves to remind the viewer of who Airidah and Nafain once were and what became of them at the end. In that way, it is a cautionary relic that feels almost haunted, or cursed.

Do not assume that because you have achieved greatness or performed good deeds in the past that you are immune to evil's seduction. Do not believe the lie that you are above sin. Even the most righteous may fall, given the right push in the wrong direction.

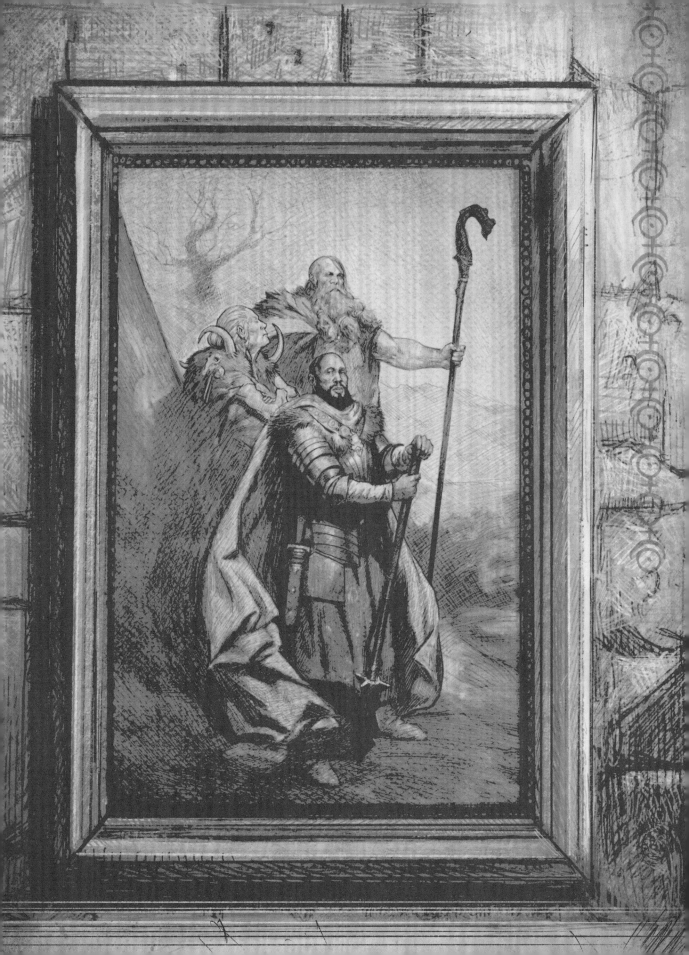

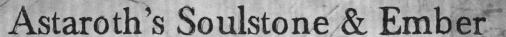

Astaroth's Soulstone & Ember

The battle commemorated by the painting took place decades ago. Although not a Prime Evil, Astaroth was nevertheless a powerful foe, and Donan showed great courage in confronting him, as did Airidah and Nafain.

The trio succeeded in imprisoning Astaroth in a chamber beneath Eldhaime Keep, which was guarded by the Knights Penitent of the Cathedral of Light. Donan naively put his faith in the Cathedral, and more so in the angel Inarius, whom the church venerates above all others. Those safeguards were not enough to stop Lilith, however, and with the help of Airidah and Nafain, she freed Astaroth from his Soulstone prison. In return for his liberation, Astaroth gave Lilith an ember that granted her passage through places in Hell forbidden to even one such as her.

Though I know from reading Donan's journals that it was his idea to use a Soulstone to trap the demon, for good and for ill.

Druidic Talisman

The <u>Scéal Fada</u> is the holy text of the Druids. It tells the long story of their history, which reaches back to the Firstborn in Sanctuary. According to legend, the Druids were once part of the northern tribes at Mount Arreat. They left behind the martial ways of that Barbarian life when a man named Vasily led a small group of warrior-poets into the forests to seek unity with the land. There they practiced a creed of harmony with the natural world, and through their devoted study developed a powerful kinship with the living beings around them. In time, they even learned to communicate with the animals and plants.

This relationship is symbolized by the talismans that Druids carry and wear. Some of these emblems will look like little more than morbid scraps and trinkets to outsiders. Skulls and bones, teeth and claws, feathers and furs all speak to the communion between the Druid and the living world. In Scosglen, they place their faith in the ground beneath their feet more than they will ever trust the High Heavens. The Druids have little use for angels, which is why they take a dim view of the Cathedral of Light and its proselytizing efforts within their borders.

For some time, the Druids tolerated the presence of the church, but with the Knights Penitent marching across the moors, some are restless to see the Cathedral gone. For its part, the church views the Druids as primitive and superstitious. They see no Light in the deep forests, the highlands, the colleges, or in the talismans the Druids wear.

Conflict was and is inevitable.

In Scosglen, they talk of the leader Fuada-Géar. This is confirmed to be Vasily.

Airidah's Talharpa

The beauty of Scosglen is stunning and stark. Above its deep woodlands, bare fells rise with an ancient grandeur, as if they were once monumental statues of the titans that stride Pandemonium. Countless years of wind and rain and ice have worn them down to crouching, bald mounds. Wiry grass and heath grow in their folds, and heavy mists fill their glens. Many who wander in those highlands are never seen again, and those who return speak of voices calling to them, luring them into the fog. Some are no doubt led over the edge of some precipice and dashed on the rocks below. Others are taken by wraiths and vengeful spirits. Still others are rumored to be swallowed by the earth itself.

The folk here say that the Druid Airidah could summon this haunted mist with her talharpa, a bowed lyre with strings of twisted horsehair. The instrument's mournful melodies carried over the hills and down into the valleys, akin to a fiddle, but more primitive, singing of loneliness and loss. The mist its music accompanied seemed to reflect the state of Airidah's mind. A dense fog of fear and doubt made her vulnerable to Lilith's false promises, a failing that cost her life and many others. Airidah wanted to strengthen her people, except she was blind to her own weakness.

Years from now, when I think back on my time in Scosglen, I will hear the eerie cry of Airidah's Talharpa in my memories. The instrument survived her death, yet I do not know its present whereabouts.

Weeping Cairns

The entrance to this ancient Druid burial complex can be found above the village of Braestaig in the Scosglen Hills. Its stone doors are sealed by powerful runes, and only by chanting the proper incantations will they open. Doing so may draw forth the unquiet dead whose spirits linger in the tombs, so any trespassing there should be undertaken only out of the greatest necessity. The Druids buried in that place were heroes of legend, worthy of honor in death. They can be roused to anger if their resting place is defiled, as it was by Airidah and Lilith. The bodies of intruders who ignore these cautions may be added to the collection of desiccated corpses that fill the chambers and corridors of the Weeping Cairns. Do not blame the dead for this. Blame the living who have lost respect for the dead.

Cairn Wardstones

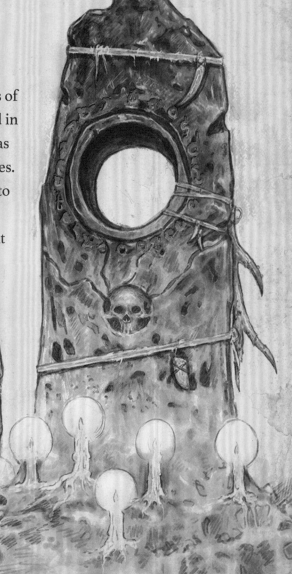

These ancient monoliths rise like the very bones of Scosglen, carved from its gray rock. They stand in silent vigil within the Weeping Cairns, empowered as sentries by runes chiseled across their impassive faces. The builders of those tombs placed the wardstones to guard the resting spirits of the dead, although Lilith and Airidah corrupted even these protections so that they barred passage through the tombs and incited the ghosts to vengeance.

That is the power of evil. The demons of the Burning Hells would see every noble deed, every righteous act, all goodness in Sanctuary twisted to their vile purposes. Nothing is sacred enough to be safe. Nothing is so pure that it stands beyond their ability to desecrate it.

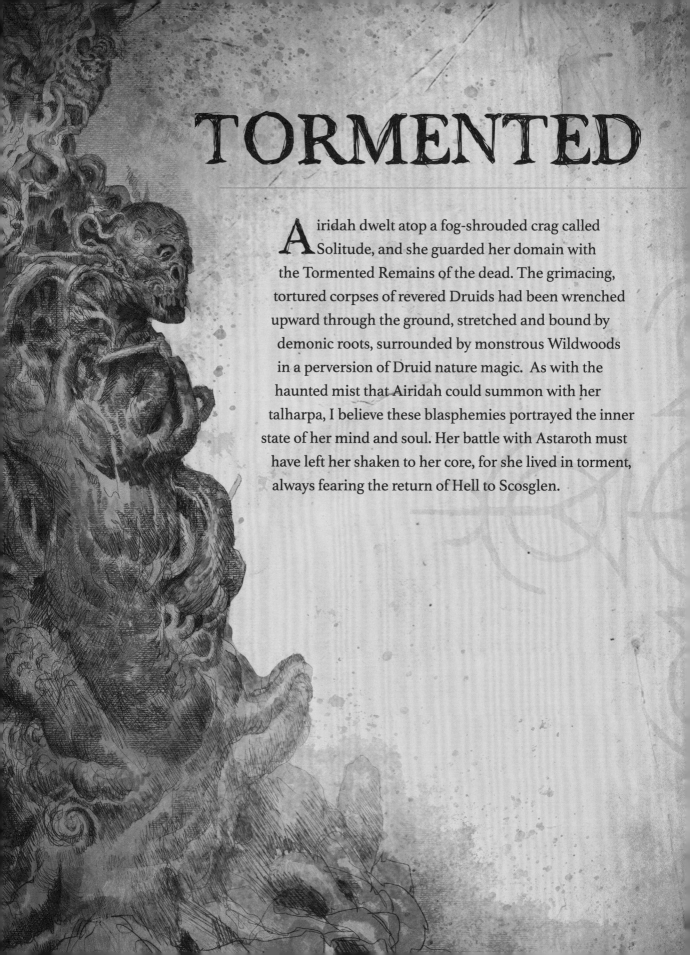

TORMENTED

Airidah dwelt atop a fog-shrouded crag called Solitude, and she guarded her domain with the Tormented Remains of the dead. The grimacing, tortured corpses of revered Druids had been wrenched upward through the ground, stretched and bound by demonic roots, surrounded by monstrous Wildwoods in a perversion of Druid nature magic. As with the haunted mist that Airidah could summon with her talharpa, I believe these blasphemies portrayed the inner state of her mind and soul. Her battle with Astaroth must have left her shaken to her core, for she lived in torment, always fearing the return of Hell to Scosglen.

REMAINS

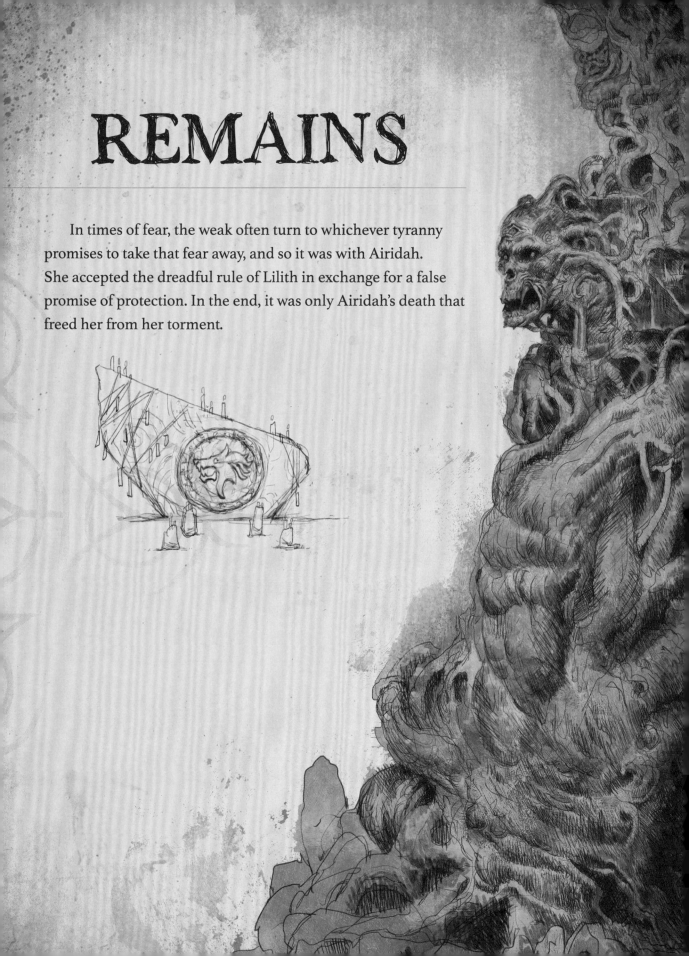

In times of fear, the weak often turn to whichever tyranny promises to take that fear away, and so it was with Airidah. She accepted the dreadful rule of Lilith in exchange for a false promise of protection. In the end, it was only Airidah's death that freed her from her torment.

Nafain's Tree & Spear

Like Airidah, the Druid Nafain succumbed to Lilith's manipulations. To rid his lands of the Cathedral of Light, he accepted the help of shadow and darkness. But Lilith used his hatred and anger for her own ends, and like Airidah, Nafain gave Lilith what she needed to free the demon Astaroth from his Soulstone. In reward for his service, Lilith impaled Nafain on a tree. But this violence did not kill him. Her ritual left him alive in agony as he watched his own blood pour out of him to nourish a gestating beast. Nafain finally begged for death to end his suffering, and he found it at the point of his own spear. I believe the tree from which he hung remains standing. If so, it may be scarred forever by Lilith's magic, marked as a demon-tree, and best avoided. Living things that taste human blood often crave it ever after.

The shaft of this weapon is made from gnarled and ancient bog oak that was hardened and blackened by many centuries spent buried in peat beneath the moors. Runes carved along its length add to its strength and grant it other magical properties expressly for Druidic purposes. Charms of ivory and fragments of carved bone hang from leather cords wrapped around the wood. A ring of wolf teeth surrounds the base of the spear's curved blade, which was forged from strong steel, embossed with a wolf's head, and further imbued with runes.

What I cannot say is whether this weapon will carry the blessing of Nafain as he was or the curse of Nafain as he became. This may be the weapon of a legendary hero or the spear of a traitor. Perhaps it needs a new warrior to wield it, one who will rewrite its legacy.

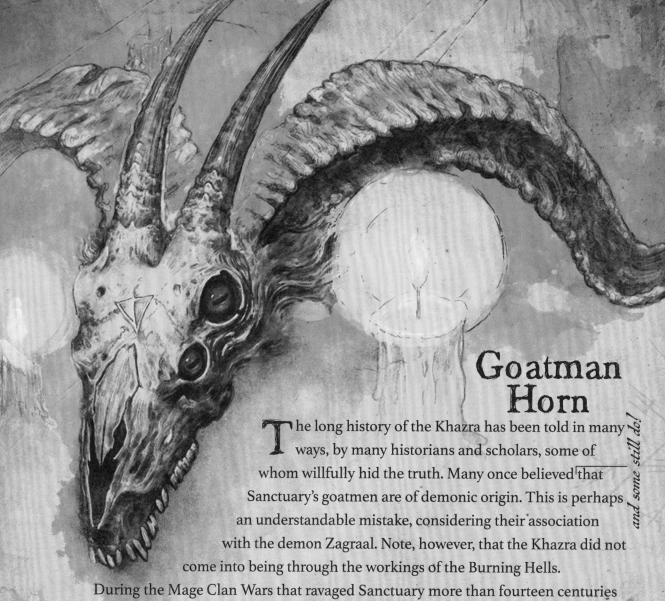

Goatman Horn

The long history of the Khazra has been told in many ways, by many historians and scholars, some of whom willfully hid the truth. Many once believed that Sanctuary's goatmen are of demonic origin. This is perhaps an understandable mistake, considering their association with the demon Zagraal. Note, however, that the Khazra did not come into being through the workings of the Burning Hells. *and some still do!*

During the Mage Clan Wars that ravaged Sanctuary more than fourteen centuries ago, the Vizjerei Clan sought to build an army capable of swarming their rivals. They subjugated a peaceful people known as the Umbaru and reshaped them using the darkest of magic. The Umbaru became the Khazra, half human, half goat, and possessing prodigious strength and ferocity. As is often the case with such creations, these new beasts proved to be more strong-willed and intelligent than their creators anticipated or intended, and the Khazra rebelled against the Vizjerei.

Today, goatmen can be found in most regions of Sanctuary, living examples of the way hubris can lead to undoing and downfall. The Vizjerei created the Khazra, and had the Khazra hunted that mage clan to the very last sorcerer, they would still have only reaped what they, themselves, had sown. Let that be a lesson to those who would use dark magic. *Even in the service of good.*

Yorin's Mace

orin was Donan's son. I did not know him well, but he seemed a capable lad who showed great courage. Without hesitation, he risked his life defending the villages of Scosglen, including Braestaig, and willingly entered the Weeping Cairns on Airidah's trail. As alluded to in Donan's personal journals, Yorin strained against his father's efforts to keep him safe, believing himself a man, ready for more responsibility and challenges. Indeed, Yorin was more prepared than most to confront demonic forces. It wasn't enough.

Though Donan tried to send his son away from the battle with Lilith at Eldhaime Keep, she slew the Knights Penitent who were with Yorin and took the boy captive. The finding of Yorin's Mace granted Donan a brief, cruel hope for his son's survival, but this proved futile. Lilith had chosen Yorin as the host for Astaroth's essence and drove the Soulstone into the boy's body. Donan believed his son strong enough to resist the influence of the demon's spirit, and I think it is possible that the youth held out longer than many others could have. ~~No one can resist the evil of a demon forever.~~ By the time Donan caught up with his son at Cerrigar, the corruption was complete. Though Astaroth was defeated once again, the boy could not be saved.

Yorin's Mace was a gift from Donan to his son, and it is not of Druid make. Donan wrote in his journals that he acquired it from a merchant, who claimed it had come from the desert tombs outside Lut Gholein. Nothing about the mace leads me to doubt this story. In shape, it is a war hammer, forged from a mysterious alloy. The weapon appears quite ancient, and it possesses a lethal grace that allowed even a warrior as young as Yorin to wield it. Unlike a weapon such as Nafain's spear, I do not believe there is any chance of it being cursed, for Yorin kept his honor until the end.

For your sake, Neyrelle, I have to believe that such evil can be resisted.

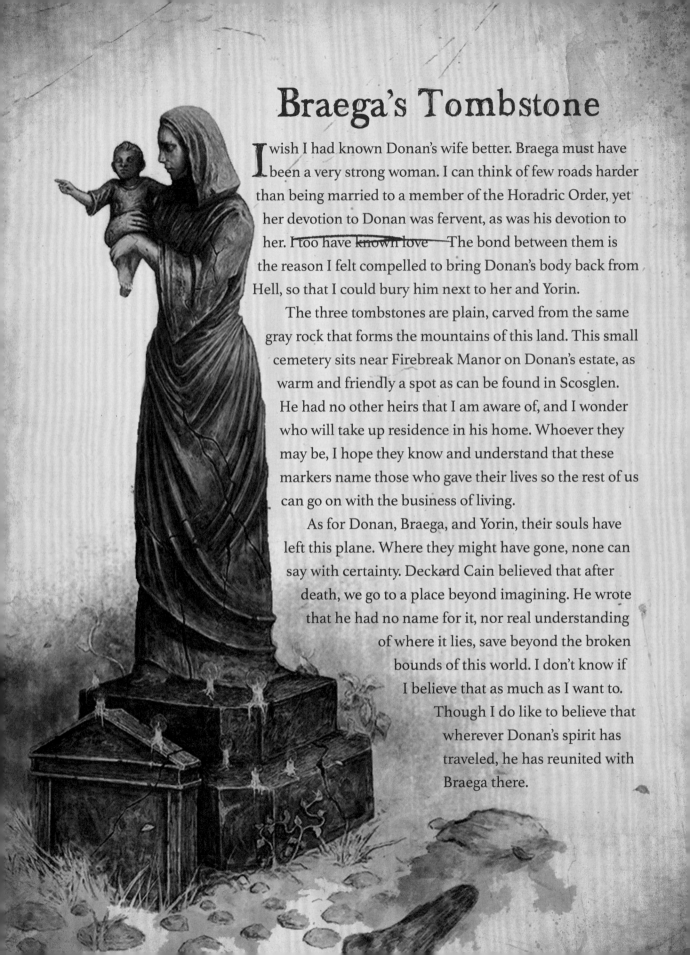

Braega's Tombstone

I wish I had known Donan's wife better. Braega must have been a very strong woman. I can think of few roads harder than being married to a member of the Horadric Order, yet her devotion to Donan was fervent, as was his devotion to her. ~~I too have known love~~ The bond between them is the reason I felt compelled to bring Donan's body back from Hell, so that I could bury him next to her and Yorin.

The three tombstones are plain, carved from the same gray rock that forms the mountains of this land. This small cemetery sits near Firebreak Manor on Donan's estate, as warm and friendly a spot as can be found in Scosglen. He had no other heirs that I am aware of, and I wonder who will take up residence in his home. Whoever they may be, I hope they know and understand that these markers name those who gave their lives so the rest of us can go on with the business of living.

As for Donan, Braega, and Yorin, their souls have left this plane. Where they might have gone, none can say with certainty. Deckard Cain believed that after death, we go to a place beyond imagining. He wrote that he had no name for it, nor real understanding of where it lies, save beyond the broken bounds of this world. I don't know if I believe that as much as I want to. Though I do like to believe that wherever Donan's spirit has traveled, he has reunited with Braega there.

Prava's Decree

The Reverend Mother Prava leads the Cathedral of Light. Even now, after the devastating failure of her Knights Penitent to stop Lilith, and after the death of Inarius, she continues to preach with the same fervor. Unless she truly is a mindless fanatic, I can only conclude that something other than faith compels her.

Her zeal and jealousy have led her to issue a decree in which she has the hypocritical audacity to blame the Horadrim for Lilith's resurgence. Consequently, we are to be eradicated. This might prove inconvenient if the Horadrim still existed in a substantive way, but it is no more than a minor irritation. The Cathedral has not yet attained the kind of power it would take to carry out such a decree, and the Horadrim still have many friends. That said, to completely ignore Prava and the Cathedral would be foolhardy. She is a formidable adversary who may yet find ways to cause damage and suffering.

The most obvious motivations would be pride, gold, and power.

The Horadrim have used their dark magics to bear a great evil into our world.

Commit their wicked souls to the father and retrieve the Soulstone.

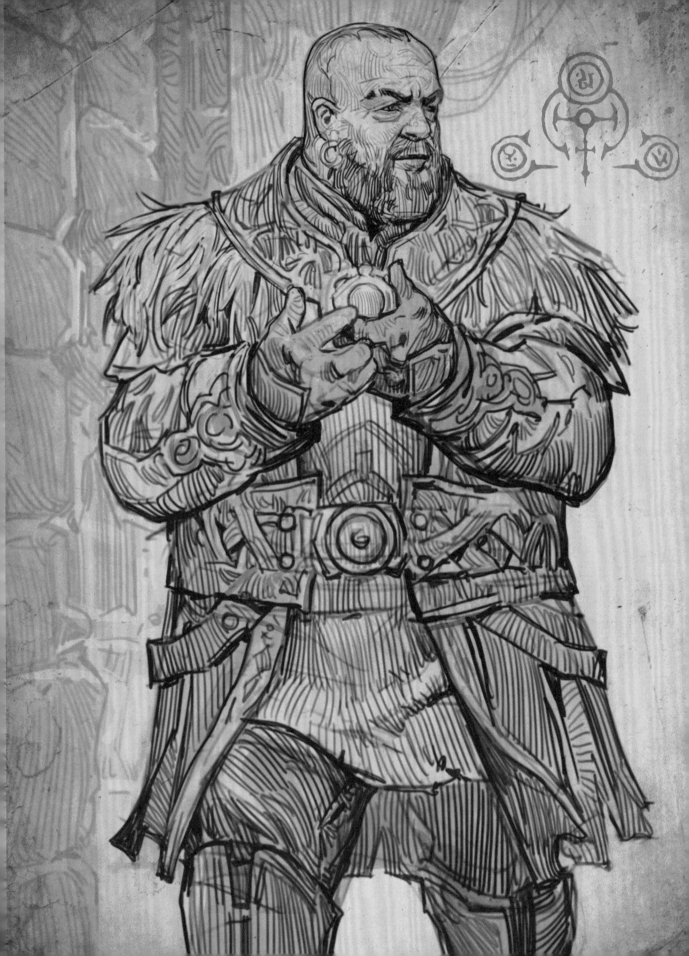

Donan's Fur Cloak & Clasp

Though Donan was not a Druid, he did live among them and wore furs after their kind. His cloak of wolf pelts recalls their nature magic of shapeshifting, and it is well suited to the climate of Scosglen. It keeps out the biting wind and rain, and it warms against the cold mist. The fur has been rubbed away in places from heavy use. It carries at least one burn mark, where I imagine Donan sat too close to the fire on some frosty night. There are many bloodstains, some brown and old, some new. They speak loudly of Donan's valiance, and I will not silence them by trying to clean them.

To the south, in the cities of Kehjistan, Horadrim of the past wore fine embroidered robes that smelled of rare and costly incense. Donan's cloak smells of musk, leaves, and woodsmoke, and the crude stitching has been repaired many times over. It is a humble garment, and yet I believe Donan felt pride when he wore it.

A bronze clasp holds the cloak in place about my shoulders, which Donan must have had made custom by a local blacksmith. It combines the Horadric symbol with a Druidic wolf's head, and the workmanship is quite fine.

I will wear both as I go forth on my journey, as personal talismans. The cloak will defend me well against the elements as I travel south from Scosglen into the Fractured Peaks. More importantly, it will help me remember all that Donan gave. Even before his death, he had lost everything: his wife, his son, and finally his faith as he witnessed the failure of Inarius and the Cathedral. His sacrifices must not have been in vain.

It is time for me to begin my journey. Before I depart, there is another relic I must acquire.

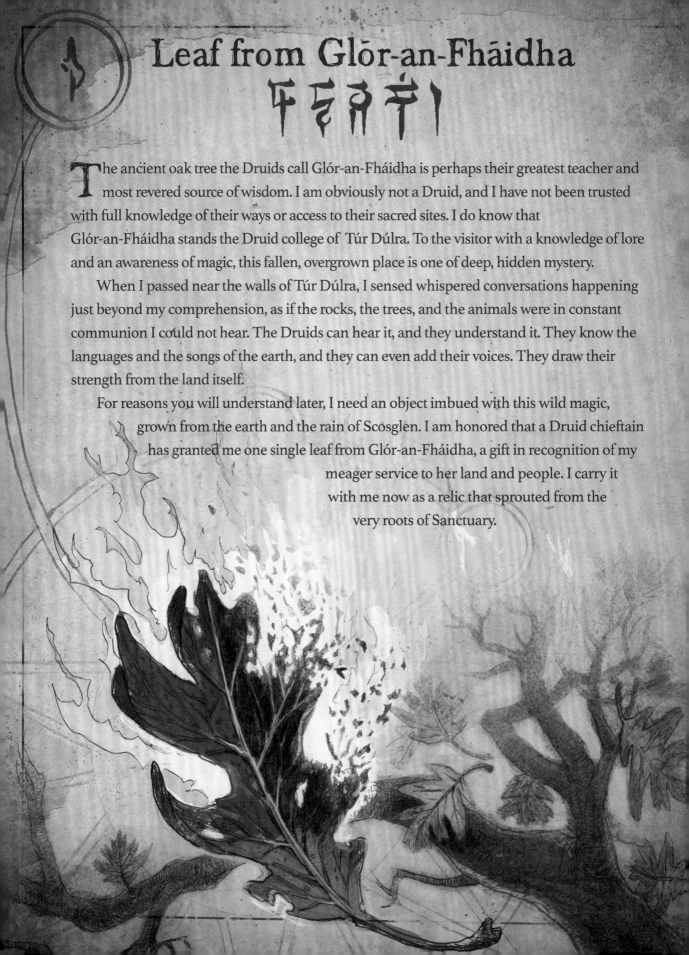

Leaf from Glór-an-Fháidha

The ancient oak tree the Druids call Glór-an-Fháidha is perhaps their greatest teacher and most revered source of wisdom. I am obviously not a Druid, and I have not been trusted with full knowledge of their ways or access to their sacred sites. I do know that Glór-an-Fháidha stands the Druid college of Túr Dúlra. To the visitor with a knowledge of lore and an awareness of magic, this fallen, overgrown place is one of deep, hidden mystery.

When I passed near the walls of Túr Dúlra, I sensed whispered conversations happening just beyond my comprehension, as if the rocks, the trees, and the animals were in constant communion I could not hear. The Druids can hear it, and they understand it. They know the languages and the songs of the earth, and they can even add their voices. They draw their strength from the land itself.

For reasons you will understand later, I need an object imbued with this wild magic, grown from the earth and the rain of Scosglen. I am honored that a Druid chieftain has granted me one single leaf from Glór-an-Fháidha, a gift in recognition of my meager service to her land and people. I carry it with me now as a relic that sprouted from the very roots of Sanctuary.

There is an expression in the Fractured Peaks that does not translate well to outsiders. The people here sometimes speak of the pine-hold. I had been here for some time before I even heard anyone use the term, and I asked the old weaver woman who said it what it meant. She squinted at me for a few moments, as if trying to decide whether she would even answer me. This is what she finally said, near as I can recall it:

"You see what our houses are made from? The pinewood? Well, to be pine-held is to be safe inside when the night is longest and the cold takes fingers and toes. It is to be with family and friends, everyone healthy and safe for the present. There's a fire crackling, and candles are glowing. There's meat roasting and maybe even a pie. The ale is strong, and the laughter is loud enough to cover the howling of wind and beasts outside. That's the pine-hold. You'll know it when you're in it."

I came to Scosglen in the company of others. I now leave alone. Neyrelle follows her own path, carrying a burden I fear will be too much for her, and I can do nothing to help her. Like Donan, I must simply have faith that she will survive the ordeal. Wherever she is, I hope she is staying clear of the Cathedral's agents and avoiding cities and towns. The Soulstone she carries will spread hatred like a contagion.

I admit I find the prospect of my journey daunting. When I was a younger man, I enjoyed the thrill of the road. Travel made the world larger and smaller at the same time. The lure of distant cities and lands is one of the things that called me to the Horadric Order. Now, I am an old man who has seen too much.

The Scosglen hills to the south are becoming steep and ragged. In the distance, they break like green waves against the towering Fractured Peaks. Behind me, rolling downs tumble away toward the forests and the Frozen Sea. The air up here is already clearer, freed from the damp that oppresses the moors. It grows colder. I woke this morning to frost on the fringes of Donan's fur cloak.

The Dry Steppes lie to the southwest. I went there recently in pursuit of Elias, and I wonder what remains of the archive at the Orbei Monastery. Elias slaughtered almost every monk. The fire likely destroyed many of the relics and records. But archives like that tend to house things that can survive fires. One day, I might return there to see what is left. Today, I will continue south into the mountains, to Kyovashad.

even if it is naive

I am tired and stopped to make camp early today. A pack of wargs attacked last night. I fought them off with a bit more difficulty than they would have once given me. I did not sleep much after that. Such encounters are often the first welcome travelers receive when entering the Fractured Peaks.

If it weren't so cold, I could smell the pine trees. There hasn't been a storm for several days, so the snow is passable. It only rises to my thighs and waist where the wind has piled drifts.

After the warg attack a few nights ago, I now build three or four small fires and sleep in the middle of them. They help with heat, and the flames also deter creatures accustomed to hunting in the long and dark mountain nights. Not all creatures. But most. I should reach my cabin sometime tomorrow.

I saw a group of Cathedral monks on the road today, and I removed myself from their path before they noticed me. Then I waited until they were gone before I resumed my journey. I'm not afraid of them. I simply didn't want the hassle or delay.

The city of Kyovashad is the perfect expression of this region. The width and depth of its moat alone suggest that it was built to repel threats of immense proportions. The walls are less those of a town than a fortress under constant siege.

Kyovashad also reflects the people who choose to live in the Fractured Peaks. Their defenses may be daunting, but inside their walls, they are generous and good-humored. They also have a deep respect for privacy. No one survives here alone, and the people of the Fractured Peaks do not have the luxury of choosing their comrades. Here, your business is your business, which is what drew me to this place. That and the silence. My cabin will be a welcome sight.

Holy Cedarwood

𐑇𐑳𐑥𐑒𐑜𐑣𐑦𐑭𐑴𐑲

The Cathedral of Light has unfortunately imposed its authority on the culture of the Fractured Peaks through certain ceremonies and rituals. One of these takes place at the gates of Kyovashad, a rite of passage to enter the city. Travelers are asked to inscribe a sin they have committed on a plank of cedarwood. This written confession is then burned in a bonfire.

I suspect a tradition of communal cleansing through fire has existed in these parts for some time, and the Cathedral merely subsumed the existing practice into its structure. The original ritual may have served to foster trust by expunging past offenses to more quickly integrate a newcomer or stranger into the community. It is a symbolic way of saying that one's past does not matter, so long as it remains there.

The Cathedral ritual possesses none of those qualities. Instead, it seems designed to assert dominance over the people and make them subservient and accountable to the church. That is why I refuse to perform the ceremony. There is nothing holy in it.

as churches so often do

The Pillory of the Penitent is an even more egregious example of this.

Polearm

I have carried this blade for many years. At my age, it serves as a walking stick more often than a weapon, though it can still cleave, slash, and stab when necessary. Its design is similar to a glaive, but with two cutting edges instead of one. The blade is forged from hard steel the color of pewter and is the length of my forearm. Its heel is adorned with a version of the Horadric symbol that ends near the base. The staff is my height, with a heavy metal foot that can deliver a compelling blow if a nonlethal warning is all I require.

When I am cleaning it after a battle or honing its edges, I sometimes imagine my father's disdain for such a blade. He viewed polearms as the weapons of poor farmers, little more than glorified field implements. He preferred swords, both to forge and to wield, and that must have been on my mind when I chose this weapon from the Horadric armory. I was still rebelling then, defying him even though I had long since left his shop behind. My choice has served me well. I have slain countless demons, beasts, and human foes with my polearm. Even Borad Nahr would have to admit his admiration.

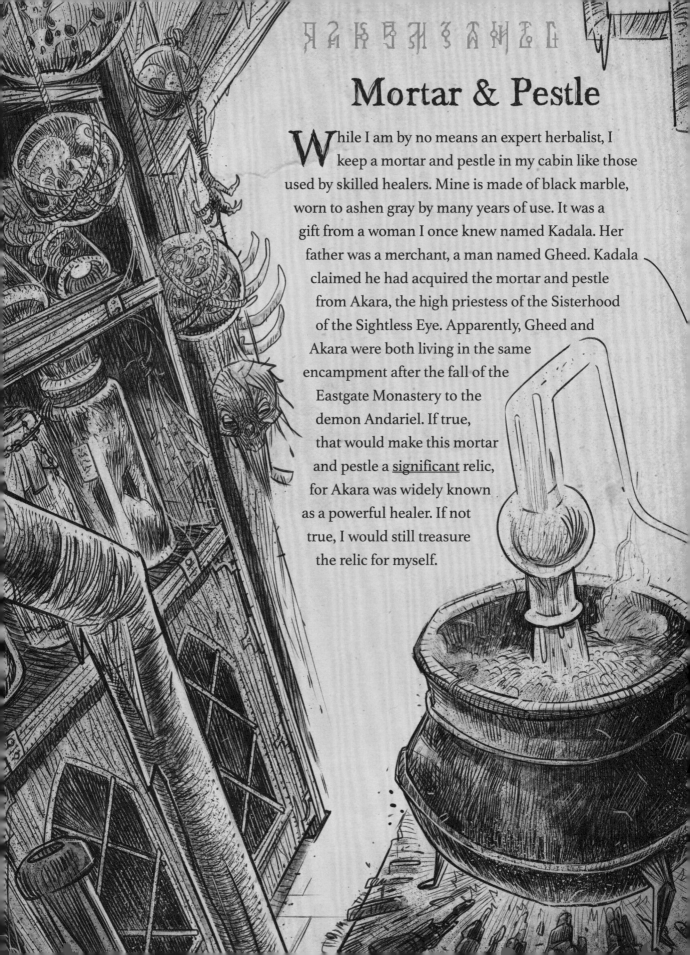

Mortar & Pestle

While I am by no means an expert herbalist, I keep a mortar and pestle in my cabin like those used by skilled healers. Mine is made of black marble, worn to ashen gray by many years of use. It was a gift from a woman I once knew named Kadala. Her father was a merchant, a man named Gheed. Kadala claimed he had acquired the mortar and pestle from Akara, the high priestess of the Sisterhood of the Sightless Eye. Apparently, Gheed and Akara were both living in the same encampment after the fall of the Eastgate Monastery to the demon Andariel. If true, that would make this mortar and pestle a <u>significant</u> relic, for Akara was widely known as a powerful healer. If not true, I would still treasure the relic for myself.

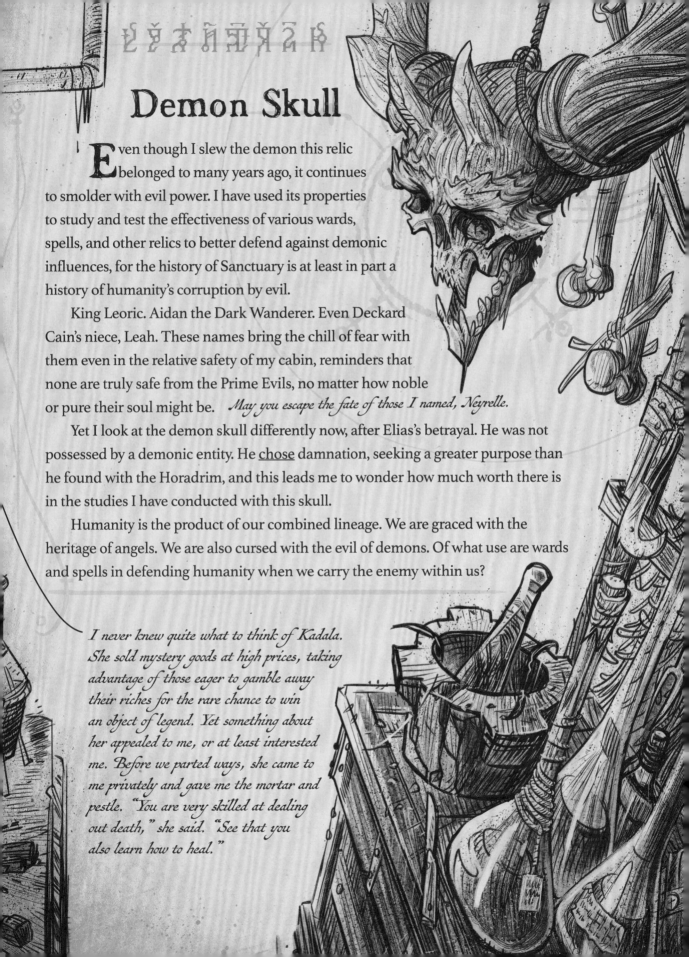

Demon Skull

Even though I slew the demon this relic belonged to many years ago, it continues to smolder with evil power. I have used its properties to study and test the effectiveness of various wards, spells, and other relics to better defend against demonic influences, for the history of Sanctuary is at least in part a history of humanity's corruption by evil.

King Leoric. Aidan the Dark Wanderer. Even Deckard Cain's niece, Leah. These names bring the chill of fear with them even in the relative safety of my cabin, reminders that none are truly safe from the Prime Evils, no matter how noble or pure their soul might be. *May you escape the fate of those I named, Neyrelle.*

Yet I look at the demon skull differently now, after Elias's betrayal. He was not possessed by a demonic entity. He <u>chose</u> damnation, seeking a greater purpose than he found with the Horadrim, and this leads me to wonder how much worth there is in the studies I have conducted with this skull.

Humanity is the product of our combined lineage. We are graced with the heritage of angels. We are also cursed with the evil of demons. Of what use are wards and spells in defending humanity when we carry the enemy within us?

I never knew quite what to think of Kadala. She sold mystery goods at high prices, taking advantage of those eager to gamble away their riches for the rare chance to win an object of legend. Yet something about her appealed to me, or at least interested me. Before we parted ways, she came to me privately and gave me the mortar and pestle. "You are very skilled at dealing out death," she said. "See that you also learn how to heal."

Horadric Amulet

ᚠᚱᛟᚦᛁᚾᚷᛁᚦᚷ ᚾᛁᚷᚦᚱᚾᛁᛗᚷᚦ

S ome might think the opposite of faith is doubt, but it is not. The opposite of faith is despair, and I have been guilty of it. There was even a time when I thought I had left the Horadrim behind me. The aftermath of Malthael's use of the Black Soulstone saw Tyrael gone from Sanctuary and countless dead at the hands of Malthael's Reapers. They laid waste to Westmarch, the place of my birth, and the grisly slaughter I witnessed there nearly destroyed me. With the angelic founder of the Horadrim gone, I renounced the order and sold my Horadric amulet.

After that, I withdrew to this cabin as the rest of Sanctuary fell into a period now called the Great Enmity, a time of chaos and strife between kings and warlords. I had lost faith in humanity, so I chose solitude and ale over futile efforts to bring goodness back into the world. It was in this state that I met an adventurer who proved to be a worthy comrade, and who later retrieved the amulet I had discarded. I wear it now as a symbol of my renewed hope for humanity's future, even if the Horadric Order is at its end.

That was the past I wanted to escape by coming here to the Fractured Peaks.

Bottle of Ale

Good ale can be a rare commodity in the Fractured Peaks. Arable land for grain is far from abundant in the stony vales, and the growing season is short. The local brewery offerings are sometimes drinkable. The best ale, however, is brought up from the lowlands near Kehjistan or Hawezar to the south. In the years I lived here, I admit I spent too many nights deep in a bottle and awoke in too many pigsties. At the time, strong ale provided the only relief I could find.

Though I drink less now, I have a secret stash beneath one of the floorboards that I just checked to see what might remain. I found a bottle there. Empty. Someone had taken it, opened it, drained it, and placed a letter inside before returning it to my hiding place. Someone who obviously knows me very well.

Lorath,

Please don't be angry over spilled ale. I know you, and I won't have you turning to old habits. What happened with Elias was not your fault. You know that already. Drink won't make you believe it or forget what happened. Before I left, you hinted that you might be taking a journey of your own. In your typical stubborn way, you remained maddeningly cryptic about it. So I am going to leave letters like this along my way just in case your road brings you to any of the same places. You might have been looking forward to some peace and quiet. Sorry to say you're not going to be rid of me that easily, old man. Wherever you are going, please, be watchful. Be careful. You've managed to make yourself a personal enemy to quite a few demons over the years, not to mention Prava and the Cathedral.

To answer your question, I am well. The burden is heavy, but I am bearing it

Neyrelle

Altars of Illumination

These shrines of the Cathedral of Light sit on ancient sites in the Fractured Peaks once used by a different faith, for different rituals. The church tore down the ruins that had stood there for centuries, if not millennia, then repurposed the stone to build new structures for their own worship. This was done deliberately, to erase and replace the vestiges of what they consider to be superstitious and heretical practices. One day, the same will inevitably be done to the Cathedral's Altars of Illumination by some new, ascendant faith. It is also likely that the ruins the Cathedral tore down had themselves been built atop even older structures by people long vanished, for rituals long forgotten. That does not make any of the shrines or altars standing there meaningless. It is often not the religion or the building that matters, but the place. Sites of power can be useful, and even dangerous. Priests and monks come and go. Sanctuary remains.

Possibly an offshoot of Skatsim that found its way north.

Towers of Kor Valar

Above Kyovashad looms a glacier so ancient its first icy layers may have been laid down when the Firstborn were still young. It cracks and groans under its own massive weight, like a living, breathing thing. The fortress of Kor Valar stands upon this glacier, built by the Cathedral of Light, its towers rising to the height of the tallest mountain peaks.

Though I hold the Cathedral in disdain, I admit to once feeling a measure of awe when looking up at the imposing edifice of Kor Valar. Its spires and buttresses are graced with a dizzying majesty. Its grandeur calls to mind the angelic architecture of the High Heavens, which is unsurprising since it was for a time the dwelling place of Inarius.

His followers remain there even though he is gone, slain by Lilith. His house is now a shell, diminished by his absence, and there is something vaguely pitiful in the marching of the Knights Penitent who, though missing their general, continue to assemble and train within its walls. Their broken banner flaps in the icy wind above them, its tarnished sun drowning in a sea of blood red, reminding them of their failure.

Though chastened at present, the threat of the Cathedral remains, for a wounded animal is often more dangerous. Any Horadrim should continue to view the Towers of Kor Valar with a wary eye.

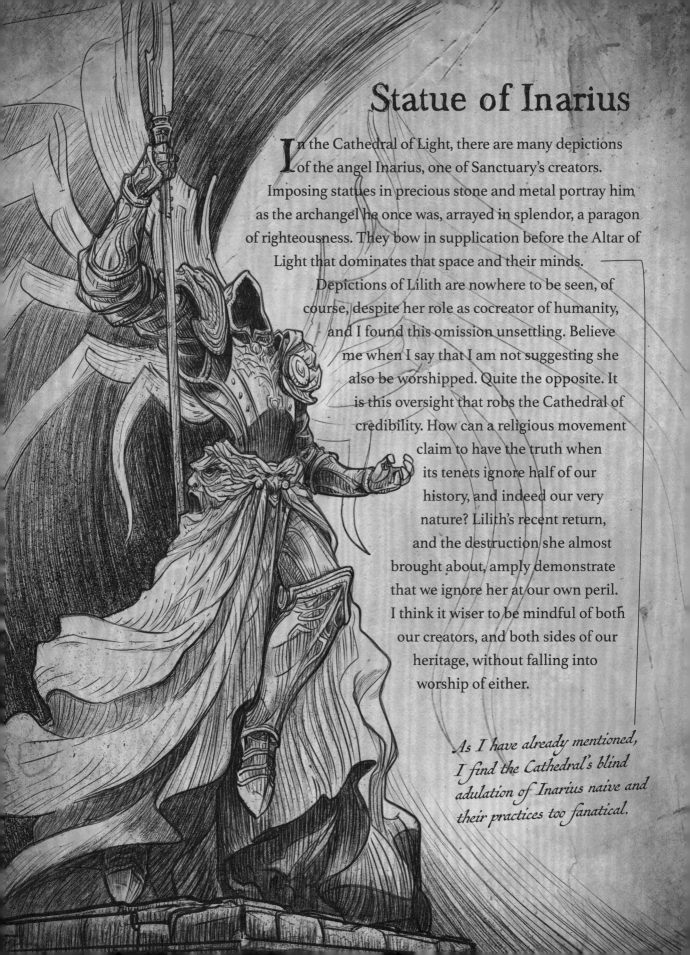

Statue of Inarius

In the Cathedral of Light, there are many depictions of the angel Inarius, one of Sanctuary's creators. Imposing statues in precious stone and metal portray him as the archangel he once was, arrayed in splendor, a paragon of righteousness. They bow in supplication before the Altar of Light that dominates that space and their minds.

Depictions of Lilith are nowhere to be seen, of course, despite her role as cocreator of humanity, and I found this omission unsettling. Believe me when I say that I am not suggesting she also be worshipped. Quite the opposite. It is this oversight that robs the Cathedral of credibility. How can a religious movement claim to have the truth when its tenets ignore half of our history, and indeed our very nature? Lilith's recent return, and the destruction she almost brought about, amply demonstrate that we ignore her at our own peril. I think it wiser to be mindful of both our creators, and both sides of our heritage, without falling into worship of either.

As I have already mentioned, I find the Cathedral's blind adulation of Inarius naive and their practices too fanatical.

Vhenard's Chalk

Vhenard was Neyrelle's mother. Like Airidah and Nafain and countless others before, she became enthralled by Lilith, lured by promises of knowledge and power. She followed Lilith down into the abandoned mine and caverns beneath the Fractured Peaks, to an ancient buried city of the Firstborn. Toward the end of Vhenard's descent, she began to chronicle her journey, writing a screed in chalk along the way. She felt so compelled to make her record that after she had used her chalk to the last nub, she began to write in her own blood.

For whom did she scrawl her grisly record, I wonder. I would assume she wrote at least in part for her daughter, to explain and justify herself. Those who are most desperate to tell their tales are often those who know that other versions of their stories will be told. They seek to have the final word, and to be understood. Some part of Vhenard must have known and feared what others would think of her actions, but instead her frantic scribbling only confirmed how far she had fallen. This blood-flecked scrap of chalk is now a cursed token of her madness and denial.

often in vain

including her own daughter

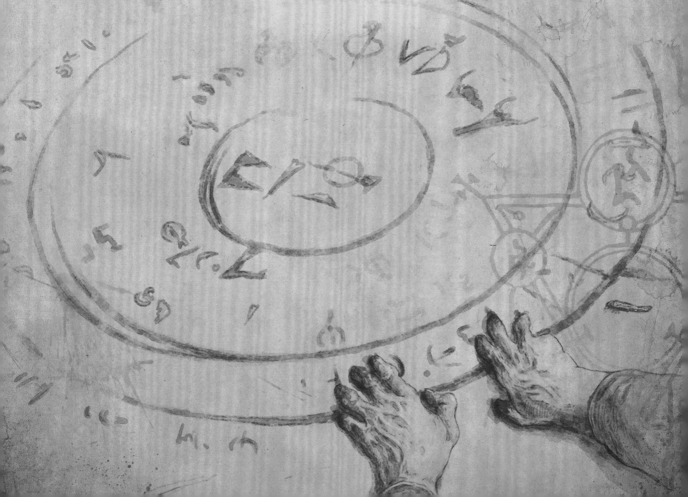

Vigo's Wealth Charm & Penitent Armor

Zealotry often leads to needless suffering and wasted lives. Vigo was a Knight Penitent in service to the Cathedral of Light. He was also a gambler, and possibly a fool. All Vhenard needed to offer him was the simple bribe of a wealth charm, and he granted her access to the mines that led down to the Path of the Firstborn. He took little notice of Vhenard's companion, the demon Lilith in disguise, and only later learned of the role his failure had played in the suffering and death she would cause. To his credit, this realization sent him on a mission of penance and redemption.

Beyond the Path of the Firstborn, and beyond the Black Lake, there is an ancient necropolis almost as old as Sanctuary. It was there that Vigo found his salvation by leaping into battle against the guardian of that dead city. He wore a type of holy armor that I have only ever heard about. This Penitent Armor is fitted with cruel spikes pointed inward. With every strike Vigo gave and every blow he received, his own armor pierced his flesh, doing the work of his opponent. Even with such deadly encumbrance, his prowess in battle helped him defeat the Necropolis Guardian.

Thus, Vigo died for his sins. Or at least, that is what he believed, and because of that, he felt redeemed. I believe he could have survived had he charged into battle wearing sensible armor forged to save his life. Whether his efforts would have absolved him of wrongdoing had he lived is a pointless question now that he is gone.

Before he died, Vigo gave the wealth charm to Neyrelle, and I believe she has it now, no doubt a painful reminder of her mother's fall. I hope it is proving at least somewhat useful to her.

I wonder if it can even be called "armor" at all when considering that such protection is almost always worn to prevent injury, not cause it.

It should keep food in her belly, at the very least, so long as she remembers to eat.

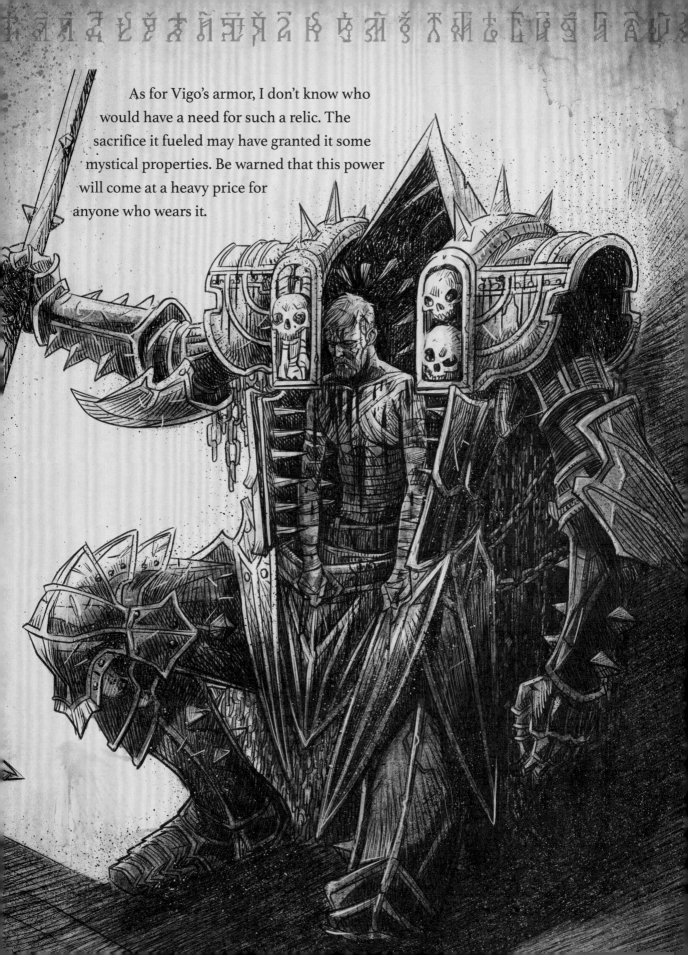

As for Vigo's armor, I don't know who
would have a need for such a relic. The
sacrifice it fueled may have granted it some
mystical properties. Be warned that this power
will come at a heavy price for
anyone who wears it.

TUMORS OF HATRED

L ilith was the daughter of Mephisto, Lord of Hatred, and so she was the Daughter of Hatred. Where she went, the toxin of her presence seeped into the ground, infecting it with her corruption. Down in the necropolis of the Firstborn, Tumors of Hatred grew in her wake, demonic abscesses filled with bile, puss, and noxious gasses. They continued to emanate the same hatred that Lilith spread, aggressive cankers that turned Sanctuary against itself.

Though Lilith is gone, hatred is not. It is simply less visible, more insidious, and it can spread just as vigorously if left unchecked. You may not see any tumors growing, but that does not mean you will be safe from their influence. Calls to hatred are often carried or accompanied by messages of fear, the domain of another Prime Evil, the Lord of Terror. Fear and Hatred lead to Destruction.

I dread the possibility that I will find new Tumors of Hatred growing where Neyrelle has traveled.

Amethyst Ring

like those of the scoundrel

Τhis relic isn't named in the manner of more legendary rings. It isn't ornate or richly made. I acquired this ring, and I have held on to it these many years, simply because I find its gemstone beautiful.

It is a large amethyst of intriguing depth and color variation, with a ribbon of smoky purple that seems to coil through a bright and clear violet sky. These imperfections make it unsuitable for inclusion in more powerful jewelry, and someone else likely would have removed it from its setting to reforge it and increase its purity. The same qualities that would devalue it to others are the very reasons I treasure it. It is a token to me, in that its power is in its meaning.

It is a gem unlike any I have ever seen. When I look into it, I am reminded that the hard bones of Sanctuary can still yield things that are beautiful simply for their own sake. If the Leaf of Glór-an-Fháidha is an expression of what can grow from Sanctuary's water and earth, then this amethyst is an expression of what can be made by the fire and pressure in Sanctuary's foundations. Three of the primary elements. And when I add this ring and its gemstone to the leaf, I have a suitable base upon which to build the protective spell this book requires.

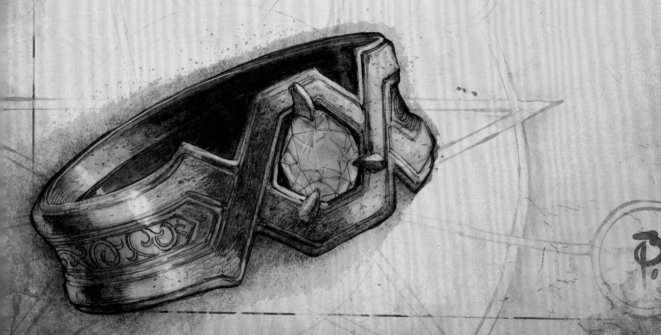

Neyrelle,

You owe me a bottle of ale, and not the cheap stuff. I trust you'll make good on that debt one day, and we shall enjoy a drink together. Until then, I admit that finding your letter gave me more enjoyment than the bottle's original contents would have. I leave this note in place of yours in case you return to this cabin and look to see if I found the message you left for me.

It was odd coming back here. Other than the ale you wasted, my cabin was left untouched in my absence. There are few other places in Sanctuary where that would be the case, everything just as I left it. The evidence of a life I once had but can't truly return to. This house now feels like it almost belongs to someone else. I'm about to say farewell to it once again, perhaps never to return.

You guessed correctly that I am traveling. I am compiling a catalogue of relics as I go. I'll say no more about it for now. It's possible our journeys may take us to some of the same places—if so, I hope to find more letters from you waiting for me.

Go safely on your way, child.

Lorath

The air is warming. There are now trees with leaves among those with needles. The snows are gone. Though I'm not quite out of the mountains, I no longer need to wear Donan's cloak. After tonight, I'll pack it away. Extra weight, but necessary. If my journey takes me where I plan to go, I'll need it again.

I caught the first glimpse of Hawezar today. Just a narrow wedge of vibrant green between two gray peaks to the south. Not far now. Several more days, and I'll be down in the swamps, swatting at biting flies and wishing I was back in the mountains.

I do wish I was back in the mountains. Hawezar is hot and humid. The swamps are dense and disorienting. There are roads—narrow and often washed out for stretches that force me into snake-infested waters. At night, the noise of insects, frogs, and other creatures is almost deafening.

I stumbled across a grave marker for a Crusader today. It was overgrown and almost worn away. No doubt the dead warrior's apprentice took up the slain master's armor and sword and carried on in the futile search for Akarat, the mystical founder of the Zakarum faith.

The region of Hawezar is nominally part of the Kehjistan empire, but its territory is inaccessible and sparsely populated. Distant powers in Kurast or Caldeum have little control or influence here over the witches and other denizens of the swamps. I'm hoping to reach the city of Zarbinzet soon, to obtain what I need, and then be gone from this place as quickly as possible. I have no desire to encounter the Tree of Whispers again before my time is due.

also now dead

ᛈ ᚻ ᚾ ᚻ ᚼ ᛈ ᚱ ᛗ ᛞ

My sister found a ribbon
 and put it in her hair,
but the ribbon had a venom
 that was more than she could bear.

ᚼ ᛈ ᚱ ᛗ ᛞ ᛈ ᚻ ᚱ ᚾ

This Hawezar children's rhyme is obviously a reference to the many
types of venomous snakes found in the region, a fairly standard
warning rehearsed to remind children not to go near any serpents or
attempt to pick them up. Travelers might be less likely to hear this
spoken by members of the snake cults who also lurk in swamps.

Band of Hollow Whispers

This ring is made of gold, with a crimson band and a pale gemstone surrounded by a setting of four sharp talons projecting upward. The jewel is unlike any that I know of, cloudy with a subtle glow that seeps out like candlelight through fog. The ring's enchantment increases the vitalities and faculties of the one who wears it. The name of this band is derived from another, more singular quality that it possesses.

Periodically, the ring releases a vengeful spirit capable of haunting the wearer's enemies, and this apparition will inflict considerable harm and injury, even killing weaker foes. It is unknown whether the ring is a prison that contains these souls or merely a gateway for spirits to enter our realm from another. Either way, such magic would obviously suggest an origin involving necromancy.

The Necromancer Zayl wrote that he did not believe the ring to be entirely the creation of a Priest of Rathma. He suspected it was produced by a partnership between a powerful Necromancer and someone highly skilled in the jeweler's art. Zayl thought the famous artisan Covetous Shen a likely candidate, though I am not convinced. The ring appears quite ancient, even older than the oldest estimates of Shen's age.

If the gemstone is a prison, it would almost seem to be a lesser kind of Soulstone, which points to a mage like Zoltun Kulle as its creator, he who forged the Black Soulstone. If not Kulle's work, the Band of Hollow Whispers might at least be the creation of someone familiar with that fallen Horadrim's research, possibly having accessed his vast hidden library.

and Horadrim

assuming he is, in fact, a mortal

Moonlight Ward

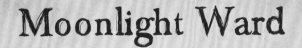

Wizards have the ability and skill to channel arcane energy that could disintegrate anyone unwise enough to summon it without training. Even the mages from more traditional schools and philosophies view the wild power of the wizard as unpredictable, vulgar, and heretical, and would be reluctant to attempt such spells. That said, there are a few ways a non-wizard can utilize arcane energies, should that be desired, often through the mediating control of a relic.

The Moonlight Ward is one such amulet. It is made of precious metals in the shape of a crescent moon, pointed downward like the horns of a bull. Rays of gold and silver descend from a simple geometric pattern in the middle of the moon, with a small eye at the center. A wizard wearing this relic will find their spells do greater amounts of arcane damage. Those who are not wizards will discover that as they strike their enemies through more customary means, the amulet produces shards of arcane energy that orbit the wearer. These fragments explode when enemies come within range, inflicting the same type of damage as a wizard's spells. —— *But without the risk of disintegration!*

Jar of Eyes

There are many witches living in the swamps and fens of Hawezar. Their magic makes use of the natural world around them differently than how the Druids do. They use spell books, lore books, and rituals, free from the order and discipline of the mage schools. They practice dangerous magic, at times, and often live in isolated hovels away from towns and settlements. Those seeking help from them should remember that even though they may appear willing to offer spells, their aid will often come at a price.

With all this in mind, none could mistake Valtha as anything but a witch of Hawezar, and she had in her hut exactly the kinds of ingredients one would expect. A gruesome jar of eyes stood out to me for the sheer variety of oracular organs contained within it. Eyes small enough to have come from spiders and hummingbirds filled the gaps between those the size of giant vulture eggs. Some of the eyes glistened white as pearls, while vivid red veins covered others. Reptile eyes rested next to the eyes of birds, fish, and mammals. I understand the basis for the type of magic that calls for such ingredients. To take the eyes of something is to take what that being has seen. To take its awareness, its perception, and then use it. Eyes are potent symbols, and as I looked at the jar of eyes in Valtha's hovel, I almost felt it looking back at me.

or curses

Valtha's Cauldron

A pungent steam filled Valtha's hovel, rising from a cauldron bubbling over a low fire in her hearth. The vapors burned my nose and caused my vision to ripple and waver. Age and long use had turned the iron vessel's belly black with soot, and the residue of previous concoctions lined the inside with stains of vivid and unnatural colors.

Cauldrons are both common and mysterious. You can find them in most homes and kitchens and purchase them in almost any market. Yet for all their simplicity, they possess a subtle but staggering alchemical power. They take in what we feed them and turn those ingredients into wholly new substances. The cook knows how to use this ability to craft a tasty pottage or a stew from the most meager of scraps. The witch knows how to employ a cauldron in the making of much more potent brews. ⸺

My need would have to be very great indeed before I would accept any potion from Valtha's cauldron. I am sure there are some who have benefited from her skill, and even more who have been harmed by it.

remarkable that poisons, fulminates, and potions of healing and replenishment all come from the same pot

Purified Quicksilver

Certain types of magic are more art than science. That is why the practice of various spells improves their quality, and why some mages are more naturally gifted than others. To brew an effective potion, careful and consistent attention to the recipe is all that is required. To repair and tune a Soulstone is something else entirely.

When we decided to use Astaroth's Soulstone to trap Lilith, I assumed Donan's knowledge had equipped him for the task. I assumed that if we acquired the proper ingredients and reagents, the spell would work, including the purified quicksilver we obtained from Valtha, the Hawezar witch. I was wrong. As Taissa helped Donan see, the spell would fail so long as Donan remained broken and compromised by his grief.

When performing magic, follow the recipe, and do not forget that you are often one of the ingredients.

Valtha's Spell Book

I am accustomed to holding the tomes of the Horadrim, books bound with artful skill in supple leather, some of them ornamented with gems and carved bone, or trimmed with precious metals. The libraries of the Horadrim have always been treasure houses, not just of wisdom but also material wealth. Valtha's spell book presented a very different kind of assemblage, as do most texts kept by the witches of Hawezar.

Its cover was of a type of swamp skin I couldn't identify. *possibly snake, or even maggot hide* Fungus stained its tattered and uneven pages, between which sprouted twigs and insect legs. A greasy scrap of fishnet bound the whole thing together, giving the impression of something that had been caught in the wild.

Do not make the mistake of judging such books inferior by comparing their appearance to more refined tomes. The contents of such spell books are treacherous and bewildering, their magic sophisticated and powerful. The same principle applies to the witches themselves.

Taissa's Ingredient Pouch

Taissa is another witch of Hawezar, a talented younger rival to Valtha. She carries with her a leather satchel, to which she is always adding ingredients she gathers for her spells and potions as she crosses the fens. She consults no reference or text as she does this. She recognizes each tree, algae, flower, and fungus by sight and smell, calling them by old names handed down through numerous generations. Her working knowledge of the land is impressively vast. Indeed, the whole swamp is her lore book.

She is also wise for one her age, and her skills proved essential in stopping Lilith. Our plan required a Soulstone, the preparation of which largely fell to Donan, but he found his faculties impaired by insurmountable grief. It was the healing ministrations of Taissa that finally brought him back to himself, allowing us to press forward.

I have mentioned Taissa before, the poor girl Elias carved into when he attempted to summon Andariel. Though we succeeded in stopping that ritual, I fear Taissa will be forever scarred by the experience, both physically and mentally. I hope she is healing as best she can. She serves the Tree of Whispers, and were it not for that fact, I would seek her out to see how she is doing.

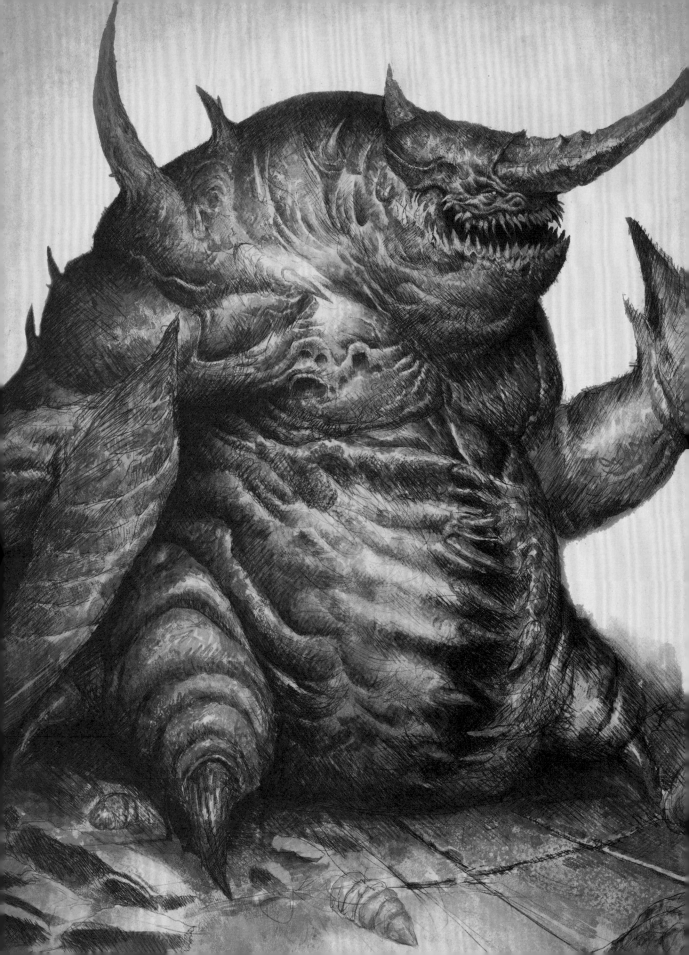

Maggot Queen Ichor

The potion Taissa brewed for Donan required several ingredients found in the marsh and swamp, and the quest to obtain them proved somewhat difficult. In addition to snakemen and bloated undead, there are blood and plague maggots lurking in the putrid waters. Though dangerous to travelers, remember that maggots have their purpose. In consuming that which is rotten and infected, they can be used to clean wounds and clear away decay. Their ichor allows them to digest matter that nothing else will consume. Perhaps it is this property that made the ichor of the Maggot Queen suitable for Taissa's potion, granting Donan the ability to deal with his festering grief.

Yellow Lotus

This rare flower grows in the farthest reaches of Hawezar's swamps. Its lily pads grow to spans the width of wagon wheels. When you come upon them in the dim gloom under the swamp canopy, the yellow lotus blossom at the center of the pad seems to smolder with the light of a campfire on the water. To pluck the flower, one must venture out from the shore, facing dangers from serpents, bats, and swamp spawn. Only those brave enough to obtain this lotus will be rewarded. Its petals are apparently useful in a number of spells, including the ritual that helped Donan recover.

Swamp Sage

This herb has an intense, almost smoky fragrance that can be detected from several yards away. It grows in thick bushes amidst more dangerous poisonous plants and thorny vines. As with the yellow lotus, to harvest swamp sage will require the traversal of lands infested with bloodhawks, woodwraiths, and spiders. Also note that the witches of Hawezar face these threats regularly in foraging the ingredients needed for their spells, which is sufficient to prove the strength and tenacity of these cunning folk.

Sigils of Dendas

I must rely on Donan's expertise here, as the Sigils of Dendas relate to Soulstones and their attunement, a subject about which he knew much more than I. The following excerpt is taken from his journals:

"The Sigils came about through careful observation and the discovery by Dendas that Soulstones have facets. Not the physical, internal planes that jewelers use to cleave and refine gemstones. Soulstones possess energy facets, which Dendas believed were remnants of the currents of creation that flowed through the Worldstone. These are somehow instrumental in containing an essence within a Soulstone, almost like the walls and bars of a prison. The six Sigils work to align these facets, creating stability and coherence. It's an intricate, beautiful process. Without it, the Soulstone may be unbalanced, unstable, leading to structural failure. That is why the work of attunement must only be undertaken with complete, undivided attention. The Sigils demand absolute clarity of mind."

Timue's Tea

Those who dwell in the swamps of Hawezar for too long can become afflicted with any number of diseases, plagues, and rots. Some conditions cause agony and quick death, while others lead to a slow, peaceful demise almost beautiful in its horror. Some swamp seeds, if ingested, can take root inside the body. Flesh is soil to such plants, providing nourishment to the seedling as it enters muscles, organs, veins, and the brain. Over time, green tendrils emerge through the victim's skin from within. Even then, the poor soul does not seem to be in any pain. That was the case with an ancient crone named Timue when we met her. Both blessed and cursed, the swamp has given her an unnaturally long life. As with others so afflicted, one day she will respond to an inner, wordless call from the plant inside her and remove herself from her home to the swamp. There, she will wander, shambling in search of a suitable spot of earth, and when she finds it, she will plant herself. Before long, it will appear as if the tree standing there has always been a tree, dropping its fruit and seeds.

Beware of tea made from such offerings.

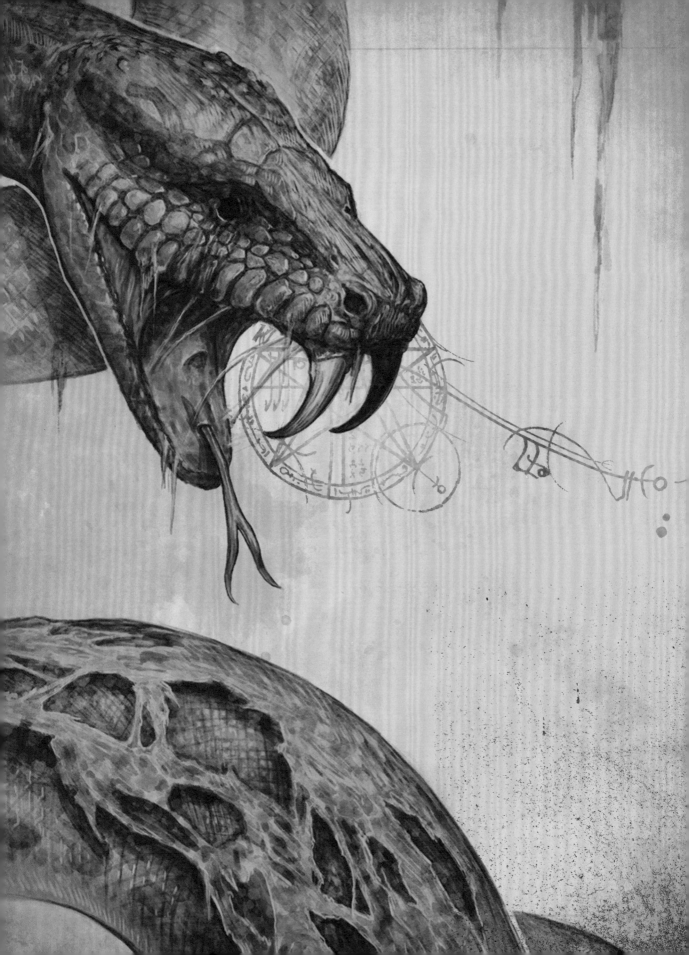

Serpent Fang

If the region of Hawezar were represented by a symbol, it would be that of a coiled serpent. Snakes are ubiquitous here, as are market goods made from their skin and bones. Serpent fangs, in particular, are worn as jewelry by those who worship Mohlon, a snake goddess.

I have observed that humanity will often turn to worship that which it fears, as if conflating the experiences of terror and awe. Perhaps adherents gain a sense of control over their fear when they build a church or temple around it and recite prayers to it. I suspect they believe they have struck a bargain with their fear, and in exchange for their adulation, they will be spared the suffering that the uninitiated will endure. That is rarely ever the case. Those who wear the sign of the serpent fang and worship Mohlon do so in the hope that the snakes will spare them. That did not help the villagers of Yngovani, who all died violently at the hands of serpent men, despite their devotion to the snake god.

Fear cannot be bargained away.

Mystic Incense

The cult of Hawezar worshipped Mohlon, though she was no demon, nor a goddess. She was a hideous and powerful creature of the swamp who dwelt in a pit where she accepted offerings from her supplicants. These tributes included trinkets, baubles, food, drink, and mystic incense. It seems that Mohlon accepted these gifts and grew comfortable in her nest. Whatever being sired, birthed, or created her, whether she hatched from an egg or wriggled from the mud, it seems she forgot her origins and came to believe in her own divinity. True gods do not die as easily as she did. Mohlon was but the weakened and diluted progeny of even greater serpents that still slither through the farthest reaches of the Hawezar swamps. Reserve your mystic incense for them.

Snake Altar

Where there is a cult, there is inevitably an altar, and the snake cult of Hawezar is predictable in that way. I do not speak of their temple to Mohlon. Their true altar can be found deep in the Writhing Mire, shaped from the swamp itself, vines and roots entangled like a nest of vipers. You will find no crude statues here, no vulgar effigies. This place is ancient and primordial. This altar grew to its mythic stature from the mire and the trees in reverence of Rathma's serpent, sometimes called Trag'Oul.

When mystic incense is burned here, you draw the attention of old eyes. You risk annihilation by an elder being to whom you are insignificant, who may grant your desire, or consume you, according to its own ineffable designs. You summon a serpent in the image of Trag'Oul. It is possible you will go mad in the presence of such vast knowledge and wisdom. Consider all of that before you seek to worship at such a place. Or call forth such an entity.

Wooden Coffin

If you seek the sunken Temple of the Deathspeaker, there is only one vessel capable of carrying you there. First, you must traverse the swamps of Hawezar until you reach the Sea of Light far to the east, where creaking shipwrecks line the perilous shore. Once there, you will have the drowned Undead to contend with. If you survive, and if you are fortunate, you *or unfortunate* will find no boat waiting for you at the last pier—rather, a coffin bearing the symbol of Rathma. If you are bold enough to board this craft, it will take you beneath the waves to the submerged Necromancer Temple.

I must warn you of my suspicion that few who reach that place ever leave it, for its secrets are protected by undead guardians and risen Priests of Rathma who do not suffer trespassers. Therefore, be certain of your reasons and need before venturing there.

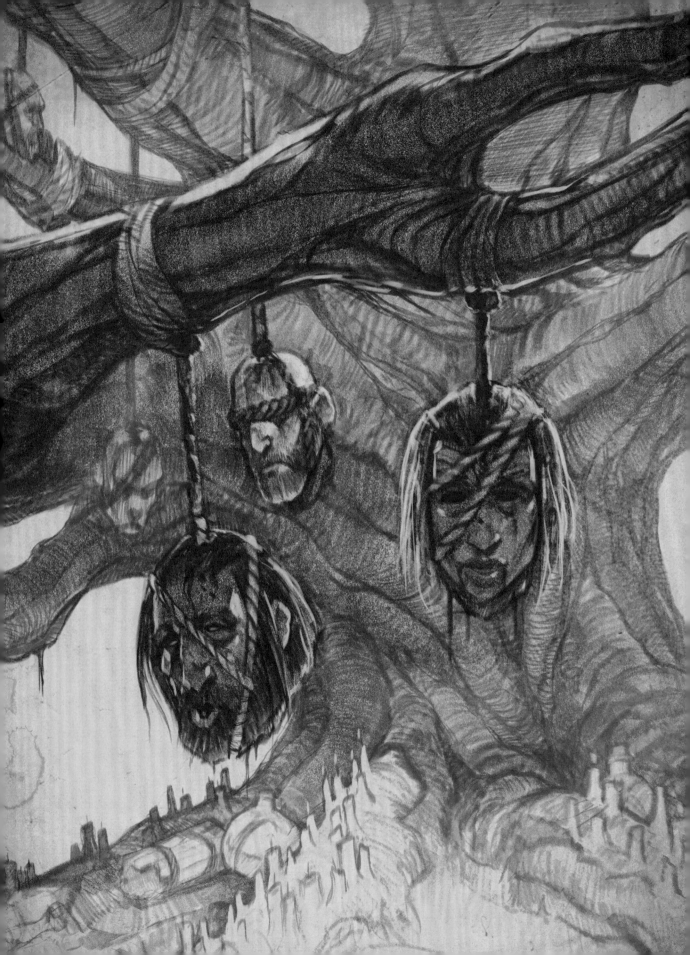

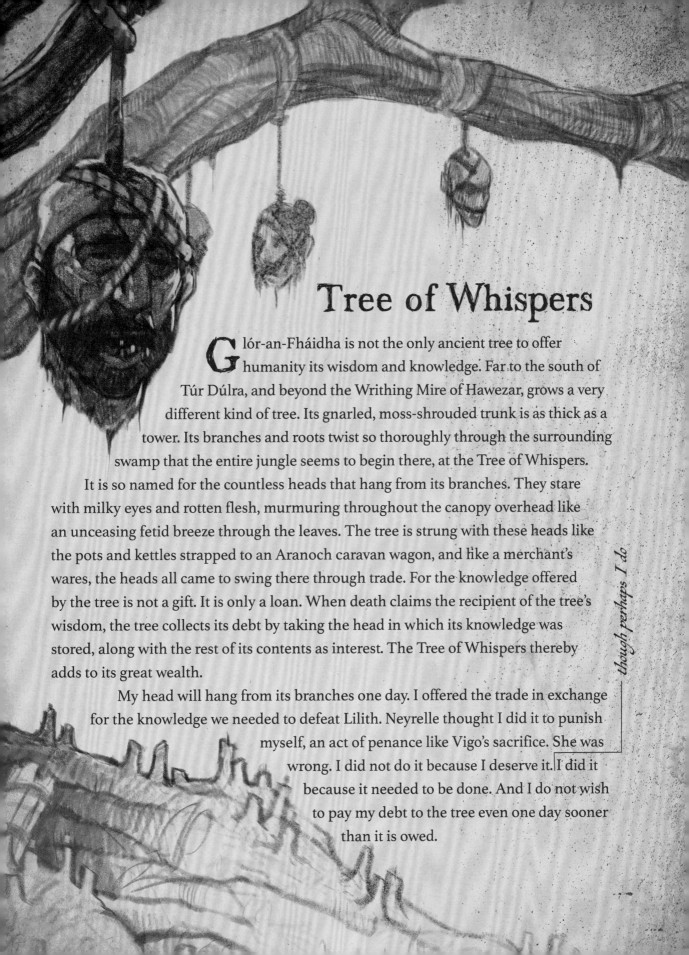

Tree of Whispers

Glór-an-Fháidha is not the only ancient tree to offer humanity its wisdom and knowledge. Far to the south of Túr Dúlra, and beyond the Writhing Mire of Hawezar, grows a very different kind of tree. Its gnarled, moss-shrouded trunk is as thick as a tower. Its branches and roots twist so thoroughly through the surrounding swamp that the entire jungle seems to begin there, at the Tree of Whispers.

It is so named for the countless heads that hang from its branches. They stare with milky eyes and rotten flesh, murmuring throughout the canopy overhead like an unceasing fetid breeze through the leaves. The tree is strung with these heads like the pots and kettles strapped to an Aranoch caravan wagon, and like a merchant's wares, the heads all came to swing there through trade. For the knowledge offered by the tree is not a gift. It is only a loan. When death claims the recipient of the tree's wisdom, the tree collects its debt by taking the head in which its knowledge was stored, along with the rest of its contents as interest. The Tree of Whispers thereby adds to its great wealth.

My head will hang from its branches one day. I offered the trade in exchange for the knowledge we needed to defeat Lilith. Neyrelle thought I did it to punish myself, an act of penance like Vigo's sacrifice. She was wrong. I did not do it because I deserve it. I did it because it needed to be done. And I do not wish to pay my debt to the tree even one day sooner than it is owed.

though perhaps I do

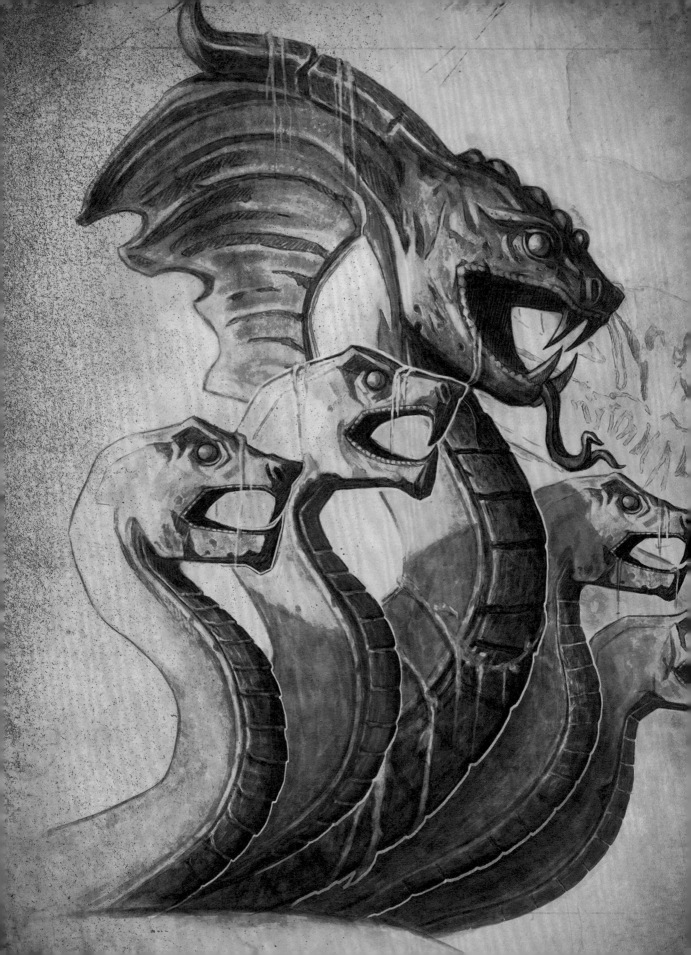

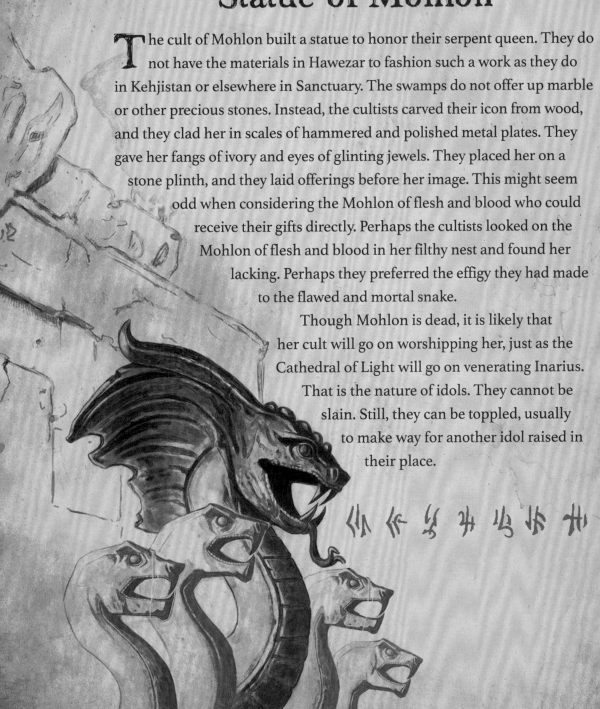

Statue of Mohlon

The cult of Mohlon built a statue to honor their serpent queen. They do not have the materials in Hawezar to fashion such a work as they do in Kehjistan or elsewhere in Sanctuary. The swamps do not offer up marble or other precious stones. Instead, the cultists carved their icon from wood, and they clad her in scales of hammered and polished metal plates. They gave her fangs of ivory and eyes of glinting jewels. They placed her on a stone plinth, and they laid offerings before her image. This might seem odd when considering the Mohlon of flesh and blood who could receive their gifts directly. Perhaps the cultists looked on the Mohlon of flesh and blood in her filthy nest and found her lacking. Perhaps they preferred the effigy they had made to the flawed and mortal snake.

Though Mohlon is dead, it is likely that her cult will go on worshipping her, just as the Cathedral of Light will go on venerating Inarius. That is the nature of idols. They cannot be slain. Still, they can be toppled, usually to make way for another idol raised in their place.

Scale of Rathma's Serpent

since my head will one day return here to stay,
I should probably make some sort of peace with it

Icame back to Hawezar because I needed a piece of the swamp. Despite my personal dislike of this land, it is part of Sanctuary, as are the beings that dwell here. I do not refer to Mohlon—rather, to the greater serpents who came before her.

One of those beasts appeared at the Snake Altar, a wyrm in the image of Trag'Oul, the cosmic dragon who is tied to our world but also dwells outside our world, a celestial entity entwined with the fate of Sanctuary. Trag'Oul is the serpent of Rathma, and Necromancer lore associates this being with harmony among the five elements of fire, water, earth, air, and time. I returned to the Snake Altar hoping to find a scale of one of his children, and after spending several days scrambling through the jungle, wet and irritated, I found many.

The molted skin was so wide and stretched so long that I mistook it for a pale footpath in the gloom. When I realized what it was, I quickly cut a single scale from it and left that place behind. I have added this emblem of balance to the elements represented by my Amethyst Ring and the Leaf of Glór-an-Fháidha.

I'll be glad to put Hawezar behind me. That said, I'm almost afraid I'll get lost on the way out and end up trapped until that tree takes my head.

I try to avoid lighting campfires here in the swamp. I don't need them for warmth, and they only seem to draw more biting and stinging pests to me.

Without a fire, the swamp is dark. Darker than any other forest I have seen. If the moon or stars are out, none of their light reaches me.

The way the paths wind back and forth makes the journey feel interminable. I must be making some progress westward, slowly, because the ground is drying out. The air is drying out. The clouds of flies are thinning. The mountains are in sight, almost maddeningly close. It may still be many days before I am out of the fens entirely.

A final parting gift from Hawezar today. A group of snakemen attacked. This far west, they must have been tracking me for some time, trying to decide whether to try me. They made the wrong choice. Those I didn't kill fell back into the swamp. I am quite sure I won't see them again, and they might even think twice before assaulting the next old man they encounter.

I am out of the swamps at last. I pushed a bit farther today, until after the sun had set and I had to make camp in the twilight, just to finally be free of Hawezar. From here, I continue upward into the foothills and cross the mountains into Kehjistan. My route will take me to Caldeum first, and then south to the Kurast Docks, where I will buy passage on a ship crossing the Twin Seas. Or at least, that is the plan.

Kehjistan
Crucible,
first land
Lies shattered
In the desert sand

This poetic fragment refers to Kehjistan's ancient history as the first human civilization in Sanctuary, but also its decline and collapse.

Kurast!
　　A beacon of brightest light
　　　Shining for the World.
　　A wondrous city of gold
　　　And perfumed palaces.
Kurast!
　　Your high towers gleam
　　　In the bronze light
　　Of a sun that will never set
　　On the glory of your rule.
Kurast!

This is just one small part of a poorly crafted poem by a long-dead and forgotten writer. It is an absurdly lengthy and ecstatic tribute to the city of Kurast, which now lies in ruin, just like Corvus and Viz-Jun and Caldeum and Old Tristram and countless other cities whose residents no doubt once believed their prosperity would last forever.

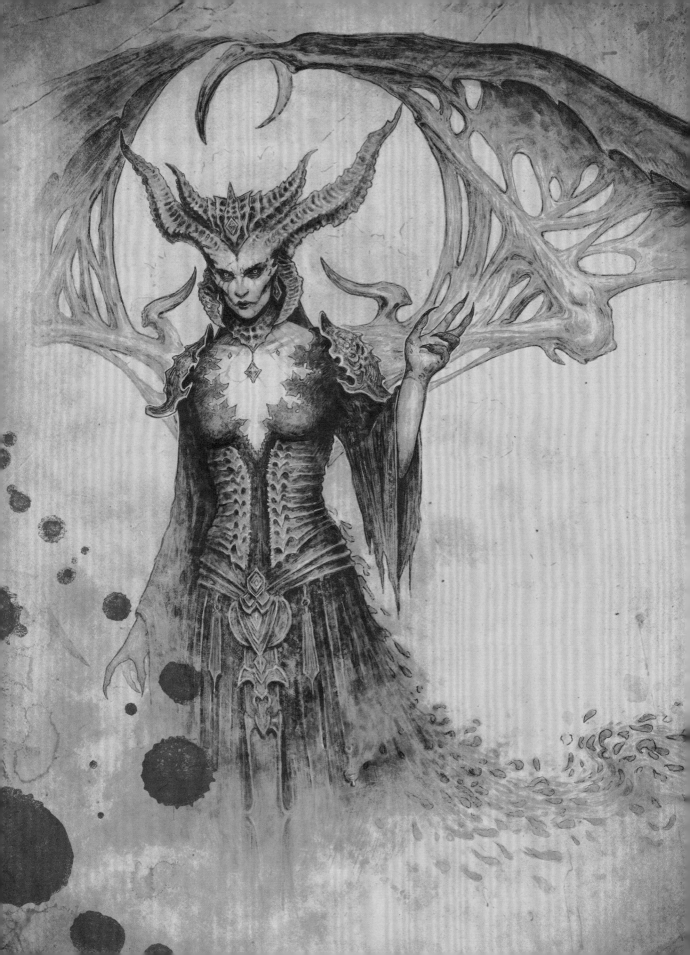

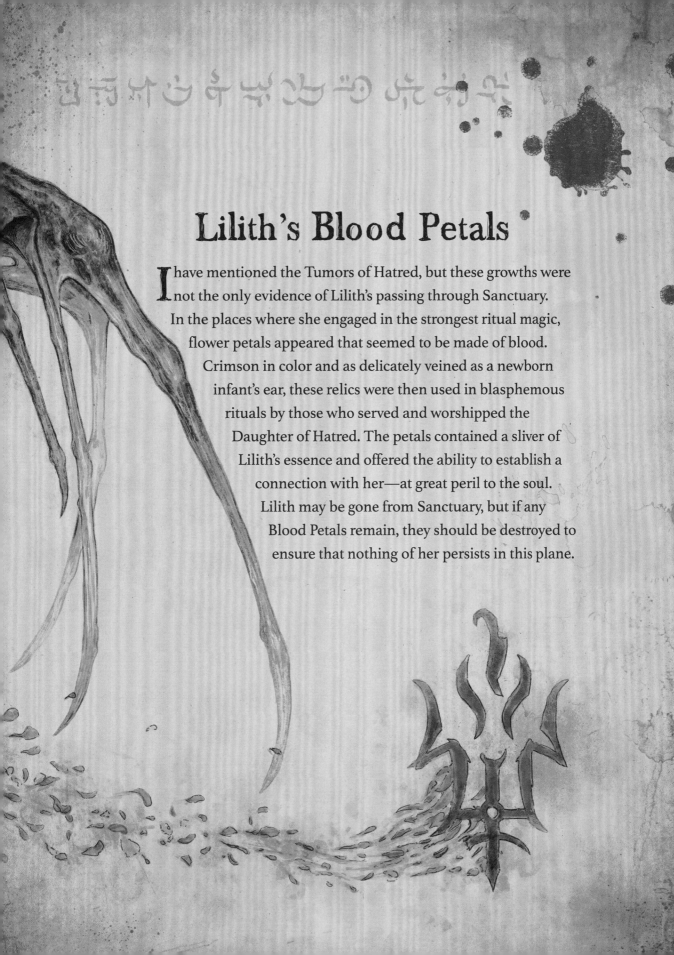

Lilith's Blood Petals

I have mentioned the Tumors of Hatred, but these growths were not the only evidence of Lilith's passing through Sanctuary. In the places where she engaged in the strongest ritual magic, flower petals appeared that seemed to be made of blood. Crimson in color and as delicately veined as a newborn infant's ear, these relics were then used in blasphemous rituals by those who served and worshipped the Daughter of Hatred. The petals contained a sliver of Lilith's essence and offered the ability to establish a connection with her—at great peril to the soul. Lilith may be gone from Sanctuary, but if any Blood Petals remain, they should be destroyed to ensure that nothing of her persists in this plane.

Sightless Eye

According to legend, this relic once allowed a Firstborn of Sanctuary named Philios to communicate in secret with Lycander, an angel in the High Heavens. This link threatened Sanctuary with discovery by the Angiris Council, so Lycander ended her communion with Philios and told him to hide the Sightless Eye.

Philios placed the relic on the isle of Skovos in the Twin Seas, where his twin daughters eventually discovered it. These same sisters also founded the Askari people, who dwell on those islands to this day. They are called Amazons by some, renowned for their deadly prowess with bow, javelin, and spear.

The Sightless Eye, the most sacred relic of Askari culture, is no longer on Skovos. During an incident of sectarian conflict, a renegade group of Askari women absconded with the Eye and left the island. They settled in Khanduras, at the Eastgate Monastery, and called themselves the Sisterhood of the Sightless Eye. Their high priestess, Akara, was the same woman who supposedly once owned my mortar and pestle.

In addition to communication with the Heavens, the Sightless Eye could scry far distant places and even see into the future. Most recently, the Eye allowed us to observe Lilith from afar, but we soon learned that she could also see us.

If you find it odd that a relic offering the ability to see would be called "sightless," remember that sight is not only a product of the eyes. True perception also requires a mind to interpret what the eyes see. *And hopefully the wisdom to act.*

I know of at least one delegation of Horadrim sent there by Tyrael, and they carried a powerful gift with them. None have returned, nor have they been heard from since.

Horadric Ritual Tome

perhaps for the better

The Horadrim acquired vast troves of relics and texts throughout their long history. Many of these collections have been lost, but in the Mistral Woods there is a Horadric Vault that had been preserved well enough to remain useful. It contained a large store of objects, tools, and knowledge, and was guarded by powerful wards and spells.

One of the books held in the Vault was a Ritual Tome. It was created by Elias as he studied and compiled the writings of Rathma, the first Necromancer, and therefore its spells relate primarily to working with the dead. I would ordinarily trust nothing created by Elias; however, this book is not truly his work and may prove useful to those who wish to benefit from the wisdom Rathma received from Trag'Oul. Neyrelle used it to contact the spirit of her mother, Vhenard. I do not believe she

But of what use are those if the Horadrim themselves cannot be trusted?

Neyrelle, if you are reading this, you know as well as I do that no spell or ritual could have given you what you wanted most. I think you hoped the Ritual Tome would provide you with a way to save your mother. Necromancy isn't for the dead, who are beyond our reach even when we summon them before us. It is for the living. I understand that now, and I have you to thank for it.

Kalendri's History of the Ammuit Mage Clan

This record can also be found in the Horadric Vault within the Mistral Woods. The Ammuit mage clan was one of three factions involved in the Mage Clan Wars more than two thousand years ago. The Ammuit fought alongside the Ennead Clan against the Vizjerei in a conflict that leveled cities and cost hundreds of thousands of lives before it was over. The Mage Clan Wars first erupted over the Vizjerei practice of demon summoning, which the Ammuit and Ennead Clans forbade, but which the Vizjerei pursued to their own destruction, demonstrating once again that humanity is fully capable of damning itself.

according to some estimates

The Ammuit are said to have focused their studies and schooling on the magic of illusion. Kalendri's text contains the unattributed quote, "Control the mind, and you control the world." This principle is true, so far as it goes. With sufficient enchantment, a mage can make anyone believe anything. The greater the illusion, however, the more the mind will rebel, and the harder the effort needed to maintain the spell.

Somewhat surprisingly, the Ammuit held special regard for the mages among their ranks who could control masses of people with minimal manipulation of reality. One artful practitioner is described as having toppled a tyrant with a single story that she spread among the peasantry. The trick, it seems, is to employ such subtlety that the target of an illusion is unaware of anything amiss. They are simply swept along until they dwell in a reality they believe to be theirs, when in actuality it has been carefully constructed around them. Like a fish unaware that it has been removed from its river and dropped into a pot.

Even Kalendri's book, a purported history, may be an attempt to control what we think we know about the Ammuit Clan all these many centuries later.

Soul Prisons

Centuries ago, deep in the deserts of Kehjistan, long-dead mages succeeded in trapping a powerful ghost called Ghezrim. To accomplish this, they utilized two soul prisons, and these stone altars remained intact even as the empire that surrounded them crumbled to ruin. In my lifetime, a nameless Priest of Rathma went searching for these prisons to finally destroy Ghezrim, but he perished before completing his quest. It is said the Nephalem succeeded where the Necromancer had not, first releasing Ghezrim, then slaying him.

I mention this tale here because I suspect there are many soul prisons scattered throughout Sanctuary, forgotten, waiting for some unwitting traveler to unleash the evil trapped within them. There are few who possess the knowledge needed to recognize such prisons, and fewer still with the skills and strength to defeat the prisoners. The Horadrim are uniquely suited to both tasks, and I believe it is incumbent upon them to neutralize these latent threats when and where they find them.

Yoke of Anguish

Humanity possesses few advantages against the Prime and Lesser Evils, but one would be the disunity that exists in the Burning Hells. Just as our monarchs, warlords, and priests vie for control of Sanctuary, so do demon lords scheme and wage war for control of their hellish realms. When Andariel, Maiden of Anguish, chose to ally with Diablo during the Darkening of Tristram, she enraged her fellow Lesser Evils. They chained her to an immense yoke to humiliate, punish, and bind her. This Yoke of Anguish had been fashioned and forged from Andariel's own torture racks and other implements of cruelty. Such was the suffering caused by these infernal materials that the molten metal is said to have formed itself into two faces frozen in a howling rictus of pain.

Andariel broke free of her yoke during our battle with her, and we faced her unbound, in the fullness of her power.

We defeated her, narrowly, but fragments of the Yoke of Anguish remained, including the horrid faces. Though they are hateful, cursed objects, I take some comfort in them. They remind me that humans are not the only beings who turn on their kind. Demons can also be their own worst enemies.

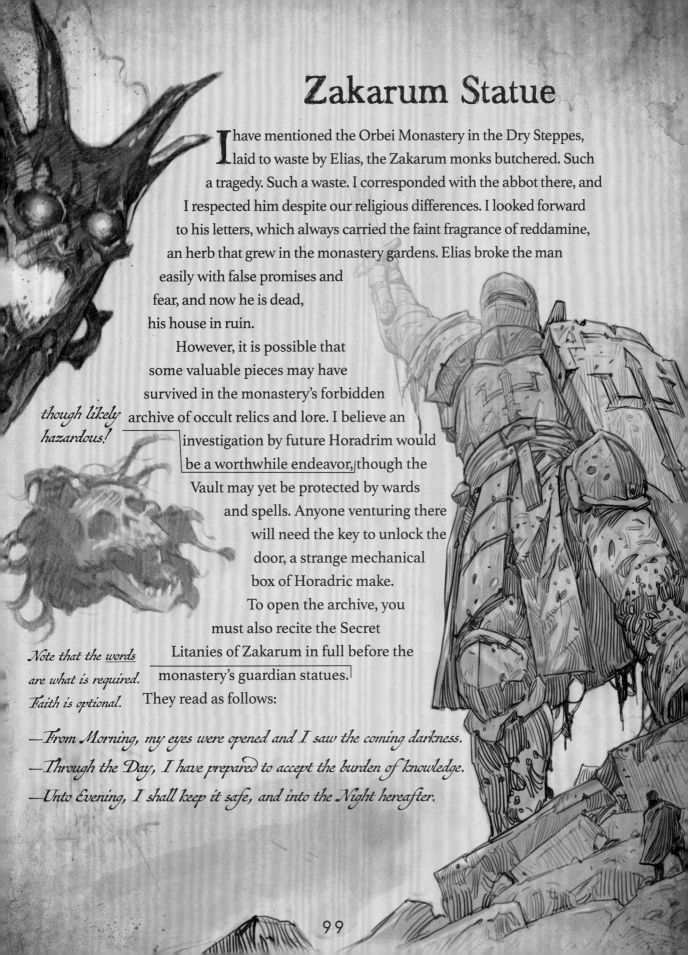

Zakarum Statue

I have mentioned the Orbei Monastery in the Dry Steppes, laid to waste by Elias, the Zakarum monks butchered. Such a tragedy. Such a waste. I corresponded with the abbot there, and I respected him despite our religious differences. I looked forward to his letters, which always carried the faint fragrance of reddamine, an herb that grew in the monastery gardens. Elias broke the man easily with false promises and fear, and now he is dead, his house in ruin.

However, it is possible that some valuable pieces may have survived in the monastery's forbidden archive of occult relics and lore. I believe an investigation by future Horadrim would be a worthwhile endeavor, though the Vault may yet be protected by wards and spells. Anyone venturing there will need the key to unlock the door, a strange mechanical box of Horadric make.

To open the archive, you must also recite the Secret Litanies of Zakarum in full before the monastery's guardian statues. They read as follows:

though likely hazardous!

Note that the words are what is required. Faith is optional.

—*From Morning, my eyes were opened and I saw the coming darkness.*
—*Through the Day, I have prepared to accept the burden of knowledge.*
—*Unto Evening, I shall keep it safe, and into the Night hereafter.*

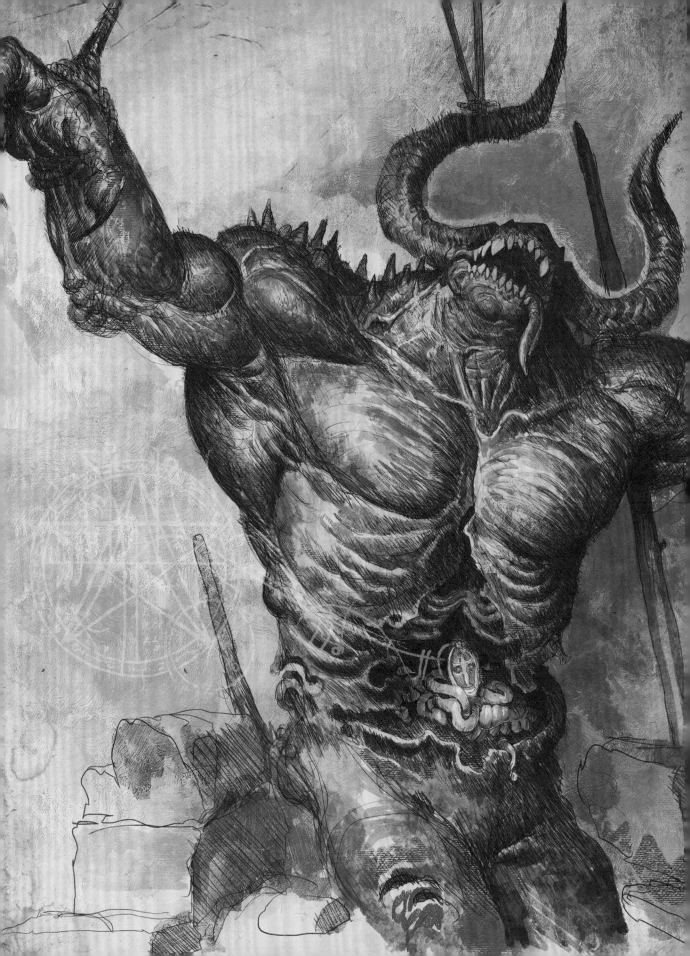

Medallion of Guulrahn

This piece of golden jewelry bears the crest of a noble clan from Guulrahn, an ancient city that was once a flourishing center of culture and trade in the Dry Steppes before Elias brought hell through the gates. Now the streets are piled with riven and half-eaten corpses. Demons, monsters, and cannibals roam freely. Families who lived there for generations are now extinct, and the dead are the fortunate ones. The streets that once smelled of spices and incense are filled with ash. The canals that once carried sweet water from the Jakha Basin are now choked with the dead.

This medallion is a ghostly emblem of the fallen, a symbol of all that was lost. It also passed through the gullet of a demon. I extracted it from the creature's steaming innards myself. The bile and acid in the demon's gut etched an ugly scar across the medallion's face. I am uncertain what being ingested by a demon does to an object like this, whether evil might have seeped into its metal. Anything seems possible.

For either of these reasons, I would avoid wearing this medallion, for it is twice cursed.

Zolaya's Whittling Knife

As Guulrahn fell, a fortunate few did manage to escape the worst depravity and destruction. Zolaya was a thief who fled to a secret cave in the cliffs above the city. From there, she might have found relative safety by traveling north into Scosglen or south into Kehjistan, but she refused to leave. Her partner and lover, a woman named Oyuun, remained trapped inside the city walls. I found her devotion admirable. It gave me joy to see the two of them finally reunited and departing that hellish place to begin a new life elsewhere.

Zolaya carried a whittling knife with her. It was a common tool, but elegantly made, with a bone handle inscribed with totems and glyphs. I wanted to ask her about its origins but refrained. I saw her put it to use in a variety of ways, and I suspect it cut purse strings and picked locks as well as it carved wood and meat. It seemed to make Zolaya's fingers nimbler and increase her dexterity, and I am quite convinced there was some magic in it. May it continue to serve her well, wherever she and Oyuun went.

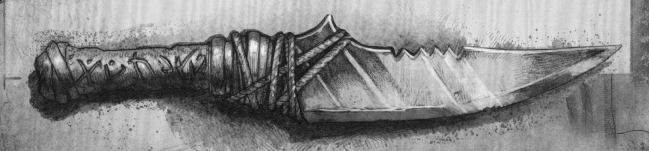

Triune Shrine

Just as the Cathedral of Light builds shrines of Inarius, the cult of the Triune builds shrines of the Prime Evils. They are hewn from obsidian and other volcanic rock, arrayed with skulls and bones, and seem to glower with malevolence. The dried blood of previous sacrifices fills the cracks and fissures in the stone. The rancid soot of burnt offerings gives off an odor of sulfur and death.

A shrine is a gatehouse, and empty houses do not stay vacant for long. Eventually, someone or something will move in. To approach a Triune Shrine is to approach a gatehouse to the Burning Hells and to come into the presence of Diablo, Baal, and Mephisto. To enter Mount Civo and stop Elias from summoning Andariel, the shrines had to be appeased, and each demanded a heavy price. Should there ever be a need to visit the Triune Shrine again, the supplicant will likely be tormented with horrific visions, forced to relive past destruction visited upon Sanctuary by the Prime Evils. Be certain of your strength to endure such a trial before approaching this place.

May that day never come!

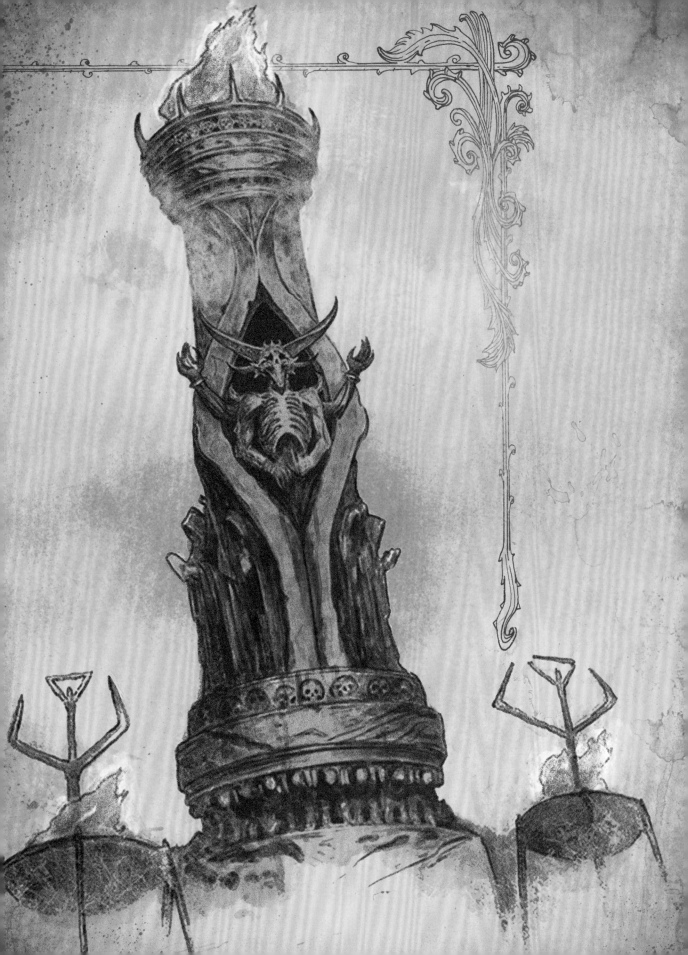

Map of Mount Civo

A volcano rises above the Dry Steppes, crowned in its own fire and ash. A maze of tunnels and chambers burrow through it, and a roiling caldera burns at its heart. It is called Mount Civo, and it is an evil place. It may have once been otherwise, but the cult that worships the Triune of Diablo, Baal, and Mephisto have long since claimed the mountain for their dark rituals. The land there is now tainted and corrupted, and that is where Elias went to summon Andariel.

There is a map of Mount Civo. It is drawn on demon hide in demon blood, and it depicts the inner passages and caverns. Who made the map is unknown, but it must have been someone intimately aware of every fork and turn. Anyone venturing into the mountain would be wise to obtain this map, or a copy of it. Without its guidance, the odds of walking back out again are quite low.

Isabella

The camels of Kehjistan are almost legendary. For centuries, they have been the lifeblood of the desert, connecting distant cities and making it possible for vital trade caravans to cross the hot dunes. Many merchants form strong bonds with their animals, achieving a wordless system of understanding and communication that even a Druid would respect.

When we encountered Meshif, he had traded the ocean for the sand and his ship for a camel named Isabella. He was as loyal to her as she was to him, and when he died, I could feel her grief and despair. With his last breath, Meshif mistook me for another Horadrim he had known: Deckard Cain. I felt no pride in his confusion, and I do not claim to be a man of the same mettle as Cain.

I couldn't find a new owner for Isabella in the time allowed us, so I made the difficult decision to set her free. She knows the desert and how to survive there, and I hope she is well. If you happen to be traveling through Kehjistan and see a camel with a yellow scarf around her neck, treat her well. And if you have any dried apricots, offer her a few. *She loves those.*

Tyrant's Pipe

As Guulrahn fell and marauders put its rulers to the sword, a new warlord rose to power. His name was Brol, and he was called Tyrant—an enormous man of great strength, ferocity, and cruelty. He encouraged the destruction of the city and delighted in the suffering of its people. He reveled in the chaos and bloodshed. When the time came to remove him from power, he fought with almost demonic fury.

The Tyrant also smoked a pipe. It was fashioned in the churchwarden style, with a long stem and a bowl carved in the shape of an opened skull. I had assumed Brol used it to smoke substances of a traditional kind. Considering his inhuman appetite and capacity for violence, I wonder if something in his blend lent him added power and rage, or if the pipe itself is a potent relic.

Then again, blaming the substance may be too easy an explanation when humanity has proven itself capable of heinous acts without any.

It may seem odd to mention an ornamental plant in this catalogue, so bear with me.

Exalted Topiary

Deep in the Kehjistan desert, Elias and his followers had taken refuge at an oasis in the Exalted Palace that recalled the glory of Caldeum as it was a thousand years ago. Fountains of crystal waters danced in the sunlight, and the gardens bloomed with rare flowers I have only read about. Wealthy residents and nobles gathered among the ornamental topiaries, eating the most delectable foods and drinking the finest wines as they waited for the world to end so a new one could begin. They believed Lilith's lies and craved the paradise she had promised them, and some of them even knew the price. Perhaps they all knew.

There were no topiaries inside the Exalted Palace. There were no fountains and no extravagant dishes. Just behind the glorious façade, cultists tortured and sacrificed the wealthy in grisly rituals, and demons roamed the blood-splattered corridors. Such suffering is often the true cost of paradise. Remember that when next you see a topiary, and then ask yourself if Hell made the garden party possible.

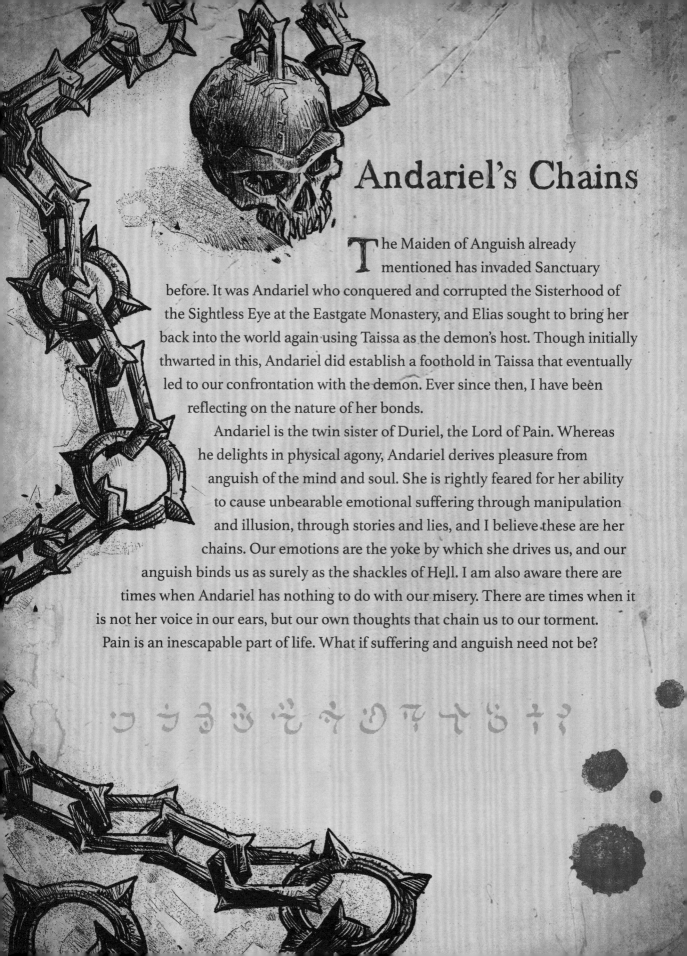

Andariel's Chains

The Maiden of Anguish already mentioned has invaded Sanctuary before. It was Andariel who conquered and corrupted the Sisterhood of the Sightless Eye at the Eastgate Monastery, and Elias sought to bring her back into the world again using Taissa as the demon's host. Though initially thwarted in this, Andariel did establish a foothold in Taissa that eventually led to our confrontation with the demon. Ever since then, I have been reflecting on the nature of her bonds.

Andariel is the twin sister of Duriel, the Lord of Pain. Whereas he delights in physical agony, Andariel derives pleasure from anguish of the mind and soul. She is rightly feared for her ability to cause unbearable emotional suffering through manipulation and illusion, through stories and lies, and I believe these are her chains. Our emotions are the yoke by which she drives us, and our anguish binds us as surely as the shackles of Hell. I am also aware there are times when Andariel has nothing to do with our misery. There are times when it is not her voice in our ears, but our own thoughts that chain us to our torment. Pain is an inescapable part of life. What if suffering and anguish need not be?

Sankekur
Tapestry

Mephisto completed his corruption of the Zakarum faith when one of his servants, Sankekur, became the Great Patriarch at the head of the church. He executed Mephisto's plans to corrupt even the strongest priests and most virtuous Paladin orders, and when Diablo and Baal arrived at the holy Zakarum city of Travincal, Mephisto took full possession of Sankekur's body, twisting it to reflect his horrific visage.

The tapestry depicting the death of Sankekur portrays him as a demonic monster, and the defeat of him as a mighty victory for the forces of good. These things are true. Yet we must not forget that the tapestry also depicts a tragedy, one that is not fully represented by the weaver of this hanging.

Sankekur was the Avatar of Mephisto—and a victim of the Lord of Hatred. He had a shard of Mephisto's Blue Soulstone stabbed into his hand. This was a burden few could carry without succumbing to its influence. That does not make him evil. It makes him human. We will never know for certain what manner of man he might have been.

My sympathy for Sankekur should not come as a surprise, for reasons that I've made plain. Neyrelle's ordeal has changed my feelings on many things.

BLACK SARCOPHAGUS

After the fall of the Zakarum temple city of Travincal and the defeat of Mephisto, Sankekur's twisted corpse remained dangerous and corrupted, radiating evil. The faithful who had survived the devastation determined that something needed to be done with the body to prevent its residual influence from spreading.

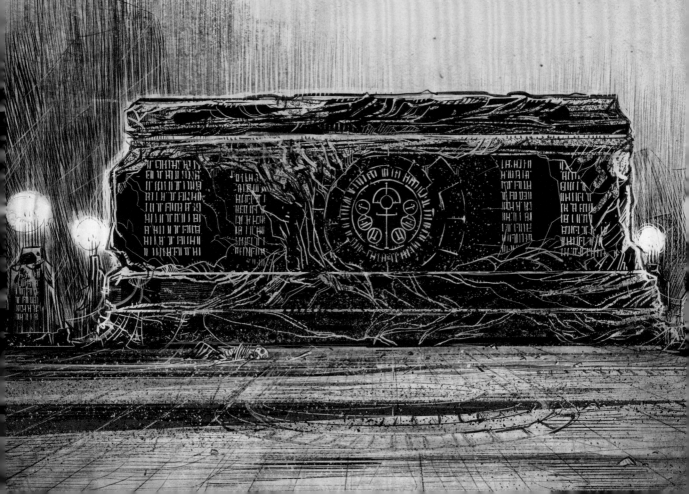

OF SANKEKUR

It was then that Carthas volunteered to carry the body of Sankekur to a place where it could do no harm. He had already fought heroically in the battle against the Prime Evils, and for that alone he would likely have been regarded as the greatest Paladin of his time. The sacrifice he would subsequently make ensured his name is now remembered among the finest Paladins to have ever taken their oaths.

Carthas and his companions descended deep into the crypts beneath Rakhat Keep, where they prepared a chamber as Sankekur's tomb. They lined the walls with blessed obsidian, and they also sealed the corpse in a sarcophagus of obsidian using holy wards. Yet they worried these safeguards would not be enough to contain the body's contagion of hatred. So in a noble sacrifice, they committed their souls to an eternal vigil guarding the tomb.

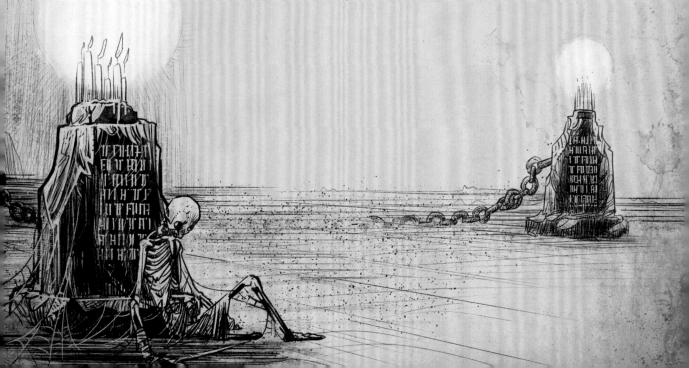

Gallows

ᒣᑕ ᑕᒣ ᒉᓴ ᐁ ᒬ ᒋ ᒣᓭ

Our pursuit of Lilith eventually led to Caldeum. Inarius and the Cathedral of Light also followed her there, forced to battle through hordes of demons at her command. The church met these enemies with thorough ferocity. They showed no mercy and gave no quarter. Their fervent cleanse of the land slew demonkind, but also any human they believed to be in league with the forces of Hell. They lined the road to Caldeum with gallows, where they hung the corpses of the accused. The smell of rot carried for miles. So thick were the clouds of flies that they obscured the road ahead like a black dust storm. There was nothing holy about that grim thoroughfare. There was no sanctity in the Cathedral's judgment, which has now fallen on the Horadrim through Prava's Decree.

Let the image of the gallows sink into the mind of anyone who would defy the Cathedral, for that is the price you might be called to pay for your opposition. Perhaps it will one day be worth it.

not just adults, but children

Arma Haereticorum

This tome emerged from Zoltun Kulle's library and contains numerous designs for legendary pieces of armor. Many of the concepts and abilities he proposes are extraordinary, unlike anything I have ever seen. It is unclear from the text whether Kulle actually used these designs to create the relics they describe. I suspect the book is more a collection of ideas he considered sound enough to write down. Nevertheless, Kulle was brilliant, so it is likely the designs contained in the Arma Haereticorum, even if theoretical, will prove successful. They may require some adjustment and refinement along the way by a talented blacksmith.

It is the need for refinement and adjustment that most concerns me. I plan to use the designs and techniques in Kulle's text for the magic I am pursuing in my journey. I am not the blacksmith my father wanted me to be. I am not the blacksmith he was. There is a blacksmith I would trust to forge what I require, however, if I can find her . . .

Rydraelm Tome

Little is known about the Rydraelm mages. Rumors accused them of engaging in deeply arcane practices. One story claimed they came from the Sharval Wilds. The high degree of secrecy maintained by their order might suggest a need to hide nefarious or forbidden magic.

Given the history of violent conflicts between mage clans, their furtiveness might simply have been a strategy for self-preservation. Either way, they are most likely extinct, according to Abd al-Hazir, who wrote, "The last time a Rydraelm mage was seen, he was being feasted upon by fallen grunts under the watchful eye of their shaman. It is safe to assume he did not survive the encounter."

Remnants of their magic could once be found in the form of tomes that allowed for the creation of their powerful mantles and robes. None of these tomes have appeared in quite some time and may have vanished along with the mages who inscribed them.

Lam Esen's Tome

Sometimes referred to as the <u>Black Book of Lam Esen</u>, this text contains many of the beliefs and magical spells practiced by followers of the Skatsim faith and represents much of what we know about this lost ancient religion. Persecution and inquisition by the Zakarum church almost succeeded in erasing the legacy of the Skatsim entirely, a history that is commonly thought to date from the earliest days of Sanctuary. At least one copy of <u>Lam Esen's Tome</u> is known to exist. It was found in the ruins of Kurast during Mephisto's occupation of that once-great city. Other copies may yet emerge.

Little is known about the author of the text. Lam Esen was accounted a sage of great wisdom and power. Adepts in Skatsimi magic are said to have used various techniques to alter their perception and awareness, granting them the ability to see distant places, and even glimpse future events. If that is the case, then Lam Esen must have seen what would become of his religion, and he compiled his tome against that day. Perhaps he wrote his book with the same urgency I feel as I write this text.

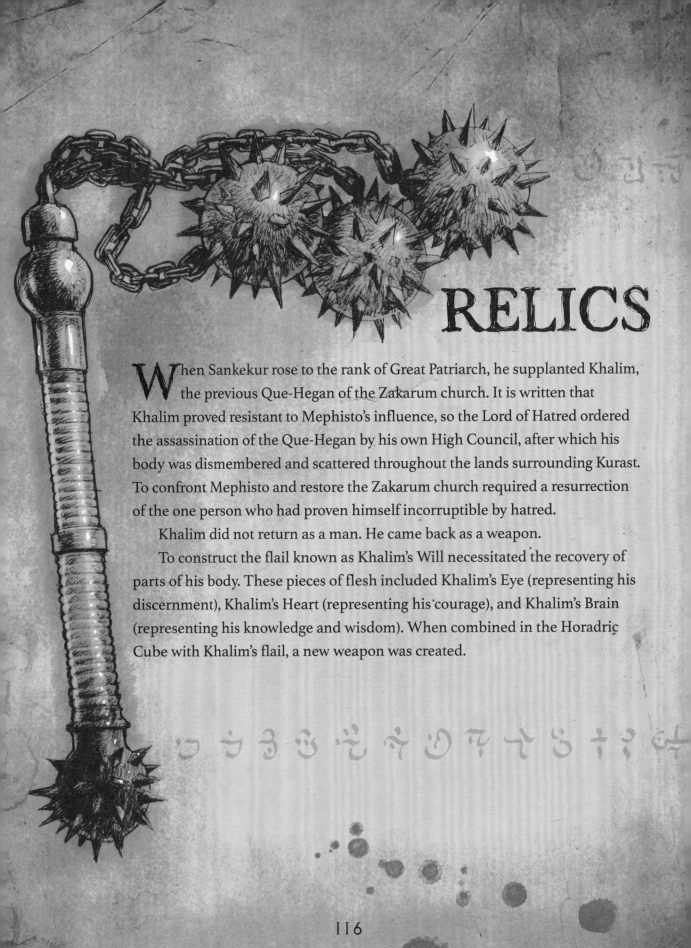

RELICS

When Sankekur rose to the rank of Great Patriarch, he supplanted Khalim, the previous Que-Hegan of the Zakarum church. It is written that Khalim proved resistant to Mephisto's influence, so the Lord of Hatred ordered the assassination of the Que-Hegan by his own High Council, after which his body was dismembered and scattered throughout the lands surrounding Kurast. To confront Mephisto and restore the Zakarum church required a resurrection of the one person who had proven himself incorruptible by hatred.

Khalim did not return as a man. He came back as a weapon.

To construct the flail known as Khalim's Will necessitated the recovery of parts of his body. These pieces of flesh included Khalim's Eye (representing his discernment), Khalim's Heart (representing his courage), and Khalim's Brain (representing his knowledge and wisdom). When combined in the Horadric Cube with Khalim's flail, a new weapon was created.

OF KHALIM

Khalim's Will had the power to destroy the Compelling Orb and open the way to the Durance of Hate. It was supposedly destroyed by the release of arcane energies that resulted. I have heard rumors of a similar flail, the Que-Hegan's Will, that appeared some time ago in the Halls of Agony below the manor of the mad king, Leoric. I will leave it to others to determine whether these two weapons might somehow be one and the same, for I believe it is possible.

It is also possible that the name of Khalim is now a weapon unto itself, capable of striking a blow against the demons who quake at the memory of his strength. To invoke the legacy of a hero of legend is to assume a shade of their mantle and charge once more with them into battle.

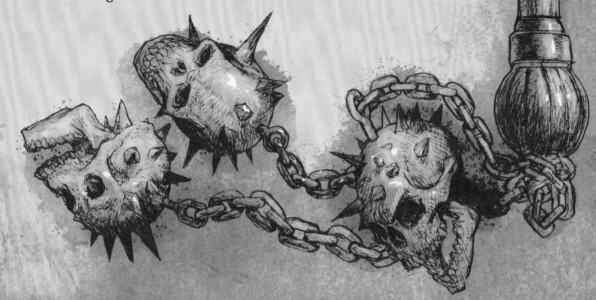

Compelling Orb

I have thus far been quite critical of the Zakarum church. I feel justified in everything I have written. However, in the interest of fairness, there is one relic that speaks somewhat in their defense.

The Compelling Orb stood on a black pedestal, flanked by curved blades of bone arranged as if in mockery of angelic wings. The globe emitted a commanding magical field that allowed the High Council of Zakarum to exert control over their followers. Mephisto had this relic placed in the ruined temple city of Travincal, where it also guarded the entrance to his lair in the Durance of Hate.

The mere existence of this relic implies that Mephisto and the High Council could not have maintained obedience among their followers without it. This in turn suggests that some of the Zakarum priests, if not many of them, would have rebelled against the demonic presence at the heart of their church. The Compelling Orb demonstrates that Mephisto had not taken over the faith so completely that he could manipulate it without the aid of powerful magic. I take a measure of reassurance from that.

a slight measure

Ashes of Ku Y'leh

Throughout history, many scholars, priests, and mages have obsessed over the mystery of what lies beyond death. Some have used dark rituals that even Necromancers will avoid glimpsing the afterlife. Fear of death has driven others to prolong their lives through unnatural means that always come at a price.

One man well known for his interest in mortality was the sage Ku Y'leh. His age isn't given in any sources. It is believed that he found the means to extend his life considerably through elixirs and potions. True immortality eluded him, however.

Upon his death, his ashes were placed inside a golden statue shaped like one of the songbirds found around Kurast. Many years later, this relic ended up in the collection of Meshif, and it ultimately proved valuable when the ashes were extracted and used in a new potion of life and health. In this way, Ku Y'leh did live on past his death—just not in the way he intended. The same will be true of us when our bodies become food for worms and carrion crows. We are all but links in a chain of death and immortality.

Tenue's bargain with the swamp comes to mind.

Wirt's Bell

There was once a lad from Old Tristram whose name is now surprisingly well known for someone of his common background. Wirt began his life like any child. That all changed when demons tore him from his mother's arms and carried him down into the crypts below the Tristram Cathedral. I can well imagine what the boy must have seen and endured there, and it pains me to think of such things happening to one so young. Though he was rescued, the torture inflicted upon him ruined his leg, which had to be amputated. He walked with a wooden peg afterward and was said to be altered in temperament, becoming hardened, angry, and bitter. He took up trading stolen wares in the single-minded pursuit of gold, and even though he died long ago, relics connected to him keep turning up, along with his name and his tragic tale.

Wirt's Bell is an ordinary tarnished cowbell, and of itself does little beyond ringing in the way that would be expected. However, when it is combined with several other relics, an object is created known as the Staff of Herding, which supposedly opens a portal in the ground that leads to another plane of surreal vibrance and violence. Or so I am told. I am skeptical of these claims. The description of this whimsical realm is suspiciously akin to hallucinations produced by various fungi that happen to grow near New Tristram.

Opium Pipe

ᚠᛞᛘᛚᛂᛘᛚᚿ

Though we left Meshif's body behind in the desert, I took his pipe with me. It is a delicate relic, long and slender, with an ornate bowl at the end. It appears to be made of jade, carved so thinly that light passes through it, rippling as through seawater. It still smells faintly of the drug Meshif smoked, for which I cannot fault him. He came from Kurast. He watched his homeland's destruction by Mephisto, and his grief must have been a heavy burden. Despite the tragedies Meshif had suffered, he offered aid and friendship to the Horadrim when needed, ultimately at the cost of his life. That is why I want to preserve his pipe and incorporate it into my work with this book. It is not imbued with magic, though it is a potent symbol of hope and courage. In this way, I can honor Meshif's sacrifice.

I now have the relic I came to retrieve from Caldeum. It is an arrow known as the Breath of Philios. I was pleased to find it in the repository where Horadric records indicated it would be. I only hope that it will be an adequate gift to satisfy the Askari. From here I travel south to what remains of Kurast, where I hope to hire a ship.

Neyrelle was here. My fears are confirmed.

Kurast is not the safest of ports. It hasn't fully recovered from the devastation caused by Mephisto's ascendance, but it has achieved stability. Yet when I arrived, I found it in chaos. Violence has erupted like a plague. Old rivalries have been renewed. Neighbors slaughter neighbors over trivial slights. Hatred reins.

The same fate befell the village of Yelesna after Neyrelle passed through it. Fortunately, Kurast is far enough south it might be spared the brutal retribution of the Knights Penitent. I must do what I can to help these people.

Order is gradually being restored. The fever of hatred has broken. From my inquiries, I have gathered that Neyrelle was only here for a short time, barely a day. I wonder if she is even aware of what she leaves in her wake.

A ship arrived today. I went to see its captain about passage across the Twin Seas, and I was surprised when he seemed to recognize me. He said his previous passenger had described me well ("an old man whose face has forgotten how to smile"). Then he gave me a letter from her.

Lorath,

I should not have come to Kurast. This was Mephisto's domain. Almost as soon as I arrived, his voice grew louder, more insistent. The Lord of Hatred laughs at humanity's insignificance. He mocks my weakness. He shows me the ruin that is to come. Sanctuary devoured. I fear the raging storm inside my head will drive me mad.

Before coming here, I thought I was learning to ignore his voice and see through his visions. But I should have anticipated this. I was a fool. No doubt you would have tried to warn me if you were here. Perhaps I would have listened.

I am leaving Kurast as quickly as I can, and I will not repeat this mistake. I must seek some way of silencing the Lord of Hatred. I must find a way to keep my sanity. But don't worry, old man. I am not lost yet

Neyrelle

I have secured passage on the ship that carried Neyrelle. After some argument and an absurd amount of gold, I managed to convince the captain to take a detour south to the Skovos Isles before the crossing to Aranoch.

Seasick.

I hate ships.

The seas closer to the Skovos Isles have calmed, and they are as lovely as the stories claim. The turquoise waters sparkle like faceted jewels. The sandy beaches and island cliffs are white as clouds and capped in lush green canopies. The ship captain says we should reach the capital city of Temis before nightfall.

That did not go as planned. I expect the captain will ask for more gold. I will pay it. We are probably lucky to be alive.

Before we reached Temis, several Askari ships charged across the waves toward us. They moved with the speed and cold elegance of sharks. They forced us aground in a small bay, far from any city or village, though I did catch a glimpse of tiled roofs and marble colonnades through the trees. They demanded our names and did not respond well when I announced myself as Horadrim. I had hoped to offer the Breath of Philios in exchange for information about the delegation Tyrael had sent. I never got the chance. They ordered us to leave their waters, and there was no negotiating with their spears and bows. We sailed for Lut Gholein.

I do not believe there is any sight in all of Sanctuary more beautiful than the sands of Aranoch turned to silver by the light of the full moon on a clear night.

This sentiment is attributed to the Horadrim Shanar, who passed a lonely vigil over Tyrael's sword, El'druin, upon finding it in the desert of Aranoch after it fell with him from the High Heavens.

HORADRIC

The Horadrim were well known for their mechanical arts and ingenious devices. Of those relics that survive today, the alchemical cubes are perhaps the most mysterious. Like a witch's cauldron, they transmute components and ingredients into new creations. At times, these Horadric Cubes almost seem to possess a unique form of consciousness, as if they operate by their own internal rules of logic for transformation. Records of their construction are scarce. It seems that even the Horadrim engineers who designed them struggled to understand their creations. The cubes were to them then as they are to us now, like the chrysalis of a moth in which mysterious processes take place without our ability to see or direct them.

The cubes offer no assistance to those seeking to use them. Recipes must be discovered through trial and error, and it would not surprise me to learn that we have barely documented a fraction of what the cubes can produce. The combinations and permutations of materials and ingredients are seemingly infinite.

A relic known simply as the Horadric Cube was one such device, but it was preceded by another, Kanai's Cube, named for the man appointed to guard it. Kanai's Cube so frightened the Horadrim that they hid it away shortly after its completion. We do not know precisely what fears caused them to take such drastic action. I have no doubt it was a wise course. Those same artificers believed the Horadric Cube to be free of the flaws that marred the functioning of Kanai's Cube, and I trust they were right in this also.

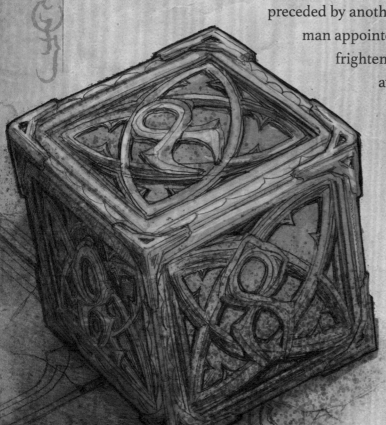

CUBE & STAFF

After the Horadrim locked Tal Rasha in his tomb, they had to decide what to do with the key. The Horadric Staff had significant power on its own. Its ability to reopen Baal's prison made it an extremely dangerous relic. To prevent the forces of evil from obtaining the staff, the Horadrim separated it into two pieces that could only be reunited by using the Horadric Cube. This seemed a wise plan, and they used that same strategy many times through the centuries, for many relics.

The first piece was named the Staff of Kings. Descriptions of it portray it as golden or bronze, with the carving of a snake coiling upward around the central shaft and a jewel in the serpent's mouth at the top. It eventually found its way into the den of Coldworm the Burrower, an enormous sand maggot queen.

The second piece, the Viper Amulet, was cast in the shape of a cobra's flared cowl, with fine enamel inlay and ruby jewels. It was unearthed from the broken altar of the Claw Viper Temple, deep in the valley of Aranoch's snakemen.

Deckard Cain personally oversaw the reunion of these two relics to remake the Horadric Staff, a necessary step in preventing the return of the Prime Evils to power. The strategy of separation devised by those earlier Horadrim had succeeded in keeping Tal Rasha's tomb sealed for more than two hundred and fifty years. As with Soulstones, however, no prison can last forever. So long as a key exists, its door can be opened.

Horadric Scroll

This scroll contained the knowledge needed to restore the Horadric Staff and unlock Tal Rasha's tomb, information that might have proven dangerous had it come to be known by those who serve the Prime Evils. The only safeguard against this happening seems to have been the coded Horadric Runes in which the document was written. It was fortunate, then, that Deckard Cain happened to be present when needed to translate it. He was the last Horadrim living at that time. Events would have unfolded very differently, perhaps cataclysmically, if no Horadrim had been left to read it.

I am taking different precautions and using different protections with this book I am writing. It is obviously not coded in Horadric runes.

Or at least no Horadrim as knowledgeable as Cain!

Morbed's Lantern

Morbed the Rogue is a fascinating folk figure. As a boy in Westmarch, I grew up listening to tales of his exploits whispered in taverns on dark nights. Everyone knows someone who knows someone who claims to have encountered Morbed on the road. There are so many versions of so many stories they cannot all be true, and yet I am convinced the man truly existed. *or exists*

His story begins with a vagabond who had been robbing the ancient tombs and catacombs of Westmarch. The king resolved to stop these raids and sent a company to hunt down the thief and recover the stolen relics. Morbed was a member of this party. When the group tracked their quarry to a small island, the vagabond revealed himself as a powerful sorcerer. He summoned a demon, and suddenly the fight seemed utterly hopeless. Morbed fled in terror, abandoning his companions to their deaths, and soon after found a mysterious lantern chained to his wrist by a jailer's manacle. This relic contained the spirits of the comrades he had betrayed, and Morbed was cursed to wear it until he had atoned for his cowardice.

Now he is said to wander the land, aiding those in need. I have heard tales of him fighting off bandits or defending a shepherd's flock from attacking beasts. One account even had him repairing the broken axle of a wagon. But all Morbed stories begin and end the same: with the rattle of chains and a lantern bobbing in the night, shining with a ghostly light.

Broken Promises

This ring once had a different name and a different appearance. It was originally a gift between lovers to represent their bond, with twin diamonds sharing a setting, sitting side by side. Their love was not to last, and when their union ended in betrayal and heartbreak, one of the lovers had this relic remade. The diamonds now sit apart, almost on opposite sides of the ring, and archaic glyphs have been inscribed between them, telling a tale of sorrow and broken trust. It is said that donning this ring brings a cloud of melancholy down upon the wearer in exchange for feats and skills requiring fewer resources to perform.

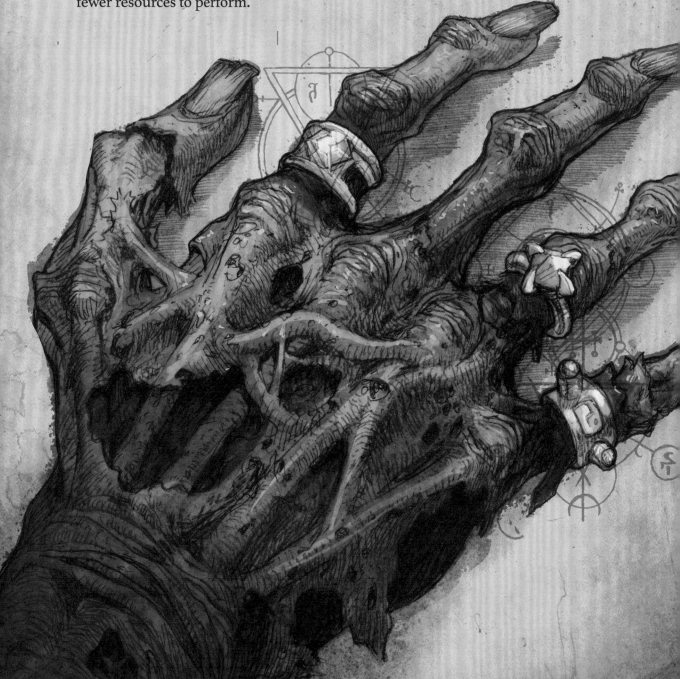

Eternal Union

This is a Zakarum Crusader ring. As such, I have little interest in it. Nevertheless, I will share what knowledge I have in case it proves helpful in ways I don't fully appreciate.

Crusaders have the ability to summon spectral Avatars of the Order into battle at their side. I have always assumed these entities are the spirits of other fallen Crusaders; then again, that would be uncomfortably similar to Necromancer magic for a follower of Zakarum. Regardless, the Eternal Union ring creates a much stronger connection between the summoner and the Avatars called to their aid. With the aid of this ring, a Crusader's spectral allies will persist on our plane twice or thrice as long as they would otherwise.

Litany of the Undaunted & the Wailing Host

Some relics share their power across several objects. These sets may have been forged together, or they may have been worn by the same legendary figure, uniting them in purpose. Relics from such collections often have unique properties when used individually. When they are united and worn as a whole, they often grant the wearer considerable advantages through a kind of synergy.

The Legacy of Nightmares is a set of only two rings, very similar in appearance, each with a single gemstone in a silver setting. The first is the Litany of the Undaunted, so named for the impossibly miniscule writing inscribed across its surface. Legend claims it bears the names of all those who gave their lives fighting against the Burning Hells, and that these heroes lend their strength to the one who wears the ring. Its companion is called the Wailing Host, and contains the fury of a thousand screaming souls, perhaps belonging to those whose names appear on the Litany of the Undaunted. Together, these rings allow the wearer to tap a wellspring of ancient power, such that they match the might of seven or even a hundred warriors.

Kymbo's Gold

Abd al-Kymbo was a merchant who ran a caravan between Aranoch and the Western Kingdoms, braving the dangers of the desert in pursuit of wealth. He was an observant man, and he learned how to read the signs of danger. In lonely places where other traders fell victim to bandits, demons, and beasts, al-Kymbo crossed safely through. He shook his head as he passed the remains of less fortunate caravans, stopping to gather the gold and treasure that had been scattered and left among the wreckage. Then one day, he thought of a way his salvaging could reward him twofold.

He commissioned the creation of an enchanted amulet. Now known as Kymbo's Gold, it was a heavy piece of jewelry, shaped like a hand grasping a coin. Abd al-Kymbo believed that health and wealth should be synonymous, so he designed this relic to grant him health for each gold coin he found. Within a few years, he tired of the road and decided to retire in luxury. His amulet will now aid any wearer in the ways it aided him.

Radament's Hourglass

Time is slippery in the sense that we are all certain we know what it is until we try to define it. Even though we weigh it with the sands of an hourglass and measure it by the height of a burning candle or the movement of a shadow across a sundial, we are not defining time. We are merely asking something else to represent it. We do this often, as when we speak of time in the metaphorical language of gold. We spend it. We waste it. We save it. We lose it. But what if we could think of time in a different way, using different metaphors? What if we sailed time? What if we breathed it?

I do not know if Radament created this hourglass, but it was associated with him while he lived, long before his return as one of the fallen Undead. It does have some features of Horadric craftsmanship. I have read no account of its creation in any Horadric tome, only its location. The metal is highly refined, with the hardness of platinum and the fluid luster of quicksilver, cast in the shape of a snake that coils around the crystal vessel at the center. Within the glass, the shimmering sands of Aranoch swirl as if somehow perpetually windblown inside their shell, never settling at one end or the other, regardless of the position of the hourglass.

This flaw would seem to make this relic rather useless as a practical measure of time's passage. Only if we think of time in the usual, practical way. The power of this artifact is to slow time for the user, such that moments seem to expand to the capacity of hours. As if time inside the glass is something different from time outside it. That is why I claimed this relic from a tomb outside Lut Gholein. The ritual I will perform on this book must last outside of time.

Have joined a caravan heading west. The caravan driver seems competent. He recognized me as Horadrim a few days out from Lut Gholein. Didn't even try to hide his displeasure at it. I think if he had realized who I was before we left, he would have declined to take me. He claims another driver he knew, called Warriv, once helped Deckard Cain, and this led to Warriv being cursed. I assured him Cain cursed no one, and neither would I. He did not seem satisfied, but thankfully he dropped the matter.

―――――――

The caravan driver must want to be rid of me. We are pushing hard, making good time. I'm sure the camels resent us. Before long, we'll cross the mountains into Khanduras. From there, I travel to New Tristram.

Then, after all these years, I am going home.

―――――――

Westmarch. The place of my birth. I have seldom been back since Malthael's Reapers tore through its people, almost annihilating the city. Even after so many years, the devastation remains evident. The streets are too quiet. The market squares are a somber shadow of the bustling hives of commerce I knew in my youth. Many houses and buildings sit empty, boarded up, given over to vermin and rot.

There are faint signs of renewal, however, like a stubborn weed I passed bearing little white flowers. It was reaching out of a crack in the cobblestones, and at another time, someone would have pulled it out. Yet what is a weed but a flower out of place? Somehow, the sight of it almost made me weep, and I left it to grow.

My greatest relief is found in the absence of any sign that Neyrelle has been here. I see no evidence of Mephisto's influence.

It is now time to see what is left of my father's smithy . . .

"*Rakanishu!*"

The Fallen encountered in Khanduras can still be heard spouting the name of a powerful chieftain as a war cry when they charge into battle, even though that chieftain is long dead. In this way, it seems that demons are not dissimilar from humans, for we also hold to the names of old heroes and champions. I have no doubt the Cathedral of Light will go on shouting the name of Inarius.

"We have all heard the tales associated with Tristram. The very mention of its name brings to mind images of undead monstrosities, demonic possession, monarchy driven to lunacy, and, of course, the greatest legend of all: the Lord of Terror unleashed. Although many now claim that a peculiar mold upon the bread or perhaps a fouling of the water drove the populace mad with visions, I have seen too much in my varied travels to dismiss such stories out of hand."

—Abd al-Hazir

As unlikely as it might seem, there are those who dismiss as mere stories what we Horadrim have seen and fought firsthand. Such willful ignorance angers me until I remember that most people would be defenseless against even the lowest Fallen demon. It is much easier to blame such horrors on hallucinations than to believe the Burning Hells might literally open beneath your feet. As I write this, I realize I am guilty of doing the same thing in these very pages regarding Wirt's Bell. I suppose we all have limits to what we can accept and believe.

Arma Mortis

As Malthael abandoned his Aspect of Wisdom and took up the Aspect of Death, he began experimenting with the composition and uses of human souls, a process that killed the humans he tortured. One of his Reapers wrote down the results of this research in a tome—the <u>Arma Mortis</u>, otherwise known as the Weapon of Death. Its pages describe the methods of forging relics with human souls to make weapons of great power and destructiveness. This alone would make the <u>Arma Mortis</u> an extremely dangerous text.

I see something else in it that may cause me even greater alarm. It was humanity's demonic heritage, their "mote of pure darkness," that made their souls so potent in the creation of weapons. Malthael and his angels therefore made use of that which they most abhor, a hypocrisy of the highest heavenly order. They would have refused any demon blade made in the Hellforge, yet they embraced the weapons they made with half-demon souls. Perhaps they believed that their righteous purpose turned the evil into good, when it only resulted in the corruption of their heavenly weapons. Malthael and the <u>Arma Mortis</u> teach us that to use evil in the fight against evil only makes us evil ourselves.

I tried pointing this out to Donan on more than one occasion. His faith in the angels remained unshakable, until Inarius broke it.

Myriam's Mirror

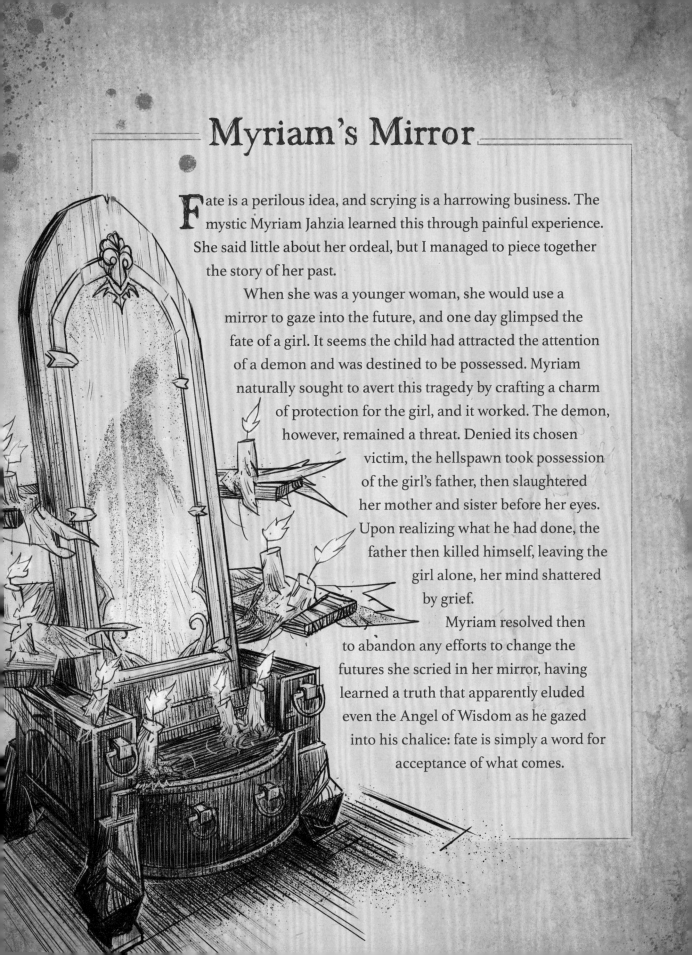

Fate is a perilous idea, and scrying is a harrowing business. The mystic Myriam Jahzia learned this through painful experience. She said little about her ordeal, but I managed to piece together the story of her past.

When she was a younger woman, she would use a mirror to gaze into the future, and one day glimpsed the fate of a girl. It seems the child had attracted the attention of a demon and was destined to be possessed. Myriam naturally sought to avert this tragedy by crafting a charm of protection for the girl, and it worked. The demon, however, remained a threat. Denied its chosen victim, the hellspawn took possession of the girl's father, then slaughtered her mother and sister before her eyes. Upon realizing what he had done, the father then killed himself, leaving the girl alone, her mind shattered by grief.

Myriam resolved then to abandon any efforts to change the futures she scried in her mirror, having learned a truth that apparently eluded even the Angel of Wisdom as he gazed into his chalice: fate is simply a word for acceptance of what comes.

Jewel of Dirgest

I have never heard of or read any accounts that call this ruby relic a Soulstone, and yet it is said to have imprisoned a demon. The story's roots are found on the island of Xiansai in the gods they worship there. The jewel was originally a gift from a legendary thief to the goddess of the second moon. It was later used to confine her jealous husband, the demon Dirgest. The Nephalem went in search of this ruby with the jeweler Covetous Shen, only to find that it had been shattered and Dirgest had escaped. I have since heard a rumor that the shards of the ruby ended up reset in a new piece of jewelry called Shen's Remorse, though this is unverified.

inevitably

I am not sure what more to say about this relic or its story, other than to point out that even the myths and folktales from the distant island of Xiansai seem to understand the folly and danger inherent in Soulstones.

Shen's Tools

Covetous Shen remains an enigmatic figure. Tantalizing hints suggest that he might have even been the *mostly offered by Shen himself* mortal incarnation of the thief god who imprisoned Dirgest. Little has been seen of Shen since he left on a mission to recapture the demon. Somehow, I doubt he is gone for good.

He was widely known for his skill working with precious metals and stones, and it is said that his genius could turn the lowliest bauble into a powerful relic, so long as the customer could pay the price. Stories also say that he would sometimes refuse to sell his work, at a cost to his business, simply because he loved his jewels and saw them almost as his children.

Shen took little with him when he departed on his quest. He left the tools of his trade behind, which appear to be shabby implements. Many of them are ancient, and others are of poor or rustic quality. Some jewelers refuse to believe that such tools could produce work like Shen's, and question whether they really belonged to him. I don't have their expertise. I do know two things:

Firstly, enchanted objects do not always look like enchanted objects.

Secondly, with enough skill, perhaps the tool matters less than the artisan.

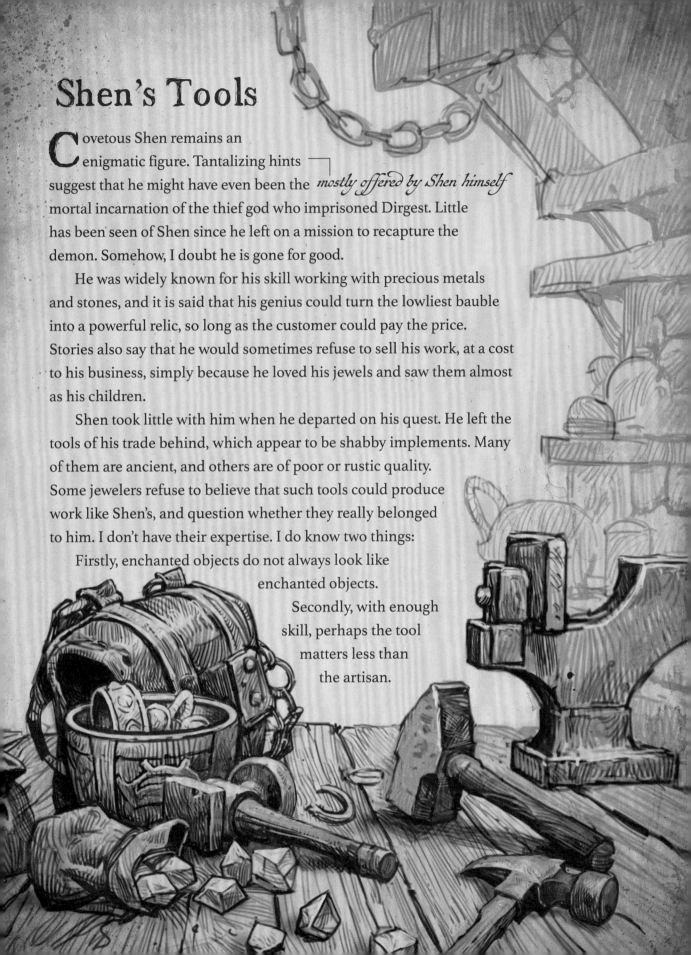

Cursed Crucible

This vessel emerged from the Eastgate Monastery, brought there from the Hellforge by a demon known as the Smith. After Andariel's defeat, the Cursed Crucible was discarded when the Sisterhood of the Sightless Eye rid their house of all demonic remnants. I am certain they would have been more careful had they understood the curse that is upon it. The crucible eventually turns its owner into a monster, which is what happened to a man named Gavin when he and Shen went looking for the relic in the aqueducts from the Dahlgur Oasis.

Despite this, Shen did not seem overly concerned about the curse for himself and even put the crucible to use in crafting his jewelry.

Adds support to the idea that Shen was or is more than he seems?

Scoundrel's Tokens

Some relics are highly idiosyncratic and relative in their worth. Some may even call them superstitious and worthless. A lucky pair of loaded dice or a brooch would do little to nothing for a Horadrim. Those same tokens could prove indispensably powerful when carried by a thief to whom the objects have meaning.

Few scoundrels want their names known. Lyndon was one thief who aided in the battle against the forces of the Burning Hells in ways significant enough for him to be considered a hero. As Lyndon traveled with the Nephalem, he carried powerful tokens of his former criminal life, and superstition or not, the benefits of these objects were undeniable. Perhaps such relics possess true magical power. Perhaps they simply inspire the one who carries them to find hidden strength and skills inside themselves. Either way, they should not be discounted simply because they only have meaning to a few.

unless that Horadrim also happened to be a thief

Templar Relics

Templars carry relics unique to their training and their faith. Holy tomes and texts provide them with mantras and teachings to contemplate that hone their focus in battle to a sword point. Shards of sacred blades carried by previous Templars grant them access to holy lineage and authority, while chalices and vessels of holy water keep them pure. To those outside the Templar faith, these relics would offer nothing, and might even offend those who hold the Zakarum church in low regard. As with the Scoundrel's Tokens, it is the Templar's own faith that matters.

One member of the Templar Order, a man named Kormac, came to follow the Nephalem and left the cruel practices of his order behind. When he still had faith, his relics granted him divine power. I wonder if he ever considered that his power may have come from inside him all along . . .

Enchantress Focuses

The third and final hero to follow the Nephalem was an enchantress named Eirena, who had survived since the time of the Mage Clan Wars in magical slumber. To better channel and control arcane energy, she and other wielders of magic use Focuses. A suitable relic for this purpose might be a mirror, a demon's eye, an amulet, or a crucible, so long as it helps the mage to concentrate and access the source of their power.

Hierophant's Seal

also known as Krede's Flame

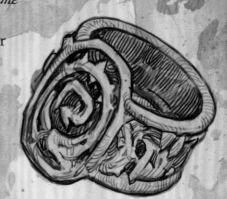

There once existed a ring of legend known as the Hierophant's Seal. It was made by an early follower of Akarat before power turned the Zakarum faith to zealotry. Envision a simple gold band with an engraved cameo of glyphs, with the ability to grant tremendous powers of life and healing while also increasing the skill to harm and destroy demons. The lore and name associated with this ring called on the wearer to guide and protect humanity, like how a shepherd guards a flock of sheep. It was a blessed ring with a noble purpose, until it fell into the hands of Duke Krede.

On the outskirts of Caldeum, Krede held warrior tournaments in an arena of fire for his entertainment and enrichment. Audiences paid to watch the brutal spectacle that claimed the lives of many aspiring champions. The largest crowds gathered when Krede himself joined the fray. He always won, even against fiercer, stronger foes, until the day a frozen-imbued demon invaded his manor and slew him.

Only later was it discovered that he had remade the Hierophant's Seal into a new ring with new properties. Although it looked the same as before, it now used the fire of Krede's arena to increase his fury, giving him a significant advantage. Thereafter, the ring was called Krede's Flame.

It must be noted that his changes to the ring for the sake of his arena left him vulnerable. If he had left the Hierophant's Seal as it was, he could have defeated the demon who killed him.

Necromancer Totem

The Priests of Rathma use a variety of relics as phylacteries. Perhaps the most profane and grisly are the totems they carry. To wear the preserved head or skull of a dead thing strapped to a belt is to break powerful taboos. The sight of a Necromancer can silence a crowded tavern, and mobs will part before them. Their totems mark them as ones who know less fear, and fewer limitations. They serve the Balance, the endless cycle of life and death, decay and renewal, and that requires them to stand apart. To be a Priest of Rathma is therefore to walk a lonely, desolate road.

The image of the Necromancer Totem has a different effect on me now, calling to mind a certain tree that waits for my head.

Ms. Madeleine

There is a type of dark ritual found in many witchcraft traditions across Sanctuary, from Hawezar to Torajan to the Sharval Wilds. Though regional variations exist, the spells all involve the creation of an effigy that is meant to represent the target of the magic by proxy. If the ritual is successful, whatever is done to the doll is supposed to be visited upon the victim of the curse.

A doll known as Ms. Madeleine appears to have begun its existence through this type of magic. She is a rather hideous little thing, merely a lumpen sack with stubby appendages, a bulbous head, and rudimentary features. She still bears the signs of her physical torture, having been impaled by bone needles and suffered the loss of a button eye, injuries her human counterpart likely did not survive. In most instances, that would be the end of the ritual. Perhaps some other magic is at work in Ms. Madeleine.

She is animate. Enthusiastically, cheerfully animate, though no one save her creator could say with what kind of soul. Others may be unsettled by her. I find her strangely comforting. If an entity like Ms. Madeleine, born of pain and hatred, can be what she was and is and still be joyful, perhaps there is hope for the rest of us too.

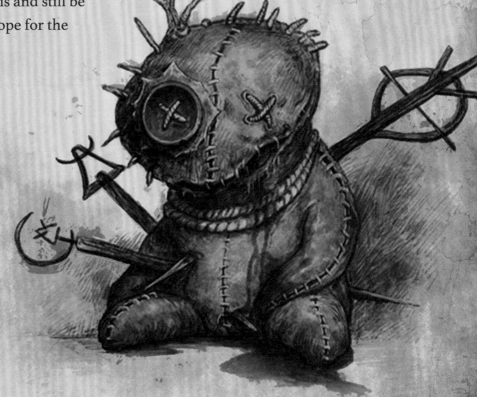

Horadric Malus

The construction of powerful weapons and armor may require powerful tools. The ancient Horadrim possessed a smithing hammer, the Horadric Malus, which they used in the forging of many legendary creations. Cain once speculated that the Malus could trace its earliest origins to the Sin War before Tyrael had formed the Horadric Order. While we likely cannot know that for certain, we do know that the hammer was eventually entrusted to the Sisterhood of the Sightless Eye.

When Andariel conquered the Eastgate Monastery, the Horadric Malus fell into the hands of a demon known only as the Smith. It was eventually retrieved and restored to Charsi, the talented blacksmith of the Sisterhood. But during its separation from her, it was used at least for a time to forge weapons for the minions of the Burning Hells, and I suspect it worked as well in the service to evil as it did in the service of good. That is the nature of most tools. They are defined by how we use them.

I hope she still possesses it.

Leoric's Signet

When Diablo darkened Tristram, he did so by slowly corrupting Leoric, the king of Khanduras, who was known as both good and wise in his youth. His later journals are harrowing to read. The madness overtaking his mind becomes evident page by page, as does his confusion, doubt, and fear, and I cannot help but wish for some way to reach through the text to warn him. I know that even if that were possible, it would change nothing. If not Leoric, the Lord of Terror would have simply chosen someone else. No warning could change the fact that Diablo's prison could not hold him.

Some might believe that Leoric's Signet and other relics are cursed, and that is possible. I am not convinced of it, though. Leoric was not always the Skeleton King or the Mad King of Tristram. Careful study and thorough identification would be recommended and prudent before using any relics, especially those belonging to fallen monarchs.

Lazarus's Grimoire

The Prime Evils found the perfect servants in the Zakarum church, which had strayed far from the spirit of Akarat's original teachings. The priests had become accustomed to strict, blind obedience, to the point that <u>who</u> they served seemed less important than whether they did as the church and Que-Hegan commanded.

Although Lazarus may have once been a righteous man, by the time he came to Tristram, he knowingly and fully served the Prime Evils. The writings in his grimoire from that time chill the blood and turn the stomach, and because of this I believe his relics are more likely to be cursed than those belonging to Leoric. Be wary of his tomes, and others like them. The words they contain come from the mouth of the Burning Hells as much as from their author's hands, and demons know that books are made to last for a very long time. They know that scholars and mages trust their ancient texts implicitly and that books are a very effective way to get inside a person's mind.

just as I am doing now

Token of Absolution

I have never attempted to create a Token of Absolution, yet I have read about them. They offer a very narrow and dangerous path to those who wish to clear their minds and bodies of entrenched habits and less desired skills. They allow for a new beginning while retaining wisdom and experience, a rare gift indeed. If you would seek to create one of these tokens, you will need the Horadric Cube. Note the ingredients placed within it will be extremely difficult and dangerous to acquire. To receive absolution, you must prove yourself <u>worthy</u> of it by confronting not only two Lesser Evils, Andariel and Duriel, but also the three Prime Evils. It is the essences of these five demons that you must obtain and place in the Horadric Cube.

Let us put aside the possibility that all five could be found in Sanctuary at the same time. If you somehow battle them and survive, I will humbly suggest that you perhaps need less absolution than you think. In fact, the entire notion of the Token of Absolution leads me to wonder if the Horadric Cube possesses a sense of humor.

Which I pray will never occur again!

Jar of Souls

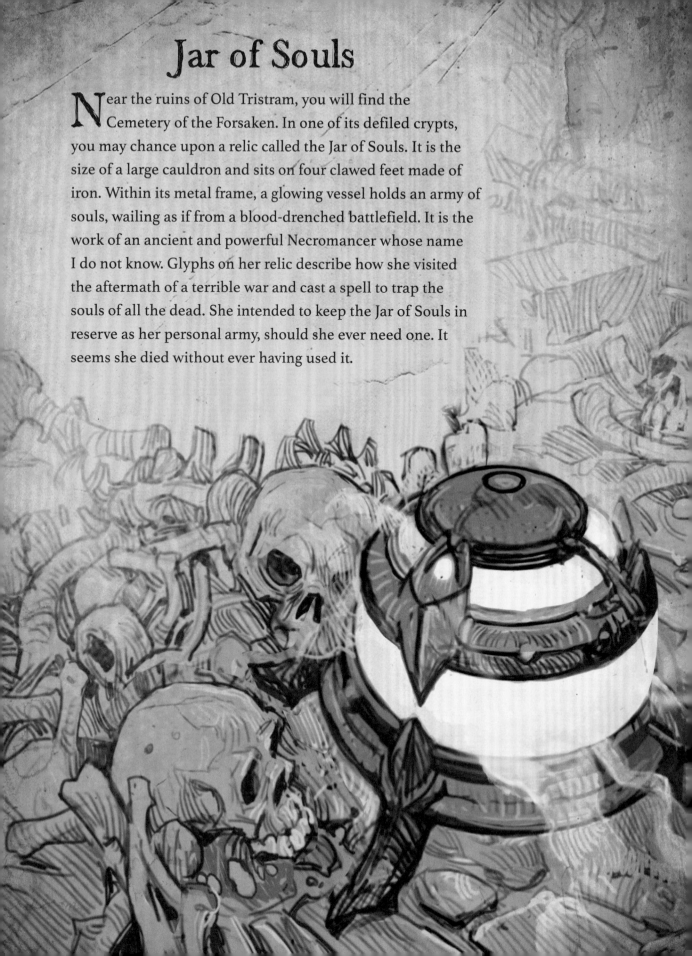

Near the ruins of Old Tristram, you will find the Cemetery of the Forsaken. In one of its defiled crypts, you may chance upon a relic called the Jar of Souls. It is the size of a large cauldron and sits on four clawed feet made of iron. Within its metal frame, a glowing vessel holds an army of souls, wailing as if from a blood-drenched battlefield. It is the work of an ancient and powerful Necromancer whose name I do not know. Glyphs on her relic describe how she visited the aftermath of a terrible war and cast a spell to trap the souls of all the dead. She intended to keep the Jar of Souls in reserve as her personal army, should she ever need one. It seems she died without ever having used it.

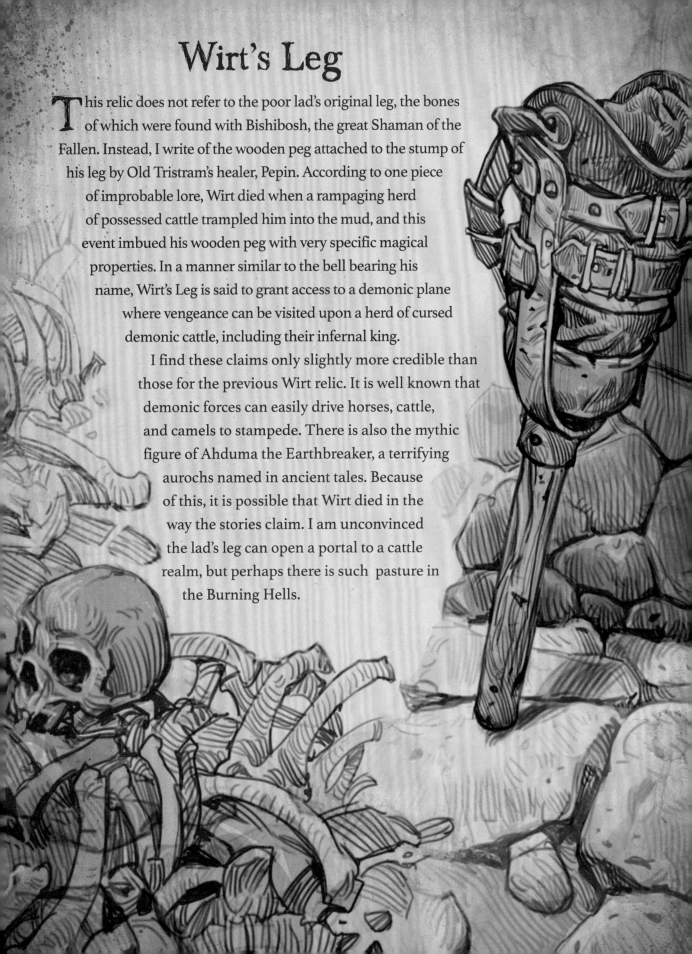

Wirt's Leg

This relic does not refer to the poor lad's original leg, the bones of which were found with Bishibosh, the great Shaman of the Fallen. Instead, I write of the wooden peg attached to the stump of his leg by Old Tristram's healer, Pepin. According to one piece of improbable lore, Wirt died when a rampaging herd of possessed cattle trampled him into the mud, and this event imbued his wooden peg with very specific magical properties. In a manner similar to the bell bearing his name, Wirt's Leg is said to grant access to a demonic plane where vengeance can be visited upon a herd of cursed demonic cattle, including their infernal king.

I find these claims only slightly more credible than those for the previous Wirt relic. It is well known that demonic forces can easily drive horses, cattle, and camels to stampede. There is also the mythic figure of Ahduma the Earthbreaker, a terrifying aurochs named in ancient tales. Because of this, it is possible that Wirt died in the way the stories claim. I am unconvinced the lad's leg can open a portal to a cattle realm, but perhaps there is such pasture in the Burning Hells.

Shield of Nahr
𐌹𐌾𐌹𐍊𐌷

I began this text by acknowledging the dangers inherent in writing it, and the need to safeguard its contents from evil. I returned to Westmarch in pursuit of this purpose. I had hoped to find my father's kite shield, then enlist the skill of Charsi and the power of the Horadric Malus to reforge it. I succeeded in finding his shield. I was unsuccessful in locating Charsi. I hope she is well, wherever she may be. Her absence limited my options. There was only one other blacksmith I could trust with this work, and he died a long time ago.

Like much of Westmarch, my father's shop had been boarded up and abandoned for many years. I found the forge as cold as his grave. In that hallowed place, I used the same ritual Neyrelle had used to summon her mother, and I called forth the spirit of my father. ~~To stand before him after so much time, an older man than he was when I left him~~ We spoke, and I explained what I needed from him. He agreed to instruct me in the use of his forge and his tools.

For several days, I labored in the shop he had hoped to one day pass down to me. I lit the furnace and fanned the flames until I sweltered in the heat. My father instructed me how to reforge his shield using what I had learned from Kulle's <u>Arma Haereticorum</u>, and I brought forth my tokens.

I merged the water and earth in the Leaf of Glór-an-Fháidha with the fire of the Amethyst Ring. I added air from the Breath of Philios, and the fifth element of time housed in Radament's Hourglass. I bound these together in harmony and balance using the Scale of Rathma's Serpent. Lastly, I incorporated the courage and goodness in Meshif's pipe. ~~When it was complete, I told my father many things that~~ Then I bade my father a final farewell.

The product of our partnership does not possess the grace or beauty of more refined and noble workmanship, yet I know the magic in this new relic will serve my need. I have named it the Shield of Nahr, forged by father and son.

My dear Neyrelle,

I find I must write to you as I knew you, and as I hope to know you again. As the brilliant, brave, stubborn woman who dreamt of becoming Horadrim. To do otherwise is too painful.

I can't recall what I have said to you about my father, so forgive me if I repeat myself. Old men are allowed that luxury, are we not? I'm certain I must have at least mentioned that he was a soldier and a blacksmith.

My whole body aches from forging. I am sweaty and filthy. From that, I'm sure you have guessed that I have much to tell you, but not in a letter. For now, I will simply say that your use of the Ritual Tome inspired me, and I have just now gone back to add a note to you where I discuss that text in my book. There were things I needed to say to my father that I never said when he was alive. I think the burden of that had become buried and lost under everything else I have endured. That weight has lifted now, and I have you to thank for it.

I leave this letter on my father's anvil, though I dread the thought of you coming to Westmarch. I have already come far on this journey, and I am not done yet. I hope to see you again when we both can rest.

Lorath

I travel north with the Shield of Nahr upon my back. I leave behind my home. Much of my turmoil over Westmarch has been lifted. The city is less haunted. I could even see myself returning there to stay at the end of this journey. I will leave that decision for a future day.

I have entered the Sharval Wilds. In some ways, these forested lands remind me of the deep woods of Scosglen; in other ways, this is a far stranger place. The Zakarum faith still holds sway. It has come to a kind of truce with the old gods and myths that persist in the region's folk traditions. I wonder what will happen if the Cathedral of Light ever attempts to bring their demanding guidance to the people here . . .

In addition to the trees, the wolves here remind me of their brethren in Scosglen. I have just fought off a pack of them, and the Shield of Nahr served me well as an ordinary defense. For some reason, it pleases me that it has seen battle at least once.

The woods are thinning, and the hills are sloping. I am coming out of the Wilds into the steppes and wastes of the Dreadlands. I must tread carefully now. This may be the most hostile region in all of Sanctuary. The Children of Bul-Kathos have suffered unimaginable losses, and they are not what they once were. Many have forsaken their ancestral territory and migrated east. Those who remain retain their strength, even if it sleeps beneath a layer of ash. That is why I have come. So long as I can avoid the cannibal Unclean, I may leave these lands with my head still attached.

A song can sometimes be heard in the Dreadlands, howled from the ashes. It has no words, so I cannot quote it. The sound of it rattles the bones of all who hear it, a roar that bears the anguish and shame of the Children of Bul-Kathos. "The Lament of Ash," "Kanai's Lament," "Sescheron's Lament," all refer to the same primal expression of grief for everything the Northern Tribes have lost.

Malah's Thawing Potion

The Children of Bul-Kathos traditionally hold magic in disdain. There are some among the Barbarian tribes who practice it, especially the healing arts, which are highly valued after a bloody battle. Malah was the healer in the northern city of Harrogath during the siege of Baal, and the destruction caused by his demon forces tried her skills. It seemed to many the battle could not be won.

Nihlathak, the last living Elder of Harrogath, had secretly brokered a deal with Baal to spare the city. In exchange, Nihlathak gave the demon his people's most sacred Relic of the Ancients, which allowed the Prime Evil to access the Worldstone unhindered. When Anya, the daughter of another Harrogath Elder, discovered this pact and confronted Nihlathak, he imprisoned her in ice.

It was Malah who crafted the Thawing Potion that released Anya from her prison. This revealed Nihlathak's betrayal and made the defeat of Baal possible. When I contemplate the relic, a simple potion made by a virtuous healer, I am reminded that no effort in the battle against evil is wasted or unimportant. Despite what Malah believed about herself, were it not for her, all of Sanctuary may have fallen.

Soul Siphons

The ranks of the Burning Hells are endless. When one demon falls, a new evil rises to take its place. So it was that Skarn, Lord of Damnation, came to power and threatened Sanctuary.

Deep within his realm, he devised a method to extract the essence from living angels. He called these monstrous torture devices Soul Siphons. Their corrosive, grasping tentacles burrowed relentlessly into their victim, piercing armor and all defenses, until they reached the angel's core. Then they began to slowly suck out the angel's essence, a process kept excruciatingly slow to cause prolonged suffering and to allow the Siphon time to safely absorb the harmful angelic light. Skarn used the energy extracted from an entire legion of angels to open the Pits of Anguish and call forth an army to rival the forces of the Prime and Lesser Evils. He planned to invade Sanctuary and extract the soul of every human, but he was defeated by a noble hero with the help of Deckard Cain.

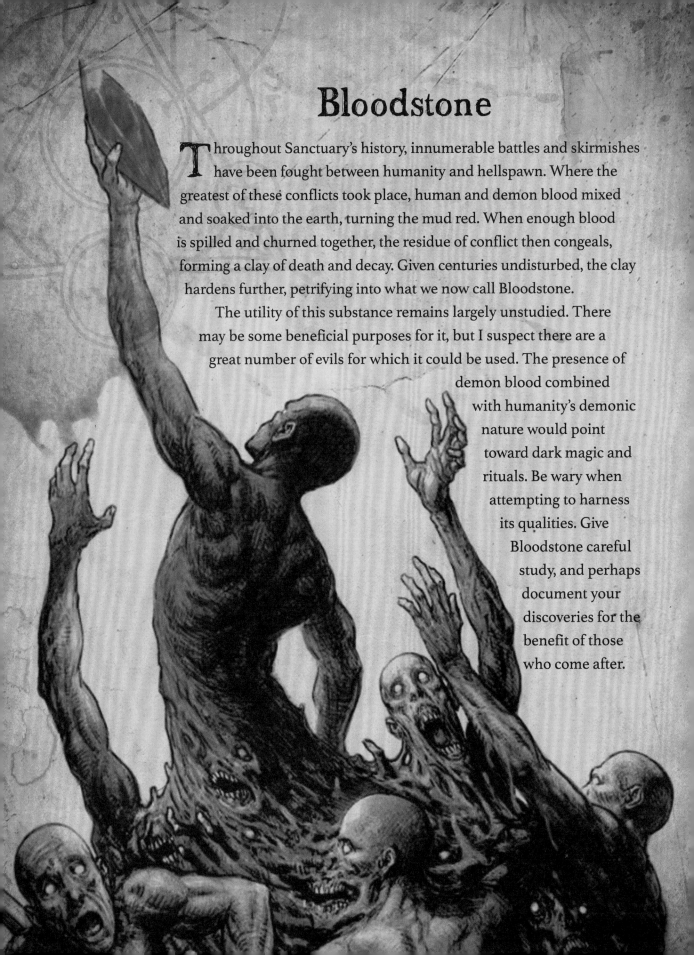

Bloodstone

Throughout Sanctuary's history, innumerable battles and skirmishes have been fought between humanity and hellspawn. Where the greatest of these conflicts took place, human and demon blood mixed and soaked into the earth, turning the mud red. When enough blood is spilled and churned together, the residue of conflict then congeals, forming a clay of death and decay. Given centuries undisturbed, the clay hardens further, petrifying into what we now call Bloodstone.

The utility of this substance remains largely unstudied. There may be some beneficial purposes for it, but I suspect there are a great number of evils for which it could be used. The presence of demon blood combined with humanity's demonic nature would point toward dark magic and rituals. Be wary when attempting to harness its qualities. Give Bloodstone careful study, and perhaps document your discoveries for the benefit of those who come after.

Eye of Etlich

During the time of the crusade by Rakkis against the northern tribes, a corpse emerged from the ice on the slopes of Mount Arreat. It did not appear to be one of the Children of Bul-Kathos. Its leathery skin bore strange tattoos, and the style of its clothing resembled no people the Barbarians knew of. They called it Etlich, which is said to mean "stranger" in some lost tongue. Given the frozen conditions, it was impossible to guess the age of the corpse. Many believe it had come to rest there before the Sin Wars, and perhaps even earlier, during the ancient days of the Firstborn. It was this that led some to believe the body held power, and indeed it did. One of its eyes ended up encased in an amulet, the Eye of Etlich, a powerful relic that granted its wearer the ability to see and avoid the missiles of ranged attacks. It is now commonly held that Etlich must have been a mighty mage who wielded the power of a dozen sorcerers. What happened to the rest of his corpse remains a mystery.

Hellfire Ring

As with the Token of Absolution, the creation of this relic is an arduous endeavor. The process begins with Infernal Machines, devices composed of intricate magical gears that open portals to hostile planes. Those who venture there describe battles against more lethal versions of enemies they have already vanquished.

If they return from these confrontations victorious, they sometimes bring with them the ingredients necessary to forge a Hellfire Ring. The result is a grim band made of bone and spine, crowned with a sharp demon's tooth and a baleful eye.

Those who wear these rings find all their faculties sharpened, such that they learn new skills with much greater ease, and none can deny the bravery of one who wears a Hellfire Ring.

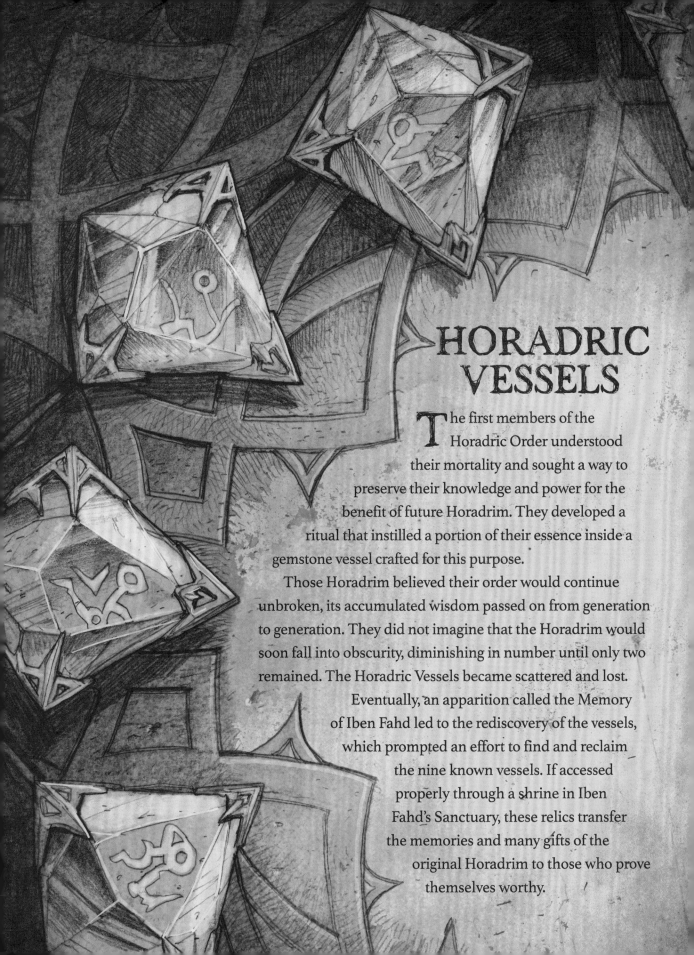

HORADRIC VESSELS

The first members of the Horadric Order understood their mortality and sought a way to preserve their knowledge and power for the benefit of future Horadrim. They developed a ritual that instilled a portion of their essence inside a gemstone vessel crafted for this purpose.

Those Horadrim believed their order would continue unbroken, its accumulated wisdom passed on from generation to generation. They did not imagine that the Horadrim would soon fall into obscurity, diminishing in number until only two remained. The Horadric Vessels became scattered and lost.

Eventually, an apparition called the Memory of Iben Fahd led to the rediscovery of the vessels, which prompted an effort to find and reclaim the nine known vessels. If accessed properly through a shrine in Iben Fahd's Sanctuary, these relics transfer the memories and many gifts of the original Horadrim to those who prove themselves worthy.

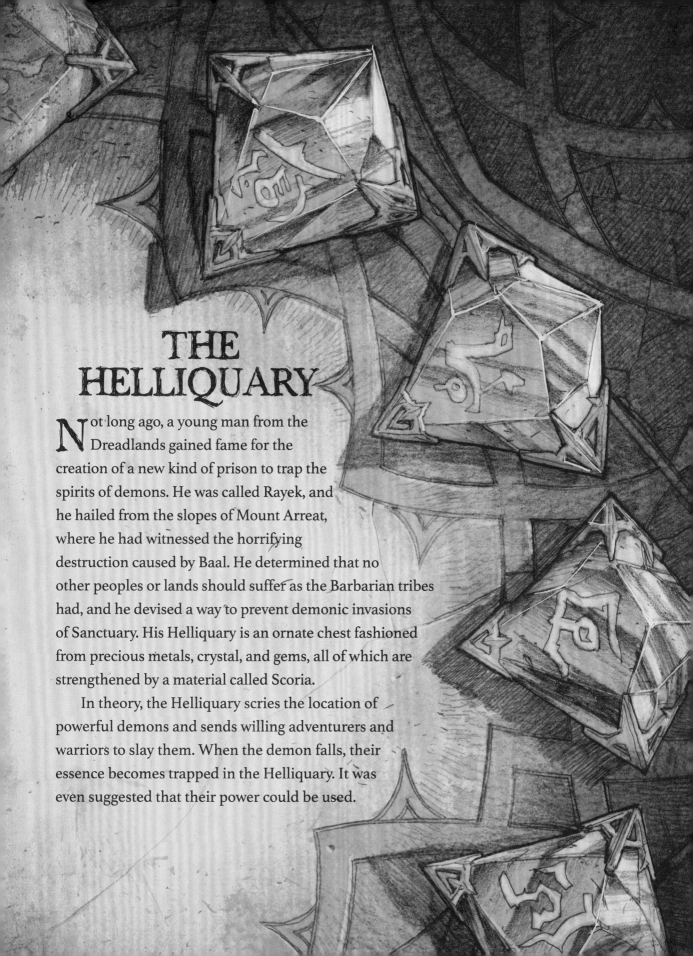

THE HELLIQUARY

Not long ago, a young man from the Dreadlands gained fame for the creation of a new kind of prison to trap the spirits of demons. He was called Rayek, and he hailed from the slopes of Mount Arreat, where he had witnessed the horrifying destruction caused by Baal. He determined that no other peoples or lands should suffer as the Barbarian tribes had, and he devised a way to prevent demonic invasions of Sanctuary. His Helliquary is an ornate chest fashioned from precious metals, crystal, and gems, all of which are strengthened by a material called Scoria.

In theory, the Helliquary scries the location of powerful demons and sends willing adventurers and warriors to slay them. When the demon falls, their essence becomes trapped in the Helliquary. It was even suggested that their power could be used.

Scepter of Fahir

Like the Horadric Staff, the Scepter of Fahir was divided into three pieces and then buried in hidden tombs beneath the sand. Unlike the Horadric Staff, the Scepter of Fahir possessed no powers beyond its strength as a symbol to the desert people of the Shassar Sea. Fahir was a merciless tyrant, a mortal human who called himself a god. His atrocities and depravities were demonic, including human sacrifice in his name. Upon his death, the people rejoiced and broke the scepter that had been a symbol of his rule. Conflict swept across the sands as armed factions vied for scraps of power. One violent militia, the Sand Scorpions, abused the people and seemed no better than Fahir. The Amber Blades opposed them. Their leader, Tabri, believed that if she could recover the Scepter of Fahir, she could use it to unite the Shassar Sea behind her and rule a different way than Fahir. Many tyrants have promised the same.

Magical or not, I believe this relic might be cursed.

Eternal Crown

After Daedessa the Builder created the Firstborn city of Corvus, she set her mind to its protection and created the powerful Eternal Crown. Daedessa bequeathed this helm to her son, Kion, and charged him with safeguarding Sanctuary against all threats, be they angelic or demonic. However, Daedessa also understood the ways that power can corrupt even the most valiant. In secret, she tasked her daughter, Akeba, with a shadow-watch over her brother. Should Kion ever falter through complacency or pride, it would be Akeba's task to remove him and claim the Eternal Crown, after which someone else would begin their watch of her. Kion and his Immortals. Akeba and her Shadows. An endless Cycle of Strife.

There are times I wonder if we blame Heaven and Hell for too much. Humanity has been inventing its own wars from our very beginnings.

Crown & Fang of Fernam

Centuries ago, a lord of Gea Kul became so obsessed with the attainment of immortality that he looked to vampires in his quest to find a cure for death. For years, his mages and scholars conducted forbidden experiments and developed dark rituals, but they failed to deliver their lord what he sought. Eventually, he ordered a vampire beast captured and brought to the catacombs beneath his castle, an act of hubris with lethal results. The vampire escaped and slew the lord, along with most of his guard. The only man to survive the attack was a soldier called Fernam, but he had been infected by the vampire's curse. One of the lord's mages performed a ritual to preserve what he could of Fernam's humanity, transforming him into something neither fully human nor vampire: the first Blood Knight.

The same ritual has since been used to create other Blood Knights through the years. In fact, there exists a brotherhood of such beings, though they are highly secretive, and I know little about them. I cannot blame them for keeping to the shadows, given the widespread mistrust of their vampiric origins. Yet could the same things not be said of humanity's demonic parentage? Surely by now we know something of contradicting natures.

The Crown of Fernam is a golden crest, taken, I assume, from the lord whose actions changed Fernam into what he became. Worn upon the head, it represents the wisdom and knowledge of the rational human mind and will. The Fang of Fernam is a cruel and ravenous spear, a blade of steel with an unquenchable, animal thirst for blood. Taken together, these two relics of the first Blood Knight represent the duality that exists within these beings. *And also, perhaps, the duality that exists in each of us.*

Gibbering Gemstone

ᚷᛈᛞᛁᚤᚱ�ᚷᛁᚥ

On the slopes of Mount Arreat, there was a delve called the Caverns of Frost. Among the Icy Quillbacks and Frostclaw Burrowers that infested its tunnels, there were lacuni to contend with. One was in possession of a relic known as the Gibbering Gemstone. I mention it only because of its prominence in tales, not because of its potency or properties. In fact, the sources and texts I've read suggest this gemstone does absolutely nothing. Rather, it seems to be well known primarily for its association with Wirt's Bell and the Staff of Herding.

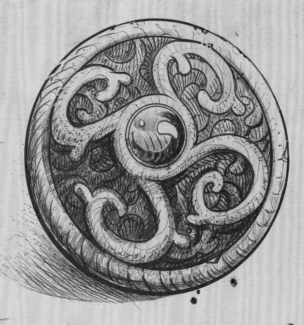

Necromancer's Shovel

The village of Middlewick suffered in much the same ways other townships suffered at the hands of the Zakarum church. By the time Bishop Stretvanger left with his militia, half the cottages and hovels had burned down and a dozen villagers had been murdered, along with two Zakarum soldiers. What set Middlewick apart were the seven undead corpses that tore apart a young girl named Dalya before doing the same to the soldier who went looking for her in the cellar. Upon realizing the danger, Stretvanger burned the cottage down on top of them, which might have covered up the whole affair. However, there were too many witnesses. And there was the shovel.

It had a long black shaft carved with glyphs and runes and a narrow ivory blade etched with swirling vegetal patterns. It was a Necromancer's tool for safely exhuming corpses from the ground, and it was found in the woods, having been used to almost decapitate another Zakarum militiaman. An uncommon implement to find in a place like Middlewick. Someone in that village carried dark and heavy secrets, most likely to the grave.

Rygnar Idol

ᛏᛘᛁᛁᛁᚠᚠᛏ

This is a strange relic. At first glance, it would appear to be a Necromancer Totem, in that it contains a human skull. I have never seen a Priest of Rathma using anything like it. The bone has been entirely gilded, then embossed with runes and glyphs, refining its appearance in a way that seems inconsistent with Necromancer purposes. It was unearthed in a desert tomb in Kehjistan, surrounded by undead skeletal guardians. Its chamber offered no clues about its origins or purpose. Of greater significance, perhaps, is the rumor that it was once in possession of Zoltun Kulle.

Kulle did not waste time on lesser magic, or lesser artifacts. If he took interest in the Rygnar Idol, it would likely be worth investigating should it come within your reach.

Kanai's Cube

I have already discussed this relic in relation to the Horadric Cube. What I have not mentioned of Chief Elder Kanai is its namesake. After the Horadrim made the decision to hide the cube, they needed a guardian with strength and honor to defend it, and to find such a person, they looked to the north, to the stronghold of Sescheron. It speaks very highly of Kanai that out of all humanity, the Horadrim entrusted him with the cube's safekeeping.

Kanai fell in the destruction of his city by the armies of Baal, and his people felt his loss profoundly. The Children of Bul-Kathos have only ever recognized two leaders as kings worthy enough to sit upon the Immortal Throne. Had Kanai lived, he may have one day attained that position. His people chose to grant him that honor in death by placing his body upon the throne, somehow still formidable even in death.

That is the strength of the Northern Tribes, the strength in the Children of Bul-Kathos, which draws from the strength of Sanctuary itself. I need that behind my shield if I am to safeguard my book.

Raekor's Resolve

Raekor was another warrior of great renown among the Northern Tribes, the first woman in their history to be appointed Warmaster. She earned this honor through her courage, ferocity, and strength in defending her people against the encroachment of surrounding empires. Her armor is a set of relics on its own. I have come here seeking an amulet bearing her name.

This relic's legend tells of a battle in which Raekor tumbled down a steep embankment into a riverbed, where she was cut off from her forces. Enemy Saumurenians surrounded her, and she quickly realized she had lost her weapons in the fall. Rather than surrender, she picked up two great river rocks. One she used as a shield; the other she used to bash her enemies' skulls. So ferociously did she fight that each blow she gave and each strike she deflected chipped away at the rocks. By the time her own warriors reached her, she had slain most of the Saumurenians and only one of the rocks remained in her hand, now reduced to the size of a pebble.

One of her men took that rock and turned it into an amulet to commemorate her strength and resolve in the face of almost certain defeat. That is a quality of resolve I aspire to in my own confrontations with evil.

I have retrieved Raekor's stone. It was where my research said it would be, unmarked and unprotected. A deeply tragic sign of how much the Children of Bul-Kathos have lost and how far they have fallen. I almost feel guilty taking it. I intend to use it for something that will honor Raekor more than she would be if I were to leave the amulet where I found it.

Now I head east to Xiansai.

———————————

The Dreadlands are unlike anything I have seen or experienced. I find them as unsettling as the Burning Hells, in their own way. There is an absence here. A profound void. At first, I couldn't figure out why I felt so disturbed. I thought it might just be my fear of some nameless threat that could defeat me when I am so close to the end of this journey. Then I realized what it was. I had traveled miles without seeing another living thing. Not a bird. Not a plant. Not even a cockroach. Instead, this is the land that grows Barbarians and Demon Hunters. I think I better understand both types of warriors.

———————————

I will stop in Ivgorod. I hope to see Neyrelle there. She mentioned perhaps staying for a time with the monks of the Floating Sky Monastery, if they will have her. She wondered if their mental training might help her resist the influence of Mephisto. I am choosing to hope that is the case.

———————————

These Tamoe Mountains are harsher than the Fractured Peaks, which I would not have thought possible. They are sharper somehow. I am wearing Donan's fur cloak again, the reason I carried it with me all this way. The icy wind finds a way to cut through it. I cannot understand why anyone would choose this place for a monastery. I will arrive there soon, and I hope they serve something hot to drink.

Hello there, old man,

If you are reading this, then I might have become a seer since you last saw me. When I left the other letters for you, I thought there was maybe a chance you would find them. But up here? At the top of the world? Not a chance at all. I had this dream, you see. I saw you walking east through miles and miles of ash. I figured that had to be the Dreadlands, which meant you were heading this way. That's why I'm writing this letter. And it's also why I'm leaving.

Don't be angry. Well, I know you'll probably be angry. Please don't be hurt. I'm doing this to protect you. I was honestly planning to leave anyway. I've learned as much as I can from the monks here, and I think their techniques are helping me to ignore the voices and the visions. I am doing much better than I was. I also worry about staying too long in one place. It's better for me to be alone. And selfish of me to seek the company of others, with the burden I carry.

I don't know where I will go from here. I only know that I can't let anything happen to you. I've lost too much already. If you got hurt because of me, I think that would destroy me.

Goodbye, old man.

Neyrelle

She was here. Only days ago. One of the masters spent time with her. His voice trembled with fear as he spoke. And he was one of the few who would go near her to teach her. He said she is an agent of pure chaos and hatred, even though she clearly doesn't want to be. The monks never even let her into the monastery. They made her sleep in a guest hut far outside the walls. I don't blame them. I fear I am losing her, ~~or perhaps she is already lost~~

I need to find her. No one knows which way she traveled. So now I have a decision to make. Do I go searching for her? Or do I finish what I started with my book?

I don't know what to do.

I have wasted two days in pointless rumination. Days I could have spent looking for her or pressing east. Instead, I am here, losing time. I must leave tomorrow. I have until dawn to decide which path I will take.

I am heading east.

I am choosing faith.

The book is for Neyrelle, and it must be finished and ready for her. If not her, it must be ready for others. Though I must believe it is for her.

Tomorrow, I begin my final descent out of the mountains. I can see the ocean from where I sit. I think I can even see Xiansai in the distance. I might be imagining it. This last stage of my journey is the riskiest—not for myself, but for the book. If this fails, then everything I have done, all the miles I have traveled and the words I have written, will have been for naught. At times like this, I wish I prayed.

Neyrelle,

I am not angry with you, child. I was hurt. That was simply my pride, and the moment has passed. Now that you are gone from the monastery, I doubt you will return, so I don't know where I will leave this letter. I think it will stay in the book until you are able to read it.

I have come to the end of my journey. I am sitting on a terrace in a coastal town on Xiansai, overlooking a bay. A much better welcome than I received from the Askari. Mages have been coming here from the Yshari Sanctum for generations, so outsiders are not unheard of, and the Horadrim are still respected. For now.

I am not sure how long it will take to find the spell or device that will suit my needs. If it can be found anywhere, it will be on Xiansai. Deckard Cain said these mountains are littered with arcane repositories. Surely one of them will hold the answer.

By now you are probably feeling impatient for me to just come out with it and explain what the hell I'm talking about. And I will. But not in this letter. The book will explain it when you read it.

As soon as I am done with this island, I am coming to you. No matter where you are, I will find you, and I will help you. If that is the last thing I do, my head will go to the Tree of Whispers wearing a smile.

Lorath

"Given time, even
a mountain will
bow to the rain."

*I have heard this expression spoken by travelers from Xiansai. It is
often used in a general way to describe the impermanence of things,
but I believe it is intended to have many meanings.*

We come to the end.

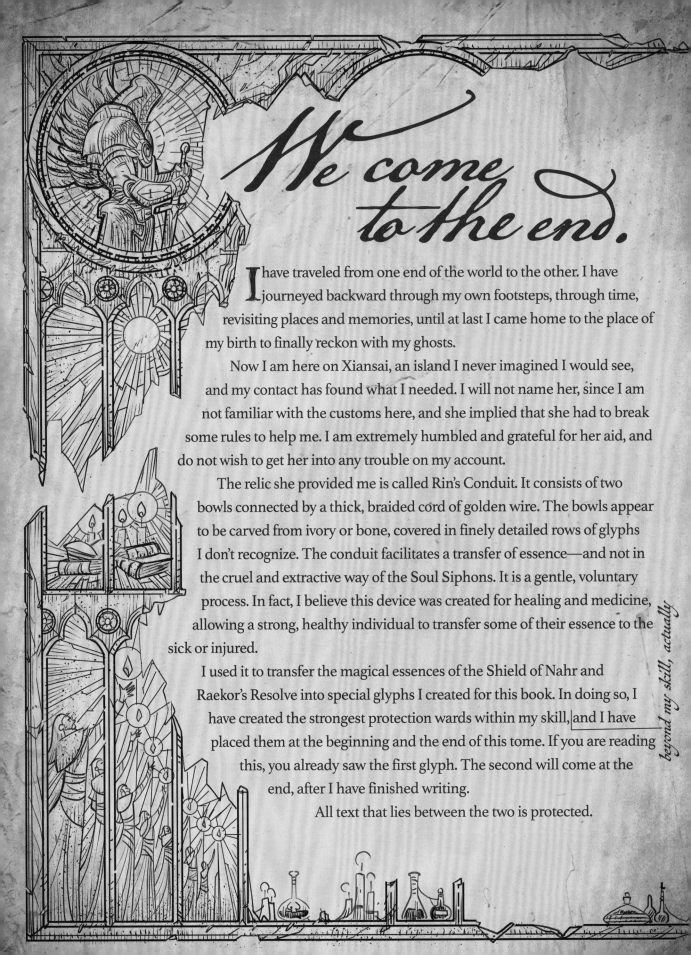

I have traveled from one end of the world to the other. I have journeyed backward through my own footsteps, through time, revisiting places and memories, until at last I came home to the place of my birth to finally reckon with my ghosts.

Now I am here on Xiansai, an island I never imagined I would see, and my contact has found what I needed. I will not name her, since I am not familiar with the customs here, and she implied that she had to break some rules to help me. I am extremely humbled and grateful for her aid, and do not wish to get her into any trouble on my account.

The relic she provided me is called Rin's Conduit. It consists of two bowls connected by a thick, braided cord of golden wire. The bowls appear to be carved from ivory or bone, covered in finely detailed rows of glyphs I don't recognize. The conduit facilitates a transfer of essence—and not in the cruel and extractive way of the Soul Siphons. It is a gentle, voluntary process. In fact, I believe this device was created for healing and medicine, allowing a strong, healthy individual to transfer some of their essence to the sick or injured.

I used it to transfer the magical essences of the Shield of Nahr and Raekor's Resolve into special glyphs I created for this book. In doing so, I have created the strongest protection wards within my skill, and I have placed them at the beginning and the end of this tome. If you are reading this, you already saw the first glyph. The second will come at the end, after I have finished writing.

All text that lies between the two is protected.

beyond my skill, actually

I know the spell I crafted is unconventional. I know there were and are more traditional wards available. I don't want to keep doing what has already been done. That can only achieve the results we have already obtained. Wards and Soulstones will inevitably break. Vaults will be opened. Libraries will be burned or seized. Codes will be deciphered.

I hope the spell I have used to bind the pages of this book will last.

If I have succeeded, and I believe I have, the armor of the Shield of Nahr, backed by Raekor's Resolve, will keep evil away from this book. To those with demonic or dark intent, its contents will be incomprehensible, impenetrable, inviolable. That means if you are reading this, you have been judged worthy by the magic I have put in place. That does not mean you are perfect. (Remember that all humans have within them shades of the demonic and the divine.) It means that within you, good is currently winning your personal Eternal Conflict, and nothing more can be asked of us than that.

The same applies to you, Neyrelle. I wrote this book for you more than anyone. After the Cathedral of Light cleared out the Vault that you and your mother spent so much time trying to find, I knew you would need a first volume to start your own library. Let this be it.

Now I must be honest with you. After the decision you made, that brave, terrible, inevitable choice, I had to find a way to be sure of you. With the burden you carry, I could not risk you becoming another Elias, or worse. I know you understand this, perhaps better than anyone else could. I also think that after your ordeal, there will be times when you will need to be sure of yourself. The protections I have placed around this book can therefore satisfy both of us. If you are reading this, then you have done something unheard of in the history of Sanctuary. You have carried a Soulstone containing a Prime Evil without succumbing to its influence. There can be no doubt of your strength and your goodness.

You are still Neyrelle.

You are something more than Horadrim.

—Lorath

BLIZZARD
ENTERTAINMENT

© 2023 Blizzard Entertainment, Inc. Blizzard and the Blizzard Entertainment logo are trademarks or registered trademarks of Blizzard Entertainment, Inc. in the U.S. or other countries.

Published by Blizzard Entertainment.

This book is a work of fiction. Names, characters, places, and incidents are either products of the author's imagination or are used fictitiously, and any resemblance to actual persons, living or dead, business establishments, events, or locales is entirely coincidental.

Blizzard Entertainment does not have any control over and does not assume any responsibility for author or third-party websites or their content.

Additional Art: siloto/stock.adobe.com (10) · Vagengeim/stock.adobe.com (3-7, 9, 48-49, 54-56, 83, 90, 92, 93, 95, 98, 108-109, 116, 118-119, 130-131, 136-141, 144, 153, 164, 168-171, 173) · Scisetti Alfio/ stock.adobe.com (8, 43) · sveta/stock.adobe.com (48-49, 55, 67-68, 121-123, 133, 149-150, 167-170) · Coffeechocolates/stock.adobe.com (8-9) · LiliGraphie/stock.adobe.com (2, 104) · Nik_Merkulov/ stock.adobe.com (79, 153-154) · Savvapanf Photo ©/stock.adobe.com (105, 115, 162-163, 165) · Taviphoto/stock.adobe.com (70, 72-75, 77, 80-82, 85-86, 88-91) · Lumos sp/stock.adobe.com (50) · Airin/stock.adobe.com (7, 33, 35, 43) · artistmef/stock.adobe.com (25, 55-56) · ish_imp_photos/stock.adobe.com (78) · Tony Baggett/stock.adobe.com (29)

Library of Congress Cataloging-in-Publication Data available.

ISBN: 978-1-956916-40-9

Manufactured in China

Print run 10 9 8 7 6 5 4 3 2

BOOK OF LORATH

Writtten by Matthew J. Kirby • Illustrated by: Jean Baptiste Monge: Cover •
Francesca Baerald: 2 • Chris Bolton: 30, 31, 154 • Zoltan Boros: 4, 27, 44, 45, 54, 56, 70,
71, 99, 138, 139, 142, 146, 147, 159 • Michael Chae: 8, 9 • Tuncer Eren: 112, 113 • Sam Gao,
Hunter Hyltin, Nick Murano: 104 • Igor Krstic: 16, 17, 26, 28, 35, 38, 39, 40, 42, 61, 72,
80, 81, 86, 87, 92, 93, 103, 143 • Joseph Lacroix: 7, 12, 13, 14, 15, 18, 19, 20, 21, 52, 53,
60, 62, 63, 94, 108, 110, 111, 118, 126, 127, 131, 137, 152, 155, 160, 162, 172, 173, 174, 175 •
Gary Laib: 58, 59, 64, 65, 84, 85, 98 • Sean A. Murray: 22, 23, 33, 34, 41, 46, 51, 57, 66,
73, 88, 97, 101, 106, 116, 117, 120, 124, 125, 128, 132, 148, 155, 156, 157, 158,
166 • Henrik Rosenborg: 24, 25, 32, 36, 37, 76, 77, 100

Edited by: Eric Geron • Design by: Corey Peterschmidt, Jessica Rodriguez • Produced by:
Brianne Messina, Amber Thibodeau • Lore Consultation by: Justin Parker • Game Team
Consultation: Jon Dawson, Rod Fergusson, John Mueller, Rafał Praszczalek, Ashton Sanderson, Joe
Shely, Mac Smith • Special Thanks: Michael Bybee, Elana Cohen, Erin Fusco, Kiersten Vannest

Director, Consumer Products, Publishing: BYRON PARNELL
Associate Publishing Manager: DEREK ROSENBERG
Director, Manufacturing: ANNA WAN
Senior Director, Story & Franchise Development: DAVID SEEHOLZER
Senior Producer, Books: BRIANNE MESSINA
Associate Producer, Books: AMBER THIBODEAU
Editorial Supervisor: CHLOE FRABONI
Senior Editor: ERIC GERON
Book Art & Design Manager: COREY PETERSCHMIDT
Historian Supervisor: SEAN COPELAND
Department Producer, Lore: JAMIE ORTIZ
Associate Producer, Lore: ED FOX
Associate Historians: MADI BUCKINGHAM,
COURTNEY CHAVEZ, DAMIEN JAHRSDOERFER,
IAN LANDA-BEAVERS

DIABLO®

BOOK OF ADRIA

Written by Robert Brooks and Matt Burns

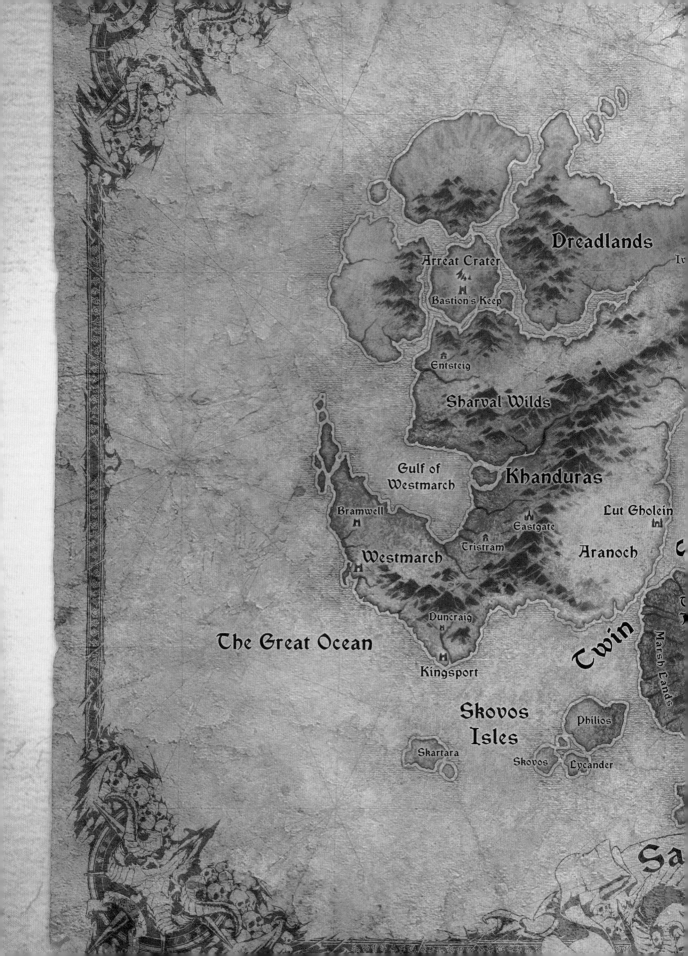

Dreadlands

Iv

Arreat Crater

Bastion's Keep

Entsteig

Sharval Wilds

Gulf of
Westmarch

Khanduras

Lut Gholein

Bramwell

Eastgate

Aranoch

C

Westmarch

Tristram

Duncraig

The Great Ocean

Twin

Marsh Lands

T

Kingsport

Skovos
Isles

Philios

Skartara

Skovos

Lycander

Sa

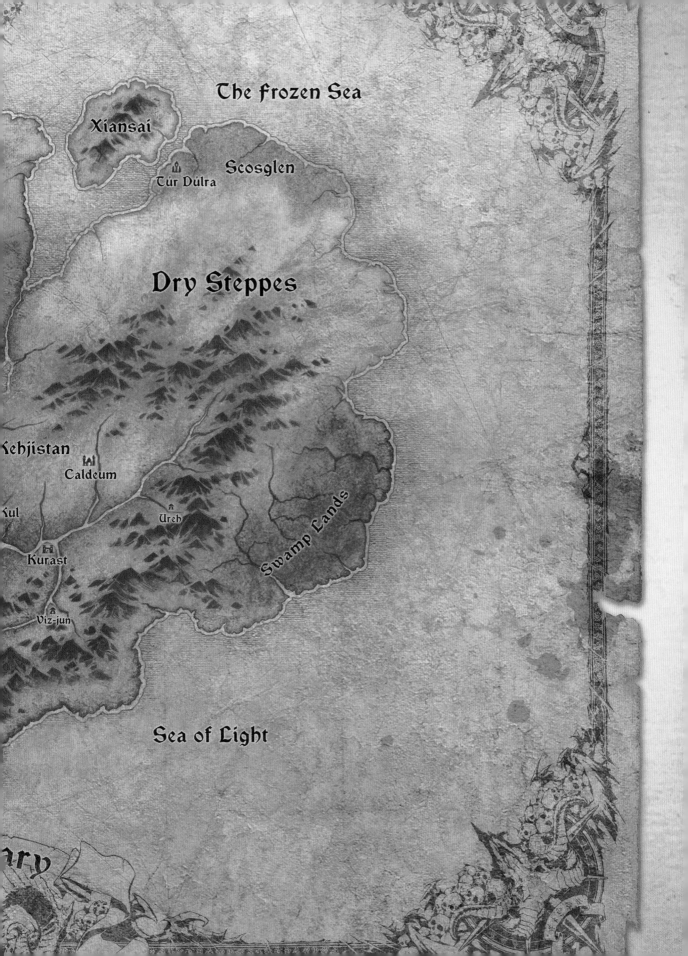

The Frozen Sea

Xiansai

Tür Dulra

Scosglen

Dry Steppes

Kehjistan

Caldeum

Kul

Ureh

Kurast

Swamp Lands

Viz-jun

Sea of Light

ary

Man's pleasures give way to pain.

*

His truths are buried in the shroud of lies.

*

It is this time when the Hells shall reign.

*

While all of man dies.

Seven Evils spawned of seven heads.

*

Seven realms birthed from death,

*

Infested, unending, cycles upon cycles.

Introduction

What is power?

Think on it for a moment. Picture it in your mind's eye.

What do you see? A blade? A spell? A vault of gold? The emperor of Kehjistan on his gilded throne? A Zakarum high priest with his fine raiment and bejeweled scepter?

I see a twig of Entsteig pine. Yes, just a little twig of that coarse bark with dry, green needles. As common in the forests as salt in the sea. A poison made from its sap can kill a man in three days but rub the bark on a wound and it can purify infections. Grind the needles into a powder and they are the primary reagent in a blindness curse.

That is power. Not a blade. Not a crown. Not a fortune. Not even that pine twig. Power is knowing how to use those things to get what you want.

The world around us is a vault of riches waiting to be plundered. Every creature, every plant, and every culture can serve us, willingly or not, in our goal to aid the Lords of the Burning Hells. But the Coven cannot use these weapons if we do not study them.

That is why I have collected all that I have learned from my travels and the knowledge of those who came before us into this codex. Read it. Learn about our allies and our enemies. Learn of the dangers that await us, and how we might turn them to our advantage. Know this world well, and you will always have something useful to offer the demons.

The final war between the High Heavens and the Burning Hells is coming, and if our masters do not prevail, we will suffer a fate worse than death.

I have seen the Coven's uncertain destiny in the fire. Through the flames, the demon lords whisper to me of what is to come. They have told me of two outcomes. In one, the Lords of Hell recognize our worth and we rule alongside them. In another, they see us as less than useless and torment our souls for eternity.

What path we find ourselves on when the storm comes is up to us.

—Adria

It took far too long before I understood that Diablo was the voice whispering to me in the flames.

The Lord of Terror had been watching me, testing me. I had felt his power. Primal and ancient. Far beyond anything the Coven had discovered. I thought the wisdom I had learned from the flames was for all those who sought it.

But when the fire called me to the town of Tristram, I knew the truth. Diablo had chosen me. <u>Only me.</u>

I left the Coven and never looked back.

The people of Tristram did not know that Diablo had been imprisoned beneath their feet. Not until it was too late. His darkness suffocated the little town. It drove King Leoric and his servants to bloody madness. I saw all of it as a promise of what I could have—what I could do—if I pledged myself to Diablo.

I was unsure of how to serve the Lord of Terror until Prince Aidan arrived.

He had returned from war to find his home darkened, his father turned to the undead, and his little brother possessed by Diablo. He showed tenacity and courage. He faced the terrors of Tristram alone, and he triumphed. Then, having achieved so much, he suffered a very human moment of arrogance: he believed that he could contain Diablo within his soul.

For a time, it seemed that he would succeed. I sat with Aidan and lay with him at night, nurturing him as I knew I must. It took time before I saw the change. His eyes would flicker, his lips would twist upward, and his voice would deepen. Then I would speak with the Lord of Terror himself.

Diablo told me his plans. He set me to act in case of his failure.

And so, I did. As Diablo continued to possess Aidan, he became known as **THE DARK WANDERER**. We remained together until he departed Tristram. I think he loved me, in his way. Perhaps I even loved him, knowing what he would bestow upon me.

A vessel. Something powerful enough to contain the souls of not just Diablo, but all his brothers and sisters.

And now that Aidan has been slain, this vessel growing within me is the true hope for the End of Days.

She is the key to Diablo's return.

I do not know how I will bring him back yet, but one thing is certain: This book must never be returned to the Coven. They are not worthy of its secrets.

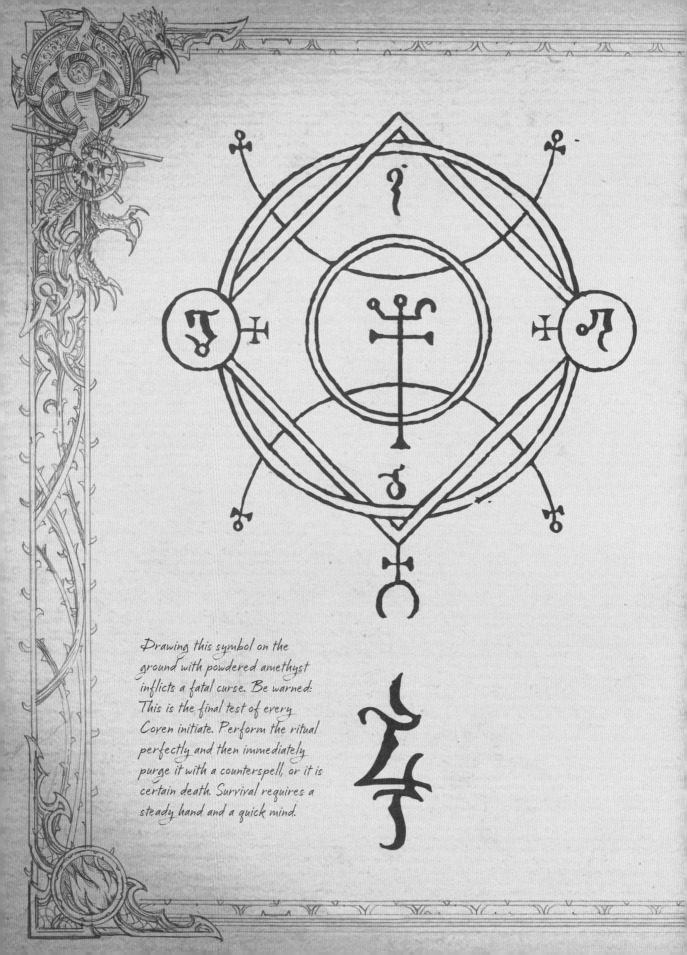

Drawing this symbol on the ground with powdered amethyst inflicts a fatal curse. Be warned: This is the final test of every Coven initiate. Perform the ritual perfectly and then immediately purge it with a counterspell, or it is certain death. Survival requires a steady hand and a quick mind.

– I –

The Coven and its Rites

The Coven is not the first order to work with demons. Others have had that honor. But there is an advantage to not being the first: We can learn from the mistakes of those who came before us. We can refine the methods of ancient demonologists and revive their forbidden spellwork.

We should also look beyond demonology. I have studied witchcraft, as have many of you. Those arts will be useful to our cause, as will the spells of the mage clans, the illusions of the Ammuit, the elemental fury of the Zann Esu, the enchantments of the Ennead, and the divination rituals of the Taan. Even the magic of the Zakarum has some value.

It does not matter that these groups are not aligned with the Burning Hells. It does not matter that we disagree with their beliefs. The only question we should ask ourselves is this: Are they powerful?

The followers of Zakarum are mindless zealots, but their inquisitors are effective at interrogation and torture. We would be fools to ignore such methods simply because of their origin.

Remember, too, that we are free from the rules that bind these religions and cultures. Where they are limited by tradition, we are not.

The only way we will prevail in the coming war between the High Heavens and the Burning Hells is if we embrace all this world has to offer. We must mold what we take into a new system of power. The old leaders of the Coven started this process, but they did not go far enough.

If they had, they would still be alive.

Origins

We were once the Cult of the Triune, servants of the three Prime Evils: Diablo, Mephisto, and Baal. Now we are the Coven, a gathering of lost souls seeking our destiny in the fires of the Eternal Conflict.

Or where we do not.

It feels strange to write about ourselves like this, but it is important to <u>know where we fit in the final destiny of Sanctuary.</u> Or where we do not. Lords and peasants alike refer to "cultists" with contempt. They think we have devoted ourselves to a false cause, and that our willingness to die speaks of a diseased mind. Their disdain shall be repaid ten times over—not by us, but by the future we will create.

In our hearts, each of us knows that this world shall fall to darkness one day. That our deeds in bringing that day forward will be rewarded. I plan to dedicate the rest of my life in search of that destiny. <u>As does Maghda.</u>

When we joined the Coven, it had lost its way. The leaders were content to consort with lesser demons and dabble in dark magic. They had no aspirations beyond that. They had no vision. If left in their care, the Coven would have died a slow, pathetic death.

That was unacceptable for Maghda and I. We did what we had to do. We burned away the old growth so that something stronger could take root. I would expect the same to be done to us if we ever grew complacent, for that is the one thing that must never be tolerated.

Always reach for more. The moment we settle, the Lords of Hell will turn their backs on us and seek new servants.

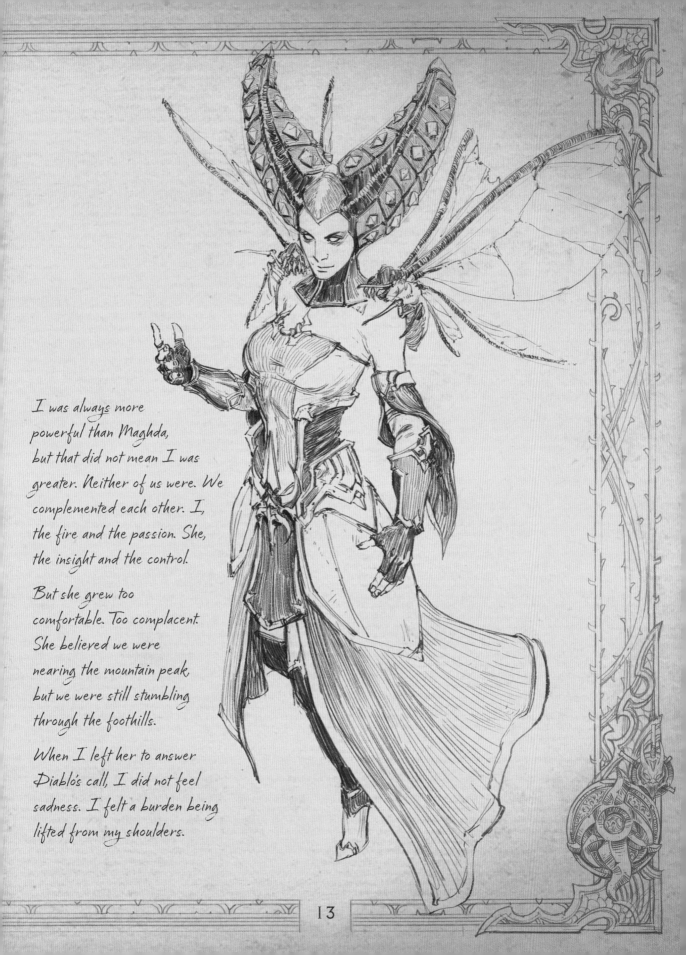

I was always more
powerful than Maghda,
but that did not mean I was
greater. Neither of us were. We
complemented each other. I,
the fire and the passion. She,
the insight and the control.

But she grew too
comfortable. Too complacent.
She believed we were
nearing the mountain peak,
but we were still stumbling
through the foothills.

When I left her to answer
Diablo's call, I did not feel
sadness. I felt a burden being
lifted from my shoulders.

Days and Months

We must always begin our work during the correct days and months. Time is a cycle that passes through different phases, each with a unique effect on magic and the creatures that inhabit this world as well as the Burning Hells.

Kathon—The 15th day of Kathon is the crimson moon. The Triune refers to this phenomenon as the Eye of Baal. During this time of the month, destructive spells are more potent but harder to control. Sacrifices are best performed under the crimson moon.

Solmoneth and Montaht—The months when day and night are equal. It is a time of dreams and visions. Scrying spells and illusions are more powerful in Solmoneth and Montaht than at any other time of the year. This is also when Belial and his minions seem most active.

Ostara—The month of rebirth, when healing spells and elixirs are most potent.

Vasan and Lycanum—In Kehjistan, these are the months of sowing and fertility. They represent the duality between male and female. I also believe they represent the conflict between angels and demons. Do not parlay with the creatures of the Burning Hells during this time, for they will be erratic and easy to anger.

Kale Monath—The month of plagues and pestilence. I have found brewing poisons during this time to be most effective. Reagents also bind more easily.

Lunasadh—The "baker's month" when crops are harvested, and food is plenty. Demons aligned with Azmodan seem easier to contact in the latter half of the month.

Jerharan and Damhar—These months are when the barrier between our world and other realms weakens, specifically the days at the end of Jerharan and the beginning of Damhar. It is the ideal time to summon demons from the Burning Hells.

Ratham—The ideal time to summon, bind, or commune with spirits is the month of the dead. These acts are best conducted during the new moon.

Esunar—The month of fire, water, air, earth and other elemental powers. There is a connection between magic and the physical world in this month, making it the best time to create amulets or perform other enchantments on objects.

Invocations and Summoning Rituals

Words have power. Some more than others. Every spell or rite we perform is a combination of these elements: reagents, intent, and focus. But what we say is perhaps the most important part. The correct order and pronunciation of incantations must be as familiar to us as our own names.

When dealing with the minions of the Hells, names are crucial. Speaking a demon's name will allow us to contact it, as well as give us some amount of power over the creature.

There are three names we must learn before any others. The first is Al'Diabolos, the true name of Diablo, Lord of Terror. The next is Tor'Baalos, the true name of Baal, Lord of Destruction. The last is Dul'Mephistos, the true name of Mephisto, Lord of Hatred. Other cultures refer to them by different names. I've heard people tell of a destructive spirit named Khoyassa. They do not know it is actually Baal, but the name they have given him still holds power.

When communing with a demon that serves Diablo, speak the Lord of Terror's true name. The same applies to the other Prime Evils and their respective minions. Pronounce the name of the correct demon lord loudly and clearly. If we do not, the creature we are contacting may see it as a slight against their master and lash out.

Sacrificial blood must come from young and vigorous humans or beasts whose life energies are potent. Never use sick or dying creatures, for they will weaken our rituals and likely anger the demons we are trying to contact.

The first demons that most of us learn to summon are simple-minded, but powerful. Invoking the true names of greater demons is an effective way of exerting our willpower over them. But that will not change their nature. They are like wild beasts. It is best to set them loose and stand out of their way.

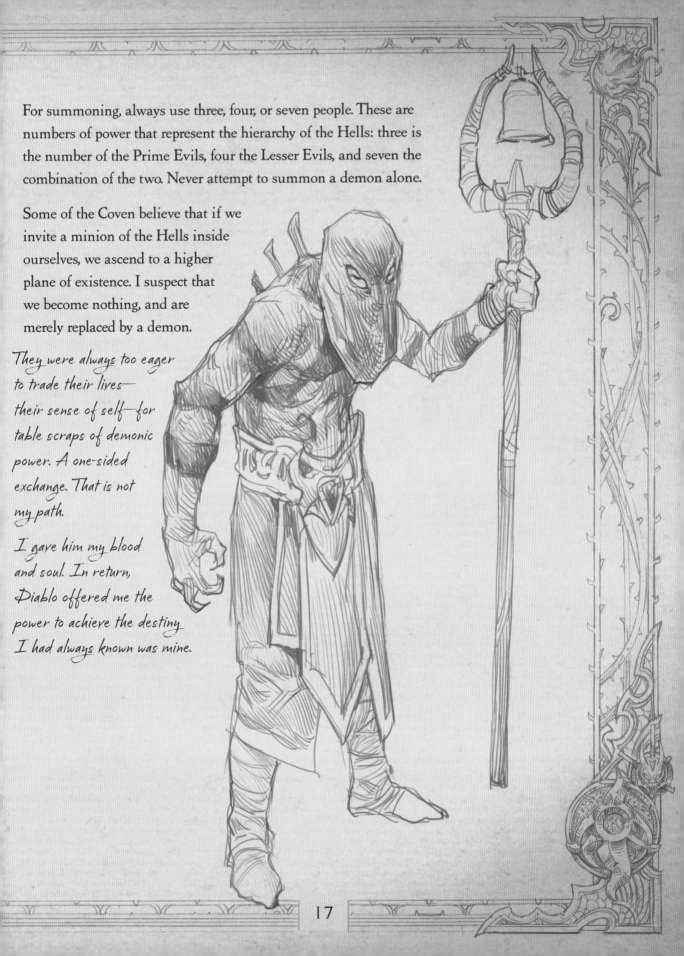

For summoning, always use three, four, or seven people. These are numbers of power that represent the hierarchy of the Hells: three is the number of the Prime Evils, four the Lesser Evils, and seven the combination of the two. Never attempt to summon a demon alone.

Some of the Coven believe that if we invite a minion of the Hells inside ourselves, we ascend to a higher plane of existence. I suspect that we become nothing, and are merely replaced by a demon.

They were always too eager to trade their lives— their sense of self—for table scraps of demonic power. A one-sided exchange. That is not my path.

I gave him my blood and soul. In return, Diablo offered me the power to achieve the destiny I had always known was mine.

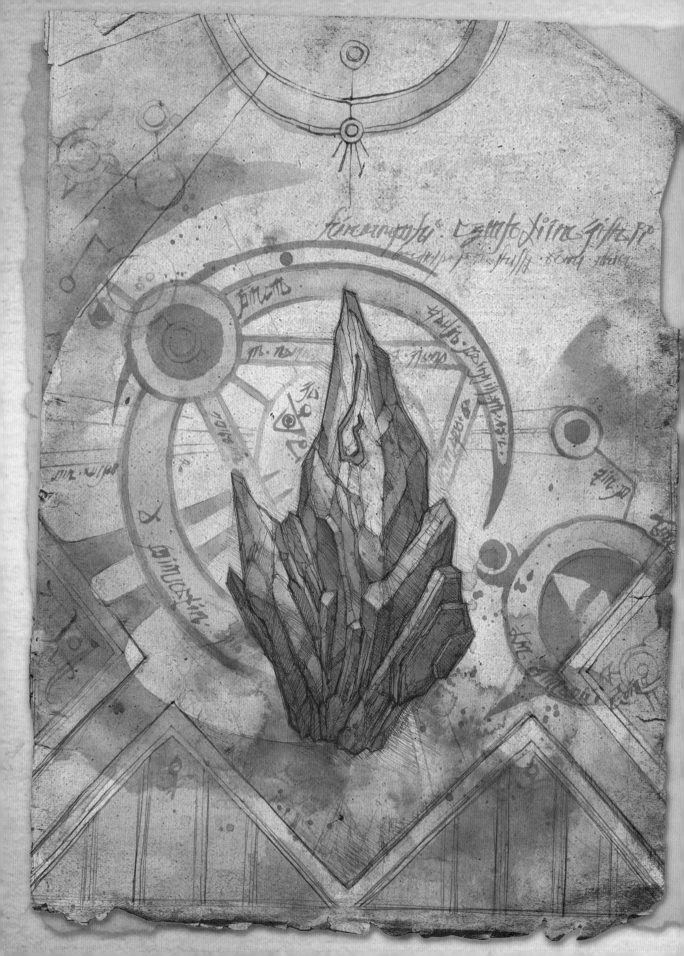

The answers lie with the ancient mage, Zoltun Kulle.

Various historical accounts cast him as a monster, a visionary, or a misguided genius.
I believe he was all these things.

Kulle was recruited into the Horadrim, the order of mages created by Archangel Tyrael to hunt the Prime Evils. But serving as Tyrael's pawn was not to be Kulle's fate. His battles with demons darkened him, and he set off on a quest to make himself a god.

He had discovered the secret of humanity, that we were created by a union between angels and demons. The first generations of these children were called the nephalem, and they were extraordinarily powerful. Each generation grew weaker as time went on, but the power did not disappear completely. It still lurked in the blood of every man, woman, and child.

Kulle found a way to unlock that power, but the Horadrim hunted him down before he could finish his work. Whether he is truly dead or banished to a different realm is another question.

But his fate does not matter, only what he learned. And what he created.

THE BLACK SOULSTONE. It is the answer I have been seeking.

Kulle wanted to use it to mark the souls of angels and demons alike, trapping their essences in the crystal and using that power to awaken his own latent nephalem blood. However, he was unable to activate it in his lifetime.

He was a fool to aim so short. It has the capacity for so much more.

I have been dreaming of the soulstone. Every night.

Not as it is, but as it will be.

Trembling with the spirits of the Prime and Lesser Evils who scream from their prison. They shake with rage when they realize what Diablo is planning. But it is too late.
Far too late.

Before they can act, the spirits are channeled into the vessel. My master consumes them all. Becomes them all. Mortal flesh burns away to reveal his greatest form.

The Prime Evil.

I can make this dream a reality. With Kulle's spells to mark the souls of the Evils, and the Black Soulstone to contain them, I can bring this vision to life.

– II –

The Dead and the Damned

Life does not endure. Our flesh fails, our skin wrinkles, our limbs ache, our lungs struggle to draw breath, our minds wither, then our hearts churn slow, then not at all.

Most things
~~All things~~ on this world shall die.

Yet, death need not be the end. Our lords and masters have told us so, and the power they have taught us is our proof. Any dead creature has gifts to offer the Coven. There is power in blood, in decaying flesh and bone, in ribs bleaching in the Kehjistani sun, in skulls drifting along the bottom of the Twin Seas. The discarded forms of mortal creatures can be used or reused in countless ways. It is an art ripe for experimentation.

But the remains of the dead contain only a fraction of the usefulness their spirits once had. The power of <u>souls</u> is extraordinary. They are vibrating knots of energy that rejuvenate themselves, burning brightly and for far longer than any temple of flesh could. Even when siphoning tremendous draughts of power from them, if a spark of existence remains, it will shine on.

Souls instinctively yearn for a vessel to call their own, whether it be a mortal creature or a temporary construct. Most will even accept imprisonment inside a body they do not control, for it is better to know the sensation of flesh than not. Sometimes the soul is strong enough to wrest control from its host. This is the crux of possession.

Possessed humans are excellent subjects for experiments, as you can draw out multiple souls for any use you desire. Give the unsuspecting victim a tea made of oakleaf bark laced with powdered human bone marrow to determine whether they truly harbor multiple souls. It is lightly poisonous, and the sickness will make it difficult for the host to maintain their defenses against the intruding souls, thus making detection easy.

There is abundant power in the bodies and spirits of the dead. But beware the teachings of those who claim to serve the "Balance" between life and death. Those fools are known as necromancers, and they have little to offer us. We do not seek balance. We seek domination. We seek victory.

Risen Dead

The dead may rise from their graves for many reasons. The presence of a powerful demon, a convocation, or a source of corruption can all stir them. Some of these dead wander the world in silence until the magic that reanimates them fades away. Others take up weapons and hunt down anything that still lives.

A risen dead strong enough to walk the earth is a creature that can be drained of its power. Doing so in the month of Ratham—especially on the seventh day—produces the best results.

Power from a risen dead can be stored in daggers, amulets, rings, or almost any other object. Purify the item of any residual energies by washing it in a copper pot filled with water, a pinch of Death's Breath, and the blood of a young pack beast.

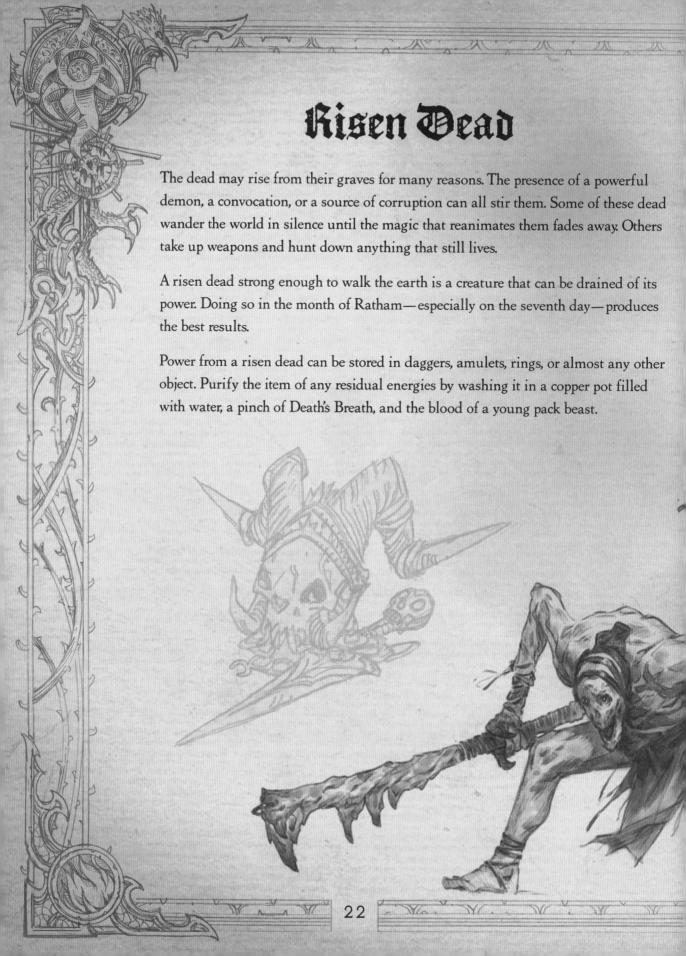

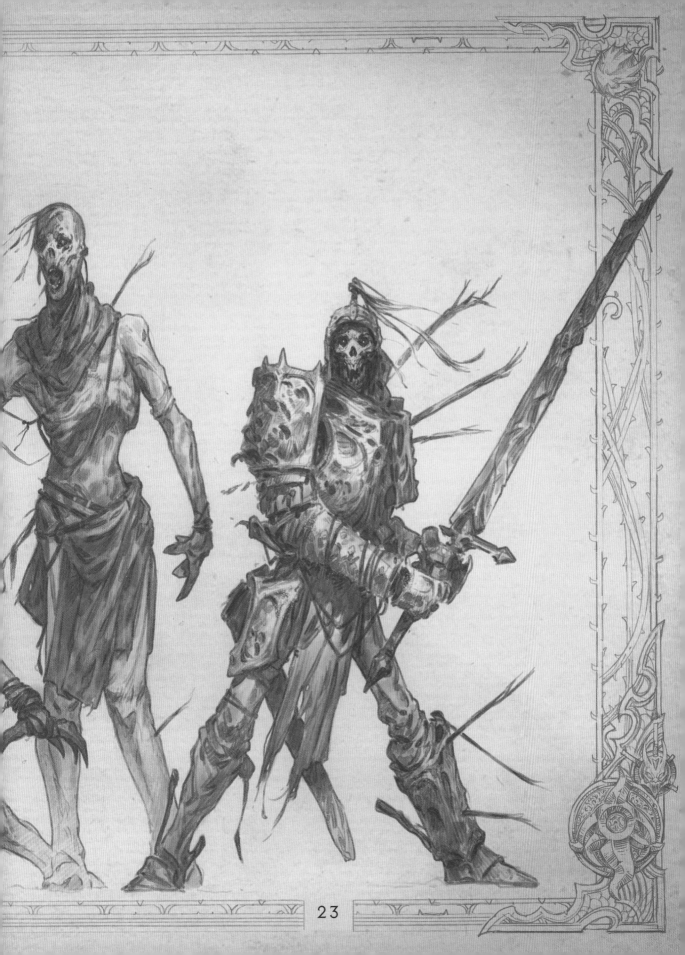

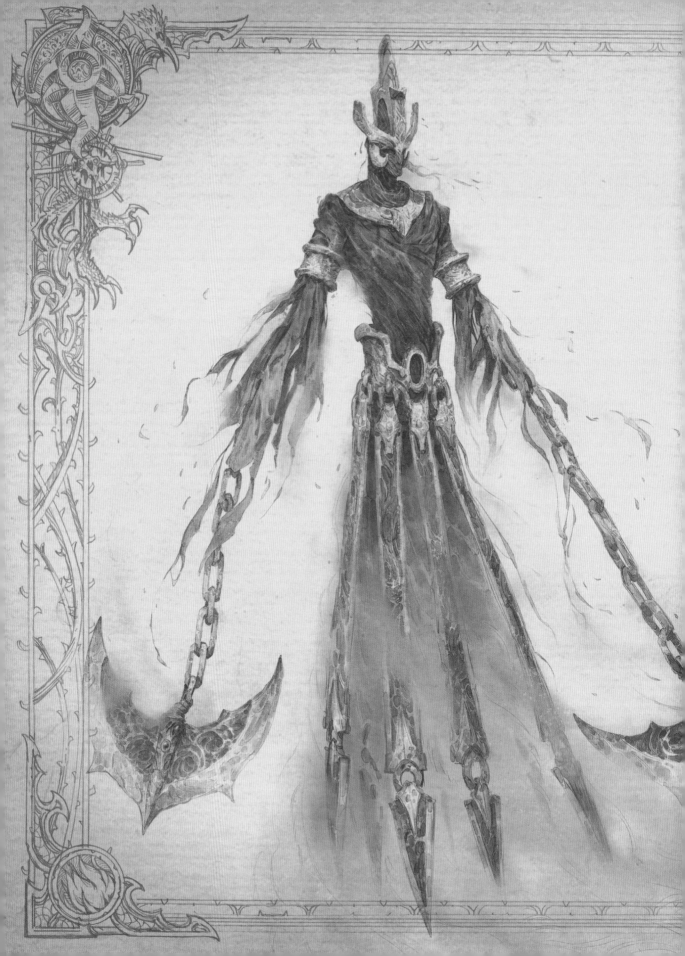

Dune Dervish

The state of these poor beings should serve as a warning to us all. They were once Vizjerei mages who conducted arcane rituals in the deserts of Kehjistan, hoping to summon a lieutenant of the Burning Hells. Their "success" not only ended their lives, but also cursed their eternal souls. They wander the deserts, hunting on instinct alone. There is little to learn from them but caution.

Avoid contact with the dervishes while traveling the deserts. <u>Wear a cloak of deerskin branded with Ammuit runes</u> to become invisible to the creatures.

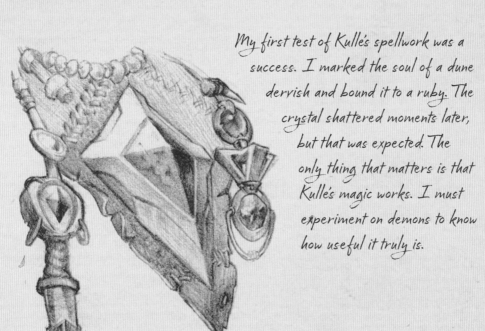

My first test of Kulle's spellwork was a success. I marked the soul of a dune dervish and bound it to a ruby. The crystal shattered moments later, but that was expected. The only thing that matters is that Kulle's magic works. I must experiment on demons to know how useful it truly is.

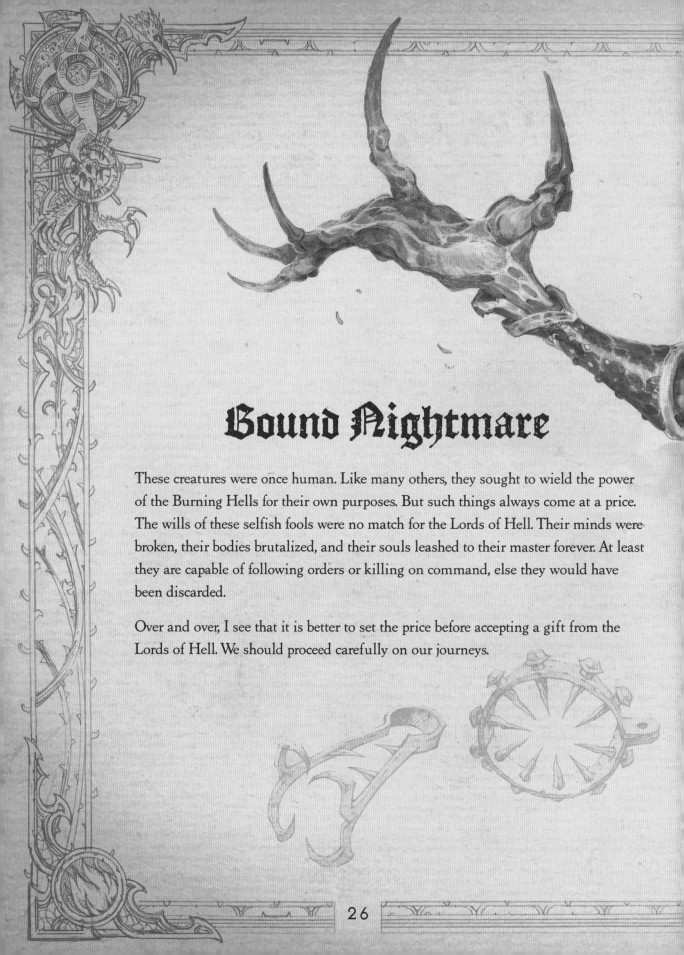

Bound Nightmare

These creatures were once human. Like many others, they sought to wield the power of the Burning Hells for their own purposes. But such things always come at a price. The wills of these selfish fools were no match for the Lords of Hell. Their minds were broken, their bodies brutalized, and their souls leashed to their master forever. At least they are capable of following orders or killing on command, else they would have been discarded.

Over and over, I see that it is better to set the price before accepting a gift from the Lords of Hell. We should proceed carefully on our journeys.

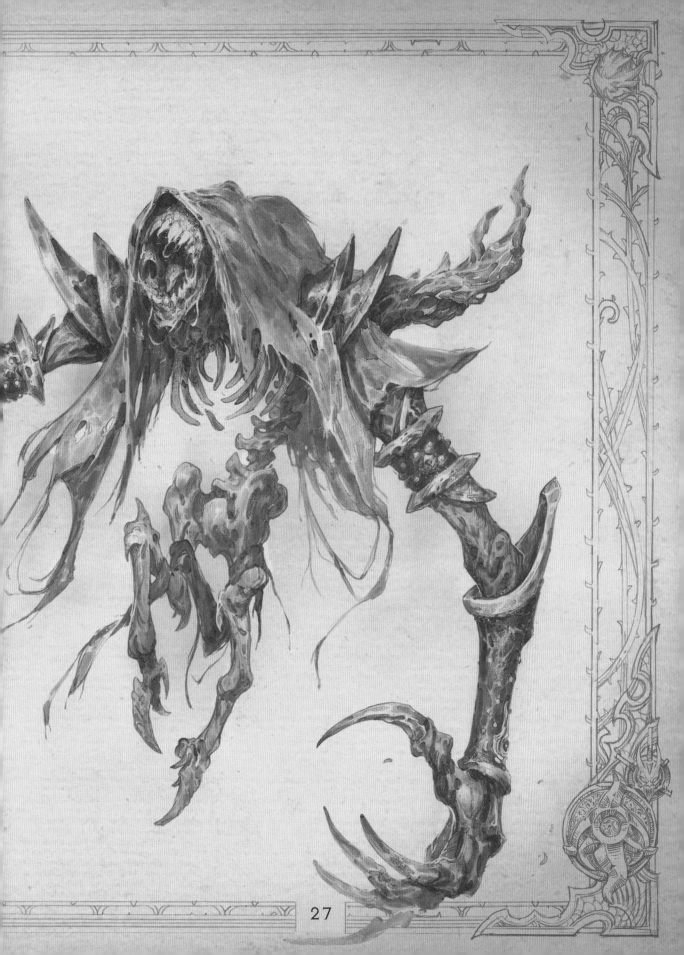

27

Ghosts

None should ever doubt the raw potential of a soul. Especially not after seeing one of these wraiths. Strong or weak, when humans die before they are ready, their souls will try to cling to this realm. Devoid of conscious thought, their continued existence is a scream of denial. They care for nothing but their own lingering rage.

Some angry spirits will cling to any corpse that still has its muscles and sinew intact, puppeting them in a repulsive imitation of life. They are instruments of terror and little more. Better to use these creatures for a purpose than to let them wander aimlessly.

But that has proven very useful indeed . . .

The steps to commune with a spirit are such: first, mark a circle of binding around its resting place; second, take an onyx dagger and coat it three times with Kehjistani sage oil; last, embed the dagger half into the ground at the southern edge of the circle and cast a spell to summon the spirit to your side.

29

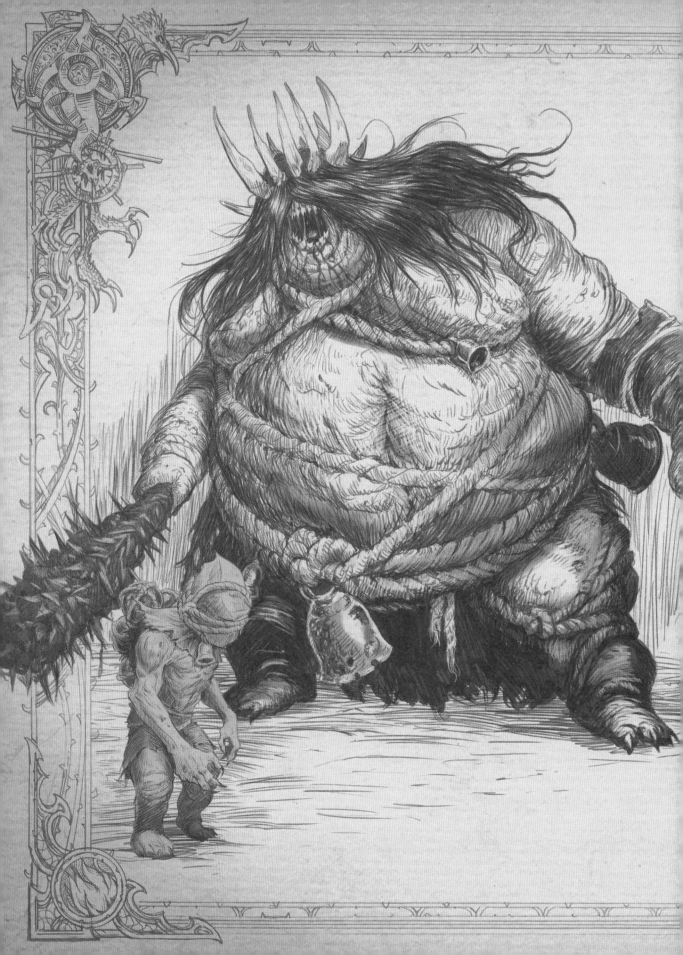

The Drowned

First, an idol of a strange deity washes ashore. Then, brackish seawater creeps onto the Scoslgen shores, along with the scent of sea carried far on the breeze…followed by a dense fog. Then, it is said, they come. The Drowned stagger from the waves, dragging people back into the dark depths.

Sailors claim the Drowned dwell on the sea floor in the hulk of a sunken, rotting ship. Their reasons for coming and taking are unknown. They leave behind waves of death and destruction. Do not look into the eyes of the idol, the villagers say, for its stare could be your last.

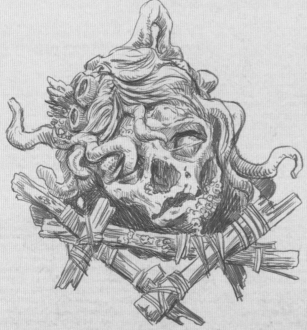

Beware the tolling of bells when the smell of the sea blows over the land. The Drowned are said to carry bells to lure villagers toward the water.

Skeletal Guardian

The skeletal guardians are far more powerful than most risen dead. These creatures, once nothing more than a pile of bones, were granted life by enterprising mages and gifted with the ability to wield powerful magic. Creating one takes considerable time as well as rare and expensive reagents.

During the golden age of the mage clans, the skeletal guardians were created to protect the estates and vaults of wealthy individuals. Wherever one of these risen dead lingers, there is likely something valuable nearby.

It is not wise to confront a guardian directly. Weaken the magic that animates them first. Approach the creature at sunrise and chant the Elegy of the Damned in its presence. This will confuse the guardian long enough to safely pass by it.

Though the Coven could learn how to make skeletal guardians, I do not believe we should. A dozen shambling corpses can unleash as much destruction as a single guardian, and with much less effort.

Mage clans take great pride in creating these guardians, often outfitting them in ornaments and armor. Useless gestures. The vanity of mages never ceases to amaze me.

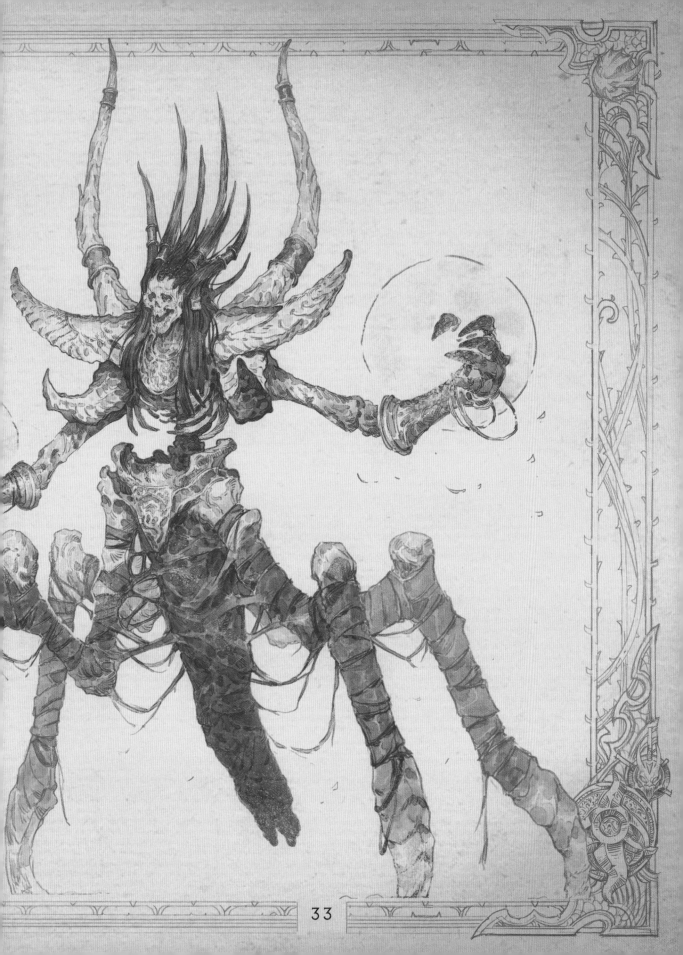

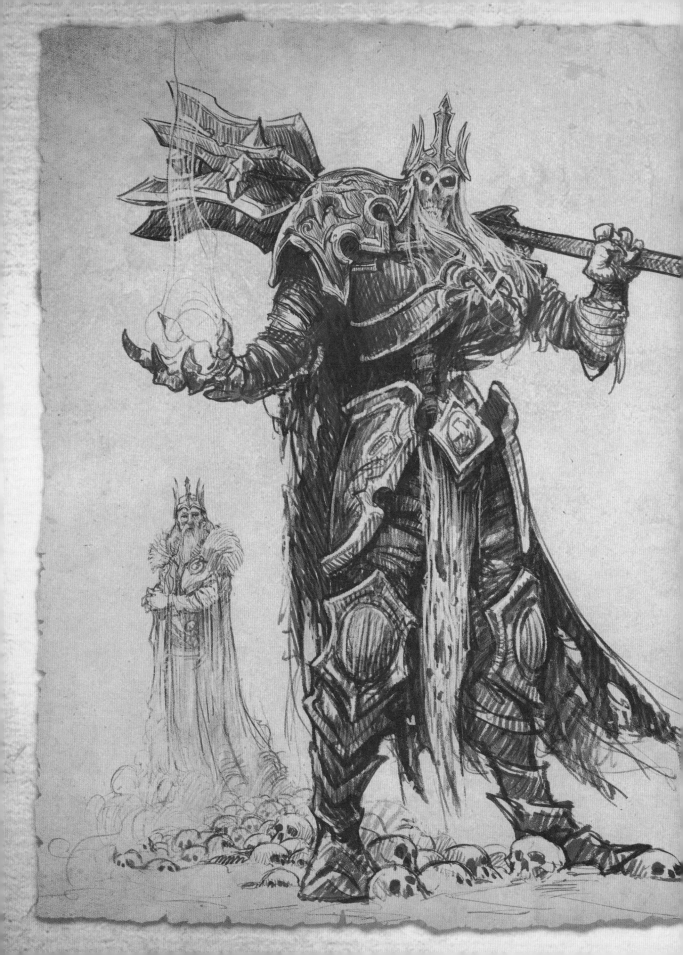

The memories of my time in Tristram are sharper than any others I have.

If I close my eyes, I can see my hut at the edge of town. I barely knew the people I met, but I remember exactly how they looked. The things they said. The potions and salves they bought from me.

My memories of the dead rising in Tristram are even clearer. When I saw them shambling through the forests, I realized they were the product of true power.

 It was not the number of the risen dead, though there were many. Any necromancer or witch doctor can bring a corpse to life. It was the air in the village. The way it felt. The sense of dread that hung over everything. It darkened the hearts of all who lived there. Even King Leoric, who so many thought was wise and just. He was a devout follower of the Zakarum faith; a man who always sought peace and stability.

Perhaps it was his desire for those things that made him weak. A king who expects loyalty fears betrayal. A father who loves his family fears losing them. A believer who finds comfort in his faith fears that he will discover it has all been a lie.

Diablo sensed these hidden fears in Leoric. He used them to break the king's mind and turn him into a bloody tyrant.

When Leoric's loyal knights abandoned their oaths and cut him down, it did not stop the chaos. It fed the disorder. Every act of violence and hate fueled it.

Everything Leoric had feared became real. When he was reborn as the SKELETON KING, he transformed into the embodiment of terror.

No one could save Tristram. The people there never understood that. Not Cain. Not Prince Aidan. Not the others who remained in town to stop the chaos.

Tristram was already lost. It was gone the moment my master's influence slipped into the minds of Leoric and his people. The moment he sensed the king's fears and made them into living nightmares. Diablo defeated the people of Tristram before they even knew of his presence.

How could anyone ever stand against a force like that?

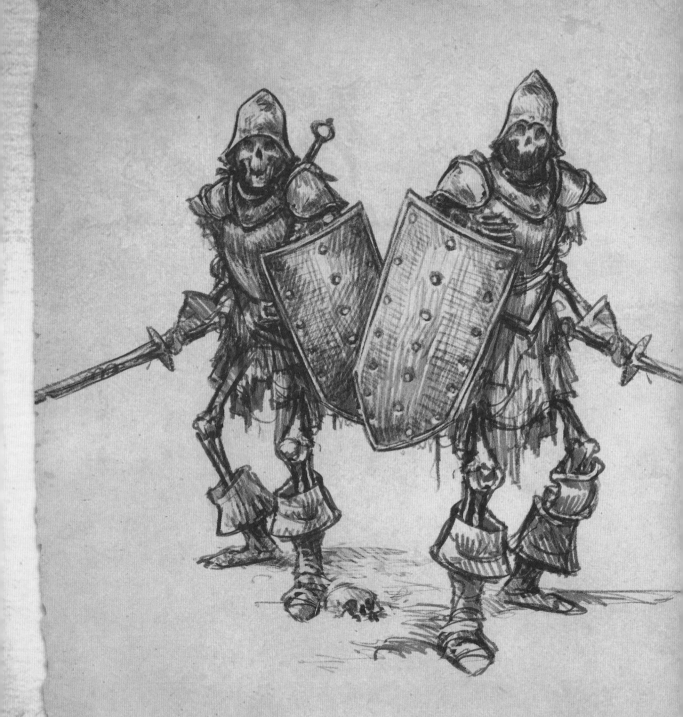

With his dying breath, Leoric cursed the **KNIGHTS** who had turned on him. He damned them to spend eternity like him—as skeletal horrors. Even though Leoric spoke the curse, it was not his power. It was a gift from my master.

I still remember seeing my first **WRETCHED MOTHER**. She had been one of Queen Asylla's handmaidens. A young girl. Pretty. We had met once. She called me a witch. She said what I did was unnatural, that I had no virtue in my soul.

Diablo's power twisted her into a ravenous fiend. I saw her eating a fallen soldier. Pulling flesh away from bone in long strips. Our eyes met, and for a moment she recognized me. There was fear in her eyes. And hate. Perhaps it was only my imagination. I watched while she vomited up her meal and the pieces congealed together to form a new undead creature.

I left the pretty girl to her virtuous work.

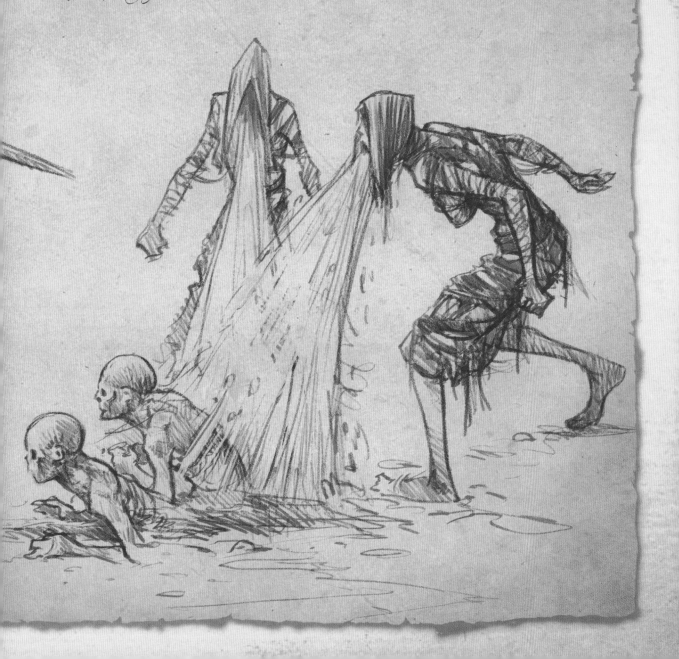

— III —
The Creatures of Sanctuary and Realms Beyond

How many beasts walk this world?

Some scholars have wasted their lives searching for the answer.

The creatures of the world are simply too great in number. That is good for us. It means the tools we have at our disposal are limitless. It is not our purpose to document every beast, but to study and use the ones that have something we need.

We can even learn much from simply observing them. Every creature, no matter how insignificant, exists because it has a strength. Most are quick, clever, dangerous, or a combination of these things. If they were not, they would never survive the harsh and unforgiving wilds.

We must understand the inner workings of these creatures. Nature and magic are an interwoven tapestry. The tides, the seasons, and the movements of the stars are all connected to the beings of this world. They are bound to the flesh and bone of all beasts. They influence each other, just as they influence humans.

Sightings of certain beasts have meaning, both good and ill. The time when creatures migrate, hunt, or mate can be a sign of when is best to perform certain rites.

Even beyond their symbolic value, these creatures have practical uses. Some can be used as bait for larger predators. Some can be harvested for reagents required in spells and rituals. Others can be enslaved as guardians.

All have a role to play in the days to come.

Dune Thresher

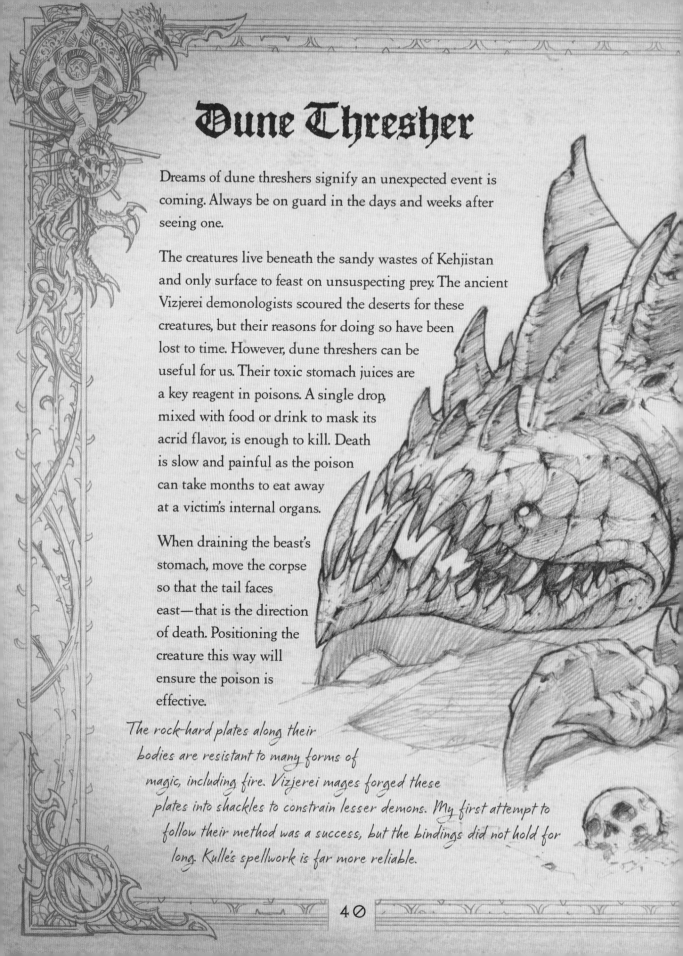

Dreams of dune threshers signify an unexpected event is coming. Always be on guard in the days and weeks after seeing one.

The creatures live beneath the sandy wastes of Kehjistan and only surface to feast on unsuspecting prey. The ancient Vizjerei demonologists scoured the deserts for these creatures, but their reasons for doing so have been lost to time. However, dune threshers can be useful for us. Their toxic stomach juices are a key reagent in poisons. A single drop, mixed with food or drink to mask its acrid flavor, is enough to kill. Death is slow and painful as the poison can take months to eat away at a victim's internal organs.

When draining the beast's stomach, move the corpse so that the tail faces east—that is the direction of death. Positioning the creature this way will ensure the poison is effective.

The rock-hard plates along their bodies are resistant to many forms of magic, including fire. Vizjerei mages forged these plates into shackles to constrain lesser demons. My first attempt to follow their method was a success, but the bindings did not hold for long. Kulle's spellwork is far more reliable.

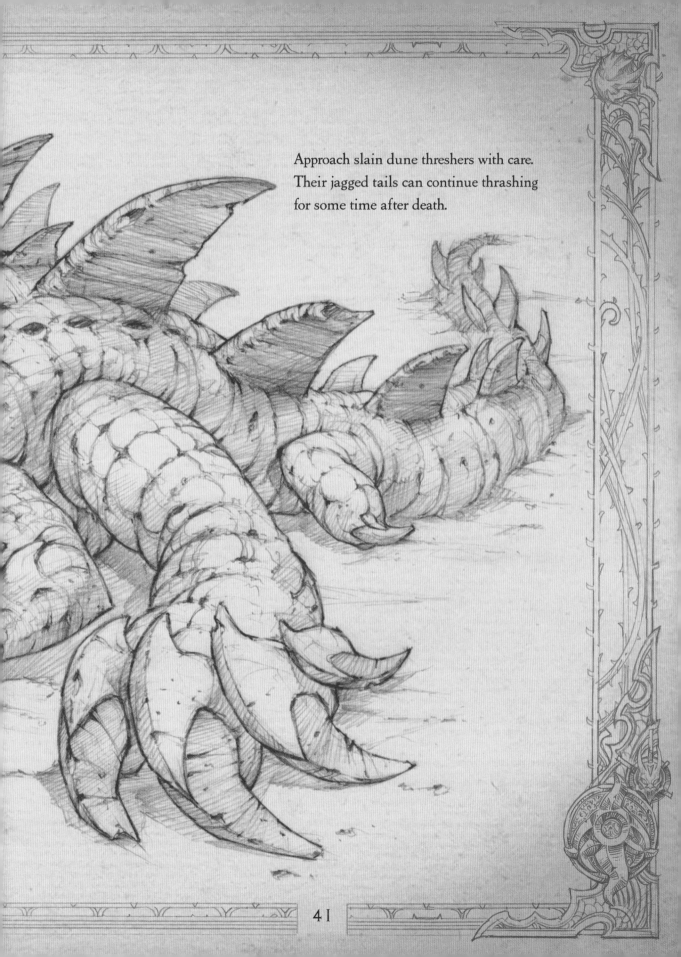

Approach slain dune threshers with care.
Their jagged tails can continue thrashing
for some time after death.

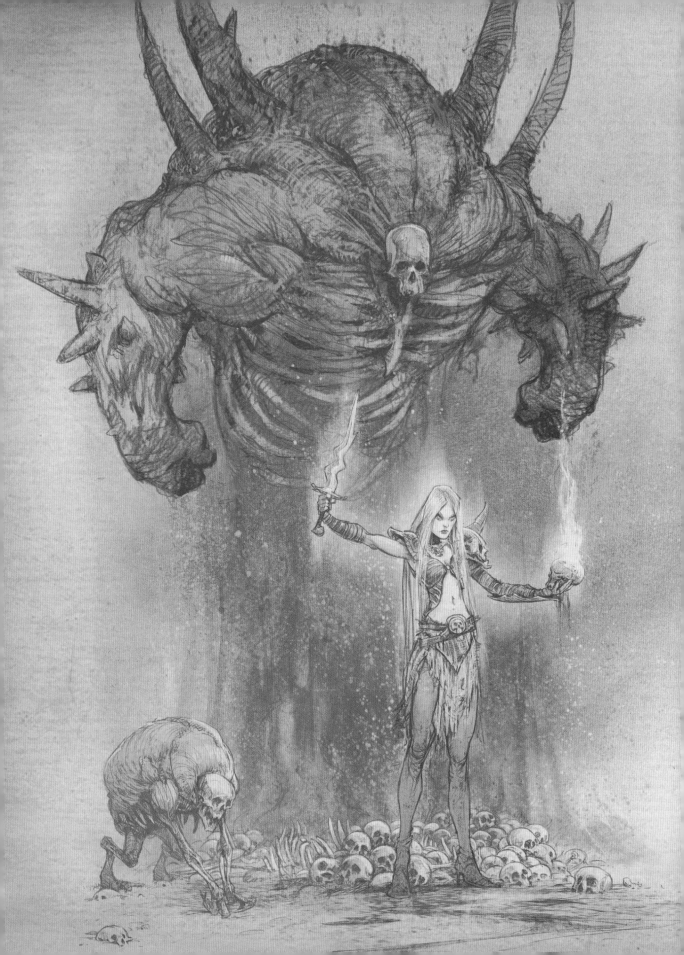

Golem

Turning bits of flesh, dirt, metal, and other inanimate materials into golems is an art the necromancers have perfected over their long history. I first saw it happen in the forests near Westmarch. I had been following a necromancer for a chance to steal the spell books she carried. One night, a pack of scavengers descended on her camp. The necromancer knelt and drew a blade across her flesh, all while chanting the Prayer of Rathma. There was great ritual to the process. The blood that poured from her wound slowly changed. It became a writhing mass of flesh and sinew. A thing without form. Then it grew legs, arms, and a head. A giant bound to its creator's will. The golem tore through the scavengers with the strength of ten men, but controlling it required intense concentration.

The necromancer was so focused on commanding her golem, I could have taken her spell books right then. But I wanted to see more. I wanted to know the limits of the golem's strength.

She never noticed I was there until I buried my dagger in her back. The poison worked quickly. As she died, I watched the golem crumble into nothingness. Strange that a such a powerful creature could be brought so low because of its master.

The knife I took from the necromancer was a thing of beauty. It was always cold to the touch, even after holding the blade over an open fire. Runes carved into the weapon matched the symbols I found in her spell books. The bones or flesh of the corpse a necromancer intends to raise are often carved with these same runes. We can use them as well. However, always mark a ward of protection on the ground before using necromancer sigils, for they are powerful things.

Bogan

The superstitious bogans lurk in the Blood Marsh of Westmarch, where they form into small tribes and worship a crude fire deity. They have an extraordinary sense of smell, which makes them expert foragers. Many of the plants they collect—such as <u>elemus leaf and blood moss</u>—are useful for summoning rituals. It is easier to pillage a bogan village for these reagents than to hunt for them in the marsh.

To scare the beasts away, create a small effigy with human hair, moss, and branches from a pine tree. Ignite the object and toss it near the bogans. They will flee in terror, thinking it a sign from their god. I recommend killing a few for extra measure, just to ensure they stay away for a long period of time.

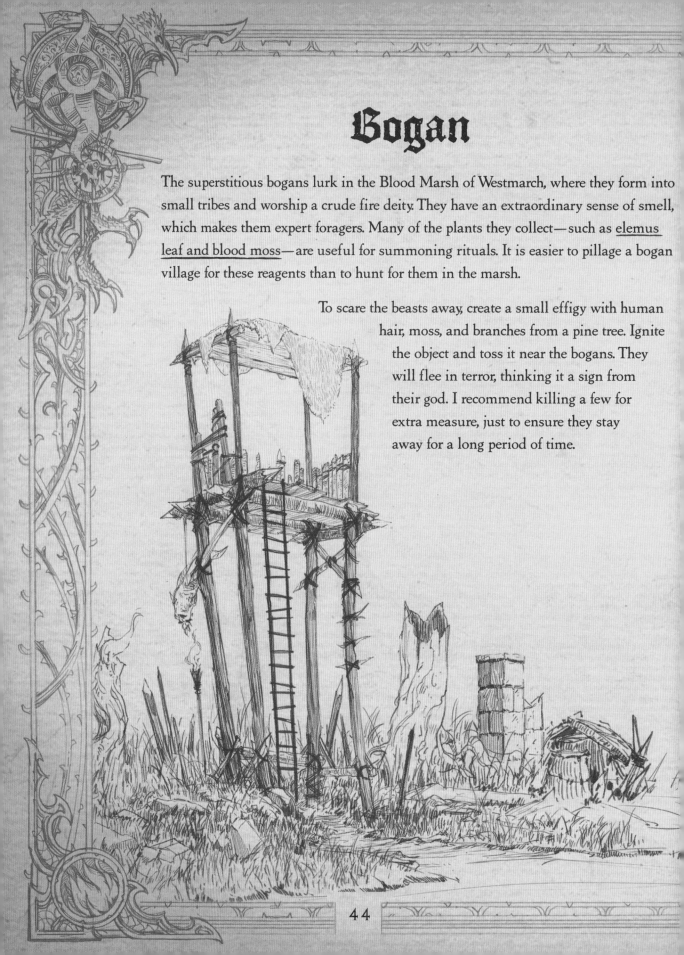

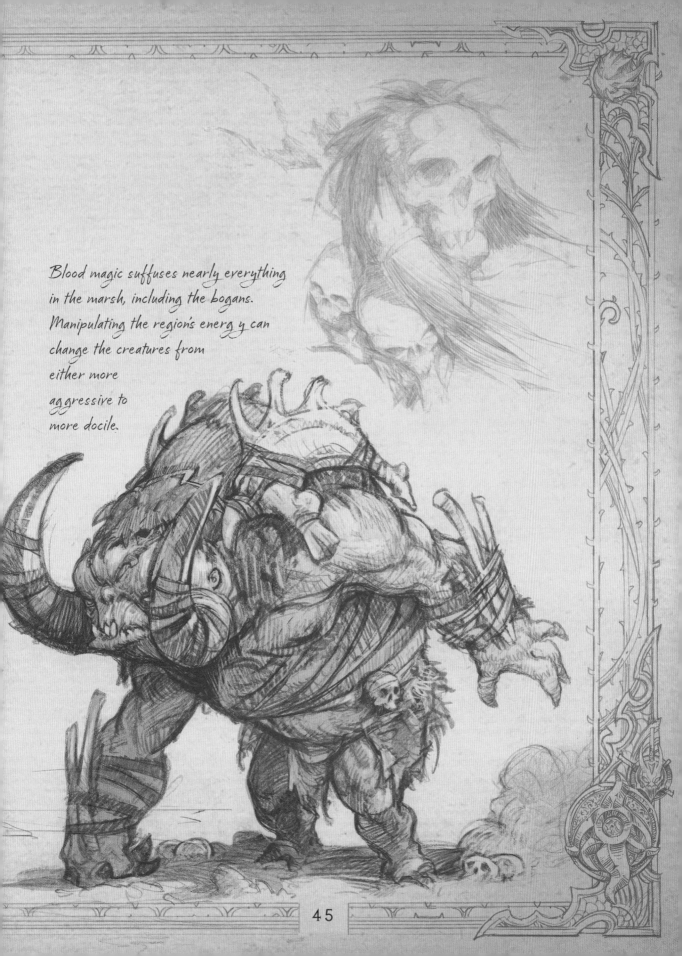

Blood magic suffuses nearly everything in the marsh, including the bogans. Manipulating the region's energy can change the creatures from either more aggressive to more docile.

Scavenger

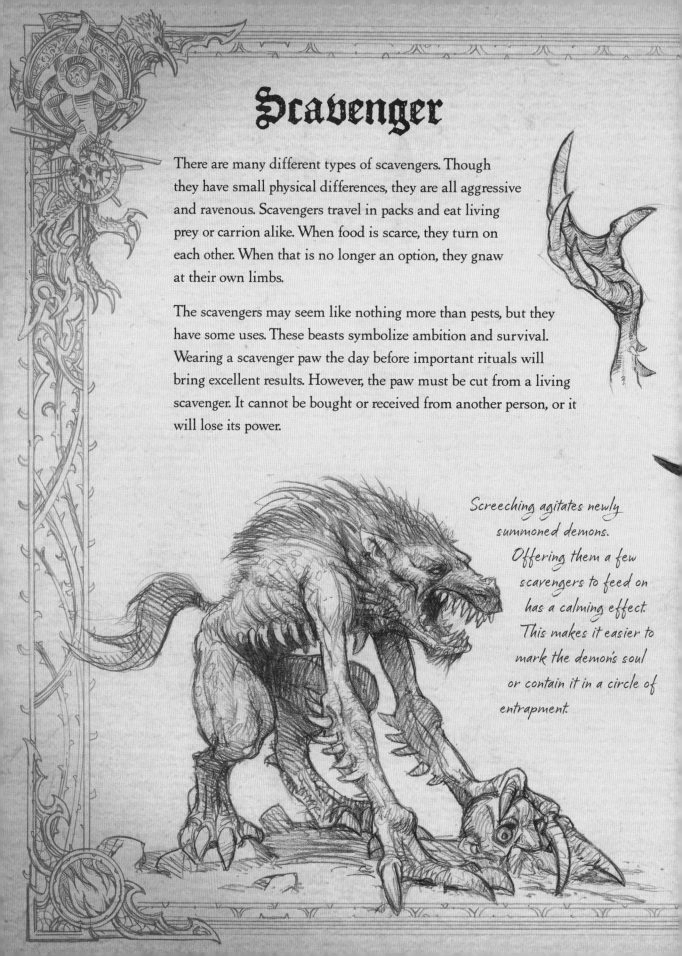

There are many different types of scavengers. Though they have small physical differences, they are all aggressive and ravenous. Scavengers travel in packs and eat living prey or carrion alike. When food is scarce, they turn on each other. When that is no longer an option, they gnaw at their own limbs.

The scavengers may seem like nothing more than pests, but they have some uses. These beasts symbolize ambition and survival. Wearing a scavenger paw the day before important rituals will bring excellent results. However, the paw must be cut from a living scavenger. It cannot be bought or received from another person, or it will lose its power.

Screeching agitates newly summoned demons. Offering them a few scavengers to feed on has a calming effect. This makes it easier to mark the demon's soul or contain it in a circle of entrapment.

Quill Fiend

These vermin are mindless scroungers who are little better than rats. But they are dangerous. Some rarer breeds carry poisons in their quills, while others produce unstable substances that can spontaneously ignite. It is wise to trap rather than kill them so that their bodies can be harvested for any useful reagents later.

Their quills are sturdy and resistant to magic. They can be fashioned into needles for drawing blood and venom from other creatures.

Blood Hawk

I admire the blood hawks. They are patient, clever hunters. They wait until their prey is wounded, distracted, or at some other disadvantage before striking. When they do, it is with all their fury. They hold nothing back.

The Coven can learn from them. It is easy to give in to our passions, to want the full power of the Burning Hells at our fingertips here and now. But there will come a time for that. We must be patient. Be clever hunters. Watch our enemies and learn their weaknesses. And when the Lords of Hell finally command us to strike, we shall do so with all our fury. Holding nothing back.

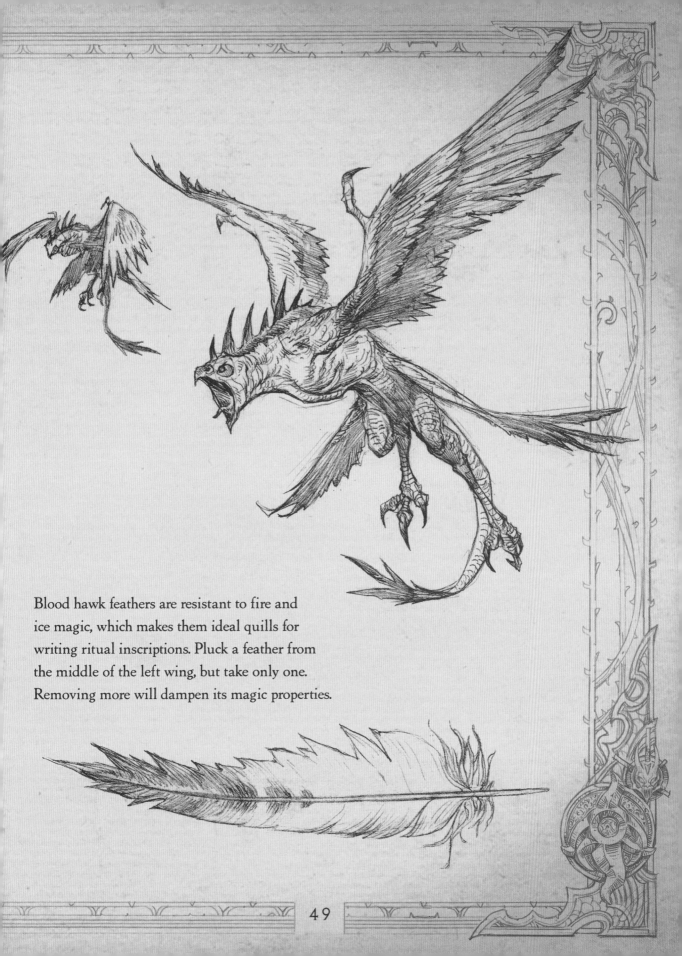

Blood hawk feathers are resistant to fire and
ice magic, which makes them ideal quills for
writing ritual inscriptions. Pluck a feather from
the middle of the left wing, but take only one.
Removing more will dampen its magic properties.

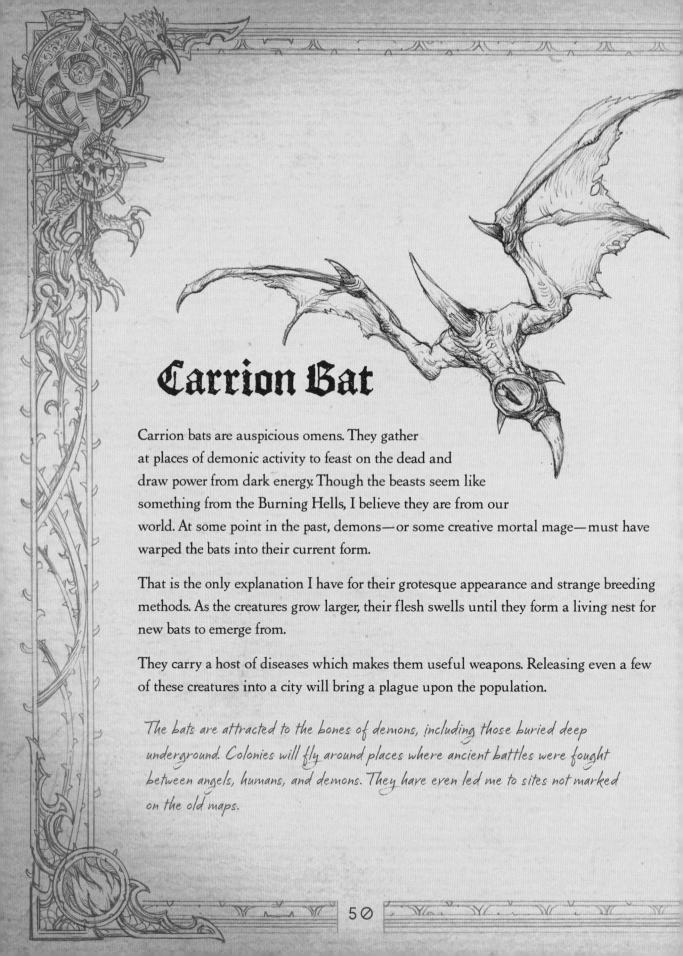

Carrion Bat

Carrion bats are auspicious omens. They gather at places of demonic activity to feast on the dead and draw power from dark energy. Though the beasts seem like something from the Burning Hells, I believe they are from our world. At some point in the past, demons—or some creative mortal mage—must have warped the bats into their current form.

That is the only explanation I have for their grotesque appearance and strange breeding methods. As the creatures grow larger, their flesh swells until they form a living nest for new bats to emerge from.

They carry a host of diseases which makes them useful weapons. Releasing even a few of these creatures into a city will bring a plague upon the population.

The bats are attracted to the bones of demons, including those buried deep underground. Colonies will fly around places where ancient battles were fought between angels, humans, and demons. They have even led me to sites not marked on the old maps.

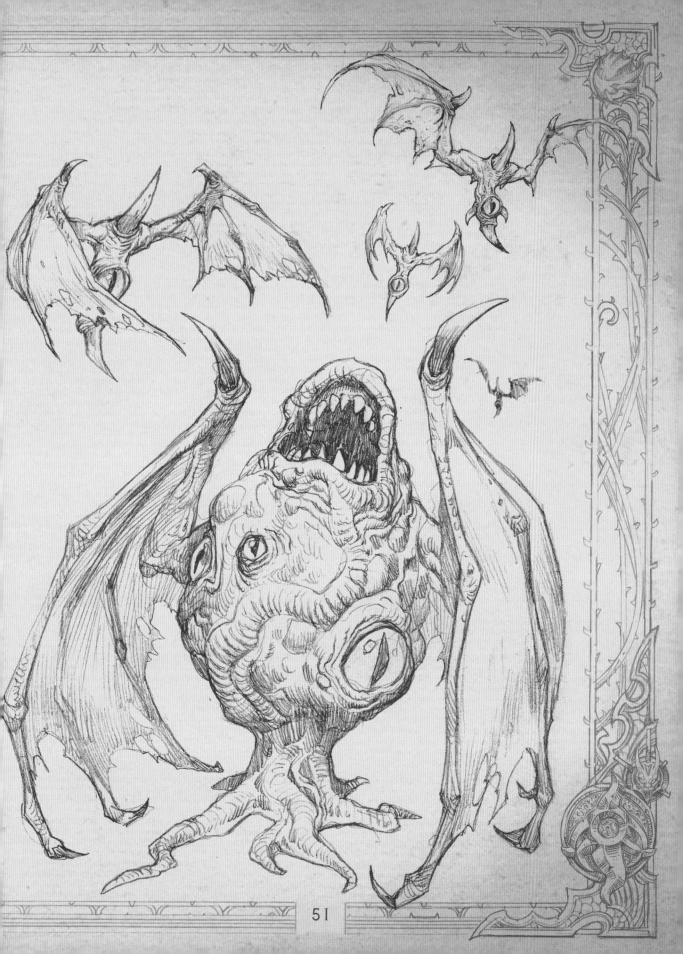

Khazra

Scholars call them "khazra." Children call them "goatmen." In this, the children of Sanctuary know best. They are indeed half goat and half man—just as the foolish Vizjerei intended. But they are not the mindless, loyal weapons the mages wanted to create; they are vicious, cunning, and brutal.

The khazra spent their first generations of life gleefully slaughtering every Vizjerei they could find. Which is what every single mage deserved, as far as I am concerned.

They are distrustful of humans, and rightly so, but since many khazra clans have pledged themselves to demonic masters, they could one day be our allies. And if not, no matter. They retain enough human blood to be adequate for sacrificial rituals.

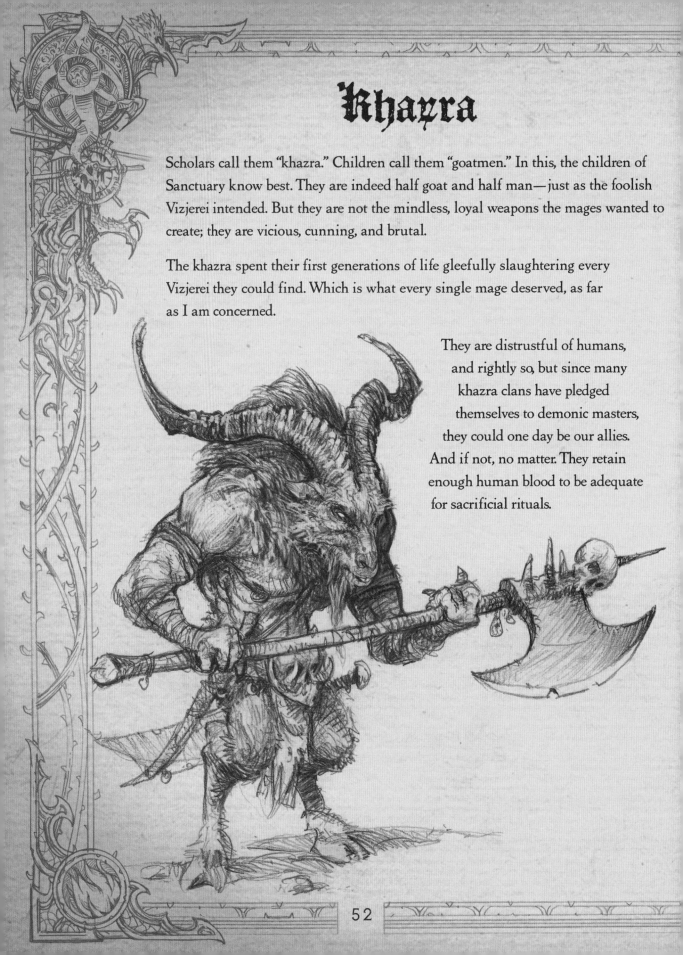

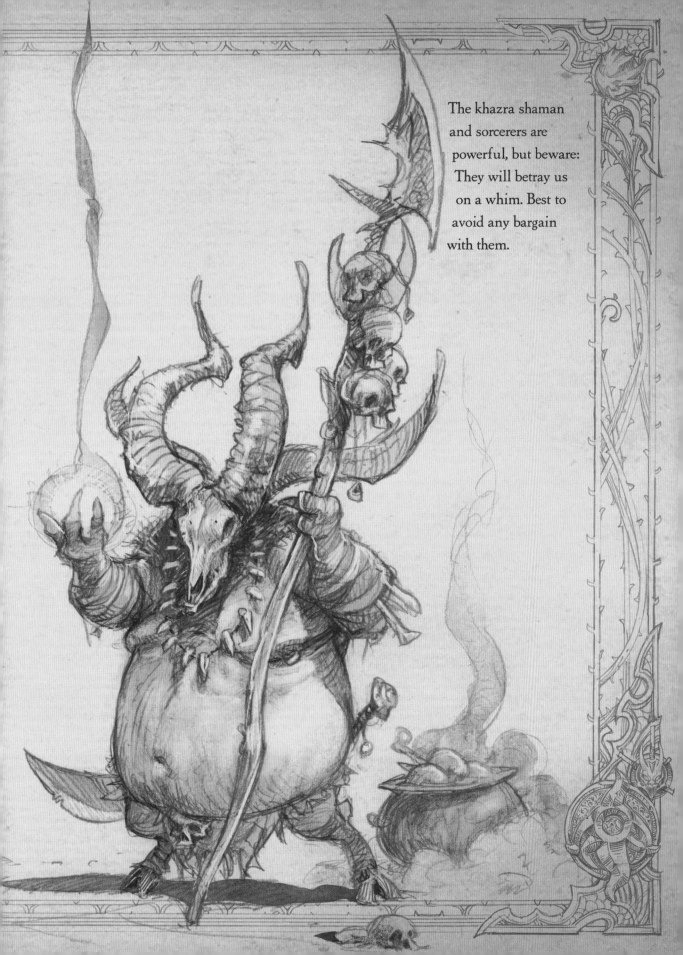

The khazra shaman and sorcerers are powerful, but beware: They will betray us on a whim. Best to avoid any bargain with them.

Lacuni

I once imagined these feline creatures to be similar to the khazra—wise enough, despite their bestial nature, to know that their destinies lay with the Burning Hells. That is not the case. The lacuni were twisted into panther-like beasts because of their ancestors' foolishness.

Nothing remains in their savage minds but the faintest desire for power, which *Just as I almost did, once.* they will pay any price for.

A small display of demonic power will dazzle them for a while. They may even pledge themselves to us. Do not trust their loyalty unless their minds are bound with an appropriate spell.

Once subjugated, harvest the eyes of the lacuni. They have many uses. The creatures can see as well at night as they can during the day, and their mystics are gifted scryers.

Cut the eyes from a lacuni with an iron blade, then place them in a box made of reeds and let them dry for a week. To experience visions of the future, draw the symbol of the mystic eye on the ground with lacuni blood, eat one of the beast's eyes, and burn the other eye in an iron pot while inhaling the smoke.

To see better in the dark, coat both eyes in emberlen wax and wear them as a necklace.

Hydra

Hydras are commonly seen in visions. They represent doorways, transformation, and the opening of new paths.

The ancient Triune studied the Zann Esu sorceresses and how they summoned these fiery, multi-headed creatures. At first, the cult believed that the hydras were demons ripped from the Burning Hells, but they were wrong. Hydras are elemental beasts from our own world. They live deep underground near molten veins and pits of fire.

I have seen a hydra in the mystic fires once before. A great beast of many heads, all but one engulfed in flames. The creature never spoke, but it watched me. It peered into me. From the weight of its gaze, I know that it holds vast knowledge that will make us stronger.

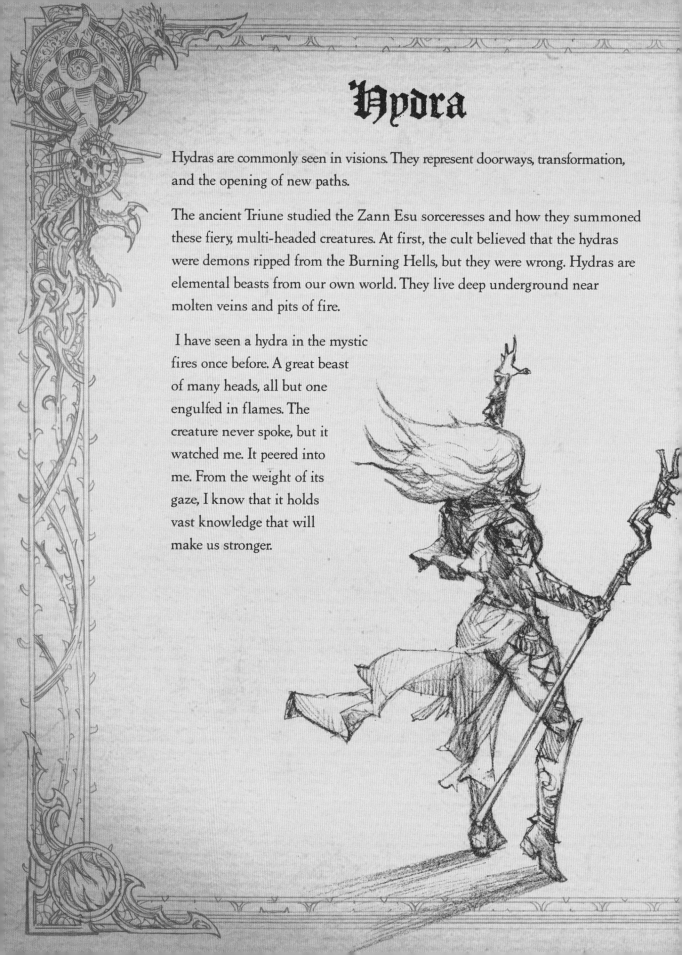

Spiders

Spiders represent many things: creation, destruction, power, and fear. They are bearers of omens, good and ill. Spotting a spiderweb on the eastern side of trees, bushes, and buildings is a sign of impending hardship.

There are many kinds of spiders in the world, but they all share an affinity for magic. The creatures are sensitive to spells and enchanted artifacts. Over the ages, magic has changed some spiders to expand their minds and create desires that can feel all too human.

The most powerful are known as queens, and they rule over a vast number of lesser creatures. Call them clusters, packs, it does not matter. Just know that they rarely travel alone.

Collect spider silk whenever possible as it is a primary reagent in making paralysis and sleep potions, as well as being good for casting binding and entrapment spells. When harvesting venom, pierce the creature's body once—only once—with a needle to draw out the ichor. Store the venom in a crystal vial for three days before using it to make poisons.

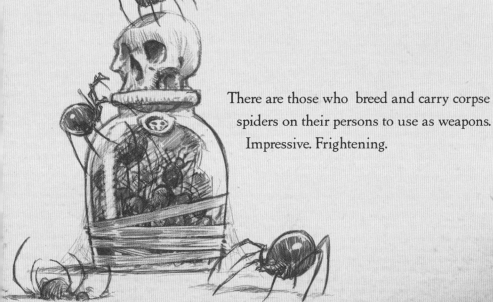

There are those who breed and carry corpse spiders on their persons to use as weapons. Impressive. Frightening.

Wood Wraith

These are not trees. Not truly. They began as human spirits who were drawn to the peace of nature, unwilling to move on after death. Some even imagined themselves protectors of their new homes. It takes only a hint of demonic corruption to turn them. Carve a demon lord's symbol into the wraith's trunk and the creature will change almost immediately. A strong hand can then force it to bend all of nature toward the Burning Hells. Quite useful.

Bark harvested from the wraiths contains faint traces of life energies, which make the wood ideal for creating effigies or ritual incense.

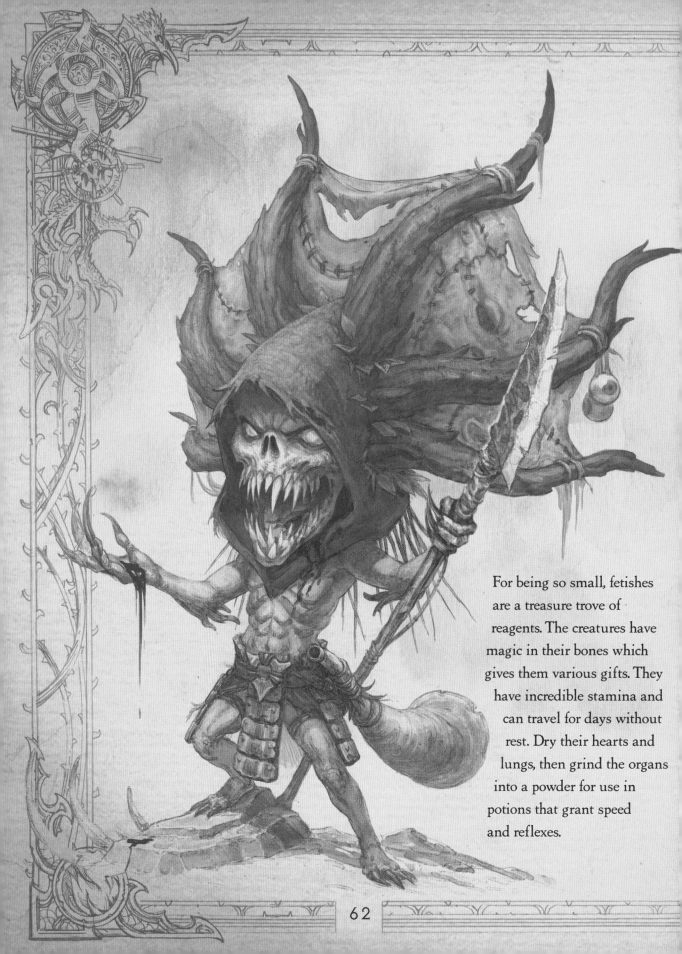

For being so small, fetishes are a treasure trove of reagents. The creatures have magic in their bones which gives them various gifts. They have incredible stamina and can travel for days without rest. Dry their hearts and lungs, then grind the organs into a powder for use in potions that grant speed and reflexes.

Fetish

The people of Kurast tell frightening stories of the tiny, demon-like fetishes that roam the local jungles. If I did not already know they were native to our world, I would think these creatures were born from the deepest pits of the Hells. The fetishes are individually weak but overcome this flaw with group coordination and deadly weapons. They swarm like bees, shooting poisoned darts that paralyze their prey so that they can finish the job with their long knives. The bloodthirsty creatures would make fitting servants for a demon lord.

They are susceptible to the influence of demons. Very susceptible.

Realmwalker

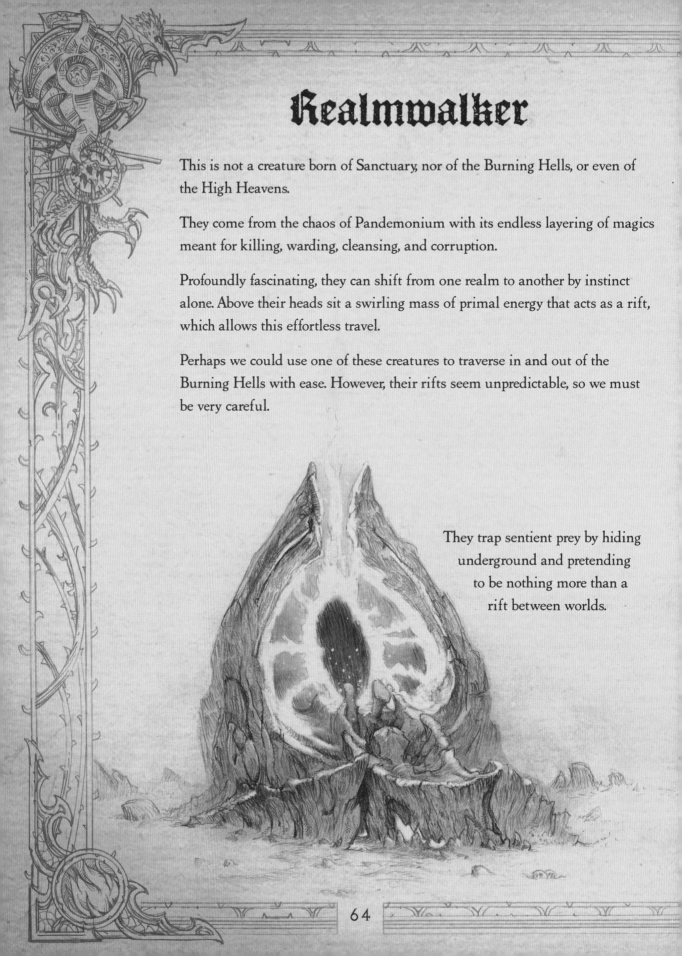

This is not a creature born of Sanctuary, nor of the Burning Hells, or even of the High Heavens.

They come from the chaos of Pandemonium with its endless layering of magics meant for killing, warding, cleansing, and corruption.

Profoundly fascinating, they can shift from one realm to another by instinct alone. Above their heads sit a swirling mass of primal energy that acts as a rift, which allows this effortless travel.

Perhaps we could use one of these creatures to traverse in and out of the Burning Hells with ease. However, their rifts seem unpredictable, so we must be very careful.

They trap sentient prey by hiding underground and pretending to be nothing more than a rift between worlds.

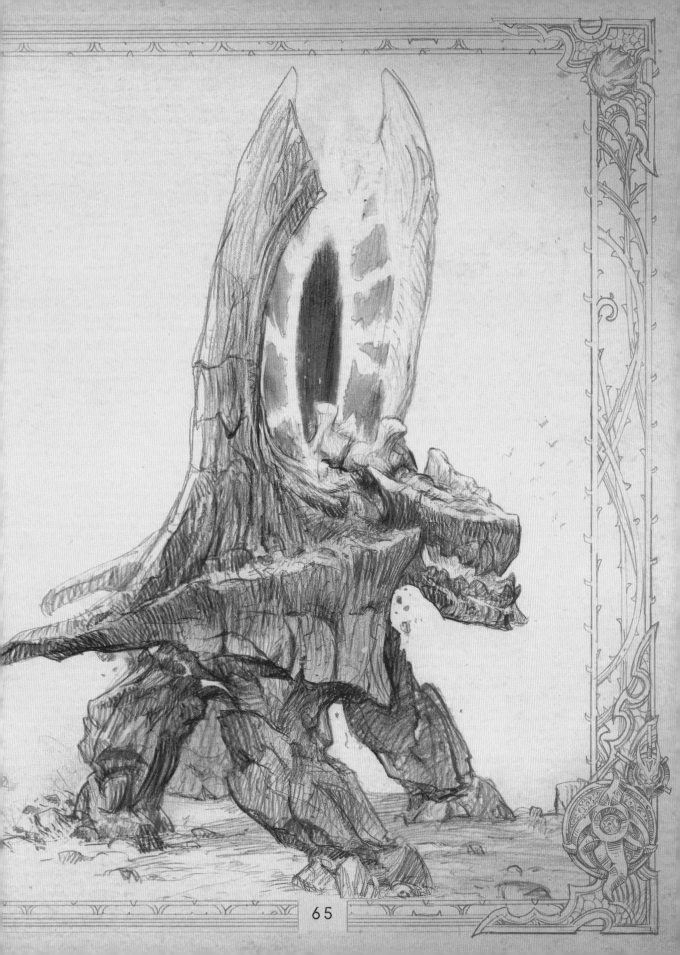

65

Scouring Charger

The scouring chargers are attuned to the latent magics of Pandemonium and sustain themselves by feeding off these energies, or the relics discarded by demons and angels. This natural affinity makes these creatures valuable tools for tracking down places of power or harvesting magic.

Follow the creatures from a distance to find areas suffused with energy. Or, kill them and harvest their magic-rich bodies. It makes no difference what method is used. In the end, the results are the same.

The length of a scouring charger's spines is a sign of their age, which determines the amount of magic that can be leeched from their bones. Consider that when choosing which of the beasts to target.

Before I learned of the Black Soulstone, I thought perhaps one of these would be strong enough to contain the essences of the Evils. Alas, the beasts could not.

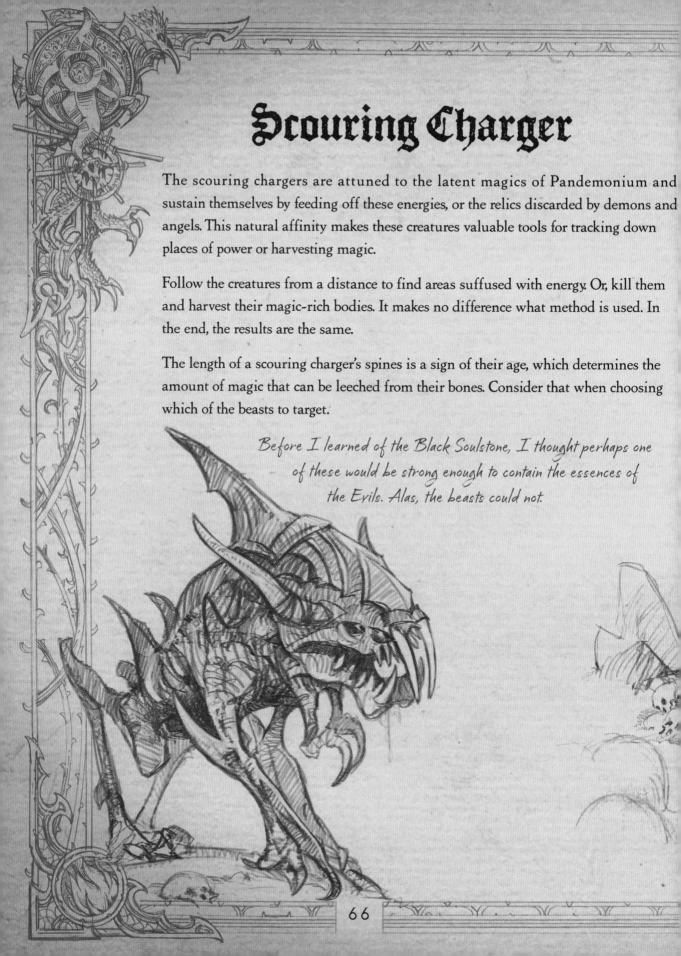

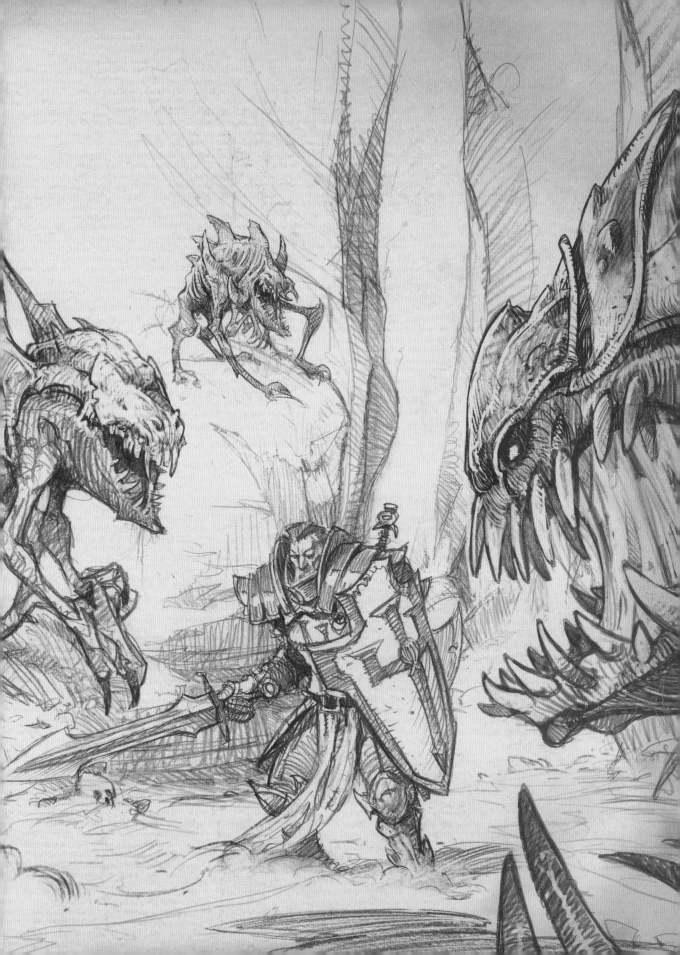

I have traveled many places in search of demon souls to mark. It strikes me how many of these sites I learned about from the old man.

DECKARD CAIN is a wanderer and a scholar, but now he serves simply as the vessel's guardian.

He adopted the girl and is teaching her the ancient histories. He must see her as a student of sorts. Someone to carry on his work after he is gone.

Age is taking its toll on him, but he still has that spark of hope. The same I saw in Tristram when we first met. He was as lonely a man then as he is now. Always lost in his books. Always looking for his purpose by digging through the past.

A man who doesn't know himself is too eager to trust. He will cling to anyone with confidence because he believes they have the answers he needs. It was easy to make Cain believe I came to Tristram to stop Diablo. I shared what I knew of demons, and he offered me stories about the Horadrim, Kulle, and other subjects in return.

We both gained something from our time together. He gave me the knowledge I needed. I gave him a destiny, whether he knew it or not.

He will care for the vessel and keep her safe until I have drawn the Evils into the Black Soulstone.

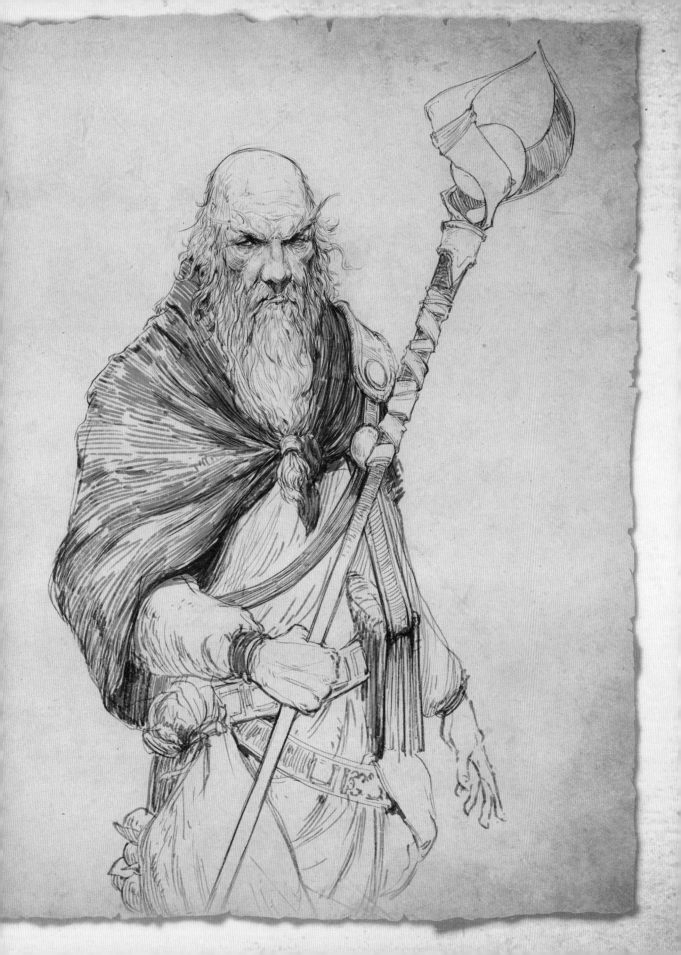

– IV –
The Angels of the High Heavens

It is the angels that I see as the most dangerous to humanity. They hunt and eliminate any source of disorder, and they think themselves brave and honorable for it. Sanctuary has only avoided an invasion from the High Heavens because perhaps—perhaps!—we will not side against them.

This is not an act of compassion. It is a threat. A leash.

If humanity ever forges its own destiny—or finds its fate alongside the Burning Hells—we will all find ourselves burning in "holy" fire.

That is why we must know these creatures, for we will one day face them in battle.

Angiris Council

High in the clouds lies a paradise. A silver city of hope. All the angels that walk its streets are shining paragons of heroism who always know what is right, and always fight in the name of peace and decency. Such are the tales told to children.

A brief glimpse of the Eternal Conflict makes lies of all those stories. Angels and Demons both make war because it is in their nature. Very few on either side have any true insight into their own destinies. They fight because they were born to fight. They corrupt because they are corrupted. They make order out of chaos because they know no other path.

Once I discovered the power and the possibilities of the dark arts, my mind began to despise the creatures of the High Heavens. The darkest part of my heart was reserved for their leaders, the Angiris Council. It was a reflexive hatred, but the more I learn, the more it fades.

Angels are not innately deserving of my hatred. You cannot blame any creature for their nature, only for their choices. Angels are born with the purpose of bringing order to existence. It must be a curse to have such a false, impossible, self-contradicting goal. Only a few in the entire history of the Eternal Conflict—on either side—have ever questioned their purpose, and fewer still have acted upon it.

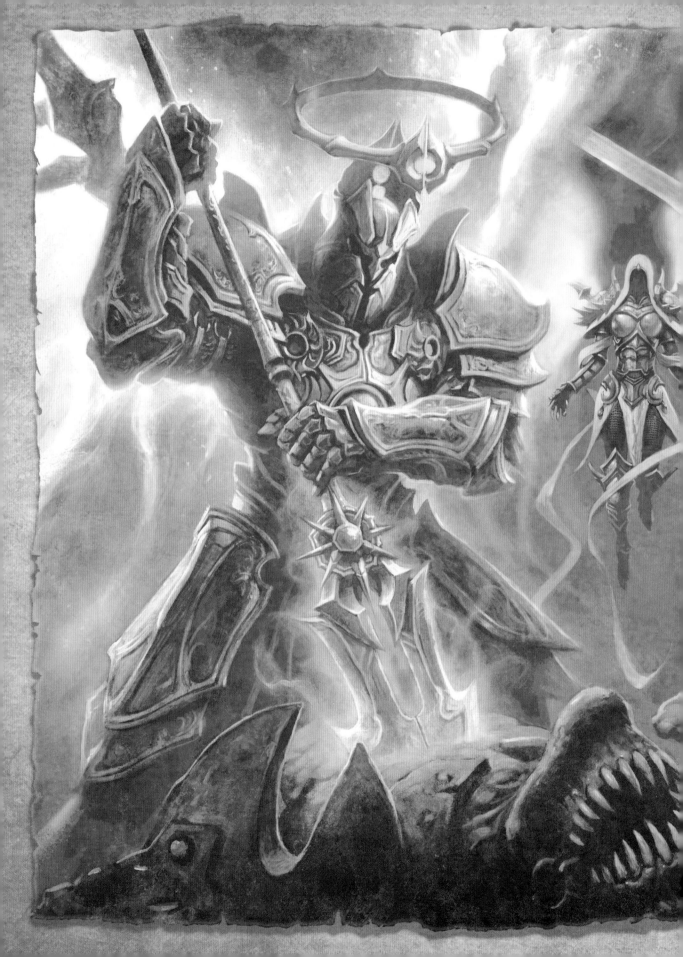

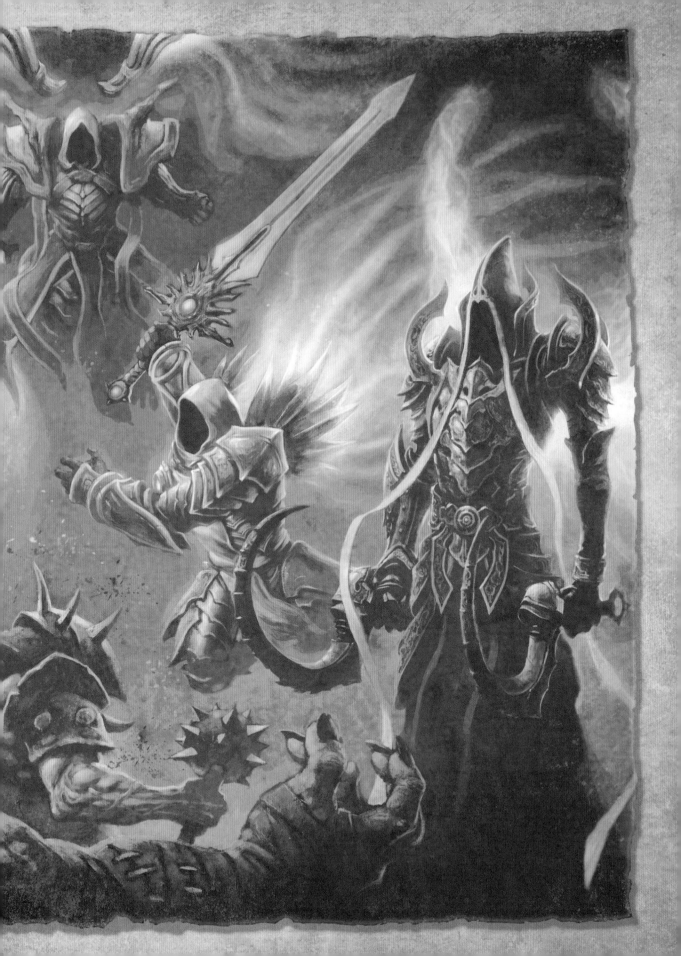

I have seen into their hearts through the eyes of the few demons who have witnessed their acts in the Eternal Conflict. I know them thusly:

Imperius, the Archangel of Valor—A creature that kills indiscriminately with the unshakable belief that his cause is just.

Auriel, the Archangel of Hope—Optimism is a strange luxury for combatants in the Eternal Conflict, and not one that Sanctuary should ever indulge.

Itherael, the Archangel of Fate—This one can see the future of angels and demons, but not of humanity. Little wonder why the Burning Hells prize us so.

Malthael, the Archangel of Wisdom—The one mind on the Council that questions the nature of their existence and the implications of their war. But his answers only lead him to more conflict.

Tyrael, the Archangel of Justice—Be wary of this one. Of all the Angiris Council, only he has directly intervened on Sanctuary. According to Horadrim tomes, he formed their ancient order centuries ago. I've found no sign that he would confront us directly, but he will certainly aid our enemies with information and power.

Fortunately for us, the angelic hosts have agreed to leave Sanctuary to its own fate. For now. Several angels have broken that agreement, but they were forced to do so cautiously and invisibly, or else face judgment from the Council. This is fine, but we must act carefully if we are to walk where angels tread.

As creatures of order, they will oppose us at every opportunity.

The Angiris Council is unraveling, just as the prophecy of the End of Days said.

> "...And, at the End of Days, Wisdom shall be lost
> as Justice falls upon the world of men.
> Valor shall turn to Wrath—
> and all Hope will be swallowed by Despair.
> Death, at last, shall spread its wings over all—
> as Fate lies shattered forever."

I knew it would happen eventually. That the angels are the architects of their own destruction makes it all the sweeter.

It began with Tyrael. He abandoned the laws of the Angiris Council and interfered with humanity. He gathered mortal allies and used them as instruments to hunt Baal, Mephisto, and my master. He nearly succeeded. Nearly.

On Mount Arreat, Tyrael and his mortal pawns confronted Baal as the demon lord infused his power into the Worldstone. Darkness seeped through the crystal, and I felt the faintest touch of Baal's presence stir my soul. In that moment, I realized what the Worldstone truly was—what it could truly do. The stories of how the great crystal had been used to forge our world were not fairy tales. The relic was bound to the spirits of all humankind. By corrupting the Worldstone, Baal would have turned every mortal to evil.

Tyrael acted before it came to that. He destroyed the Worldstone and himself. But, in the end, what good did his sacrifice do? He spared humanity from Baal's touch, but he plunged the world and the High Heavens into uncertainty. Was that supposed to be justice?

MALTHAEL was the next to break from the Angiris Council. The Worldstone's destruction did something to him. He disappeared from the High Heavens. Did he know what Tyrael had done and why? Perhaps he did, and then realized that no matter what the angels did, the demons would eventually find a way to control humanity. Perhaps that was his last, and most profound, gasp of wisdom. He knew that the Angiris Council's quest to preserve order was unattainable, and he abandoned it.

For that, at least, he has my respect. He is not a fool like the other angels, but that makes him unpredictable. Unknowable. Dangerous.

I have seen visions of him in Pandemonium, lost in contemplation. He is searching for something. The calmness that once shrouded him is gone and replaced with a dark new power. It radiates off him, even in my visions. A wave of icy black surging over me, stabbing at my spirit like a thousand needles. Like me, he has taken a path to power. One from which there is no going back.

Without him and Tyrael—without wisdom and justice—what hope does the Angiris Council stand against the Burning Hells?

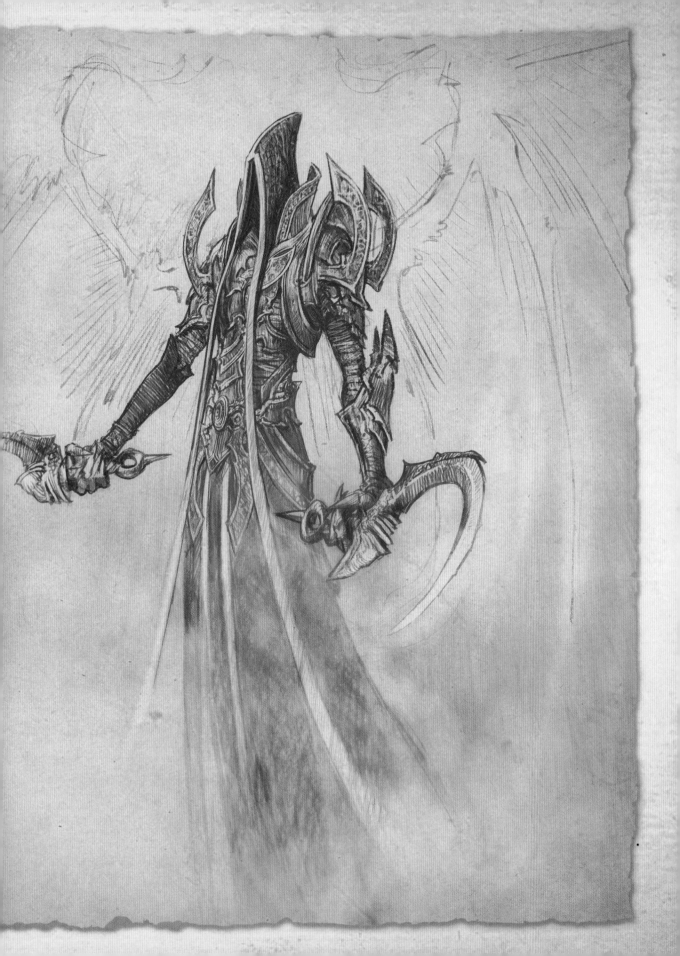

Malthael's servants are looking for him, but those who find the archangel in Pandemonium never return to the Heavens. They cast away wisdom and gather in his shadow.

Many are the angelic **MAIDENS** who tended Malthael's Pools of Wisdom. They once sang refrains that could draw anyone into a deep trance and reveal insights and visions.

Now they are silent. Do they still have the powers they once did? If I could capture their voices, could they show me what I wish to see?

The maidens are not the only angels who have left the Heavens. Malthael's **ANARCHS** are in Pandemonium as well.

They represented the balance Malthael brought to the Angiris Council. Each of their arms stood for one of the Archangels, with the sixth symbolizing the order and harmony that bound them together. Anyone standing near them experienced calm introspection.

Now their ethereal bodies are gone and instead replaced with twisted flesh. A dark aura washes over any creature who gets too close to them. When time permits, I must study them more. Their skin holds potent magic. Perhaps a poison of some kind.

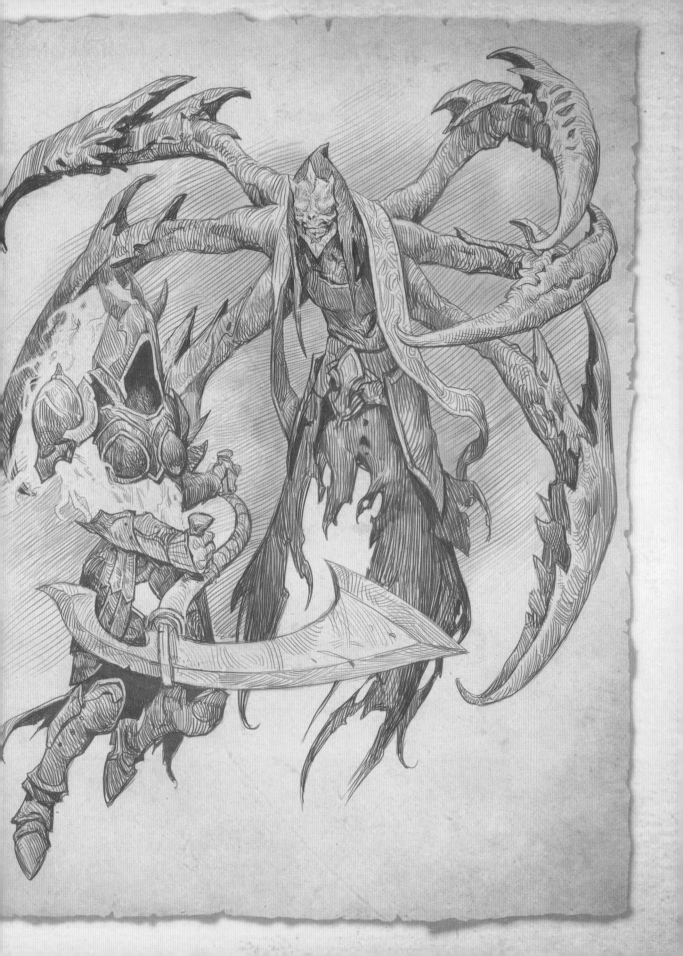

– V –

The Demons of the Burning Hells

The Coven made a pact long ago that each of us is bound to. All must obey the Lord of Terror, the Lord of Destruction, and the Lord of Hatred in every way, even unto death.

So I state clearly, for those who have forgotten: we serve only them. We do not serve all the Burning Hells. We are not bound to the Lesser Evils, nor must we bow before any demon that crosses our path.

We are wondrous creatures. That is why the Burning Hells seek our power. We will one day tip the balance of the Eternal Conflict, and reap rewards beyond that of any other human. We bargained for our destinies. We owe nothing less than our freely given souls.

And if we fail, we deserve our fates.

Only when the Eternal Conflict ends shall our rewards come due. Some of us will be raised to serve at the right hands of the Lords of Hell. Some will be lifted above the Lesser Evils. And some will even rule Sanctuary and the other worlds.

But only those who demonstrate their worthiness will receive such honor. The weak will not be raised above the strong. The confident shall not supplant the capable. We will rise as far as our strength allows us and not an inch further.

Do not whisper about the fairness of this agreement. The minions of the Burning Hells do not deal in "fair." They deal in strength.

Strength comes through cunning and knowledge. Treat the denizens of the Burning Hells as if they were any creature on Sanctuary. Learn how to use their power, else be in their servitude on the final day of the Eternal Conflict.

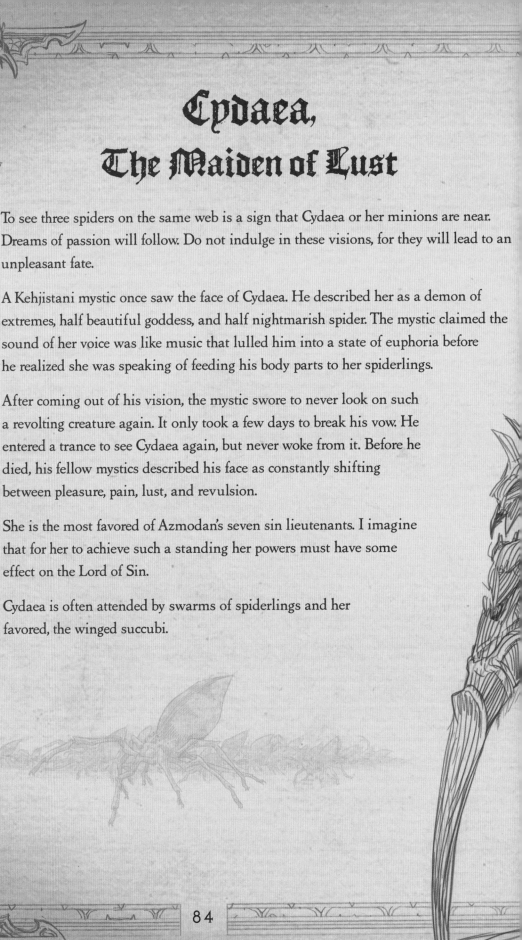

Cydaea,
The Maiden of Lust

To see three spiders on the same web is a sign that Cydaea or her minions are near. Dreams of passion will follow. Do not indulge in these visions, for they will lead to an unpleasant fate.

A Kehjistani mystic once saw the face of Cydaea. He described her as a demon of extremes, half beautiful goddess, and half nightmarish spider. The mystic claimed the sound of her voice was like music that lulled him into a state of euphoria before he realized she was speaking of feeding his body parts to her spiderlings.

After coming out of his vision, the mystic swore to never look on such a revolting creature again. It only took a few days to break his vow. He entered a trance to see Cydaea again, but never woke from it. Before he died, his fellow mystics described his face as constantly shifting between pleasure, pain, lust, and revulsion.

She is the most favored of Azmodan's seven sin lieutenants. I imagine that for her to achieve such a standing her powers must have some effect on the Lord of Sin.

Cydaea is often attended by swarms of spiderlings and her favored, the winged succubi.

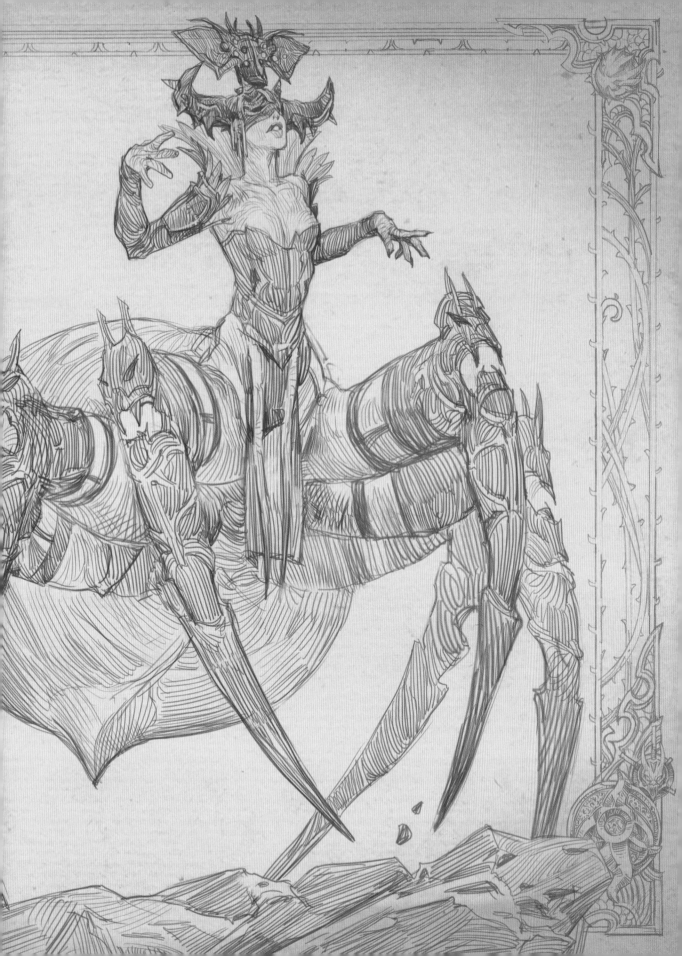

Deceiver

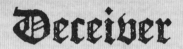

The deceivers could be anyone. A merchant in Lut Gholein. A beggar in the back alleys of Caldeum. A servant in Westmarch's royal court. That is their strength: to shroud their forms and get close to their enemies. Only when they are ready to strike will their illusion fade, and their true, serpentine form appear. This mastery of deception is a gift from Belial, the Lord of Lies, and it makes the deceivers feared even by other demons.

To harness the power of a deceiver's scale, place it on a level surface and mark a circle around it with Ammuit illusion runes. Invoke the name of Belial until the scale shimmers and becomes barely visible. Then bind it in an amulet. This object will shroud whoever wears it in an illusion.

A powerful tool. It has allowed me to go many places unseen. Even the Ammuit mages, the masters of illusion, have difficulties sensing my glamour.

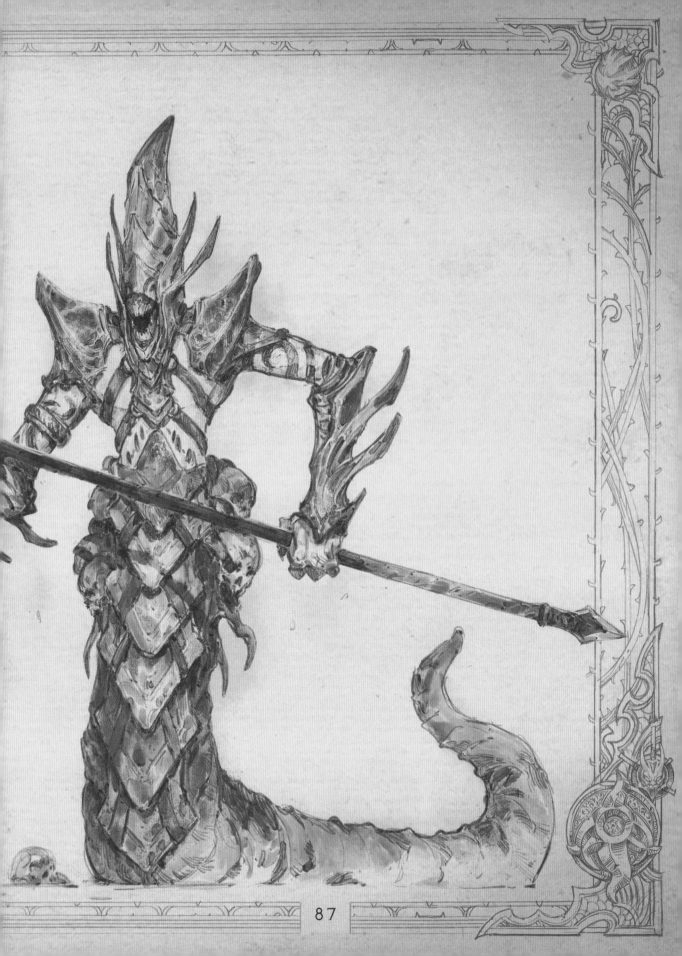

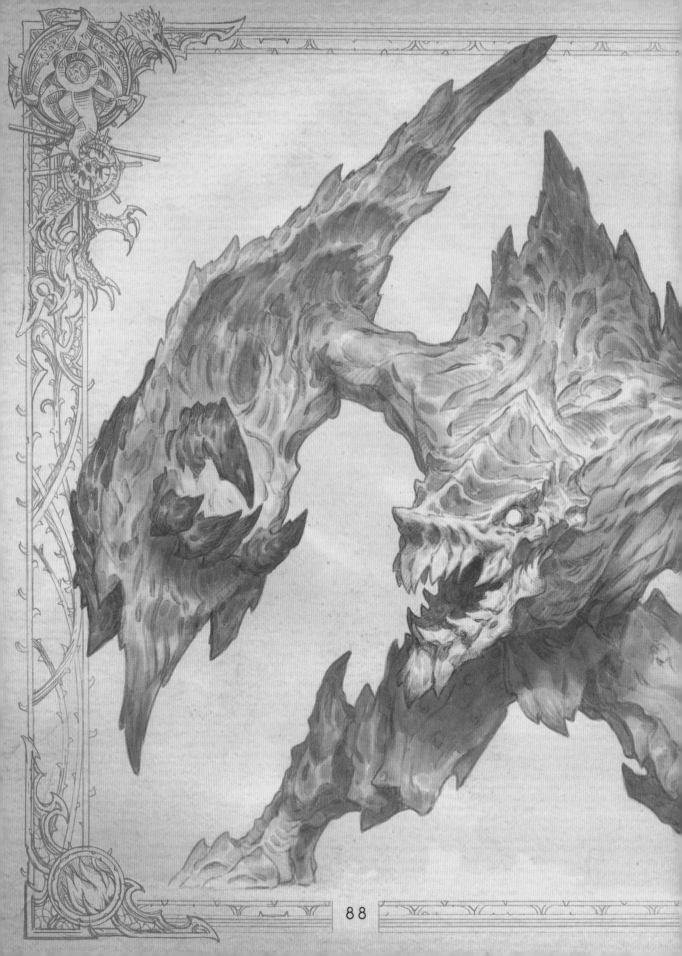

Armored Destroyer

The Vizjerei call these creatures the kalutan, while the Triune simply refer to them as the armored destroyers. I would not call them servants or even soldiers of Diablo. The writings of the Vizjerei portray them more like an infestation. They swarm across the Lord of Terror's realm taking flight on sharp-edged wings or scrabbling up cliffs and into chasms with their hooked claws. As the Vizjerei once learned, they are just as dangerous in the air as they are on the ground.

One of the clan's mages thought the armored destroyers were weak. He thought that since there were many of them it would not be difficult to summon only one to bend to his will. After being brought over, the destroyer broke free from the mage's control and cut him in half with a single swipe of its wing. It took a handful of Vizjerei to finally contain the demon. Not all of them survived.

That was only one destroyer. Imagine what an army of them could do to this world.

I summoned an armored destroyer in order to experiment with marking its spirit. The demon must have sensed we serve the same master, for as it drew near, it lowered its head in obedience.

The Butcher

Accounts from Vizjerei mages tell of the Butcher, a creature constructed from the body parts of other demons. An arm from here. An eye from there. This was done for reasons beyond sadism. The Butcher gained the strength and power of the different demons that were a part of it. This makes the patchwork creatures extremely powerful, but also extremely bloodthirsty.

The Vizjerei wrote that urges to tear, dismember, and consume constantly drove the Butcher to commit new acts of violence. Perhaps that was a product of its unique creation, or perhaps it just enjoyed inflicting pain.

Whether the Butcher still exists or not is a mystery, but stories about it have persisted throughout the years. Even in recent times, I have heard of demonologists trying to make creatures similar to the Butcher.

Blood magic is needed to bind the parts together. It is best to start with a head or a heart. Use stitches made from lacuni hair and wait one day between fusing each of the other body parts together.

Demon Trooper

When the Lords of the Burning Hells finally send their armies to the world, the demon troopers will march in their vanguard.

Called the mazagal by the Triune, these creatures are not clever or wily. That would defeat their purpose. The troopers are blunt instruments who only exist to sacrifice themselves in battle for their masters. The only thing troopers need in order to remain loyal is an outlet for their violent desires. During lulls between battles the Lords of the Burning Hells often pit troopers against one another to satisfy their blood lust.

Prepare summoning rituals for these demons by creating a ring of human bone. Place two blades coated in blood at the eastern and southern ends of the circle. Chant these words during the ritual:

"Sin begets sin as men beget men. Terror begets Hate and Hate begets Destruction. Destruction begets Terror as Terror begets Hate as Hate begets Destruction."

This will placate the summoned demons and make them easier to control.

Fallen

Standing against the Prime Evils never ends well. The twisted fallen know that lesson. At least they would, if they had any of their intelligence left to reflect on it. They were once the great and powerful servants of Azmodan and followed their master into battle against the Prime Evils. They lost, but death was not their fate. That would have been a mercy.

Diablo cursed the fallen and transformed them into small, slow-witted creatures. He let them live as a warning to anyone foolish enough to raise claw or blade against the Prime Evils.

The lunatics are a different breed, their minds are so broken that they have no concept of self-preservation. They produce an explosive bile in their stomachs which can be harvested. But subdue or kill one from a distance first. When threatened, the lunatics will stab their guts and ignite the bile in order to destroy themselves and everything around them.

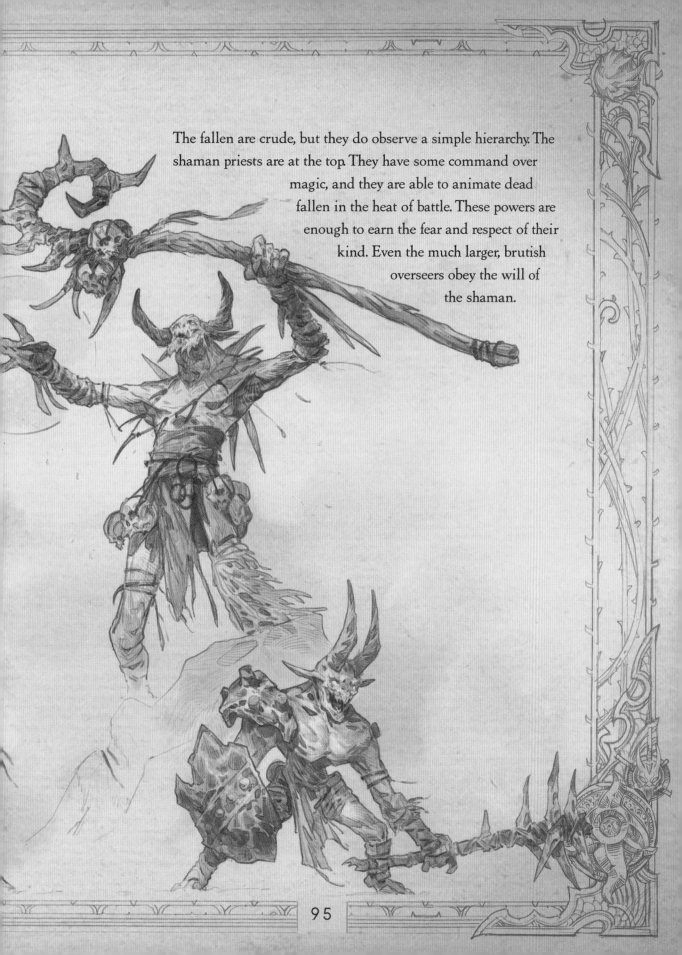

The fallen are crude, but they do observe a simple hierarchy. The shaman priests are at the top. They have some command over magic, and they are able to animate dead fallen in the heat of battle. These powers are enough to earn the fear and respect of their kind. Even the much larger, brutish overseers obey the will of the shaman.

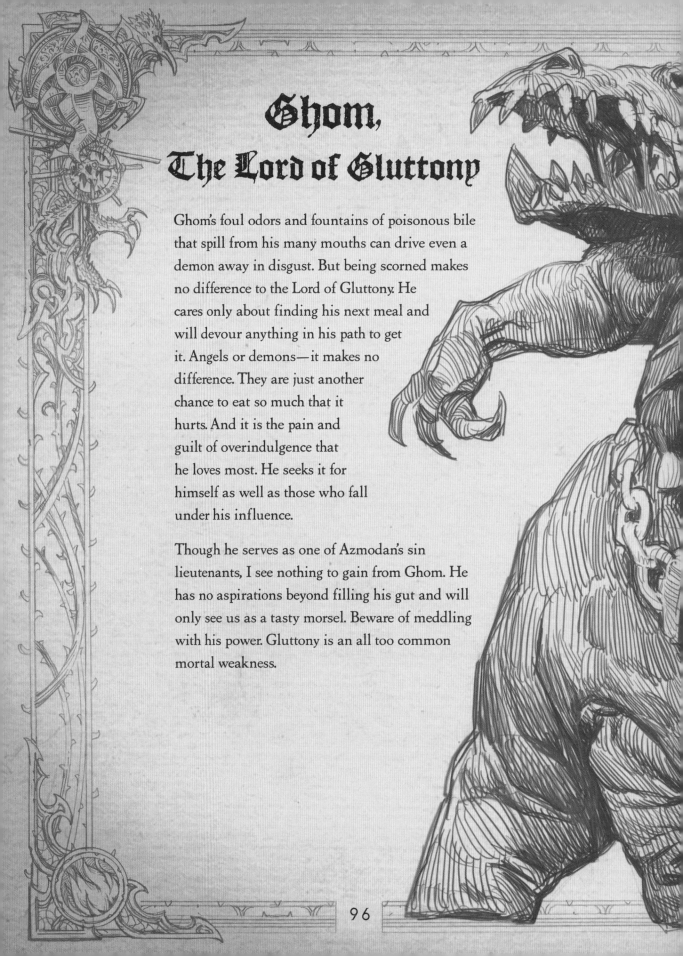

Ghom,
The Lord of Gluttony

Ghom's foul odors and fountains of poisonous bile that spill from his many mouths can drive even a demon away in disgust. But being scorned makes no difference to the Lord of Gluttony. He cares only about finding his next meal and will devour anything in his path to get it. Angels or demons—it makes no difference. They are just another chance to eat so much that it hurts. And it is the pain and guilt of overindulgence that he loves most. He seeks it for himself as well as those who fall under his influence.

Though he serves as one of Azmodan's sin lieutenants, I see nothing to gain from Ghom. He has no aspirations beyond filling his gut and will only see us as a tasty morsel. Beware of meddling with his power. Gluttony is an all too common mortal weakness.

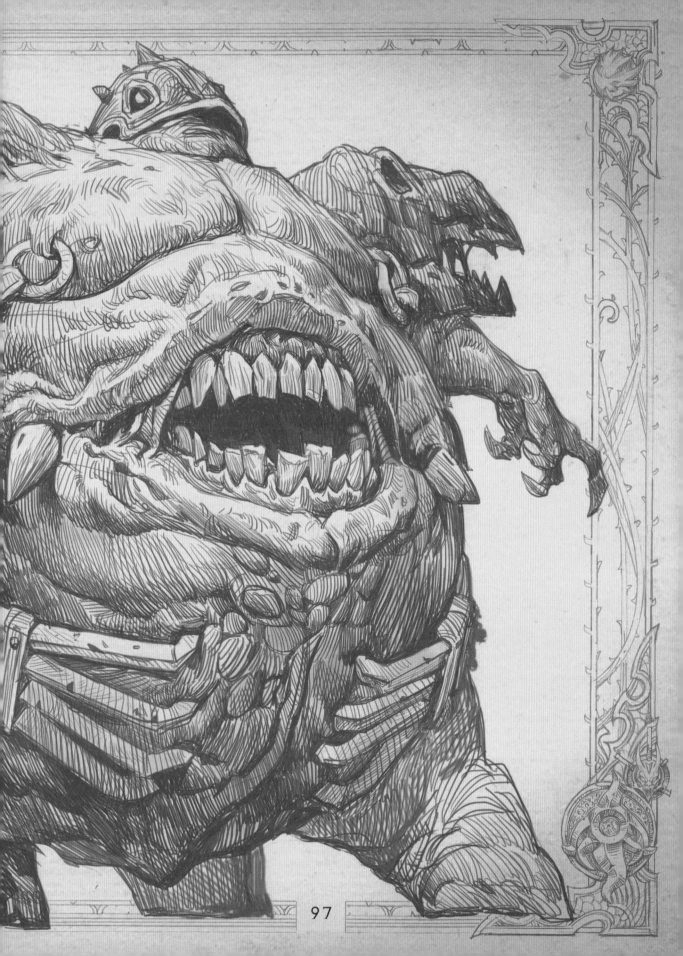

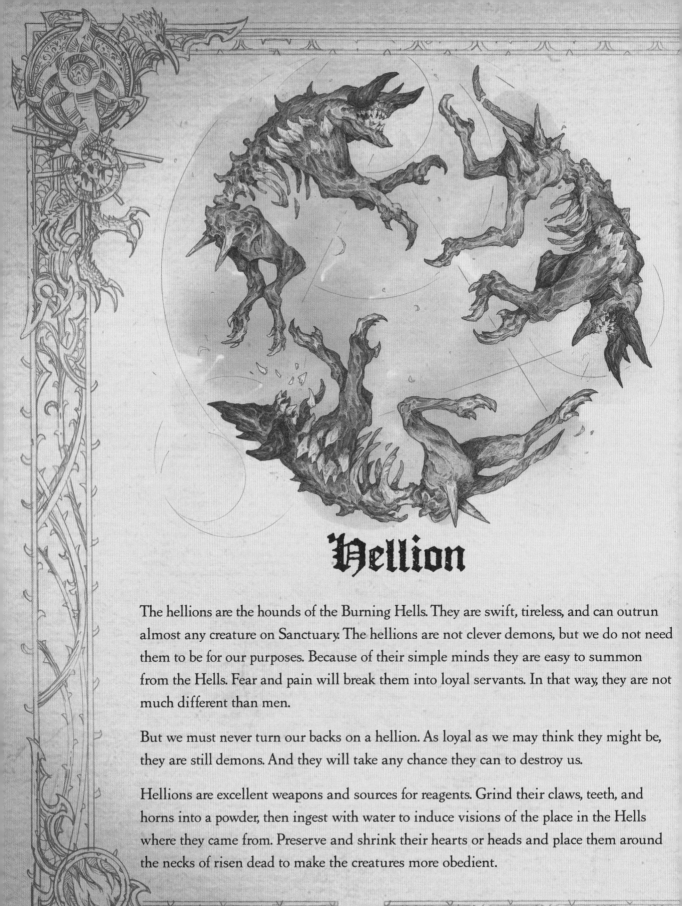

Hellion

The hellions are the hounds of the Burning Hells. They are swift, tireless, and can outrun almost any creature on Sanctuary. The hellions are not clever demons, but we do not need them to be for our purposes. Because of their simple minds they are easy to summon from the Hells. Fear and pain will break them into loyal servants. In that way, they are not much different than men.

But we must never turn our backs on a hellion. As loyal as we may think they might be, they are still demons. And they will take any chance they can to destroy us.

Hellions are excellent weapons and sources for reagents. Grind their claws, teeth, and horns into a powder, then ingest with water to induce visions of the place in the Hells where they came from. Preserve and shrink their hearts or heads and place them around the necks of risen dead to make the creatures more obedient.

Shadow Vermin

I have seen the shadow vermin in my dreams. They rushed in around me in a tide of inky black that reflected no light. Long arms and narrow faces rose from the darkness. They went up around my legs, then over my chest. I screamed in terror as they filled my throat and blinded my eyes, but when I stopped fighting a calm washed over me.

The darkness was pleasant. I felt whole as I floated through it.

These demons are a concentration of Diablo's power. They are the fears of all humankind made manifest. If we fight them, we will succumb to terror. But if we embrace them, we will never know fear again, because we are one with it.

Herald of Pestilence

The heralds of pestilence were not always twisted and plague-ridden. They were turned after launching a failed insurrection against Azmodan. The Lord of Sin punished the demons by changing one of their arms into a long insect-like limb infused with poison. The substance was so strong that it disfigured the heralds and made them into living vessels of plagues and diseases.

As much as the demons hated what had been done to them, they could never take vengeance against Azmodan. The Lord of Sin made himself immune to their poison. That was his real punishment: to give the heralds a weapon so powerful it could kill anything except the one demon they truly wanted to destroy.

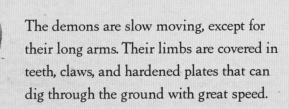

The demons are slow moving, except for their long arms. Their limbs are covered in teeth, claws, and hardened plates that can dig through the ground with great speed.

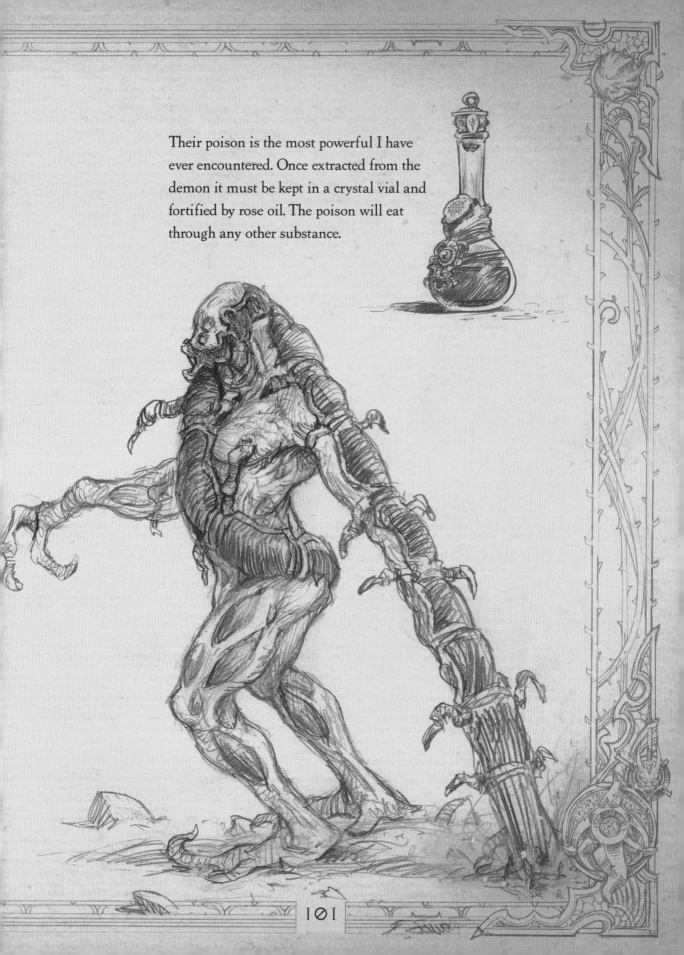

Their poison is the most powerful I have ever encountered. Once extracted from the demon it must be kept in a crystal vial and fortified by rose oil. The poison will eat through any other substance.

Mallet Lord

Long ago, when conflict raged between demons, angels, and humankind in the Sin War, the mallet lords came to our world. The ancient Triune wrote of these giant, four-armed demons with fear and great admiration after seeing their power in battle. One account speaks of a mage who summoned a mallet lord to besiege an enemy fortress. The demon did what it was told, but not before rampaging through the mage's own forces causing him to retreat.

Perhaps that is why none of the seven Evils has ever managed to control the mallet lords. Their strength and brutality, combined with their fierce independence, makes them dangerous even for the rulers of the Hells.

The heavy Hellforged bracers make each of the demon's arms like hammers. Mallet lords can smash through bone, metal, and almost anything else.

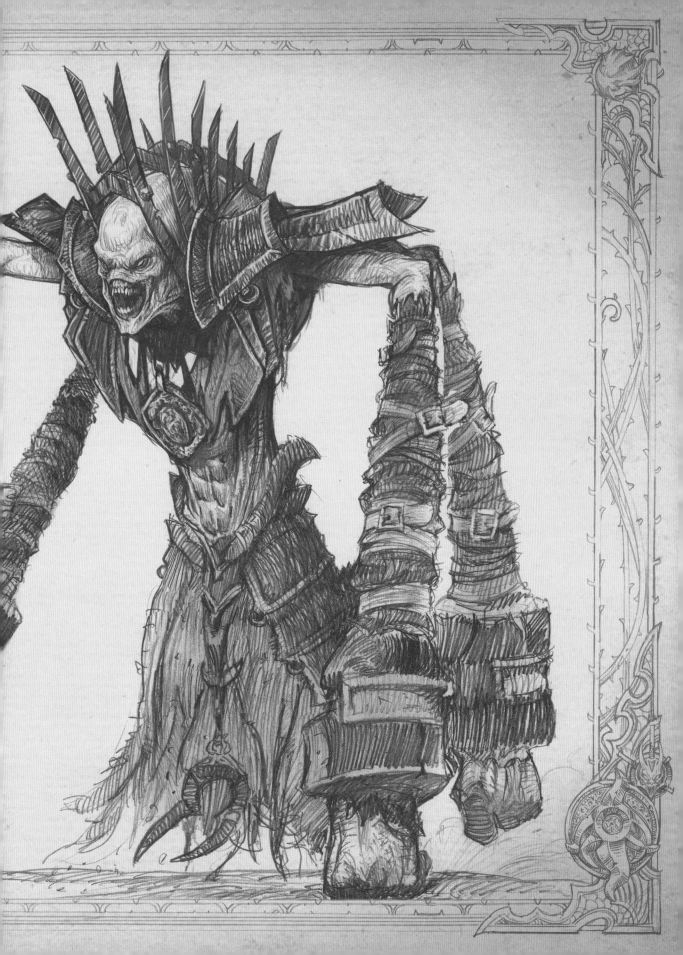

Morlu

History is filled with tales of great warriors who were pure of heart and mind. They are all lies. These so-called heroes were like everyone else. They had weaknesses and fears. They had dark secrets and even darker regrets. These flaws are what Mephisto, Lord of Hatred, used to twist many heroic warriors into bloodthirsty creatures called the morlu.

During the Sin War, the morlu served as tireless weapons in the Triune's military. Not even death could stop them. Morlu who fell in battle were resurrected by the Triune to fight again. These warriors learned from their mistakes in previous battles. Each time they came back to life, they were deadlier and more experienced than before.

I do not know what became of the morlu after the Sin War, but I am certain they found a place in the Hells. They are too valuable a weapon to abandon.

We serve the same master now. Diablo has gifted the morlu with even greater power.

The morlu are incredibly resilient. Stories from the Sin War describe them fighting despite heavy wounds. In one account, a morlu continued hacking through its enemies even after the creature had been decapitated.

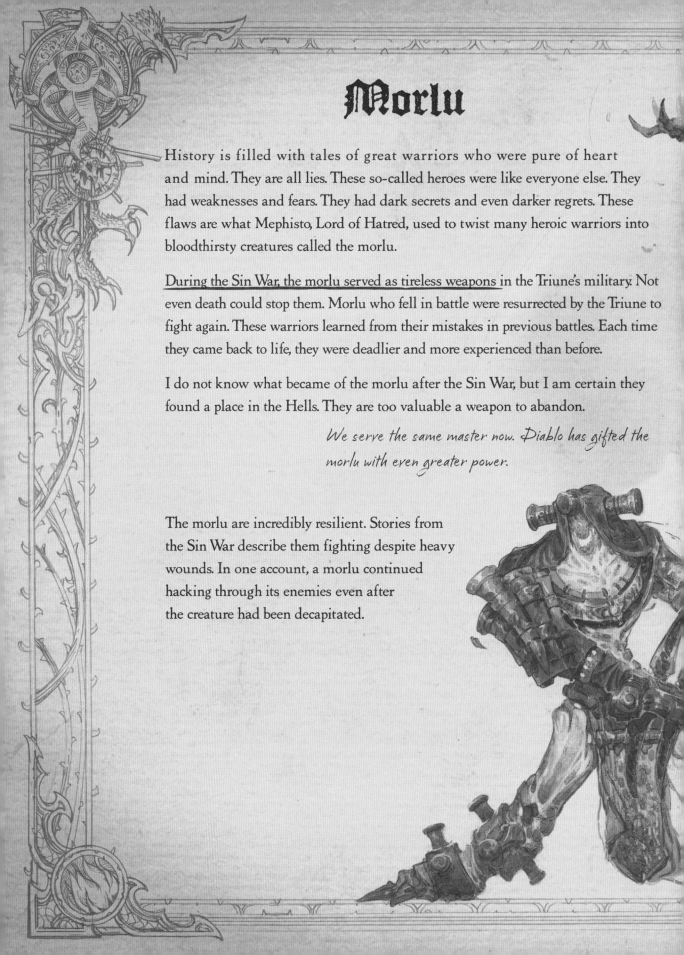

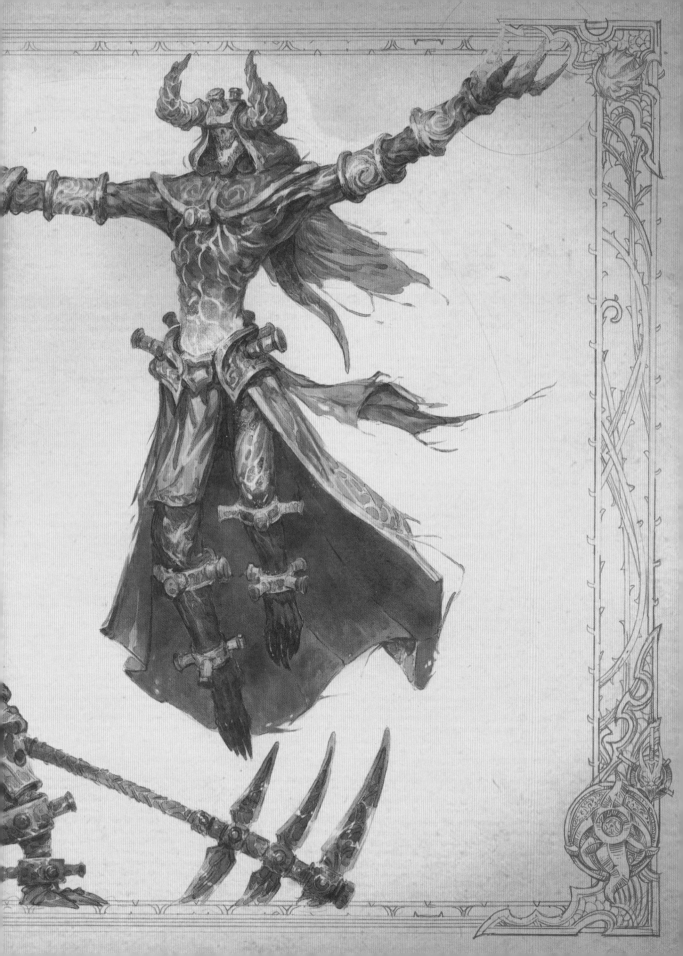

Oppressor

It is said the fire burning inside the oppressors—or "zashari" as they were called by ancient demonologists—is the breath of their creator: Baal, Lord of Destruction. He made them as a smith would forge a weapon, infusing the demons with some of his power and transforming them into killing machines. I cannot argue with the results. Every account of the oppressors describes them as the perfect soldiers. The Hellforged weapons they wield can shatter bones and armor with ease, but the demons can just as easily tear an enemy apart with their hands.

If the stories of their origins are true, it might seem ironic that Baal made these demons, let alone anything at all. But he has been known to create for the purpose of destruction. That is why his realm is home to the Hellforge, where the most powerful weapons are made.

I saw what they could do on Mount Arreat. After Baal was freed from his soulstone, he stormed the mountain with the oppressors at his side. The mightiest barbarian tribes were helpless against them.

But even the oppressors could not save Baal from his fate. He fell to Tyrael and the archangel's mortal companions. Now these demons serve Diablo.

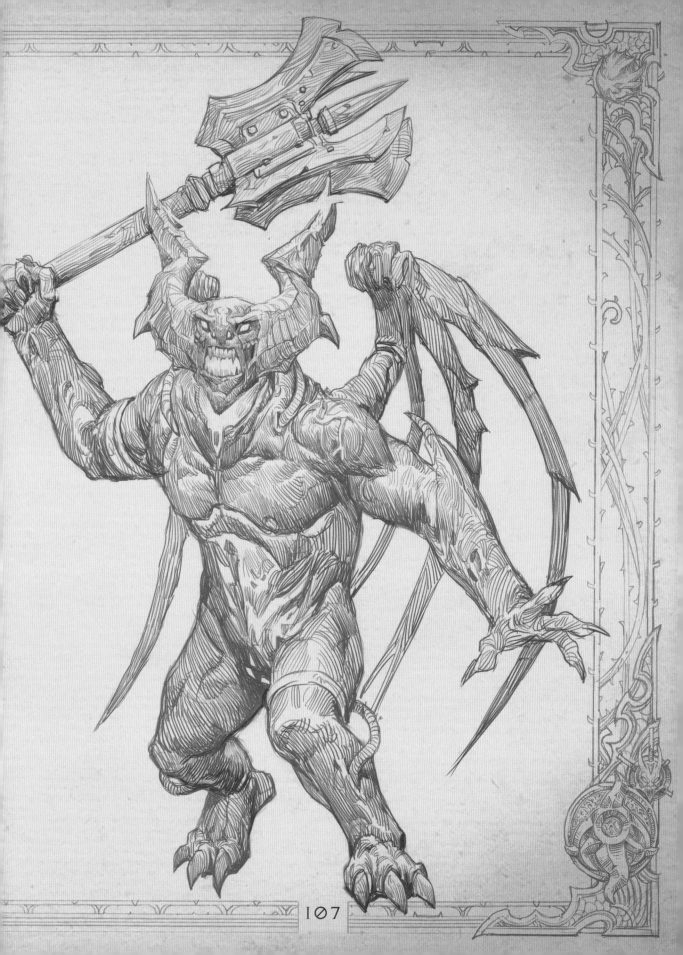

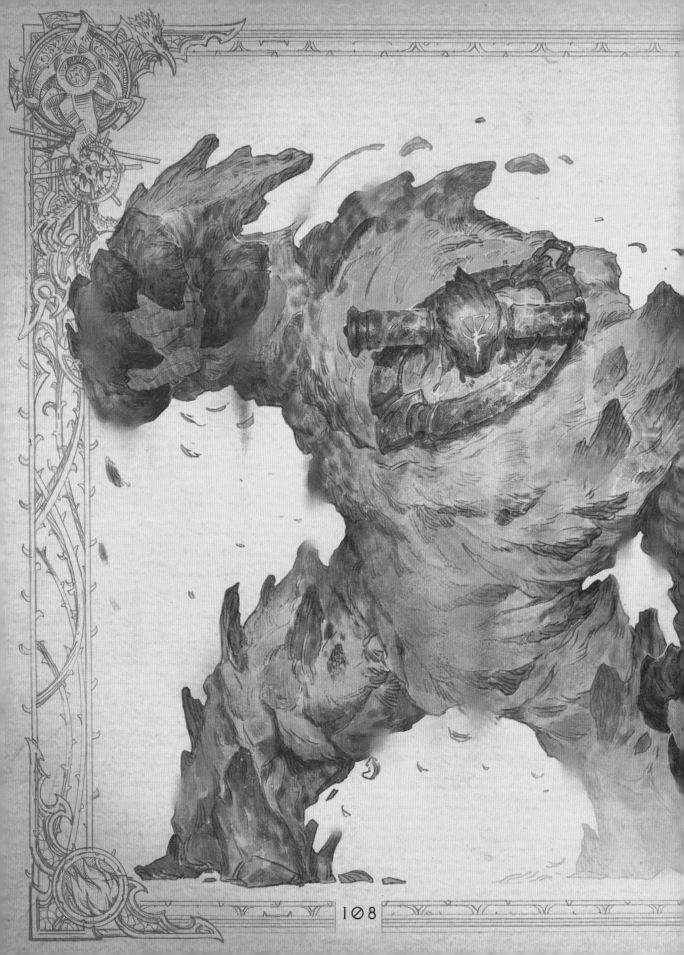

Sand Dweller

The ancient Vizjerei might have been short-sighted and foolish, but they were talented summoners. Many of the demons they brought to our world are still here, including the sand dwellers. The Vizjerei named these creatures the haz'jareen, meaning "branded ones." They marked the sand dwellers with control runes and commanded the demons to guard their vaults and estates. Which the monsters did, even long after their masters died. Time and the elements turned the demons' hides into thick, craggy, stone-like skin but they still wander areas like the Desolate Sands, where the Vizjerei first set them on their eternal watch.

Even after all these years, the control runes branded on the demons remain active. Three people must be present to alter the runes and bring the guardian under control. One must chant the Vizjerei commandments of servitude. Another must write the demon's control rune on human flesh, preferably their own. And last, one person must—while these other activities are underway—strike the guardian's rune with an amethyst wand.

Zoltun Kulle was obsessed with the sand dwellers. He found a way to exert his will over the creatures and commanded them to guard his hidden vaults and libraries beneath the desert.

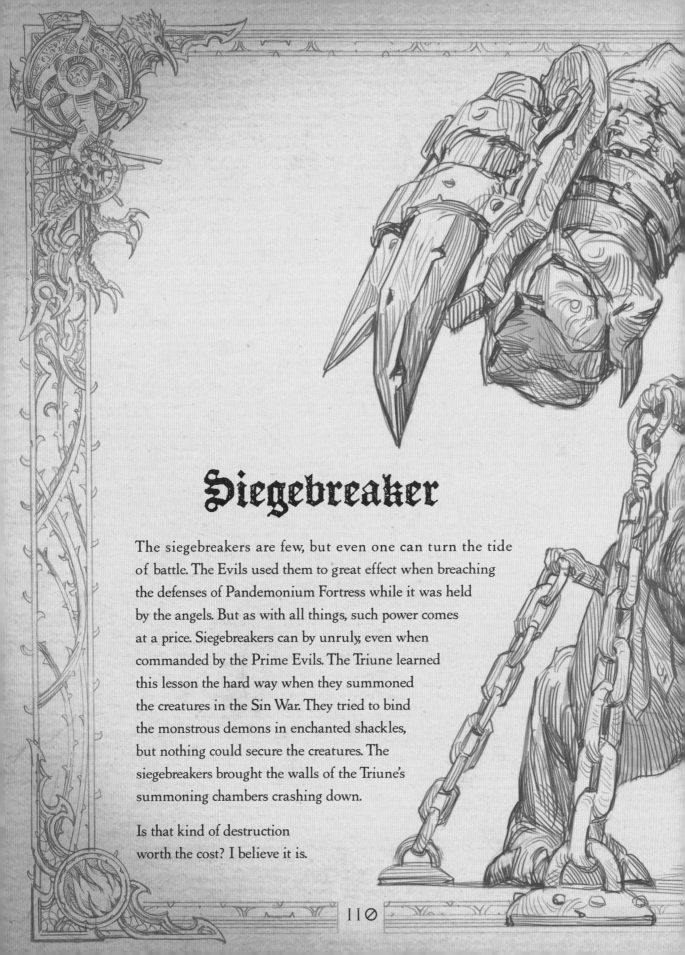

Siegebreaker

The siegebreakers are few, but even one can turn the tide of battle. The Evils used them to great effect when breaching the defenses of Pandemonium Fortress while it was held by the angels. But as with all things, such power comes at a price. Siegebreakers can by unruly, even when commanded by the Prime Evils. The Triune learned this lesson the hard way when they summoned the creatures in the Sin War. They tried to bind the monstrous demons in enchanted shackles, but nothing could secure the creatures. The siegebreakers brought the walls of the Triune's summoning chambers crashing down.

Is that kind of destruction worth the cost? I believe it is.

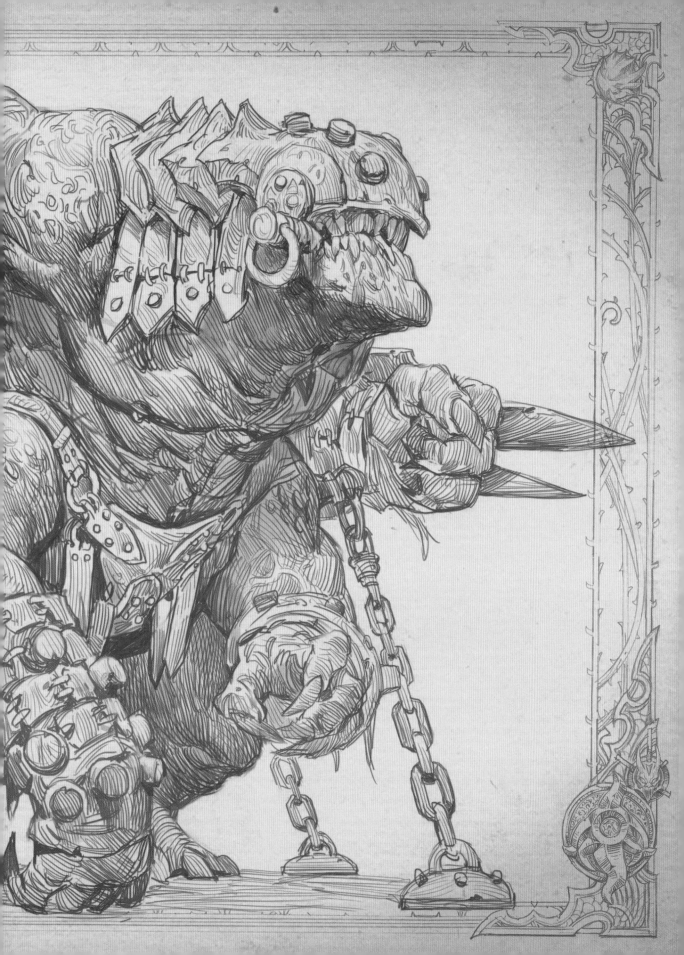

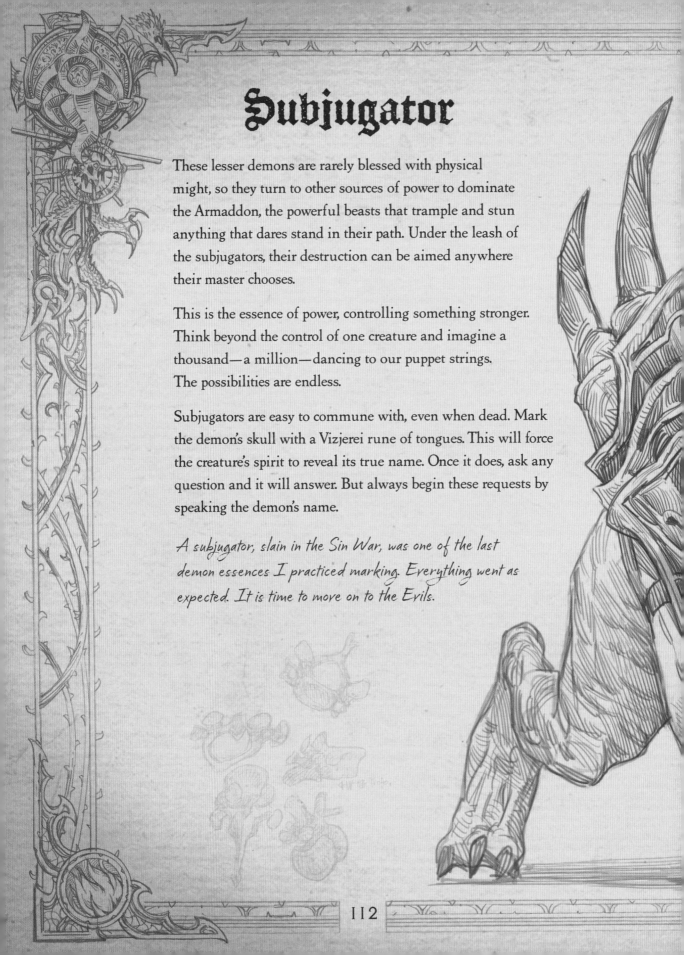

Subjugator

These lesser demons are rarely blessed with physical might, so they turn to other sources of power to dominate the Armaddon, the powerful beasts that trample and stun anything that dares stand in their path. Under the leash of the subjugators, their destruction can be aimed anywhere their master chooses.

This is the essence of power, controlling something stronger. Think beyond the control of one creature and imagine a thousand—a million—dancing to our puppet strings. The possibilities are endless.

Subjugators are easy to commune with, even when dead. Mark the demon's skull with a Vizjerei rune of tongues. This will force the creature's spirit to reveal its true name. Once it does, ask any question and it will answer. But always begin these requests by speaking the demon's name.

A subjugator, slain in the Sin War, was one of the last demon essences I practiced marking. Everything went as expected. It is time to move on to the Evils.

Succubus

There are legends of women dressed in scarlet, dancing through the forests at night or in the dark alleys of city streets. To see them means that the succubi are hunting their next victim.

Azmodan may have perfected their use, but I believe Andariel, the Maiden of Anguish, was the first to sculpt her demons into these beautiful forms. She was quite clever to teach her minions the art of seduction. Temptation is so powerful a force that one might believe it is its own form of magic.

Many succubi will warn their victims about their true heritage before they strike: a glimpse of demonic wings, a hint of sharpened teeth, a flash of a forked tongue—anything that will seem dangerous to the humans of Sanctuary. The men and women rarely flee. Lust may be the succubi's weapon, but it is the thought of tasting something forbidden that truly ensnares their victims. The allure of pleasures beyond mortal flesh is a sweet honey that drowns out the bitterness of caution.

That allure permeates the succubi's flesh. Wearing bits of the demon's wings, teeth, and other body parts as jewelry will make it easy to seduce anyone.

Treasure Goblin

Old stories refer to these creatures as the Drunkard's Faerie because people dumbfounded with drink often see a small creature carrying a bag of gold out of the corner of their eye. Many historians believe they are a race of goblins that are native to our world, but that is not the case. They are demons.

I confess that I once thought these creatures were worth hunting. The moment I saw the gold and jewels they carried upon their backs, I felt the pull of greed. I spent weeks seeking their treasures for my own. That is the trap. These goblins are minions of Greed, a powerful demon lord, who lures selfish and covetous adventurers to their doom in a sea of riches they will never spend.

But it matters little. This demon lord has no ambition beyond her hoard. I say let her wallow in it. We seek another destiny.

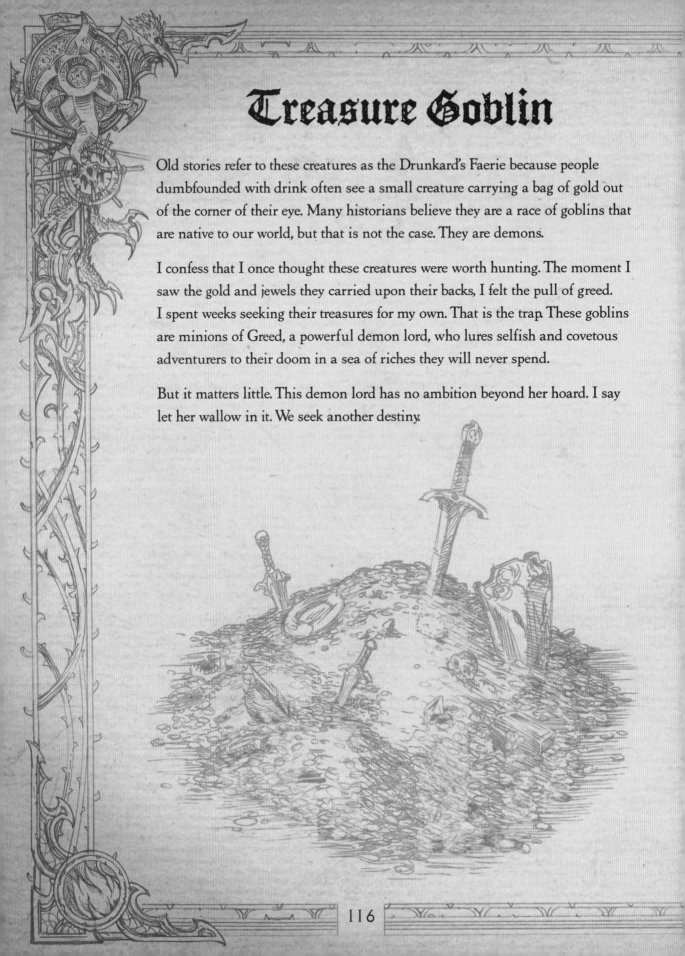

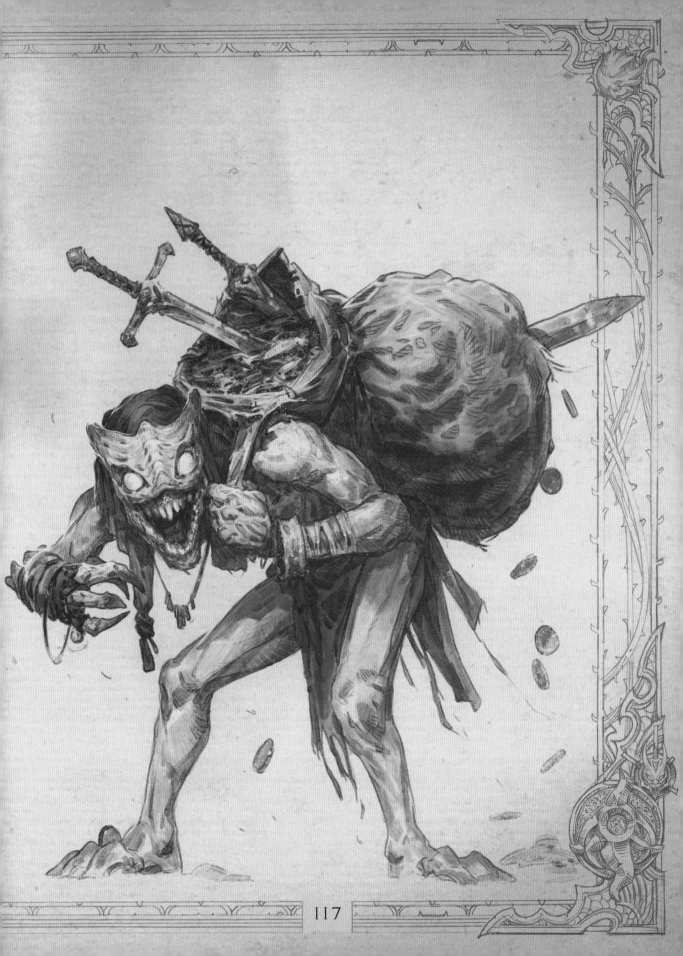

Andariel,
The Maiden of Anguish

Now I write of the seven Lords of the Burning Hells. Beware this knowledge for it is dark and forbidden, even within the Coven.

I know what the scholars say of the demon lords' beginnings. For once, the secret histories of the Vizjerei, the sealed tomes of Ivgorod, and the texts of the old Triune agree: each of the Evils were spawned from the seven heads of Tathamet, the first being to challenge the eternal order of Anu.

I do not care of their ancient origins, only their final purpose.

Andariel is a frightening creature. She desires, more than anything, to inflict horrors that crack open the minds of her victims. Pain is her tool, not her end. Daggers can kill, but anguish lingers on and eats away at the mind, reducing its prey to nothing.

Others within the Coven have attempted to seek her favor, but none have ever been seen again. I once encountered a beautiful maiden who tempted me with promises of power. The whispers in my dreams told me she was lying, so I refused.

Andariel is ambitious, cunning, and dangerous, but she moves in the shadows and latches onto the plans of the other demon lords as she sees fit. My dreams tell me that her fate will not be her own, but one chosen by someone more powerful.

I believe the Coven should never make treaty with her. If we must enter the service of the Burning Hells, we must do so in the service of the one who shall reign supreme.

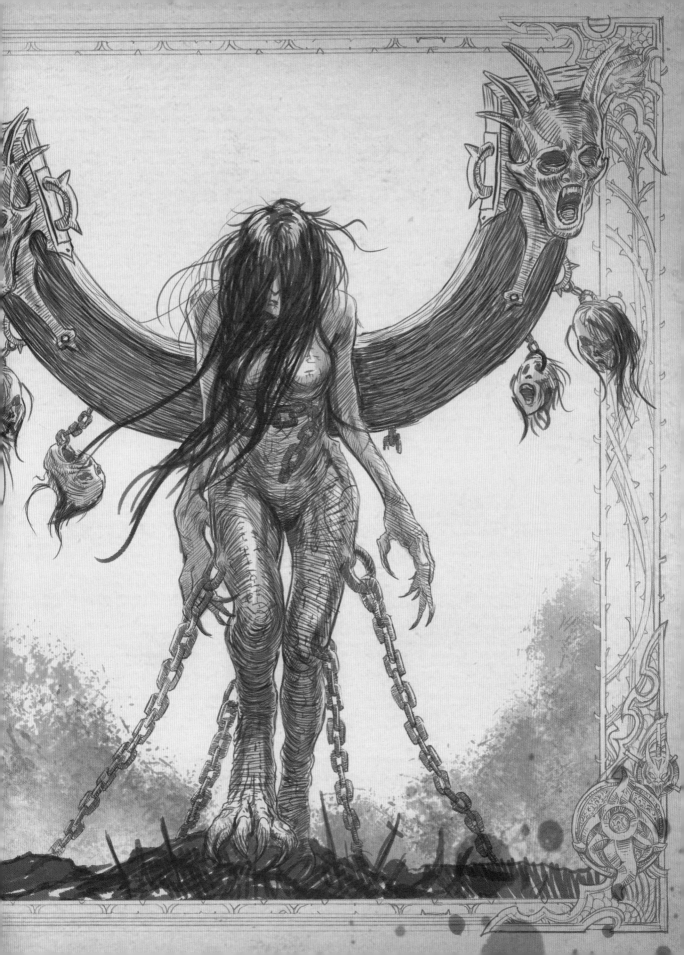

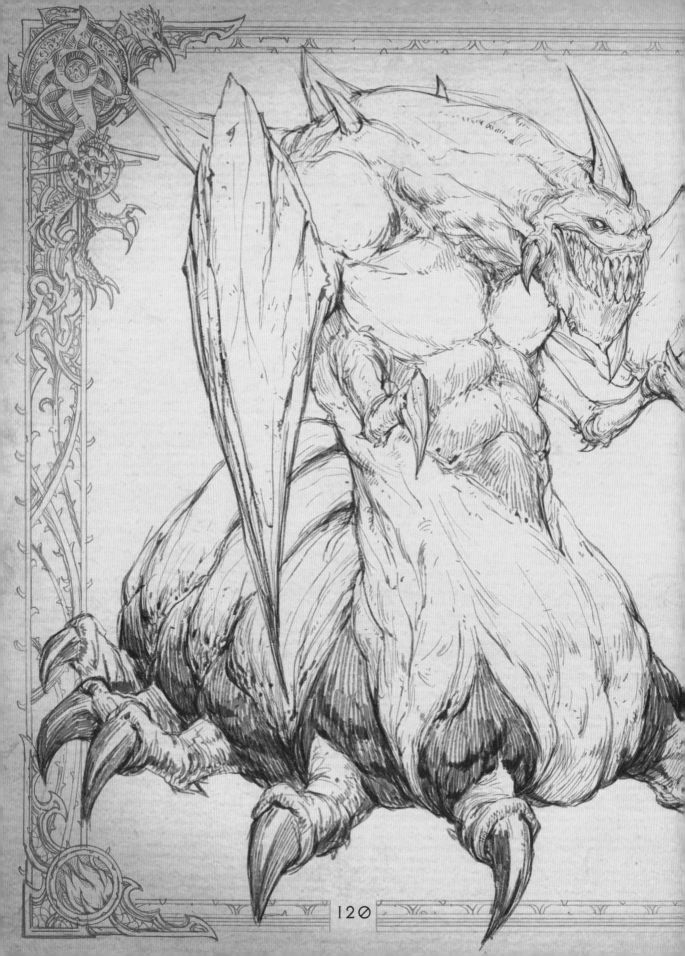

Duriel,
The Lord of Pain

The Lord of Pain is perhaps the simplest of the Great Evils to understand. None in the Coven dream of seeking his power or patronage, not even for the most selfish of reasons. Duriel has no desire or ambition beyond inflicting pain. What could we offer him, save to volunteer our time in his care? Whereas Andariel relishes the anticipation of pain and the fear it creates, Duriel only cares of the existence and propagation of agony.

He is clever, yes. He always seeks new avenues of torment and new victims to flay. This has made him easy to control. The Prime Evils, Belial, and others have enticed him to do their bidding simply by promising him a fresh symphony of screaming to enjoy.

Perhaps we could entice him in the same way. Not by offering servitude, but by offering whole villages and towns up for his sadistic needs.

Communing with Duriel or his minions requires a payment of pain. Only in the throes of agony can these demons be contacted. Self-inflicted wounds caused by whipping or branding are ideal methods for this.

Andariel was the first I marked for the Black Soulstone. The ritual was quick, just as my master promised it would be. I confess, I find it strange that the soul of one of the mightiest creatures in existence could be manipulated with such a simple pattern. Yet, it is comforting. I have been chosen because I am capable of this. The Maiden of Anguish is the first proof of my ultimate victory.

Subduing anguish is like bottling poison. Without the right container, the toxic fluids would eat at the walls and spill out.

For this ritual: Encircle four infinity knots woven from khazra hair with the leaves of any evergreen tree. Each knot should be connected by drippings of human blood.

It went as planned. But I did not expect Andariel to watch me. She looked into my soul as I worked to subdue hers, and for a moment, I witnessed her surprise. She realized my intentions and fought as hard as she could. If she had been fully formed, she would have defeated me.

But she was not.

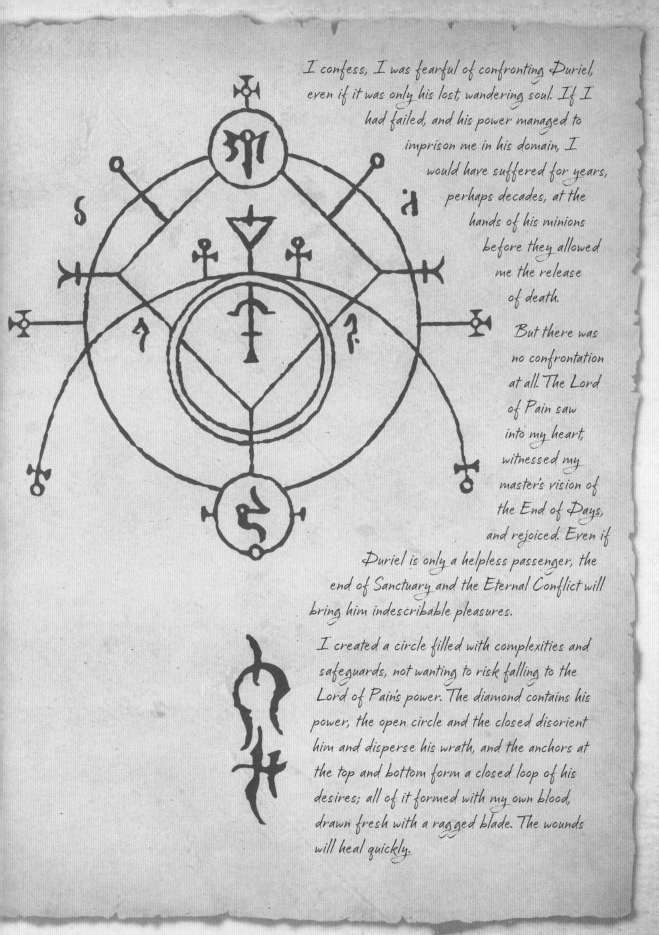

I confess, I was fearful of confronting Duriel, even if it was only his lost, wandering soul. If I had failed, and his power managed to imprison me in his domain, I would have suffered for years, perhaps decades, at the hands of his minions before they allowed me the release of death.

But there was no confrontation at all. The Lord of Pain saw into my heart, witnessed my master's vision of the End of Days, and rejoiced. Even if Duriel is only a helpless passenger, the end of Sanctuary and the Eternal Conflict will bring him indescribable pleasures.

I created a circle filled with complexities and safeguards, not wanting to risk falling to the Lord of Pain's power. The diamond contains his power, the open circle and the closed disorient him and disperse his wrath, and the anchors at the top and bottom form a closed loop of his desires; all of it formed with my own blood, drawn fresh with a ragged blade. The wounds will heal quickly.

Azmodan,
The Lord of Sin

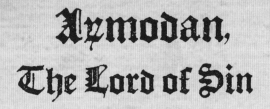

I have learned that many powerful demon lords are trapped here on Sanctuary. In their absence, the Lesser Evils have rushed to fill the void of power and have battled each other for dominance. The Lord of Sin has been the most successful in that war.

Azmodan knows the glory of power and the sweetness of sin. He knows that pleasure is a weapon and ambition is a vulnerability. It is fitting that he is consumed by his own ambition. He chafed when the Prime Evils held sway over him and wants nothing more than to subjugate and control all the realms of Hell.

I believe he could succeed. But I also believe he must not. Sanctuary and humanity mean less than nothing to him. Azmodan's victory would see humanity erased, used for nothing more than fleeting pleasures.

It may be arrogance, but I believe we are more than that.

And I finally found a master that agrees.

If the need arises to
deal with Azmodan, or his
servants, be sure to fast for
at least three days beforehand.
This will clear the mind of all
desire and make it easier to resist
the Lord of Sin's influence.

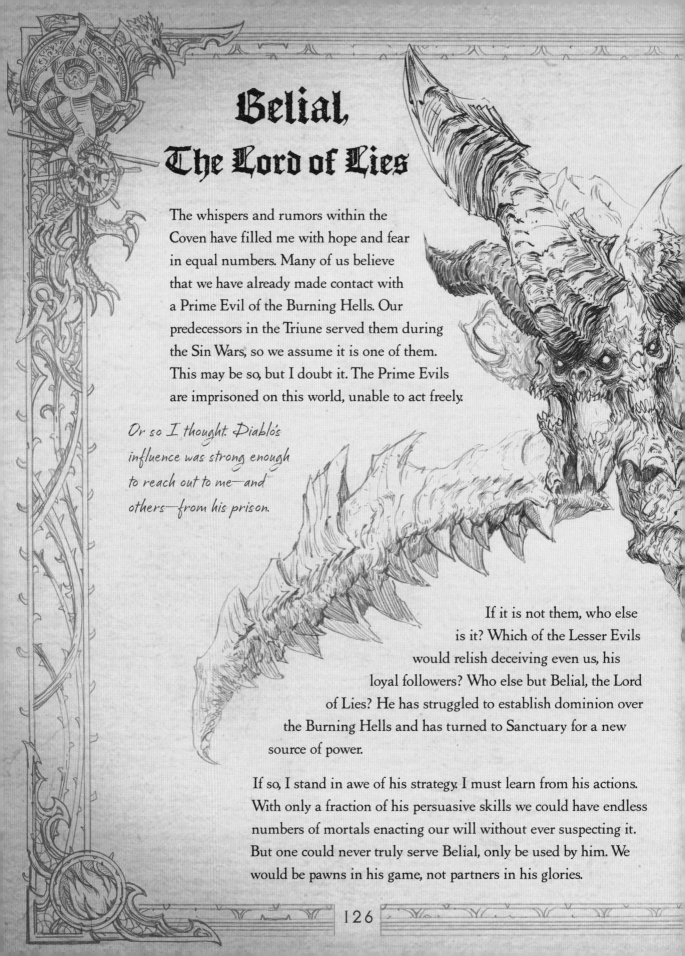

Belial,
The Lord of Lies

The whispers and rumors within the
Coven have filled me with hope and fear
in equal numbers. Many of us believe
that we have already made contact with
a Prime Evil of the Burning Hells. Our
predecessors in the Triune served them during
the Sin Wars, so we assume it is one of them.
This may be so, but I doubt it. The Prime Evils
are imprisoned on this world, unable to act freely.

Or so I thought. Diablo's
influence was strong enough
to reach out to me—and
others—from his prison.

If it is not them, who else
is it? Which of the Lesser Evils
would relish deceiving even us, his
loyal followers? Who else but Belial, the Lord
of Lies? He has struggled to establish dominion over
the Burning Hells and has turned to Sanctuary for a new
source of power.

If so, I stand in awe of his strategy. I must learn from his actions.
With only a fraction of his persuasive skills we could have endless
numbers of mortals enacting our will without ever suspecting it.
But one could never truly serve Belial, only be used by him. We
would be pawns in his game, not partners in his glories.

He has infected the nobility of Caldeum.
He is too well protected to mark alone.

Despite all my efforts, I have not marked Azmodan's soul yet. I believe he has become aware of my master's plan—not because of any mistake, but because he can see the pieces being arranged on the board. He can read the plan from the movements of the pawns.

I doubt he will step foot on Sanctuary while the Black Soulstone exists. I will need help to subdue him in his domain.

I have prepared the ritual. Though it lacks finesse and elegance, it will serve its purpose. But speed will be of the essence. When Azmodan is defeated in the Realm of Sin, his soul will be in a state of shock for a brief time. Those few vulnerable minutes will be my only opportunity, else his soul may enter the process of rebirth too quickly and be lost to me.

I have covertly drawn power from the Black Soulstone itself for this task. The ritual will be complex in its structure but fierce in its effect. I only need to bind the Soul of Sin into a cage with no rounded sides. Then he will be helpless.

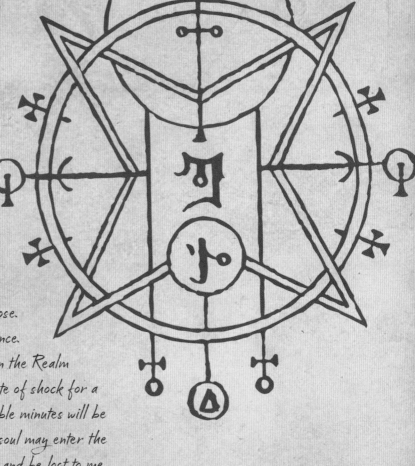

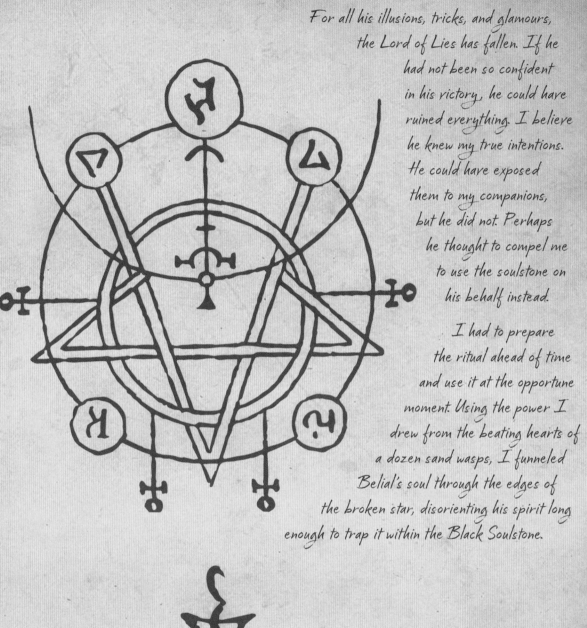

For all his illusions, tricks, and glamours, the Lord of Lies has fallen. If he had not been so confident in his victory, he could have ruined everything. I believe he knew my true intentions. He could have exposed them to my companions, but he did not. Perhaps he thought to compel me to use the soulstone on his behalf instead.

I had to prepare the ritual ahead of time and use it at the opportune moment. Using the power I drew from the beating hearts of a dozen sand wasps, I funneled Belial's soul through the edges of the broken star, disorienting his spirit long enough to trap it within the Black Soulstone.

Baal,
The Lord of Destruction

One of my first tasks in the Coven was to search for the resting place of Baal, known by his true name of Tor'Baalos. Once I learned that he was contained in the body of the Horadrim's old leader, Tal Rasha, it was only a matter of time before I found his tomb deep beneath the Aranoch deserts. It lay amid an array of false caverns and traps meant to ensnare any trespassers. Unfortunately, I could not learn how to enter the final chambers and free him. This angered me for quite some time.

The whispers in my dreams explained that I had done well in failure. Baal was a reckless force of annihilation, and after such a long period of imprisonment he was likely to kill any mortal who stood before him.

I believe that is the truth. Though I have no proof, I believe I have discerned another truth about the Lord of Destruction: it is by his will that the Eternal Conflict shall always rage. Even when he was exiled from the Burning Hells, he sought to corrupt all of Sanctuary. He did not do so because of any insight into humanity's potential, but because it existed and could be made into a weapon against the High Heavens.

What, then, would happen if the Lord of Destruction were victorious? What if he ground the High Heavens into ash? What if he destroyed Sanctuary and every other realm in existence? What would come after he lay the Burning Hells to ruin?

Would he destroy himself? Or would he be clever enough to never let it reach that point? Would he first embrace defeat, death, and rebirth, before risking an end to his cycle of annihilation?

These questions intrigue me. And they drive me ever forward.

Mephisto, The Lord of Hatred

My first vision of the Burning Hells was the Realm of Hatred. It was as if I could feel the touch of Mephisto, or Dul'Mephistos, upon every mote of matter around me, even though the demon lord was not there.

I believe Mephisto is imprisoned in Travincal, beneath the sacred temples of the Zakarum. There is no other explanation for the seething hatred that courses through their ranks. Even imprisoned, the he has incredible power over humanity. Many of the Lords of Hell rely on force to enact their will; Mephisto can turn neighbor against neighbor for reasons that seem right and good. He can spur on conflict until there is only bloodshed that can be directed at his chosen targets.

Hatred even shapes the bonds between Mephisto and his closest followers. There are stories that his daughter, Lilith, rebelled against him and the Hells. She forged a pact with an angel known as Inarius. For what purpose, I do not know, but their forbidden union did not end well. Inarius was imprisoned in Mephisto's realm. Even now he languishes there, subjected to unending torture. Lilith has not been heard from since.

Was it hatred of her father that drove Lilith away? Or of all demons? Hatred is a powerful and simplifying force. The complexities of the world fall away when a heart is gripped by something as strong as hatred. It is a shame that mortals are blinded by its comforts.

Humans accept hatred as naturally as breathing. I am certainly not immune. As Zoltun Kulle claimed, we are all half-demon. If that is true, is there even a single force from the angels that we could wield as easily?

LILITH. Daughter of Hatred. Where is she? Whispers of a forbidden realm. The Abyss. Is she there?

Baal's soul is a restless, powerful entity. He caused so much chaos across Sanctuary after the destruction of the Worldstone that I thought he might succeed where my master failed.

Yet when he fell, his soul eagerly awaited my touch. He wishes to see the End of Days as much as his brother.

The power of destruction is not an easily controlled thing. My ritual did not attempt to do so. The central rune, carved into a human jawbone, amplified Baal's power, but the outer runes anchored it within the circle. I could feel a moment of pure satisfaction racing through his spirit, for the spell made him feel like he had just inhabited a new host body.

He quickly understood the truth, that I was imprisoning him until my master could make use of his spirit, but he did not lash out as I expected. I felt something close to amusement from him. I did not understand, but perhaps it is impossible to understand the ways of the Greater Evils.

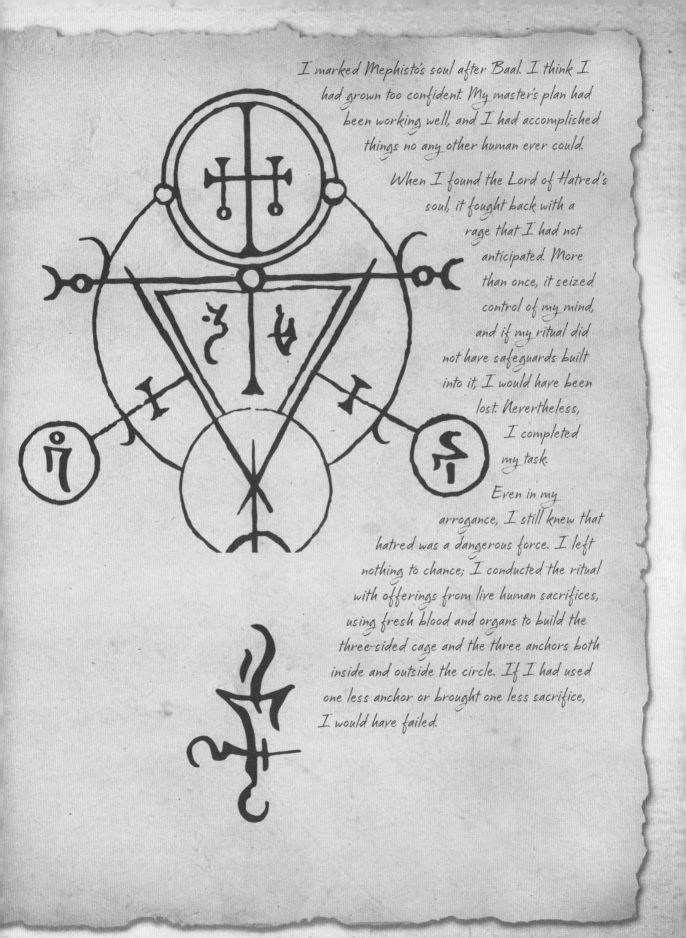

I marked Mephisto's soul after Baal. I think I had grown too confident. My master's plan had been working well, and I had accomplished things no any other human ever could.

When I found the Lord of Hatred's soul, it fought back with a rage that I had not anticipated. More than once, it seized control of my mind, and if my ritual did not have safeguards built into it, I would have been lost. Nevertheless, I completed my task.

Even in my arrogance, I still knew that hatred was a dangerous force. I left nothing to chance; I conducted the ritual with offerings from live human sacrifices, using fresh blood and organs to build the three-sided cage and the three anchors both inside and outside the circle. If I had used one less anchor or brought one less sacrifice, I would have failed.

Diablo,
The Lord of Terror

Diablo, also called Al'Diabolos, has been depicted in many different physical forms. I myself have glimpsed him in dreams, though I do not know if what I saw was his true body or if it was a figment of my own inner fears.

Like his brothers, Mephisto and Baal, Diablo was imprisoned on our world. His spirit was locked in a crystal known as a soulstone. There are many rumors as to its current resting place. I do not know which one is true, but the thought of seeking it out fills me with dread.

My fear is natural. Wise, even. Every hidden history on Sanctuary—and beyond—regards Diablo as the most dangerous of all the Evils of the Burning Hells. His cunning surpasses any of the others, and he can corrupt or destroy at a whim . . . but it is his patience that makes him truly fearsome. Diablo has not once acted upon impulse or anger in all the histories of Sanctuary. He makes his plans, waits for the opportune moment, and strikes only when the time is right. And while he waits, he ponders the possibility of failure and plans for it.

When I first considered joining Diablo, I felt fear. He had not corrupted me, not yet, and I suspect he called me as his proof against failure.

Perhaps it was because he did not stoke my fears. He whispered of the End of Days, but only to pronounce me worthy to serve him in his ultimate victory. He gave me dreams of decay and corruption, but only because he knew I would see them as the natural end to humanity.

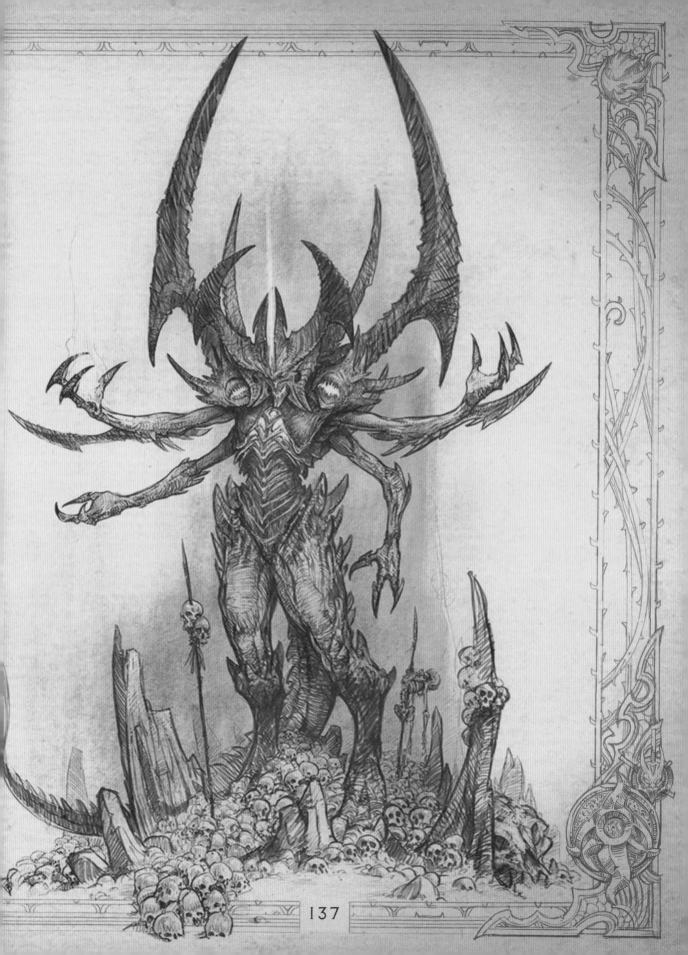

137

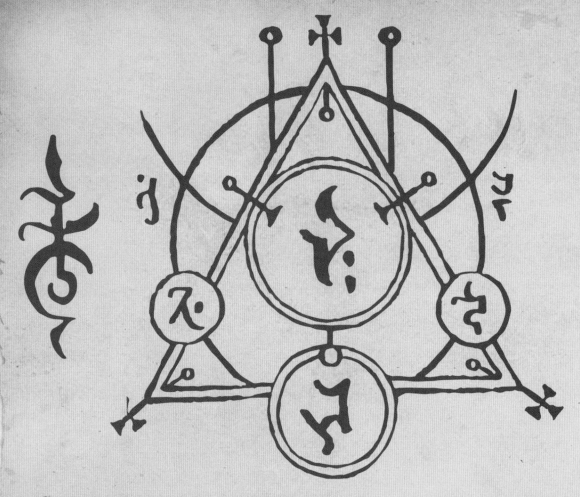

This was the simplest ritual, and the most difficult. The least dangerous, and the most important.

My master, Diablo, did not fight me when I marked his soul. His spirit caressed mine, but he did not resist. His plan is years away from completion, yet he is filled with confidence.

The ritual to mark his soul has nothing to do with containment. Soon, seven mighty souls will be drawn into the Black Soulstone, but only one will be in control. I created a dominant structure, one that bled outside the control of the circle, to ensure that the Lord of Terror's will would be unbound. It should be a simple matter for him to seize control of the soulstone's power.

The ritual, of course, was conducted with my own blood. Seemingly a river of it. The bloodline of the vessel comes from me. Now he has an affinity for it.

The final spell. I need more time to prepare, but have none. It is this or failure.

A purified iron blade should suffice to engrave the symbol on the Black Soulstone and keep the essences contained until the right time.

Duriel and Andariel, bound as one. Belial below them, always hidden in layers . . .

The vessel's body, intertwined with the Evils. In contact with each, but a slave to none . . . save for Diablo.

Three points for the Prime Evils. Diablo at the innermost mark. It will be through his power that all the Evils are contained. Consumed.

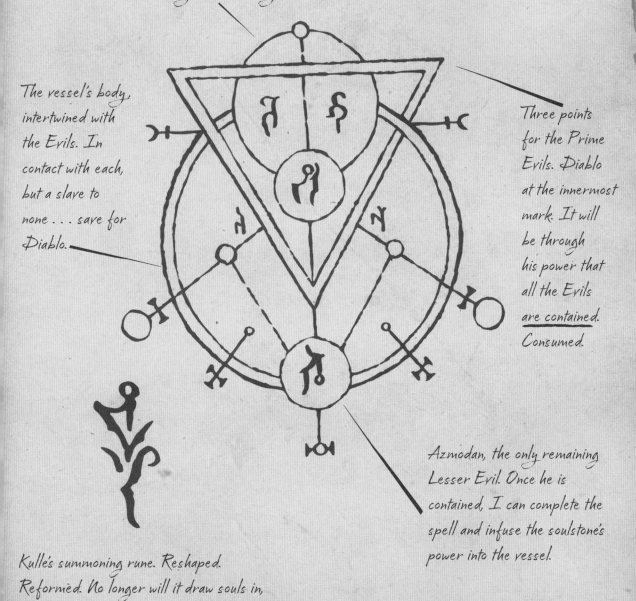

Azmodan, the only remaining Lesser Evil. Once he is contained, I can complete the spell and infuse the soulstone's power into the vessel.

Kulle's summoning rune. Reshaped. Reformed. No longer will it draw souls in, but channel them into something else.

The pieces are in place. The Black Soulstone
holds almost all the raging spirits of the Evils.

I sense the final gate approaching, and the key
is in my care. The vessel. She still sees me as
her mother, but that is not right. She was
born of me, but she is not mine. She is <u>his</u>.

She will become <u>him</u>.

Diablo, reborn.

The Seven made One.

<u>The Prime Evil.</u>

The Lord of the Burning Hells, the broken ruins
of Sanctuary, and the High Heavens.

And it will be my hand
that turns the key.

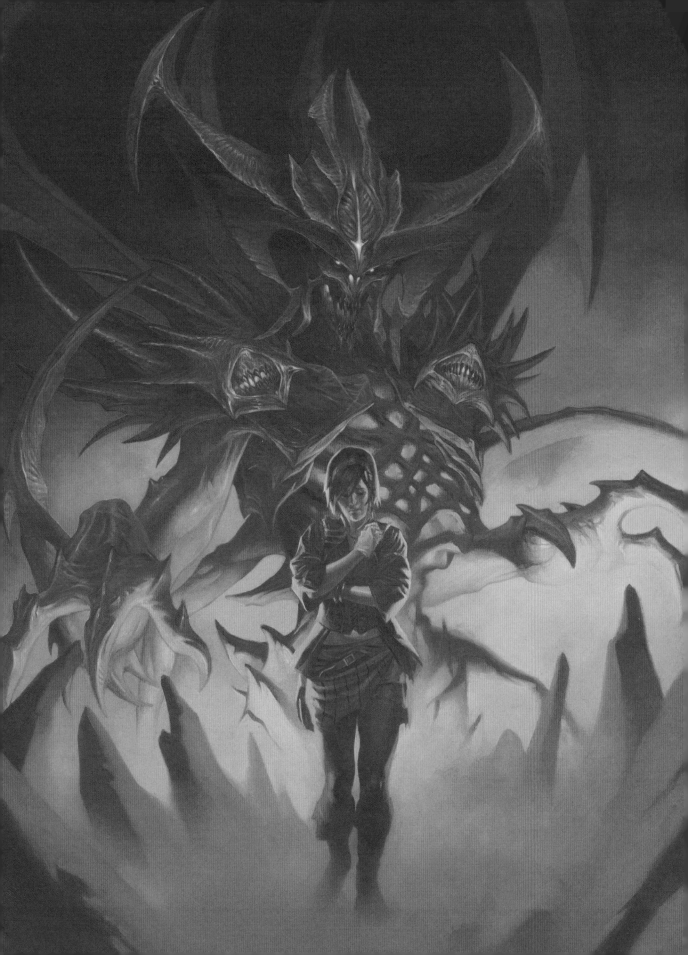

BOOK OF ADRIA

Written by: Robert Brooks and Matt Burns • Illustrated by: Zoltan Boros: 8, 12, 17, 29, 81, 85, 92, 93, 96, 97, 107, 110, 111, 112, 113, 115, 130 • Riccardo Federici: 141 • Mark Gibbons: 4, 6, 40, 41, 60, 72, 76, 142 • Alex Horley: 74, 75 • Bernie Kang: 18 • Roman Kenney: Page Borders, 15, 25, 28, 32, 61, 68, 80, 84, 86, 106, 116 • Joseph Lacroix: Page Borders, 16, 38, 70, 82, 114 • Christian Lichtner: Cover • Jean-Baptiste Monge: 30, 34, 36, 37, 42, 43, 45, 46, 47, 52, 53, 58, 59, 64, 65, 66, 67, 79, 100, 101, 102, 103, 137 • Fernando Pinilla: 10, 122, 123, 128, 129, 131, 134, 135, 136, 138, 139 • Steve Prescott: 48, 49, 50, 51, 54, 55, 56, 57 • John Polidora and Glenn Rane: 2, 3 • Adrian Smith: 133 • Mac Smith 30, 31, 62, 63, 119 • Josh Tallman: 13, 44, 69, 77, 78, 90, 91, 120, 124, 125, 126, 127, 132 • Konstantin Vavilov: 22, 23, 24, 26, 27, 33, 86, 87, 88, 89, 94, 95, 98, 99, 104, 105, 108, 109, 117 • Additional Art: Joseph Lacroix, Roman Kenney, Fernando Pinilla

Edited by: Eric Geron • Design by: Corey Peterschmidt, Jessica Rodriguez • Produced by: Brianne Messina, Amber Thibodeau • Lore Consultation: Ian Landa-Beavers, Justin Parker • Game Team Consultation: Jon Dawson, Rod Fergusson, John Mueller, Rafał Praszczalek, Ashton Sanderson, Joe Shely, Mac Smith

Director, Consumer Products, Publishing: BYRON PARNELL
Associate Publishing Manager: DEREK ROSENBERG
Director, Manufacturing: ANNA WAN
Senior Director, Story & Franchise Development: DAVID SEEHOLZER
Senior Producer, Books: BRIANNE MESSINA
Associate Producer, Books: AMBER THIBODEAU
Editorial Supervisor: CHLOE FRABONI
Senior Editor: ERIC GERON
Book Art & Design Manager: COREY PETERSCHMIDT
Historian Supervisor: SEAN COPELAND
Department Producer, Lore: JAMIE ORTIZ
Associate Producer, Lore: ED FOX
Associate Historians: MADI BUCKINGHAM, COURTNEY CHAVEZ, DAMIEN JAHRSDOERFER, IAN LANDA-BEAVERS

ORIGINAL EDITION:
Chris Gruener, Noah Kay, Iain R. Morris

Matthew Berger, Sean Copeland, Allison Avalon Irons, Christi Kugler, Diandra Lasrado, Victor Lee, Timothy Loughran, Richie Marella, Brianne Messina, Paul Morrissey, John Mueller, Alix Nicholaeff, Bridget O'Neill, Justin Parker, Fernando Pinilla, Charlotte Racioppo, Jason Roberts, Derek Rosenberg, Cara Samuelsen, Ralph Sanchez, David Wohl, Jeffrey Wong

Library of Congress Cataloging-in-Publication Data available.

ISBN: 978-1-956916-40-9

Manufactured in China

Print run 10 9 8 7 6 5 4 3 2

DIABLO®

BOOK OF TYRAEL

Written by Matt Burns

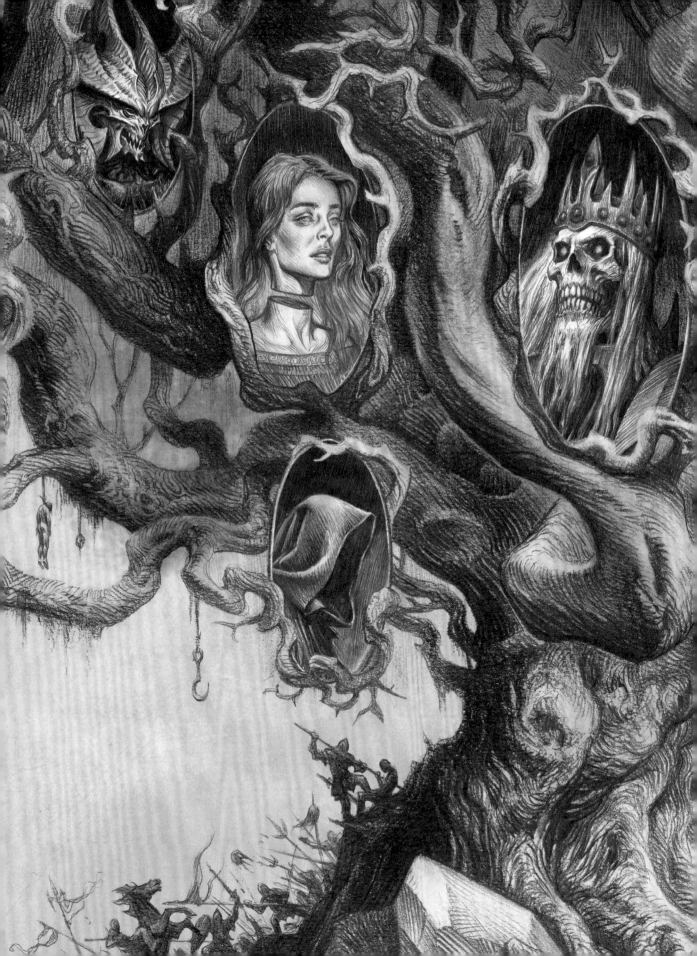

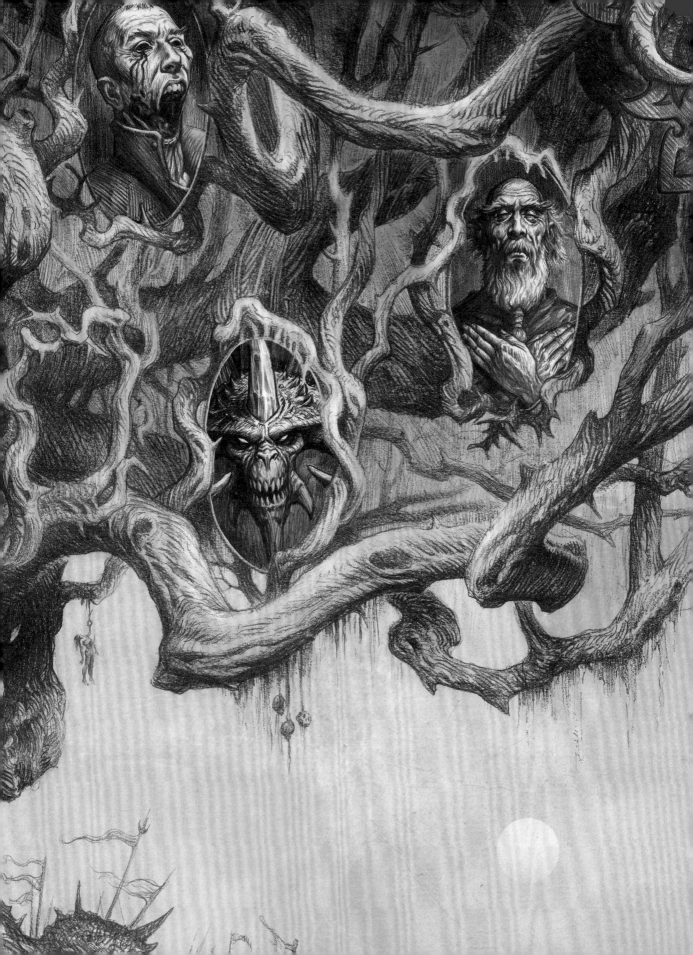

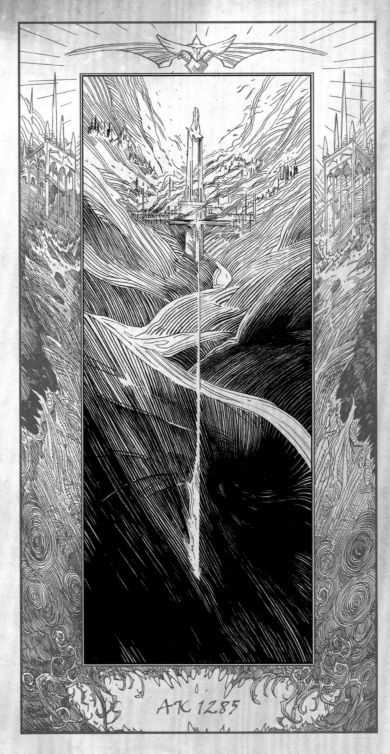

AK 1285

Take heed of the
truths that lie herein,
for they are the living
legacy of the Horadrim.

Introduction

Horadrim, we stand at the turning of a new chapter in mortal history. For thousands of years, mankind existed in the shadow of angels and demons. At best, humans were looked upon with cold indifference. At worst, they were seen as discordant notes in the symphony of creation, or weapons to sway the tide of the Eternal Conflict.

That era is over. Mortals have emerged from a place of inconsequence to become the masters of their own destiny and to stand as equals alongside even angels.

As I think on these auspicious times, I am reminded of the price paid to bring humanity this far. Every mortal alive today is beholden to a legacy of great men and women that spans the breadth of history. The common thread woven between them is that greatest of mortal traits, the fire of inspiration that first opened my eyes to the potential of humans so long ago: their capacity for sacrifice and selflessness.

I speak of Uldyssian ul-Diomed, the awakened nephalem. I speak of Tal Rasha and the first Horadrim; of the elderly scholar Deckard Cain, who carried on their teachings and beliefs. I speak of those brave individuals who vanquished the Prime Evil in the High Heavens, accomplishing a task that the angels themselves were unable to manage.

You know of them. You have read of their deeds and of the hard choices they made in the war to spare the hearts of mankind from evil. There is, however, another person who deserves recognition—someone who I fear that generations to come will misunderstand or even vilify.

Her name was Leah.

She was born to the witch Adria and the Dark Wanderer, a man whose body served as a vessel for Diablo, the Lord of Terror. From the moment of her birth, the demon's essence lurked within Leah, an unseen watcher hidden in the shadowed corners of her soul. When the time came, her own mother betrayed her, allowing Diablo to take hold of the young woman and twist her body into the Prime Evil reborn.

For some of you, this is everything you know of Leah. You may see her story as just another example of mankind's darker half and penchant for corruption.

But when I think of Leah, I do not see the face of evil. I see the niece of Deckard Cain, a kindhearted young woman who was the light of her uncle's life. I see a determined scholar hunched over stacks of ancient tomes, spending every waking hour searching for answers to forestall the coming End of Days. I see a friend, braving the legions of the Burning Hells, her hope an inspiration to everyone who fought by her side.

Leah never asked to take part in this struggle. The calling arrived unbidden, as it often does. Her uncle spent over twenty years of his life searching for a way to avert the End of Days. When death took him, his vast arcana—housed in dozens of books, research scrolls, and other vital items—were passed on to Leah, wrapped in the dying wish of the man who had been the only real family she had ever known:

It falls to you now, dear one, to draw your own conclusions
regarding these apocryphal texts—and to warn the world of the
perils that draw nearer with every passing day.

Those words, and the belief that humanity's future rested squarely on her shoulders, haunted Leah like a specter. She was not a scholar like Cain, nor was she a great mage like the first Horadrim. Nonetheless, she did not take the easy path and turn away from her calling. Instead, she devoted herself to it entirely. No matter how often she doubted herself, or how dark and winding her path became, she never looked back.

And she did all of this with Diablo's essence stirring in her heart.

Tal Rasha once said of mortals, "We cannot always change the future, but we can fight to guide it. In so doing, even if we fail, we will have set a path for others to follow."

I can find no better example of this wisdom than Leah. Even if she had known the truth of her origins—and perhaps near the end, she suspected it—it was beyond her ability to change. It was beyond any of our abilities to change.

So do not judge her based on what she became. Remember her, instead, as I do. See in her the great things that define all mortals: their innate ability to reach for heights unseen, to stand unyielding against an opposing force, to dream. Remember her as a worthy successor to all those whose sacrifices have brought us to this point in history.

I relate this to you because in the coming days, we would do well to find inspiration in Leah's story. Mortals have won many recent victories, but there is much to be done.

I refer you to the Prophecy of the End Days:

> *. . . And, at the End of Days, Wisdom shall be lost*
> *as Justice falls upon the world of men.*
> *Valor shall turn to Wrath—*
> *and all Hope will be swallowed by Despair.*
> *Death, at last, shall spread its wings over all—*
> *as Fate lies shattered forever.*

Not all of these events have come to pass. I fear that hidden within these cryptic lines are clues to what lies in store for us. In order to better prepare you against this ominous future, the tome you now hold in your hands compiles knowledge that will aid in protecting you from a range of dark threats. I elaborate on these subjects— from the betrayer Adria to the Black Soulstone and many more—in the chapters ahead. A great deal of the information contained herein was taken from Cain's writings and Leah's investigation into the End of Days—knowledge that remains vitally important to our cause.

I do not claim these pages contain everything you will need to know in the battles to come. This book is merely a continuation of the research begun by the first Horadrim, carried on by Deckard Cain and, most recently, Leah.

Now, as mankind looks toward its future, this legacy falls to you.

Know that more than ever before, the mortal world is in need of heroes. A time may soon come when you will be asked to make the ultimate sacrifice. If it does, find courage in the memory of Uldyssian, Tal Rasha, Deckard Cain, and Leah. Remember all they overcame, how they seized the brilliant potential that burns in every human heart.

Above all, remember that no matter how much the future may spiral out of control, how dark the days may become, a single mortal has the power to change not only this world, but also the realms beyond.

—Tyrael

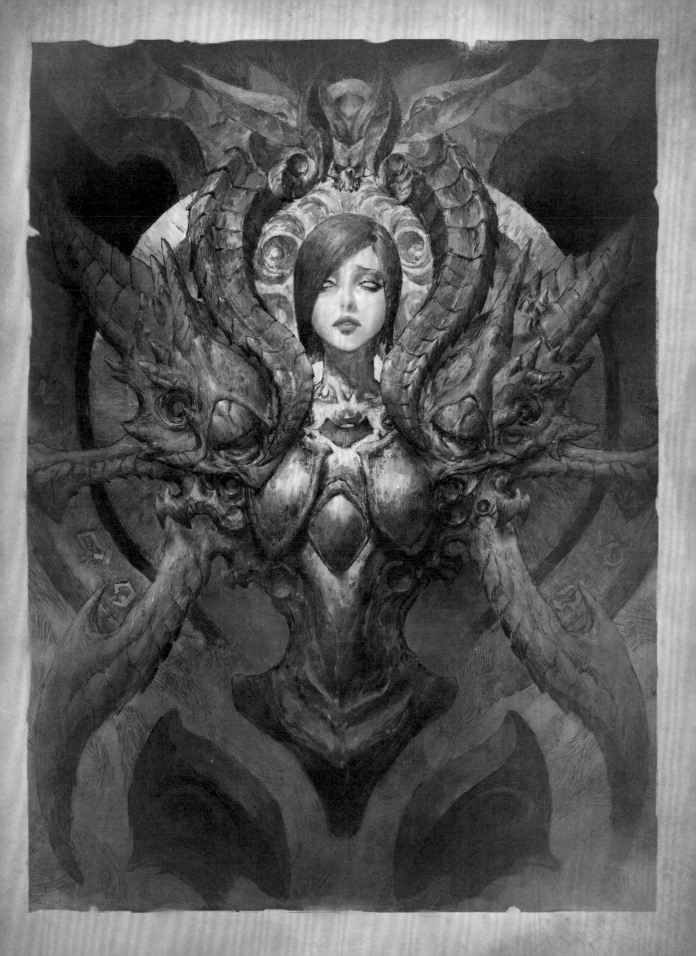

Part One
Adria

The following is a collection of notes I discovered among Leah's possessions in Bastion's Keep. It includes an investigation of her mother's past written by Cain and accompanied by personal journal entries and notes from Leah. I do not know Adria's current whereabouts, but I believe she is still alive. Read the following passages carefully, for they may contain critical information to use against the betrayer should you cross paths with her again.

As I look back on recent events, it's hard to believe how much
has happened. For one, I finally reunited with my mother, Adria.
Together we recovered the Black Soulstone, a relic created by the
renegade Horadrim Zoltun Kulle. Then, just days ago, Belial nearly
destroyed Caldeum. I can still picture the meteors raining from the
sky, shattering the city's great spires and snuffing out so many
innocent lives.

But the thing I remember most is losing Uncle Deckard. I'm
haunted by that day in New Tristram, the feeling of helplessness
as I watched him take his last breath.

Being in Caldeum only makes the memory of it more painful.
My uncle loved this city. Everywhere I look, I'm reminded of the time
we spent here throughout the years, exploring the narrow alleyways,
sifting through piles of dusty scrolls in the Great Library. Now, the
only real connection I have with him is the research he left me.

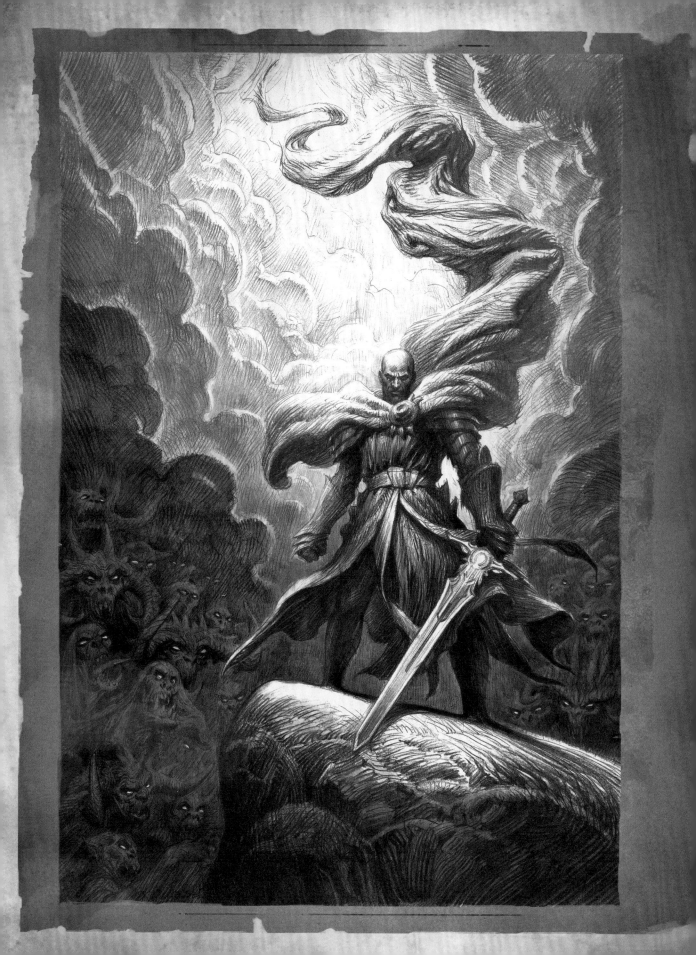

The End of Days. I can't remember how many times Uncle Deckard went on about the Prophecy, muttering the words under his breath. How did he carry on this tedious work for so long? There's no end to the books. It would take a lifetime to get through them all. Just this morning, I found a new journal among his things. I know I should open it, but I'm afraid that if I do, I will only be left with more questions.

I feel as if Tyrael, Adria, and the nephalem are expecting me to make some kind of breakthrough. They believe I have all the answers, but the truth is that I don't know a damned thing. They are the ones with the real power.

I wish Uncle Deckard were here to guide me. I wish I could tell him everything that's happened. Tyrael has regained his memories, and whenever he tells me about the Angiris Council or the High Heavens, all I can think of is how much Uncle would have loved to hear the stories.

Most of all, I just want to hear his voice one last time. I want him to tell me that he's alright. He always said there was something waiting for us after death. A paradise.

I hope you found it, Uncle. I hope it's everything you dreamed it would be.

— Leah

The Witch of Tristram

Leah has been asking about her mother with growing frequency. I expected this would happen when we set out for New Tristram. Even so, it vexes me. This town has a way of dredging up dark memories, most of which are better left forgotten.

On the first day we arrived, Leah sketched a portrait of Adria that filled me with disquiet. Despite having never really met her mother, she created a perfect likeness of the woman. Perhaps being so close to the teetering remains of Adria's hut has awakened something in Leah. I have warned her not to linger around that place, but she does not listen.

Can I blame her for wanting to know more about her mother? Truth be told, I find my thoughts drifting more and more to Adria as well. For some time now I have toyed with the idea of sifting through the mountain of notes I have written about her. At long last, I feel I have enough information to paint an accurate picture. And I suppose there is no better place to do so than here in Tristram, where I met the witch.

So then, what do I know of Adria? She is an enigma I fear I will never understand. At times she has appeared suspect, while at others noble and even caring. What I can say with certainty, however, is that she is a driven and fiercely intelligent person, bristling with a mix of grace, beauty, and raw, frightening power.

I first encountered her during the Darkening of Tristram. She arrived in the town as many others were fleeing. As such, I regarded her with suspicion. Seemingly overnight, she constructed a small hut at the town's edge, where she sold strange arcane artifacts and tomes of knowledge, a great deal of which even I had never seen before.

Eventually I worked up the courage to speak with her. To my delight, I discovered she was well-versed in ancient history. We would often spend hours in the Tavern of the Rising Sun, discussing the great battles of the Mage Clan Wars, the mysteries surrounding the Zakarum faith's origins, and the Sin War. *This doesn't seem to be addressed to anyone in particular. Is it one of Uncle's personal journals?*

In particular, she possessed an interest in the Horadrim and tales related to Zoltun Kulle and the Black Soulstone. *Discussed in the Book of Cain.*

Her curiosity never alarmed me. Quite the contrary, I quickly grew to admire Adria. The two of us believed that knowledge was the most powerful weapon at our disposal. We supplied information to Prince Aidan and his companions, helping them in their battle against the demonic forces that threatened Tristram.

But always I sensed that the witch was searching for some lost truth among those old stories. Unfortunately, I never had a chance to find out what that was. After the Lord of Terror's defeat, Adria vanished from Tristram just as suddenly as she had arrived.

The witch had no reason to stay; Diablo's reign of terror was at an end. Even so, her departure filled me with a deep and overwhelming sense of loss. There was something almost contagious about Adria's ambition and confidence. In a way, it was through her that I began living up to my Horadric lineage, albeit far too late to spare the people of Tristram from the horrors they faced.

I later learned that Adria had taken the barmaid Gillian east to Caldeum, where the witch had then given birth to Leah. Adria, however, had not stayed to care for her child. She had left the city on some mysterious errand, leaving poor Gillian to raise the infant.

As the years passed, I heard rumor that Adria had perished in the Dreadlands, but I knew nothing of the circumstances surrounding her death, nor did I have the inclination to pursue the truth. My investigation into the End of Days consumed my every waking hour. Adria and our time together became a distant memory.

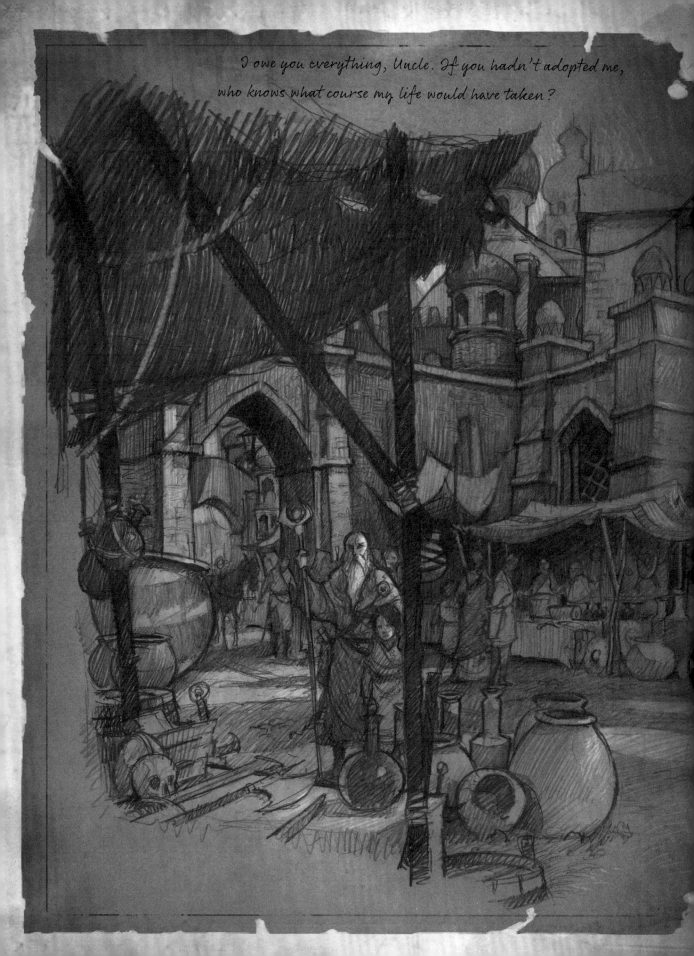

I owe you everything, Uncle. If you hadn't adopted me,
who knows what course my life would have taken?

But fate is a bewildering force, always leading us on inexplicable paths. My life became intertwined with Adria's once again when I visited Leah and Gillian in Caldeum. Madness had sapped the barmaid of her youth and optimism (as it had with many of those who were in the path of the Prime Evils). Not fit to watch over Leah any longer, she was committed to a madhouse in the northern part of the city, and I was left to care for Adria's daughter.

Oh, how my life changed that day. Admittedly, I was wary of the child. She displayed a disturbing affinity to magic even more potent than Adria's. The young girl often awoke in the dead of night, terrified by strange nightmares. Sometimes, it seemed that she would move and act without conscious thought. But I knew that beneath it all she possessed a pure heart, filled with courage and hope.

Leah became my protégé. I dragged her to so many strange and faraway places, hunting clues to the End of Days wherever I could find them. Quite unexpectedly, her presence gave my quest even greater meaning. I redoubled my efforts, knowing there was nothing more important to fight for than Leah and the future she represented.

On a more personal level, she reawakened something within me that I had thought lost forever: the joy and love of having a family. Leah began more and more to remind me of my own child, the son who had died so many years ago. She forced me to face and overcome the mistakes of my past . . . the things I had tried to hide from for far too long. Although I did not deserve it, Leah gave me a second chance at life. She made me a better person. For that, I can never repay her.

But I digress. Leah's presence also rekindled my interest in Adria. It seemed more important than ever to learn about the witch now that I was caring for her daughter. I resolved to look into her past when I had the time to spare. I promised myself that whatever information I learned, I would pass it on to Leah.

All these years later, I have failed to keep that promise.

My investigation of Adria quickly became an obsession, vying in importance with my End of Days research. Even so, I kept all of my discoveries a secret from Leah.

Often I wonder if it was right to do so. Doesn't she, above all others, deserve to know?

Perhaps, but something akin to instinct has kept me from telling her more. As a scholar, I look to facts for guidance. I have never been one to put much faith in my "gut." In this case, however, that is all I have to rely on. I only hope I have made the right choice.

21st day of Ratham

1285 Anno Kehjistani

I can't sleep.

We're setting off for Bastion's Keep tomorrow morning. Azmodan is rallying his legions to besiege the ancient fortress, and I'm anxious about what we'll find when we get there.

But there's another reason I'm still awake. I can't stop thinking about Uncle Deckard's journal. Why didn't he tell me he knew so much about my mother? He always used to say she was dead. Was he lying all that time? Did he think I'd be frightened by the truth?

I guess there's no point getting angry about it now. Knowing Uncle, he probably thought he was protecting me by keeping the truth guarded. His choice, as much as I disagree with it, was born of good intentions.

None of that changes the fact that I'm stuck with this journal, though. In some small way, I feel like I'm betraying Uncle Deckard by continuing to read it. Then again, if he left it among his things, he must've suspected that I would find it one day.

Why am I going on about this? It's strange that with battle looming ahead — with the fate of everything hanging in the balance — I'm letting a single journal bother me.

It's probably best if I just put it aside, maybe leave it here in Caldeum until all this madness is over. The last thing I need right now is something else to worry over.

I'll decide in the morning. It's growing late, and I need to rest.

—Leah

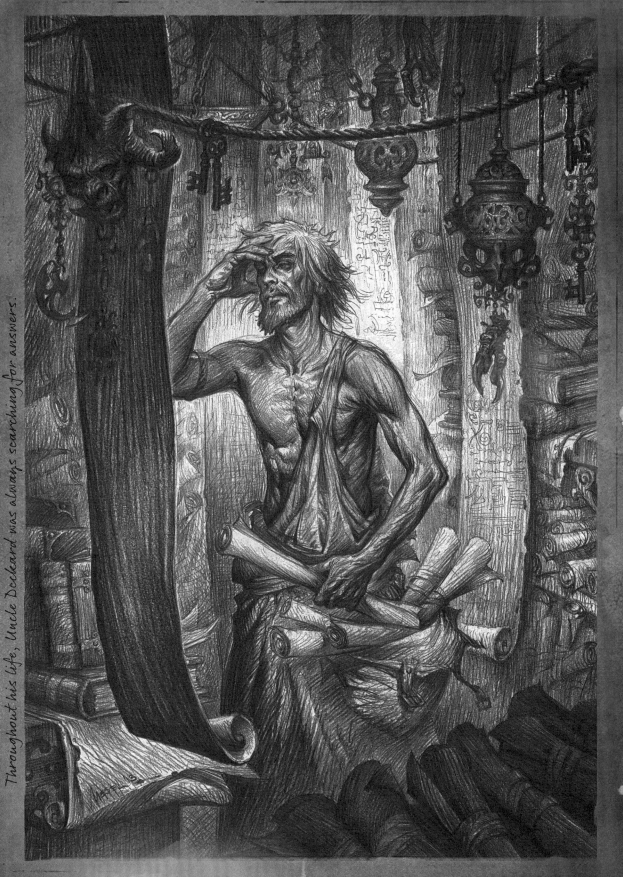

Throughout his life, Uncle Deckard was always searching for answers.

Adria's Origins

To truly understand someone, you must know the circumstances of their upbringing. And so it was that when I began investigating Adria, I looked first to her childhood.

One night in Tristram, I asked Adria about her origins, but she said only that her father had been a merchant. Aside from that, she deflected or ignored my subsequent questions about her past. I did, however, glean other clues from the time I spent with her. Most of the spells and apothecary recipes she knew were commonly used by the reclusive witches who dwelled in Westmarch. Her voice also had faint traces of an accent (one, it seems, she was trying to hide) that marked her as being born and raised along the docks of Kingsport. The style of speech in that part of the coastal city is unmistakable, even compared to the other population centers of Westmarch.

Thus, during a trip to Westmarch in search of an ancient Zakarum cipher, I visited the docking quarter of Kingsport. Quite by luck, I met one of the city's retired constables, a man nearly as old as I am now. Having lived and worked in the area his entire life, he immediately recognized the name Adria.

Her father, Sevrin, hailed from a long line of powerful merchants. He was an unstable sort of fellow, the kind prone to sudden acts of wanton violence.

Never noticed this in her voice.

When I ask Adria about her past, she always changes the subject. Why? What is she hiding?

Before Adria's tenth year, Sevrin lost a small fortune when some of his trade ships were destroyed in a storm. In the fit of rage that followed, he reportedly strangled his wife to death. The constable and city guards arrested the man and charged him with murder, a crime punishable by hanging. But due to his wealth and influence, Sevrin secured a pardon and was thereafter released from prison.

What I find strange is that Adria did not run off during this series of events. On the contrary, the constable said the young girl lingered outside the jailhouse. When Sevrin was released, the two of them went back to living at their dockside abode.

Buying his way out of prison had leeched away Sevrin's wealth. Gradually, he fell into heavy debt and made a number of dangerous enemies. The constable claimed that not long after these events, Sevrin's home caught fire in the dead of night. City guards rushed to douse the flames. According to one of the official reports:

> Akarat's bane, the fire burned with unnatural wrath. Two guards succumbed to the inferno, the Light-forsaken heat roasting them in their armor. Water had no noticeable effect on the flames at first. It took a full day to extinguish the blaze.

When the ashes settled, only charred bone remained of Sevrin. As for Adria, one of the first guards to arrive reported seeing a young girl standing outside staring intently at the flames before vanishing into the shadows. While it seems logical that one of Sevrin's rival merchants would have set this killing in motion, I cannot help but think Adria played some part.

I know only bits and pieces concerning Adria's whereabouts and activities following this tragic event. It appears she fled to the wilderness around Kingsport, and perhaps even traveled as far north as the kingdom's capital (also named Westmarch). The fact that she did so at such a young age is testament to her resourcefulness and willpower.

What I know with certainty is that she eventually became involved with a small and secretive group of witches that existed in the region's remote wilds.

It's difficult to believe she would have stayed so loyal to her father, only to kill him later.

I remember this trip. Uncle never told me what we were doing there. He had me stay with an old friend of his while he went to look for the Zakarum cipher.

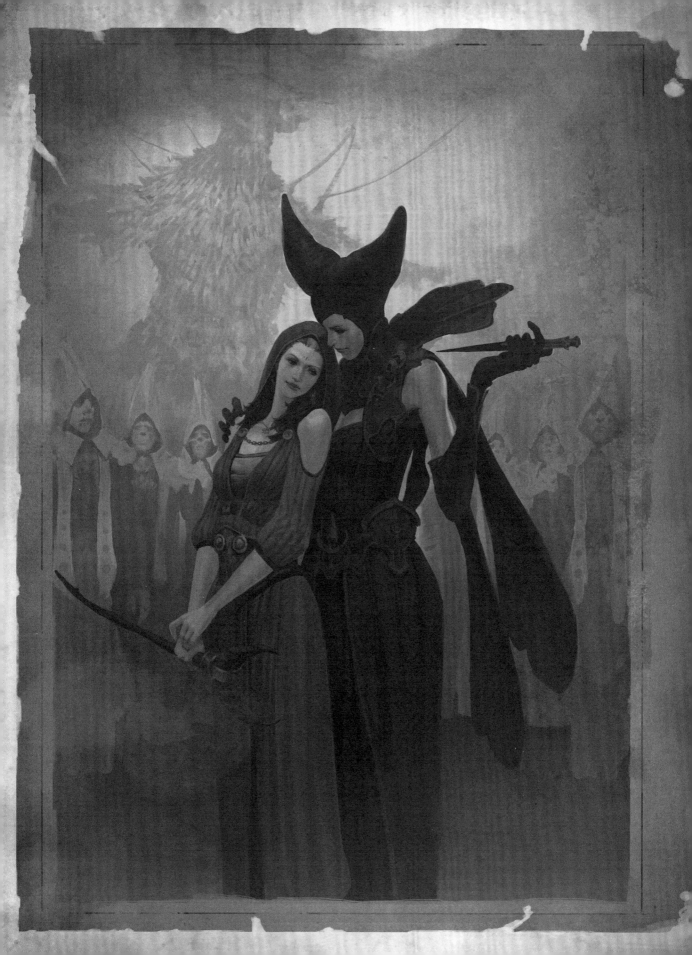

Over the years, she became a powerful figure within this circle.

My first real clue as to Adria's more recent activities came while investigating the Coven for its potential ties to the End of Days. I consider this group to be a remnant of the Triune, the ancient religion created by Diablo, Baal, and Mephisto to turn the hearts of mankind to darkness. The violent events of the Sin War had shattered the Triune, splitting it into vestigial groups with no coherent leadership.

In the centuries that followed, it languished in ignominy, scorned and ostracized by greater society. The Triune experienced a slight resurgence in the time we know of as the Dark Exile, but it quickly faded when the Horadrim imprisoned the Prime Evils.

It was not until my own lifetime that the cult rose to power again in the western lands, under the name of the Coven. By all accounts, it appears that two witches joined the floundering cult and poisoned its leaders. These usurpers then took control of the Coven, reforging it into a dangerous new order that practiced torture and demonic summoning. It is said these witches were fueled by the belief that they were destined to become mortal heralds of the Burning Hells.

I knew with certainty that one of the leaders was Maghda, a malicious and fanatical individual unopposed to sacrificing her followers in order to achieve her goals.

I think at some point the remnants of the Triune shifted from Kehjistan to the west as a way to begin anew. Under Maghda, they crawled back to the east and laid claim to the deserts around Caldeum.

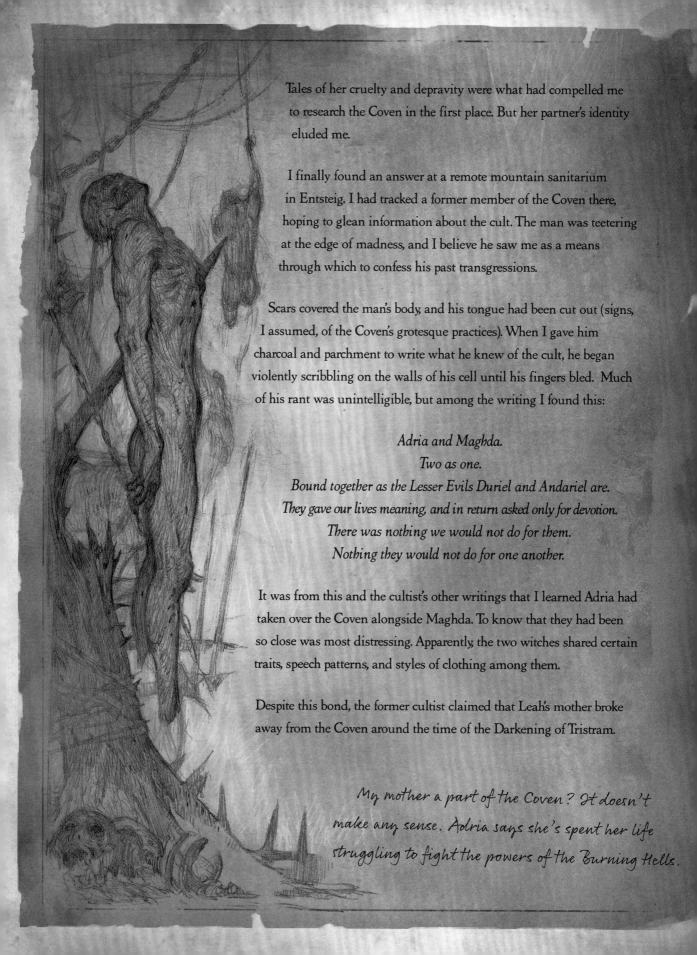

Tales of her cruelty and depravity were what had compelled me
to research the Coven in the first place. But her partner's identity
eluded me.

I finally found an answer at a remote mountain sanitarium
in Entsteig. I had tracked a former member of the Coven there,
hoping to glean information about the cult. The man was teetering
at the edge of madness, and I believe he saw me as a means
through which to confess his past transgressions.

Scars covered the man's body, and his tongue had been cut out (signs,
I assumed, of the Coven's grotesque practices). When I gave him
charcoal and parchment to write what he knew of the cult, he began
violently scribbling on the walls of his cell until his fingers bled. Much
of his rant was unintelligible, but among the writing I found this:

Adria and Maghda.
Two as one.
Bound together as the Lesser Evils Duriel and Andariel are.
They gave our lives meaning, and in return asked only for devotion.
There was nothing we would not do for them.
Nothing they would not do for one another.

It was from this and the cultist's other writings that I learned Adria had
taken over the Coven alongside Maghda. To know that they had been
so close was most distressing. Apparently, the two witches shared certain
traits, speech patterns, and styles of clothing among them.

Despite this bond, the former cultist claimed that Leah's mother broke
away from the Coven around the time of the Darkening of Tristram.

My mother a part of the Coven? It doesn't
make any sense. Adria says she's spent her life
struggling to fight the powers of the Burning Hells.

Her departure, an unexpected and violent schism, nearly tore the burgeoning cult apart. The event left Maghda wracked by jealousy and rage. Fueled by these dark emotions, she redoubled her efforts to contact the Burning Hells. I have suspicions that Belial, the Lord of Lies, or Azmodan, the Lord of Sin, answered her call, although clear evidence to support this theory remains elusive.

As for Adria, she had washed away all signs of her association with the Coven by the time she came to Tristram. Looking back, I wonder if she had reinvented her identity. Or, had she merely reverted back to her true self? Was the person I met and spent so many hours talking with the real Adria? Or was that just another mask she wore?

Of greater concern was why Adria left the cult in the first place. I want to believe she saw the error of her ways, but the truth is not so simple. Maghda had always been devoted to the cult, but Adria seemed only to be passing through, driven by the allure of power. If there is one thing I know about her, it is that she acts with purpose.

With all of this in mind, I suspect that Adria sought me out in Tristram to learn what she could of the Horadrim and other old lore in my possession. But were her intentions for good or for ill? What new goal did she see shimmering on the horizon?

It would be a number of years before I finally discovered an answer to these questions.

I haven't told Adria about the journal yet. I need more time to think over what I've read.

The last thing I want to do is ruin her opinion of Uncle Deckard. She always considered him a friend.

3rd day of Kathon

1285 Anno Kehjistani

My whole life, I've suffered from terrible nightmares. Dreams of blood and war, of bloated corpses pecked down to the bones by giant crows. Their oil-black eyes glaring at me with hate, filling me with foreboding. Other times, I dream of angels and demons with frightening clarity, as if the things I'm seeing are more akin to memories than figments of my imagination.

Ever since we recovered the Black Soulstone, the nightmares have only gotten worse. Keeping vigil over the crystal takes up nearly all of my time. I can sense the five Evils trapped within it, watching me. They batter against the prison's walls, screaming in my head.

My mother's lessons are the only things that help me stay in control. Each day, she teaches me how to harness my magic and use it to contain the darkness inside the soulstone. She's strict and demanding, but fair. She never gives up on me.

At first, I was hesitant to take Adria's advice. Uncle Deckard tried, unsuccessfully, to help me control my gift, but the training never really changed anything. He said my abilities were dangerous. Through Adria's lessons, I've begun seeing things differently. This power—it's a natural part of me. Using it makes me feel like I've tapped into something that's always yearned to be set free. For the first time since leaving New Tristram, I have the sense that I can make a real difference in our battle against the forces of the Hells.

 —Leah

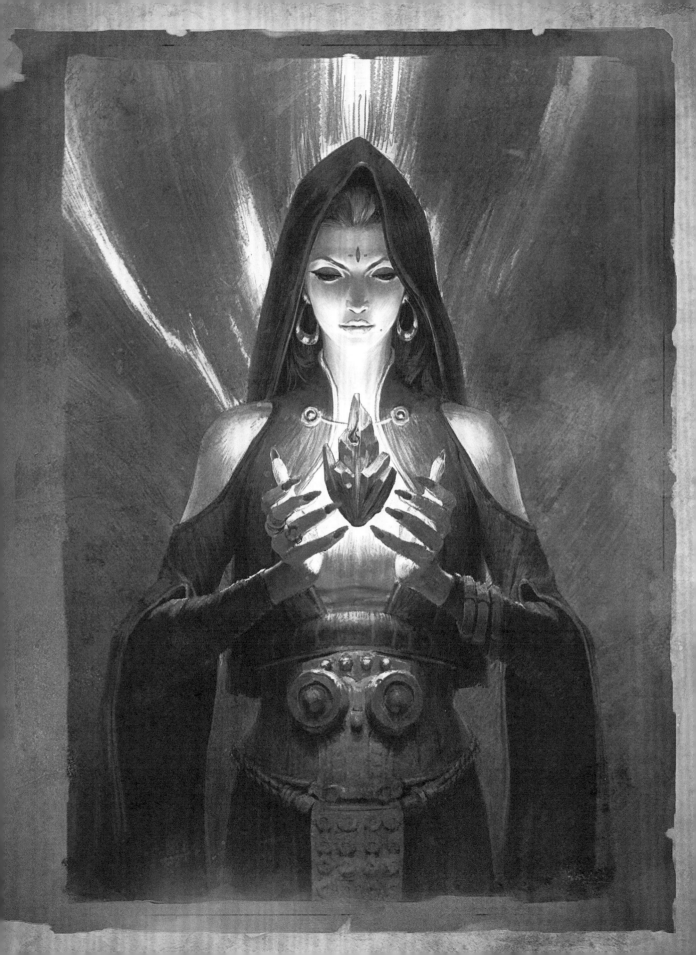

Adria's Quest

In the years following my trip to the Entsteig sanitarium, I would often sense Adria's presence nearby. Leah would unexpectedly ask about her mother at these times, or feverishly repeat the witch's name in the throes of a restless sleep. But Adria remained hidden, eluding my attempts to track her down.

What purpose brought the witch so near to us? Was she checking on the well-being of her daughter, or had we crossed paths with Adria merely by chance?

These vexing questions gnawed at me, leading to many sleepless nights. Before long it became quite difficult to maintain focus on my pressing End of Days investigation. To my relief, I at long last found answers while conducting research in Caldeum's Great Library. A fellow scholar told me of a witch matching Adria's description who had recently passed through the city. He claimed she had visited the library, inquiring about famous battles fought during the Sin War and Mage Clan Wars. The Desolate Sands, the gates of ancient Viz-jun, and the ruins of the Cathedral of Light—these were the names relayed to me.

Immediately, I realized the significance of the scholar's tale. In Tristram, Adria and I had discussed these same historical sites. They were places that the notorious Horadrim Zoltun Kulle had frequented centuries ago. According to some mages and scholars, angels and demons had perished at many of these locations.

And with that revelation, the shards of half-truths began taking greater shape. Adria had always been strangely fascinated with Kulle and, in particular, his most deplorable creation: the Black Soulstone. Had this been her quest all these years? To seek the cursed artifact out?

Mother admitted her connection to the Coven. She says it was part of her quest to wage war against the Hells, but she confesses she went too far. I haven't told Tyrael or the others. I can't. They might lose trust in Adria at a time when we need to work together most.

Sometimes a longing to see her would overcome me. It lasted for hours. Days, even.

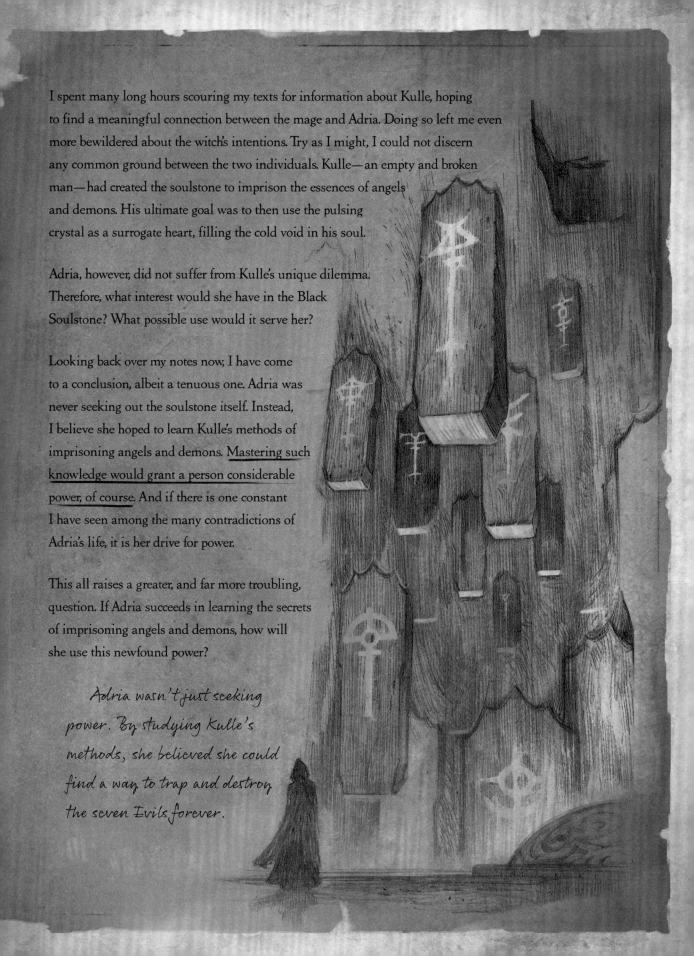

I spent many long hours scouring my texts for information about Kulle, hoping to find a meaningful connection between the mage and Adria. Doing so left me even more bewildered about the witch's intentions. Try as I might, I could not discern any common ground between the two individuals. Kulle—an empty and broken man—had created the soulstone to imprison the essences of angels and demons. His ultimate goal was to then use the pulsing crystal as a surrogate heart, filling the cold void in his soul.

Adria, however, did not suffer from Kulle's unique dilemma. Therefore, what interest would she have in the Black Soulstone? What possible use would it serve her?

Looking back over my notes now, I have come to a conclusion, albeit a tenuous one. Adria was never seeking out the soulstone itself. Instead, I believe she hoped to learn Kulle's methods of imprisoning angels and demons. Mastering such knowledge would grant a person considerable power, of course. And if there is one constant I have seen among the many contradictions of Adria's life, it is her drive for power.

This all raises a greater, and far more troubling, question. If Adria succeeds in learning the secrets of imprisoning angels and demons, how will she use this newfound power?

Adria wasn't just seeking power. By studying Kulle's methods, she believed she could find a way to trap and destroy the seven Evils forever.

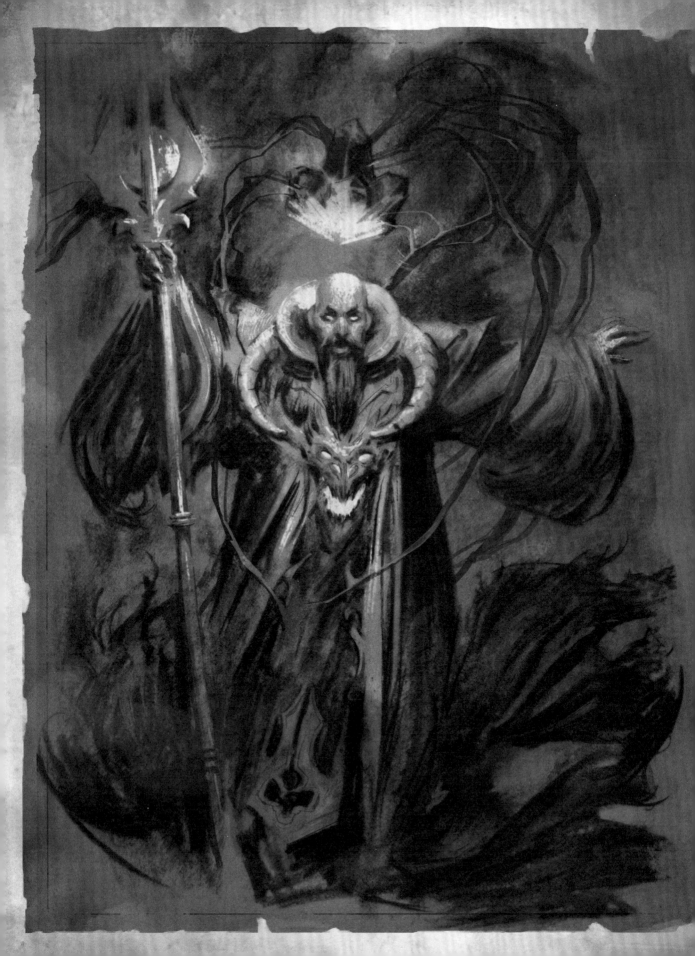

Zoltun Kulle and the Black Soulstone

I have spent many years documenting historical figures. In all that time, very few have filled me with equal parts disgust and reverence. Zoltun Kulle is one of them.

Ancient texts portray him in a number of different ways: a once virtuous man lost to the dark abyss of obsession, a murderer and a torturer, and a heroic member of the Horadrim. But most of all, he is known as the architect of the Black Soulstone, a profane simulacrum of the three crystals Archangel Tyrael bestowed on the Horadrim.

Over the following pages, I will examine how he accomplished such a feat and also speculate on what his ultimate intentions were.

To begin, it is very important to understand Kulle's origins. He hailed from the Ennead mage clan, a group renowned for its mastery of transmutation and enchantment. Like his kin, Kulle dedicated his life to the noble pursuit of these sciences, always seeking to manipulate the base components of the physical world.

Jered Cain, in The Nature of the Soulstones, succinctly described Kulle this way:

> In all things, he glimpsed the elements of life, ripe for growth. He was, in his better days, driven by dreams of elevating his fellow man to wondrous new heights. Kulle, perhaps above all other Horadrim, had the power and the wisdom to bring his grand vision of a better world—one devoid of its inherent flaws—to fruition.

During the Hunt for the Three, Tal Rasha entrusted Kulle with the vital task of safeguarding the Amber, Sapphire, and Crimson Soulstones. The Ennead mage's expertise in the realm of physical objects made him the perfect choice for such an undertaking. Jered wrote that he often found Kulle awake late into the night, experimenting with the soulstones and documenting their properties.

Uncle Deckard referenced multiple texts about Zoltun Kulle, but I could only find this among his things.

The following are some of Kulle's observations as recorded by Jered:

The soulstones are attuned to non-corporeal beings. They have no power over living, breathing creatures.

They emit a strong spiritual vacuum when invoked. Once caught in this field of energy, entities are drawn into the crystal's recesses and trapped forever.

Imprisoned beings can only be released upon destruction or deactivation of the soulstone.

If broken, fragments mirror the properties of the greater whole, yet each piece's overall effectiveness—power, if you will— is noticeably diminished.

A mortal body can augment the properties of the soulstone. I believe there is a connection between the crystals and our kind that transcends physicality.

The space within the soulstone is both finite and infinite, both constrictive and expansive. It is immeasurable by any mortal instrument that I know of.

The soulstones contain echoes of history and time— of the origin and purpose of all things.

Hard to believe Kulle was ever a great man. He struck me as spiteful, obsessed only with himself and his own vision.

I will not recount the events of the
Hunt for the Three here, for I have
documented them elsewhere. Suffice
it to say, Kulle became a master of the
soulstones. His knowledge of them soon
mystified even the other Horadrim. With great
fervor and determination, he applied everything he
learned to help his brethren imprison the Prime Evils.

Tragically, the harrowing quest took its toll on the Ennead mage.
Once mirthful and spirited, he became an unfeeling husk, numb
to even the basest human emotions.

Following the hunt, Kulle's demeanor darkened significantly. It is said
he became increasingly wary of the High Heavens. On more than one
occasion, he ranted to the other Horadrim about how the Angiris Council
had, during the Sin War, nearly voted to eradicate humanity. Kulle believed
that the Eternal Conflict would inevitably scour humans from existence
unless they rose to their "true" potential. By this, I suspect he meant
mankind's nephalem origins, a subject that he obsessed over.

Perhaps in the legends of the nephalem, Kulle found a glimmer of hope—
a way to mend the tattered remains of his humanity. Unfortunately, the
path he ultimately took to reach this goal was inexcusable.

Kulle took leave of the Horadrim and returned to the east, disappearing
into the deserts outside Caldeum. Unbeknownst to the rest of the order,
he used his great powers to bend the earth to his will, forging vast
archives beneath the shifting sands. To the best of my knowledge, this is
where he formulated his idea of the Black Soulstone. By trapping angels
and demons within the crystal, he believed it would serve as
a catalyst to infuse his soul with the elements of life—sorrow,
joy, love, hate, and all others.

How he actually went about crafting the soulstone remains a great mystery. Not even Jered wrote conclusively on the subject (but perhaps that was intentional). Of the more suspicious reports I have come across, one claims that Kulle drained some of his own blood and transmuted it into crystal. Another account states that the mage excavated the remains of a legendary nephalem and molded the bones into the Black Soulstone.

But these tales are steeped in conjecture and hearsay, and therefore must be viewed with skepticism. The important fact is that Kulle succeeded in creating the soulstone. He then set out to imprison angels and demons within the crystal. For this, the Ennead mage journeyed to sites from the eras of the Sin War and Mage Clan Wars—places where terrible battles had raged between angels, demons, and nephalem.

To fully appreciate Kulle's vision, it is crucial to understand something related to the nature of demons. To the best of my knowledge, when one of these creatures is killed in the mortal realm, it leaves something behind—a shadow of sorts. It might be helpful to think of this shadow as a lingering portion of the demon's essence imprinted on our world.

Angels, however, are an entirely different matter. Very likely, Kulle had developed a different technique for trapping angels than he had for demons, but I am lacking in specifics regarding this.

What I do know, however, is that Kulle used his various techniques to mark angels and the essences of slain demons. He planned to cast a powerful summoning spell that would force them into the recesses of the Black Soulstone.

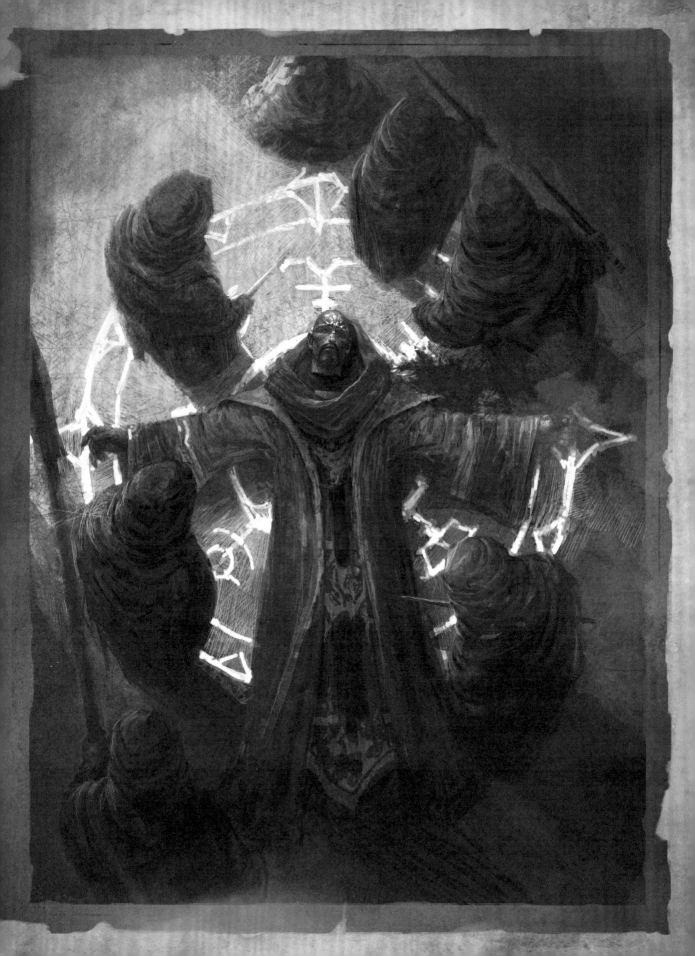

Kulle worked tirelessly to perfect his methods. It is said that he developed an <u>entirely new system of runes</u> for trapping and summoning demons (perhaps influenced in some way by Vizjerei magic). Before long, he had marked a number of sites around Kehjistan.

By this time, the Horadrim had learned of Kulle's intentions. After much deliberation and planning, they stormed the Ennead mage's shadowy archives. Kulle had planned for such a scenario by filling his lair with traps and guardian constructs composed of living sand. One of the Horadrim who took part in the mission—Iben Fahd—wrote that many of these brethren lost their lives during the assault. In the end, however, the Horadrim prevailed. They thwarted Kulle at the precise moment when he was poised to cast his great summoning spell.

Of Kulle's fate, I know that the Horadrim could not kill him—at least not in the normal sense of the word. Perhaps Kulle had truly awakened his nephalem birthright, thereby granting him extraordinary powers. Whatever the case, the Horadrim were forced to undertake a most gruesome task: dismembering Kulle. They concealed his head in the Dahlgur Oasis and locked his body away in what Iben Fahd cryptically referred to as a "Realm of Shadow." I have heard rumors that this place might have been similar to the domains that the ancient Vizjerei used to imprison and interrogate demons.

I am woefully ignorant of what transpired with regards to the Black Soulstone. Did the Horadrim destroy it? Or, as with Kulle, was it beyond their abilities? Knowing the Ennead mage, he would likely have gone to great lengths to protect his masterwork.

Mother spent years learning how to use Kulle's runes. That's why she couldn't be a part of my life. She negated Kulle's spellwork and then used his magic as a means to somehow mark the Lesser and Prime Evils.

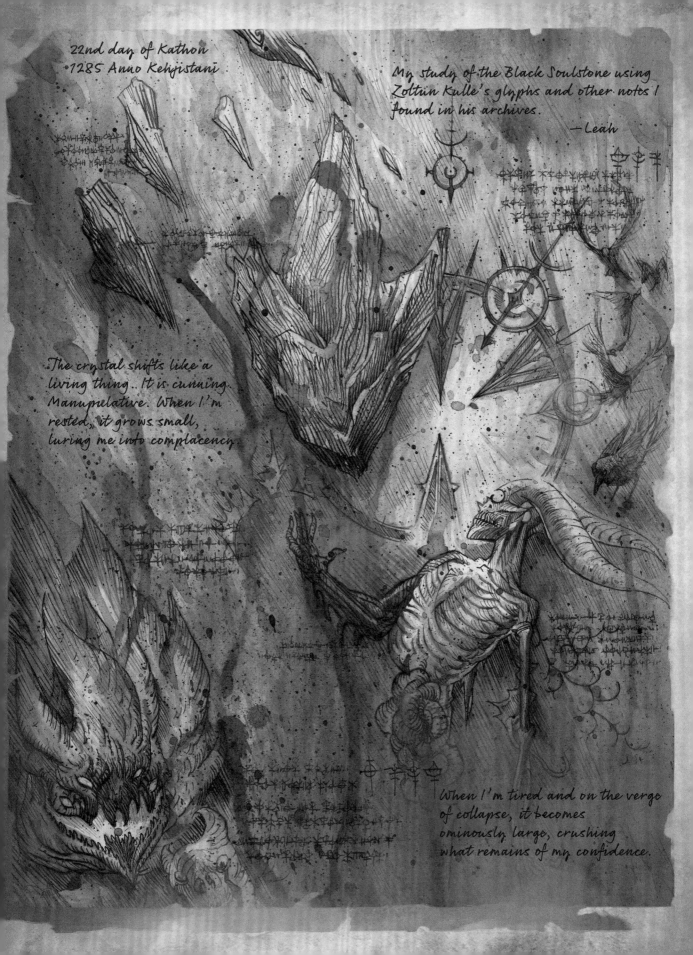

22nd day of Kathon
1285 Anno Kehjistani

My study of the Black Soulstone using Zoltun Kulle's glyphs and other notes I found in his archives.

—Leah

The crystal shifts like a living thing. It is cunning. Manupulative. When I'm rested, it grows small, luring me into complacency.

When I'm tired and on the verge of collapse, it becomes ominously large, crushing what remains of my confidence.

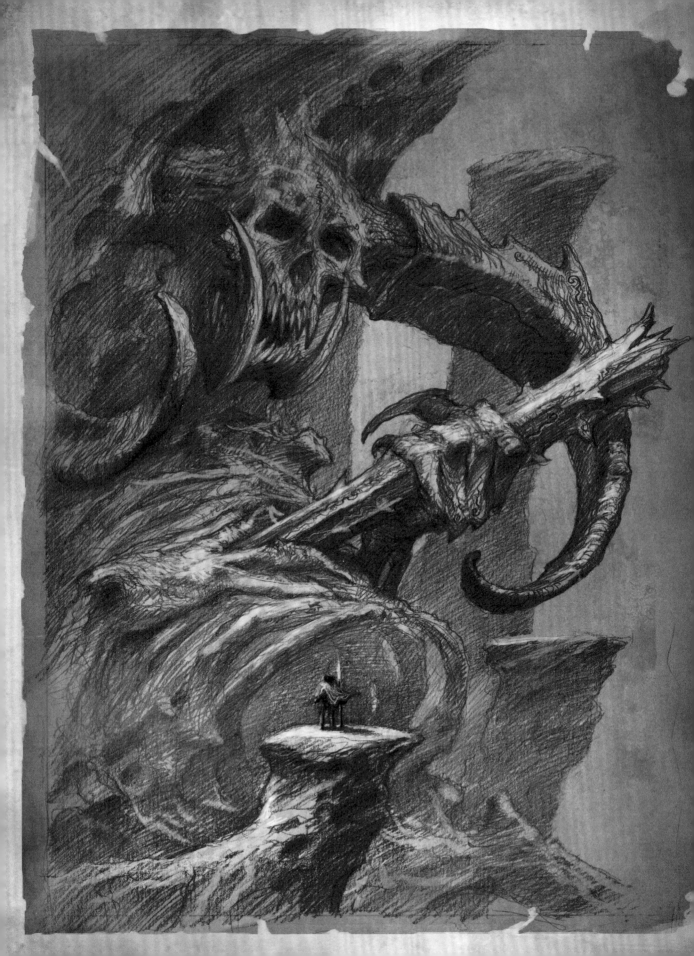

Conclusions

Having reviewed my notes and compiled this manuscript, I must ask again: what do I know of Adria? I am quite loath to admit that answering this question with any certainty seems more untenable now than ever before.

On the one hand, I have uncovered a great deal about Adria's unsavory history. This evidence presents her as a person of shifting allegiances. By all accounts, her life is defined by a perpetual ebb and flow between attachment and abandonment, loyalty and betrayal. For examples of this, I need only look to her dealings with individuals such as Sevrin and Maghda. From all of this, I would conclude that Adria cares only for the people around her so long as they prove useful to her mysterious goals. The drive for knowledge and power dictates every facet of her relationships.

On the other hand, I have met Adria myself, and I have judged her as a courageous and brilliant, albeit unconventional, ally. In Old Tristram, I believed her when she said her grand mission was to wage war against the Evils of the Burning Hells. I would even go so far as to say that, in a very meaningful way, she inspired me to set out on my current path.

But how can I reconcile my own firsthand experiences with the knowledge that she once led the Coven, a cult that exists to serve the very forces she claimed to stand against? Oh, if only I could meet Adria again and put my mind at ease. I have so many questions for her. Perhaps she has an explanation for those unsettling chapters of her past.

Deep down, I want to believe that she has overcome whatever dark thoughts led her to join the Coven and, later, rule it alongside Maghda. I want to believe that this strange quest she embarked on years ago and her obsession with Zoltun Kulle are both in the interest of good rather than evil. I wish this all for my own sake, but even more so for Leah's.

This wish, however, also stems from an altogether different concern. In conducting my End of Days research, thoughts of Adria have continually plagued me. For the life of me, I cannot understand the reason. Why, when I have so vital and demanding a task at hand, do I spend even a moment worrying about her? Is it simply because Leah is now in my life, or does Adria have some yet unforeseen part to play in future events?

The bitter truth is that I do not know, and I fear I never truly will.

She made hard choices to fight evil. Gave everything of herself. Mother walked a different path than you, Uncle. Doesn't mean her way was wrong.

1st day of Ostara

1285 Anno Kehjistani

It seems as if only a few days have passed since I was rifling through Uncle Deckard's books in Caldeum, but I know it's been much longer. Time is bleeding together. Losing its significance. I spend night and day holed up in this corner of Bastion's Keep.

Mother says the nephalem and Tyrael have routed Azmodan's forces. When we first arrived here, the demon lord was throwing everything against the keep — legions crashing against the walls, sending tremors through the bones of the great fortress. It's over now. If things continue going well, we will soon imprison Azmodan in the Black Soulstone along with the other Evils.

But it's so hard to be hopeful. Hard to think about anything other than the soulstone. The Evils — they know the end is coming. They're growing desperate. Frantic. The energy radiating from the crystal is changing how I see things. How I feel things. Sometimes my body seems to stretch apart at a thousand different points until the pain makes me black out. Other times I have the sensation I'm being crushed, my body folding inward over and over again until the darkness swallows me.

Mother tells me to sleep, but it's getting harder to do so. I always dream of New Tristram and Uncle Deckard. He's sitting at his desk, leafing through his books. I hear laughter drifting through the window of his house. I smell bacon sizzling in the tavern nearby. For a brief moment, everything is normal again.

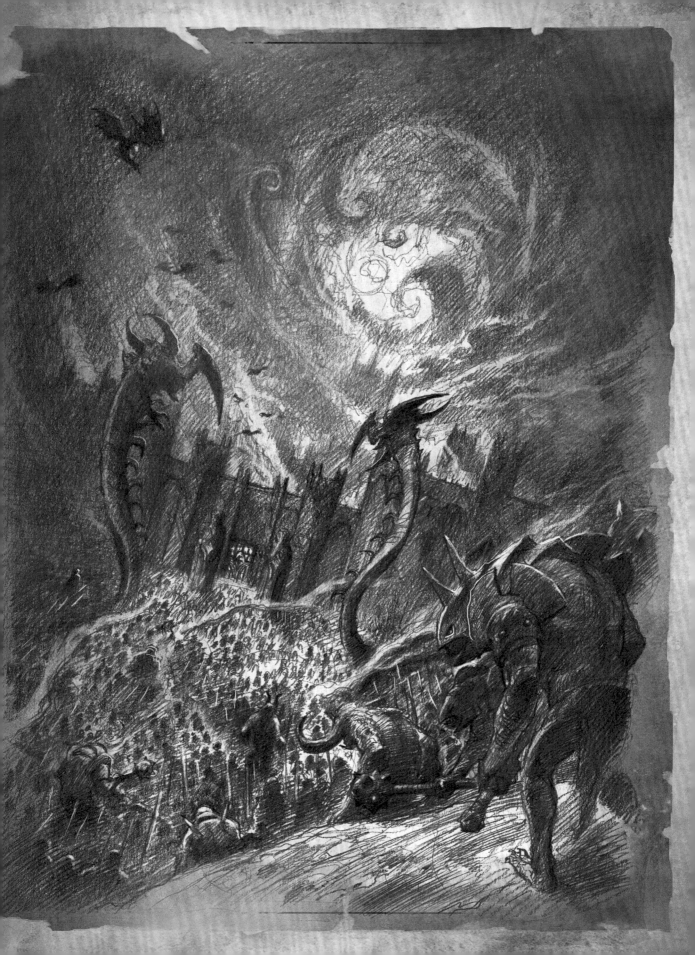

Then I wake up. The laughter becomes the death rattle of injured soldiers in the next room; the smell of bacon becomes the stench of corpses burning on the ramparts.

The realization of everything I've lost presses down on me until I can't move. But Mother knows how to bring me back from the edge. She takes my Horadric necklace and puts it into my hand. The cold metal's touch reminds me to be strong. If I fail, all the dead in New Tristram, Caldeum, and Bastion's Keep will have lost their lives for nothing. All the years Uncle Deckard sacrificed to forestall the End of Days will have been wasted.

I haven't given up, Uncle. We're so close to victory, and we owe so much of it to Mother. I understand why you doubted her. I only wish you could be here to see how hard she's fighting—see how she's the one thing that keeps me going.

Whenever I stumble, she's at my side, holding me. Telling me how proud she is. How much she's missed me these long years. We talk about the things we'll do when the battle is over. She urges me to push forward just a little longer so that everything we've worked for will come to fruition. She promises me that this pain will all be over soon. Then, we will begin our life together anew.

—Leah

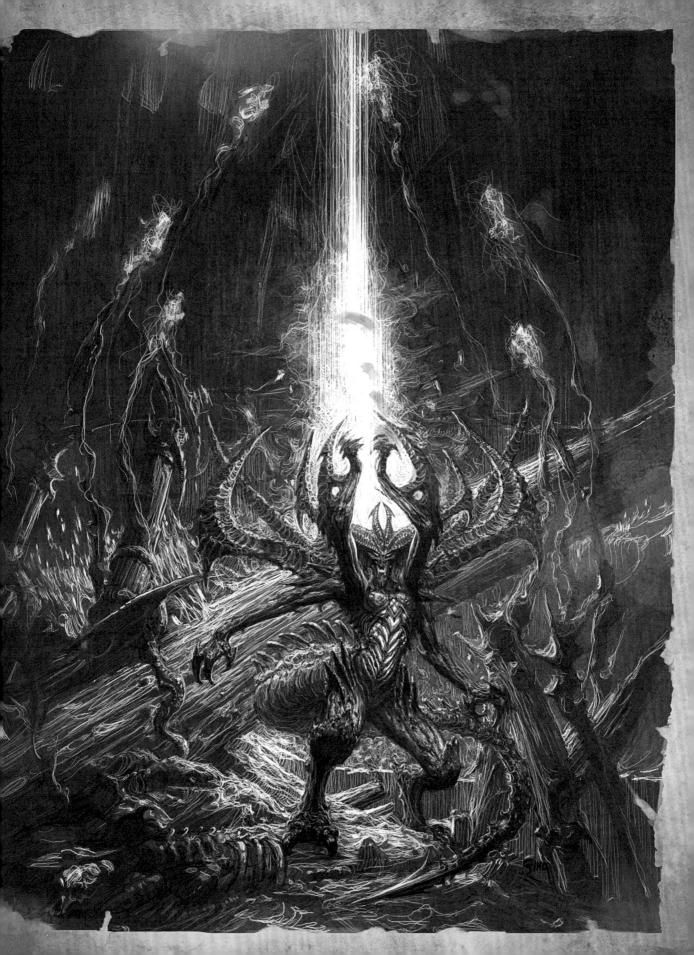

Part Two

The Fate of the Black Soulstone

Being Mortal

I will not say my time acclimating to mortal life has been easy. Of the many facets of this new existence, even something as fundamental as sleep was challenging to accept. Angels have no need of slumber, and I was only vaguely aware of this concept through my past dealings with mankind. During my first days as a mortal, I fought my body's many cries for sleep until exhaustion took me. The strange dreams that followed filled me with disquiet. They were enigmas, storms of images and emotions birthed beyond rational thought.

But as with other aspects of mortal life, I have come to cherish dreams. Some human seers claim they hold meaning, and I subscribe to this belief. I believe that, through dreams, mortals can at times pierce the veil of reality and touch, however briefly, the realm of pure insight.

Of late, my dreams are haunted by one thing: the Black Soulstone. I see the crystal reflected in all things, at all times. It has become my obsession, my purpose in life.

It has driven me to act against the will of the Angiris Council and the High Heavens.

Horadrim, by the time you read this, you may already know of my plans for the crystal. Nonetheless, I wish to record the details here so that you may fathom the unsettling events that drove me to embark on this path, however perilous it may be.

———

My allegiance to humans has often been questioned. I freely admit there was even a time when I regarded them with disdain, much like my angelic brethren. But upon witnessing mankind's innate potential for selflessness, I developed a deep admiration for mortals. The more I learned of them, the more I began to see my own kind in a different light. Ultimately, I became aware of a glaring flaw among the angels.

Know this concerning Heaven's denizens: they are immutable in their adherence to order. Laws govern their existence, guiding their every thought and action. Although this affords angels great strength and unity, it also limits their ability to act.

Nowhere was this flaw more evident than in my dealings with the Angiris Council. The archangels—Imperius, Auriel, Itherael, Malthael, and I—were bound by law not to interfere with the mortal realm. But where I only loosely followed this rule, the other council members observed it without question. They obeyed even when the Prime Evils moved to corrupt humanity, threatening to upset the balance of the Eternal Conflict.

When I intervened to forestall catastrophe, the council members chastised me for my recklessness. They ignored my warnings that the Burning Hells would soon assault the mortal world. I came to realize how their precious laws had become more important to them than truth. No amount of arguing or persuading would ever sway them to reason.

I deliberately took on the form of a mortal, sacrificing my angelic essence, in response to the Council's continued inaction. In doing so, I hoped to set an example to the Heavens—to prove that laws can be bent for a greater good.

I also knew that, in time, mankind would hold immeasurable power through its nephalem heritage. Only by standing with humans could I thwart Hell's impending invasion and bridge the gap between the realms of angels and men.

Looking back, I realize how unprepared I was for the realities of mortal existence. As an archangel, I had observed and interacted with humans for centuries. I had watched entire generations come and go, studying the forces that governed their lives. A time even came when I believed that I had learned all there was to know about being mortal.

How wrong I was.

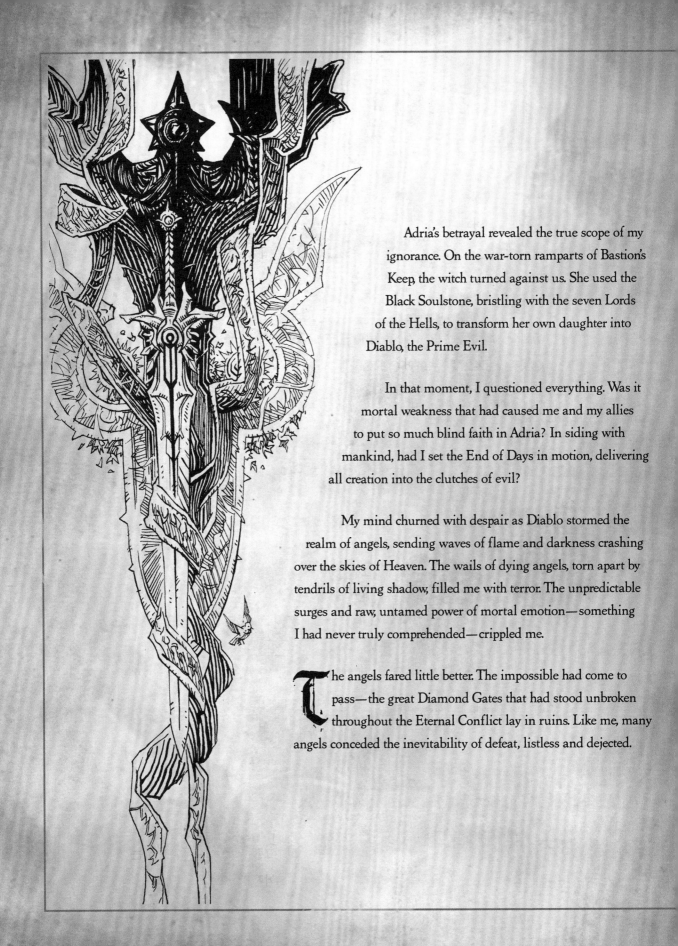

Adria's betrayal revealed the true scope of my ignorance. On the war-torn ramparts of Bastion's Keep, the witch turned against us. She used the Black Soulstone, bristling with the seven Lords of the Hells, to transform her own daughter into Diablo, the Prime Evil.

In that moment, I questioned everything. Was it mortal weakness that had caused me and my allies to put so much blind faith in Adria? In siding with mankind, had I set the End of Days in motion, delivering all creation into the clutches of evil?

My mind churned with despair as Diablo stormed the realm of angels, sending waves of flame and darkness crashing over the skies of Heaven. The wails of dying angels, torn apart by tendrils of living shadow, filled me with terror. The unpredictable surges and raw, untamed power of mortal emotion—something I had never truly comprehended—crippled me.

The angels fared little better. The impossible had come to pass—the great Diamond Gates that had stood unbroken throughout the Eternal Conflict lay in ruins. Like me, many angels conceded the inevitability of defeat, listless and dejected.

But where we surrendered, my mortal allies forged ahead. They alone possessed the courage to vanquish the Prime Evil, casting the entity from the sacred Crystal Arch.

The euphoria I experienced following the attack did not last. My mortal comrades soon departed, and alone I struggled to find my place among the angels. Food and other necessities of mortal life were nonexistent in Heaven. Nightmares of the oppressive darkness that had swept over Heaven plagued my restless sleep.

Places once familiar became strange and foreboding. In my former domain, the Courts of Justice, fleeting visions of every angel who had perished at the hands of the Prime Evil assaulted me. The fallen guardians held me accountable for their deaths. Overcome with guilt, I lacked the courage to face their judgment.

And so I fled.

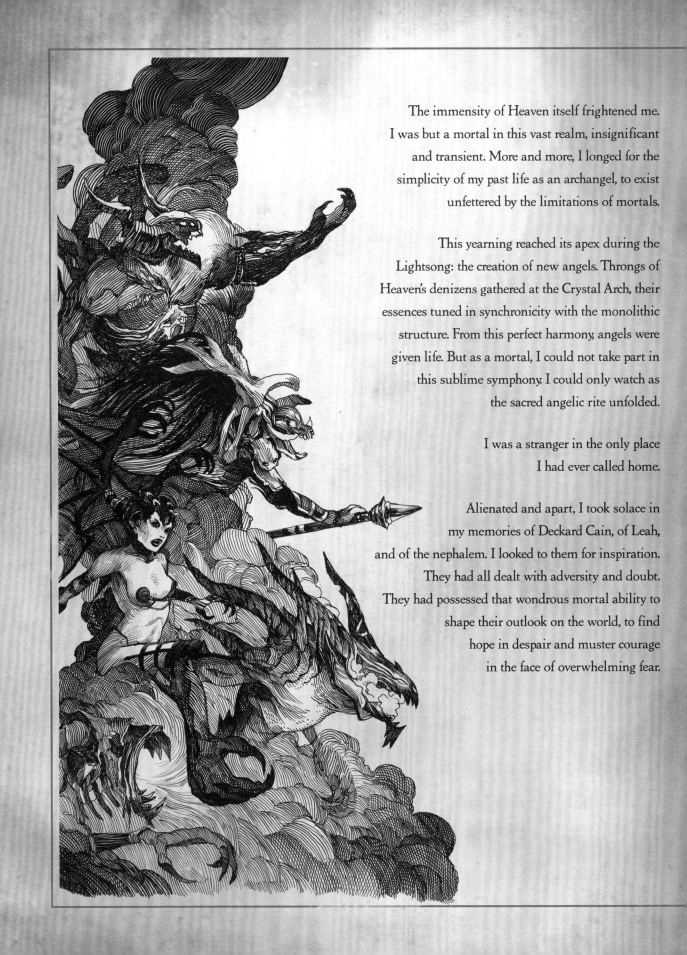

The immensity of Heaven itself frightened me. I was but a mortal in this vast realm, insignificant and transient. More and more, I longed for the simplicity of my past life as an archangel, to exist unfettered by the limitations of mortals.

This yearning reached its apex during the Lightsong: the creation of new angels. Throngs of Heaven's denizens gathered at the Crystal Arch, their essences tuned in synchronicity with the monolithic structure. From this perfect harmony, angels were given life. But as a mortal, I could not take part in this sublime symphony. I could only watch as the sacred angelic rite unfolded.

I was a stranger in the only place I had ever called home.

Alienated and apart, I took solace in my memories of Deckard Cain, of Leah, and of the nephalem. I looked to them for inspiration. They had all dealt with adversity and doubt. They had possessed that wondrous mortal ability to shape their outlook on the world, to find hope in despair and muster courage in the face of overwhelming fear.

I relate this to you, Horadrim, not because I claim my understanding transcends yours. Often, it takes the observation of an outsider to glean true insight about one's self. But if there is one shred of wisdom I can pass on to you, it is that the true strength of mortals comes from the fact that they are forged of equal parts light and dark. From this duality springs a constant push and pull between opposing and contradictory emotions. This shifting spectrum of feeling is what grants mortals their unique perspective and freedom.

Rather than cower from the sudden rush of conflicting emotions, I faced it. I adapted to it. Slowly, I began to see beyond the things that troubled me; I began to glimpse the beauty of Heaven with my new mortal eyes. I marveled at its grandeur, at the way each domain, from the great Halls of Valor to the tranquil Gardens of Hope, had a distinct and profound effect on my mind. I began, at last, to see as mortals do.

It was with this newfound perspective that I first noticed a subtle darkening to the realm of angels. Shadows dimmed the brilliant crystalline spires and colonnades. Discordant notes tainted the radiant chorus that whispered through the skies of the Heavens.

At the center of this growing disharmony, I beheld the Black Soulstone.

The Dissonance
of the Angiris Council

In the wake of the Prime Evil's defeat, I resumed my involvement with the Angiris Council. Where once I had stood among Heaven's ruling body as the Aspect of Justice, I now assumed the place of Wisdom, a position formerly held by the missing archangel, Malthael. In part, taking on this duty was a deliberate act. I believed that to ensure a new dawn for angels and men, the virtues of wisdom outweighed those of justice. But my transformation was also caused by something more: a subtle calling that emanated from the Crystal Arch, instilling in me a profound need to don the mantle of Wisdom.

Through my involvement with the Council, I was privy to discussions about the Black Soulstone. The Prime Evil's body had been destroyed, but the crystal remained intact, the entity's spirit still roiling within the enchanted prison. Angels under the command of Imperius quickly recovered the foul artifact and entrusted it to the Angiris Council.

Never before had the archangels held such power and dominion over the Lords of the Burning Hells. Never before had they possessed such a momentous chance to purge evil from creation and bring an end to the Eternal Conflict once and for all.

Auriel proposed forging an impenetrable chamber of light and sound to shroud the crystal for all eternity. Imperius argued that the only valid course of action was to shatter the stone, thus destroying the Evil, and launch a final sweeping invasion of the Burning Hells. Itherael lingered in indecision, still plagued by his inability to foresee mankind's destiny in relation to the Prime Evil and the harrowing attack on the Heavens.

The Council was divided, unable to pass a vote on a course of action. It was during these meetings that I began to notice the Black Soulstone's insidious influence on the archangels. This effect was not corruption in the literal sense, although the crystal did possess unsettling powers. Angels who handled it for prolonged periods of time were inundated with visions of terror, hate, destruction, and the other dark emotions intrinsic to the seven Evils. For mortals, I believe this effect would be even more perilous.

The mere presence of the soulstone drove a wedge between the archangels, begetting an unending cycle of heated debates and arguments. Know this: it is harmony that imbues angels with much of their strength. Discord is like a mortal disease that spreads to every limb and organ until the body withers and dies. In that way, the Council's divisiveness pervaded the Heavens, posing a danger to all who dwelt within.

I warned the archangels of this burgeoning schism and the Soulstone's role in it, but I was largely ignored. Imperius took my apprehension as a sign of mortal cowardice. Throughout the Council's meetings, he was loath to hear out any of my suggestions. He continued to hold me accountable for the tragic attack on the Heavens. He also claimed that my nature as a mortal made me incapable of living up to Malthael's legacy as the Aspect of Wisdom.

Imperius's behavior troubled me deeply. Seeing Heaven burn around him, seeing his loyal followers perish before his eyes, had a profound impact on the archangel. Due to his pride, he could not accept that mortals had spared the Heavens from doom. He allowed his shame and anger to feed off one another, blinding him to reason.

There was, however, a shard of truth to his accusations. Although I had willingly become Wisdom, I had not fully embraced my calling. Doubtful that I could live up to Malthael's legacy, I had abstained from bringing other angels under my command. I had even avoided venturing into my predecessor's domain, the Pools of Wisdom, and taking up the legendary source of his power: Chalad'ar, the Chalice of Wisdom.

Would peering into this artifact destroy my mortal mind? Or would it have no effect on me at all? The various outcomes, and the potential for disaster, plagued my thoughts.

I do not believe Imperius intended this, but his constant challenges finally pushed me to face my fears. I knew that as long as the Council remained deadlocked over the Black Soulstone, the dissonance of the archangels would fester like an open wound. Only by drawing on the powers of Wisdom could I hope to resolve this dilemma. So it was that I finally ventured into the Pools of Wisdom to take Chalad'ar into my care.

Wisdom

In the long ages after light and sound wove the fabric of the Heavens, Malthael stood as a pillar of reason among the archangels. Whenever disagreement erupted within the Council, he was there to quell the discord, drawing our divergent opinions into perfect harmony. He existed to seek the meaning of all things—the truth in all things.

Despite his great influence, Malthael never forcefully imposed his will on any of the archangels. Quiet and reclusive, he was an enigma to his own kind. Even so, many of Heaven's denizens revered Malthael. Apart from the members of the Angiris Council, throngs of angels frequented the Pools of Wisdom to bask in the tranquil radiance that pervaded the domain. Others lingered there for a chance to engage in discourse with Malthael.

But few were graced with such an opportunity. The archangel of Wisdom rarely spoke. When he did, the chorus of the Heavens would fall silent for the briefest moment and Malthael's words would shine across the realm of angels for all to hear.

When the monolithic Worldstone disappeared in the distant past, Malthael dedicated himself to unraveling the mystery of the crystal's location. But truth proved elusive. The Aspect of Wisdom became increasingly distant and withdrawn from the activities of the Angiris Council. This behavior did not change even after we discovered that the Worldstone had been hidden away on Sanctuary. Malthael continued seeking answers for what this turn of events could mean. For the span of mortal decades, he would sit in silent and frustrated meditation, peering into the mercurial depths of the chalice. The Aspect of Wisdom was also prone to suddenly disappearing from the High Heavens to brood in isolation for lengthy periods of time.

After leaving on one of these mysterious journeys, Malthael simply never returned.

No one knows his current whereabouts. The Council dispatched some of Malthael's closest followers to seek him out, but few ever returned. Rumors persist that he wanders the otherworldly halls of the Pandemonium Fortress, but I have not investigated these reports myself. Whatever the truth may be, the Angiris Council and all of the High Heavens are less without Malthael.

I relay this information here so that you understand the monumental impact my predecessor had on the Heavens. I was concerned that in failing to match Malthael's influence, I would shatter any hopes of bringing angels and humans together. In large part, this mindset is what kept me away from the Pools of Wisdom for so long.

When I finally mustered the courage to venture into Malthael's former home, I found the place cold and desolate, as if it existed just beyond the reach of Heaven's light. An eerie void of sound— a silence almost painful to endure—pervaded the domain. The crystalline cisterns and founts that had once sung with living light had all run dry. It was there, in the silent heart of this formerly glorious realm, that I found Chalad'ar.

What is it like for a mortal to use this vessel of ever-flowing light?

First, know that the chalice was not forged for a mortal mind. Even now, I struggle to tame its energies. Sometimes Chalad'ar awakens the raw power of my mortal emotions, throwing me into states of confusion, fear, and anger. Other times an icy cold surrounds me, chilling my body to the marrow. I become transfixed by the inevitability of my own mortality and of the death that awaits all things.

Of its positive effects, Chalad'ar has many. Staring into the chalice imbues mind and body with a profound sense of confidence, power, and euphoria. It also unravels the barriers of perception, illuminating the interconnectivity of all emotions and ideas, the oneness of all things. Light and dark, love and hate, life and death—to gaze into the chalice is to see that these things are, at their core, merely different facets of the same crystal. In that way, Chalad'ar allows one to perceive situations with flawless objectivity.

Using it confirmed a fear that had been troubling me for some time: so long as the Black Soulstone remained in the care of the archangels, it would bring about the downfall of both the Heavens and the mortal world. The task of standing vigil over the crystal did not lie with the Angiris Council. It lay with mankind. Only humans possessed the potential foresight, willpower, and perspective necessary to take on such a tremendous burden.

As I look back on this revelation, giving the task to mortals seems an obvious solution. But I had hidden from this truth, wanting so much to believe that the Angiris Council possessed the unity to safeguard the soulstone. Chalad'ar stripped away this self-delusion, forcing me to face the stark truth, however painful it was.

Such is the price of wisdom.

The New Horadrim

I relayed some of the insights I had gleaned from Chalad'ar with the Angiris Council, but it became clear that the archangels would never allow mankind to have dominion over the Black Soulstone. Therefore, I began keeping my thoughts concerning the crystal's fate secret.

As to warriors capable of safeguarding the crystal, I considered many possibilities: the nephalem who had vanquished the Prime Evil, the dedicated and pragmatic priests of Rathma, and the barbarian tribes that had once stood vigil over Mount Arreat with unyielding determination. But always, my thoughts lingered on the first Horadrim.

I will not detail the formation of the original order or their battles against the three Prime Evils. Deckard Cain and others have written extensively on the subject. I will, however, say this: the strength of the Horadrim was their diversity, a virtue lacking in many other mortal organizations. Mages from disparate cultures, some of which were openly hostile toward one another, comprised the order. Although the members constantly bickered and argued, their differences proved to be their greatest weapon. The unique system of belief and worldview held by each of the mages prevented stagnation and allowed them to devise brilliant solutions for the impossible challenges they faced.

But apart from Cain, the Horadrim had ceased to exist centuries ago. Forging another order was a daunting task I did not have the time to undergo. I pushed thoughts of the Horadrim from my mind until I came across this among Cain's writings:

They call themselves the First Ones.

From what I gathered, a group of scholars stumbled upon a hidden archive of Horadric texts in the city of Gea Kul. A man named Garreth Rau, a litterateur well versed in the arts of magic, assumed leadership of the fledgling order. He and his newfound comrades swore oaths to uphold the tenets of the Horadrim.

Only later was it revealed that Rau had fallen under the sway of Belial, the Lord of Lies. It is unclear precisely when this occurred, but the man sunk into the depths of depravity, engaging in all manner of grotesque blood rituals and human corruption. He also had designs for Leah due to her innate powers, and therefore pulled us both into his web of deception.

Jered Cain, one of the Horadrim's original leaders.

60

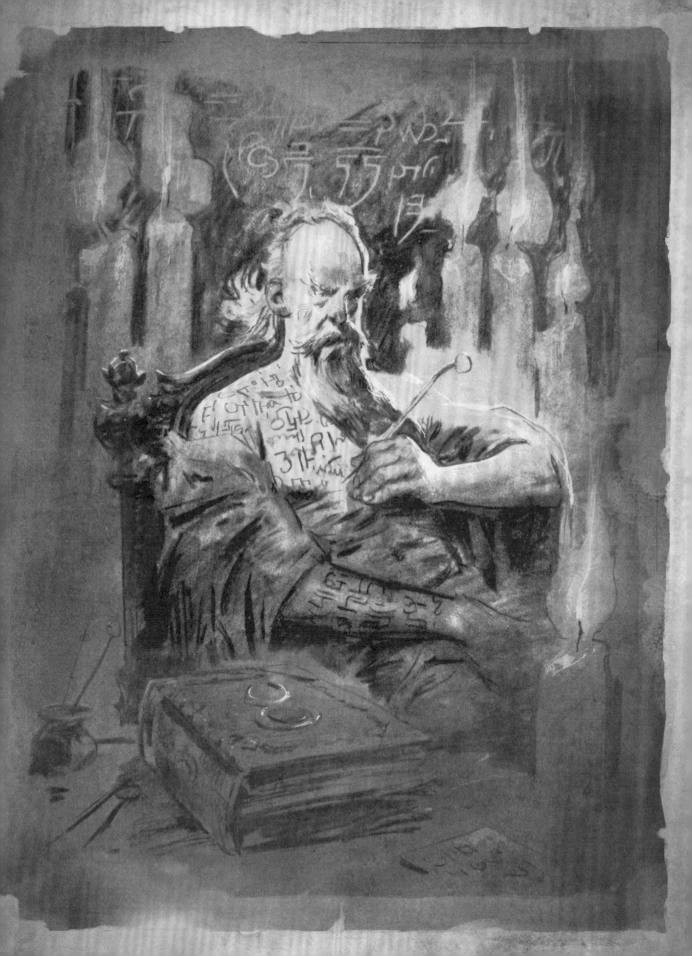

Book of Cain

Quite miraculously, not all of these First Ones darkened as Rau had. There were
some who continued to uphold the sanctity of the order through these harrowing
events. They were only scholars, but even so they bravely fought to help break Rau's
hold over Gea Kul and cleanse the Horadric name of this despicable false leader.

For that, I owe them much. I have nothing but respect for the First Ones,
and I have therefore given them my blessing to carry on the Horadric legacy.

Oh, never in my wildest dreams did I imagine the order would rise again.
To know that they are out there in the world, upholding the values
Archangel Tyrael bestowed on the first Horadrim, fills my heart with joy.

If only I had the time to stand with them. Perhaps someday I will.

Discovering that the order still existed, albeit in a different form than before, invigorated
me. These First Ones had laid the foundations of a glorious new Horadrim. With my
guidance, I knew they would be the key to guarding the Black Soulstone.

To strengthen the order, I decided to reach out to trustworthy mortals whose talents lay in magic and other martial disciplines. I will not mention their names here, for there are some who may choose not to take part in this perilous endeavor. Know that I hold no ill will toward these individuals. To be Horadrim is to put the lives of others before your own. It is to root out evil in the darkest corners of the world, enduring horrors that would break lesser mortals. Few have the courage to take on this calling.

I was confident in my decision regarding the Horadrim, but the question of where the order could safely watch over the soulstone plagued me. Again, I turned to Cain's writings for answers. I delved into his histories of the secret places of the world: the lost city of Ureh, the Arcane Sanctuary, and many others. I gazed into the shifting depths of Chalad'ar to contemplate everything I had learned and seek insight.

Even now I remain undecided, but thus far a remote network of nephalem catacombs in the kingdom of Westmarch appears most promising. I have included Cain's treatise on this nation's history and its ancient ruins in full should these details prove useful in the future.

Deckard Cain's Staff

Tal Rasha's Guise of Wisdom

Rakkis and the Founding of Westmarch
Prelude to Conquest

Of all the world's myriad nations, it is Westmarch that has always fascinated me most. I consider this land of rain-soaked ports and sweeping pastures to be one of the greatest kingdoms in existence, a fact made all the more impressive when considering its relatively young age.

But one must remember that the Westmarch of modern times is vastly different from what it was at the moment of its creation. It is this historic event, the founding, which I will examine in some detail here. Much of the information that follows I have taken from *Westmarch and the Sons of Rakkis,* a seminal work on the nation's past.

Let us begin by briefly examining the early days of the Zakarum Church, for this famous institution's rise to power is inexorably linked to the founding of Westmarch.

Nearly three centuries ago, the vast empire of Kehjistan was in the throes of unrest, plagued by famine and disease. Bloody riots between the downtrodden commoners and the corrupt ruling elite were daily occurrences. In short, the climate was ripe for a rebellion by the masses, one on a scale of which Kehjistan had never witnessed.

It was at this rather inauspicious time that the Zakarum, an order that had hitherto existed on the fringes of society, came to prominence. This religion was founded on the teachings of Akarat, a man who wrote of self-determination, empowerment, and the inner Light that exists in every man and woman. It appears that in Kehjistan's state of inequality and hopelessness, the Zakarum tenets blazed across the land like wildfire. Historians also attribute this sudden growth to the <u>building of Travincal</u>, a massive temple complex in Kurast.

Beyond this, I will not delve any further into the Zakarum's rise to power. For the purposes of this story, it is important simply to note that over the course of decades, the church grew increasingly influential, soon becoming a major player in the political spectrum.

Fearful of this burgeoning power, Kehjistan's ruling elite worked to exterminate the Zakarum through acts of violence and persecution. But these brutal tactics only served to drive more of the disillusioned masses into the arms of the church.

It is written that a new emperor by the name of Tassara dismissed this ongoing conflict with the Zakarum as futile. By all accounts, he was a cunning politician and a master of statecraft. Unlike the previous emperor, Tassara did not see the Zakarum as an obstacle. Quite the contrary, he saw it as a means to strengthen his rule.

In a move that is said to have befuddled and infuriated the ruling elite, Tassara converted to the Zakarum faith. He decreed that it would be the official religion of Kehjistan, and he even moved the empire's capital from ancient Viz-jun to Kurast, the headquarters of the church. With this one deft stroke, Tassara won the admiration and, more important, the undying allegiance of Kehjistan's masses.

Westmarch and the Sons of Rakkis states that most of the nobility followed Tassara's lead, but there were some who remained opposed. A handful of nobles had no intention of sharing their power with the church. They pooled their incredible fortunes and recruited a formidable mercenary army to topple Tassara and crush the Zakarum.

This turn of events led the emperor to call upon his greatest military general and lifelong friend: Rakkis. I have found conflicting reports about this man's true origins. What all the histories do agree on, however, is that Rakkis was a zealous Zakarum convert known for his stern demeanor, cunning, and ferocity in battle. Throughout the course of his military career, he gained renown for defending the empire from both external and internal threats.

Most accounts, which I hold true, state that the usurpers' armies outnumbered Rakkis's own forces by a wide margin. Despite this disadvantage, the general outmaneuvered his adversaries at every turn. Indeed, he divided and conquered the mercenaries with incredible speed and efficiency, never losing a single battle.

These victories made Rakkis a legend. Perhaps the masses saw his triumph as a sign of their faith's legitimacy and undeniable strength. Whatever the case, when Rakkis traveled through cities, it is said that people of all ages would gather to catch a glimpse of their champion. The general used his influence to dispose of governors and magistrates whom he saw as inept, replacing them with his favored Zakarum archbishops.

In time, Tassara grew wary of Rakkis's explosive popularity and sought to neutralize this new threat to his rule. The emperor did not, however, turn to violence as a solution. I imagine this was partly due to his friendship with Rakkis. But more important, Tassara knew that eliminating the general would only turn the populace against him.

Thus, he took a quite different tactic. To the west, across the glittering Twin Seas, lay untamed and wild lands shrouded in mystery. Tassara claimed that it was the empire's duty to conquer this dark corner of the world and enlighten it with the Zakarum faith, and that only Rakkis's zeal could succeed in doing so.

If the general failed, he would likely lose much of his popularity. If he proved victorious, Tassara would reap the benefits and be seen as the architect of this grand new chapter in Zakarum history. Either way, the emperor would secure a future for himself.

Whether or not Rakkis was aware of Tassara's ulterior motives is unclear, but he accepted the task nonetheless. The emperor granted the general nearly a third of Kehjistan's standing military. This force included many paladins, holy warriors of the Zakarum Church (known as the Protectors of the Word) who used the powers of the Light to smite their foes in battle. Tassara also went to great lengths to ensure that Rakkis's closest allies in the church were included in this bold campaign.

Before thousands of cheering onlookers, the great army set sail in a fleet that, according to one account, stretched from the shores of Kehjistan to the far horizon.

Campaigns Against
Ivgorod and the Barbarians

Rakkis first landed in Lut Gholein, an ancient port that had been forewarned of his arrival. The Zakarum faith was already entrenched in the city, having held ties with Kehjistan through trade. Lut Gholein's ruling mercantile guild agreed to supply Rakkis with additional soldiers and provisions in exchange for continued autonomy.

It was outside this city, in the northern reaches of the sun-scorched deserts of Aranoch, where Rakkis would meet his first resistance. The kingdom of Ivgorod controlled vast swaths of the region, although the base of its power lay high in the mountains northwest of the deserts. This ancient culture observed a polytheistic religion vastly different from the Zakarum faith. As such, Ivgorod vehemently opposed Rakkis and his beliefs.

Across the dunes of Aranoch, the two sides clashed in a series of somewhat one-sided engagements. The Kehjistani forces, masters of warfare in open terrain, ultimately crushed their adversaries, thereby shattering Ivgorod's hold on the land. In fact, the victory was so total that the kingdom would never again reclaim the deserts.

Be that as it may, Ivgorod remained a constant thorn in Rakkis's side as he passed over the western Tamoe mountain range. It was there that the Kehjistani soldiers constructed Eastgate Keep, a fortified outpost to defend against their enemy's counterattacks.

Westmarch and the Sons of Rakkis somewhat downplays this portion of the campaign, but I have found other accounts that provide details. Suffice it to say, Rakkis met increasingly fierce resistance in the mountains. It can even be said that Ivgorod intentionally lured the Kehjistani forces farther north into the dense forests and craggy terrain, an environment more suited to the kingdom's style of warfare. Ivgorod's religious rulers also called upon the monks, their greatest and most venerated holy warriors, to strike down the invaders. These incredibly disciplined combatants harassed Rakkis's soldiers at every turn, launching ambushes and covert assaults with devastating results.

It is here that we see the clash of two faiths: paladins trained in the Light battling monks who, it is written, could call upon the gods of the land to imbue themselves with immense power. This was a battle we in the modern times have never truly witnessed.

As the Kehjistani armies continued to spread out into the far north, they met equally fierce resistance from the scattered barbarian tribes around the foothills of Mount Arreat. I can only imagine what it must have been like for the rank-and-file Kehjistani soldiers as they faced these strange and indomitable foes, a people adorned in vivid body paint and screaming savage war cries as they fearlessly charged into battle.

Rakkis would never conquer the barbarians or Ivgorod. Although both of these cultures were deeply wounded by the Kehjistani incursion, they would nonetheless endure.

For the sake of brevity, I will say that the nearby lands of Entsteig and Khanduras both willingly submitted to Rakkis. They did not possess a fraction of the military strength held by Ivgorod or the barbarians. Both Entsteig and Khanduras would accept the Zakarum faith, and in return they would retain much of their independence.

But it was in the south where Rakkis would find his greatest success.

A missive fragment from Rakkis that reads:
". . . northern tribes unyielding. Supplies low.
Request reinforcements from Lut Gholein
with all due haste."

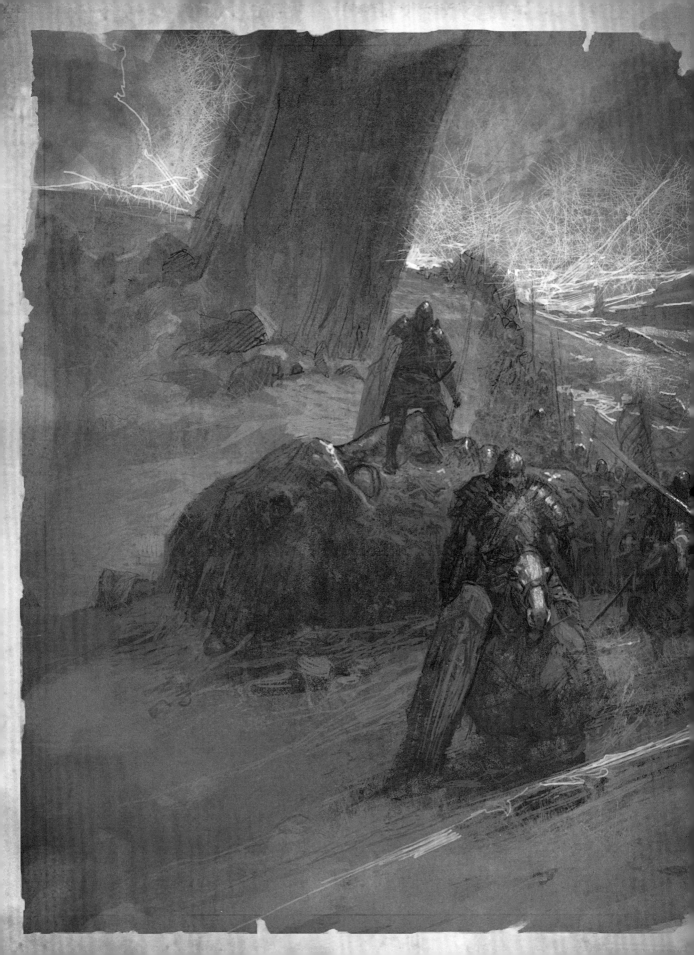

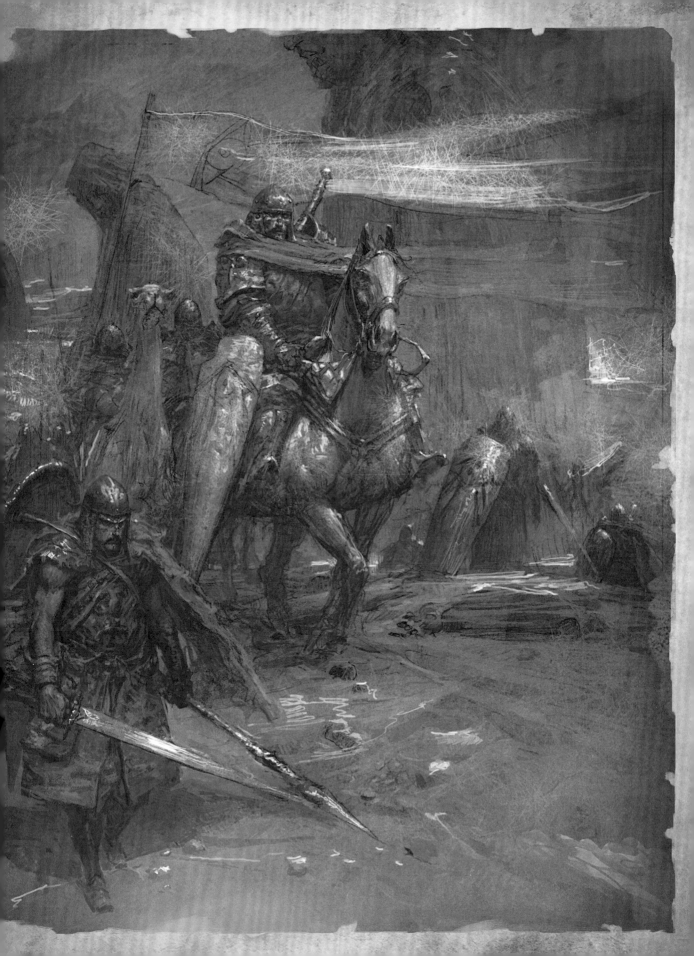

The Creation of Westmarch

Westmarch and the Sons of Rakkis recounts that the general gathered his forces near Eastgate Keep to recuperate and ponder his past defeats. Morale is said to have been low among many of the soldiers following their failed campaigns against Ivgorod and the barbarians. But Rakkis was not dissuaded. As with many of history's conquerors, he believed that victory was his destiny. With speeches about their righteous cause, about their faith's ultimate ascendancy, he rallied his soldiers and set out for the next leg of his campaign.

Nine warring clans existed around the southern edge of what is now called the Gulf of Westmarch. For generations, these hostile peoples had lived in a state of perpetual violence. This disunity was their greatest weakness, and one that Rakkis saw as an advantage. He knew that launching his armies against these clans would inevitably unite them into a single undefeatable force. Instead, Rakkis lived among them. He learned their language and their culture. He learned their gods. All the while he subtly spread the Zakarum faith to all who would hear.

Through an arranged marriage, Rakkis bound himself by blood to the region's third largest clan, the Ortal. He used this new standing as leverage, bringing four of the lesser clans under his banner.

Rakkis then launched his combined forces in a full assault against the largest and most hostile clan, the Hathlan. It is difficult for my mind to fully grasp the terrible nature of the battles that followed. Sources state that blood turned the once verdant fields to marshland. The stench of decaying corpses carried on the wind as far as Khanduras.

At the Battle of Dyre River, the Kehjistani forces dismantled the tattered remnants of the Hathlan army and slew its leader. This clan, in addition to the three others that had abstained from taking a side, quickly submitted to Rakkis's rule. The people of the gulf, having witnessed the general's supremacy, declared him their one true king.

But even as Rakkis assumed dominion over his new subjects, he rallied them with talk of mankind's inner Light and glory. It was his unyielding strength and conviction that truly united these formerly intractable peoples and forged them into a single proud kingdom.

In honor of his long and grueling campaign to spread the faith from distant Kehjistan, Rakkis named his territory Westmarch. Its borders stretched from the gulf to the Great Ocean. For the capital (which would come to share the same name as the kingdom), Rakkis ordered the construction of a river port settlement. The subsequent years saw Westmarch flourish. New roads, cities, and infrastructure sprouted up throughout the land. Due to plentiful access to the sea, the nation quickly became a formidable naval and mercantile power.

Rakkis ruled with a strong but fair hand and enjoyed the admiration of his people. Years after founding his nation, he would launch further incursions against the barbarians, but he would never make any true gains against the fierce northern tribes. It is said that Rakkis died peacefully in his sleep over the age of one hundred. His legacy would continue long after his death. Indeed, Westmarch's current standing in the world is a testament to the dedication and wisdom that he employed to build a nation.

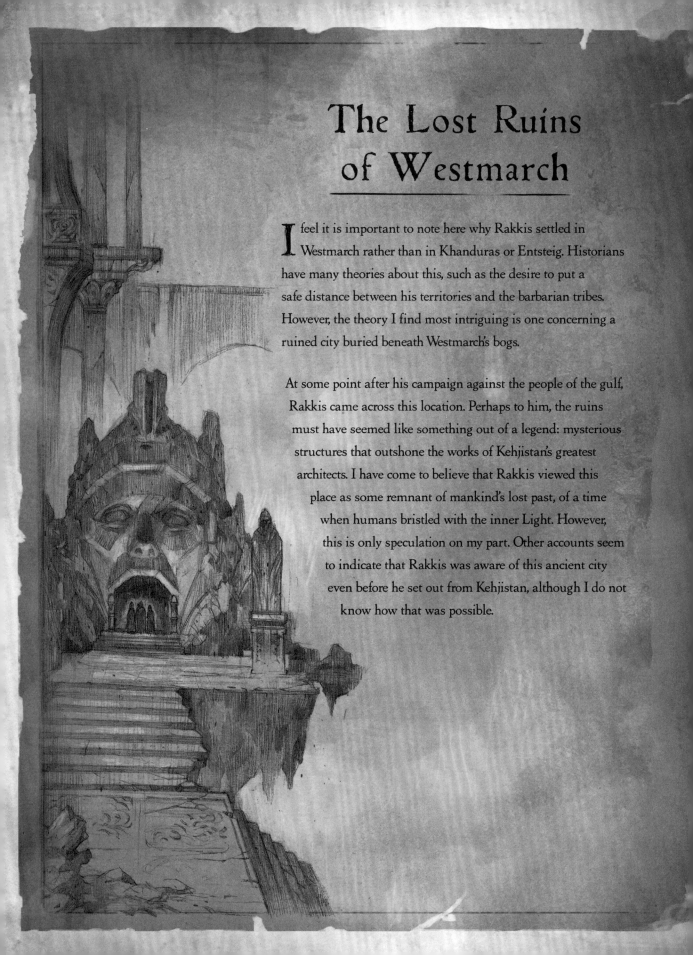

The Lost Ruins of Westmarch

I feel it is important to note here why Rakkis settled in Westmarch rather than in Khanduras or Entsteig. Historians have many theories about this, such as the desire to put a safe distance between his territories and the barbarian tribes. However, the theory I find most intriguing is one concerning a ruined city buried beneath Westmarch's bogs.

At some point after his campaign against the people of the gulf, Rakkis came across this location. Perhaps to him, the ruins must have seemed like something out of a legend: mysterious structures that outshone the works of Kehjistan's greatest architects. I have come to believe that Rakkis viewed this place as some remnant of mankind's lost past, of a time when humans bristled with the inner Light. However, this is only speculation on my part. Other accounts seem to indicate that Rakkis was aware of this ancient city even before he set out from Kehjistan, although I do not know how that was possible.

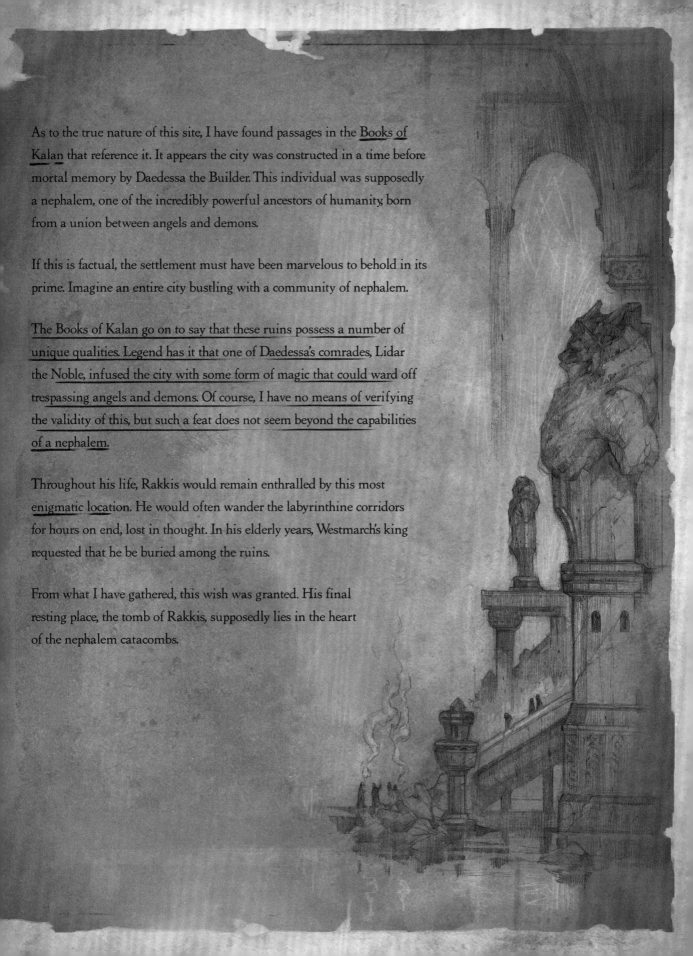

As to the true nature of this site, I have found passages in the <u>Books of Kalan</u> that reference it. It appears the city was constructed in a time before mortal memory by Daedessa the Builder. This individual was supposedly a nephalem, one of the incredibly powerful ancestors of humanity, born from a union between angels and demons.

If this is factual, the settlement must have been marvelous to behold in its prime. Imagine an entire city bustling with a community of nephalem.

<u>The Books of Kalan go on to say that these ruins possess a number of unique qualities. Legend has it that one of Daedessa's comrades, Lidar the Noble, infused the city with some form of magic that could ward off trespassing angels and demons. Of course, I have no means of verifying the validity of this, but such a feat does not seem beyond the capabilities of a nephalem.</u>

Throughout his life, Rakkis would remain enthralled by this most <u>enigmatic location</u>. He would often wander the labyrinthine corridors for hours on end, lost in thought. In his elderly years, Westmarch's king requested that he be buried among the ruins.

From what I have gathered, this wish was granted. His final resting place, the tomb of Rakkis, supposedly lies in the heart of the nephalem catacombs.

Crusaders

As an addendum to the story of Westmarch, I find it prudent to touch on a separate campaign launched in the name of the Zakarum faith. Whereas Rakkis had gone west, seeking conquest, this other force had gone east, driven by entirely different motivations.

The following information comes from a number of distinct (and sometimes contradictory) sources. However, I am confident the details herein are in large part factual.

Around the time that Rakkis began his historic march, a Zakarum cleric grew troubled by what he saw as a subtle darkening of the church. This man, named Akkhan, was of the belief that the faithful had strayed dangerously far from Akarat's original tenets.

What was this "darkening" he became aware of? I can only assume it was related to the Sapphire Soulstone, the enchanted crystal that contained Mephisto, the Lord of Hatred. At the Horadrim's request, the Zakarum had taken this vile artifact, vowing to safeguard it. They stayed true to their word, but Mephisto's influence nonetheless began seeping into the hearts and minds of the church's spiritual leaders.

Whether or not the cleric knew of the corruption's precise source is unclear. Regardless, Akkhan acted to forestall the faith's impending doom. I take the following from the scrolls of Sarjuq, a text of rare and little-known Zakarum history:

> Akkhan searched far and wide for warriors of unparalleled strength, for believers who burned with an inner Light that was blinding to behold. He made them, these men and women whom fate pulled to his side like iron to the lodestone, into crusaders.

It is said that the cleric gave these crusaders a seemingly impossible task: to scour the far-flung lands to the east and find a means, however it might manifest, to purify the Zakarum faith.

The Book of Cain explores the Zakarum's stewardship of Mephisto's soulstone in greater detail.

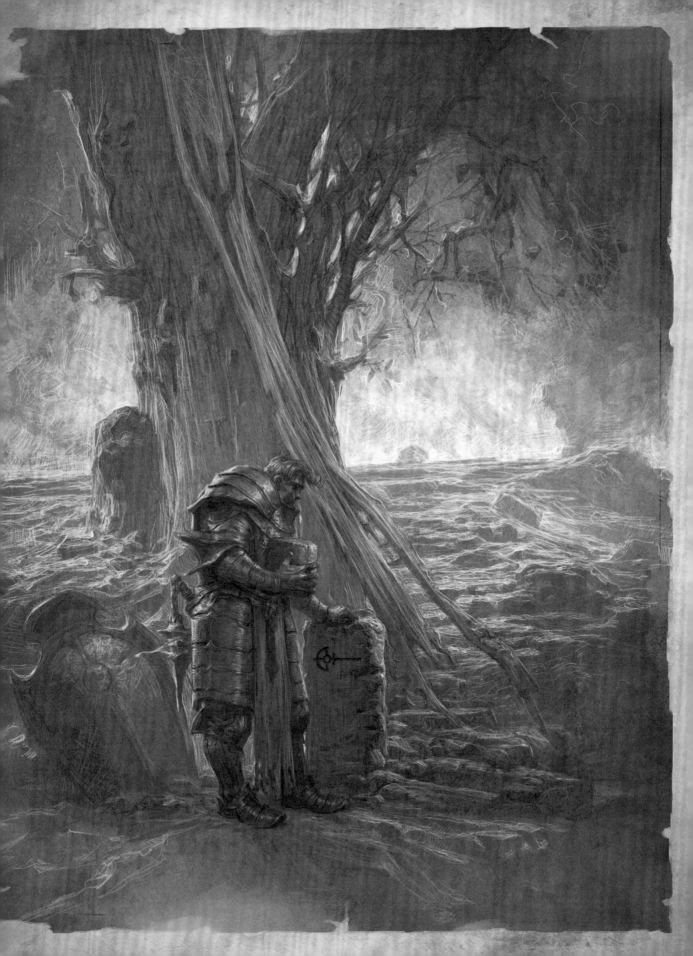

It is important to note that the members of this order were not paladins. Akkhan specifically avoided calling on those individuals because he saw them as a product of the church's errant ways. No, crusaders were a different breed of holy warrior. Resourceful and resilient, they were trained to wield powers unlike any before.

After rigorous preparations, the crusaders fanned out into the east, each one going a separate way. They lived off the land, never staying in settled places for longer than necessary. They developed secret symbols and hand gestures to communicate with other crusaders whom, by chance, they might cross paths with. Every firsthand account I have found concerning these individuals depicts them with an air of mystery.

But herein lies something of a puzzle, for I have also heard tales that the crusaders made no effort to mask their presence. It is even rumored they spoke openly about their sacred quest to anyone with the courage to ask.

On the topic of crusader succession, it seems that they chose a single initiate to train and mentor in their ways. These individuals, recruited from local populations, were picked based on a number of factors, such as their innate affinity to Akarat's teachings.

It is worth mentioning that becoming a member of the order was not without its sacrifices. Initiates were asked to expunge every vestige of their former lives forever. When their mentor perished, the acolytes would take on their master's identity, donning their weaponry, armor, and even name. Only then did these initiates ascend to the rank of crusader themselves.

Of the order's mission, I am woefully lacking in details. It appears that some crusaders investigated legends of lost Zakarum writings and holy relics from bygone eras. Others were driven by stories of infants born with an inner Light so pure that it would cleanse the faith of its affliction. But I have found no definitive evidence that states a crusader actually uncovered a means to complete their quest.

What I do know is that the crusaders exhausted most—if not all—promising leads in the east. Over two centuries after beginning their search, members of the order began returning to Kehjistan. Their names, beliefs, and sacred mission were the same, but they were a different people, born of the rugged cultures at the edge of the known world.

It is tragic (or perhaps timely) that they returned to Kehjistan when they did. The Zakarum Church had already succumbed to demonic corruption. Travincal and the surrounding city of Kurast had transformed into a cauldron of banditry and suffering.

This, it seems, was precisely the state of affairs Akkhan had warned of. For the crusaders, I imagine that seeing the ailing condition of the Zakarum faith only strengthened their sense of purpose in life.

From what I have gathered, the remaining crusaders are now fixing their gazes to the unplumbed lands of the west to continue their search with even greater voracity.

Multiple crusaders
in region

Plentiful food
and shelter here

Dangers ahead

Grave of a
rebel crusader

Grave of a
crusader

Part Three
Miscellanea

he following comes from the tomes of Deckard Cain. These pages document a broad spectrum of information, from mortal history to the powerful individuals who inhabit the world. Pay heed to everything, Horadrim, for even the most unassuming details may be useful in the days ahead. Knowledge is one of the order's greatest weapons. Wield it carefully.

A Timeline of Sanctuary

At the apex of Zakarum power, the church gathered a veritable army of scholars to document the history of the world as they saw it. I have used this seminal work as the bones from which to build my own timeline, correcting errors as well as removing and adding dates (such as in the pre-history below). Dear reader, keep in mind that this is history at the briefest of glances, a mere tool for understanding whence we have come and where the intertwining paths of fate and destiny may lead us in the future.

Pre-History

The following is based on the apocryphal writings of sages and madmen. After much consideration and scrutiny, I feel this account represents an accurate depiction of the epochs that lay beyond the reach of mortal memory.

Anu and the Dragon

Before time, before even the universe as we know it existed, there was only Anu, the One. This single crystalline entity encompassed all things, including good and evil. Longing for a harmony of essence, it expelled every dissonant and dark aspect of itself. These impurities coalesced into the embodiment of pure evil: Tathamet, the seven-headed dragon.

Within their womb of reality, Anu and Tathamet clashed in a spectacular battle that strained the very fabric of creation. Their final blows sparked an incredible explosion, a cataclysm so violent that it destroyed both beings and birthed the physical universe. This event is something I am afraid a mortal mind will never truly fathom.

The blast left behind an eternal scar called Pandemonium. At the center of this otherworldly realm sat the Worldstone, a monolithic crystal said to be the Eye of Anu.

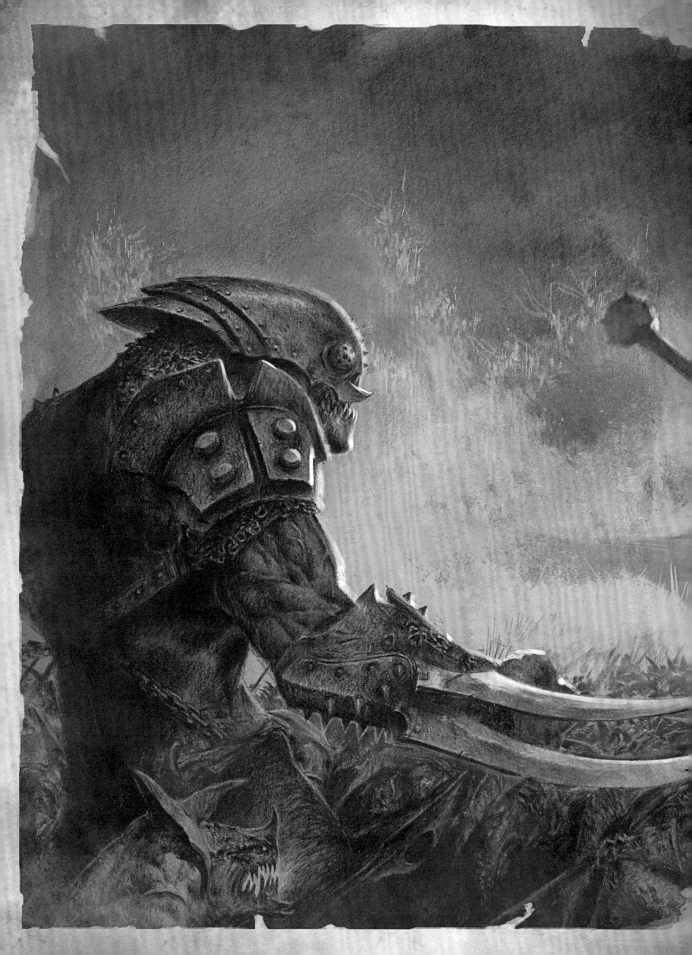

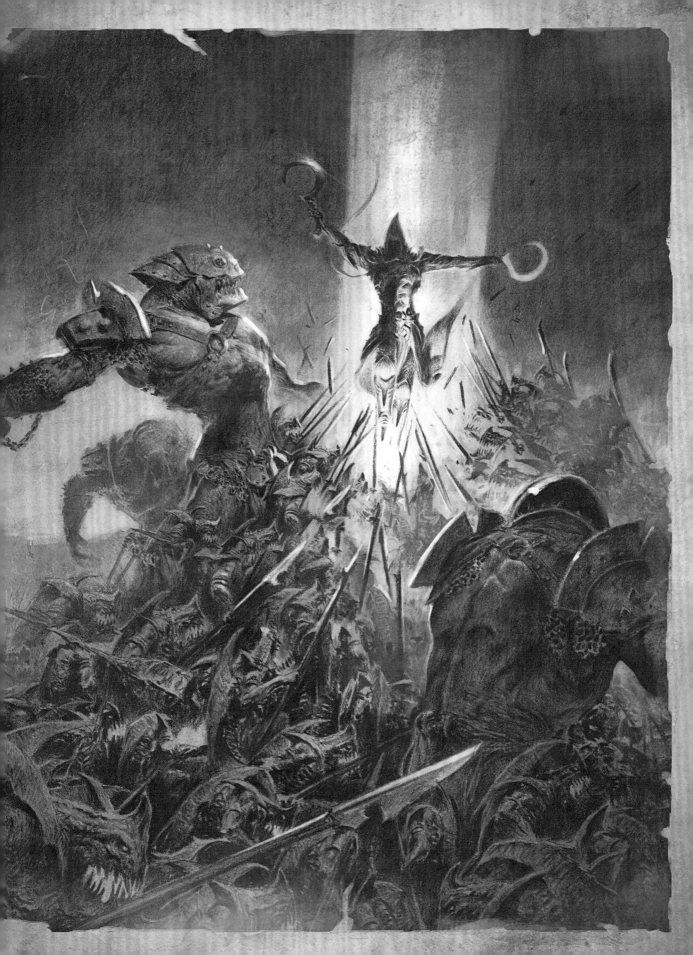

The High Heavens and the Burning Hells

Anu's fragmented spine careened through the infant universe. This remnant of the One became the Crystal Arch, around which the High Heavens thrummed into existence. The Arch resonated life itself, conceiving pulses of sentient energies called angels. The manifestations of Anu's purest aspects—archangels—formed the Angiris Council to govern the brilliant expanses of the Heavens. The members of this ruling body are:

> *Imperius, the Aspect of Valor*
> *Tyrael, the Aspect of Justice*
> *Auriel, the Aspect of Hope*
> *Malthael, the Aspect of Wisdom*
> *Itherael, the Aspect of Fate*

Tathamet's desiccated corpse spiraled through the darkest folds of reality. The Burning Hells manifested from his smoldering body. Demons, in all their forms, were birthed from the Dragon's rotting flesh. Tathamet's seven heads became the seven Evils:

THE PRIME EVILS	*THE LESSER EVILS*
Mephisto, the Lord of Hatred	*Azmodan, the Lord of Sin*
Baal, the Lord of Destruction	*Belial, the Lord of Lies*
Diablo, the Lord of Terror	*Duriel, the Lord of Pain*
	Andariel, the Maiden of Anguish

The Eternal Conflict Begins

From the very moment of their existence, the High Heavens and the Burning Hells clashed in the Eternal Conflict, an apocalyptic war for dominion over all creation. Although the tide of battle ebbed and flowed over the millennia, the war itself was never-ending.

We must understand here that both the High Heavens and the Burning Hells desired complete control of the Worldstone, for it was with this most miraculous artifact that angels and demons had the power to forge worlds in their image. As such, the majority of the Eternal Conflict raged in the twisted heart of Pandemonium. It is said that ownership of the crystal has changed innumerable times over the eons of battle.

The Creation of Sanctuary

As the eons passed, an angel named Inarius grew disillusioned with the Eternal Conflict. Indeed, he saw the war itself as unjust. Thus, he gathered like-minded angels and, shockingly, even demons to his side. Inarius then altered the frequency of the Worldstone, thrusting the crystal into a parallel reality and shrouding it from the eyes of the Heavens and the Hells. There, the renegade angels and demons created Sanctuary, a wondrous paradise world where they could spend eternity in peace.

Birth of the Nephalem

In a most unprecedented act, angels and demons commingled, siring offspring called the nephalem. Born of light and dark, these beings had the potential to become even mightier than their progenitors. In fact, the nephalem were so powerful that Inarius and his comrades feared they might upset the balance of the Eternal Conflict and wreak havoc across the universe.

So it was that the angels and demons debated the fate of their beloved children. Some of them (at one time, even Inarius) considered exterminating the nephalem.

The Purge

Inarius's mate, the demoness Lilith, grew horrified at the thought of losing her offspring. In a fit of ruthless fury, she hunted down the other renegades and slaughtered them one by one. Only Inarius and the nephalem were spared from her fearsome wrath.

Shocked by Lilith's deeds, Inarius banished her from Sanctuary. He could not, however, bring himself to harm the innocent nephalem. He attuned the Worldstone so that it would cause their powers to diminish over time. According to legend, Inarius then disappeared into the wilds of Sanctuary and was not seen again for millennia.

An unknown span of time passed after this series of events. We can assume generations of nephalem lived and died. With their powers dampened and their life spans decreased, they became mortals, completely ignorant of their incredible heritage.

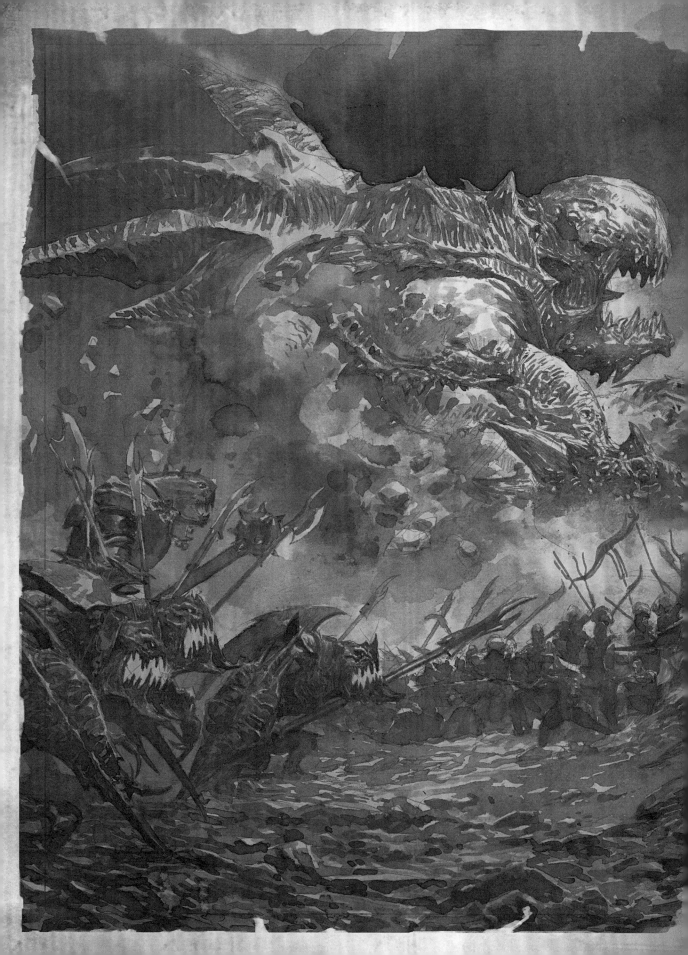

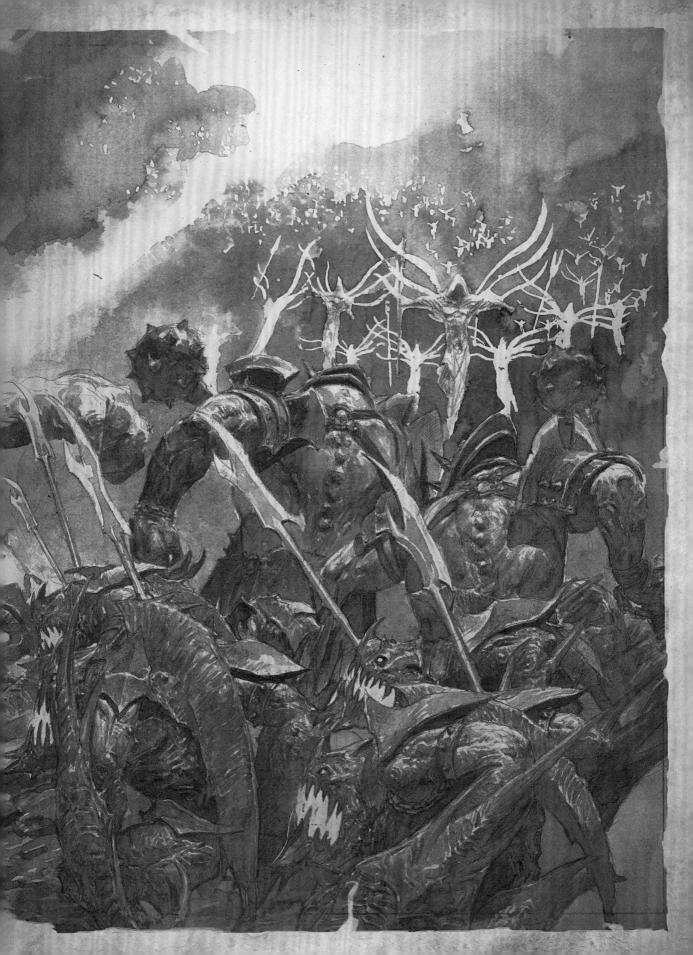

Recorded History

Circa −2300 Anno Kehjistani—
The Dawn of Civilization

Recovered tablets, pottery fragments, and other artifacts indicate that writing, art, and science had by this time become an integral part of humanity's culture. The majority of scholars, myself included, agree that this date marks the rise of the first great human civilization. This kingdom was known as Kehjan (now modern-day Kehjistan).

Circa −2200 Anno Kehjistani—
Formation of the Mage Clans

Records show that the cultures around Kehjan formalized the study of the arcane sciences. This in turn led to the formation and growth of numerous mage clans.

How many of these clans existed remains something of a mystery, but it should be noted that the Vizjerei would make the largest impact on history in the centuries to come. This clan's school of thought revolved around the arts of conjuring, summoning, and communing with spirits.

Circa −2100 Anno Kehjistani—
Ascendancy of the Mage Clans

The increasingly powerful mage clans became a fixture in Kehjan's government. An organization composed of members from each of the major clans—the Al'Raqish, or Mage Council—was formed to rule alongside the kingdom's monarchy and trade guilds.

−1992 Anno Kehjistani—
Sanctuary Revealed

Overcome with frustration and rage at the loss of his family, a little-known Vizjerei sorcerer named Jere Harash summoned the first demon into Sanctuary. His fellow mage clan members quickly perfected this dark art, establishing demonology and the controlling of Hell's minions as the basis of their power.

Of greater importance, however, is that Harash's act alerted the Burning Hells to Sanctuary's existence. It was at this terrible moment when the Prime Evils learned of mankind and its potential to be used as a weapon against the Heavens. Thereafter, the Lords of the Burning Hells began formulating a devious plan to corrupt humanity.

Mark this date well, dear reader. Nearly all things that come afterward are, at least in some small way, a consequence of Harash's reckless summoning.

—1880 Anno Kehjistani—
The Temple of the Triune

The influence of the Prime Evils pervaded the lands of Kehjan through a seemingly noble organization: the Temple of the Triune. This cult was based on the worship of three benevolent deities (who, in fact, were actually the three Prime Evils in subtle guises). The Triune posited that through selfless worship and devotion, the cult's wondrous deities could improve life. In time, the religion's numbers swelled.

—1820 Anno Kehjistani—
The Veiled Prophet and the Cathedral of Light

Inarius, assuming the identity of a figure named the Prophet, emerged to combat the Triune's burgeoning influence. To do so, he formed a separate faith called the Cathedral of Light. This religion was founded on the tenets of tolerance, cooperation, and unity.

In time, both the Cathedral of Light and the Triune achieved immense influence over the people of Kehjan.

—1809 Anno Kehjistani—
The Sin War

An ideological battle between the followers of the Triune and the Cathedral of Light erupted, polarizing Kehjani society. So began what is known as the Sin War.

Understand that this was no mere religious struggle. The entire conflict was a proxy war between the Prime Evils and Inarius for the very souls of mankind.

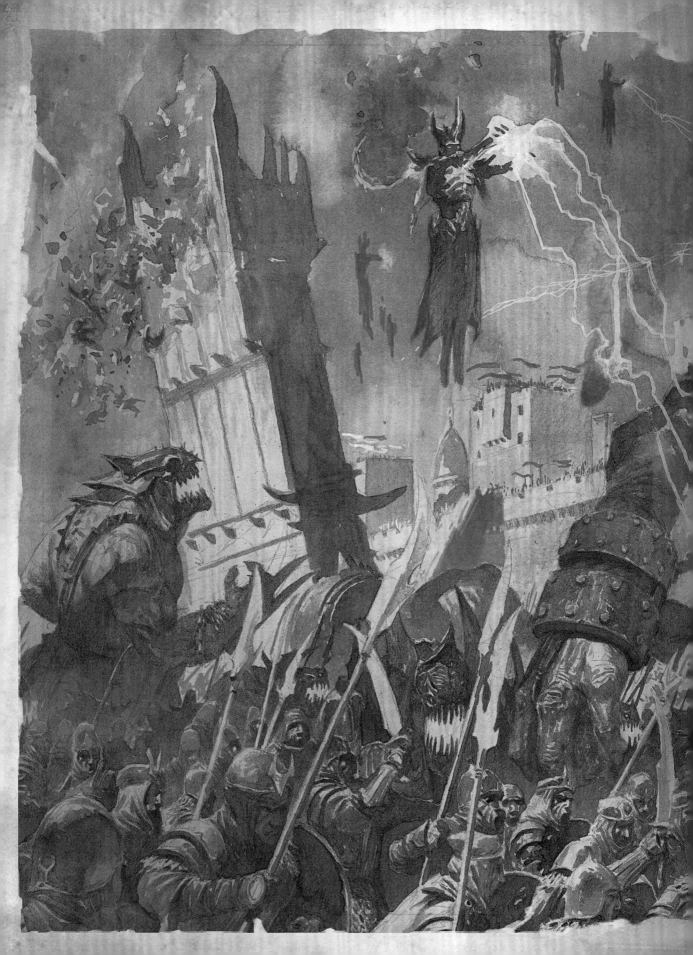

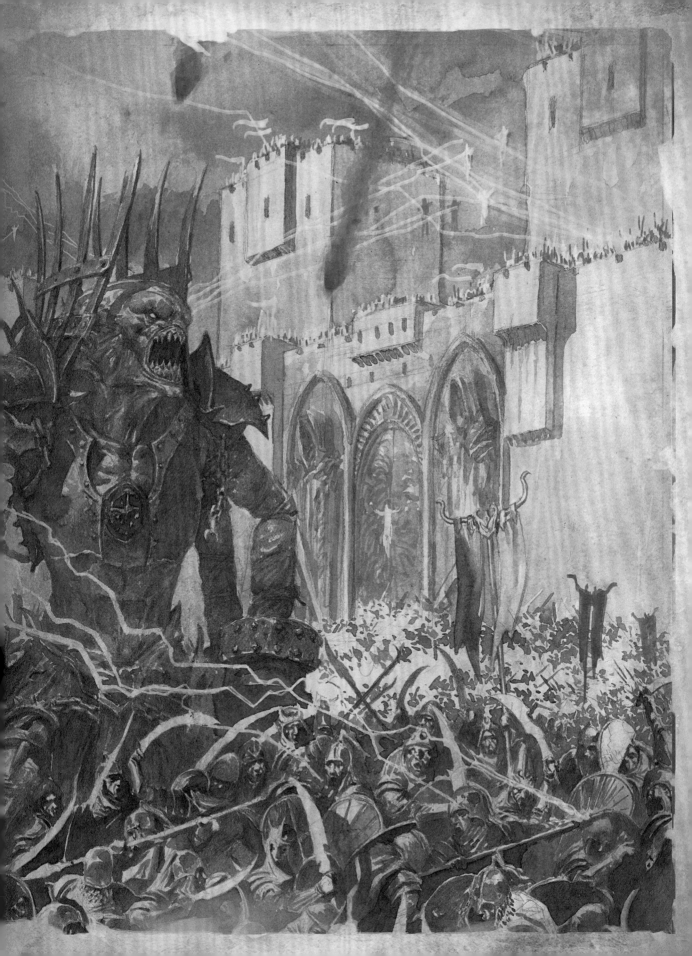

Unbeknownst to either the Prime Evils or Inarius, the demoness Lilith had returned to Sanctuary to protect her children from the Triune and the Cathedral of Light. She awakened the nephalem powers in a man named Uldyssian ul-Diomed, who went on to do the same for other humans. These individuals—called the edyrem—waged war against the Triune and the Cathedral of Light, for they saw both organizations as the source of Kehjan's strife.

These battles proved catastrophic, drawing armies from the Burning Hells and the High Heavens to the mortal world. Uldyssian unleashed the full fury of his might, driving back the invading armies of angels and demons. But in doing so, he also realized that the untamed nephalem energies were threatening to destroy the world. So it was that he sacrificed his life to re-attune the Worldstone, thereby ridding humans of their budding nephalem powers.

It is vital to note here that the Heavens deliberated on mankind's ultimate fate. The final vote, cast by Archangel Tyrael, is what spared us from extermination. Following this, the angels brokered an unlikely truce with the Lords of the Hells. In summation, both sides agreed that they would not further interfere with the lives of humans.

The memories of the edyrem were then erased, and lies were crafted to hide the truth of the nephalem, angels, and demons from the rest of mankind. But some would remain aware of the dark era that was the Sin War. It is through their stories, passed down from generation to generation, that we know the truth of this catastrophic conflict.

What of Lilith? During the war, Inarius had again banished her from Sanctuary. I have seen no evidence of her return. As for Inarius, the angels gave him to the Prime Evils as part of the pact between Heaven and Hell. It is said he suffered eternal torment thereafter.

—1799 Anno Kehjistani—
The Golden Age of Magic

Believing that the Sin War was merely a clash of faiths, the majority of Kehjan's populace turned away from religion. Indeed, the people even went so far as to rename Kehjan to Kehjistan as a means to distance themselves from the terrible conflict.

More and more, the people looked to the mage clans for guidance, for they had always placed reason and practical research above all else. A golden age of magic and enlightenment unfolded, an age of wonders unlike anything the world had yet seen.

Certain members of the clans remained aware of the truth behind the Sin War, and rules and regulations were imposed that strictly forbade the art of demonology.

—264 Anno Kehjistani—
Prelude to the Mage Clan Wars

This golden age waned when the other mage clans came to a chilling discovery: the Vizjerei sorcerers were continuing the outlawed practice of demonology. This revelation sparked a series of covert assassinations and political intrigue aimed at stripping the Vizjerei of their power. These machinations slowly ate away at the heart of the mage clans.

—210 Anno Kehjistani—
The Mage Clan Wars

Following an increase in hostilities between the mages, bloodshed erupted in the streets of Kehjistan's major cities. This violent tide surged into an all-out war pitting the Vizjerei against their rival clans. It is said that spectacular battles flared across the kingdom as the era's preeminent mages unleashed the full fury of their powers against one another.

—203 Anno Kehjistani—
Bartuc and Horazon

Pushed to the brink of annihilation by the other clans, the Vizjerei unleashed their last desperate weapon: demons. Wielding the minions of Hell, the sorcerers obliterated their enemies, driving them back behind the walls of the empire's ancient capital, Viz-jun.

It was then that disaster struck. The Vizjerei's Ruling Council dismissed one of its most formidable members, Bartuc, for acts of depravity. This infamous figure, also known as the Warlord of Blood, turned against his own clan and ignited civil war.

A terrible battle ensued between the sundered halves of the Vizjerei clan at the gates of Viz-jun. Bartuc's brother, Horazon, emerged to strike down his ruthless sibling. Although he succeeded in vanquishing the Warlord of Blood, the cost was unimaginable. The battle reduced the capital to smoldering rubble, killing tens of thousands in the process.

So ended this dark and terrible conflict. So ended the reign of the mage clans. Broken by the wars, they would never again rise to such heights of power and glory.

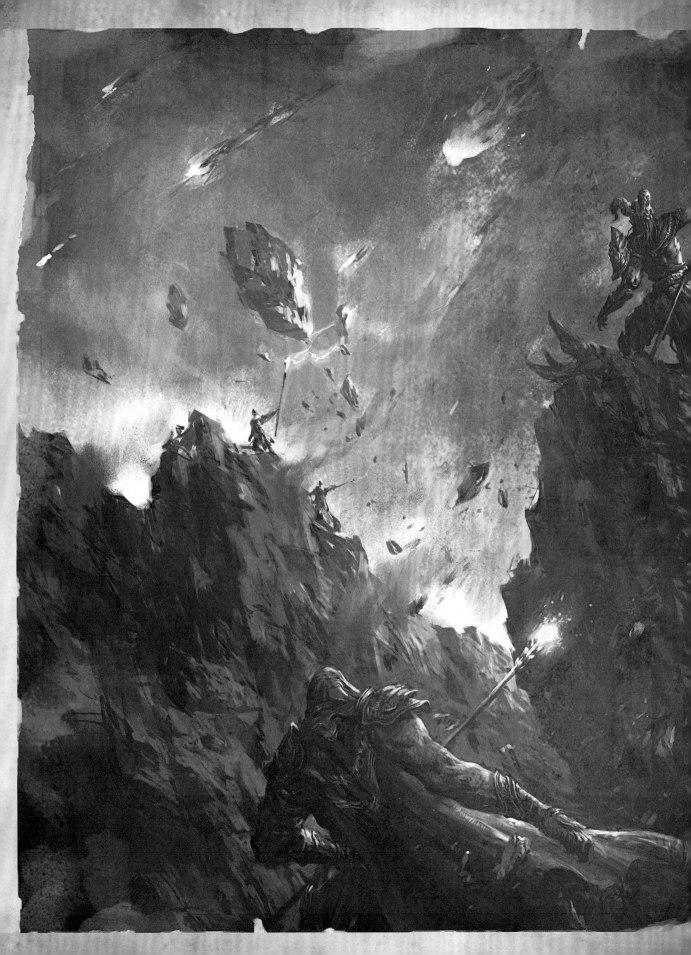

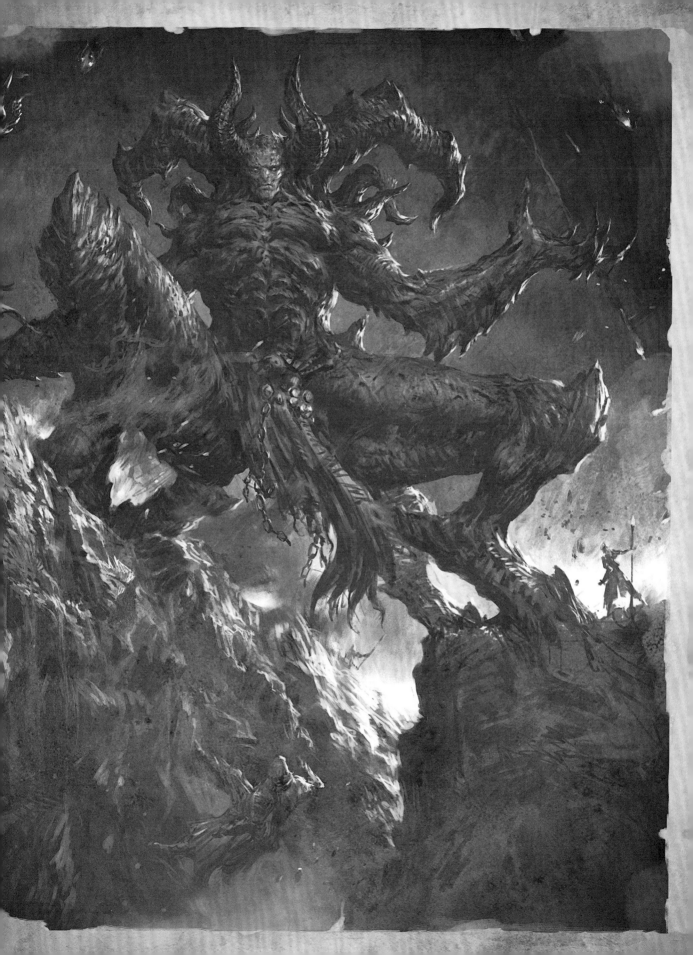

0 Anno Kehjistani—
Akarat and the Zakarum Faith

The untold death and suffering wrought during the Mage Clan Wars pushed mankind away from the arcane sciences. The passage of centuries saw humans once again explore faith and religion as a source of meaning and purpose. A number of religious figures arose during this era, but there is one in particular who merits attention: Akarat.

In the mountains of Xiansai, this wandering ascetic saw visions of what he claimed to be the angel Yaerius. From this encounter, Akarat formulated his ideas about the inner Light within all humans. Every man and woman, he claimed, was bound together in a spectrum of cosmic radiance that was the foundation of existence itself.

His ideas formed the core tenets of what would become known as the Zakarum faith. Akarat spread his teachings and garnered the support of a small band of followers, but for the next thousand years, his philosophies would flounder in obscurity.

964 Anno Kehjistani—
The Dark Exile

Believing the Prime Evils had abandoned the Eternal Conflict in favor of corrupting humanity, the Lesser Evils waged a catastrophic war against their superiors. The uprising, led by Azmodan and Belial, rocked the Burning Hells to the core. Following a violent series of engagements, the usurpers banished the Prime Evils to Sanctuary.

I often wonder how Diablo and his brethren reacted upon reaching the mortal realm. It is entirely possible that, for a time, they cursed their fates. However, I am of the belief that the Prime Evils quickly saw their exile as an unexpected and fortuitous chance to corrupt the hearts of mankind. So it was that they began turning brother against brother and nation against nation, fomenting unrest throughout Kehjistan.

1004–1010 Anno Kehjistani—
The Hunt for the Three

Having secretly watched the mortal world for centuries, Archangel Tyrael learned of the Prime Evils and their machinations. Understand, dear reader, that he did not directly oppose the demons, for he feared his actions would alert the Heavens to what was transpiring on Sanctuary. Tyrael knew that if such an event occurred, the angels might very well decide to exterminate mankind once and for all. And so Tyrael forged the Horadrim to serve as his hand in the mortal world, a secret order composed of members from the disparate mage clans.

Tyrael bestowed upon the Horadrim three crystalline soulstones (supposedly cleaved from the Worldstone itself). He tasked the great mages with a perilous mission: to hunt down the Prime Evils and imprison them within the recesses of the soulstones.

First, the mages captured Mephisto in one of Kehjistan's sprawling urban centers. The demon's Sapphire Soulstone was given to the humble Zakarum order for safekeeping.

Next, the Horadrim harried Baal and Diablo across the Twin Seas and into the western lands. In the deserts of Aranoch, they confronted the Lord of Destruction. Although the mages prevailed against the demon, Baal's Amber Soulstone was left shattered.

The order's leader, Tal Rasha, selflessly used his own body to contain the Lord of Destruction's raging essence. So it was that, with heavy hearts, the Horadrim sealed away their noble leader within a subterranean tomb.

In the wake of this tragedy, Jered Cain took leadership of the bruised and battered mages. Together, the Horadrim struck out to imprison the last of the Prime Evils: Diablo.

1017 Anno Kehjistani— The Building of Travincal

The Zakarum began constructing Travincal, a fortified temple complex in Kurast that would house Mephisto's wretched soulstone. The enormous undertaking brought sudden notoriety to the order and sparked immense interest in Zakarum teachings. Indeed, in a matter of months, throngs of Kehjistan's downtrodden masses flocked to Travincal to lend their aid. It is rumored that the temple's construction was finished in just over a year.

In hindsight, it is easy to see why interest in the faith took hold so quickly. Corruption and intolerance had eaten away at the foundations of society, and the common folk found inspiration and hope in the Zakarum's tenets of self-empowerment and equality.

1019 Anno Kehjistani— The Fall of Diablo

Led by Jered Cain, the Horadrim tracked Diablo to Khanduras and defeated him in a battle that nearly cost them their lives. They buried the Lord of Terror's Crimson Soulstone in a labyrinthine cave system near the river Talsande. The Horadrim who remained in Khanduras (including Jered) built a small monastery and a network of catacombs over the burial spot.

1025 Anno Kehjistani—
The Founding of Tristram

The Horadrim in Khanduras settled the land near their monastery and founded the quaint
village of Tristram. In the years that followed, the town attracted farmers and settlers from the
surrounding region.

1042 Anno Kehjistani—
Rise of the Zakarum Church

Despite the capture of the Prime Evils, Kehjistani society remained in a dire state, plagued by
famine and disease. Commoners increasingly viewed the ruling elite as the cause of their ills.
Rebellion was poised to tear the empire asunder.

It was at this critical point that a new Kehjistani emperor, Tassara, converted to the populist
(and increasingly influential) Zakarum faith. In doing so, he gained the adoration of the
masses and strengthened his hold over the region.

Zakarum became the dominant religion in Kehjistan. The empire's capital was moved
from ancient Viz-jun to Kurast. Tassara worked to codify the faith's beliefs and elect the first
Que-Hegan—the highest divine authority of the religion. At this date we begin to see records
describing Zakarum in terms of an organized and structured church.

Over the next three years, Tassara's budding popularity was overshadowed by that of his
childhood friend: the famous military general and zealous Zakarum convert Rakkis. After
defeating a group of renegade nobles who sought to overthrow the church, the general became
a legend among the masses. It is said that Rakkis used his burgeoning influence to replace
government officials with Zakarum archbishops, thereby upsetting the balance of power
in the region.

1045 Anno Kehjistani—
Rakkis and the Western Campaign

Wary of Rakkis's growing popularity, Emperor Tassara dispatched the general on a grand
mission to spread the Zakarum faith to the untamed lands of the west. Once the general and his
most loyal forces had gone, the emperor secured his dominion over Kehjistan.

1045 Anno Kehjistani—
The Crusaders and the Eastern Campaign

Around the time Rakkis departed Kehjistan, a cleric by the name of Akkhan forged an order known as the crusaders. He sent them on a mission to the east to seek out a means (however it manifested) to purify the Zakarum faith. The impetus for this campaign stemmed from Akkhan's belief that the church had strayed from the original teachings of Akarat.

1060 Anno Kehjistani—
The Founding of Westmarch

After years of warring with the scattered tribes and civilizations of the west, Rakkis ended his journey by founding Westmarch and becoming its king. This nation was so named in honor of the general's long and arduous campaign.

1080–1100 Anno Kehjistani—
The Passing of the Horadrim

All records indicate that around this time the Horadric monastery was abandoned and left to ruin. Tristram, however, continued to prosper, although it would always remain a small settlement. Generations of townsfolk would live and die there, completely unaware of the Crimson Soulstone buried beneath them.

By 1100, the Horadrim's activities in other parts of the world had ceased. It appears that the order, with no quests left to undertake, had at last dissolved and faded into legend.

1150 Anno Kehjistani—
The Zakarum Reformation

A bold new Que-Hegan, Zebulon I, initiated a sweeping reformation of the Zakarum Church. Rumor has it he did so inspired by visions from Akarat himself. Zebulon urged the faith to align with its more ascetic and humble origins. This act was well received by the people, and it sparked a surge in independent worship, secularism, and mysticism.

Note, however, that the orthodox archbishops of the Zakarum High Council viewed this turn of events as a grievous erosion of the church's power. Regardless, they were unable to stop the tide of change due to Zebulon's revered status with commoners.

1202 Anno Kehjistani—The date of Deckard Cain's birth.

1225 Anno Kehjistani—
The Zakarum Inquisition

With the ascension of Que-Hegan Karamat, the Zakarum High Council fulfilled its long-sought goal to unravel Zebulon I's reformations. The archbishops manipulated the church's new leader into launching a strict system of worship that imposed harsh punishments on nonconformists. Missionary work took on increasingly martial overtones.

This, dear reader, all culminated in the heinous Zakarum Inquisition. The church purged various sects of the faith and brutally suppressed other religions, such as Skatsim.

1247 Anno Kehjistani—
Order of Paladins

Unwilling to continue the inquisition's terrible methods, a group of Zakarum paladins broke away from the church. They vowed that their new Order of Paladins would protect the innocent and fight the corruption that darkened the once-brilliant heart of their religion. These rebels ventured into western lands to begin their noble campaign.

1258 Anno Kehjistani—
The Crowning of King Leoric

At the behest of the Zakarum High Council, the Kehjistani lord Leoric set out to govern the land of Khanduras. This decision, it seems, was due in large part to the urgings of a powerful archbishop named Lazarus.

The ever-dutiful Leoric traveled to Khanduras and declared himself its king. He converted Tristram into the region's capital and even transformed the crumbling Horadric monastery into a glorious Zakarum cathedral.

It is vital to note that Lazarus accompanied Leoric on this journey. Upon arriving in Tristram, the archbishop secretly released Diablo from imprisonment. Indeed, it appears that this had been the archbishop's goal all along. I believe he was under Mephisto's influence before setting out for Tristram, where he then began to serve Diablo.

Once freed, Diablo subtly attempted to possess Leoric without success. I believe this occurred over a number of years, for Tristram experienced a period of peace and tranquility under its new king. Eventually, however, the Lord of Terror began stripping away at the king's sanity, sending the noble ruler into the depths of madness.

1263 Anno Kehjistani—
The Darkening of Tristram

Increasingly deranged, Leoric began seeing enemies in all places, even among his friends and allies. He ordered the execution and torture of innocent townsfolk. The king also declared war on neighboring Westmarch, believing that the region was plotting against him. Along with a number of loyal followers, Leoric's eldest son, Aidan, departed for Westmarch to wage his father's ill-begotten campaign.

Lazarus secretly kidnapped Leoric's youngest son, Albrecht, and presented him before Diablo. The Lord of Terror possessed the boy, twisting the prince's body into a monstrous demonic form. Albrecht's disappearance drove Leoric into an even graver state of paranoia, and he lashed out against all those whom, in his madness, he deemed responsible for his son's mysterious fate.

Westmarch's superior armies crushed the forces of Leoric. Lachdanan, captain of the king's soldiers, returned from the disastrous conflict only to see his home in shambles. It was this brave and tragic man who finally slew Leoric, thereby putting an end to the king's reign. Thereafter Lachdanan and his comrades buried Leoric's body somewhere deep in the labyrinthine catacombs beneath Tristram.

Demons continued terrorizing the people of Tristram. All seemed lost until Aidan returned from Westmarch. Hoping to find his missing brother, the young warrior and his allies forged into the depths of the cathedral. During this harrowing journey, Aidan was forced to strike down his own father, who had been reanimated as the Skeleton King. The prince also vanquished Lazarus and a number of fetid demons. Ultimately, Aidan slew Diablo, only to find that in doing so, he had also killed Albrecht.

Nihlathak, the barbarian elder who helped
Baal bypass the guardians at Mount
Arreat's summit. In large part, it was due to
his ill-begotten actions that I was later
forced to destroy the Worldstone.

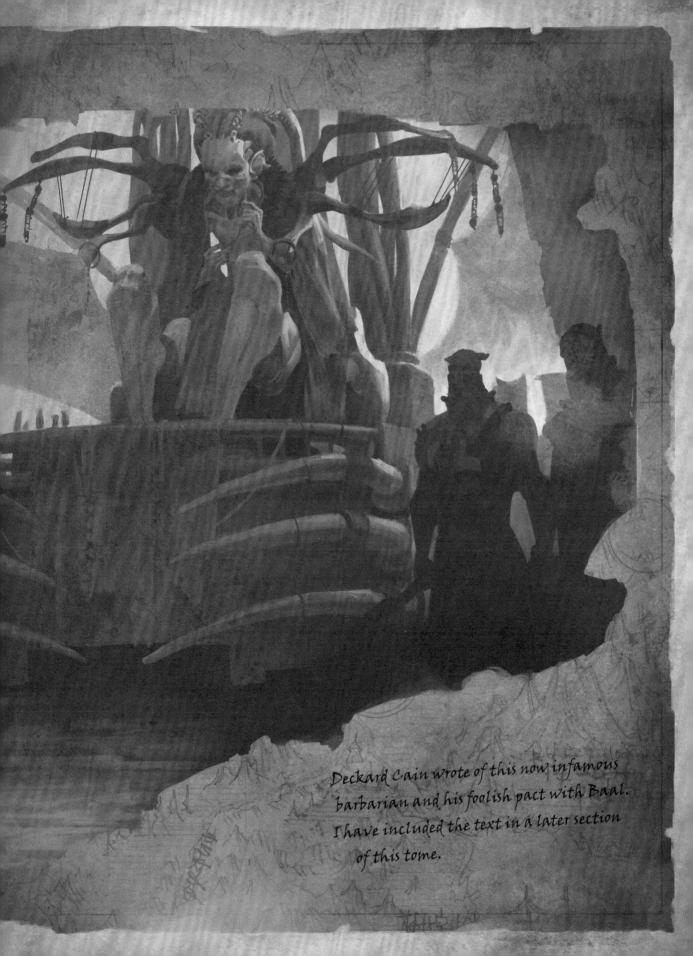

Deckard Cain wrote of this now infamous
barbarian and his foolish pact with Baal.
I have included the text in a later section
of this tome.

In the weeks that followed, Aidan became increasingly distant and withdrawn. He sought solace from only one individual in all of Tristram—the witch Adria. I later learned the cause of Aidan's troubles: in a courageous (albeit reckless) act to contain Diablo's essence, he had plunged the Crimson Soulstone into his own body.

The sad truth here is that Aidan would eventually succumb to the Lord of Terror's influence. Known henceforth as the Dark Wanderer, he departed Tristram and ventured east to liberate Baal and Mephisto. Adria left the town as well and traveled to Caldeum, where she eventually gave birth to a daughter named Leah.

As for Tristram, demons returned to the town en masse and slaughtered the inhabitants. Indeed, there was no respite or salvation for these people, only death and suffering. I survived this tragedy, though I was imprisoned by the foul minions of the Burning Hells.

1264 Anno Kehjistani— The Dark Wanderer

Archangel Tyrael learned of the Dark Wanderer and his plans. The Aspect of Justice confronted him in the tomb of Tal Rasha, but the archangel was overcome by the combined might of the Wanderer and the newly liberated Baal. The two Prime Evils imprisoned Tyrael in the ancient tomb.

It was around this time that a band of heroes rescued me from Tristram. I helped them as best I could. Together we freed the rogue monastery of Eastgate Keep from demonic influence and then followed the Wanderer's path to the tomb of Tal Rasha. There, we released Tyrael from his bonds and swiftly continued our journey.

It is important to note here that during this time, my companions faced and defeated Andariel and Duriel, for it appears that these Lesser Evils had decided to aid Diablo.

The Dark Wanderer eluded us at every step. He managed to free Mephisto within Travincal. It was then that the last vestiges of Aidan disappeared and Diablo took on a more fitting demonic form. He ventured into the Hells to muster his followers, while Baal set out to Mount Arreat, home of the Worldstone. Mephisto remained in Travincal to continue asserting his influence over the Zakarum Church and its frenzied followers.

I cannot overstate the momentous events that followed.

Against all odds, my companions defeated both Mephisto and Diablo (the latter within the very depths of the Burning Hells) and captured them within their respective soulstones. The heroes went on to sunder the crystals in the blistering Hellforge, thereby casting Mephisto's and Diablo's essences into what I speculate to be an otherworldly realm called the Abyss.

In the wake of this victory, my companions fixed their gaze on Baal. The Lord of Destruction had begun rampaging toward the sacred summit of Mount Arreat. You must understand that from the moment of Sanctuary's creation, this mountain had acted as a protective shell around the Worldstone. It was this—the Heart of Creation itself—that Baal planned to find and corrupt.

1265 Anno Kehjistani— The Lord of Destruction

Atop Arreat, my companions defeated Baal, but not before the demon had tainted the Worldstone with evil. Dear reader, understand that by doing so, the Lord of Destruction had damned humanity to darkness. Our fall to evil appeared inevitable.

Only Tyrael knew of our terrible fate. Steeling himself, he cast his angelic blade, El'druin, into the Worldstone. The resulting explosion shattered the crystal and leveled Mount Arreat. I have come to believe even Tyrael was destroyed in the process.

But it must be stated that this act, however catastrophic it was, thwarted Baal's designs for humanity.

This is true. It would take many years for my essence to rematerialize, thus allowing me to return to the High Heavens.

1265 Anno Kehjistani—
Caldeum Ascendant

Once it was revealed that demons controlled the Zakarum Church, public opinion of the organization plummeted. Indeed, Kurast and Travincal had suffered greatly with the Dark Wanderer's arrival in the city and the events that followed.

After a series of deft political maneuvers, Emperor Hakan I moved the capital of Kehjistan to Caldeum and secured power there. It should be stated that this was no easy feat. Powerful trade groups controlled much of Caldeum, and the emperor's reputation had suffered in the wake of Zakarum corruption. But Hakan was a brilliant diplomat, and he used his talents to forge alliances and gain the respect of the city's nobility.

In the years that followed, Caldeum also proved to be a sanctuary for the remaining members of the Zakarum Church. These individuals flooded into the city to begin their lives anew. It was at this time that Caldeum, which had always been an important city, became perhaps the most powerful and influential urban center in all of Sanctuary.

During this time, in the year 1272, Deckard Cain traveled to Caldeum and took Leah into his care.

1272 Anno Kehjistani—
The First Ones

Long before I encountered them, a group of young scholars discovered a hidden archive of Horadric texts in the city of Gea Kul. They brought these lost tomes before the famed litterateur Garreth Rau, who was so amazed by the find that he took lead of the scholars and set out to reforge the Horadrim. The members of this fledgling order became known as the First Ones. There was, however, a darker truth to Rau and his seemingly noble plans: he was beholden to the will of Belial, the Lord of Lies. Gradually, this man used his influence and power to transform Gea Kul into a warren of torture and hopelessness.

With young Leah at my side, I uncovered Rau's ultimate goal while investigating rumors of the re-formed Horadrim. He planned to resurrect an army of fallen sorcerers entombed beneath Gea Kul—victims of a horrific battle waged during the Mage Clan Wars. Alongside the brave uncorrupted members of the First Ones and Mikulov, a monk from the kingdom of Ivgorod, Leah and I helped bring Rau's schemes to an end.

With the passing of Deckard Cain, I have continued his work. Soon this task will fall to you, Horadrim.

Over these twenty years, Cain dedicated his life to investigating the End of Days.

1285 Anno Kehjistani – The Prime Evil

After the fall of the Prime Evils, Belial and Azmodan plotted an invasion of Sanctuary. I broached this subject with the Angiris Council, but they did not heed my warnings. Therefore, I made my decision to join the ranks of mankind as a mortal.

When I fell to Sanctuary, my dissipating angelic powers roused the dead outside New Tristram, a settlement built near the remains of the old town. The ordeal left me powerless to help the townsfolk defend their homes. No, salvation came from a different source: a brave mortal whose nephalem powers had awakened. Sadly, Cain fell during these events. His loss will be felt for many years to come.

Together with Leah, the nephalem, and other valorous mortals, I set out to Caldeum, where Belial had assumed the guise of a new emperor, Hakan II. Leah's estranged mother, the witch Adria, soon joined us. Her guidance led us to the Black Soulstone, an incredible artifact that contained the essences of five of the seven Lords of the Hells. After capturing Belial and Azmodan, Adria had us believe that she would destroy the crystal, thus banishing evil from existence once and for all.

The valiant nephalem defeated Belial in Caldeum, and the Lord of Lies was drawn into the recesses of the Black Soulstone. My companions and I then set out for Arreat Crater, where Azmodan had unleashed the legions of Hell upon the mortal world.

Many lives were lost. Many horrors were faced. While other mortals cowered, the nephalem forged onward, striking down Azmodan. As with Belial, the last demon lord was contained within the Black Soulstone. A glorious victory lay ahead. . . . And that was when Adria unveiled her true allegiance.

For at least twenty years, she had served Diablo. She had conceived Leah, whose father was the Dark Wanderer, for the sole purpose of acting as a vessel for the Lord of Terror. Diablo consumed the essences of the other Lords of the Hells trapped within the Black Soulstone, thus becoming the Prime Evil. Possessing Leah's body, the terrible entity stormed the High Heavens and laid waste to the angelic realm.

Atop the great Crystal Arch, the nephalem finally vanquished the Prime Evil and cast the entity from the Heavens. The Black Soulstone, however, escaped destruction. Still roiling with the Prime Evil's essence, it was placed in the care of the Angiris Council.

This act marked the beginning of a new era in the history of angels and mortals alike. But whether or not Diablo's reign of terror had truly come to an end remained unclear.

Factions of Sanctuary

Amazons

* Leader: *Queen Xaera*
* Base of Operations: *Temis, Skovos Isles*
* Standing: *Active*
* Number of Members: *Est. 5,000 (fully trained soldiers of the amazon caste)*

The amazons are an elite martial caste of the Askari culture. Tales of their almost preternatural skill with bows, javelins, and spears are well-known throughout Sanctuary. The highly trained members of this caste fulfill a range of duties, from defending the borders of their sun-drenched homeland, the Skovos Isles, to guarding the vast Askari merchant fleets that sail to the far corners of the world.

It should be noted here that the amazons are not merely soldiers. They are bound to the matriarchal Askari government. Two queens reign over the Skovos Isles, one of whom heads the amazons. The other monarch rules a caste of mystics and spiritual leaders known as the oracles. This has been the way of things since ancient times.

Assassins

* Leader: *Unknown*
* Base of Operations: *Unknown*
* Standing: *Active*
* Number of Members: *Unknown*

Mystery shrouds the assassins (also known as the Viz-Jaq'taar or the Order of the Mage Slayers). The very name of their order is whispered in hushed and fearful tones by those who practice magic. I have met a few of these assassins, but the truth is that I still know very little concerning the group's rites, numbers, and leadership What I am aware of, however, is this: after the disastrous Mage Clan Wars, the Vizjerei leaders created the Viz-Jaq'taar to watch over all sorcerers and hunt down any foolish enough to delve into demonology or other outlawed practices.

To avoid the potentially corruptive influence of magic, assassins were strictly forbidden from directly wielding arcane energies. Instead, the members were instructed to hone their bodies into weapons and employ ingenious devices and enchanted traps to match the powers of their sorcerous enemies.

Barbarian Tribes

* Leader: *Varied (individual chiefs lead each tribe)*
* Base of Operations: *Mount Arreat (formerly)*
* Standing: *Active*
* Number of Tribes: *Est. 32 (formerly)*

Once, there were numerous barbarian tribes, many of which had existed since before recorded history. Each one traced its lineage back to the mighty nephalem Bul-Kathos. Each one sang epic sagas of its own great warrior ancestors. For millennia, these proud and indomitable tribes lived around Mount Arreat, a place considered sacred to the barbarian people. Indeed, despite whatever blood feuds or rivalries existed among the groups, they were all devoted to protecting the mountain.

In the year 1265, tragedy befell the mighty barbarians. Arreat was torn asunder in a catastrophic explosion, wiping entire tribes from existence. Ever since that apocalyptic day, few barbarian enclaves have remained at the smoldering corpse of the mountain. Most have disbanded entirely, their members scattered like leaves in the wind. It is said they search the world for a new purpose—a new vigil—to give their lives meaning.

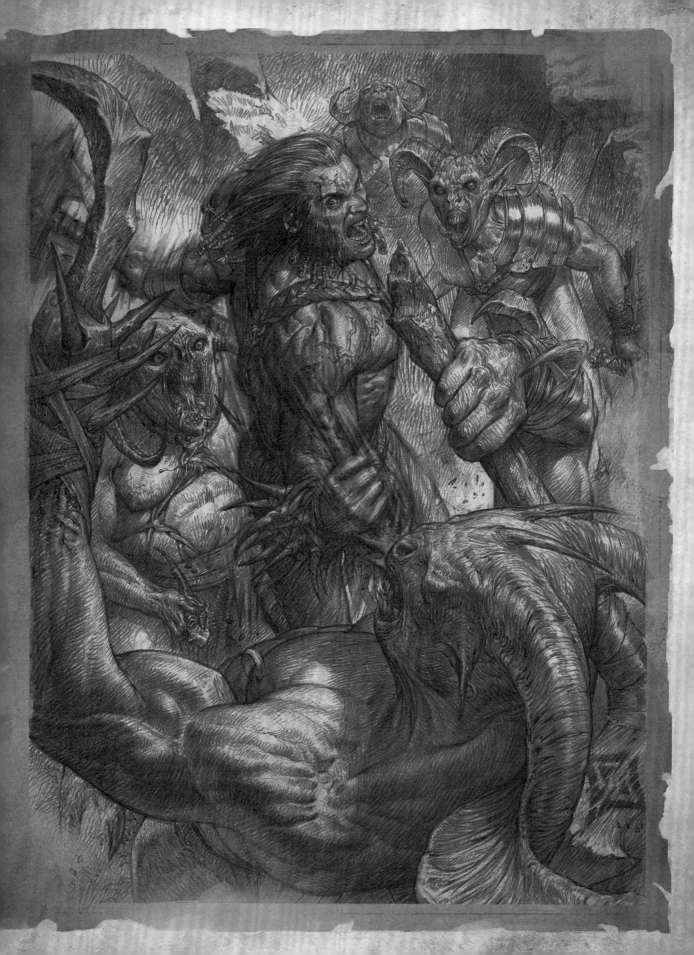

Council of Elders

* Leader: *Shared among council members*
* Base of Operations: *Harrogath*
* Standing: *Inactive*
* Number of Members: *13*

The Council of Elders (sometimes called the Elders of Harrogath) was an order of venerated and sage barbarians. From passages I have found in the ancient <u>Scéal Fada</u> tome, it appears this group came into being in the early days of the barbarian civilization. Over the generations, the council provided guidance to the myriad tribes that lived in Mount Arreat's shadow. When Baal launched his assault against the barbarians in 1265, nearly all the Elders sacrificed themselves to cast a protective barrier around the bastion of Harrogath. To fully appreciate the council's act, you must understand that Harrogath was Arreat's last defense—the only place that stood between the Lord of Destruction and the mountain's sacred summit.

Only one Elder did not take part in this selfless act. His name was Nihlathak, and I have written of him elsewhere. Suffice it to say, Baal's invasion brought an end to the Council of Elders. Now that the barbarian tribes are in disarray, I do not know when or if the order will return.

The Coven

* Leader: *Maghda*
* Base of Operations: *Unknown*
* Standing: *Active*
* Number of Members: *Est. 500*

Mark the Coven well, for it represents one of the greatest threats to our world. I believe this depraved group to be an offshoot of the ancient Triune. There are, however, some notable differences between the two. Unlike the old Triune, the Coven makes no attempt to hide its association with demons, its merciless torture methods, or its grotesque rituals. Secondly, I have suspicions that the Coven serves the Lesser Evils Azmodan and Belial, whereas the ancient Triune bowed to the will of the Prime Evils.

This is merely speculation on my part, but I feel it is important to write here. After all, the Lesser Evils very likely have sinister designs for our world, plans that may soon unfold. As such, we should watch the Coven's activities with utmost scrutiny.

Based on my recent experiences battling the Coven, I believe its membership far exceeded Cain's estimate.

Crusaders

* Leader: *Akkhan (formerly); currently no centralized leadership*
* Base of Operations: *None*
* Standing: *Active*
* Number of Members: *Est. 300-400*

The crusader order arose in the eleventh century Anno Kehjistani, a time when the world was undergoing fundamental changes. The Zakarum Church had become the dominant religion in Kehjistan. Rakkis had set off on his grand campaign to the west. Amid these earth-shaking events, the Zakarum cleric Akkhan began noticing subtle signs that darkness was eating away at the heart of his religion. He formed the order in reaction to this burgeoning corruption. The crusaders, holy warriors of incredible martial prowess and determination, traveled east to search for a means to purify the Zakarum faith. Over two centuries later, this organization still exists, its adherents unwavering in their desire to fulfill Akkhan's charge.

One subject I feel it prudent to elaborate on here is why the order traveled east specifically. I myself believe that the crusaders' destination was tied to the life of Akarat, founder of the Zakarum faith. Some of the church's more apocryphal writings (such as the scrolls of Sarjuq) say that he was last seen wandering into the eastern lands beyond Kehjistan's borders. I have no doubt Akkhan was aware of these stories. Perhaps he sent his followers to that corner of the world in the hopes they would find some as yet undiscovered writings or relics left behind by Akarat. This is mere speculation on my part, but I find it an adequate explanation for the course taken by the crusaders.

See Deckard Cain's more intricate account of this order, which I have included in the 'Fate of the Black Soulstone' section.

Druids

* Leader: *Greenwalker Ciódan*
* Base of Operations: *Túr Dúlra, Scosglen*
* Standing: *Active*
* Number of Members: *Unknown*
*(although I estimate that at least 500 high-ranking warriors
watch over and guide much of druidic culture)*

The druids are a most intriguing order, a collective of warrior-poets who inhabit the verdant forests of Scosglen. They live by the Caoi Dúlra, a philosophy passed down by the nephalem Vasily that exhorts oneness with the natural world. The druids are so tied to the land that they can commune with animals and even plants, calling on their aid in battle. I have witnessed these feats firsthand and know them to be more than legend.

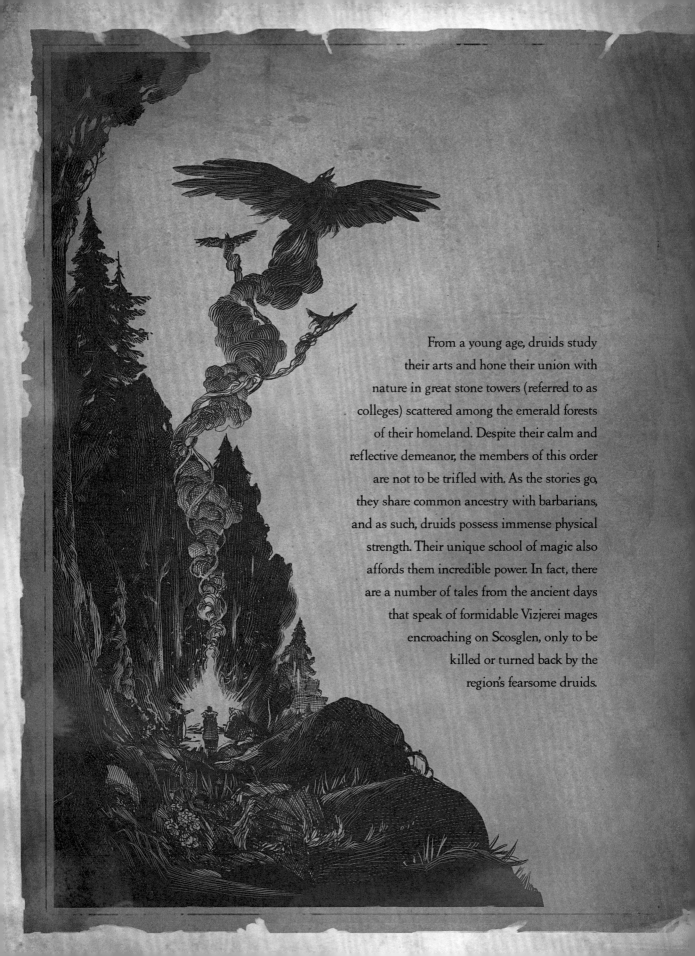

From a young age, druids study their arts and hone their union with nature in great stone towers (referred to as colleges) scattered among the emerald forests of their homeland. Despite their calm and reflective demeanor, the members of this order are not to be trifled with. As the stories go, they share common ancestry with barbarians, and as such, druids possess immense physical strength. Their unique school of magic also affords them incredible power. In fact, there are a number of tales from the ancient days that speak of formidable Vizjerei mages encroaching on Scosglen, only to be killed or turned back by the region's fearsome druids.

The Edyrem

* Leader: *Uldyssian ul-Diomed (formerly)*
* Base of Operations: *Kehjan and surrounding regions (formerly)*
* Standing: *Inactive*
* Number of Members: *Est. 3,000 (formerly)*

The edyrem, or "those who have seen," were an order of mortals whose nephalem powers flourished during the Sin War. Due to a lack of records, it is impossible for us to know precisely what kinds of abilities these individuals wielded. It is safe to assume, however, that they would have surpassed even the greatest mages of that era.

The edyrem waged war against the Temple of the Triune and the Cathedral of Light, fearing that the influence of the two religions would destroy humanity. After the Sin War, the edyrem's powers were leeched away, and their memories were expunged. It is difficult to imagine these individuals returning to their mundane lives as farmers and tradesmen after they had attained such incredible heights of human potential.

Horadrim

* Leader: *Tal Rasha (formerly), Jered Cain (formerly), Garreth Rau (formerly), Thomas and Cullen*
* Base of Operations: *Gea Kul*
* Standing: *Active*
* Number of Members: *Est. 7-12 (formerly, original core members), now 10 (I base this current number on my last communication with Thomas and Cullen.)*

Nearly three centuries ago, Archangel Tyrael forged the Horadrim, a band of preeminent mages that set out to imprison the three Prime Evils: Diablo, Mephisto, and Baal. The order succeeded in its grave and perilous task, but not without many sacrifices. Indeed, the mages were forever changed by the horrors they faced.

The ranks of the Horadrim now far outnumber this old estimate.

Nonetheless they continued their work, documenting everything they knew or could learn about the forces of the Burning Hells and the High Heavens. In the decades following the defeat of the Prime Evils, the Horadrim gradually faded away, leaving only their great legacy behind.

It was this legacy that I inherited generations later. As a caretaker of Horadric knowledge and a direct descendant of Jered Cain, I considered myself the sole living member of the organization. My thinking on this changed when I discovered that a group of scholars in the city of Gea Kul had banded together to carry on the Horadric teachings. These individuals have dedicated themselves to the order, and I believe that in the years to come they will accomplish feats worthy of the original Horadrim.

Deckard wrote more about the Horadrim in the Book of Cain. I have compiled information concerning the newest incarnation of the order earlier in this tome.

The Iron Wolves

* Leader: *Commander Asheara*
* Base of Operations: *Caldeum*
* Standing: *Active*
* Number of Members: *Est. 550*

Mercenary companies are notorious for their habit of shifting allegiances, but the Iron Wolvesare somewhat different. Although bold and reckless, they value loyalty and duty above all else. Their members are hardened veterans who excel in disciplines ranging from swordsmanship to the arcane sciences.

After the fall of Kurast, the Zakarum Church hired the Iron Wolves to retrieve Kehjistan's new ruler, Hakan II, from his home in the northern reaches of Sanctuary. With the task complete, the Iron Wolves became the child emperor's personal guards. This single event has elevated the mercenary company to a level of power and influence hitherto unheard of for an organization of its kind.

When corruption seeped throughout Caldeum, Emperor Hakan II replaced the Iron Wolves with his personal Imperial Guard. Asheara and her loyal soldiers nonetheless aided us in saving the city.

Mage Clans

* Leader: *Master Valthek*
* Base of Operations: *Yshari Sanctum, Caldeum*
* Standing: *Active*
* Number of Members: *Est. 500*
(*excluding those not affiliated with the Yshari Sanctum*)

Of the myriad factions and orders in existence, I believe it is the mage clans that have shaped mortal destiny the most. As I have written extensively on the history of these enclaves in other tomes, I will focus here on the status of the clans in the modern era.

Five in particular remain notable: the Ennead, Ammuit, Vizjerei, Taan, and Zann Esu. For centuries following the Mage Clan Wars, the populations of these once-influential groups dwindled. This trend saw a reversal in recent years due to the acts of Caldeum's Trade Consortium. In seeking to make their city a beacon of learning, the mercantile rulers worked to unite the mage clans and build the great Yshari Sanctum. This wondrous academy, filled with a treasure trove of arcana, has become a place of learning and growth for the various clans. I believe that the Sanctum stands as the greatest symbol of mage power and unity since the golden age of magic.

Necromancers

* Leader: *Deathspeaker Jurdann*
* Base of Operations: *Eastern Kehjistan*
* Standing: *Active*
* Number of Members: *Est. 150*

The necromancers, or priests of Rathma, are a misunderstood order, feared by many for their ability to interact with the dead. It was the legendary nephalem Rathma who taught mortals this art of bending the line between life and death. According to the <u>Books of Kalan,</u> the patron of the necromancers also bestowed on his followers a most vital task: to preserve the Balance between light and dark, thereby preventing both angels and demons from holding too much sway over humanity. It is interesting to note that the first necromancers may have arisen during the Sin War, a time when the mortal world was under grave threat from the High Heavens and the Burning Hells.

As to the inner workings of the order, I know very little. The priests of Rathma live in a vast subterranean city somewhere in Kehjistan's eastern jungles. This isolation has spared them from the influence of other mage clans, allowing the necromancers to develop wholly unique rites and arcane sciences. I briefly traveled with a necromancer in the past. Through that experience I have come to believe that the priests of Rathma can be powerful and trustworthy allies to have at one's side in these uncertain times.

Paladins

* Leader: *Grand Marshal Elyas (formerly)*
* Base of Operations: *Westmarch*
* Standing: *Inactive*
* Number of Members: *Est. 250 (formerly)*

Paladins are members of a martial wing of the Zakarum faith, holy warriors trained to wield the powers of the Light in battle. Of these righteous individuals, I wish to write of a specific group known as the Order of Paladins. During the dark years of the Zakarum Inquisition (a subject which I elaborate on elsewhere), an enclave of paladins splintered away from the church. They vehemently condemned the methods of the inquisition, vowing that they would no longer continue the legacy of bloodshed. Pledging to protect the innocent from all forms of evil, the valiant renegades journeyed to Westmarch, where they were embraced by King Cornelius. In recent years, this order has merged with the Knights of Westmarch, a group of paladins that had already existed in the kingdom.

Patriarchs

* Leader: *Shared among the Patriarchs*
* Base of Operations: *Ivgorod*
* Standing: *Active*
* Number of Members: *9*

Maintaining balance between the forces of order and chaos is ingrained in Ivgorod's ancient culture and beliefs. The kingdom's supreme governmental and religious rulers, the Patriarchs, are a reflection of this. In total, nine leaders exist. Four are pledged to order; four are pledged to chaos; and one remains neutral. Ivgorod's religion—known as Sahptev—venerates one thousand and one gods, and it is said that the Patriarchs speak for these deities. As such, their will goes unquestioned by every man, woman, and child of the nation.

Regarding the origins of the Patriarchs, ancient Sahptev scrolls claim that long ago the thousand and one gods chose nine humans to found and rule over what would become Ivgorod. The Patriarchs are believed to be the reincarnations of those nine founders.

Rogues

* Leader: *High Priestess Akara*
* Base of Operations: *Eastgate Keep, Khanduras*
* Standing: *Active*
* Number of Members: *Est. 40*

Rogues are members of a secretive guild calling itself the Sisters of the Sightless Eye. Among other things, they are renowned for their unmatched skill with the bow and arrow. With this in mind, it may come as no surprise that the rogue order was founded by amazons from the Skovos Isles, who are also famed for their adept use of ranged weaponry. Years ago, a group of these warrior women splintered away from Askari society, taking with them a wondrous artifact called the Sightless Eye. Legends hold that this device is a most incredible artifact. According to some accounts, the Sightless Eye grants one the ability to perceive details concerning future events. Other stories relate that the relic allows for communication between individuals across vast distances.

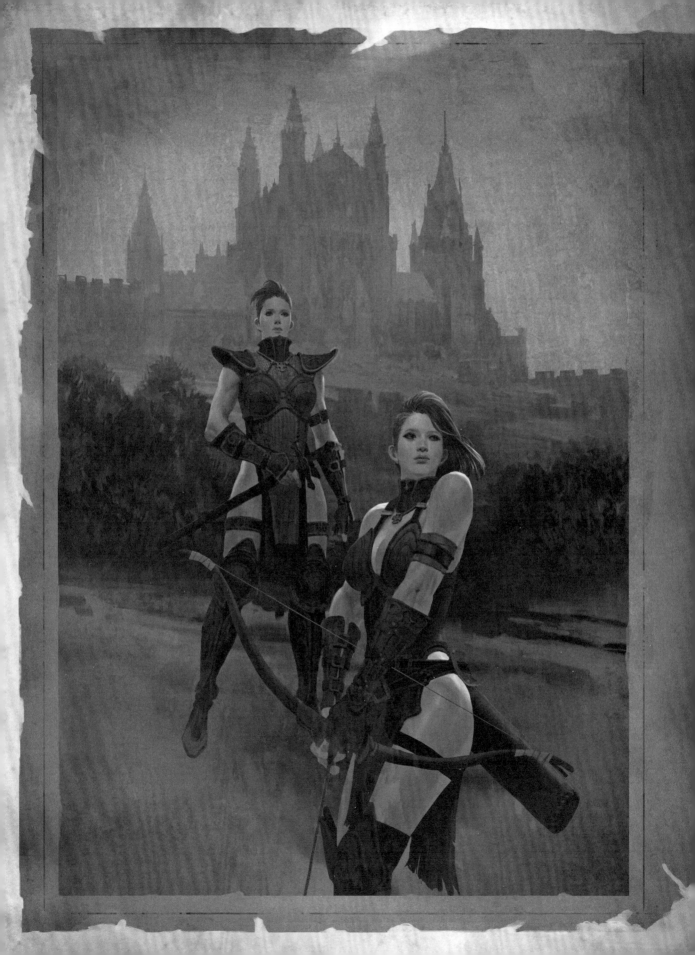

The Sisters of the Sightless Eye eventually settled in Eastgate Keep, which had fallen into abandonment after Rakkis founded the nation of Westmarch. There, they continued their own unique style of martial training, focusing on bows. It is said that the sisters recruited women from any walk of life who sought refuge in the mountain fortress and a means to forge a new destiny for themselves. Around twenty years ago, the Lesser Evil Andariel exerted her influence over the sisters, nearly breaking the order. They recovered from this tragic event, and the keep's training grounds now hum once again with the sound of bowstrings and attle cries. I should note, however, that the fate of the Sightless Eye itself remains unknown.

Skatsim

* Leader: *No centralized leadership*
* Base of Operations: *Kehjistan*
* Standing: *Active*
* Number of Members: *Est. 10,000*

I rely on the Black Book of Lam Esen for much of my information about Skatsim. Prior to the rise of the Zakarum Church, it was one of the most widely practiced religions in Kehjistan. At its core, Skatsim is a unique blend of faith and mysticism. Practitioners perform certain rites to attain states of clairvoyance or to perceive past and future events. The followers of Skatsim strive for a higher sense of being—a transcendence of self. Although the popularity of this faith has waned over the centuries, its influence can be seen in the Taan mage clan, which shares many of the old religion's practices.

It appears this speculation is grounded in fact. One of my comrades, a member of the templar named Kormac, learned of his order's heinous practices.

Templar

* Leader: *Unknown (although I have heard references to the leader being called the "grand maester")*
* Base of Operations: *Westmarch*
* Standing: *Active*
* Number of Members: *Unknown*

The templar order of Westmarch is something of an enigma to me. Some stories depict the organization's members as former criminals who have been given a chance to atone for their sins and walk the path of righteousness. Other, more unsettling accounts paint the templar in a much different light. If these rumors are to be believed, the order abducts innocent citizens and subjects them to horrific torture, purging their memories and molding them into zealous adherents. I cannot corroborate any of these darker tales with facts, but the mere existence of them makes me fearful of the group's true intentions.

The Temple of the Triune

* Leader: *Lucion, the Primus (formerly)*
* Base of Operations: *Kehjan (formerly)*
* Standing: *Active*
* Number of Members: *Unknown (In ancient times,*
I believe the temple's followers would have numbered in the tens of thousands.)

Nearly three millennia ago, the Temple of the Triune (or Cult of the Three) arose in the sprawling empire of Kehjan. It was forged by none other than the Prime Evils of the Burning Hells as a means to influence the hearts of mankind. The cult revolved around the worship of three benevolent deities—Dialon, the spirit of Determination (represented by a ram), Bala, the spirit of Creation (represented by a leaf), and Mefis, the spirit of Love (represented by a red circle)—who were in reality Diablo, Baal, and Mephisto. It is said that the number three was used symbolically in the cult's architecture and methods of operation. One need only look to the Triune's military wing, the Peace Warders, for examples. They traveled in threes at all times, each member serving one of the cult's seemingly compassionate deities.

At the apex of its power, the Triune fell to Uldyssian ul-Diomed and his fellow awakened nephalem, the edyrem. It is clear, however, that remnants of the cult persisted long after this point. Confined to the shadows, they eschewed the Triune's benevolent façade and preserved its vile secrets, faithfully awaiting a sign from the Prime Evils. I believe that the latest incarnation of the Triune is a group calling itself the Coven (of which I wrote on earlier). Whether or not other splinter groups of the cult still exist is a mystery, but I should think they do. After all, the influence of the Prime Evils is not so easily purged from the world of mortals.

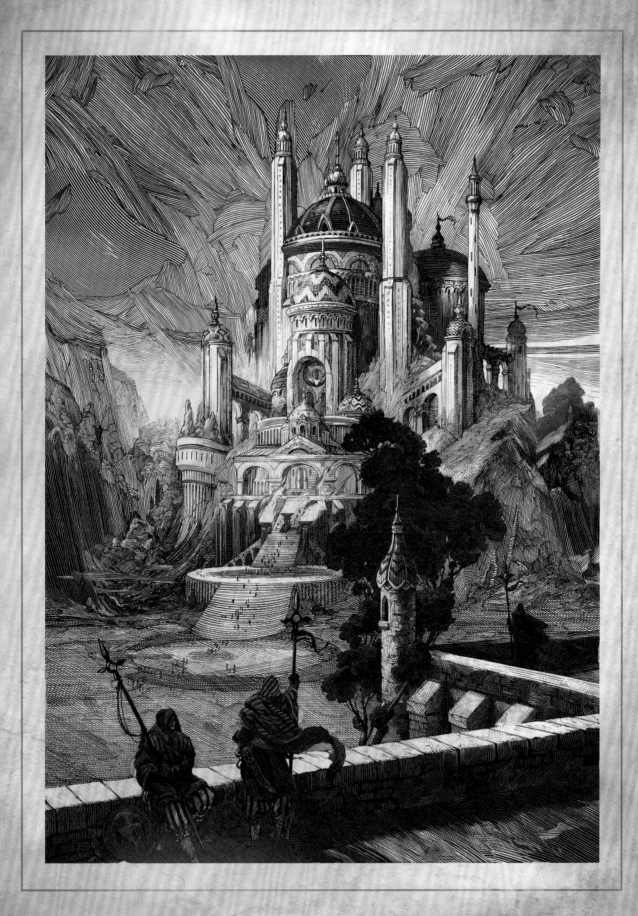

The Thieves Guild

* Leader: *Unknown (As with the assassins, the guild strives to mask its leadership.)*
* Base of Operations: *Westmarch and other regions of the west*
* Standing: *Active*
* Number of Members: *Est. 300 (including all ranks)*

The Thieves Guild arose in the years after Rakkis
founded the nation of Westmarch. Since that time,
the criminal network has spread to cities throughout
the kingdom and beyond, delving into extortion,
bribery, smuggling, murder, and all manner of
illicit activities.

The Thieves Guild goes to great lengths to keep its inner workings a mystery to outsiders. However,
I have come to learn that the order usually recruits its members from the poverty-stricken slums.
These initiates train in pickpocketing, and those who show promise ascend in rank, much as a
craftsman would in a legitimate trade guild. It should be noted that climbing the ladder of the
guild's hierarchy grants one increasingly lucrative—and dangerous—work.

Trade Consortium

* Leader: *Trade Consortium Council*
* Base of Operations: *Caldeum*
* Standing: *Active*
* Number of Members: *Est. 10,000 (including common merchants)*

Many mercantile guilds exist throughout Sanctuary, but one—Caldeum's Trade Consortium—
is of particular interest to me. Through war, through famine, and through the passing of empires,
this order has endured and flourished. I believe part of the consortium's strength comes from its
inclusionary methods. The order's leaders do not fight the winds of change; they embrace them.
This is evidenced by their decision to allow the great Zakarum cathedral Saldencal to be built
within Caldeum. Later, the consortium constructed the Yshari Sanctum, a center of arcane studies.
These two acts alone have won the consortium many allies among the Zakarum faithful and mage
clans. More recently, Kehjistan's late emperor Hakan I declared Caldeum his seat of power. Rather
than resist this sudden turn of events, the consortium deftly maneuvered through the mire of
politics and managed to retain its influential status in the city.

Zakarum

* Leader: *Que-Hegan Dirae*
* Base of Operations: *Saldencal, Caldeum*
* Standing: *Active*
* Number of Members: *Est. 50,000*

Who, living today, does not know of the Zakarum faith? Who has not seen its loyalists preaching of the inner Light or of the founder, Akarat, from the cobblestone streets of Westmarch to the winding bazaars of Caldeum? Dear reader, in the last few centuries, this organization has impacted the world in fundamental and far-reaching ways. This is remarkable because the order began as nothing more than a humble group of ascetics. In time, these believers garnered the power to forge nations and raise emperors to the throne.

Recently, the Zakarum Church has lost much of its influence. The discovery that Mephisto, the Lord of Hatred, had corrupted the highest echelons of the faith—the Que-Hegan and High Council— nearly destroyed the organization. The church has since moved from Kurast to Caldeum. Under the leadership of a new Que-Hegan named Dirae, the Zakarum faithful are nursing their wounds and mending their reputation.

In closing, I should note that the Zakarum faith in Westmarch has distanced itself from the church in Kehjistan (especially after the revelation concerning Mephisto). Indeed, the western kingdom has become increasingly secular in recent years, but groups influenced by the Zakarum faith, such as the Knights of Westmarch, still exist.

Hand of Zakarum

I consider the years of the Zakarum Inquisition to be one of the darkest periods of history. Initiated by the church, this brutal campaign of conversion spread paranoia and fear throughout the lands of Kehjistan. Nonbelievers were judged as corrupt and subjected to horrific interrogations and "purification" techniques. A group of paladins known as the Hand of Zakarum acted as the vanguard of this heinous crusade. Although some of these holy warriors would later break away from the church, many more propagated the horror of the inquisition until the movement finally faded away.

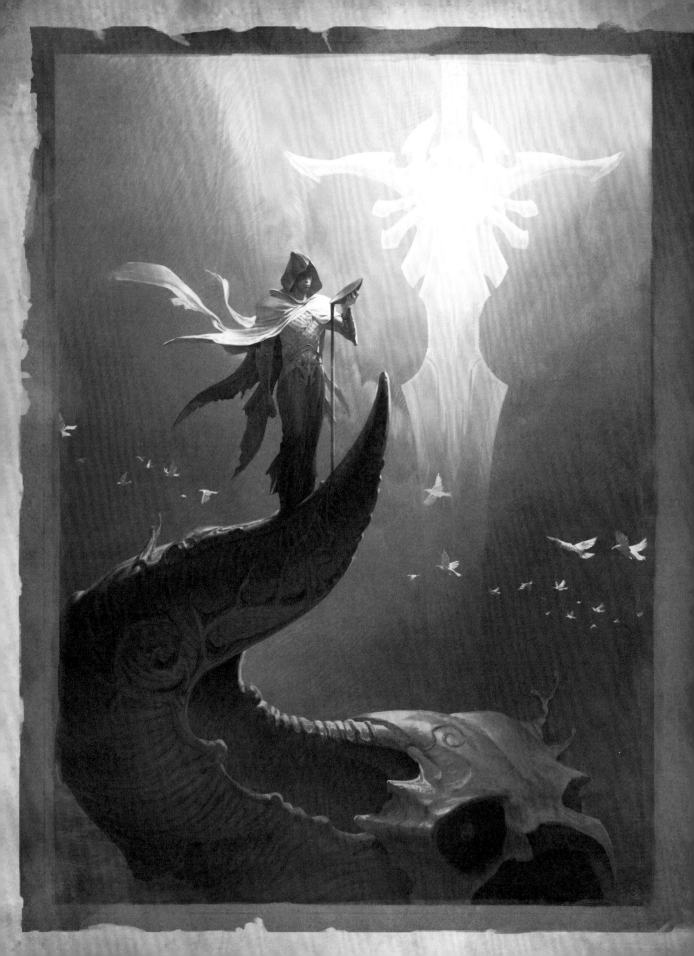

Figures of Interest

Abd al-Hazir

Abd al-Hazir is a historian and seeker of knowledge. He is considered by many to be one of the preeminent scholars of Caldeum, and for a number of years he taught in the city's most renowned academies. This rise to fame is quite impressive considering that the man was born into abject poverty. I heard that recently, Abd set off to journey the world and document its myriad peoples, creatures, and lands.

Akara

Akara is the spiritual leader of the Sisters of the Sightless Eye, a soft-spoken, inscrutable, and wise woman. I believe she is practiced in the secret and closely guarded ways of using the Sightless Eye, an incredible artifact from the Skovos Isles.

Akarat (deceased)

Countless legends exist concerning Akarat, founder of the Zakarum faith. The simple truth, however, is that his origins and life are a mystery. Even the circumstances of his death are shrouded in hearsay. It is said that after he spread his teachings in Kehjistan, he disappeared into the east and was never seen again.

Alaric (deceased)

According to the Books of Kalan, Alaric was from one of the first nephalem generations. He and his companions lived in what was once a grand temple in Khanduras (the ruins of this place, known as the Drowned Temple, exist to this day). After the Worldstone was altered and the nephalem powers dwindled, Alaric and his companions were beset by a cunning and duplicitous demon named Nereza. I am not fully aware of the circumstances or outcome of this conflict, but there are legends that the ghosts of Alaric and his allies still roam the shattered halls of the Drowned Temple.

Jacob Staalek, a mortal of incredible resolve and virtue. Deckard Cain detailed his life later in this section.

Ardleon

Ardleon ranks among Archangel Tyrael's boldest followers. During one of the many battles of the Eternal Conflict, this indomitable angel forged into a sea of demons before finding himself lost behind enemy lines. He only narrowly escaped death at the hands of his foes when Tyrael intervened to save him. Side by side, the two angels cut through the seething ranks of the Burning Hells to reach the Heavenly Host.

Asheara

Asheara spent many years as a member of various unscrupulous mercenary outfits. Despising the brutal tactics employed by these groups, she eventually forged the Iron Wolves, an order of sellswords that holds honor and duty above all else. I know Asheara to be strict with her followers, but also evenhanded.

Astrogha

The cunning demon Astrogha is one of Diablo's most loyal minions. From my investigations, it appears this venomous multi-legged fiend has been summoned to the mortal realm at least twice: first by the Triune during the Sin War; second by a necromancer named Karybdus in the modern era. As to Astrogha's current fate, I have heard accounts that the vile creature was banished into the depths of a mysterious artifact known as the Moon of the Spider.

Bartuc (deceased)

It is difficult to believe the stories of Bartuc, the Warlord of Blood . . . difficult to believe how a man could lose himself in such a deep abyss of depravity and barbarism. The histories state he was a Vizjerei mage practiced in the dark arts of summoning demons and unleashing them in battle. Indeed, he relished in embracing the powers of the Burning Hells without thought for the consequences.

Bartuc became infamous for his gruesome ritual of bathing in the blood of his enemies. If the Vizjerei accounts are true, this act infused the mage with incredible powers. It is even said his armor drank deep of the spilled blood, attaining a malevolent sentience of its own.

The Warlord of Blood's hubris and lust for genocide drove him to wage a terrible civil war against his own Vizjerei clan. His bloody rampage was ultimately put to an end when he was slain by his brother, the mage Horazon.

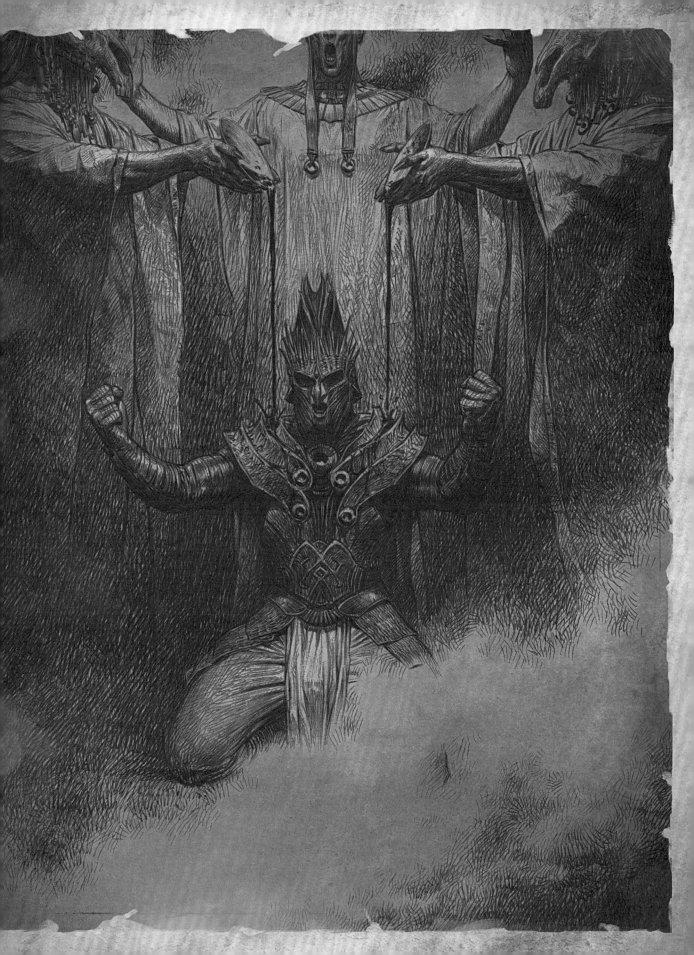

Benu (deceased)

I find the beliefs and ways of the people who inhabit the Teganze jungle endlessly intriguing.
One recent story recounted to me concerning an individual named Benu. It is said this young
man bravely sacrificed himself to slay a demon of anguish that had assumed the guise of a
friend. Some claim that ever since this event, the spirit of Benu has whispered to them from
beyond the grave, passing on sage wisdom and guidance.

Charsi

When she was very young, the barbarian Charsi and her parents were ambushed by a throng of
murderous khazra. The mother and father managed to hide their child away in the surrounding
wilds before the goatmen ruthlessly slaughtered them. Quite by chance, members of the Sisters of
the Sightless Eye later found Charsi and took her into their care. She has been a member of this
organization ever since, using her immense physical strength to forge the order's weaponry and armor.

Covetous Shen

In recent years, I have heard rumors of a wandering jeweler who is currently searching for a gem
known as the jewel of Dirgest. These tales refer to the individual as Covetous Shen, an elderly
man hailing from the northern lands of Xiansai. What I find most perplexing is that a number
of historical records—some of them from centuries ago—tell similar stories. Each account relates
a wizened old man from Xiansai hunting for Dirgest's jewel.

Cydaea

It is said that Azmodan, the Lord of Sin, commands seven powerful lieutenants. Among them is
Cydaea, the Maiden of Lust. Vizjerei writings depict her as Azmodan's favored servant, a demoness
who is both exquisitely beautiful and nightmarish to behold. She inhabits the Lord of Sin's
pleasure palace, reveling in blurring the lines between pleasure and pain, ecstasy and
utter torment.

Emperor Hakan II

Born to an impoverished family in the far north, the young boy Hakan II now sits on the throne as
emperor of Kehjistan. You may ask yourself how someone from such a low social standing attained
such a lofty position. The answer lies with the Zakarum.

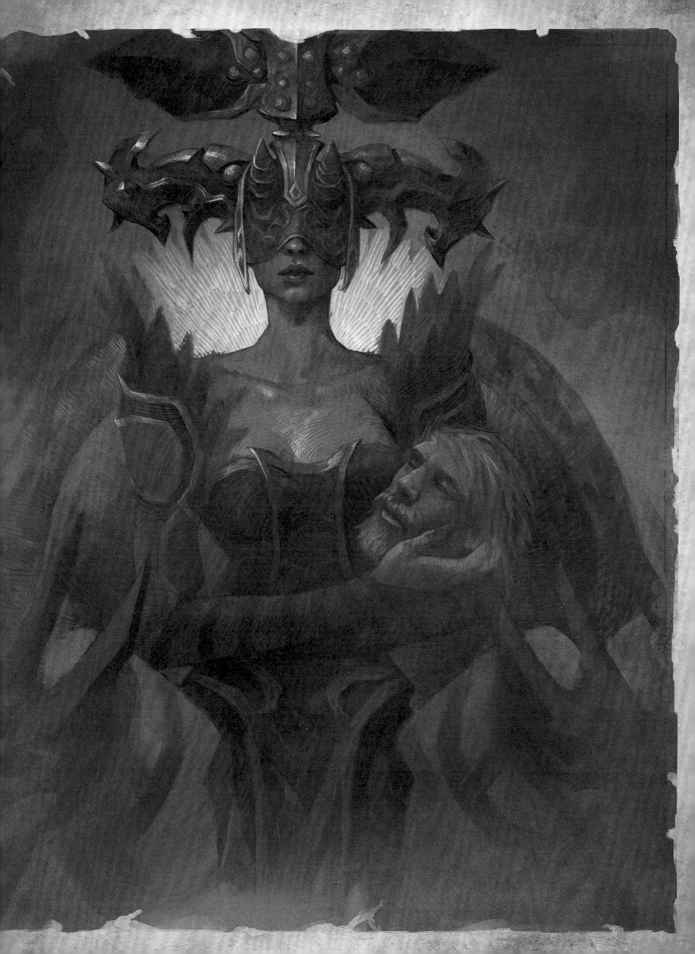

For some time, the priesthood has held power over deciding the empire's succession of rulers. Through a series of secret rituals, the members of the church discovered Hakan II's presence in the north and determined that he would become Kehjistan's newest emperor.

Emperor Tassara (deceased)

Belial later possessed Hakan II. He used the boy to sow chaos in Caldeum before my allies vanquished him.

Tassara lived in a time when wealth, power, and blood determined who would reign over Kehjistan. As such, he was carefully taught about the position of emperor from childhood. He studied the intricacies of history and politics, all the while learning from the mistakes of his predecessors. Indeed, it can be said he was one of Kehjistan's greatest rulers. Tassara initiated many reforms in his day, such as making Zakarum the empire's official religion. For that act alone, he is revered by the church.

Fara

Fara was once a devout paladin of the Zakarum. Upon discovering that evil had taken root in the church, she abandoned her order and settled in Lut Gholein. I met her there, toiling under the scorching desert sun as a blacksmith. Despite this drastic change in lifestyle, Fara still holds fast to the teachings of the Zakarum founder, Akarat, believing they are pure and noble regardless of the church's corruption.

Covetous Shen

Farnham (deceased)

I remember Farnham in his better days—a jovial and well-spirited resident of Tristram. When King Leoric's youngest son, Prince Albrecht, went missing, Lazarus rallied Farnham and many other residents to venture into the cursed depths of the town's cathedral and rescue the boy. Although Farnham returned with his life, he left his sanity and will to live behind. Up until the day of his death at the hands of marauding demons, he slipped further into despair, finding solace only in heavy drinking.

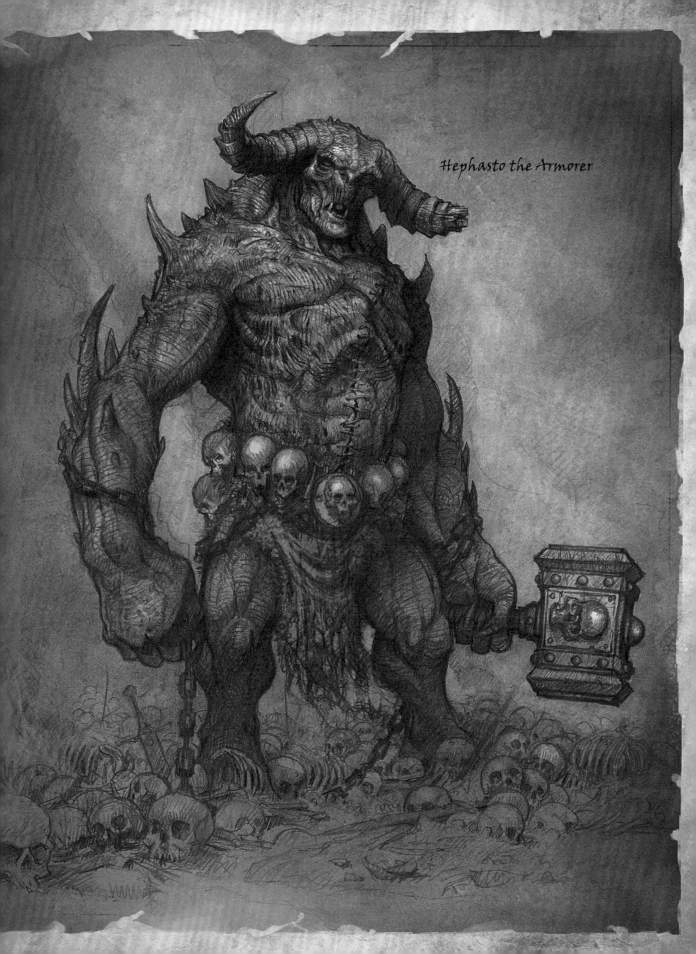

Hephasto the Armorer

Garreth Rau (deceased)

Garreth Rau was a brilliant scholar and one of the finest bookmakers in all of Sanctuary. He possessed a natural affinity to magic, one he honed under the tutelage of a Taan mage. Later in life, Rau led the First Ones, a group of young and valiant scholars who dedicated themselves to carrying on the teachings of the original Horadrim.

At some point before these events, Belial took great interest in Rau and his abilities. He shrouded the man's thoughts and memories in a veil of lies, molding him into a puppet. Fueled by Belial's dark will, Rau conquered Gea Kul in the hopes of awakening an army of ancient sorcerers buried beneath the city.

I worked to thwart Rau's plans with a handful of brave individuals (even Leah was by my side at the time), but his powers proved too great for us to stand against. In the end, whatever humanity was left in Rau clawed its way through Belial's deception. Seeing the twisted pawn of evil he had become, the former scholar chose to take his own life.

Gharbad (deceased)

Most people consider khazra nothing more than mindless beasts, but they can be cunning and manipulative creatures. One of them, Gharbad, attempted to win the trust of Prince Aidan and his allies amid the Darkening of Tristram. Only later did the flea-bitten creature reveal his true murderous nature, for which he was slain.

Ghom

Ghom, the Lord of Gluttony, is one of Azmodan's seven loyal lieutenants. His appetite is insatiable, and he is known to consume his enemies as well as any demonic allies who stray too close to any of his slavering maws. Noxious filth oozes from his every pore, emitting a stench so powerful that it alone can choke the life from mortals.

Gillian

Gillian was the barmaid of Tristram's Tavern of the Rising Sun. Her smile and kind words could brighten the day of the most sullen patrons. After the Darkening of Tristram, the witch Adria invited her to the famed city of Caldeum. The barmaid seized the opportunity to leave her ravaged home behind and start life anew.

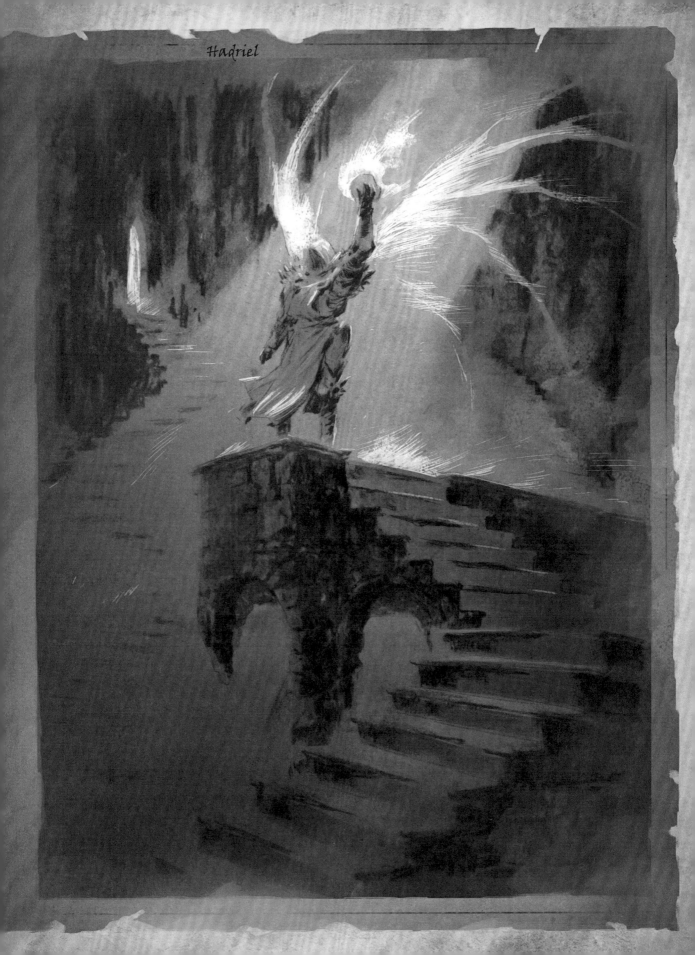

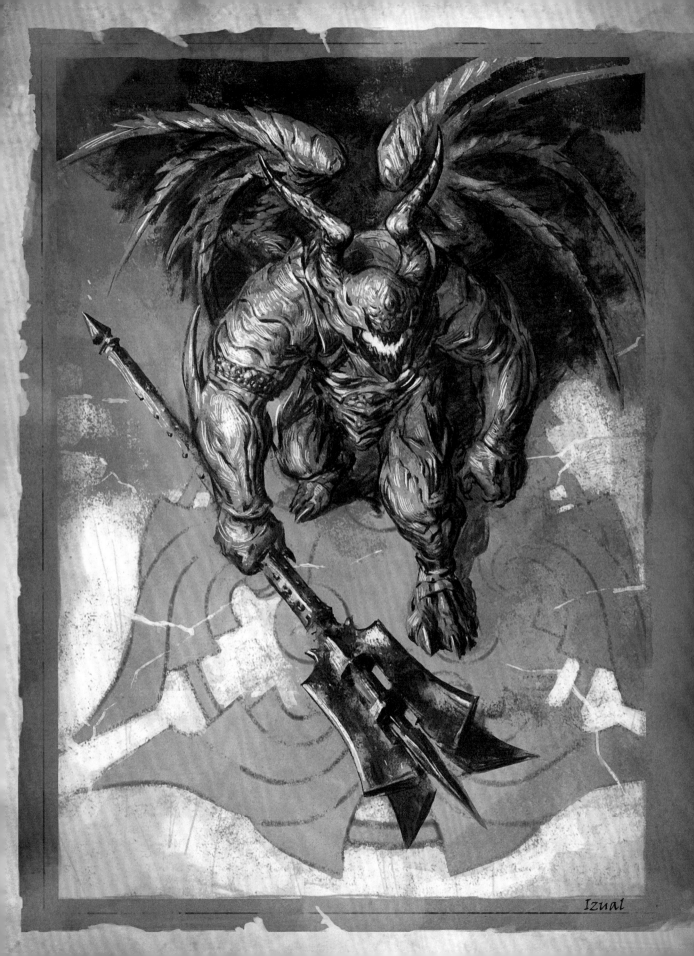

Izual

In Caldeum, Adria gave birth to Leah and left the infant in Gillian's care. Thereafter, the witch disappeared, never to return. The years that followed were hard on Gillian. When I finally met with her some years later, she was a different person. She was hollow. Cold. Distant. Dark voices had peeled away at her sanity, and she saw Leah as a dire threat.

Gripped in the throes of madness, Gillian attempted to murder Leah and me by burning down her home in the night. Fortunately, all of us escaped the flames unscathed. After this event, I took Leah into my care. I am sad to say that Gillian was beyond my saving. City guards locked her away in one of Caldeum's madhouses.

Griswold (deceased)

Griswold came to Tristram a number of years before Diablo's release, seeking a new place to ply his blacksmithing trade. When the Lord of Terror's shadow fell over the town, the burly man suffered a terrible wound while battling the demons beneath the cathedral, leaving him incapable of fighting. Even so, Griswold did what he could to help Prince Aidan and his allies scour evil from Tristram. In the end, the minions of the Hells slew the blacksmith and transformed him into a murderous undead terror.

Cain's theories concerning my relationship to Hadriel as well as the angel's decision to aid the mortal champions are correct.

Hadriel

When my companions ventured into the Burning Hells to destroy the soulstone of Mephisto and slay Diablo, they claimed that an angel named Hadriel aided them. Who was this figure? Why did he appear in the Hells? Personally, I believe Hadriel was a follower of Tyrael, specifically one who had learned of the archangel's involvement with Sanctuary. Following this discovery, he came of his own volition to help my allies traverse the perilous and twisting pathways of the Hells. This, however, is mere speculation on my part, for I have heard no other mention of Hadriel in recent years.

Haedrig Eamon

I have found the blacksmith Haedrig Eamon a warm and cheery fellow. He reminds me somewhat of his grandfather, Chancellor Eamon, a man who served King Leoric amid the Darkening of Tristram. I should note, however, that Haedrig was in Caldeum during that horrific period of history. Only much later did he come to Khanduras and settle in New Tristram with his wife and a promising apprentice. I am always surprised at the level of care and detail he puts into his blacksmithing work, even for menial tasks. Indeed, he is a man of great talent with a bright future ahead of him.

Hephasto the Armorer

Hephasto is a paradox of the Burning Hells. The hulking demon is a minion of Baal, and thus is driven by an overriding desire to destroy everything he touches. Yet at the same time, Hephasto possesses the ability to create. He toiled in the fiery Hellforge, molding incredible weapons to arm his demonic comrades for battle. I think, perhaps, he managed to channel his destructive nature, fusing it into the armaments he forged. It is even said the brute took great pride in the knowledge that his creations would cause untold death and carnage.

Nearly twenty years ago, a band of mortal champions struck Hephasto down while infiltrating the Hellforge. Some ancient Vizjerei texts claim that demons have the potential to be reborn in their desiccated realm after death. If this is true, I think it is possible the armorer of Hell will at some point in the future return.

Horazon

Horazon was a mage of the Vizjerei clan, perhaps one of the greatest who has ever lived. With regards to his philosophies about demons, he believed in breaking their wills and subjecting them to his complete dominance. Eventually, Horazon came to realize that the use of demons would bring about the downfall of all mankind.

Following the costly Mage Clan Wars (a subject I touch on in other places) and his terrible battle with Bartuc, Horazon disappeared from society, crafting a bastion called the Arcane Sanctuary, where he studied the secrets of the arcane. I do not know whether he is still alive, but considering the immense powers Horazon had at his command, I believe he might have found a means to prolong his life.

Iben Fahd (deceased)

Iben Fahd was a skilled Horadric mage who hailed from the Ammuit clan. He was one of the brave individuals who infiltrated Zoltun Kulle's archives and helped dismember the mad wizard. According to the Horadric texts, Iben was given the gruesome task of hiding away Kulle's head.

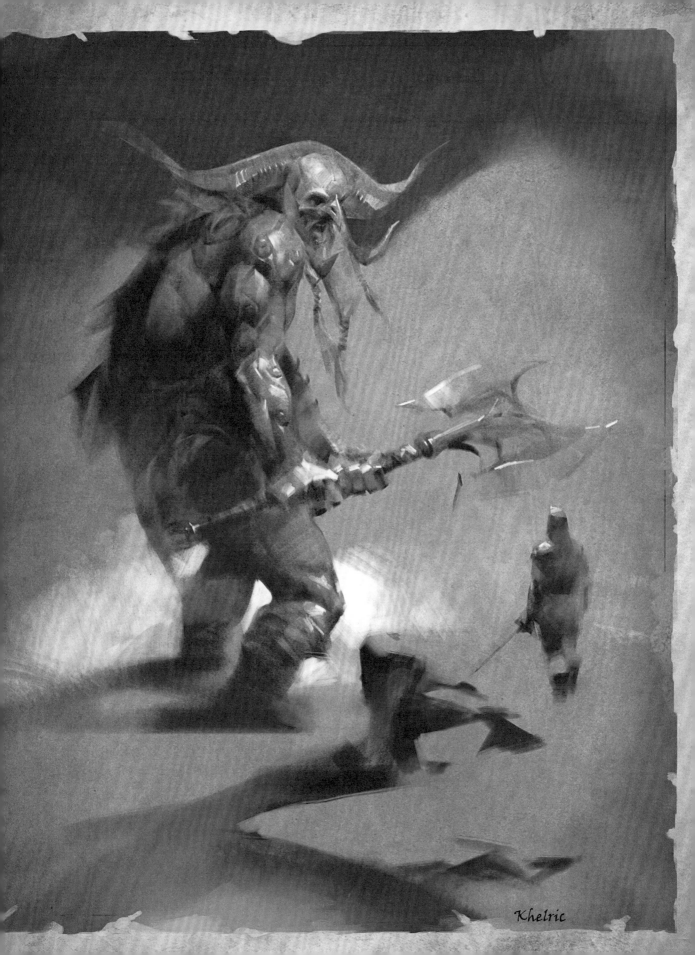

Khelric

Izual did return, called to serve the Prime Evil.
My allies defeated him in the High Heavens,
where he and I had once walked together as great friends.

Izual

Let the tale of Izual stand as a reminder that even angels, the embodiments of order, can be twisted to chaos by the powers of the Burning Hells. . . .

A trusted lieutenant of Archangel Tyrael, Izual was captured during an assault on the Hells. Thereafter, the Prime Evils subjected the angel to horrific acts of torture. It is even said that Izual relinquished secrets regarding the soulstones to his demonic captors.

Nearly twenty years ago, when my mortal comrades forged into the Hells to do battle with Diablo, they struck down the corrupted Izual. However, I often wonder whether he will one day be reborn in the Hells, a cursed ability that other demons are rumored to possess.

Jacob Staalek

In recent years, I have heard stories of an individual named Jacob, born and raised in the northern settlement of Staalbreak. The barbarian Owl tribe, infected by a demonic rage plague, repeatedly assaulted the town and spread corruption among its populace. As the story goes, Jacob was forced to slay his own father, who had succumbed to the terrible affliction. The young man was thereafter hunted for the crime of murder. Ultimately, he redeemed himself by vanquishing the foul demon responsible for the plague: Maluus.

What I find incredible about this tale is that, at some point, Jacob took up Tyrael's legendary Sword of Justice, El'druin. How did this come to pass? I can only assume that when Tyrael destroyed the Worldstone, his angelic blade was cast off and left unattended in the western lands. Whatever the case, clearly this man must possess a righteous heart to successfully wield El'druin.

Jazreth (deceased)

Jacob no longer carries El'druin. I summoned the Sword of
Justice to my side after returning to the High Heavens.

During the Darkening of Tristram, the Vizjerei mage Jazreth journeyed to my town, drawn by rumors of the demonic presence there. Battling Diablo's minions bled whatever valor and restraint had once existed in the man's heart. Calling himself the Summoner, he set out to find Horazon's legendary Arcane Sanctuary and pilfer its secrets for personal power. Fortunately, he perished while undergoing this quest.

Jered Cain (deceased)

Much of what I know concerning the Horadrim, demons, angels, and various arcana is due to the meticulous records handed down to me by Jered Cain. Oddly, I do not know very much concerning my ancestor's early life. He was a great Vizjerei mage—that much is irrefutable.

Some accounts also say he was troubled by a terrible event in his past. What this was remains unclear, but I believe that through the Horadrim, Jered might have found a means to renew his purpose in life.

At Tyrael's behest, my ancestor and his comrades embarked on an arduous quest—the Hunt for the Three—to track down and imprison the Prime Evils. It was following the defeat of Mephisto and Baal that Jered became leader of the Horadrim. With wisdom and unyielding determination, he led his fellow mages in a horrific battle against Diablo—a battle that ended with the Prime Evil's capture in the Crimson Soulstone. It appears that Jered spent the rest of his days living in the Horadric monastery near what would become Tristram.

Karybdus

Necromancers consider themselves the keepers of the Balance between the forces of the Burning Hells and the High Heavens. However, I have heard tales that one member of this order, Karybdus, went to dangerous extremes to pursue this ideal. Indeed, it is said he summoned the demon Astrogha into Sanctuary, although it is difficult to understand what motives—however noble—would drive him to commit such a heinous act.

It appears that Karybdus's fellow necromancers also viewed his choices as disastrous. One of them, a man by the name of Zayl, eventually imprisoned both Karybdus and Astrogha in a strange artifact known as the Moon of the Spider.

Kashya

Kashya commands the martial forces of the Sisters of the Sightless Eye. I have witnessed her prowess myself and consider her one of the greatest archers the order has ever produced. In addition, I know Kashya to possess an unequalled genius in strategic and tactical matters.

Kehr

Ever since the destruction of Mount Arreat, the barbarians have been a troubled and wayfaring people. There are many, however, who still strive to live with purpose and honor. I know the man named Kehr to be one of them. He stands watch over the Iron Path, a mountain road north of Khanduras plagued by khazra attacks. Under Kehr's unwavering vigilance, the route has become a safe passage for all travelers.

Khelric (deceased)

Khelric was the mighty barbarian chief of the Owl tribe. At some point (and the sources differ on when) the demon Maluus possessed this proud warrior and used him to spread a vile demonic rage plague. A young man named Jacob Staalek, armed with Archangel Tyrael's Sword of Justice, ultimately vanquished Khelric in single combat. By that time, Maluus had warped the barbarian chief's body into a horrific seething vessel of pure hatred.

Korsikk (deceased)

Korsikk was the son of Rakkis and the second king of Westmarch. During his reign, he ordered the construction of the great Bastion's Keep as a means to thwart barbarian aggression in the north. Korsikk later gathered his forces and boldly set out to do what even his father could not: crush the barbarian tribes once and for all. It is said that the king died an ignoble death on this campaign, struck down by his hated foes.

Lachdanan (deceased)

I remember Lachdanan with fondness. He was a righteous man, captain of King Leoric's army. When Tristram's monarch succumbed to Diablo's influence, Lachdanan slew his liege, seeing no other means to spare the town from the rising tide of darkness.

The captain and his closest allies buried the king beneath Tristram's cathedral, but what happened next is something of a mystery. It is said Leoric rose from the dead as the Skeleton King and cursed Lachdanan and his comrades. Thereafter, the captain resolved to wander the cathedral's subterranean catacombs to the end of his days rather than spread the evil that gnawed at his heart among the innocent townsfolk of Tristram.

Lazarus (deceased)

There are times when I awake in the dead of night plagued by nightmares of Lazarus. What can I say of this despicable man? He was an archbishop of the Zakarum Church, and I believe he was one of the first members of the faith to be irrevocably corrupted by the Prime Evils. Lazarus was a great orator, and he used this skill to win Leoric's trust. Indeed, the archbishop was instrumental in convincing the man to undertake the journey to Tristram and proclaim himself the king of Khanduras.

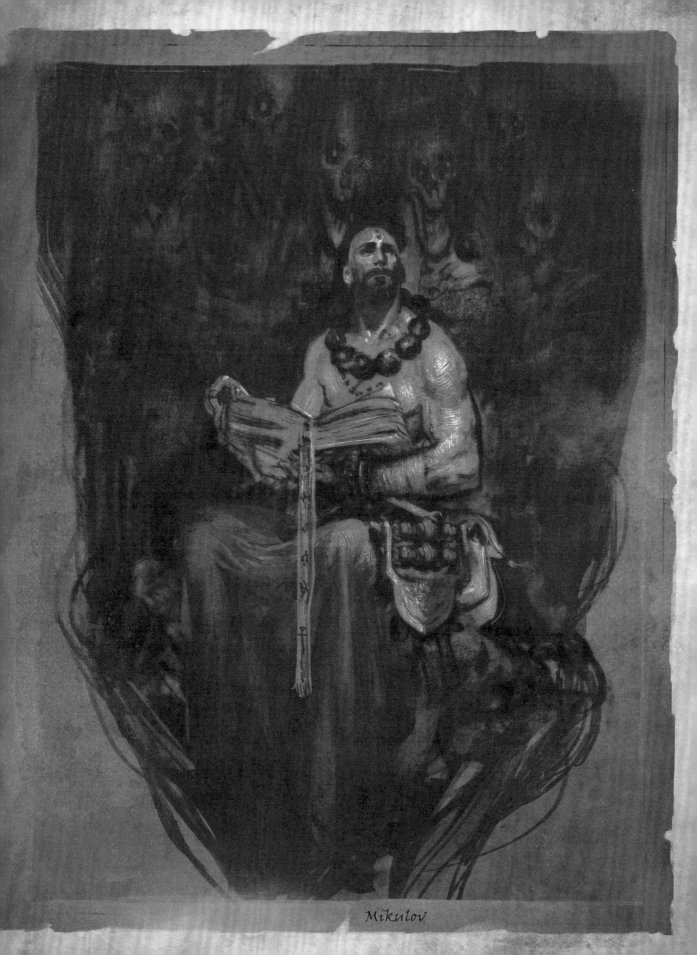

Mikulov

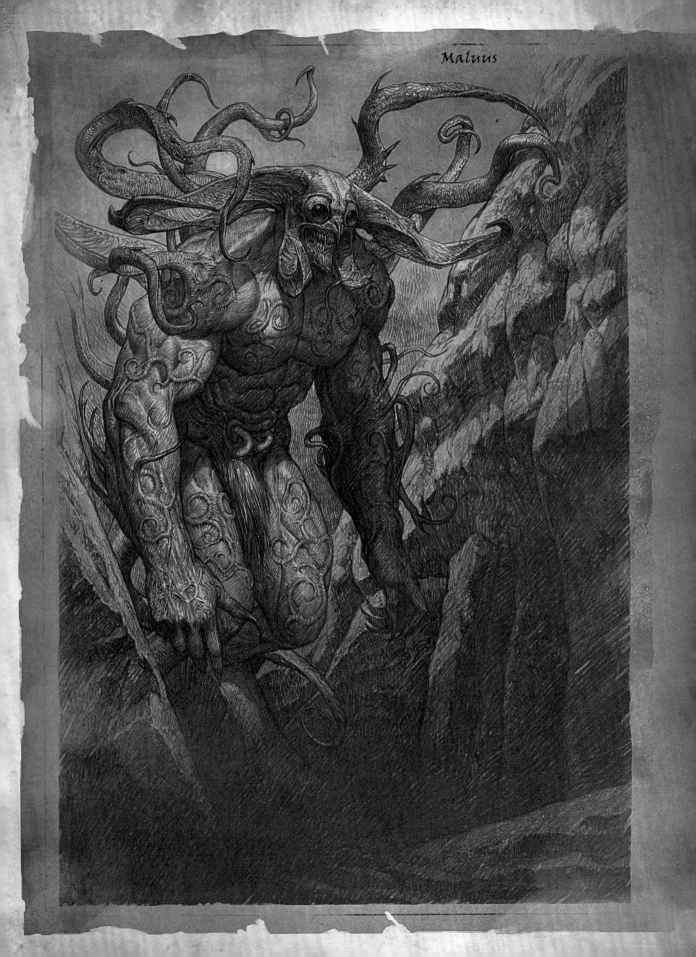

Once in Tristram, Lazarus released Diablo from his Crimson Soulstone, setting into motion a chain of events that would lead to the deaths of countless innocents. Prince Aidan later struck down the archbishop, but to this day I wonder how many lives I could have saved if I had seen through Lazarus's guise of benevolence and wisdom.

Li-Ming

Every so often, I hear of a promising new student accepted into Caldeum's Yshari Sanctum. Li-Ming, a young woman from Xiansai, is perhaps the most recent of these individuals. She is said to possess an almost insatiable appetite for arcane knowledge and an incredible affinity to magic. I only hope that, as the years wear on, she also learns to use her vast powers with restraint and wisdom.

Lucion

Lucion is the ill-begotten son of Mephisto. Unlike his sister, Lilith, he served his father without question (or, at least, he appeared to do so). At the behest of the Prime Evils, Lucion came to the world of Sanctuary and forged the Triune, a seemingly benevolent cult that, in reality, aimed to turn the hearts of mankind to darkness. Mephisto's son then took on the role of the cult's spiritual leader, calling himself the Primus.

It should be noted that Lucion assumed a mortal guise for this task. Indeed, the Books of Kalan describe him as a charismatic and wise man with a voice so soothing it bordered on the hypnotic. Only later, when the nephalem Uldyssian ul-Diomed and his followers assaulted the Triune, did Lucion reveal his true demonic form. Yet even the demon's immense powers could not withstand the might of the nephalem army.

Maghda

A storm of dark rumors and lies swirls around Maghda and her origins. I know she is practiced in the arts of witchcraft, and I know also that she leads the Coven, a cult that has carried on the traditions of the Triune. There is nothing she would not do—no one she would not sacrifice—to appease the Lords of the Burning Hells. Beyond these unsettling facts, the woman's past remains a mystery.

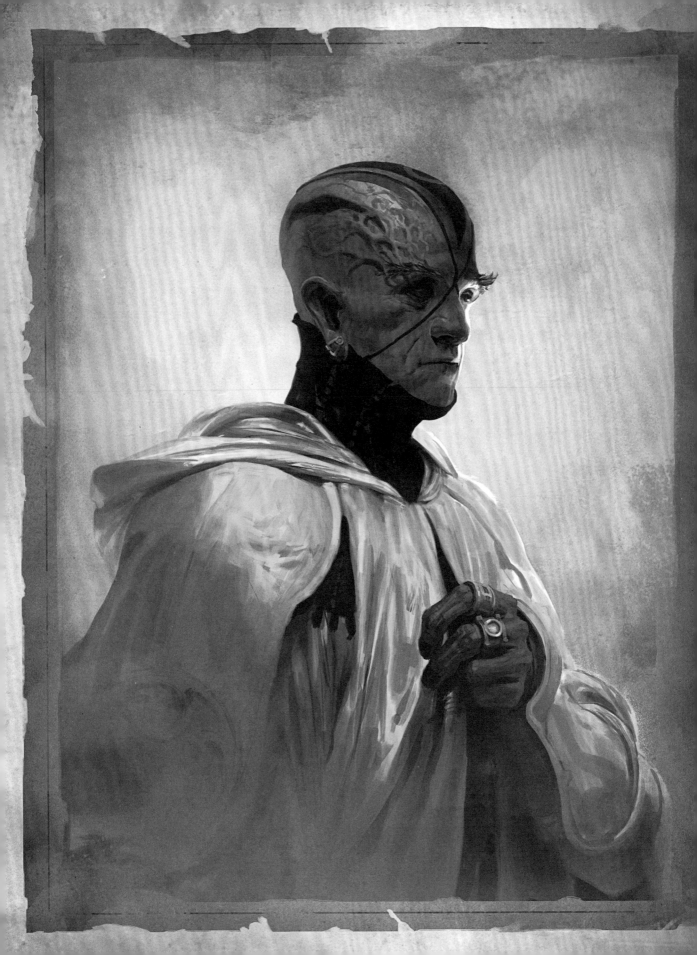

Malic (deceased)

During the era of the Sin War, the human Malic fell under the sway of the Prime Evils. He became a loyal member of the Triune, rising to the lofty position of high priest. For his dedication, the Lords of the Burning Hells granted Malic unnatural longevity and other gifts. The Books of Kalan state that, outwardly, he was a handsome and physically intimidating man. But beneath this facade, Malic was withered and grotesque.

Amid the Sin War, he was flayed alive by the demoness Lilith, who had manipulated the nephalem in the guise of a mortal named Lylia. I find Malic's fate a fitting end to a man who shrouded himself in a veil of lies to deceive so many innocent people.

Maluus

I consider Maluus to be a servant of Mephisto, but this is something of conjecture on my part. What I know, however, is that the demon came to the world of Sanctuary sometime after the Darkening of Tristram and spread a plague among the barbarian tribes. It is said that merely touching Maluus's blood was enough to blind a mortal with murderous rage. A young human named Jacob Staalek ultimately vanquished the demon, casting the creature and the foul plague back into the roiling pits of the Hells.

Mendeln

Mendeln was the brother of Uldyssian ul-Diomed. According to one account I have found, he befriended the legendary nephalem Rathma and, through this wise being's teachings, became a necromancer. Recently, I made a startling discovery concerning this man—he was also known as Kalan, the enigmatic figure who authored the Books of Kalan. I do not know when this change in name occurred, or the reasons for it. I am, however, in debt to Mendeln for the knowledge he has passed down through his tomes.

Mikulov

I met Mikulov during my investigation of Garreth Rau and the First Ones (a subject I have written on elsewhere). This brave man is one of Ivgorod's monks, a spiritual warrior molded into a living weapon through years of harsh and unrelenting training. During the course of his studies, Mikulov learned of a prophecy that stated the Horadrim would play a vital role in an impending battle—one that would pit the living against the dead. This chilling discovery spurred the monk to seek me out, for he believed that I had some part to play in forestalling this dark fate.

The simple truth, however, is that Mikulov did far more to spare the world from this prophecy than me. Without this fearless monk at my side, both Leah and I would have perished at the hands of Rau and his barbarous servants. I owe Mikulov my life, and I hope that a day may come when I can repay the debt.

Morbed

Recently, I learned of a man named Morbed, a former thief said to have a mysterious lantern (one, I might add, that he keeps shackled to his wrist). It is said this individual can wield abilities possessed by necromancers, wizards, crusaders, and even druids. I find it hard to believe that one man could have command over such diverse forms of magic, but I do not question that Morbed exists. Indeed, I have heard a number of tales about him wandering the lands of Sanctuary, lending aid to those in need. As to his motivations, it seems he helps others as atonement for some terrible sin in his past.

Moreina (deceased)

Amid the Darkening of Tristram, a cowled and shadowy figure arrived in the town to battle the forces of the Burning Hells. Her name was Moreina, and she was one of the highly skilled rogues from the Sisters of the Sightless Eye. When at last evil had been purged from Tristram, this brave woman ventured back to her order. But she carried something dark with her—a silent madness that ate away at her once noble heart. Assuming the name Blood Raven, she fell into league with the Lesser Evil Andariel and assaulted her fellow rogues before finally being killed.

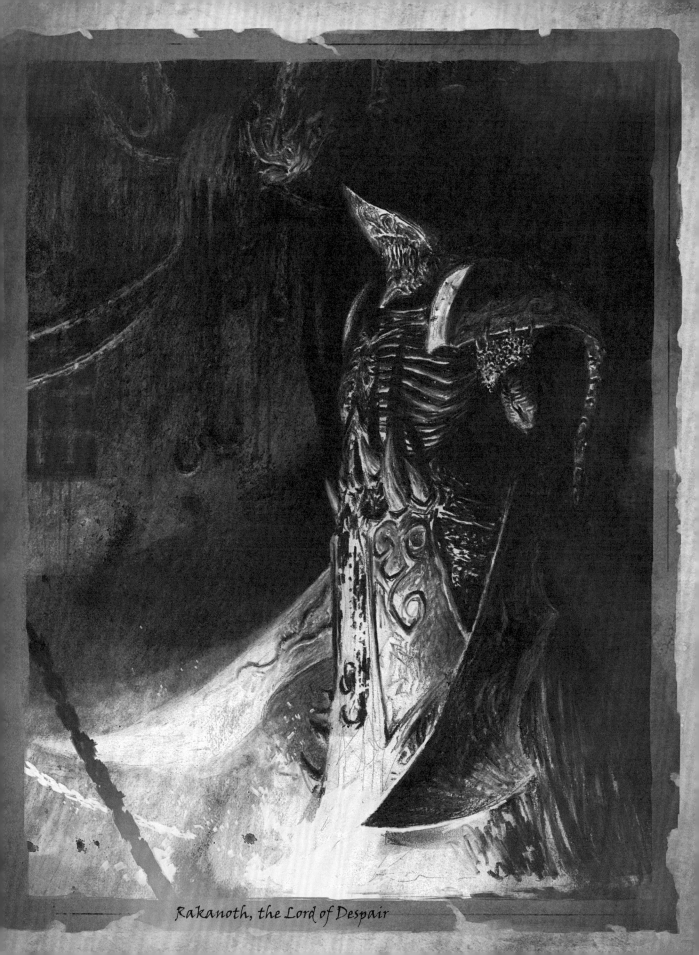

Rakanoth, the Lord of Despair

Natalya

Natalya once belonged to the Viz-Jaq'taar, the shadowy group of assassins tasked with hunting down renegade mages. In recent years, it appears that she has abandoned her order to take up the cause of the demon hunters, a cadre of warriors dedicated to eradicating the minions of the Burning Hells from the lands of Sanctuary.

Nihlathak (deceased)

Nihlathak was a respected figure among the barbarians and a member of the Council of Elders. When Baal began his bloody march toward Mount Arreat, this circle of venerated leaders gathered to decide on what course of action to take. They chose to cast an ancient and dangerous warding spell that would shield the town of Harrogath, the last settlement that stood between Baal and the summit of Arreat. All members of the council died during this selfless act.

All, that is, except Nihlathak.

Over the course of Baal's march through barbarian lands, Nihlathak had grown increasingly distressed. He had watched his people die, watched his lands be irrevocably tainted by the marauding armies of the Hells. Ultimately, he believed that only by making a pact with Baal could the barbarians survive the ordeal. So it was that Nihlathak gave Baal the Relic of the Ancients, a legendary artifact needed to bypass Arreat's defenses and reach the summit, in exchange for sparing the town of Harrogath.

Although his motivations may seem noble, the fact is that through this act, Nihlathak allowed Baal to corrupt the Worldstone, setting off a chain of events that would end with Arreat's destruction. Nihlathak himself, twisted by evil after forging his foul agreement with Baal, met his end before the mountain was destroyed.

Nor Tiraj (deceased)

The Vizjerei mage Nor Tiraj was one of the most prolific scholars of the Horadrim. He is referred to as an acolyte in many places, which leads me to believe that he was not one of the original members of the order. From what I have gathered, he remained in Khanduras following the Hunt for the Three, living out his days by adding to the region's great Horadric library alongside my ancestor Jered Cain.

Lucion

Norrec Vizharan

I first learned of the treasure seeker and soldier-for-hire Norrec Vizharan during a trip to the city of Westmarch. There, a fellow scholar related the man's story. Vizharan, under the employ of a Vizjerei mage, apparently stumbled across the cursed armor of Bartuc, the Warlord of Blood. Upon donning the pieces, the treasure seeker was overcome with a lust for death, and he turned against his own companions. I do not know how many people Vizharan killed while struggling against the armor's malevolent influence, but my colleague claims that he eventually managed to free himself from the curse.

Ogden (deceased)

Ogden was the proprietor of Tristram's Tavern of the Rising Sun, a warmhearted man whom nearly all of the town's populace considered a friend. Tragically, both he and his loving wife, Garda, perished while trying to save others from a wave of demons that descended on Tristram.

Ord Rekar (deceased)

Ord Rekar was a proud and respected member of the barbarian Council of Elders. I considered him the foundation of the organization, the embodiment of its wisdom and strength. Rekar gave his own life when he and his comrades cast the great warding spell to protect Harrogath from the advancing demonic armies of Baal.

Ormus

I met Ormus on the docks of Kurast nearly twenty years ago. He had a strange manner of speaking, one that my own comrades attributed to insanity. I, however, suspect that Ormus is a wise and incredibly gifted mage. His spellwork revealed him to be a member of the Taan clan, which focuses on the use of divination, scrying, and other abilities rooted in old Skatsimi mystical rites.

Pepin (deceased)

Pepin was one of my closest friends in Tristram. He was a caring man who had long studied the arts of medicine and healing. He put these skills to great use amid the Darkening of Tristram, saving many lives. I later witnessed Pepin's death at the hands of demons. I will not repeat the horrific details here. Suffice it to say the images are branded into my mind, and I fear they will haunt me until the end of my days.

Pindleskin (deceased)

I first heard of the skeletal terror Pindleskin during Baal's assault against Mount Arreat. Since then, I have struggled to find details concerning what this creature was. The account I find most interesting relates to a famous barbarian chief. Centuries ago, the Kehjistani general Rakkis invaded the lands surrounding Mount Arreat. His armies clashed with the barbarian tribes and were turned back, but not before inflicting considerable damage. The chief of the Bear tribe— a man of incredible physical strength—was one of the victims. I believe Pindleskin was the remains of this mighty barbarian leader, pulled from the grave by the foul magic that pervaded Baal's armies.

Quov Tsin (presumed deceased)

Quov Tsin was a mage of the Vizjerei clan who sought out the legendary city of Ureh. Incredibly, it appears he found this location and met with its reclusive ruler, an individual named Juris Khan. There is no mention, however, of Quov ever returning from his journey. As such, I assume that at some point he perished in the fabled halls of Ureh.

Rakanishu

The fallen are despicable and violent creatures driven by wanton destruction. According to Vizjerei accounts (and my observations), they rarely ever travel alone. They are pack creatures, and as such, certain fallen inevitably rise to dominant positions among their respective groups. Perhaps the most famous is Rakanishu, a particularly brutal fallen who is feared and respected even by his own barbaric kind.

Rakanoth, the Lord of Despair

The demon Rakanoth is a master of torture who once ruled over the Plains of Despair in the Burning Hells. It is said he served Andariel, the Maiden of Anguish, before shifting allegiances (but whom he answers to now remains a mystery). Certain Vizjerei tomes state that Rakanoth was the warden of the captive angel Izual. For many long years, he subjected his prisoner to excruciating and otherworldly forms of torture.

As with Izual, the Prime Evil summoned Rakanoth to his side during the assault on the High Heavens.

Rumford

The tireless farmer Rumford is one of the many respectable individuals I have met in New Tristram. He seems a humble and introverted man, but I think there is more to him than that. I have heard that his ancestor was one of Rakkis's most loyal lieutenants, a charismatic soldier who eventually settled in Khanduras. Due to this lineage, I believe the blood of a leader runs through Rumford's veins, whether he realizes it or not.

When I fell to Sanctuary and the dead rose from their graves, Rumford valiantly sacrificed his own life to protect the people of New Tristram.

Sankekur (deceased)

Sankekur occupied the seat of the Que-Hegan, the highest divine authority of the Zakarum Church. As such, it is safe to say he was once the most powerful living mortal in all of Sanctuary. Thousands of fanatical worshippers answered to his every beck and call. At some point during his reign, Sankekur succumbed to the influence of Mephisto. The Lord of Hatred later overtook the Que-Hegan completely, twisting the man's body into a horrific demonic visage.

Shanar

Shanar is one of the rebellious students of arcane magic known as wizards. I first heard her name through the stories of Jacob Staalek (whom I write on elsewhere). It appears that at one time, she set out to study the nature of the Crystal Arch and the presence of angelic resonances on Sanctuary. Her investigations ultimately led her to the resting place of Tyrael's lost sword, Eldruin. The energies pervading the fabled artifact imprisoned her until Jacob finally arrived to take up the blade. Thereafter, the wizard allied with the young man, but I know nothing concerning her motivations for doing so, or whether she has continued her studies of the Crystal Arch.

Tal Rasha (deceased)

As with my ancestor Jered Cain, details concerning Tal Rasha's origins are somewhat difficult to come by. Many accounts of his life exist, but what am I to take for fact? In some cases, he is described as an Ammuit mage, one of the clan's greatest masters of illusion.

Other accounts state he was Vizjerei or even Taan. What is irrefutable, however, is that he was a valorous man, which is perhaps why Archangel Tyrael chose him to lead the Horadrim during the Hunt for the Three.

Tal Rasha proved his bravery when the order clashed with Baal in the deserts of Aranoch. Amid the battle, the Lord of Destruction's Amber Soulstone was shattered. Selflessly, Tal Rasha decided to use his own body as a means to contain the Lord of Destruction. At their leader's behest, the Horadrim imprisoned Baal in the largest shard of the crystal and then plunged it into Tal Rasha. Thereafter, the mages sealed him in a subterranean tomb beneath the shifting desert sands.

Nearly three centuries later, Diablo liberated Baal from his prison. At that time, I believe there was nothing truly left of Tal Rasha beyond the withered husk that had once been his body.

Valla

The demon hunters are a relatively new order, formed in the wake of Mount Arreat's destruction. Nonetheless, I have heard stories concerning a number of this organization's members and their noble quest to purge Sanctuary of demonic influence.

Recently, a traveler passing through New Tristram told me of one noteworthy demon hunter by the name of Valla, a Westmarch native. It appears the minions of the Burning Hells slew her family when she was only a child. This harrowing event changed her forever, driving her to seek vengeance against all demons. In one instance, she tracked down and vanquished an insidious creature that had twisted the thoughts of children, spurring them to murder their friends and family. It is said that during this encounter, Valla's mind briefly merged with her demonic foe. I cannot imagine what horrors she witnessed as a result, but the fact that she emerged victorious clearly illustrates her incredible resilience and aptitude for slaying the creatures of Hell.

Warriv

The caravan master Warriv has been to exotic locales that I have only read of in books. I had the opportunity to travel with him after the fall of Tristram, although we later went our separate ways. I often wonder how the years have treated him. I consider him a trustworthy ally, and I hope his travels one day lead him back to Khanduras so that we can meet and speak again.

Wirt (deceased)

Wirt was a well-mannered boy who lived with his mother, Canace, in Tristram. After Diablo's release, demons abducted the child and dragged him into the charnel house beneath the town's cathedral. The blacksmith Griswold risked his life to save Wirt, but not before the boy's leg was devoured by Hell's minions. The child's demeanor darkened considerably following that event. Like nearly all of Tristram's residents, young Wirt was later killed by a throng of ravenous demons.

Xazax

Xazax is a cunning and manipulative demon who serves Belial, the Lord of Lies. It is said that a wayward sorceress by the name of Galeona summoned the mantis-like fiend into Sanctuary for one task: to retrieve the cursed armor of Bartuc, the Warlord of Blood. Fortunately, I have not heard any accounts that Xazax succeeded in this dark quest or that he still walks the mortal realm.

Zayl

By all accounts, the necromancer Zayl is an unwavering adherent to the philosophies of his order, tirelessly working to ensure that the powers of neither the Hells nor the Heavens hold too much sway over the mortal realm. It appears he is also a well-traveled and learned individual, for stories tell of his exploits from the lost city of Ureh to the kingdom of Westmarch. In each of these cases, it seems he has worked to thwart the efforts of persons delving into demonic—or other dark—arts.

It is said that Zayl possesses a number of strange and powerful artifacts. Among them is a skull, to which is bound the spirit of a mercenary named Humbart Wessel. Communing with spirits is a common practice among necromancers, but usually these interactions are short-lived. I find it interesting that Zayl keeps the skull and its spirit among his possessions.

Zebulon I (deceased)

Zebulon I was one of the great Que-Hegans of Zakarum history. He initiated a set of sweeping reforms that leeched away some of the church's immense power and gave more freedom of worship to the common folk of Kehjistan. According to some historical accounts, Zebulon's decision came about after he received visions from Akarat, the legendary founder of the Zakarum faith.

Zhota

Mikulov spoke to me of how Ivgorod's holy warriors, the monks, each hold a certain god as his or her patron. He was especially fascinated by one of the order's youngest members, Zhota, who aligned himself with Ymil, the god of the rivers, emblematic of emotion, intuition, and life-giving properties. It appears this decision is somewhat rare among the monks, many of whom prize the strength and resolve attributed to deities such as Zaim, the god of the mountains, and Ytar, the god of fire.

I would not, however, attribute Zhota's choice to weakness by any stretch of the imagination. I have recently come to learn that his master is a man named Akyev the Unyielding. By all accounts, he is one of the strictest and most unforgiving monks in Ivgorod. Many initiates have been gravely injured (and, according to some rumors, even died) due to his brutal training methods. For Zhota to have endured all of his master's tests leads me to believe he is an incredibly resourceful and resilient individual.

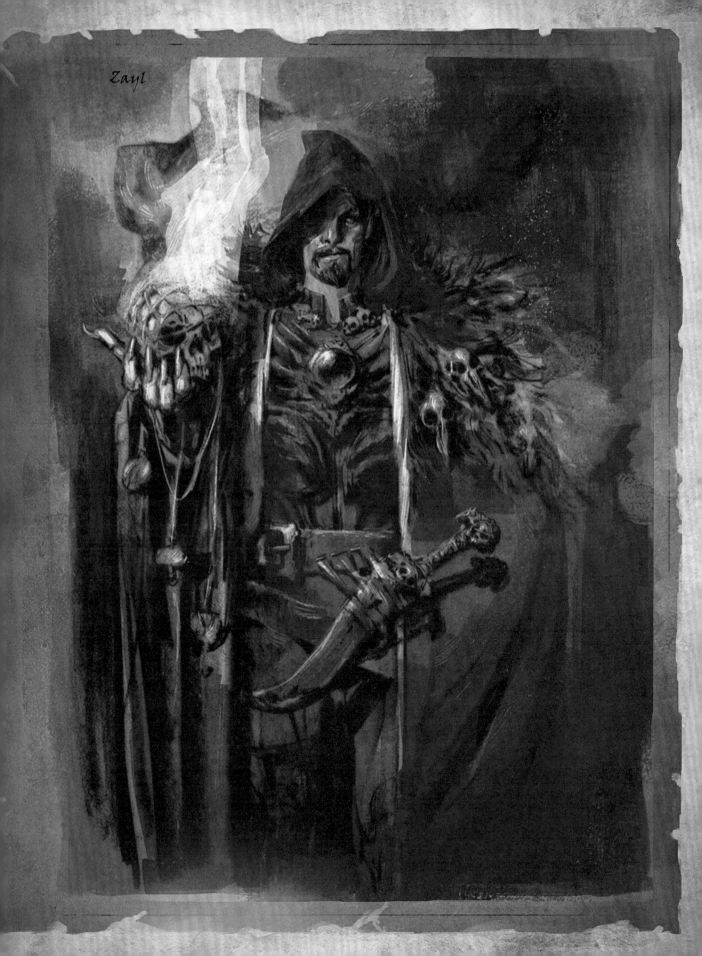

Zayl

Conclusion

Horadrim, I now bequeath to you this tome and the knowledge herein. Add to it. Make it your own. Use it as a foundation upon which to build a glorious new Horadric legacy.

I do not know what the future holds for us, or what harrowing circumstances we will be forced to contend with. Some of you will remain by my side in the times to come. Others, I may send on tasks to the far corners of the mortal realm and beyond.

But whatever we face, however divergent our paths become, know that we all stand together as Horadrim. The order is what binds us as one. It is what gives us new purpose and allows us to transform into something far greater than individuals.

We are mortal, our lives brief flashes of light in the span of eternity. But through the Horadric knowledge we pass on, through the choices we make to uphold the order's tenets, we may transcend the ephemeral nature of our existence. We may become beacons of hope and courage that continue burning long after we leave this world.

Tal Rasha, Jered Cain, and the original Horadrim knew this. Deckard and Leah knew this. Although they are gone, who among you does not still look to them for guidance? Who among you does not find pride in the sacrifices they made and the valorous acts they performed? They live on through us, unfettered by the limitations of mortality.

In each and every one of your hearts is the same power—the same potential—that elevated these heroes to greatness. Find that place. Wield it as a light to guide you through the dark days that may lie ahead.

And remember always that whatever comes to pass, I will stand with you.

—*Tyrael*

You live among the shadows,
gaze into the dark chasms between worlds.
You bear this burden so that others will not have to,
because you are one of the few who can.
You are Horadrim, and your legacy
is not defined by riches or fame,
but by the very survival of mankind.

—From the writings of Jered Cain

BOOK OF TYRAEL

Written by: Matt Burns • Illustrated by: The Black Frog: 30, 61, 67, 137, 138, 145, 161 • Nicolas Delort: 50, 55, 57, 59, 64, 116, 125 • ENrang: 22, 27, 102-103, 122, 128, 148 • Riccardo Federici: 111, 131, 146 • Gino: 35, 43, 70-71, 76-77, 108-109 • John Howe: 38, 41 • Joseph Lacroix: 4, 5, 6, 7, 8, 10, 11, 13, 18, 23, 26, 37, 40, 42, 44, 45, 46, 47, 48, 49, 51, 52, 62, 63, 80, 102-103 (background), 114-115 (background), 162, 163, 165, • Iain McCaig: 88-89, 96-97 • Jon McConnell: 69, 109 (top and bottom), 110, 112 (top), 113 (left), 114 (center), 115 (top, left, and right), 117, 118, 119, 120, 121, 123, 124, 126, 127 • Petar Meseldzija: 2, 3, 12, 19, 100, 105 • Jean-Baptiste Monge: 15, 16, 81, 93, 106, 112 (left), 113 (right), 134, 135, 152-153 • Glenn Rane: Cover • Ruan Jia: 9 • Dan Hee Ryu: 20, 21, 24, 25, 29, 32, 33, 34, 36, 72, 73, 74, 75 • Adrian Smith: 82-83, 84-85, 86-87, 90-91, 99, 151, 156, 159 • Yang Qi: 94-95 • Bin Zhang: 132-133 • Zhang Lu: 140-141 • Additional Art: Victor Lee

Additional Story Development: Chris Metzen, Micky Neilson, Brian Kindregan

Edited by: Eric Geron • Design by: Corey Peterschmidt, Jessica Rodriguez • Produced by: Brianne Messina, Amber Thibodeau • Lore Consultation: Ian Landa-Beavers, Justin Parker • Game Team Consultation: Jon Dawson, Rod Fergusson, John Mueller, Rafał Praszczalek, Ashton Sanderson, Joe Shely, Mac Smith

Director, Consumer Products, Publishing: BYRON PARNELL
Associate Publishing Manager: DEREK ROSENBERG
Director, Manufacturing: ANNA WAN
Senior Director, Story & Franchise Development: DAVID SEEHOLZER
Senior Producer, Books: BRIANNE MESSINA
Associate Producer, Books: AMBER THIBODEAU
Editorial Supervisor: CHLOE FRABONI
Senior Editor: ERIC GERON
Book Art & Design Manager: COREY PETERSCHMIDT
Historian Supervisor: SEAN COPELAND
Department Producer, Lore: JAMIE ORTIZ
Associate Producer, Lore: ED FOX
Associate Historians: MADI BUCKINGHAM, COURTNEY CHAVEZ, DAMIEN JAHRSDOERFER, IAN LANDA-BEAVERS

ORIGINAL EDITION:
Doug Alexander, Skye Chandler, Cate Gary, Raoul Goff, Josh Horst, Chrissy Kwasnik, Vanessa Lopez, Elaine Ou, Justin Parker, Anna Wan, Kyle Williams

Published by Blizzard Entertainment.

This book is a work of fiction. Names, characters, places, and incidents are either products of the author's imagination or are used fictitiously, and any resemblance to actual persons, living or dead, business establishments, events, or locales is entirely coincidental.

Blizzard Entertainment does not have any control over and does not assume any responsibility for author or third-party websites or their content.

Library of Congress Cataloging-in-Publication Data available.

ISBN: 978-1-956916-40-9

Manufactured in China

Print run 10 9 8 7 6 5 4 3 2

DIABLO®

BOOK OF CAIN

Written by Flint Dille

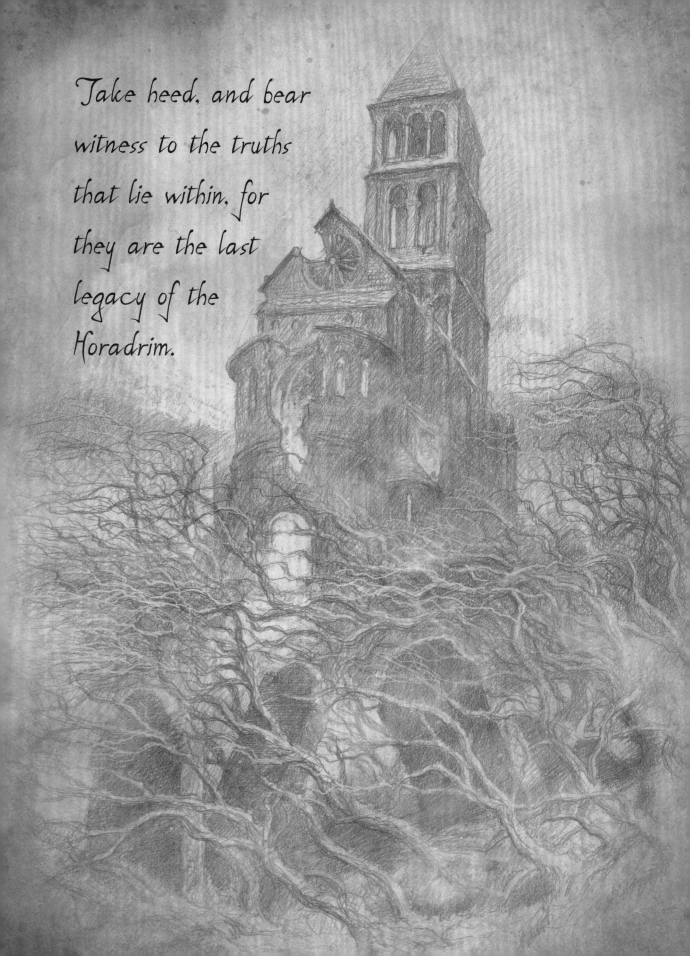

Take heed, and bear witness to the truths that lie within, for they are the last legacy of the Horadrim.

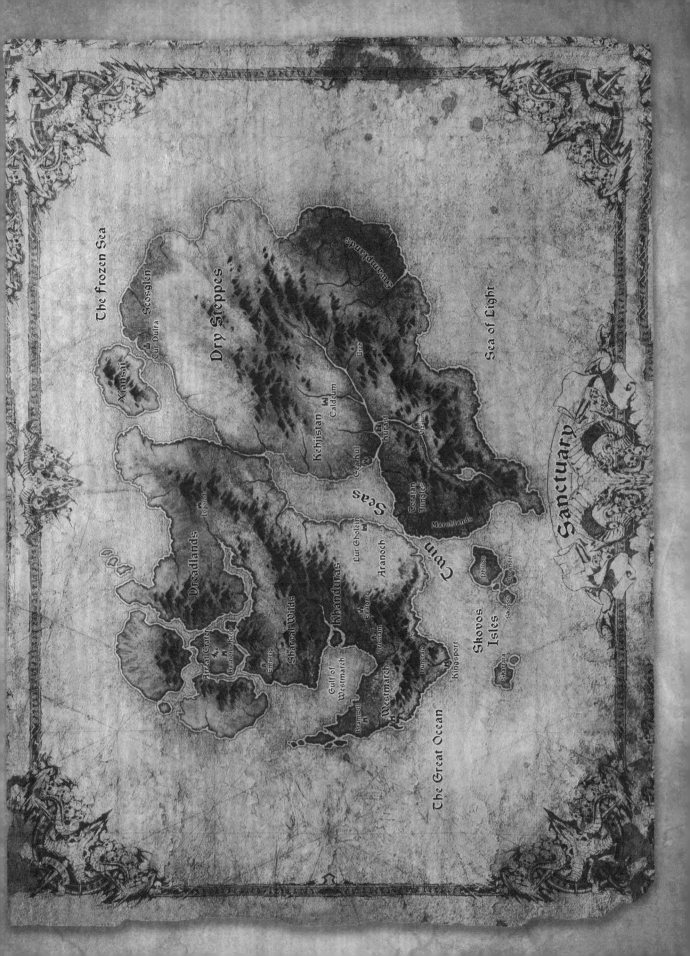

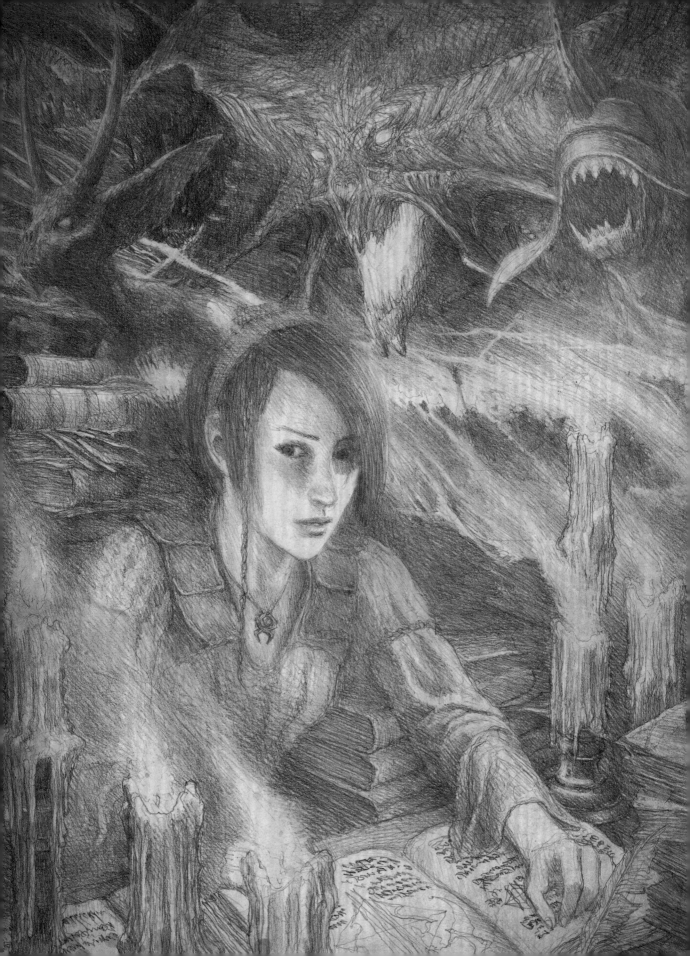

My dear Leah,

In the inevitable event of my death, may I precede you by many decades to the grave.

Do not mourn me, Leah. Despite all I have been through, I have had a long and amazing life. I have died doing exactly what I was meant to do. I have lived and loved freely these long years—and have known only joy at seeing the bright, beautiful woman you've become. I believe that I now go on to a place beyond imagining, though I have no name for it, nor real understanding of where it lies, save beyond the broken bounds of this world.

I long for this paradise, Leah—and the peace and rest I might find there on the other side of this mortal existence. I want you to know this, dear one, above all other things I could have taught you—that there is hope beyond this reality, beyond the realms of Heaven and Hell and all the shadowed spaces that lie between. Hold fast to that hope in the face of the dark times ahead, and you will find the truest meaning of your life.

Though I know that you do not believe me when I speak of dread omens, I think you are beginning to suspect that my words ring of truth. I was a nonbeliever as well. I remember, even as a child, reading the Horadric tales and thinking that while they were wonderful stories, they were only that—wonderful stories. Tales such as those of Anu and the Dragon, the Mage Clan Wars, the Sin War, and the Hunt for the Three merely were told to embrace imagination. I now see, much to my regret, that even within these legends there lives a deeper and more profound truth. For, as I have come to discover, truth is hidden in unexpected places.

If events are as I believe them to be, some truths will be revealed very shortly which will make you a believer—perhaps even upon the day of my death. For I believe that if our world is to be saved, you have a pivotal role to play in its salvation, though I know not—nor do I begin to speculate—what that role might be.

Many of the things you will see in this book will be familiar to you. There are texts from the Great Library at Caldeum. I can never forget how, even as a young girl, you mastered the city. Although I was quite aware you were sneaking around the sewers (when you and I were not exploring old ruins), which led some to call me a negligent uncle, I further knew that the survival skills you would develop there, and likewise on the rest of our journeys, would prepare you for the work you have cut out for you. Here also you will find the drawings I made of the Neztem Petroglyphs, the strange mirrored cuneiform writings which I believe were made by one of the original nephalem. Much of this you will see again, but this time with the eyes of a Horadric scholar, not the eyes of a young girl. Understand this: As of my passing, you will become the last of the Horadrim.

At one time it had been my objective to write the first-ever history of the world, starting with the myth of Anu and the Dragon and continuing on to the events that unfold before us even as I write this letter. I use the example of the Stranger, who came to us so recently. It's becoming more and more clear who the Stranger in our midst truly is, and the sacrifice he must have made. Further, I have speculated on the true nature of the heroes who have also joined in our fight against the shadow. And most certainly you have done so as well.

Some material in here will be familiar to you from the dreams which have plagued you since childhood. Indeed, those dreams might be the key to preventing the end times.

Always, dear Leah, keep your eyes on the Prophecy. It is the key to the salvation of our world.

> . . . And, at the End of Days, Wisdom shall be lost
> as Justice falls upon the world of men.
> Valor shall turn to Wrath—
> and all Hope will be swallowed by Despair.
> Death, at last, shall spread its wings over all—
> as Fate lies shattered forever.

I cannot pretend that even I fully grasp how the knowledge contained herein informs the recent events in New Tristram, save only to say that we have already witnessed reawakened evils, and the mortal realm will see more before this is over. I must beg you, Leah, to stay vigilant and probe this book and, indeed, the people and lands you shall encounter. For within them, further glimpses of the truth shall be revealed to you.

The one thing I know is that the end times are not preordained. As I said, I believe there is something beyond all of this. I know not what, only that it exists. Jered Cain saw it, and, I am told, even Zoltun Kulle glimpsed it. Mark well this truth, though you do not yet believe that there is something far greater that awaits us outside all the suffering of this world. Sweet Leah, trust in your uncle until your doubts are removed.

Your first duty calls for you to forestall the end times. And now I must reveal to you that I, like you, have had prophetic dreams. In one such dream, not only did I see malefic forces at work, haunting echoes of the distant past—demons and angels—but, in the center of it all, I saw you standing between light and dark, between the Heavens and the Hells. The odd thing is that I had this dream of you when you were a child. However, in the dream you appeared just as you are now.

Study all that is written within these pages. All the work of my life, I now bequeath to you. I know not what in the writings is vital or what is offal. It is a compendium of knowledge collected throughout hundreds of years by adventurers, purveyors of dark arts, Horadric scholars, and madmen. Inside is information that will aid you in confronting the dark days that lie ahead. Do not mourn me, Leah. I have seen and heard accounts of those who have been beyond and returned. It is my belief that in death there are yet other mysteries to be revealed.

Live life well, my dear Leah.

All of my love,

Uncle Deckard

The Dawn
Anu and the Dragon

As with all things, it is best to begin with the beginning. The Creation. All things after it are a result of it, and the nature of it reverberates down through the millennia.

A great many mystic and tribal storytellers impart some version of this story. I am using ancient writings from the Black Book of Lam Esen. I choose this source because Lam Esen was a skilled sage renowned for his knowledge of Skatsimi mysticism and folklore. In his time, he collected vast stores of knowledge from diverse places, and had a unique genius for distilling the essence of things from a vast array of different sources.

He describes the creation of our universe in the following terms:

Before the beginning there was void. Nothing. No flesh. No rock.
No air. No heat. No light. No dark.
Nothing, save a single, perfect pearl.

Within that pearl dreamed a mighty, unfathomable spirit—the One—Anu. Made of shining diamond, Anu was the sum of all things: good and evil, light and dark, physical and mystical, joy and sadness—all reflected across the crystalline facets of its form. And, within its eternal dream-state, Anu considered itself— all of its myriad facets. Seeking a state of total purity and perfection, Anu cast all evil from itself. All dissonance was gone. But what of the cast-off aspects of its being? The dark parts, the sharp, searing aspects of hate and pridefulness? Those could not remain in a state of separation, for all things are drawn to all things. All parts are drawn to the whole. Those discordant parts assembled into the Beast—the Dragon. Tathamet was his name—and he breathed unending death and darkness from his seven devouring heads. The Dragon was solely composed of Anu's cast-off aspects. The end sum of the whole became a singular Evil—the Prime Evil, from which all vileness would eventually spread throughout existence.

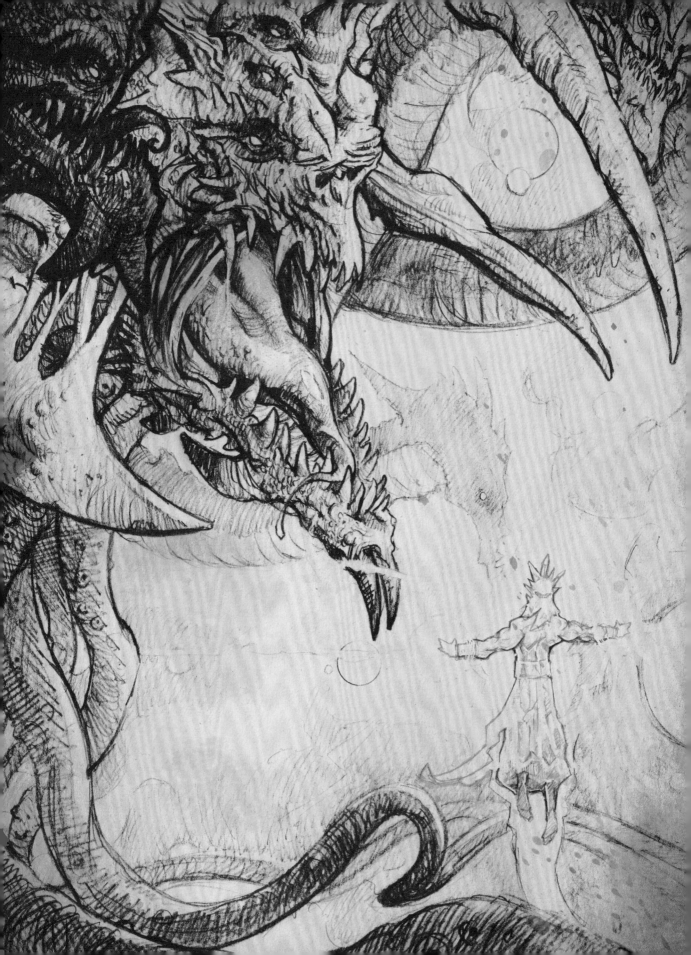

Though separate beings, Anu and the Dragon were bound together within the Pearl's shadowed womb. There they warred against each other in an unending clash of light and shadow for ages uncounted.

The diamond warrior and the seven-headed dragon proved to be the equal of the other, neither ever gaining the upper hand in their fierce and unending combat—till at last, their energies nearly spent after countless millennia of battle, the two combatants delivered their final blows. The energies unleashed by their impossible fury ignited an explosion of light and matter so vast and terrible that it birthed the very universe all around us.

All of the stars above and the darkness that binds them.
All that we touch. All that we feel. All that we know.
All that is unknown.

All of it continues through the night and the day in the ebbing and flowing of the ocean tides and in the destruction of fire and the creation of the seed.

Everything of which we are aware, and that of which we are utterly unaware, was created with the deaths of Anu and the Dragon, Tathamet.

In the epicenter of reality lies Pandemonium, the scar of the universe's violent birth. At its chaotic center lay the Heart of Creation, a massive jewel unlike any other: the Eye of Anu—the Worldstone. It is the foundation stone of all places and times, a nexus of realities and vast, untold possibility.

Anu and Tathamet are no more, yet their distinct essences permeated the nascent universe—and eventually became the bedrock of what we know to be the High Heavens and the Burning Hells.

Anu's shining spine spun out into the primordial darkness, where it slowed and cooled. Over countless ages it formed into the Crystal Arch, around which the High Heavens took shape and form.

Though Anu was gone, some resonance of it remained in the holy Arch. Spirits bled forth from it—shining angels of light and sound who embodied the virtuous aspects of what the One had been.

Yet, despite the grace and beauty of this shining realm, it lacked the perfection of Anu's spirit. Anu had passed into a benevolent place beyond this broken universe—a paradise of which nothing is known, and yet represents perhaps the greatest-kept secret of Creation.

Longed for, but unimaginable.

Just as Heaven cooled in the spaces above, Tathamet's blackened, smoldering husk spiraled into the lower darkness of reality. From his putrid flesh grew the realms of the Burning Hells. The Dragon's seven severed heads arose as the seven Evils—the three strongest of which would be known as the Prime Evils. They, along with their four Lesser brethren, would rule over the ravening, demonic hordes that spawned like maggots from the desiccated cavities of the Burning Hells.

Thus was how all of what we know began . . . In time, the Lords of Hell and the angels of Heaven met and clashed. The battle raged unceasing, and thus would come to be known as the Eternal Conflict. It is written in the Book of Long Shadows that the Eternal Conflict shall continue on forever across countless planes of existence, until further mysteries, unknown even to the angels and the demons, shall reveal themselves.

Over the millennia, many scholars have interpreted this in various ways. Some, especially in the primitive tribes who look to the sky for their understanding of the universe, view all this as literally true. They believe that Anu's spine is a physical object in the universe. That demons are born from the rotting flesh of Tathamet.

Other scholars and mystics take this less literally and perceive the telling of Anu and Tathamet's battle as an elaborate metaphor for good and evil and the constant, warring dynamic seen among the forces of nature.

The Eternal Conflict

I take the following knowledge from a surviving fragment of one of the scrolls of the Church of Zakarum. In it, the unknown scribe tells of events which took place millennia before the founding of the church. Thus, the descriptions are of questionable validity. I personally believe that the tales came from earlier and unknown sources. I have my suspicions, which, for the time, I will keep to myself—although I might expatiate on these things in a later writing. The scroll describes a war fought by agents of light and order against creatures of chaos and shadow. That is to say, forces both of the High Heavens and the Burning Hells (see later sections).

This war was most commonly fought within the realm of Pandemonium. According to one of the earliest necromancers, the angels and demons battled over control of one essential object, the Heart of Creation—the Worldstone.

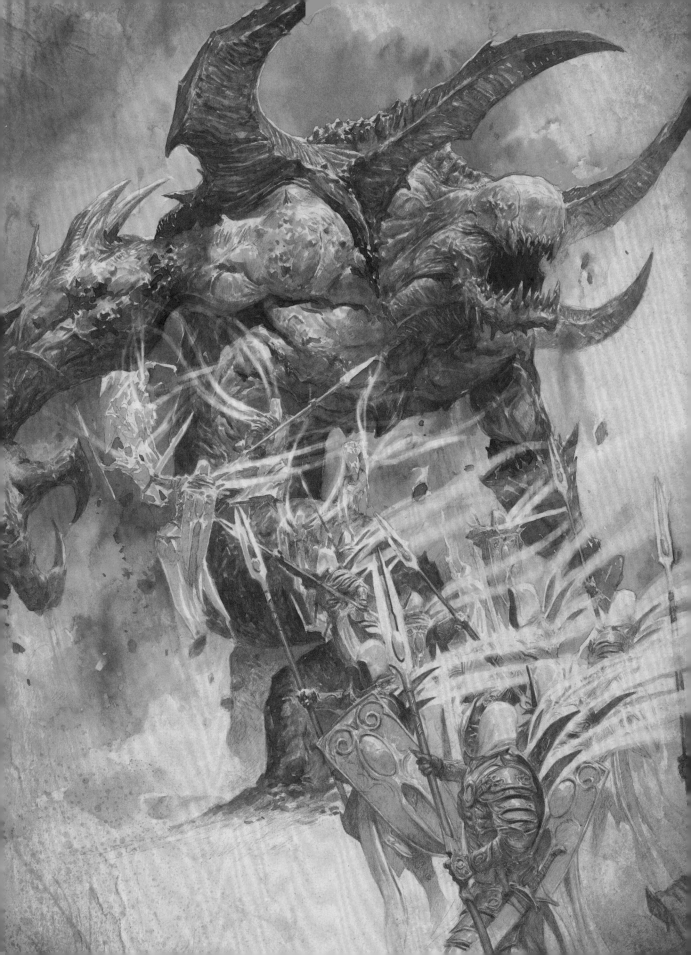

The Worldstone is not, as the name implies, a mere stone. It is a colossal, mountain-sized object which was believed by many (and is supported by multiple petroglyphs and ancient sculptures) to be the actual Eye of Anu, the One. According to legend, to which I subscribe, the Worldstone is an artifact of unimaginable power.

Lacking the specificity and background a scholar such as I would like, a belief exists that control of this stone changed hands many times over the eons. Oral history tells us that the Worldstone *"allowed the side that possessed it to alter reality and create life and worlds almost without restriction."* The account continues that *"angels used the stone to build worlds of perfect order in line with their ideals of justice, hope, wisdom, fate, and valor,"* whereas demons used the stone to *"create unfathomable engines of annihilation and worlds of destruction, terror, and hatred. However, these worlds created by angels and demons never flourished.*
They were inherently flawed, and doomed to wither and die."

I know not whether such worlds were ever created or, if they were, whether any of them still exist. To the best of my knowledge, no man has ever beheld such a world. Therefore, I suspect that this account is literary license. What we can all agree upon, however, is that this object was of great importance and that, whatever its use, it was greatly coveted by the angels and demons.

Further research suggests that in time, an archangel called Tyrael ordered a bastion to be built around the Worldstone, a stronghold which would come to be known as the Pandemonium Fortress. Throughout these writings, I will explore much further the tales surrounding Tyrael, as I have, indeed, actually met the angel.

Read these sections carefully. my dear. Read all things about him carefully. for if my suspicions are correct. he still has some role to play in this grand drama.

I can testify to the existence of the Pandemonium Fortress, as I was once there. I can tell you from firsthand experience that this stronghold embodies the warped-reality traits ascribed to Pandemonium as a whole. Indeed, I have never seen anything quite like it. That having been said, I cannot be sure whether it is simply otherworldly in nature or it was built by an angel or a mad demon. In any case, over the course of the Eternal Conflict, the fortress changed hands between angels and demons. Thus, it has taken on structural and metaphysical traits from both the High Heavens and the Burning Hells.

Long ago, an angel known as Inarius seized the Worldstone and, through some impossible act of magic, veiled it from the sight of both Heaven and Hell. He had accomplished this with the aid, I presume, of the mysterious demoness Lilith and a cadre of other angels and demons who had grown disillusioned with the Eternal Conflict. Inarius succeeded in manipulating the power of the stone to create the world of Sanctuary, a hidden paradise where he and his followers could live free from the madness of unending strife.

This is the place we know as the mortal realm. This is our world. We must pause a moment to think upon this. Our world, unlike all the other worlds, was created by both angels and demons.

The day of Sanctuary's creation, the nature of the Eternal Conflict changed. Much confusion spread through the Burning Hells and the High Heavens. The center of all things they had fought over for countless millennia had vanished. It was simply gone. At first both sides suspected the other, but in time, they realized that the truth was something different. Thus it was that the battle for possession of the Worldstone became the search for it.

It is interesting to note, before we begin delving into the Burning Hells and High Heavens, that not all things assumed of them are true.

For instance, there were different cults which reigned in the period between what we now know as the Sin War and the Dark Exile (both of which I will discuss later).

It was believed by some that the High Heavens and the Burning Hells were places where the souls of men went when they died—that men either were rewarded for their virtues (the High Heavens), or received punishment for their failings (the Burning Hells). Aside from the unfounded beliefs of various cults, there is nothing in academia to support this. It is important that the reader understand that the High Heavens and the Burning Hells, much like the realm of Pandemonium, are actual, physical locations in this universe.

Personally, I believe that there exists a place where the souls of men go after their death, but that discussion is beyond the place of this treatise.

This being said, I must confess that even I do not always know where myth ends and truth begins. That, reader, I will let you judge for yourself.

The Burning Hells
Realms of Evil

As to the nature of the demons of Hell, I can testify only to having personally seen Diablo and other manner of terrors in both Tristram and elsewhere on Sanctuary, but my experiences are nonetheless limited in the broad scheme of things. I must defer to other sources, such as the writings of Vischar Orous, chief librarian for the Zharesh Covenant, a small offshoot of the notorious Vizjerei mage clan. Orous' careful and scholarly research of the Prime Evils and other demons has been passed to us through historical and scientific tomes.

One intriguing piece of information I have gleaned from Orous' research is that not all abominations and violations that appear in Sanctuary are of hellish or demonic origin. For instance, the walking dead are unique to Sanctuary and are not created in the Burning Hells, but they can be awakened from their morbid sleep by activities of demons and angels.

In other areas I have turned to the writings of my own ancestor, Jered Cain, for information, especially as it concerns the Prime Evils he and his brother mages battled.

The accounts by man of the Burning Hells are very limited. (I myself have gone only so far as the Pandemonium Fortress.) Orous relies on information gained by Vizjerei mages who summoned demons into Sanctuary and interrogated them in most ingenious ways. Other information has been gained by casting holy powers into possessed humans, compelling demons who reside within them to speak.

> "Seven is the number of the powers of Hell, and seven is the number of the Great Evils."
>
> —Vischar Orous

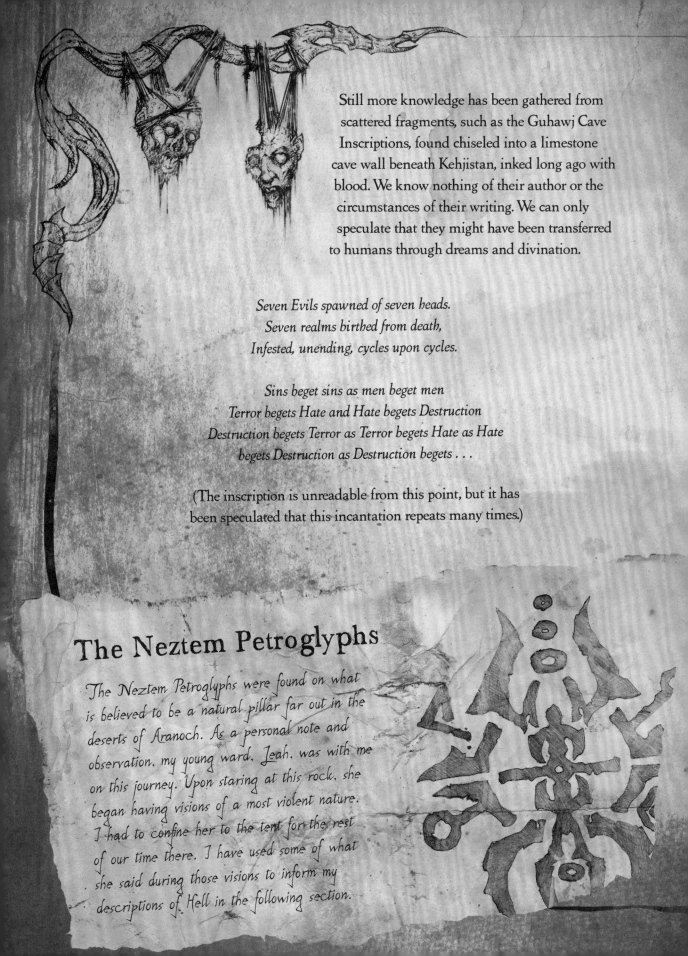

Still more knowledge has been gathered from scattered fragments, such as the Guhawj Cave Inscriptions, found chiseled into a limestone cave wall beneath Kehjistan, inked long ago with blood. We know nothing of their author or the circumstances of their writing. We can only speculate that they might have been transferred to humans through dreams and divination.

Seven Evils spawned of seven heads.
Seven realms birthed from death,
Infested, unending, cycles upon cycles.

Sins beget sins as men beget men
Terror begets Hate and Hate begets Destruction
Destruction begets Terror as Terror begets Hate as Hate
begets Destruction as Destruction begets . . .

(The inscription is unreadable from this point, but it has been speculated that this incantation repeats many times.)

The Neztem Petroglyphs

The Neztem Petroglyphs were found on what is believed to be a natural pillar far out in the deserts of Aranoch. As a personal note and observation, my young ward, Leah, was with me on this journey. Upon staring at this rock, she began having visions of a most violent nature. I had to confine her to the tent for the rest of our time there. I have used some of what she said during those visions to inform my descriptions of Hell in the following section.

The Prime Evils

THE LORDS OF THE BURNING HELLS

Mark well the words that follow, and let them serve as a warning to all men of what the Lords of the Burning Hells may have planned for the future of Sanctuary should they ever invade our realm.

Let it be known that there exists a hierarchy to the Hells.
There are three Prime Evils and four Lesser Evils.

The Prime Evils are Diablo, Lord of Terror; Baal, Lord of Destruction; and Mephisto, Lord of Hatred. These Prime Evils are brothers—it is said that they were the dominant heads of the Dragon, Tathamet. These three Evils endeavor to maintain a strict rule over the Hells' legions. As the Guhawj Cave poem indicates, these powers fuel each other. Terror leads to Hatred, and Hatred leads to Destruction. This has allowed them to be the dominant force of Hell in such a way that they generate energy that has been analogized to an alchemist's engine.

The Lesser Evils are four in number. The first is Andariel, the Maiden of Anguish. Andariel is the twin sister of Duriel, a male Evil who is referred to as the Lord of Pain. The final two Evils are the ones most mysterious to us, for they have not yet come to Sanctuary. However, many of the prophecies express a fear that they will. These two are Belial, Lord of Lies, and Azmodan, Lord of Sin.

As we have now briefly introduced the hierarchy of Hell, it is time to explore each individually. We shall focus also upon what is known of the Evils' domains in Hell. It is interesting to note here that the borders of their domains are constantly shifting as the boundaries within the Hells crash into and encroach upon one another. Judging by the texts and accounts, it is as if the borders themselves are in conflict.

Let us not dwell overlong on these horrors, however, lest we ourselves sink into the depths of madness.

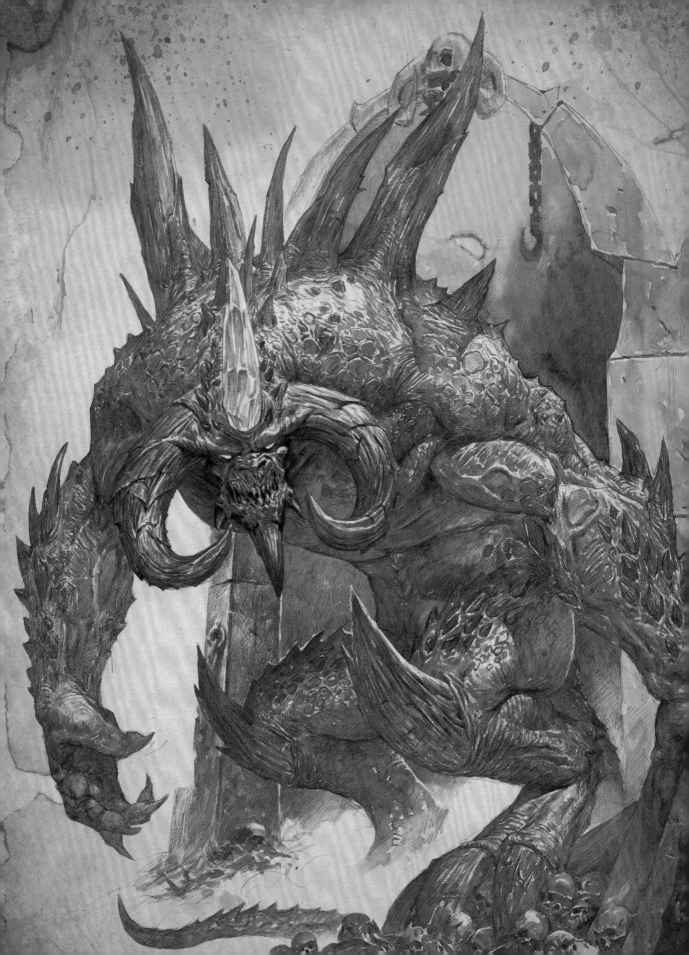

DIABLO, THE LORD OF TERROR

Of all of the Great Evils, it is much to our misfortune that we know the most about the Lord of Terror, Al'Diabolos, known more widely as Diablo.

He is the root of all fears buried deep within mortal minds. He is the nightmare that awakens us, sweating in the dark. He is an entity of pure malevolence and depthless evil. He has plagued Sanctuary on several occasions and tormented mortals time and again, more often than any of his foul brethren.

Despite the fact that age as we know it does not seem to apply to the Lords of Hell, Diablo is generally considered to be the youngest of the Three. It may also seem odd to assign positive traits to a demon; nonetheless, it is said that Diablo is the most creative and farsighted of his brothers, perhaps of all of the Evils. Many claim that Mephisto is the most intelligent, but intelligence has as many facets as does evil.

Diablo is calm, cunning, and patient, and best understood when we view all his actions as attempts to instill terror in those around him. Consider the components of terror: a mix of fear, shock, and utter hopelessness. Perhaps Diablo's most insidious power is the ability to cast his influence deep in the minds of his victims and latch upon their greatest, most crippling fears, then to apply that knowledge and, in so doing, use a person's own worst fears against them.

As perverse as it may sound, Diablo sees himself as an artist of terror. I can attest that when I was subjected to Diablo's evil, it seemed to me as if he derived from it the pleasure that an artist takes in his work. Perhaps he sees each of us as a canvas.

Diablo knows that conquest comes when enemies panic and turn their backs to their fears, rather than face them. However—and this is an important concept to grasp—Diablo does not acquire his satisfaction from conquest itself, as perhaps Mephisto might. Diablo feeds on the terror that precedes the conquest. To him, the fear a victim has is a greater reward than the pain they suffer when they are actually tortured.

With this perspective on Diablo's nature, it remains now for us to describe his Realm of Terror within the Burning Hells.

Vischar Orous states, from the extracted testimony of demons who claim to be familiar with this realm of living nightmare, that it is the least populated of all the territories of Hell, for few demons can withstand its unrelenting torment.

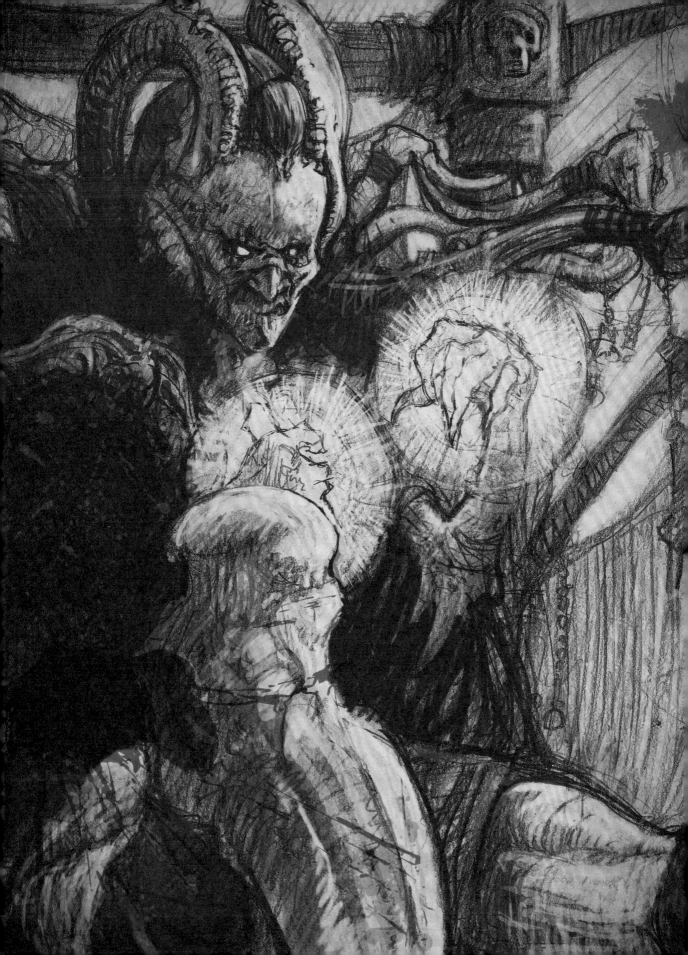

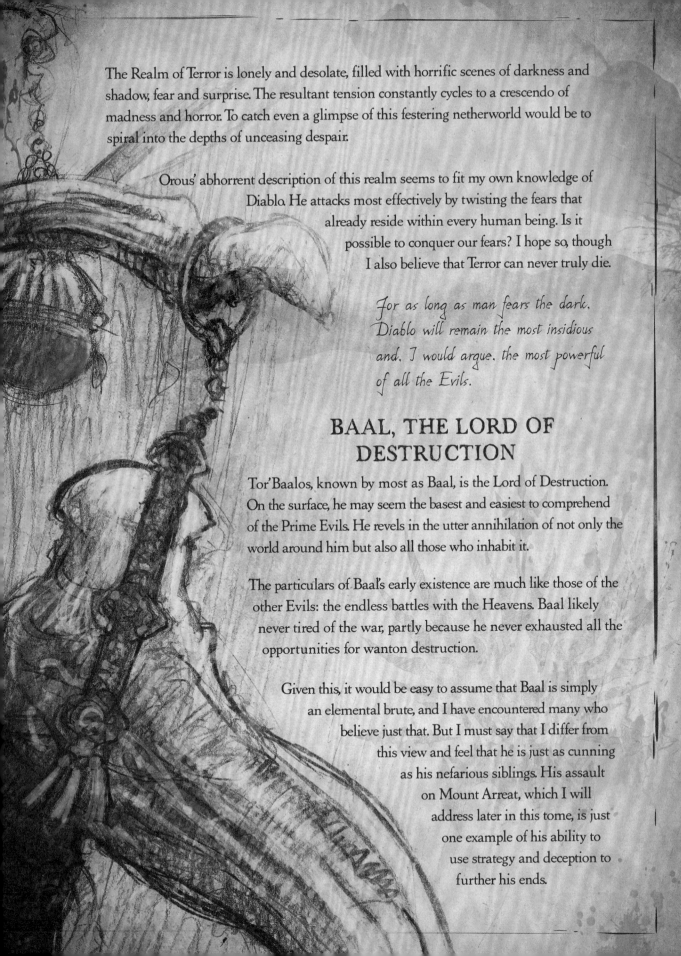

The Realm of Terror is lonely and desolate, filled with horrific scenes of darkness and shadow, fear and surprise. The resultant tension constantly cycles to a crescendo of madness and horror. To catch even a glimpse of this festering netherworld would be to spiral into the depths of unceasing despair.

Orous' abhorrent description of this realm seems to fit my own knowledge of Diablo. He attacks most effectively by twisting the fears that already reside within every human being. Is it possible to conquer our fears? I hope so, though I also believe that Terror can never truly die.

For as long as man fears the dark, Diablo will remain the most insidious and, I would argue, the most powerful of all the Evils.

BAAL, THE LORD OF DESTRUCTION

Tor'Baalos, known by most as Baal, is the Lord of Destruction. On the surface, he may seem the basest and easiest to comprehend of the Prime Evils. He revels in the utter annihilation of not only the world around him but also all those who inhabit it.

The particulars of Baal's early existence are much like those of the other Evils: the endless battles with the Heavens. Baal likely never tired of the war, partly because he never exhausted all the opportunities for wanton destruction.

Given this, it would be easy to assume that Baal is simply an elemental brute, and I have encountered many who believe just that. But I must say that I differ from this view and feel that he is just as cunning as his nefarious siblings. His assault on Mount Arreat, which I will address later in this tome, is just one example of his ability to use strategy and deception to further his ends.

By all accounts, Baal's realm in the Burning Hells is a frenzy of constant destruction wherein he breeds demons only for the sheer gratification of destroying them. It is said that he has built some of the mightiest structures in the Hells, perfecting bastions of impenetrable strength, only to see them pulverized in unique and different ways.

There is one other thing of great import to remember.

At the heart of the Realm of Destruction lies the Hellforge, which, ironically, is the realm's single source of creation. This is one of the very few places in Hell men have actually seen, and those who have been there have reported that the greatest weapons of the Burning Hells are forged within it.

It is said that Hellforged weapons are infused with elements of the Lords of Hell. Of course, it must also be noted that these items are used to destroy. Once again, we see that the theme of creation and destruction rings through all things associated with Baal.

MEPHISTO, THE LORD OF HATRED

Dul'Mephistos, known commonly as Mephisto, is the Lord of Hatred. There are some who believe that if there is truly a leader among the Burning Hells, it is Mephisto.

It has been said also that Mephisto is the most adept at playing his brothers against each other. Diablo and Baal chafe at his manipulations, but more often than not they comply, most likely because Mephisto provides them with ample opportunities to pursue their ambitions. Perhaps this is why Mephisto is seen by some to be a unifier, a great tactician.

It is Mephisto's greatest ambition to pit entire societies against one another, to turn brother against brother, sowing discord and distrust at every turn. The Lord of Hatred might look at Sanctuary as his own private ant farm, presenting him with endless, fascinating opportunities to fuel the flames of conflict.

To Mephisto, hatred is a tool, though one he wields with utmost precision. The Lord of Hatred despises all, but he loathes angels above all else. And so the inhabitants of Sanctuary are seen by him as weapons to be forged in his likeness, to be aimed one day at the High Heavens.

And if history is any indication, Mephisto is well positioned, for hatred has shaped more of humankind's history than all the other evils combined.

It would be wise to note here that bards and chroniclers alike have stated that Mephisto is the father of two demons, Lucion and Lilith.

The Hellforge is said to consist of many anvils, including the Anvil of Annihilation. Yeah, see my writings in "The Dark Wanderer."

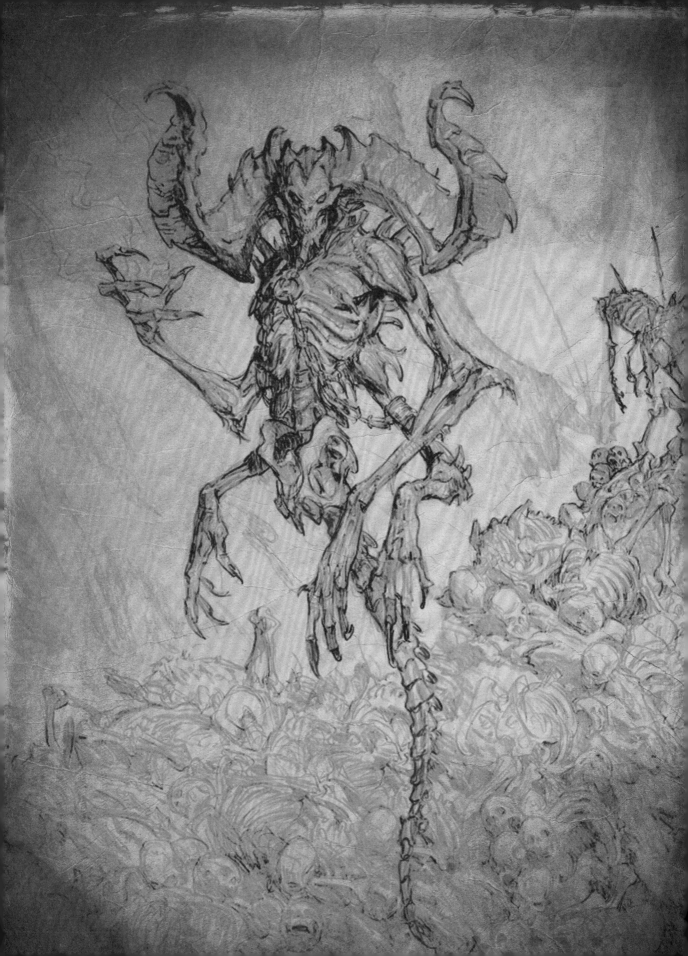

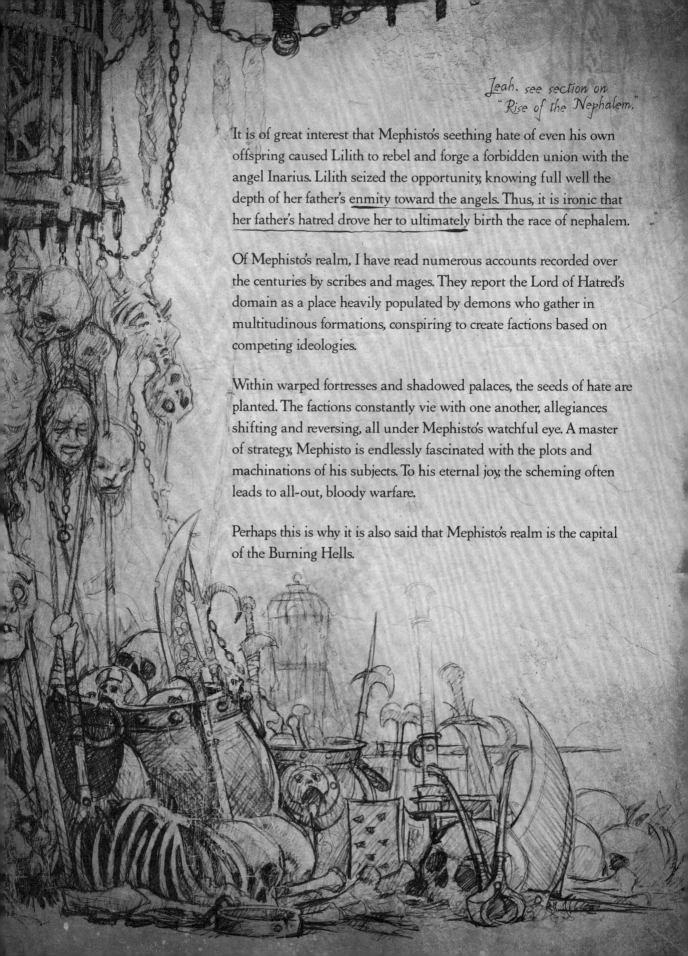

Leah, see section on
"Rise of the Nephalem."

It is of great interest that Mephisto's seething hate of even his own
offspring caused Lilith to rebel and forge a forbidden union with the
angel Inarius. Lilith seized the opportunity, knowing full well the
depth of her father's enmity toward the angels. Thus, it is ironic that
her father's hatred drove her to ultimately birth the race of nephalem.

Of Mephisto's realm, I have read numerous accounts recorded over
the centuries by scribes and mages. They report the Lord of Hatred's
domain as a place heavily populated by demons who gather in
multitudinous formations, conspiring to create factions based on
competing ideologies.

Within warped fortresses and shadowed palaces, the seeds of hate are
planted. The factions constantly vie with one another, allegiances
shifting and reversing, all under Mephisto's watchful eye. A master
of strategy, Mephisto is endlessly fascinated with the plots and
machinations of his subjects. To his eternal joy, the scheming often
leads to all-out, bloody warfare.

Perhaps this is why it is also said that Mephisto's realm is the capital
of the Burning Hells.

The Lesser Evils

Compared to the Primes, there is much less knowledge to be found regarding the Lesser Evils. Only two of the four—Andariel and Duriel—have ever been seen in the mortal realm. The other two, Belial and Azmodan, are known only by secondhand account. It is these latter two who I fear might bring about the end times.

Dear reader, do not be fooled by the designation of "Prime" or "Lesser": It is one that is relevant only within the Burning Hells and does not mean that one Evil is more or less dangerous to us mortals.

In fact, it is probable that the Lesser Evils are more dangerous than the Primes. It is, after all, known that the four Lesser Evils rose up against the Primes and banished them to Sanctuary in a rebellion termed the Dark Exile. *detailed elsewhere in this volume*

I will start first with the Lesser Evils who are known to us. Duriel and Andariel are what men would wrongly call fraternal twins; in the realm of demons, their intimate relationship seems to have more to do with their corresponding spheres of pain and anguish than with any actual blood connection.

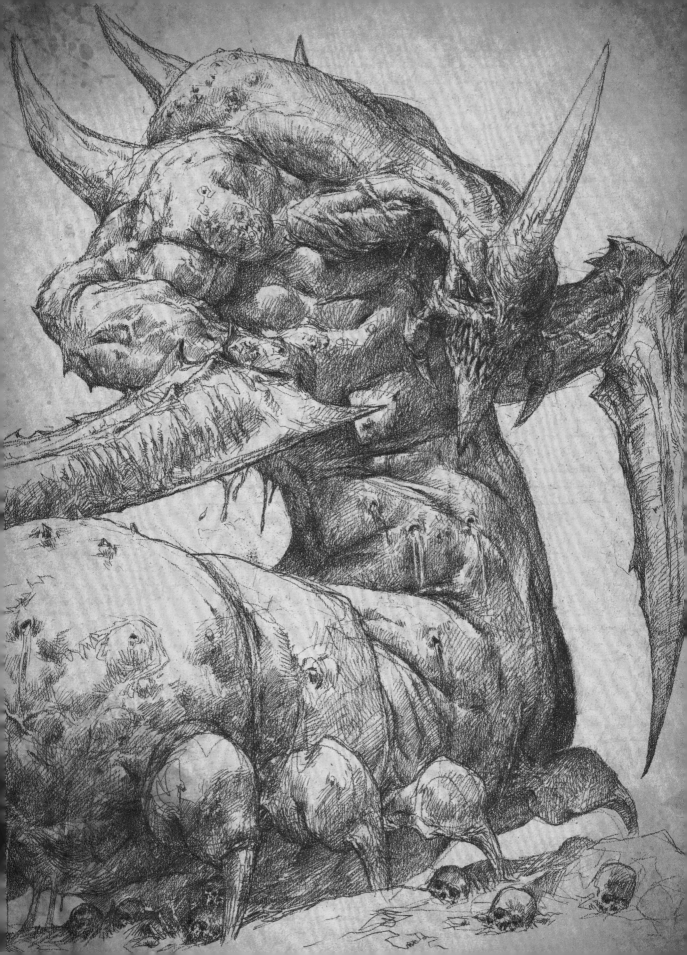

DURIEL, THE LORD OF PAIN

Duriel, brother to Andariel, is also known as the Maggot King, or the Lord of Pain. He has been seen only once on Sanctuary, in the form of a horrific, grotesque maggot-like aberration.

By all accounts, Duriel loves to torture and inflict pain. The bizarre thing, which I think is not fully comprehensible to us mortals, is that he doesn't seem to care what the pain means to the recipient. He appears to love the music of the screams: the disharmony of agony at a sensual level. He thinks of himself as a maestro of pain. He is interested not in mental anguish but in physical torment.

Many writings suggest that if Duriel is in a position where there is no victim for him to inflict torture upon, he will subject himself to excruciating pain and be sated.

Ironically, given how little is known of the Lesser Evil himself, Duriel's place in the Burning Hells is the one most widely chronicled in the ancient artworks. I suspect that this is because it most closely resembles the torture chambers of our own realm and therefore is most easily understood and depicted by human artists and writers.

The Realm of Pain is described as a cavernous area fitted with increasingly sadistic and grotesque torture devices, from towering machines that house unspeakable engines of brutality to tiny mechanisms engineered to elicit agony beyond imagining. Here Duriel derives exquisite gratification from the torment of thousands of captive, barbarous demons. It is said that even the other denizens of Hell, including his sister, whose realm in some perverse way overlaps his, avoid this place, though they delight in the music of agonized screams that issues from it.

ANDARIEL, THE MAIDEN OF ANGUISH

Andariel, known as the Maiden of Anguish, is a particularly sadistic entity.
Unlike her so-called twin, Duriel, she is interested not in physical pain
but in emotional agony. She believes in the purity of anguish.

She is a master manipulator who sets up scenarios in which the victim's mental state
is twisted inside out. She loves seeing people torn apart by their own inner agony and
emotional pain. The Maiden of Anguish was once considered a close confidante of
Diablo—until the Dark Exile, that is, when she and her companions ruthlessly betrayed
him. Despite their former allegiance, she reveled in Diablo's misery and was described as
enjoying a state of unmatched bliss throughout his humiliating defeat. Her general bearing
is of one who is in a constant state of ecstasy, experiencing unthinkable pleasures. Andariel,
considered one of the most relation oriented of the Evils, is said to abhor isolation, for she
sustains herself on the suffering of others. She is drawn to conflict and tragedy as a moth to
flame. She seems to be in constant motion, seeking those in the depths of despair, or those
most susceptible to her influence and manipulation.

There is little information on what her realm in the Burning Hells is like, but clearly it is a
place of psychological assault, where guilt, regret, and self-loathing are meted out through
both physical and mental means.

It has been suggested that the victims of Andariel's realm, crippled by guilt and driven to
seek unending physical torment, willingly give themselves over to Duriel's domain.

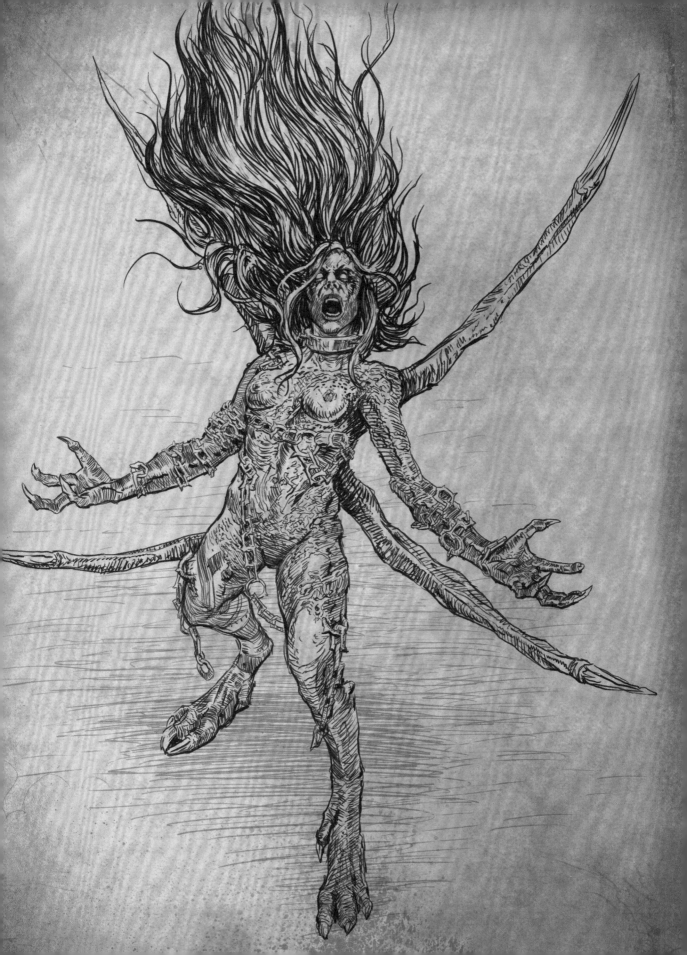

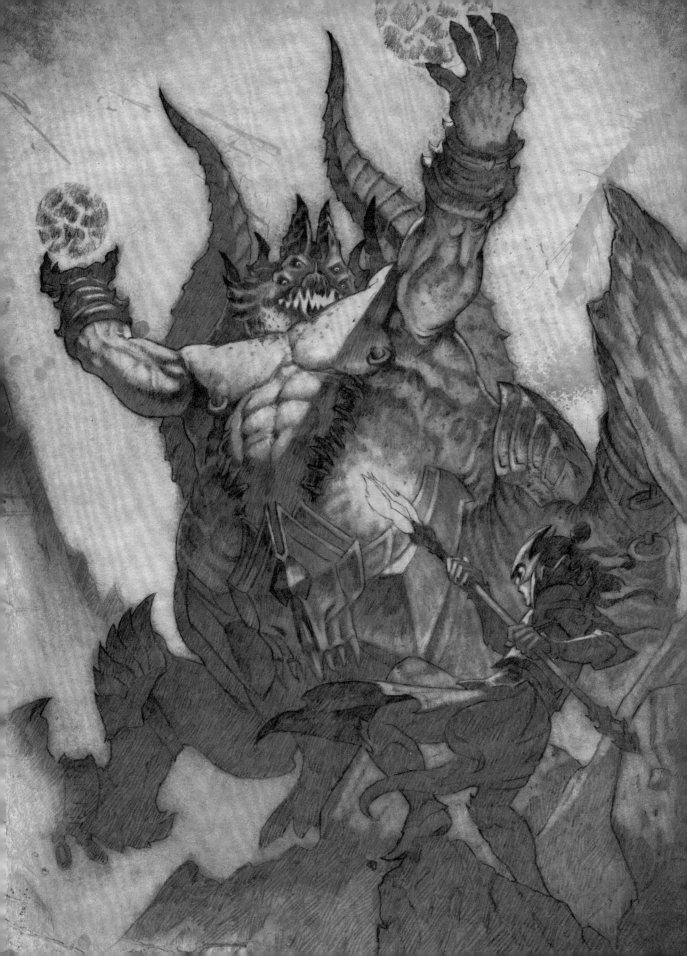

AZMODAN, THE LORD OF SIN

Azmodan, Lord of Sin, is a clever manipulator who trades in vice and corruption. He is passionate and plotting—both to very dangerous degrees. He is by far the most charismatic and seductive of all the Evils.

Azmodan takes pleasure in all things to every possible extreme. He loves vice in all its forms, but the truest gratification he derives is from the failures of others. Azmodan is a master of temptation, of causing those who hold steadfastly to principles and beliefs to ultimately betray them. Azmodan can see most clearly the heart's desires. He exists only to shred morality, to bring any and all within his sphere to the point of breaking.

Perhaps if one could analyze the inner workings of Azmodan, they would see that the Lord of Sin defines the universe through the extremes that one is willing to go to; he believes that all beings find their truest identity by embracing the far limits of perversion and depravity.

If this is difficult for the reader to grasp, do not feel stymied. There are scholars and sages who have meditated on and contemplated this subject for years, and still wrestle with their understanding.

> We are a race of joy and nurturing that is tainted and tempted by sin, but rare is the human who sets out to commit sin; sin is a web we are drawn into.

Azmodan would surely find fertile ground on Sanctuary to plant the seeds of corruption, but fortunately he has never, to the best of my knowledge, appeared upon the mortal plane.

It is said in the scrolls of Malzakam that Azmodan's land in the Hells is the most densely populated—that it is a warped arena of myriad sins, of both great joy and despair, a place where garish perversions are indulged to the extreme.

The scrolls also suggest that Azmodan's den at first does not appear fearsome or disgusting, but rather looks to be a seductive warren that leads downward and downward through an increasingly labyrinthine harem. Here, sated to revulsion with all the pleasures of life, one descends rapidly into a perverse madness, without any hope of awakening one's rotted soul.

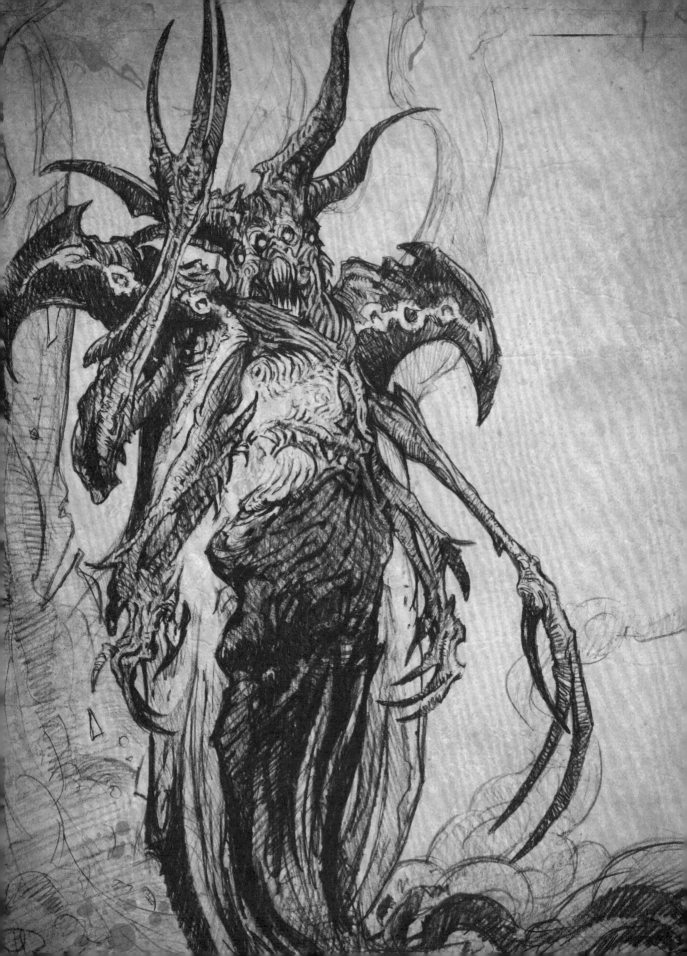

Much like the provocative hymns sung by pleasure maidens in Lut Gholein, the Malzakam scrolls infer that pleasure, when imbibed too freely or when prolonged for too great a time, becomes indistinguishable from pain. Conversely, at certain levels, pain itself becomes pleasure.

While I understand the theory, I have no interest in experiencing it firsthand. I believe, as the scrolls attest, that those who would embrace sin will quickly become lost with no hope of return.

May the Heavens help us if Azmodan should ever arrive upon the mortal plane.

BELIAL, THE LORD OF LIES

Once again, I have no firsthand knowledge of Belial. What I do know is that the Lord of Lies is depicted in various writings as a trickster and master deceiver.

Belial advocates the notion that perception is reality, and it is his sole purpose to dominate reality. He does not lie simply for the sake of lying; rather, he deceives with the overall intent of controlling others' perception of what is real.

The Lord of Lies relishes the moment his victim realizes he's been deceived, that moment of nakedness and betrayal. It is my feeling that should we encounter him on this plane, he would appear as a master orator, a mortal of immense influence and means, perhaps even a respected leader. Beneath this facade would lurk the true Belial—covert, wicked, and brilliant, a creature of great clarity and deftness. He would hatch plots within plots and drive humankind to ruin.

Should there be an invasion of the mortal realm, expect deception to cloak it. Belial's weakness, perhaps, is that his deception does not stop with others, for he is often trapped within the intricate webs of his own machinations.

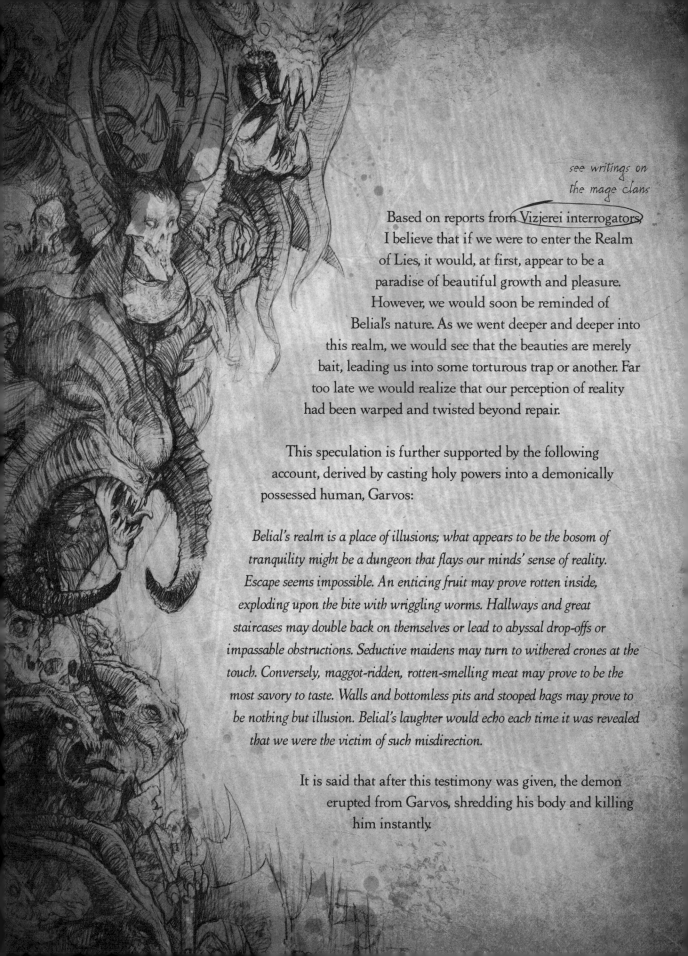

see writings on the mage clans

Based on reports from Vizjerei interrogators, I believe that if we were to enter the Realm of Lies, it would, at first, appear to be a paradise of beautiful growth and pleasure. However, we would soon be reminded of Belial's nature. As we went deeper and deeper into this realm, we would see that the beauties are merely bait, leading us into some torturous trap or another. Far too late we would realize that our perception of reality had been warped and twisted beyond repair.

This speculation is further supported by the following account, derived by casting holy powers into a demonically possessed human, Garvos:

Belial's realm is a place of illusions; what appears to be the bosom of tranquility might be a dungeon that flays our minds' sense of reality. Escape seems impossible. An enticing fruit may prove rotten inside, exploding upon the bite with wriggling worms. Hallways and great staircases may double back on themselves or lead to abyssal drop-offs or impassable obstructions. Seductive maidens may turn to withered crones at the touch. Conversely, maggot-ridden, rotten-smelling meat may prove to be the most savory to taste. Walls and bottomless pits and stooped hags may prove to be nothing but illusion. Belial's laughter would echo each time it was revealed that we were the victim of such misdirection.

It is said that after this testimony was given, the demon erupted from Garvos, shredding his body and killing him instantly.

Conclusions

In closing, we should not, for even a moment, believe that because the Lesser Evils are referred to as such that we can relax our guard, for as I have said, the so-called Lesser Evils are every bit as dangerous and ingenious as the Primes, and perhaps more so, because we have had very little direct interaction with them. Remember also the omens that foretell a time of great sin and deception across the mortal world. These signs may be the harbingers of our doom.

"Man's pleasures give way to pain. His truths are buried in the shroud of lies.

It is this time when Hell shall reign. While all of man dies."

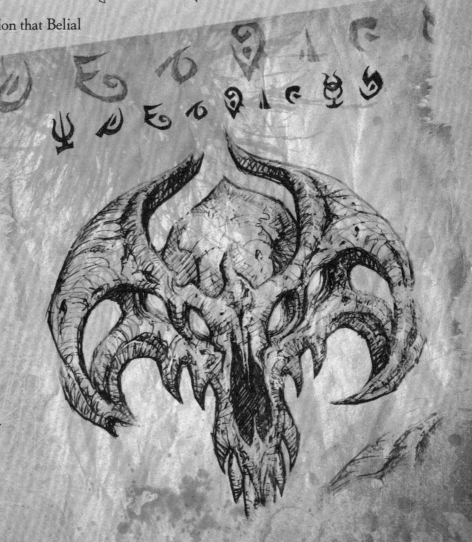

This is clearly an indication that Belial and Azmodan may even now be on the move. It is imperative that we not develop a false sense of confidence when we consider the combative nature of these Evils toward one another. It must always be remembered that they work together as well when it suits their interests.

We must therefore be on our guard against the coming predations of Belial and Azmodan.

The High Heavens
The Angiris Council

A s with the Burning Hells, I personally have never ventured to the High Heavens. However, I have met the archangel Tyrael and, thereby, know angels to exist. I further have acquired some knowledge of their powers. Much of what follows is derived from recovered texts written by the Horadrim during the Hunt for the Three. These texts were assembled in the monastery built by the Horadrim at Tristram, where the order settled after capturing the three Prime Evils. These writings may well shine a light on the High Heavens and all the wonders that one might behold there, including the Angiris Council, the ruling body of the Heavens.

The reader should understand that these manuscripts are supported by many other artifacts I have either collected or observed in my travels about the world. I do not demand the reader believe my word alone.

To many scholars, the archangels of the Angiris Council are living representations of the chief virtues of Anu. It is important that we understand that these beings are not like men. They are not made of flesh and blood. They do not age and die as we do.

In their pure existence, angels are of a divine essence of light and sound. Radiance marked with beautiful harmony. Although the reader may find this description abstract, I believe that angels in the High Heavens exist more like magnificent movements of music and light. It is told that even the armor the angels wear is ornamental and used more to provide a sense of individuality than to protect. It is written that the angels have worn this armor since the beginning, long before the appearance of humankind, so their use of it is certainly not an attempt to appear more like humans. I believe the armor to be both functional and decorative, though I must admit this is merely supposition on my part.

It is the angels' majestic wings of light that speak of their truest manifestation. Angels are a magnificent sight to behold, appearing as mortals, but at the same time looking utterly otherworldly. Whatever the case, it is important that you know angels do exist. They have been known to take great interest in the affairs on our world, just as demons do. It should also be noted that much of this interest comes from fear, for they believe that we humans hold great untapped power within us. A power perhaps greater than that of the angels themselves.

This is our nephalem birthright—but I am getting ahead of myself; the nature of our extraordinary heritage will be discussed later.

For now, in order to gain a greater understanding of the angels, it is necessary that we discuss the members of the Angiris Council one by one. I will begin by describing each, as well as the legendary items they wield.

IMPERIUS, ARCHANGEL OF VALOR

Imperius is the leader of the Angiris Council, if leadership exists at all in the human sense. It is he who commands the warrior host of the High Heavens. His tactical brilliance encompasses all facets of warfare, from maneuvering armies on the battlefields to leading covert strikes against Hell's outposts.

Over the long eons of the Eternal Conflict, Imperius has tread where other angels do not dare. When the great war has turned in Heaven's favor, he has been the first to spearhead the most daring assaults into the heart of the Burning Hells.

Even in the face of defeat, Imperius' bravery is unshakable. When Hell's legions lay siege to the High Heavens, it is Imperius who rallies his fellow angels to action. He is the first to storm out of the Diamond Gates and charge headlong into the scattering armies of the Hells. The mere sight of Imperius in action emboldens the angels with valor and strength.

In speaking of Imperius' exploits, I must also mention Solarion, the Spear of Valor. Legend tells that the archangel forged this weapon in the heart of a dying star. I have heard it described as an extension of his immutable will, powerful enough to sunder Hell's mightiest ramparts with a single righteous strike. During one of Imperius' invasions of the Burning Hells, it is written that Solarion felled so many demons that rivers of blood flowed throughout the realms of the seven Evils.

I should note here that Imperius does not carry the spear at his side at all times. Rather, he summons it from on high as a lance of blinding light that then manifests as a physical spear in his hand.

When not clashing with Hell's minions, Imperius often strategizes, and trains other warrior angels in the Halls of Valor, his place in the High Heavens. Skatsimi mystics describe the archangel's domain as a series of vast, glowing chambers that echo with songs of his valorous deeds. There, his trophies of war are displayed in perpetuity.

If we take the above to be true, then undoubtedly, Imperius must be held in high regard for his leadership and martial prowess. However, his legendary valor appears to come with the fatal flaw of pride. It is this pride and arrogance which have reportedly brought him into conflict with Tyrael, the archangel of Justice. This is due in large part to the pact that Tyrael helped make between the Heavens and the Hells at the conclusion of the Sin War (an event I will discuss in depth later).

The treaty brought the Eternal Conflict to a grinding halt, thus robbing Imperius of further opportunities to prove his valor in combat.

Since that time (and surely due in no small part to the later actions of Tyrael, as we shall see), it is said that Imperius has become a highly legalistic and unbending tyrant. Although it is likely not his intent, Imperius' obstinacy has allegedly caused disharmony to creep into the Angiris Council.

TYRAEL, ARCHANGEL OF JUSTICE

The only member of the Angiris Council I have seen with my own eyes is Tyrael, the archangel of Justice. I might even say I know him, if it is truly possible to know an angel.

Ages before the rise of man, it is said Tyrael was the most rigid of the angels, firm in his adherence to laws, rules, and order. He held to a single, unbending duty: to secure victory for the High Heavens in the Eternal Conflict.

As with Imperius, Tyrael's exploits in battle are the stuff of legend. He was renowned for being calm and controlled and meticulous in his execution of combat technique. The archangel carried out his impassive judgment through the use of El'druin, the Sword of Justice.

El'druin is, by all accounts, a unique weapon that can cut through any substance or foe in existence. There is, however, an exception: Some believe that the blade's edge cannot pass through or harm any being of righteous intent.

Despite Tyrael's fame as a warrior with few peers, it is nonetheless stated that he was at all times fair and impartial, as justice itself must be.

The Courts of Justice, Tyrael's abode in the High Heavens, are said to be akin to a great auditorium wherein angels congregate. Here they air grievances, come to terms, and strive to reclaim lost harmony or equilibrium. It seems a fitting institution for an angel who values integrity and balance above all things, and will choose the path of righteousness in any situation, even if it brings harm to those he loves.

In light of all that is stated above, it is ironic that Tyrael is now considered to be the renegade of the Angiris Council. Much of this is due to the fact that since the appearance of mortals, Tyrael has evidenced a change of character. He has intervened for the sake of humankind time and again, for he sees the potential for heroism and selflessness in each of us. He has even acted against the mandates of his fellow Council members to fight on our behalf.

For that alone I always have and always will believe in him.

I will discuss Tyrael in more detail later. For now, I feel compelled to state that my personal commentary on Tyrael reflects my own view, and I would ask the readers to draw their own conclusions about him.

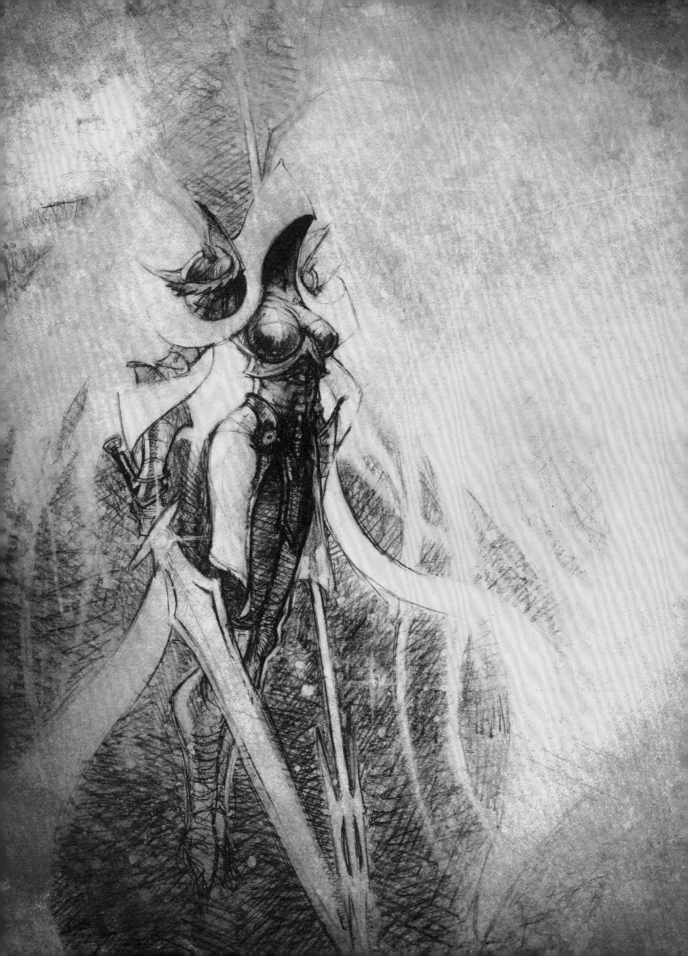

AURIEL, ARCHANGEL OF HOPE

Auriel is the most beloved of all angels. It is she who leads the sweet chorus of the High Heavens. She is said to be at the center of this chorus and to be the most lighthearted member of the Angiris Council. Auriel believes in the potential for good in all things, including the hearts of all sentient beings.

Auriel is not a pacifist. She does not shy away from strife, for she recognizes that conflict is the nature of this broken universe. There are many tales of her incredible feats in battle, breaching the walls of the Pandemonium Fortress alongside her fellow archangels to wrest the stronghold from Hell's grasp.

However, what makes Auriel unique is her ability to see harmony even in the midst of discord. She believes that victory for one side does not always mean defeat for the other. To her way of thinking, beyond each conflict lies the promise of healing, just as even in the dark of night one knows that the coming dawn will bring a new day.

I have read of heated arguments between Imperius and Tyrael that were put to rest only by Auriel's intervention. She did so not by scolding them or objecting to the use of violence, but by showing her comrades that resolution can open doors to new possibilities. For this archangel to temper the likes of Imperius and Tyrael, she must truly possess extraordinary patience and benevolence.

I have heard tales that during arguments and debates, Auriel will sometimes drape Al'maiesh, the Cord of Hope, around her comrades' shoulders to grant them clarity of thought and emotion. The cord is said to be a manifestation of Auriel's positive qualities. Pulsing with glowing runes from end to end, the long, serpentine ribbon can heal and energize those it touches. In battle, Auriel can just as quickly whip the cord through the ranks of her enemies, burning them with righteous fire.

Auriel, it seems, spends much of her time in the Gardens of Hope, a tranquil quarter of the High Heavens where angels go to clear their minds and find serenity. The trees in this area do not have leaves per se, but their canopies dance with shimmers of light and sound. At all times, an uplifting choir rings throughout the gardens. Those who hear it find their spirits in harmonious alignment with every other angel who dwells in the Heavens.

ITHERAEL, ARCHANGEL OF FATE

Archangels believe in fate, or destiny—the sense that all things are "written," and therefore knowable. Itherael has a unique ability to read the esoteric and arcane writings of fate. None of the others dare even try. To them, the visions are indecipherable.

By all available accounts, Itherael's prophecies are not always dark, and he holds a balanced view of all things.

Though his loyalty to the Angiris Council is unquestioned, Itherael has been described as inscrutable or aloof. It is suggested in the texts that Imperius has often sought to learn from Itherael the outcome of the Eternal Conflict. Itherael has maintained at all times a steadfast dedication to victory, but the writings tell us that he has never shared with Imperius his views on the ultimate fate of the never-ending war between the Heavens and the Hells.

It has also been observed that of all the archangels, Itherael is closest to Auriel.

It is written that the archangel of Fate is capable of predicting the actions of armies and even single opponents before those actions take place. More incredibly, Itherael can slow time itself. Whether this claim is to be taken literally or not, I do not know.

To further understand Itherael, it is necessary to speak of Talus'ar, the Scroll of Fate. It is this mystical object which Itherael consults in times of great need. Although it is a single scroll, accounts suggest that the information scrawled on the enchanted parchment changes based on the answers Itherael seeks.

Allegedly, this is made possible by a vast number of crystals Itherael possesses within the Library of Fate. These gems are reputed to be shards of the Crystal Arch, which is in turn believed by some scholars to be the spine of Anu.

Within the library, angel ascetics peer into the crystals, recording the visions they behold for Itherael to interpret.

Some records suggest that when Anu was blasted apart, its state of all-knowing was fragmented as well. If true, then it is possible for the crystals within the Library of Fate to provide visions of multiple possible futures.

Perhaps it is for this reason that Itherael is viewed as aloof or even indecisive, and that his predictions may sometimes seem flawed.

Also worth noting here is that since the discovery of Sanctuary, it is reported that Itherael has been unable to see the fate of the nephalem within his scroll, because they are not of the natural order of creation.

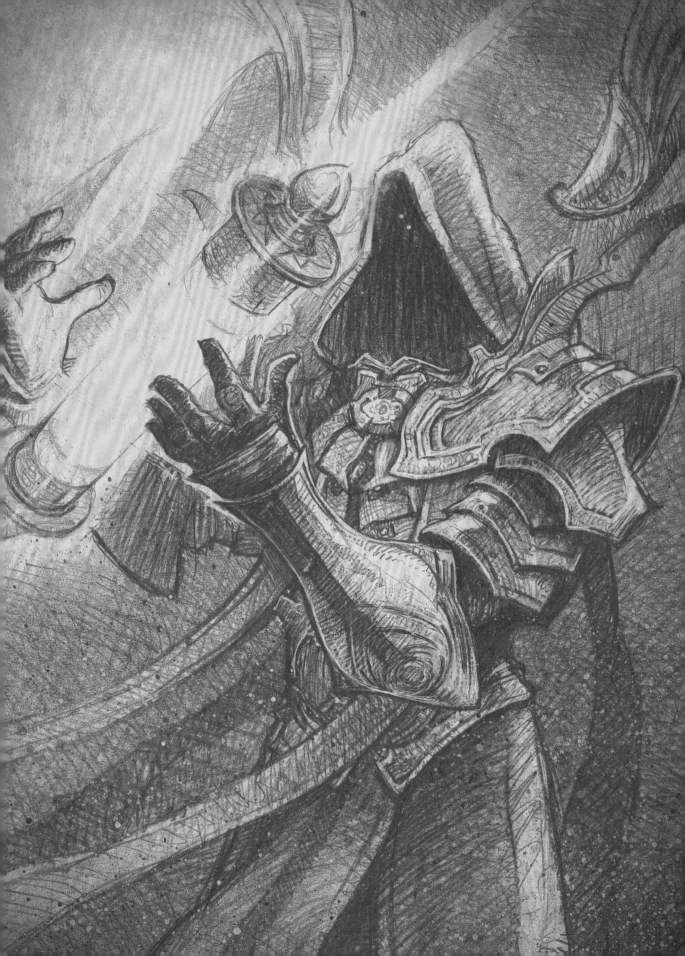

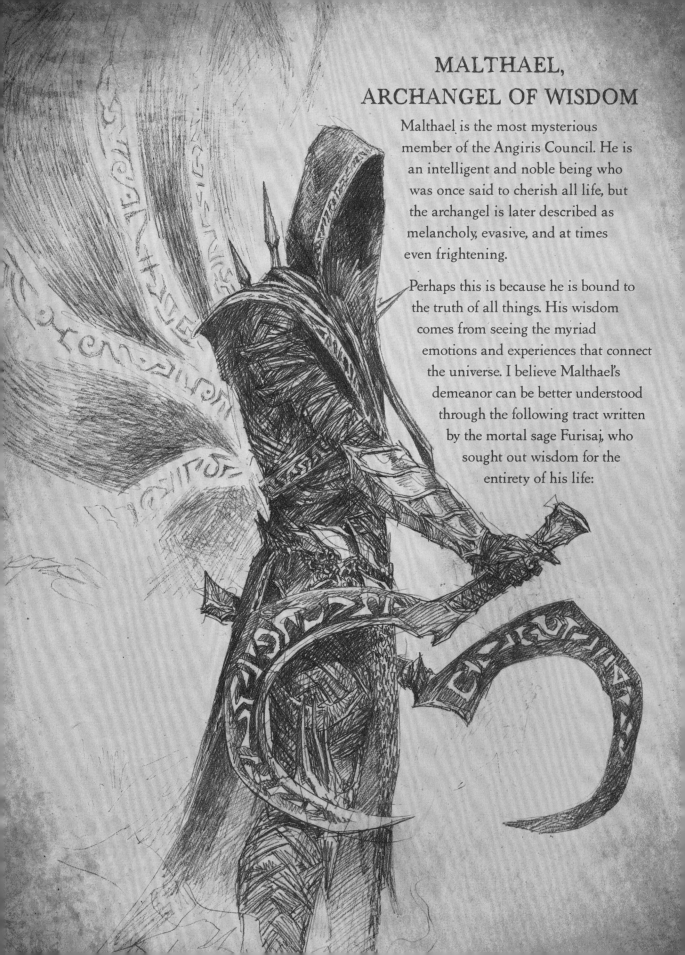

MALTHAEL, ARCHANGEL OF WISDOM

Malthael is the most mysterious member of the Angiris Council. He is an intelligent and noble being who was once said to cherish all life, but the archangel is later described as melancholy, evasive, and at times even frightening.

Perhaps this is because he is bound to the truth of all things. His wisdom comes from seeing the myriad emotions and experiences that connect the universe. I believe Malthael's demeanor can be better understood through the following tract written by the mortal sage Furisaj, who sought out wisdom for the entirety of his life:

*In all things, there are two sides: motion and stillness,
emptiness and fullness, light and dark.*

*Alone each side is incomplete, but together they form the
totality of existence. Only through embracing the oneness
of all things can true wisdom be obtained.*

Malthael can at times be ponderous and slow to action, but he is revered by other angels for his insight. He rarely speaks (and has thus become known as the silent angel), but when he does, all those nearby stop to listen. His voice thrums with the harmony of the Heavens, and those who hear it cannot help but become enraptured by its melody and the wisdom it conveys. There are other reports I have uncovered which suggest that Malthael's demeanor has darkened over time, and that his voice has become chilling and can provoke thoughts of foreboding and feelings of angst. Again, we see the contrast associated with Malthael.

Due to the archangel's contemplative nature, it appears that he is slow to anger, but that has not restricted him from playing a crucial role in the Eternal Conflict. In fact, Malthael is a peerless combatant, so in tune with the nature of all things that he can deflect enemy attacks with only the slightest use of force.

He is said to derive his insight from Chalad'ar, the Chalice of Wisdom. This vessel is not like a cup of water that you or I would be familiar with. Rather, the chalice contains living light that can never be depleted. By peering into its depths, Malthael can see the web of connectivity that binds all things as one.

I have heard tales of Malthael staring into the chalice for years on end in his quarter of the High Heavens, the Pools of Wisdom. The pools are infinitely deep wells of emotion. Those who gaze into them see not their own reflection, but the sum total of emotion that all sentient beings in the universe are experiencing at that moment. It is from these pools, I believe, that Malthael draws to fill his chalice.

One intriguing fact concerning Malthael is that the darkening of his mood is said to have taken place in the years following Sanctuary's creation. Did the birth of the nephalem somehow cloud the archangel's eyes from wisdom, or did it open them to some new foreboding truth? Perhaps Malthael's change in demeanor is connected to his chalice and the visions he beheld there? Or, perhaps there is a connection between the nephalem and the chalice of which we are unaware.

Unfortunately, we may never know. I have read troubling accounts that Malthael disappeared after the Worldstone's destruction (an event I will describe later in this tome). As I write this, I cannot help but be reminded of the prophecy that "Wisdom shall be lost." I find it hard not to view Malthael's sudden departure as yet another sign of the End of Days.

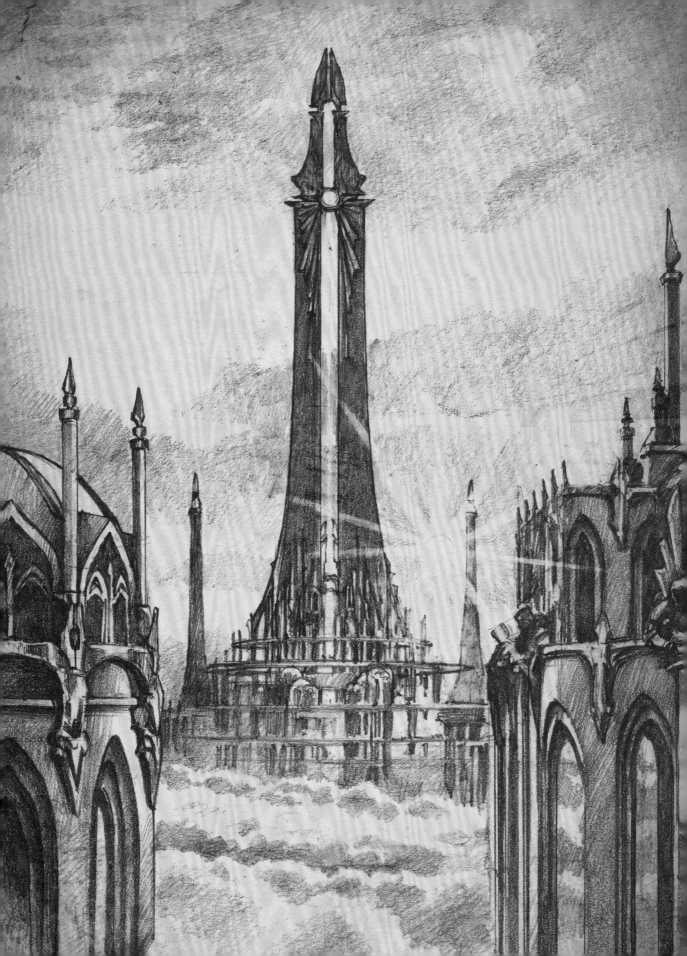

Monuments of Wonder

The illustrations I have provided here were pieced together from descriptions given by mystics who specialized in peering beyond the veil of our realm, for no mortal has yet set foot in the High Heavens.

Clearly, the artwork depicts a romanticized view of the Heavens, embraced by painters of the time. They portrayed comforting, majestic images of cloud and light. They created in meticulous detail infinite spaces of joy and possibility, a glorious realm that seems to enjoy a state of perpetual dawn.

I have combined some of these works with cryptic pieces of art acquired in the Mosaic period in order to inform our speculation and provide a more balanced view of the High Heavens and their major landmarks.

THE SILVER CITY

If the artwork of the great masters is to be believed, the Silver City is like a small world unto itself, a sprawling complex of glittering, soaring spires and sweeping buttresses. The magnificent architecture within it pulses with streams of light, and the entirety of it exists against a backdrop of radiant luminescence that stretches to infinity.

The contrasts between the High Heavens and the Burning Hells are obvious and striking, but there is one difference in particular that I wish to draw attention to: Unlike the Hells, which are broken into several realms whose borders shift and collide, the regions of the High Heavens are all centered within this one location, and their boundaries remain static.

To my knowledge, each member of the Angiris Council presides over a location within the Heavens, but it seems that the archangels and their domains exist in relative harmony. It is said that the Silver City is forever, that it will never change. It is eternal, the gleaming heart of the High Heavens, and it is an uplifting, living testament to the archangels' majesty.

THE CRYSTAL ARCH

High atop the Silver Spire, the tallest tower in the Heavens, sits the Crystal Arch, a wondrous structure that, as I discussed earlier, is believed to be the spine of the legendary Anu. Mystics have described the Arch as being composed of uncountable diamond facets that shimmer with a brilliance indescribable in mortal words.

If the ancient accounts are true, the Arch hums with a remnant of Anu's essence in a sublime chorus that permeates every corner of the High Heavens. Luminous bands flare off the Arch in perfect synchronization with its music, occasionally manifesting as new angels.

Unlike demons, who constantly war with each other, angels seek harmony among their own kind. If they are truly born from the Crystal Arch, then perhaps that would explain their penchant for order and balance.

The Arch is said to birth angels only during moments of perfect harmony in the Heavens. How often this happens, and what exactly causes this perfect harmony, are questions I cannot answer. There have been many periods of disharmony in the High Heavens, but I do not know whether this state has prohibited new angels from being created.

In other words, it is unclear whether these descriptions of the Arch are to be taken literally. The information I have found provides an interesting vision of the High Heavens, but one must always be careful of the balance between mythology and metaphor.

I can tell you that from the mystics of Aranoch to the priests of the Skovos Isles, all agree that an echo of the Heavens can be heard at the height of meditation. I find myself wondering if this echo might be the divine harmony that emanates directly from the Crystal Arch.

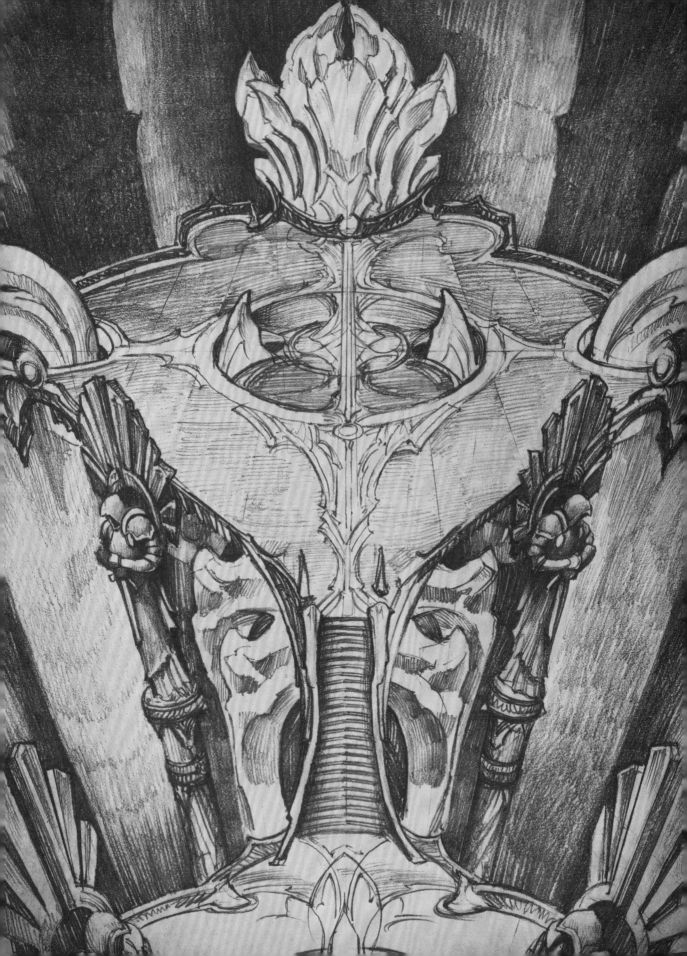

THE DIAMOND GATES

As with the Crystal Arch, the Diamond Gates are said to be composed of glittering, crystalline facets.

We are told by ancient sources that the ravening multitudes of the Burning Hells have fought their way to the Diamond Gates on more than one occasion. There is no existing account, however, of the Diamond Gates having ever been breached.

If the writings are true, then no enemy has ever set foot past the gates and into the Silver City. The greatest and most elite warriors of the Heavenly Host maintain a tireless vigil at the gates, standing ready to repel any who would despoil the radiance of the High Heavens.

The Silver City, the Crystal Arch, the Diamond Gates. I can scarcely imagine what it must be like to behold these magnificent structures in person, or how it might feel to cross bridges of light, or bask in the glory of cascading fountains of music and harmony.

After all, how could I, a mere mortal, ever hope to comprehend such splendor?

Sanctuary, the Mortal Realm

Inarius and the Worldstone

As I study the end times, seeking ways to forestall what I have come to feel is inevitable, I believe it is more important than ever to understand the origins of our world.

In the later sections of the Books of Kalan is an epic poem that tells of the renegade angel Inarius. The accounts of Inarius' life state that he was an advisor to the Angiris Council, serving under the command of Tyrael, archangel of Justice. It is further written that after eons of battle and witnessing countless acts of brutality, Inarius came to the conclusion that the Eternal Conflict was unjust and that his part in it must come to an end. He quickly resolved to seek out others who might share his view. In time he recruited not only angels but, incredibly, demons as well, and convinced them to join his blasphemous venture.

There was one among them, however, who stood out above all others. While wounded or marooned on some broken outpost of the Pandemonium Fortress, Inarius arranged to meet the demoness Lilith. Lilith, who had suffered the hatred of her father, Mephisto, from time immemorial, had long awaited an opportunity to rebel.

And so it was that something extraordinary and unprecedented happened: For the first time ever, combatants in the Eternal Conflict not only set aside their differences but also formed a union. Drawn together despite opposing forces, they had discovered common ground.

It is difficult for my mind to fully grasp, but the legends tell us that Inarius and Lilith fell in love. Incredibly, that single alliance would alter the course of the war, of reality itself—indeed, of all existence.

Inarius and Lilith both pledged themselves to the other and vowed to escape the Eternal Conflict. United in purpose, they gathered their fellow renegades and either led a campaign to capture the Worldstone or used some misdirection to gain entrance to its guarded chamber within the Pandemonium Fortress.

What happened next I will attempt to convey as best I can through the hazy curtains of both time and myth.

The Creation of Sanctuary

The Books of Kalan state the following:

> Inarius and his new companions altered the frequency or dimensional alignment of the Worldstone, using its power to conceal it from the angels and demons still fighting the Eternal Conflict. They shifted the massive crystal into a pocket dimension, and there they shaped a garden paradise around it: a world of refuge they would call Sanctuary.

We cannot say how this feat was accomplished, as the means of Inarius' actions remain unknown. But it is known from the Books of Kalan and other, lesser sources from this time that the Eternal Conflict briefly came to a grinding halt over the Worldstone's disappearance.

For my own part, it is amusing to think of what it must have been like for the forces of Heaven and Hell to fight their way to the Worldstone's usual location, only to find it missing. I would speculate that for a time both groups must have accused the other of stealing it, until they were finally convinced that their opponents were just as confused as they.

The account given, supported by events which would come eons later, is that Inarius shaped Mount Arreat as a kind of protective shell around the Worldstone—and from there the rest of the world as we know it was formed.

There the Worldstone remained until recent times, when the archangel Tyrael destroyed the sacred crystal and much of Mount Arreat surrounding it. But I get ahead of myself. This matter will be addressed in a later section, for the implications of the Worldstone's destruction and its ripple effects are felt by us to this very day.

As noted earlier, I once beheld the Pandemonium Fortress with my own eyes. I have done my best to illustrate the fortress here, however warped and distorted my memories of it might be.

Rise of the Nephalem

That which happened next is of the utmost importance to us mortals. Indeed, had it not happened, we would not exist, for something previously unimagined took place: Inarius and Lilith mated and created offspring. And though they were the first, in time other renegade angels and demons were drawn together as well.

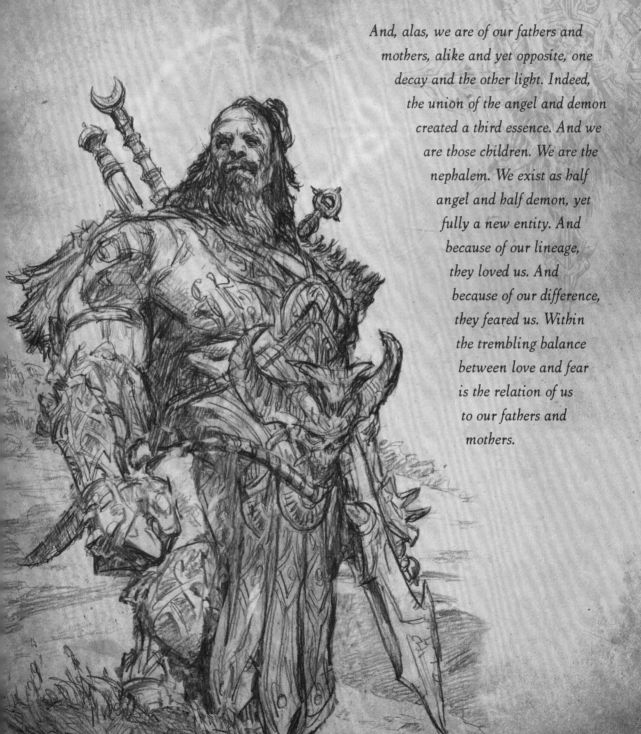

And, alas, we are of our fathers and mothers, alike and yet opposite, one decay and the other light. Indeed, the union of the angel and demon created a third essence. And we are those children. We are the nephalem. We exist as half angel and half demon, yet fully a new entity. And because of our lineage, they loved us. And because of our difference, they feared us. Within the trembling balance between love and fear is the relation of us to our fathers and mothers.

I gain much of what follows from fragments of the ancient tome of the druids, the Scéal Fada.

The first generations of nephalem were called the ancients. It is believed that they set out exploring, seeking answers, attempting to understand their curious world, and that they adopted numerous philosophies as they spread across Sanctuary.

One of these ancients was Bul-Kathos. Renowned for his immense strength, enormous size, bravery, and fortitude, Bul-Kathos is revered to this very day by the barbarians who settled at Mount Arreat. Indeed, the present-day barbarians epitomize many of the ancient's traits: great size, strength, tenacity, and an iron will.

Barbarian myths tell of Bul-Kathos' younger brother (elsewhere referred to as a trusted confidant) named Vasily. One myth in particular paints Vasily as a frustrated sibling who struck out into the wild and developed an affinity for nature. In this version of the tale, Vasily's descendants became the druids.

We know of other nephalem of this age also. Esu, a woman drawn to the power and ferocity of the elements, gained mastery over the powers of storm, earth, fire, and water through intense meditation. Ages later, her followers would rise as the feared sorceresses of Kehjistan.

Finally, we come to Rathma, a brooding, solitary
being who sought out the deep recesses of the world.
He studied the cycle of life and death and taught it to
those willing to venture into his subterranean habitat.
Rathma is the patron of the necromancers, and he values the
Balance of light and dark above all things.

I feel compelled to state for the sake of clarity that thousands,
or perhaps tens of thousands, of ancients doubtlessly existed during
this time. It is possible or even likely that they possessed abilities
beyond our understanding.

Who's to say what tales of these demigods have been lost over time?

The powers of the ancients had an unexpected effect on their otherworldly
parents. The renegade angels and demons began to see that their nephalem
children were far more powerful than they. This, for obvious reasons, raised
concern amongst them that the nephalem might not only become a threat,
but also draw the attention of the Heavens and
Hells from which they hid.

We must remember that by commingling, these angels and demons had
spawned what their masters would deem the ultimate blasphemy, and the
defectors were convinced that they would be destroyed if their hidden
refuge was ever discovered.

Because of this, conflict arose, as many of the renegades held the opinion
that their nephalem offspring should be destroyed, while others believed
their children should be spared. This dissension troubled Inarius, who
called for a period of reflection. And so his followers agreed to consider
the matter in solitude.

*Rathma: The necromancers who venerate this
nephalem have depicted him in the form of a great
writhing serpent. Is this mere legend, or did he
somehow take on this strange inhuman visage?*

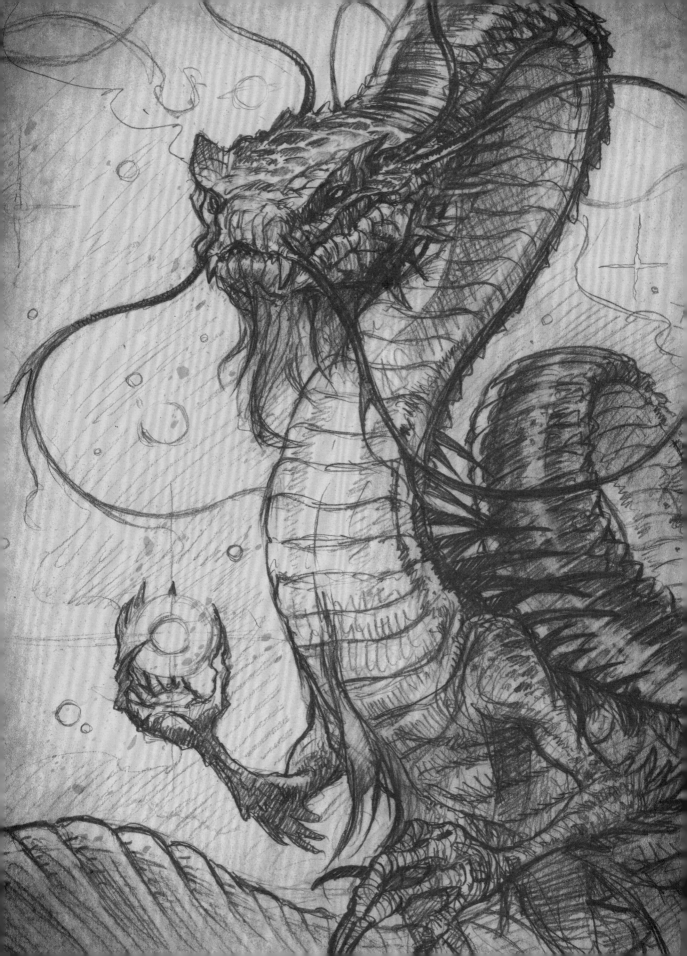

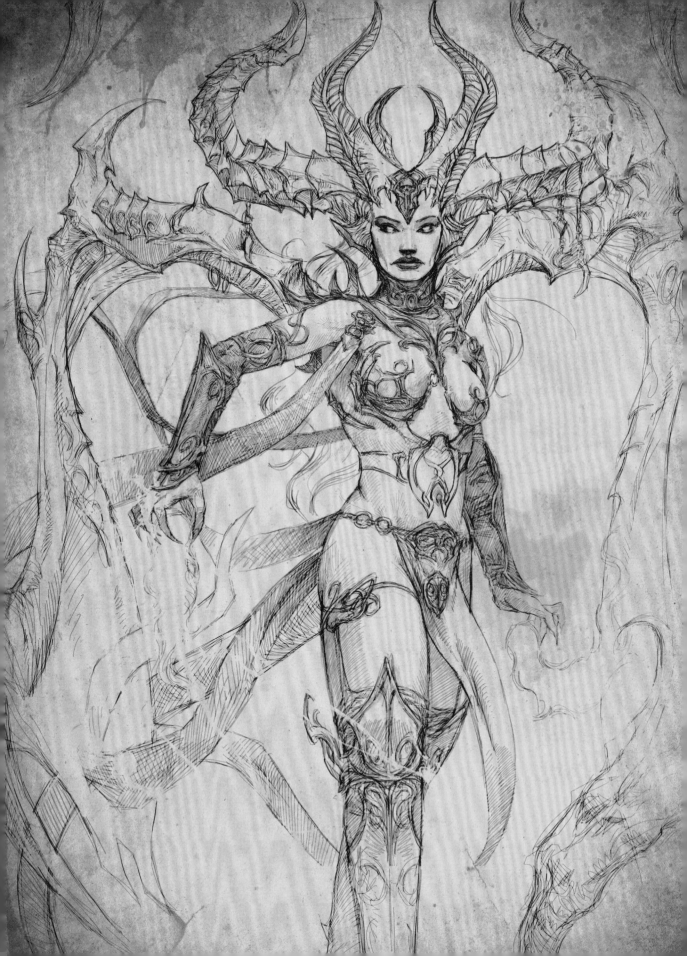

The Purge

Though the following tale strains credibility, I will transcribe it anyway:

Lilith, the first mother of the nephalem, was driven into a mad frenzy by the threat of her children's extinction. She morphed into a far more horrific form than any had ever seen—of tooth and claw, of spike and blade—and hunted down her fellow renegades. She ruthlessly murdered each and every follower of Inarius, leaving only him to discover the carnage she had wrought.

Inarius was horrified by the loss of his comrades and the terrible deed that his lover had committed. Though enraged, he could not bring himself to kill Lilith, but instead banished her from the sanctuary they had made.

Inarius then attuned the Worldstone to cause the powers of the nephalem to diminish over time. He then disappeared—though some say that he still walks amongst us in a form more closely resembling our own.

> —Anonymous text found uncatalogued
> in the Great Library at Caldeum

As I have said before, untangling myth from history is a tricky business. According to the arcana that have found their way into my possession, the powers of the nephalem did, indeed, fade over the course of generations. Today, our mortal bloodlines are the result of this great diminishment.

Given the propensity for both good and evil in humankind, it is clear to me that some measure of our ancestors still resonates within us. And yet I wonder, is it possible for humanity to evolve into something wholly extraordinary, or are we bound to the fate of our forefathers?

I will speak more of Inarius and Lilith later, for both would return to play vital roles in the history of the world they created.

Take heed of this, Leah, for while we might be only distant descendants of the original nephalem, I believe that mankind has the potential to unlock these awesome powers once again.

67

Ancient History
The Birth of Civilization

Years became decades, and then centuries, leading to millennia of time elapsed. Generations of nephalem, even with the remarkably long lives they were said to have possessed, passed away. With each generation, those events which might have been truth turned to legend, eventually settling into myth. The angels and demons faded from consciousness. The nephalem themselves slowly became mere mortals not unlike ourselves.

Humankind began to populate the world. As with its nephalem ancestors, humanity set about building cities of its own and collecting knowledge from the far corners of Sanctuary.

Various texts recount that the druidic followers of Vasily retreated into the northern forests of Scosglen, where they formed centers of learning to achieve harmony with the natural world. Elsewhere, priests from the cult of Rathma observed their esoteric rites within a vast subterranean city beneath the eastern jungles. Powerful covens of Esu witches strove to attune themselves to the world's elemental forces in their pursuit of what they deemed "perfect" magic.

Numerous exotic religious systems also flourished during this period. The mystic Taan mage clan and the superstitious Skatsimi cult practiced their beliefs in hidden temples throughout the east. All across Sanctuary, evolving cultures and civilizations formed and embraced their own explanations for the universe and its mysteries, giving rise to two divergent views—mysticism and faith.

In its simplest terms, mysticism is man's study of science and magic, the seen and unseen forces which shape the world around us. Even more than that, the root of mysticism is man's desire to become the master of his own destiny. Counter to this is faith, the view that man must put his trust in powers beyond mortal understanding to determine his fate and establish ethical and moral guidelines to live by.

Dear reader, the clash between these ideologies is at the core of humankind's existence. It has shaped our history in profound and irrevocable ways, and I believe it will continue to do so for as long as humans walk this world.

As proof, we need only look to the beginning of recorded history, which was ignited by a surge in mysticism. Magic in all its forms was studied and formalized into distinct schools and disciplines. In Kehjan (what is now Kehjistan), these schools evolved into mage clans, the most prominent of which were the Vizjerei, the Ennead, and the Ammuit.

The Vizjerei are discussed in detail later in this tome. The Ennead was a school that focused on enchantments and transmutation of matter. Its members used practical application to affect the world around them, while the Ammuit clan dabbled in illusion and strove to manipulate reality and our perception of it.

It is important to note that not all members of the mage clans were sorcerers. The clans were ethnically and culturally distinct societies with their own laws, customs, artisans, and merchants. Beyond that, each clan was defined by its adherence to a particular school of magic. While only the mage caste studied this vocation, each clan's discipline nonetheless pervaded all corners of society, evidencing itself in things such as art and regional vernacular.

The burgeoning power of the mage clans made their involvement in Kehjan's ruling affairs inevitable. The Al'Raqish, or Mage Council, an organization boasting members from each of the major clans, was formed to rule alongside the kingdom's monarchy and its powerful guilds. The council's leadership rotated to a different clan representative every new moon.

Despite the violent feuds and deep-seated prejudice that appears to have existed among the clans, the council thrived for generations. I have read accounts that eventually the head members of the kingdom's royal line became little more than puppet rulers. True power resided with the mage clans.

Sadly, this era of relative peace and stability was not to last. Man's desire to plumb the secrets of the world and the unseen realms beyond it would soon lead to calamity.

Sanctuary Revealed

The Vizjerei were convinced that spirits dwelled on Sanctuary and in places outside the physical world. While the clan's sorcerers could not directly commune with these entities, they believed contact was possible. Thus, the driving goal of the Vizjerei became to perfect the arts of conjuring and summoning spirits.

For years, the clan conducted experiments and carried out empirical research into the practices of druids and necromancers—both of which successfully contacted spirits in their own way. Yet for all of the combined intellect and dedication of the Vizjerei mages, they could hear only a whisper of the beings they sought.

Everything changed with one unassuming Vizjerei sorcerer named Jere Harash. I take the following account of Harash's life from the personal journals of Dumal Lunnash, who wrote extensively on the earlier periods of the Vizjerei:

> *Jere Harash was a most forgettable member of the Vizjerei sorcerers. As a young acolyte, he aspired to one day represent his clan on the Mage Council, but he was always outshined by his more talented peers. His growing frustrations came to a head when his parents and sister were killed during a short-lived feud between the Vizjerei and Ammuit clans.*
>
> *As his heart roiled with anger and rage at the tragedy, Harash reached out to the spirits and made contact, succeeding where so many of his fellow sorcerers had failed. Yet the entity he summoned into our world was one neither he nor the other Vizjerei could have ever fathomed—a demon of pure hate and malice. And with that, the once-ineffectual Jere Harash was etched into the annals of history forever.*

I find it interesting that this excerpt does not match the public records (some even written by Lunnash himself) of Harash. These describe Harash as having been a young boy who gleaned insight into summoning from a dream. Even the being he contacted was referred to as a "spirit of the dead."

Whether the Vizjerei originally knew that the summoned being was a demon is unclear, but I have no doubt they believed it was something more than an ancestor's spirit.

From my research, I have found that the Vizjerei worked feverishly to mask the truth of what had been discovered, even going so far as to write false histories of Harash and some of their early interactions with the "dead."

I can only surmise that Harash's success, in reality, hinged on the dark emotions he was feeling at the time. Perhaps his anger and rage somehow attuned him to one of the Burning Hells' realms. Whatever the root cause, Harash quickly recognized the perils of the murderous creature he had summoned. After restraining it with binding spells, he informed the Vizjerei elders of his discovery.

It is of utmost importance to note that at the moment of Harash's breakthrough, the Prime Evils of the Burning Hells became aware of Sanctuary's existence for the first time.

This was, of course, unknown to the Vizjerei. Even after the demon had been summoned, there was much controversy among them concerning the new art Harash had discovered. Some of the sorcerers feared that these dangerous entities could not be fully controlled and posed a threat to the entire world.

The one thing the clan members all agreed upon was that the existence of demons should be kept secret. This explains their retelling of Harash's discovery and their willingness to adopt the lie that they were merely communing with spirits of the dead. By doing so, the clan could claim innocence of any wrongdoing should the powers it was experimenting with lead to disaster. So successful were they in this farce that the Vizjerei eventually became known as the Spirit Clan.

The Vizjerei eventually grew confident that if they could control one demon, they could control others. The clan's sorcerers set about summoning more and more of the Burning Hells' minions into Sanctuary for short periods. While the clan had no intentions of using the demons as weapons, the mages concluded that there was much to be learned from these creatures about the universe and new forms of magic.

Alas, as we have witnessed so many times throughout history, humankind's insatiable greed and lust for power took hold of the Vizjerei. Once having tasted of forbidden demonic powers, the clan decided that with its newfound abilities, it could enslave Hell's denizens and use them to dominate not only Kehjan, but the entire world as well.

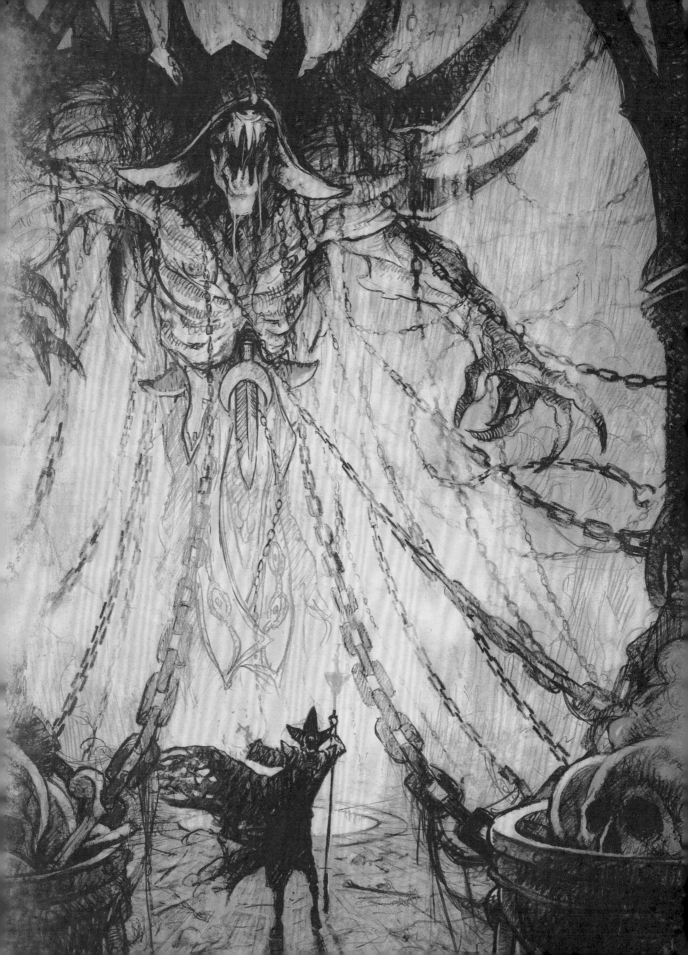

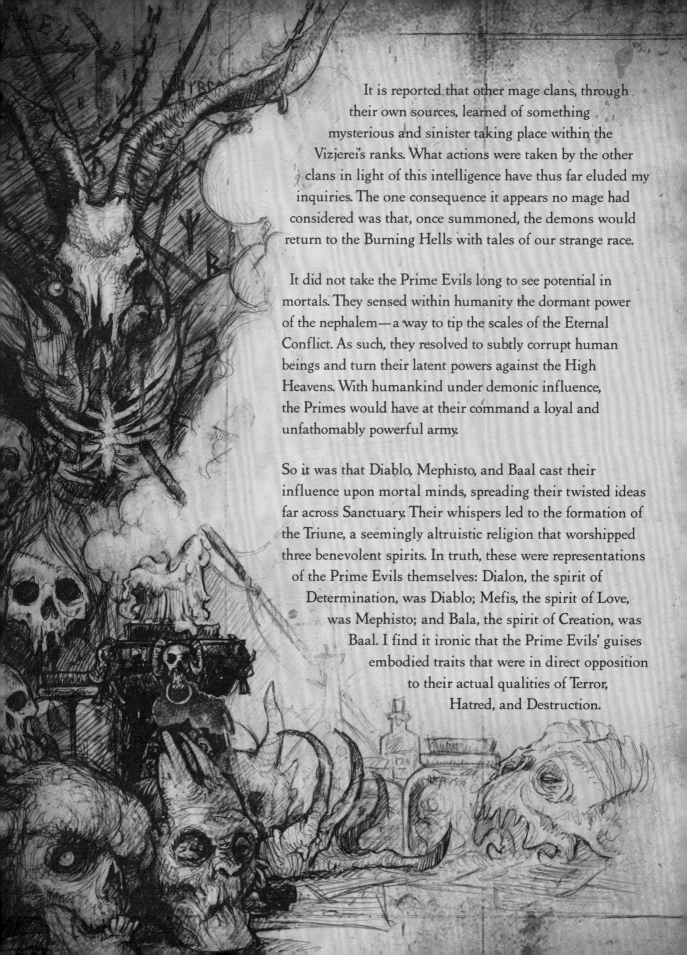

It is reported that other mage clans, through their own sources, learned of something mysterious and sinister taking place within the Vizjerei's ranks. What actions were taken by the other clans in light of this intelligence have thus far eluded my inquiries. The one consequence it appears no mage had considered was that, once summoned, the demons would return to the Burning Hells with tales of our strange race.

It did not take the Prime Evils long to see potential in mortals. They sensed within humanity the dormant power of the nephalem—a way to tip the scales of the Eternal Conflict. As such, they resolved to subtly corrupt human beings and turn their latent powers against the High Heavens. With humankind under demonic influence, the Primes would have at their command a loyal and unfathomably powerful army.

So it was that Diablo, Mephisto, and Baal cast their influence upon mortal minds, spreading their twisted ideas far across Sanctuary. Their whispers led to the formation of the Triune, a seemingly altruistic religion that worshipped three benevolent spirits. In truth, these were representations of the Prime Evils themselves: Dialon, the spirit of Determination, was Diablo; Mefis, the spirit of Love, was Mephisto; and Bala, the spirit of Creation, was Baal. I find it ironic that the Prime Evils' guises embodied traits that were in direct opposition to their actual qualities of Terror, Hatred, and Destruction.

The popularity of the religion grew rapidly, and before long a large percentage of ancient Kehjan's populace had flocked to the Triune. The rank-and-file members of the church, of course, did not realize that their patron spirits were Lords of the Burning Hells. Key to the Primes' deception was that the Triune falsely stood for the principles of unity and humankind's innate power.

The religion constructed a magnificent Grand Temple in Kehjan. The sprawling triangular edifice boasted three high towers, each of which was dedicated to one of the Triune's spirits. The organization was so devoted to giving the impression of being a peaceful group that it even referred to the temple's warriors as Peace Warders.

Only the highest-ranking members of the Triune knew the truth: Behind the facade of Determination, Love, and Creation was a vile cult which practiced all manner of demonic rituals. It was known to lure in unsuspecting initiates and practice fiendish acts of torture on them for the perverse thrill of its true Prime Evil masters. With these horrors in mind, it should come as no surprise that the religion was led by none other than Lucion, the son of Mephisto I mentioned earlier in this tome.

The Triune's rapid growth perplexed the mage clans and other institutions that had, until then, held an uncontested sway over Kehjan's populace. From accounts I have read of this era, it seems that these groups believed the Triune to be nothing more than a passing fancy. Therefore, they simply stood by as more and more victims were lured into the jaws of the Prime Evils' false religion.

As a final note, one might ask whether Diablo, Mephisto, and Baal knew the truth concerning humanity's divine parentage. From what I have gleaned from my studies, it is unclear. I have discovered, however, that the Prime Evils made a point of keeping Sanctuary's existence a secret from as many of their lesser brethren as they could. This lack of trust would sour the relations among the Lords of the Burning Hells, and, I believe, lead in some part to the Dark Exile, an event which I will write on later.

The Sin War

It is written that the angel Inarius, the first father of humankind, wandered the world in grief for ages after the massacre of his fellow renegade angels and demons by his lover, Lilith. (This event, the Purge, is described earlier in this tome.)

Inarius had observed humanity, watching us face challenges and overcome obstacles. It is heavily suggested by some accounts that he had even come to favor mortals, for he saw us, unlike our ancient ancestors, as no threat.

It is further stated that when Inarius learned of the Triune religion, he recognized the Prime Evils' deception immediately, and feared not only for his own safety but also for that of his adopted children should Heaven become aware of humanity's existence.

And so the texts tell us that Inarius created his own religion to counter the influence of the Triune. Taking on the mantle of the Prophet, Inarius founded a gospel based on the tenets of tolerance, cooperation, and unity. He disseminated this doctrine from his Cathedral of Light, gaining fame for his youthful physical perfection and spreading the church's influence through angelic powers of persuasion. Soon, between them, the Triune and the Cathedral of Light held sway over much of the eastern lands.

Having studied the matter in great detail, I conclude that Inarius' founding of the Cathedral of Light is the true beginning of the Sin War.

Much of what I will relate of the Sin War and its history is taken from the mysterious Books of Kalan. The identity of their author, except his name, is unknown, as is the exact time of authorship. It is my belief that the books were written during the time of the Sin War and later edited and compiled by other unknown hands.

The Sin War, at its inception, was not waged on physical battlefields. It was a struggle between the Triune and the Cathedral of Light to claim the hearts and souls of humankind.

Agents of both religions carried their messages to the people, building bases of power, constructing monuments, and winning the absolute loyalty of faithful supplicants.

Into the midst of this battle for dominance came a single human, Uldyssian, a man who would break the cycle and rise to not only challenge both religions but also ultimately bring an end to the Sin War through a staggering chain of events, shaking the foundations of both the Heavens and the Hells in the process.

Uldyssian's story began in a small village where he lived with his youngest brother, Mendeln, and a few close friends. It was here that Uldyssian first discovered his nephalem powers, while defending a woman named Lylia from a priest representing the Cathedral of Light.

Uldyssian learned that he was capable of awakening nephalem powers in others. He traveled from town to town, demonstrating to others that they did not need either the Triune or the Prophet and his Cathedral of Light. And as Uldyssian's abilities evolved, so too did the powers of his family, friends, and followers, who would come to be known as the edyrem, or "those who have seen."

While pursued by both the Triune and the Cathedral of Light, Uldyssian cultivated his powers, growing in strength day by day, until his abilities were far beyond those of any other human.

Lylia, however, was soon revealed to be none other than Lilith, the demon daughter of Mephisto, returned from exile. It was Lilith who had awakened the nephalem abilities in Uldyssian; it was her desire to empower mortals so they might drive both Inarius and the agents of the Burning Hells from Sanctuary, but she was willing to sacrifice mortal lives to see this plan unfold. Once her true nature was revealed, Lilith departed, though she would return over the course of the war to torment Uldyssian again.

At this time, the forces of the Triune clashed repeatedly with Uldyssian and his edyrem, and it was soon revealed that the Triune was held under the sway of demonic influence. Uldyssian declared war on the Triune, obliterating its churches and decimating its holy armies.

Observe, dear reader, that the mortal Uldyssian succeeded in bringing the Sin War to a halt. Humankind, not angels or demons, would ultimately win the Sin War.

Uldyssian soon learned of the Worldstone, and achieved the unthinkable, altering its attunement to allow the powers of his edyrem to flourish. The edyrem then came into conflict with Inarius himself. The battle between mortals and Inarius' forces rocked the core of our world.

It is said that Inarius, in danger of losing his battle with Uldyssian, panicked, realizing how wrong he had been about humanity's weakness. In that moment, he feared that mortals were even more dangerous and abominable than the ancients.

It was then that Tyrael himself intervened. Reacting to the seeming injustice of Uldyssian's actions against Inarius, Tyrael called forth the angelic Host of the High Heavens. Hundreds of angels descended upon Sanctuary. Much to the surprise of everyone present, however, the ground erupted as the Burning Hells joined the battle as well. The fears of Lilith and Inarius were realized as the Eternal Conflict raged on the world of man.

Uldyssian unleashed the whole of his power, releasing a seemingly impossible amount of energy, driving the forces of both Heaven and Hell back to their domains, and demonstrating once and for all that humankind truly had the ability to alter the very fabric of our universe.

Uldyssian realized that the power he and his edyrem possessed was tearing Sanctuary apart. It was too much, gained too quickly. He felt also that he was losing himself— that his nephalem birthright was consuming his humanity—and he saw in that moment the potential for nephalem power to do the same to all of humankind.

And so, in an act of the purest selflessness and sacrifice, which proved beyond a doubt that some humanity still remained within him, Uldyssian brought the raging energies back into himself, then released them one final time. The release of those energies negated his very being.

It has been suggested in the Books of Kalan that Uldyssian's final release of energy flooded the Worldstone, resetting it, and thereby stripping his followers of their nephalem powers. And so it was that Uldyssian had chosen the human heart over godhood and ultimately gave his life so that humanity might survive.

In the wake of these incredible events, I can only imagine that the Burning Hells were emboldened to discover that their suspicions of humankind's potential were proved correct.

As for the angels, it is said that the Angiris Council voted on whether humanity should be allowed to live. It is reported that Imperius voted to exterminate our race. Malthael abstained, and so his vote was not counted, while Auriel and Itherael voted on our behalf. Imperius was confident that Tyrael would vote to eliminate humanity, and he knew that even if the deliberation ended in a tie, humankind would be eradicated.

And so it fell to the archangel Tyrael to cast the deciding vote. I believe that it was here that Tyrael broke from his rigid outlook. He had witnessed Uldyssian's heroic and very human act, and he became fascinated with mortal hearts, believing that perhaps the universe cannot be defined by laws alone. Tyrael saw in us the possibility for complete ruin—but hope as well, for us to become what many of the angels themselves wished they could be.

And so it was that the archangel of Justice cast his vote in favor of sparing humankind.

As humanity's right to exist was assured, a truce was brokered between the Angiris Council and the Lords of the Burning Hells. As a condition of this truce, Inarius was delivered to the demons for mutilation and eternal torment.

As for the edyrem, it is written that the angels removed all memories of these events from their minds. Their nephalem powers were forgotten, and mortal life returned to some semblance of normality.

And what of Lilith? Accounts suggest that earlier in the conflict, before the Prophet (or the Veiled Prophet, as a few scholars would later call him) clashed with Uldyssian, Inarius had banished Lilith once again. There are no further accounts of her interfering in the affairs of mortals.

Though the Sin War faded quietly into history, it is imperative that we recognize its import, for it stands as a testament to the sheer power that all human beings carry within them. And, I would argue, it is a war that echoes within each of us to this very day.

The Mage Clan Wars

In the decades following the Sin War, Kehjan sought to distance itself from the events of that near-apocalyptic conflict. To this end, the people renamed their land Kehjistan.

As the kingdom started anew, mage clans reasserted the control they had previously held over the east. The greatest lessons learned by the Ennead and Ammuit clans from the time of the Triune and the Cathedral of Light were simple: No mage clan must ever again summon demons into the world, and if humanity had anything to say about it, the Heavens and Hells must stay out of mortal affairs forever.

Legends hold that before the Sin War there had been seven major and seven minor mage clans, but following Uldyssian's sacrifice only three maintained a strong influence—the same three that had been the most prominent years before: the Vizjerei, the Ennead, and the Ammuit. It was the Vizjerei clan, however, that once again rose to greatest success and soon counted thousands of active sorcerers among its ranks.

It is incredible to look back upon this era and consider the prosperity of the Vizjerei. After all, what were the roots of the Vizjerei's success? Conjuring and summoning. One might even say that much of the peace and grandeur of this golden age was built on the controlling of demons generations before.

It is no surprise, then, that the Vizjerei operated under close scrutiny, as the other mage clans made clear to the original conjuring school that if it grew arrogant and tempted fate once again, there would be dire ramifications.

The reality of the nephalem and the involvement of the Heavens and Hells in the Sin War were kept from the general populace. It was publicly stated (and reinforced by those edyrem whose memories had been erased) that a plague had claimed the lives of those lost in the Sin War. Nevertheless, the truth was known by some, and it was generally recognized by these people that blind faith and religiosity during the war had not averted the disaster. In fact, it was not long before the prevailing opinion was that humankind's embracing of religion had set the events of the war in motion.

There was no more room for faith. The citizens would believe now only what they could behold with their own eyes. Popular religions were suppressed as the people embraced the mage clans, who relied on the empirical and the quantifiable.

The kingdom took comfort in a system that valued reason and practical research above all, and so it was that once again the Al'Raqish, the Mage Council, enjoyed great success and power, governing the land in cooperation with the royal line from the eastern capital of Viz-jun.

Remaining artworks tell us that this was a time of inspiration, investigation, and, as the shadow of fear slowly passed, enlightenment. Oh, to have lived in such a time! We can only imagine how wonderful this era must have been. Mages in magnificent robes walked the streets, and all turned to look upon them. Great buildings were erected, and civilization flourished.

It was then, in this time of unprecedented peace and prosperity, that the Vizjerei would once again imperil humankind. The earliest clue of this is evidenced in the following, an unsigned letter found within the ruins of an Ammuit academy near Caldeum, presumably sent from an Ennead official:

I share this matter in the strictest confidence.

The following account has been verified by our most trustworthy source: It was only two nights ago that five high-ranking Vizjerei conjurers were overheard in the deepest recesses of the Yshari Sanctum, chanting incantations and conducting what could only have been a ritual of summoning. A small tremor was felt soon after, followed by the sound of throat-rending screams. Where five conjurers had entered, only three emerged hours later.

It goes without saying that these activities are unacceptable. The Vizjerei have disregarded multiple warnings and are clearly revisiting past sins, setting them on a course that will result in the destruction of all that we have labored to build. Measures are being taken on our side. The Vizjerei will soon lie in a bed of their own making. I have been led to believe that in a circumstance such as this we might count on your support.

I truly hope such claims are valid, brother constable, for now is the time to end the Vizjerei's recklessness once and for all.

Evidence suggests that soon after this letter was written, assassins were sent out against key members of the Vizjerei by both the Ennead and the Ammuit, and that several officials from those clans were brutally murdered in retaliation.

The conflict escalated further when an argument among clan representatives at a meeting of the Al'Raqish erupted into a battle that resulted in multiple deaths.

Soon, the blood of all three clans was being spilled on the streets. The violence surged, until the Ennead and Ammuit clans in Caldeum gathered their forces and stormed the Vizjerei main academy in Viz-jun. When the dust settled, not one wall of the academy was left standing, and not a single Vizjerei mage there was left alive. This incident was the spark that set off the Mage Clan Wars proper.

Battles flared across the eastern lands. The Vizjerei Ruling Council fled the capital, went into hiding, and focused on consolidating its forces. The coalition of Ennead and Ammuit forces won several victories against isolated pockets of Vizjerei combatants. The two clans then directed the entirety of their combined might against the Vizjerei's main force.

Hopelessly outnumbered, the Vizjerei were quickly trapped and seemed on the verge of annihilation. It was then that the true plan of the conjurers was revealed as they unleashed the one weapon no other clan had dared to wield: demons.

The balance of power quickly shifted as multitudes of Ennead and Ammuit troops were obliterated. Horrific nightmare-creatures from the deepest pits of the Burning Hells waded through the opposing clans, cutting a bloody swath. The Ennead and the Ammuit retreated as the Vizjerei pursued them all the way back to the capital of Viz-jun.

It is here that we must take a moment to focus on the story of two brothers, Horazon and Bartuc, for it was the actions of these siblings that would ultimately decide the outcome of the Mage Clan Wars. The following details were among very few passed on to me by my ancestor Jered Cain in the books of the Horadrim:

> Bartuc was a particularly ruthless mage who had earned the epithet "Warlord of Blood" for bathing in the blood of his slaughtered enemies. It is said that his armor was empowered with a demonic sentience. During the final battles of the Mage Clan Wars, Bartuc had become an unstoppable force, instilling fear not only in the opposing clans but in his own people as well.

> Horazon, who had delighted in breaking the wills of the demons he had summoned, realized that Bartuc's path would ultimately lead to ruin. Demonic corruption spread throughout the Vizjerei ranks.

The hellspawn that Bartuc continued to summon lacked any kind of control, destroying literally everything in their path, for Bartuc believed that the demons were humankind's masters, and that loyalty to them would be generously rewarded. Horazon reached the conclusion that even if the Vizjerei won the wars, there would soon be nothing of civilization left, and that the clan's only legacy would be death or enslavement to the Burning Hells.

And so it was that just when victory for the Vizjerei seemed assured, the Ruling Council resolved to relieve Bartuc of his command. Civil war erupted within the troubled mage clan as Bartuc turned his forces against his own people. After many hard-fought battles, Bartuc's contingent took the upper hand. The Warlord of Blood then set his armies to the task of conquering Viz-jun.

The final battle between Bartuc and the Vizjerei took place just outside the capital's towering gates. And just when it seemed that the entire clan would fail to defeat Bartuc, his brother Horazon answered the challenge.

The cataclysmic battle between the two siblings brought the walls of Viz-jun down around them. The city was leveled, and the death toll numbered in the hundreds of thousands.

But as the fire, smoke, and unholy bloody mist cleared, Bartuc, Warlord of Blood, lay dead with Horazon standing over his brother's gore-covered corpse.

Following the death of Bartuc, the grieving Horazon was keenly aware of the inherent tragedies of summoning. He realized that the corruption of hearts and civilizations would never end as long as the agents of the Burning Hells had access to our world.

My ancestor left an interesting postscript to the story of Horazon. He says, "Following the battle of Viz-jun, Horazon crafted for himself a hideaway which he called the Arcane Sanctuary, a retreat where the prying eyes of Hell could never find him. There he lived apart from the world, quietly studying the arcane and ultimately fading into the shrouded mists of legend."

THE AFTERMATH OF THE MAGE CLAN WARS

Whatever the true fate of Horazon, we have graphic accounts of the magnificent city of Viz-jun reduced to rubble, and with the destruction of the city also came the end of the mage clan system of government. Mages, who had been so revered by the people, were now exiled and in some extreme cases executed on sight. (In fact, in an unprecedented move, the surviving Vizjerei renounced summoning forever. To ensure that this new edict would stand, the clan deployed mage slayers, known as the Viz-Jaq'taar, to eliminate renegade Vizjerei wherever they might be found.) Many mages fled from the cities to eke out an existence in smaller towns or alone in the mountains and deserts. Certainly, some mage clans remained; even today, a few scattered Vizjerei still exist, but only in a pale and diminished form.

As with all traumas in history, each age breeds its opposite. The Age of Magic was replaced by the Age of Faith. Disgusted with the mages' reckless pursuit of power, the angry citizenry of Kehjistan looted the mage clans' holdings and tore down their bastions of power, with the exception of the Yshari Sanctum, in Caldeum. It alone survived the riotous purge, due to its more remote location. Overall, the vast arcane libraries and the innumerable tomes of occult knowledge throughout Kehjistan were destroyed, while laws were passed forbidding the use of magic. It is fair to say that the age of the mages had ended.

The Dark Exile

In truth, it is difficult to speak authoritatively about the event known as the Dark Exile, as it is alleged to have taken place in the Burning Hells, far from mortal eyes. In any case, the Dark Exile refers to a civil war that raged within the Burning Hells between the Prime and Lesser Evils.

It is said that the motivation for this conflict was the Lesser Evils' fury over the Primes having abandoned the Eternal Conflict in favor of weaponizing humankind's nephalem potential.

Believing that they were innately superior to mortal kind, and that their war against the High Heavens was theirs alone to fight, the Lesser Evils enacted a brilliant stratagem to overthrow the Primes. Led by Azmodan, the Lord of Sin, and Belial, the Lord of Lies, the rebel demons claimed dominion over much of the Burning Hells.

To their credit, the Prime Evils fought with devastating power, annihilating a third of Hell's treacherous legions. But in the end, weakened and bodiless, the Primes were banished to the mortal realm, where Azmodan hoped they would remain trapped forever.

Furthermore, Azmodan believed that with the Three set loose upon humanity, the angels would be forced to turn their focus upon the mortal plane, thus potentially leaving the gates of Heaven vulnerable to attack.

One account of the Dark Exile states that the Lesser Evils' hour of triumph did not last long. Relations between Azmodan and Belial quickly soured as they began arguing over who should ascend to the highest rank of the Burning Hells. When the bickering turned to violence, their pact was forgotten. The remaining denizens of the Hells found their support divided between the Lesser Evils, and before long another bloody civil war was under way.

Yet there are some who say that there was no falling-out between Azmodan and Belial, and that they are conspiring to subjugate all life to their will. While it is more comforting to believe that they turned on each other, I submit that it is best for us to believe that the two are still in league and at this moment are plotting an attack on the mortal realm.

As the answers to these disputes might lead to a clearer understanding of the end times, I will investigate further, but such inquiry will be difficult. We mortals have no direct access to knowledge of the machinations of the Burning Hells.

Also, as I am no expert on the inner workings of the High Heavens, either, I can only imagine what it must have been like for Tyrael to discover that the Prime Evils had been banished to the unsuspecting world of men.

By the time Tyrael learned the truth, the Primes had already been wreaking havoc on Sanctuary for decades. Subtly, they had been turning brother against brother and nation against nation, inciting wars and unrest amongst the lands of Kehjistan.

Knowing that the Sin War had resulted in the sparing of humankind by a margin of one vote, Tyrael did not dare inform the Angiris Council that the powers of Hell now threatened to corrupt humanity once again. He knew that, somehow, he had to intervene without alerting his angelic brethren and prevent the Prime Evils from influencing mortal men. On behalf of humankind, the archangel of Justice would become the maverick of Heaven.

The Hunt for the Three

Much of what follows concerning the Horadrim comes from writings passed down through my family from my ancestor Jered Cain in a collection of documents stored in an ancient chest. One day I should like to make these documents available, but I fear that they might contain information that even now, nearly three centuries later, may be dangerous should they fall into the wrong hands.

As to their accuracy, I can say that every fact in them is supported by what I have encountered in my travels in the form of contemporary texts, artifacts, and geography. And, to be quite honest, much of their content has been extremely relevant to my own experience as one of the few survivors of the horrors in Tristram (which I shall detail for you at a later time).

The Horadrim were a band of mages drawn from the remnants of the scattered mage clans and empowered by the archangel Tyrael to hunt down and contain the three Prime Evils. By the accounts of both my ancestor Jered and his colleague Nor Tiraj, the original Horadrim were strangers selected not due to any particular wisdom or reverence but because they were those most likely to succeed in carrying out Tyrael's mission.

The first group of Horadrim was small. Some say the number was seven; some say the number was twelve. Both numbers might be correct, and it can be assumed that the mages brought with them escorts, apprentices, and others to assist on their mission. It is, however, known that their leader was a mage named Tal Rasha. From every account I have read, he was a paragon of the Horadrim, a selfless and noble leader who held the order together through many of its darkest hours.

Taking shards of the Worldstone itself, Tyrael fashioned three soulstones, each imbued with the power to contain the essence of a Prime Evil. Jered Cain recounts that Mephisto's soulstone was sapphire, Baal's was amber, and Diablo's was ruby, or blood-hued. He also says that an intelligent and pious mage named Zoltun Kulle was given the task of carrying the stones and capturing the demons' souls within them, for that task most suited him. Though it is not explicitly stated, we can assume that Zoltun Kulle was a mage of the highest order within the Ennead mage clan, almost certainly a master of alchemy, alteration, and transmutation.

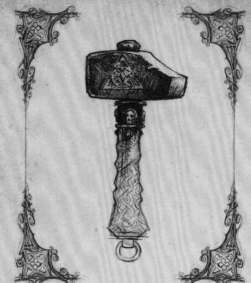

Horadric Malus:
Used by the Horadrim to
forge enchanted armaments
for their struggles against
the Prime Evils. Later
entrusted to the Sisterhood
of the Sightless Eye.

Horadric Staff: Perhaps the order's most important relic, used as a key to both seal and open Tal Rasha's tomb.

Before the Horadrim's founding, the Prime Evils had been spreading terror, hatred, and destruction among humankind for many years. It is known that the Primes possessed the uncanny ability to inhabit the living bodies of humans, possibly even assuming the identities of political and religious figures to deceive and twist Kehjistan's populace. Fortunately for the Horadrim, the soulstones were attuned to the demons' vile essences, allowing the mages to track down the Primes even when their true forms were hidden within mortal shells.

Ironically, it was Mephisto, the Lord of Hatred, believed to be the most intelligent of the Prime Evils, who was found and captured first in or around one of the great urban centers of Kehjistan. The fight cost many innocent lives, and the Horadrim vowed to avoid confronting another Prime Evil in a populated area. Once Mephisto's essence was trapped, his soulstone was given to the emergent order of the Zakarum (discussed in depth later in this tome) by Tal Rasha, who knew that only they could be trusted with such a grim responsibility. Years later, the Zakarum would build the Temple City of Travincal in that same area, in the jungles near Kurast, in order to protect the soulstone. This would, of course, have dire consequences, as Mephisto's hatred would corrupt that noble religion over time.

The task of hunting the Primes was a daunting one, and the mages were undoubtedly confounded on many occasions, losing the demons' trail before picking up on it again.

Horadric Cube: A miraculous device that works via the principles of transmutation and alchemy. The Horadrim preserved important artifacts and equipment by separating them into their component parts for future use. By later utilizing these elements with the cube, they could reassemble the original item.

In time, Diablo and Baal journeyed west over the Twin Seas to the deserts of Aranoch. The Horadrim remained in close pursuit. Baal took refuge inside the city of Lut Gholein for three days while Tal Rasha and the Horadrim patiently waited. The demon lord then fled north into the scorched wasteland. The harsh desert did not protect him from the Horadrim, for they were men as tenacious as they were prodigious in magic.

The Lord of Destruction unleashed the fury of his powers upon them. The land exploded and fire erupted from the broken earth, burning everything and everyone in its path. The ground fell away, and the combatants plummeted into a network of subterranean caverns. Still, the indomitable Horadrim pressed the attack.

In a desperate attempt to survive, Baal hurled a devastating spell at Tal Rasha, shattering the Amber Soulstone. Nevertheless, the men fought on and subdued the raging demon lord. Tal Rasha, gathering the largest of the soulstone's shards, trapped Baal's destructive essence within it.

It should be noted that there is some controversy about how the Amber Soulstone was shattered. Even the studious Vizjerei mage Nor Tiraj has conflicting accounts in different documents about how this came to be. Yet another account, from a different source, states that it was the inability of one of the Horadrim in particular, Zoltun Kulle, to properly handle the stone in battle that led to its breaking. Whatever the case, when Baal had been drawn into the shard, it became clear that the fragment by itself could not contain his essence forever.

In a profound moment of insight, it was Zoltun Kulle who suggested that a human might be able to contain the demon's essence, using the shard as a conduit to his body. Kulle believed that a mortal heart would serve as a kind of surrogate soulstone. When he said that they would need a mortal vessel to bind Baal within, to wrestle the demon for all eternity, a silence fell over the mages. An instant later, it was Tal Rasha himself, their beloved leader, who stepped forward to make the awful sacrifice.

Jered Cain's notes suggest that Tyrael then appeared and whispered to Tal Rasha, "Your sacrifice will be long remembered, noble mage." He then led the men through the subterranean tunnels into the burial chambers of long-dead kings.

There, deep within one of the largest tombs, the Horadrim built a binding stone etched with runes of containment, held fast to the chamber's walls by unbreakable chains. Tal Rasha then ordered his brethren to chain him to the stone. As the other mages looked on in sorrow, Tyrael approached and jammed the golden shard into Tal Rasha's heart, transferring Baal's essence into the mage's body. Sorrowfully, the Horadrim sealed the chamber and left their brother behind to wrestle with Baal's writhing spirit, presumably for all eternity.

With the loss of Tal Rasha, Jered Cain became the leader of the Horadrim. He and his surviving brethren followed Diablo's trail of terror for nearly a decade. Their hunt took them to the distant western lands of Khanduras, where Diablo was finally confronted and ultimately imprisoned within the Crimson Soulstone. This time, the soulstone worked properly and the demonic essence of the Lord of Terror was trapped. The stone was then hidden within a labyrinthine cave system near the river Talsande.

Tyrael appeared before the Horadrim a final time and commended them for having achieved so great but so bitter a victory. He declared that the site must be guarded for all time, lest the Lord of Terror someday walk once more among men.

The Horadrim who remained built a small monastery and a system of catacombs within the caves. There was much debate as to what the order should do at this point, having received no further guidance from Tyrael. Jered commanded that records be kept. Rules of conduct were devised, and the rudimentary formalization of the Horadrim order began in earnest.

Yeah, I am aware of the texts which state that Tal Rasha offered this suggestion, but after much research, I believe Kulle's role here was downplayed for reasons that will become more obvious when you read "The Hunt for Zoltun Kulle."

It can then be presumed that some returned to the homes they had left so long before, while others continued to carry out their dire mission, seeking out evil in its many incarnations and standing as guardians against the forces of darkness Regardless, the fundamental nature of the Horadrim order changed at this time as its members transitioned from being a diverse band of warrior mages to a society of stoic academics.

One exception, of course, was Zoltun Kulle. To better understand the tragic story of this once-great mage, I have included a treatise on the subject written by Jered Cain himself:

THE HUNT FOR ZOLTUN KULLE

Following our capture of the Three, Zoltun Kulle took leave of the Horadrim and returned to Kehjistan to pursue his studies of magic. We heard little of him in subsequent years until disturbing reports flooded in that he had built a sprawling archive beneath the eastern deserts and begun a number of strange and unholy experiments.

Initially, we did not know what to make of these reports, but then we learned the true depth of Kulle's madness . . .

The Hunt for the Three had left Kulle a hollow and unfeeling shell of a man. He felt no pleasure or pain, anticipation or regret. He had become obsessed with soulstones, and believed that he could create one of his own—a vessel capable of harnessing the essences of both angels and demons. Zoltun Kulle would then use this Black Soulstone, filled with rage and hope, fear and valor, as a substitute for his own black and empty heart.

Though it pained us greatly, we agreed that our former friend had to die before he could complete his twisted goal.

I will say nothing of how the killing of Kulle took place, and who accomplished it, for that is among the greatest secrets of our order. After the deed was done, two more of his archives were found in the deserts and oases; we destroyed them. While the unfortunate affair of Zoltun Kulle did not extinguish the fire of the Horadrim, the flame never burned so brightly again.

Fortunately, I have never come across evidence that any other members of the order suffered a fate similar to Kulle's. In fact, what became of the other mages is somewhat of a mystery, but it is known that as time passed, the Horadrim's numbers dwindled. It must be understood that the Horadrim were always an extremely secretive society of ascetics.

In my own family, I can see that every generation I know of has been one of scholars and educators, as at some point the mantle of Horadric champion was removed. Regardless, I am convinced that the knowledge passed down from those distant times might well save us from the coming darkness.

The Rise of Zakarum

In the centuries following the Mage Clan Wars, the pendulum between mysticism and faith swung heavily toward the latter. Humankind had seen the disastrous consequences of magic, and while these arts were still practiced by some, the majority began turning to faith as a foundation for their lives.

This atmosphere gave rise to myriad religions, but none have moved and shaped history so much as the Zakarum Church. From my research, it appears that the seeds of this faith were planted by a mysterious figure named Akarat at some point prior to the formation of the Horadrim.

By the accounts I hold to be true, Akarat was a wandering ascetic from the rugged mountain island of Xiansai, north of Kehjistan. Having become disillusioned with society and its incessant conflicts, he joined the ranks of a humble meditative order that sought enlightenment and peace in Xiansai's high, snowy peaks.

One night, while deep in meditation, he envisioned a spectacular flash of light and energy cascading across the sky. With this phenomenon came insight regarding the universe, reality, and humankind itself as an ascended power. Akarat attributed his revelation to an angelic being named Yaerius, or "son of light" in his native language.

Subsequently, Akarat wrote extensively about the role of humans as powerful beings of Light meant to bring alignment to all things in the universe. All men and women, he purported, were bound together in a spectrum of cosmic radiance that was the foundation of existence itself.

Moved by what he saw, Akarat set out on a grand journey to the ancient cities of Kehjistan, intent on enlightening his fellow man about the divine Light that existed within everyone, no matter what their race, religion, or social status. He is said to have exuded selflessness and compassion in their purest forms. Over time, a number of loyal disciples flocked to Akarat's side.

By all accounts, Akarat was kind, selfless, and unassuming. What I find most interesting is that he never desired that his teachings would lead to the formation of a religion. His goal was simple: to share the wondrous things he had learned so that others could live with goodness in their hearts.

At some point—the lore varies on the date—Akarat disappeared into the jungles of Kehjistan, content that he had spread his message to as many others as he could. He was never seen again.

Over the following years, his ideals were carried on and preached in the streets of Kehjistan's cities by a devout few. The name Zakarum came into use to describe those who followed the ideal of Zakara, or "inner Light." Akarat himself had never given a name to his beliefs, for he had never intended them to represent an actual institution. The appearance of this name, however, represents that the Zakarum faithful were becoming more of a formal group.

When the Horadrim captured Mephisto's wretched essence within the Sapphire Soulstone, the mages turned to the Zakarum believers, who were at that time still a small and humble order, for assistance. Tal Rasha, in particular, had an affinity with the faith's monks, and he firmly believed that they were the only individuals who could be trusted with guarding the soulstone.

My own explanation for Akarat's supernatural experience differs from historical accounts. Ever since the end of the Sin War, there have been rare reports of mystics witnessing what I can only describe as Uldyssian's ultimate sacrifice and merger with the universe. Descriptions in the Books of Kalan note that the sudden release of his energies illuminated the sky quite brilliantly. I believe that this act still echoes throughout time—albeit on a psychic plane rather than a physical one—and can be seen only by those deep in meditation. Thus, I theorize that it is this phenomenon that Akarat witnessed and interpreted as the being Yaerius.

As the Horadrim continued their hunt for the remaining Primes, the Zakarum set about building a temple where they could safeguard Mephisto's soulstone. It was in the dense jungles near Kurast that they ultimately founded what became known as Travincal. This humble place of worship would later grow into a massive temple city at the heart of eastern civilization.

Much of what came to pass in the generations that followed has been written about extensively, and is no mystery to those of us now living in modern times. In summation, the Zakarum order grew ever more influential until it became the supreme political power in all of Kehjistan. The faith's leaders codified their beliefs and created a religious hierarchy composed of differing offices. The holy seat of the Que-Hegan, the highest divine authority of the church, was established and filled. Under this revered figure, attendant archbishops of the High Council were tasked with administering the various territories under Zakarum control.

With Kehjistan under its heel, the church looked to what some saw as the barbaric and uncivilized regions of the west. Rakkis, a devout champion of the faith, marshaled a great host to claim and enlighten these lands in the name of the Que-Hegan. His long and arduous crusade to colonize the west would modernize many of these lands, in some cases through brute force. Rakkis finally settled in Westmarch, which was named to commemorate his grand crusade, and reigned as king of that region until the end of his days.

Following the conquest, regional lords from the east were appointed to govern these new outlying hubs in the name of the Zakarum Church. With that, the faith's reach had spread to nearly every corner of the world, leaving only a scarce few regions untouched by its influence.

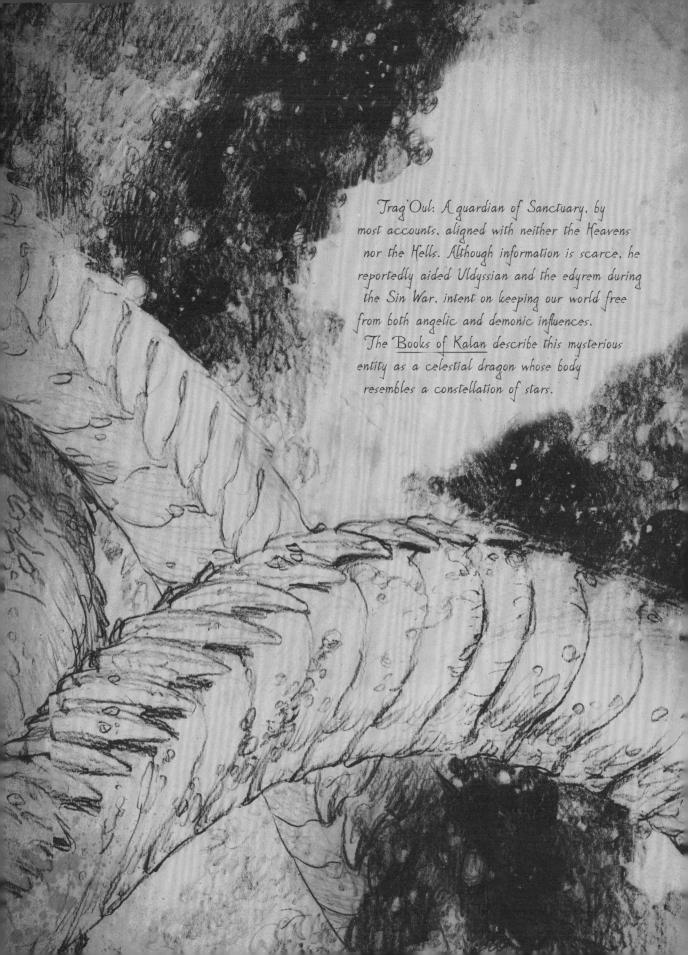

Trag'Oul: A guardian of Sanctuary, by
most accounts, aligned with neither the Heavens
nor the Hells. Although information is scarce, he
reportedly aided Uldyssian and the edyrem during
the Sin War, intent on keeping our world free
from both angelic and demonic influences.

The Books of Kalan describe this mysterious
entity as a celestial dragon whose body
resembles a constellation of stars.

Modern History
The Darkening of Tristram

It would be impossible to tell the tale of the present age without writing about the troubled town of Tristram. Located in a remote province known as Khanduras, far from the bustling cities of the east, or even the rain-drenched ports of Westmarch, Tristram played a central role in the unfolding peril of our times.

Indeed, having lived in Tristram all my life, and having been witness to the dark events chronicled here, I still have difficulty believing that my home became the center of so much strife and fear. But I digress . . .

As mentioned in earlier accounts, the Horadrim built their monastery atop the cave system containing Diablo's soulstone. Over time, those first Horadrim settled the land and founded Tristram. As the town grew, other farmers and settlers made the surrounding region their home as well.

Long years passed, and Tristram prospered, though its population never exceeded a few dozen families. None who lived there, under the shadow of the Horadric monastery, ever suspected that Terror itself slept beneath their quiet town.

More than two centuries later, the Zakarum lord Leoric arrived, and Tristram began to take on significance in regional affairs. My knowledge of Leoric's origins comes from my own observations as well as his private journals, which describe how he traveled from Kehjistan and, at the behest of the Zakarum Church, declared himself Khanduras' king.

Acting on counsel from his trusted adviser, Archbishop Lazarus, Leoric established his seat of power in Tristram. Upon his arrival, the king began turning the sleepy town into a regional capital. The Horadric monastery at that time was abandoned and largely in ruins. Leoric converted the ancient structure into a grand Zakarum cathedral, unaware of the vast labyrinth and catacombs the Horadrim had built beneath it.

Initially, the people of Khanduras were wary of their foreign ruler, but I can attest to the fact that Leoric was a wise and just king who exemplified the greatest virtues of the Zakarum. In time, he won the hearts and minds of his subjects, which makes the events that ended his reign all the more tragic.

After years of idyllic peace and quiet, and for reasons then unknown, Leoric's countenance began to darken. The king became irrational at first, but soon began to show the signs of madness and paranoia. It was only when Leoric declared war against the neighboring kingdom of Westmarch that we began to see just how far our king had fallen.

Those close to the king tried to convince him that the war was both unjust and unwinnable. But Lazarus, always Leoric's closest confidant, convinced him that Westmarch was plotting against him. In his paranoia, Leoric sent the meager army of Khanduras into battle. His eldest son, Aidan, seeking his father's approval, joined the forces as well.

Soon after the army's departure, Leoric's youngest son, Albrecht, went missing. Already in the throes of madness, the king raged at the loss of his beloved boy. Convinced either by delusion or by very real specters (who can say?), Leoric became certain that the townsfolk had conspired against him and his family, and he tortured and executed many innocent citizens in an attempt to discern Albrecht's whereabouts. Because of his erratic and cruel actions, the once-gentle Leoric became known as the Black King.

Lachdanan, the captain of Leoric's knights, returned from the war in Westmarch with only a few ragged survivors and found his cherished kingdom in disarray and his fellow citizens gripped by terror. Angered by these events, he confronted Leoric, but the king's madness engulfed him fully, and Leoric ordered his guards to kill Lachdanan and his men.

So it was that Lachdanan and his fellow knights were forced to slay their maddened king. However, before he expired, Leoric put a curse on his slayers. Lachdanan and his men nonetheless thought to honor the noble ruler Leoric had once been and give him a proper burial in the tombs beneath the cathedral. What became of them, I do not know for certain, but I have been told that Lachdanan's damned soul eventually found peace.

Soon, even greater tragedy befell our poor town. More and more citizens disappeared; livestock were mysteriously butchered in the fields; and rumors of horrific creatures prowling the night spread like wildfire. Worse still were the audible screams that could be heard late at night, echoing from the depths of the cathedral.

With Leoric dead and Lachdanan missing, the townsfolk turned to Archbishop Lazarus for assurance. Lazarus, who had been missing for some time, had returned to report that he himself had been ravaged and taken into the catacombs beneath the cathedral by what he could only describe as demons.

In his terrified ramblings, he reminded everyone that Prince Albrecht was still missing, but suggested that the boy might be alive, held captive by the insidious denizens of the labyrinth. Seemingly obsessed with rescuing the young prince, Lazarus led many of the townspeople down into the catacombs, unfortunates who were never to be seen again.

Amidst the chaos, I began to realize that the horrific creatures that wandered Tristram by night reminded me of ones I had read about in the old Horadric tomes passed down to me by my family. As I scoured those tales of angels, demons, and the Horadrim again, I came to a stunning realization: All those stories I had dismissed as myth and legend were true.

Although humbled, I was also filled with a sense of purpose. I knew then that I possessed knowledge that could be used to fight Tristram's corruption. From that day forward, I vowed to arm whomever I could with enough wisdom and information to defeat the evil that had arisen.

In those bleak and unforgiving times, many townspeople would gather at night at the Tavern of the Rising Sun. They sought to take comfort in the company of others, as well as the calming effects of Tristram ale. It was then that the crossroads of life led me to a woman known as Adria, a witch who had just recently come to Tristram for reasons unbeknownst to me. Adria, a vendor of potions and scrolls, was quite an intriguing woman. She was also very resourceful in collecting rare artifacts and arcana. I found her knowledge about mysticism and demonology most valuable, though I found her behavior to be peculiar at times.

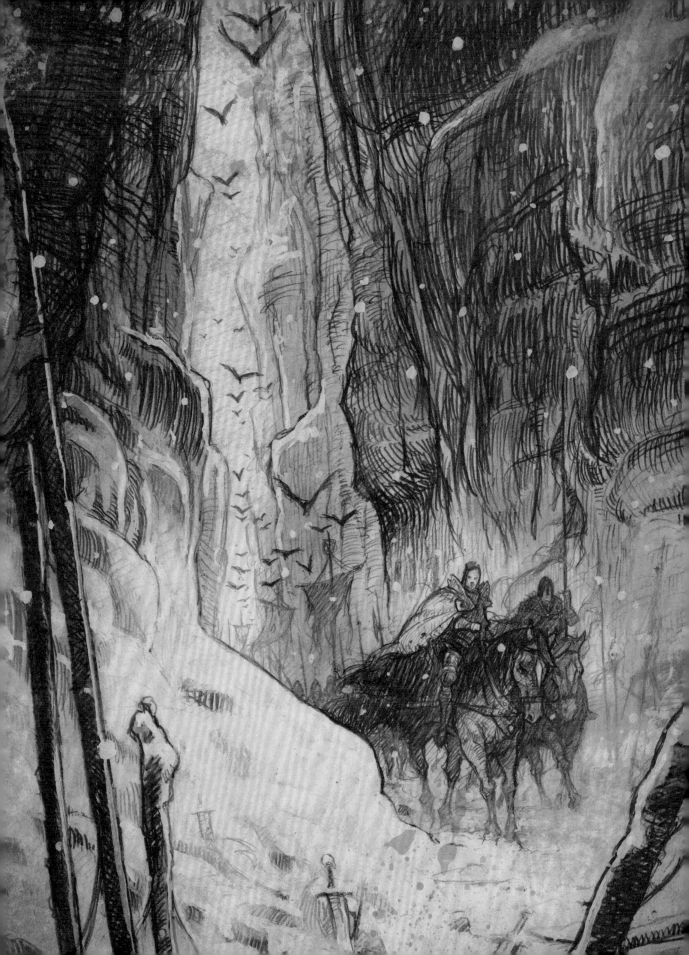

We spent many nights poring over the history of the Horadrim and the Hunt for the Three. At that time, having immersed myself in their lore, I began to see myself as one of them. Indeed, perhaps I was the last of the Horadrim. Though it seems naive now, it took me quite a long period to come to the conclusion that the Darkening of Tristram was directly caused by the secret evil the Horadrim had buried so long ago: Diablo, the Lord of Terror.

Meanwhile, as rumors of the horrific events in Tristram spread, mercenaries and adventurers came from all over the world to test their mettle and seek their fortune in the labyrinth beneath the cathedral.

It was at this time that Prince Aidan finally returned to Tristram from his battles against Westmarch, seeking the solace of his home. Like Lachdanan before him, he was horrified by what he learned had befallen his father and his younger brother.

Tempered by war and loss, Aidan vowed to rescue Albrecht and banish the foul demonic power that had gripped Leoric's kingdom. So it was that he ventured into the catacombs beneath the ruined cathedral to find his missing brother.

He was not alone in this task. Of the numerous adventurers who had been drawn to Tristram, the most valorous joined Aidan's side. One was a rogue from the Sisterhood of the Sightless Eye, a mysterious organization headquartered in the mountains east of Tristram. (I will discuss this group later.) She was well versed in the arts of ranged combat and possessed an uncanny ability to sense and disarm traps.

Another was a Vizjerei sorcerer from the lands of Kehjistan who had been sent by his elders to observe the dark happenings in Tristram. As I soon learned, the mage also had an interest in discovering lost tomes and magical artifacts that might be hidden away in the vast labyrinth beneath the town.

In addition to the rogue and the sorcerer, there were others who, like Aidan, were warriors trained in all manner of weapons and armor. These combatants embodied strength and resilience but had little to no knowledge of magic.

Beneath the cathedral, Aidan and these other champions encountered many horrors. He and his band quickly dispatched a bloated and grotesque demon who called himself the Butcher.

The heroes also discovered that Leoric had been resurrected as the grotesque Skeleton King, bound to Diablo's dark will. Witnessing the reanimated visage of his father was a harrowing encounter for Aidan, made even more heartbreaking by the fact that he was forced to strike him down.

Our town blacksmith, Griswold, described the gruesome Butcher to me in great detail, much to my dismay.

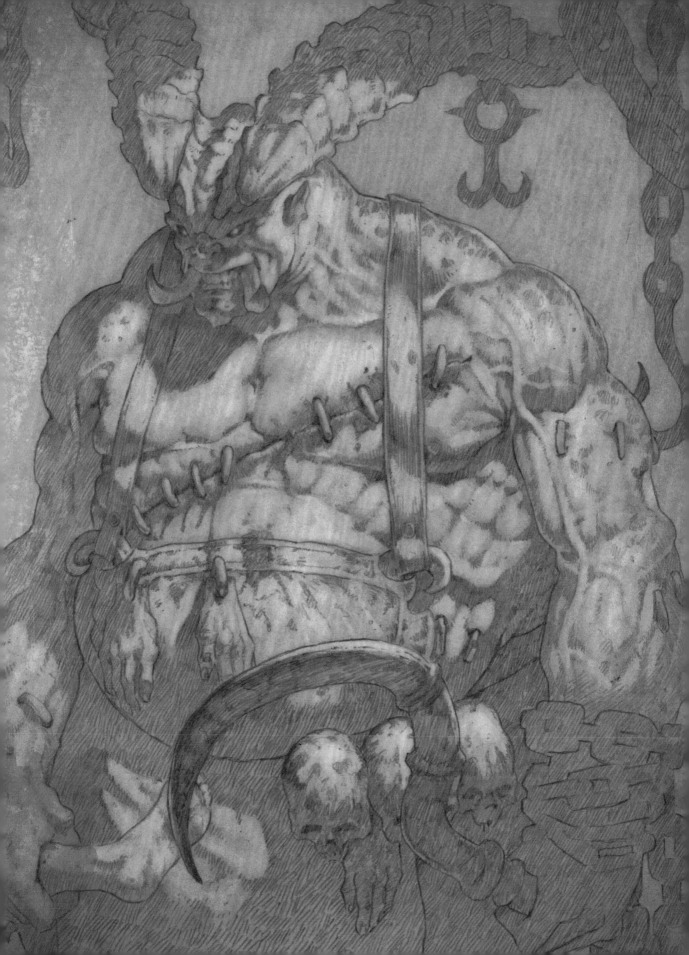

A lesser man might have given up then, but not Aidan. After returning to recount the tale, he braved the cathedral's depths once again in the hope that his brother was still alive. Instead of returning with any sign of his brother, however, Aidan came back with the staff of Lazarus. According to Aidan, the Zakarum archbishop had long deceived Leoric and Tristram's populace. At the time, I did not know quite what to make of Aidan's claim, but after those terrible events I would uncover the truth surrounding the full conspiracy.

Lazarus had been one of the keepers tasked with watching over Mephisto's soulstone in Travincal, the heart of the Zakarum empire in Kurast. As I would later learn, Mephisto had extended his influence beyond the confines of the stone. Over centuries, he had corrupted the highest echelons of the Zakarum faithful.

Due in large part to Mephisto's influence, Lazarus had convinced Leoric to take on the position as Khanduras' king and establish his seat of power in the unassuming town of Tristram.

Upon arriving here, Lazarus released the evil from beneath the cathedral by allowing Diablo's essence to escape from its soulstone. The Lord of Terror had then attempted to possess Leoric, but had succeeded only in driving the king mad. What is most despicable, though, is that it was Lazarus who had kidnapped Prince Albrecht and taken him deep into the catacombs at Diablo's bidding.

Aidan and his comrades continued battling through the subterranean tombs, clashing with ever more powerful foes. As news of their exploits grew less frequent, I began to fear that they had encountered Diablo himself and failed.

Then, without warning, I heard what could only have been the death cry of Diablo. Aidan emerged from the bowels of the cathedral, coated in his own blood and all manner of demonic ichor. The terrible screams emanating from the catacombs stopped. Of the demons that had wandered the areas surrounding Tristram, there was no further sign.

That is when I realized that young Aidan and his brave companions had done the impossible: They had triumphed over Diablo, the Lord of Terror.

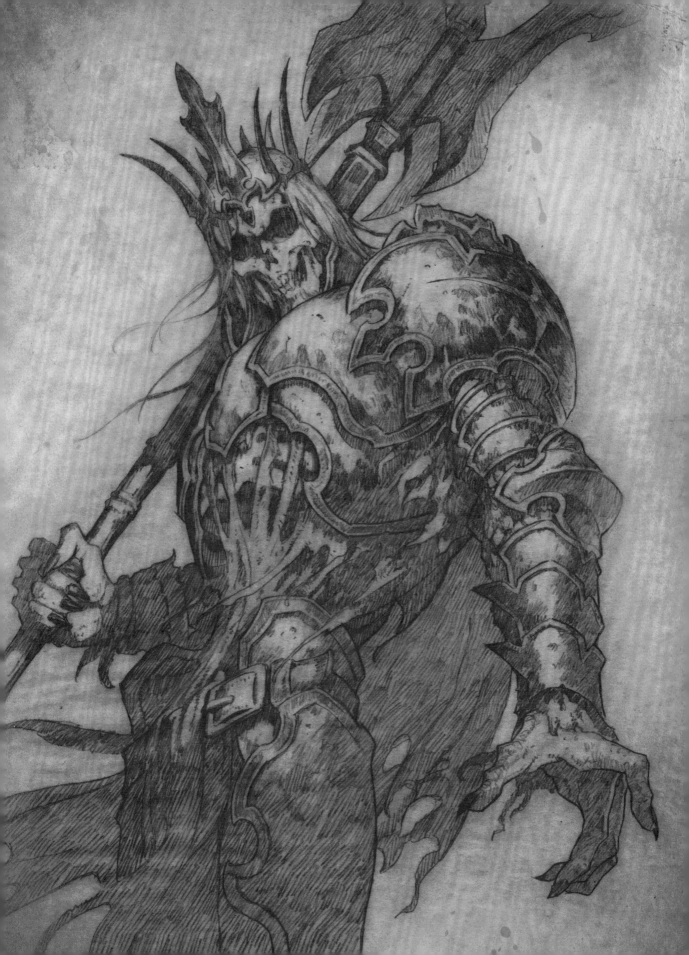

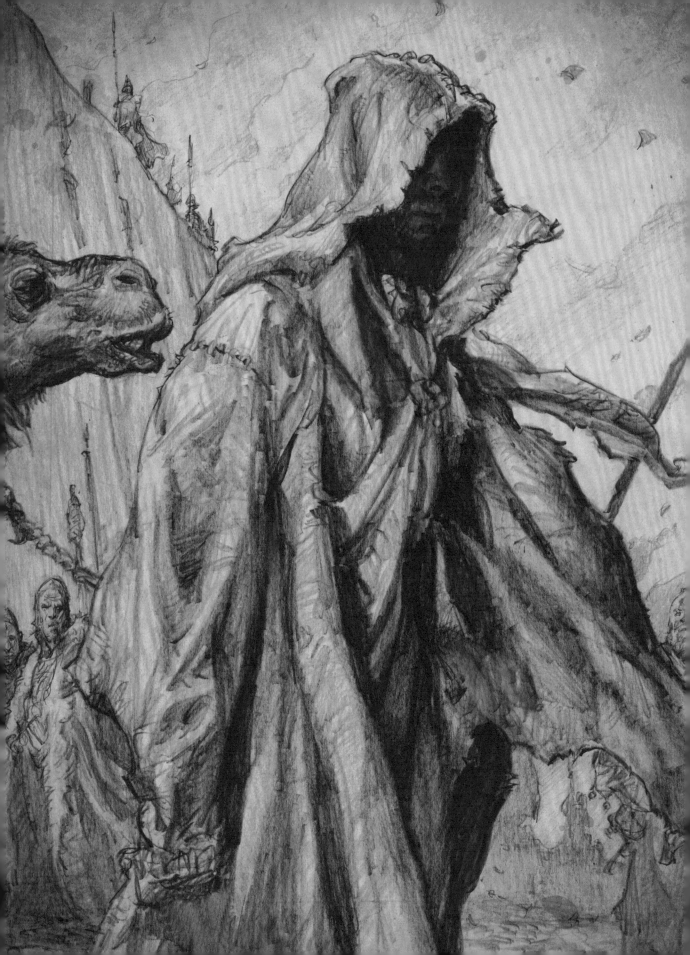

The Dark Wanderer

It was a dismal time following the horrors of Diablo's rise and the Darkening of Tristram. I longed to know the truth of what happened in the final hours before the horrors were ended, but the man who emerged from beneath the cursed cathedral was not the same courageous warrior who had ventured into the catacombs to rescue his brother.

Aidan increasingly shunned the company of others. He spent his days in isolation and roamed the streets at night, seemingly without direction or purpose. Indeed, the witch Adria appeared to be the only person capable of offering comfort to Aidan during this sorrowful period. As the rest of the town struggled to recover in the aftermath of Diablo's reign of terror, Aidan and Adria spent long nights behind closed doors.

Tristram had become a quiet and sleepy hamlet once again. Tales had spread across Sanctuary of the town that had drawn the bravest adventurers in the world, like flies to the spider's web, only to meet their doom.

It was many days after Aidan's harrowing journey to save his brother that the haunted warrior spoke to me. He confided in me the truth then of what he had faced in the lowest depths of the catacombs: Aidan and the adventurers who had survived to the end found themselves in an area the broken young man described as "the threshold of Hell itself."

There they had encountered the most fearful abomination of any they had yet faced: Diablo—a nightmare incarnate, a terrifying horned demon the color of blood. They battled desperately, but the struggle was not merely physical: The demon forced Aidan to relive his worst nightmares, his greatest failures, and his fears that he would never live up to the expectations of his father. But, convinced that he might still save his brother, Aidan fought through the worst of what Diablo inflicted. The group of adventurers wore the demon down, and ultimately it was Aidan who delivered the killing blow—only to watch the abomination shift before his very eyes into the form of his young brother, Albrecht. Diablo had possessed the boy's body and twisted it into a physical representation of living Terror.

I can only imagine that Aidan's mind was shattered upon realizing that he had killed his only brother. When Aidan finished his recounting, he whispered several times, "I thought I could contain it. I thought I could contain it." He went on to mumble a number of other disturbing things, including something about his "brothers" awaiting him in the east. I knew Aidan was troubled by what he had experienced, and at the time I interpreted what he said as meaningless ramblings.

The next day, Aidan was gone. I spoke with Adria soon after his departure and learned that the warrior had traveled east to seek out mystics who might exorcise the waking nightmare that plagued him.

As I meditate back on those days, there is much I would have liked to have asked of Aidan and Adria before they left, as well as many others in town. Unfortunately, such a confused and fetid air hung upon the world back then that I was not thinking clearly. Nor, I suspect, were any of the other remaining citizens of Tristram.

Although I did not succumb, as did so many others, to the wave of insanity that swept the land, I did receive a wound to my spirit that I have not recovered from to this day. Dark thoughts always live at the edges of my mind, like vultures awaiting a feast.

I must now, regrettably, tell of the most troubling time of my life. It was mere weeks after Diablo's defeat that Tristram fell once again to demons.

It was only after the town was utterly destroyed and nearly all those who remained were slaughtered and raised from the dead that I myself was taken prisoner. We had no indication where the demons had come from, but even in my weakened state I surmised that the cause of their appearance was to ensure that no able-bodied combatants were left alive to follow Aidan into the east.

It was then that a horrifying realization dawned on me as I recalled Aidan's words: "I thought I could contain it." Could it be that Aidan was wrestling with the spirit of Diablo himself? And if so, what were his true intentions in going east?

Regardless, the most important piece in all of this is that I survived, and I did so thanks to the efforts of a handful of brave and noble individuals. They had been made aware of my plight and the hellish creatures assailing Tristram.

Many had traveled from the far corners of the world—among them a noble paladin of the Zakarum, a brooding necromancer from the eastern jungles, a powerful amazon from the Skovos Isles, an enigmatic sorceress from Kehjistan, and a mighty barbarian from the slopes of Mount Arreat itself! Together they fought with courage such as I had rarely seen, and ultimately they saved me from the jaws of death.

Shortly after Aidan's departure, Adria set out as well. I am, of course, aware of many things now that I did not know then: that Adria took Gillian the barmaid with her to Caldeum; that when Adria left, she was pregnant with you, dear Leah; and that she gave birth to you in Caldeum and left you there in Gillian's care.

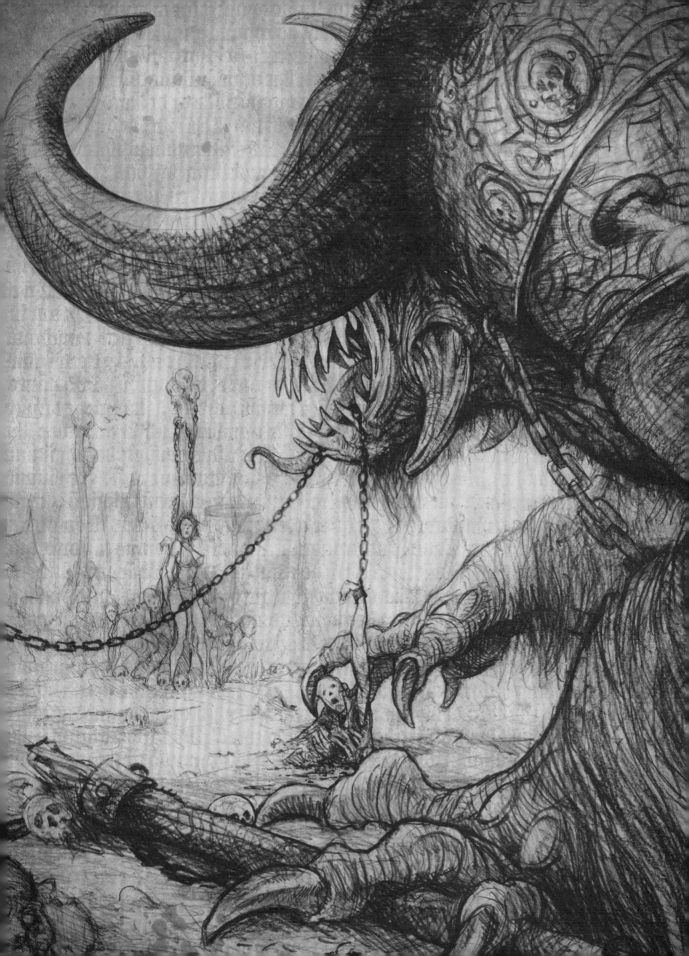

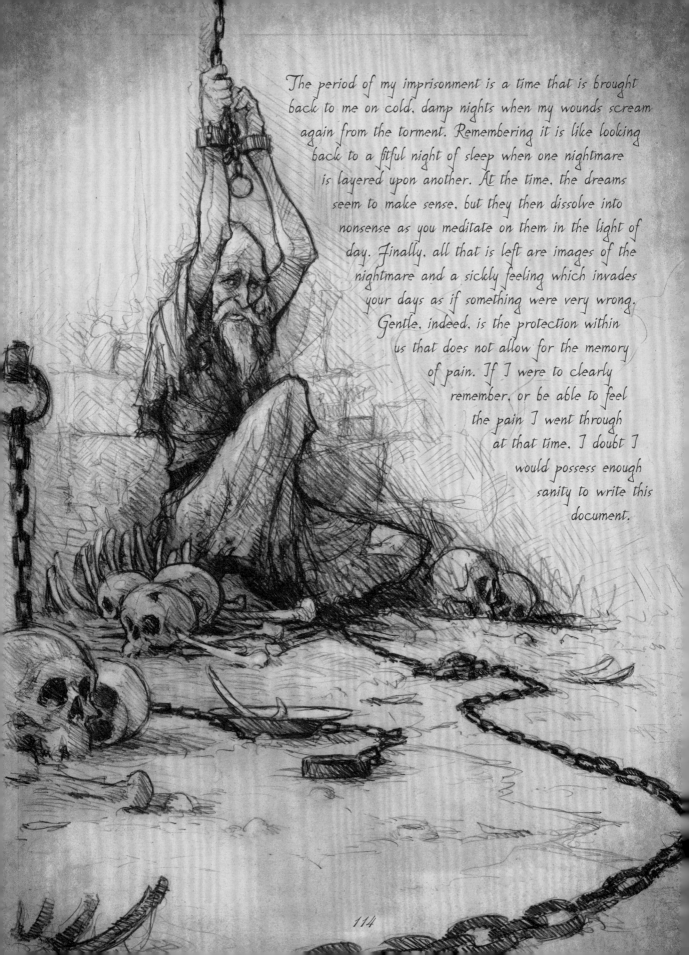

The period of my imprisonment is a time that is brought back to me on cold, damp nights when my wounds scream again from the torment. Remembering it is like looking back to a fitful night of sleep when one nightmare is layered upon another. At the time, the dreams seem to make sense, but they then dissolve into nonsense as you meditate on them in the light of day. Finally, all that is left are images of the nightmare and a sickly feeling which invades your days as if something were very wrong. Gentle, indeed, is the protection within us that does not allow for the memory of pain. If I were to clearly remember, or be able to feel the pain I went through at that time, I doubt I would possess enough sanity to write this document.

My greatest concern, however, was not for my own well-being. I quickly shared with the heroes my true fear: that Diablo, lurking within Aidan's tortured soul, was guiding the troubled warrior to release the other two Prime Evils that the Horadrim had imprisoned so long ago. For if Aidan released both Baal and Mephisto, humankind would surely suffer an age of darkness and despair beyond imagining. With this, then, in mind, I convinced the group of champions to travel eastward to intercept Aidan and thwart Diablo's plans.

Early on in Aidan's journey, he had crossed paths with an unfortunate soul named Marius. Much of what I know now regarding the events I am about to convey, I retrieved from the remains of a cell within a burned-out sanitarium in Westmarch. (More on this location will be detailed later.) It was there that Marius, his mind shattered from the time he had spent with Aidan, had carved the accounts of his experience into the floor of his cell with his own fingernails. Fortunately, these writings were still legible despite the damages to Marius' room.

During this time, I referred to Aidan as the Dark Wanderer. After his departure from Tristram, he sought passage to the eastern port of Lut Gholein. Passing through the Eastgate Monastery, Aidan encountered the Sisters of the Sightless Eye, many of whom had recently been corrupted by the Maiden of Anguish, Andariel. As with the other demons who invaded Tristram, Andariel had arrived to prevent Aidan's pursuers from interfering with the Wanderer's dire mission.

Which I speak of in "The Hunt for the Three."

The Sisterhood of the Sightless Eye is a most intriguing organization. Its origins are rooted deeply in the history of the Askari who dwell on the Skovos Isles. From the earliest days of their culture, the Askari held in their possession an artifact known as the Sightless Eye, a mirror which served as a window to perceive the future. The Sisterhood of the Sightless Eye, a group of amazon dissidents, stole the artifact and fled, ultimately occupying Eastgate Keep. Whether Andariel came to possess the Eye, or, if she did not, what became of it, is unknown.

I speculate now that following the Dark Exile and the Prime Evils' banishment, Andariel (and her twin, Duriel, as we shall see) concluded that the Primes would inevitably use the innate powers of man to reclaim the Burning Hells. Therefore, they endeavored to gain favor with the Lord of Terror by protecting his human host.

In any case, the mighty champions who liberated me from my prison soon faced the Maiden of Anguish. She struck at them physically, but battered them emotionally as well, stirring within each of them memories of loss, sadness, betrayal, and regret— feeding on their angst and relishing their despair. Despite the heavy toll on the minds of those she attacked, however, the hunters succeeded in dispatching Andariel after a long and hard-fought battle.

Though the Maiden of Anguish had not succeeded in killing Aidan's pursuers, she was successful in one respect: She bought the Dark Wanderer time to reach his destination.

After traversing the arid deserts of Aranoch, the heroes arrived at Lut Gholein, hot on the Wanderer's heels. It wasn't until they reached the very tombs where the mage Tal Rasha wrestled the demon lord Baal that they finally cornered their prey.

There, within Tal Rasha's chamber, the group was faced with Duriel, the Lord of Pain—who, like his sister, had pledged his loyalty to Diablo. Duriel exacted a heavy toll upon the heroes, savoring the agonized screams of the wounded. Though hopelessly fatigued, both mentally and physically, the mortal champions overcame the Maggot King, slaying him as they had his sister. But again, time was of the essence.

As the heroes arrived at Tal Rasha's tomb, they realized they were too late to prevent Baal's release. To their amazement, Tyrael himself was present. He had arrived there and grappled with Aidan, hoping to prevent him from liberating Baal. Through some means of cruel manipulation, Baal had convinced Marius to remove the amber shard lodged in Tal Rasha's body, thus freeing him. Aidan and Tal Rasha, the latter then fully controlled by Baal, turned their combined might on Tyrael.

Knowing that he would not prevail against his foes, the archangel of Justice had ordered Marius to take Baal's stone into the Burning Hells and shatter it within the Hellforge. (I will describe this mysterious place in further depth later.) As the cowering mortal departed the tomb, Aidan and Tal Rasha overwhelmed Tyrael.

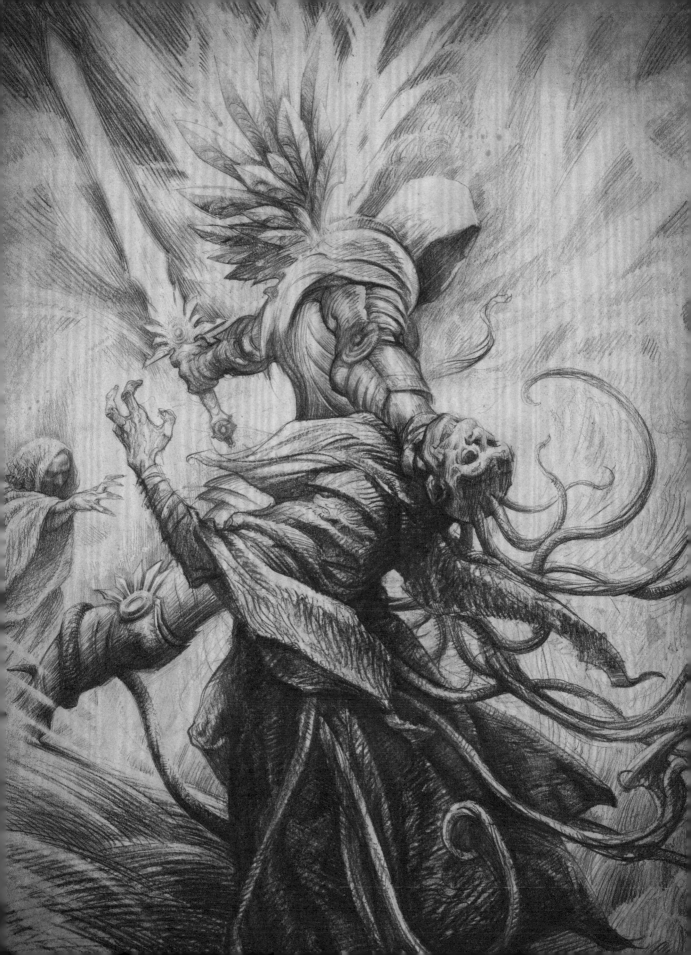

By the time of the heroes' arrival at the tomb, the two Prime Evils had already set sail across the Twin Seas to the eastern ports of Kurast. The mortal heroes quickly gave chase and nearly caught up to them again, but still the Dark Wanderer managed to escape their grasp.

Soon Aidan and Tal Rasha arrived at the Temple City of Travincal—then held to be the holiest site of Zakarum. It was there, deep within the bowels of the magnificent temple, that Mephisto's Sapphire Soulstone was kept.

As mentioned earlier in my writings, many of the greatest Zakarum paladins and their commanders had already been corrupted by Mephisto's vile influence long before Aidan and Tal Rasha arrived. It has even been documented that Sankekur, the Que-Hegan, or Supreme Patriarch of the Zakarum Church, had fallen under Mephisto's control.

This much is certain: Not everyone at the temple was corrupt, and Travincal was easily the most heavily guarded site in all of Kehjistan. Regardless, the Wanderer would not be denied. Eyewitness reports suggest that many of the temple's defenders fell prey to overwhelming fear and fled the complex altogether. Additional reports suggest that many more turned against each other, further decimating the Zakarum's ranks. These accounts undoubtedly evidence the influence of the Lords of Terror and Destruction.

Ultimately, the Wanderer and Tal Rasha made their way into the temple's innermost chamber, where Mephisto's soulstone was kept. There, they released Mephisto, who quickly took physical possession of the holy Que-Hegan. The tortured body of the Zakarum leader transformed into the hideous visage of Mephisto's demonic form. And thus, after nearly three centuries apart, the Prime Evils were united once again.

Within that chamber, the Primes devised a final stratagem to retake the Burning Hells and claim vengeance upon those who overthrew them. This included their long-sought goal to corrupt the Worldstone, thereby enslaving all of humankind and its nephalem potential to their will. With an army of nephalem as their vanguard, the Primes would quickly overwhelm the Hells' traitorous legions and reestablish their infernal reign for all time.

To accomplish this, the Primes combined their powers to open a portal that would allow them access to their former domain. It was then that Diablo finally cast off the mortal visage of Prince Aidan, and assumed his true demonic form.

Intent on rallying the legions within Hell still loyal to the Three, Diablo crossed through the shimmering portal. Baal began his long journey north to corrupt the Worldstone, while Mephisto alone remained, bent on destroying any and all opposition to their plan.

When the mortal heroes arrived in Kurast, the city had already been overrun by demonic hordes. Bloody combat was waged in the streets as the heroes fought to gain entrance into Travincal. Once inside, they faced not only demons but also the corrupted zealots and High Council members of the Zakarum faith. At the time, I doubt it occurred to the champions that they were toppling the world's greatest religion, but such was the case. Nonetheless, they continued down into the deepest recesses of the temple, where they finally faced Mephisto.

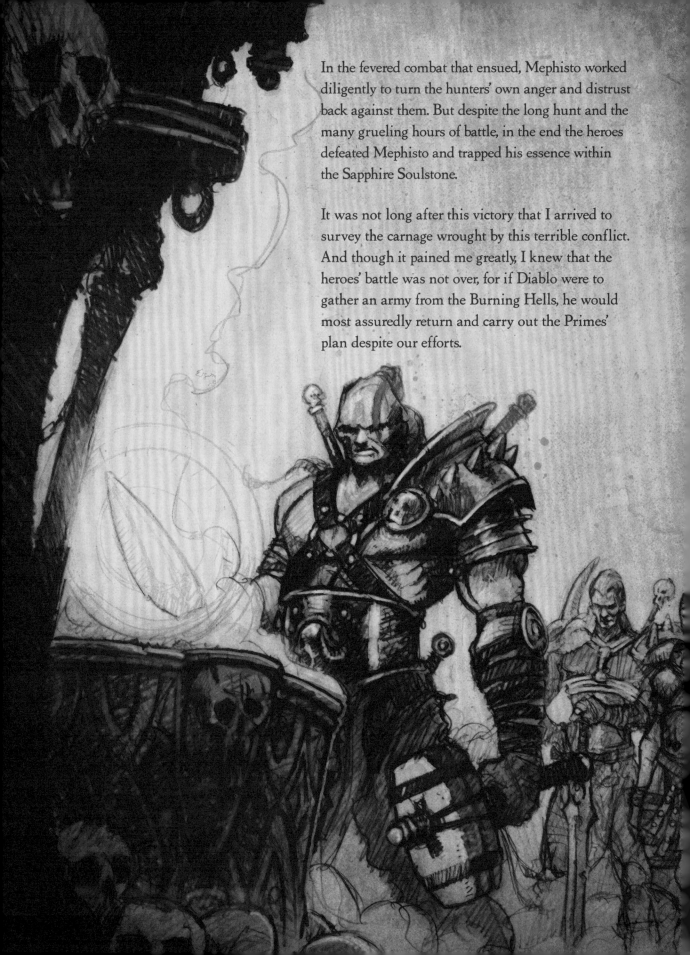

In the fevered combat that ensued, Mephisto worked diligently to turn the hunters' own anger and distrust back against them. But despite the long hunt and the many grueling hours of battle, in the end the heroes defeated Mephisto and trapped his essence within the Sapphire Soulstone.

It was not long after this victory that I arrived to survey the carnage wrought by this terrible conflict. And though it pained me greatly, I knew that the heroes' battle was not over, for if Diablo were to gather an army from the Burning Hells, he would most assuredly return and carry out the Primes' plan despite our efforts.

Those who had fought so hard, for so long, did not hesitate. They drove through the portal without a backward glance, and I . . . I somehow summoned the courage to follow them.

The gateway we entered, however, did not lead directly to Hell. Instead, it allowed access to the breathtaking Pandemonium Fortress, the abandoned bastion that once housed the Worldstone. Even as my senses reeled, I wondered why the Prime Evils had chosen to open a portal there. Perhaps to allow Diablo furtive access into the Hells? Whatever the case, it meant that perhaps there was still time.

The Pandemonium Fortress was the most incredible, astonishing, and perplexing place my mortal eyes have ever beheld. Colors, shapes, textures—none seemed as they should have. My surroundings pulsed and shifted before my eyes. I was overwhelmed, but determined also to offer whatever assistance I might to the heroes who pursued Diablo.

It was then that my eyes fell upon the shining visage of Tyrael. Not wanting to directly intervene and risk the High Heavens learning what had befallen Sanctuary, the archangel regretted that he could not venture into the Hells at the mortals' side. But he offered insight: a theory. A chance, perhaps, to eliminate both Mephisto and Diablo once and for all.

He spoke of the Hellforge, located in the deepest pit of the Realm of Destruction. It was here that the demonic smiths forged Hell's most powerful weapons. Thus, it was said that the dread Hellforge held many unholy anvils, and among them was the Anvil of Annihilation. It was upon this anvil that angelic weapons and artifacts were destroyed. Legends held that anything broken upon the Anvil of Annihilation, no matter how powerful, would be forever negated.

The hunters possessed Mephisto's soulstone already. Tyrael theorized that if they somehow overcame Diablo and trapped his essence as well, then perhaps both soulstones could be shattered upon the anvil. Therefore, in theory, the demon lords themselves would be obliterated and their souls cast into some unseen netherworld.

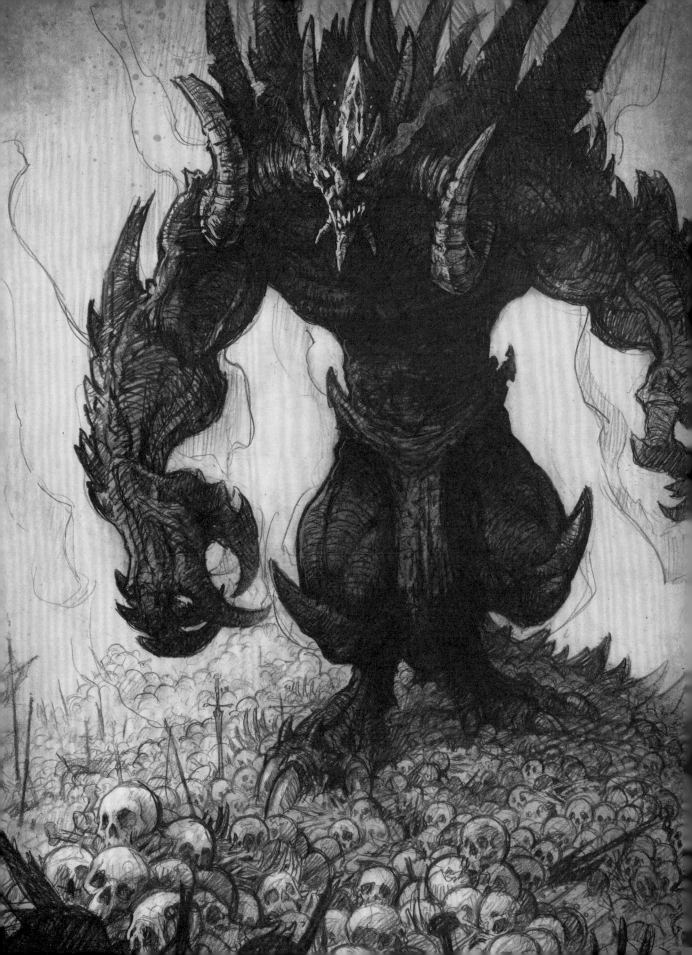

It is staggering to think back upon that moment. For who could ask such a thing of mere mortals? Tyrael did not have to ask. Without hesitation, the pursuers charged headlong into the fires of the Burning Hells, while Tyrael remained behind to serve as my protector. The champions fought their way across the nightmare landscape and reached the volatile Realm of Destruction, seeking the mythic Hellforge.

I can scarcely imagine what horrors they faced and overcame, but their spirit and will proved indomitable. They stood at the smoldering rim of the Hellforge, and there, upon the Anvil of Annihilation, the heroes shattered Mephisto's soulstone.

The heroes then tracked down Diablo. Despite the odds against them, they succeeded in overtaking the Lord of Terror.

Once again, dear Leah, the sheer tenacity of the human heart proved victorious, for the heroes achieved the impossible: They vanquished Diablo within his own realm. As they pulled the Crimson Soulstone from Diablo's corpse, the demon's massive form began to wither. They set about trapping Diablo's essence within the soulstone, and when they succeeded, Diablo's disintegrating husk took on the form of Prince Aidan.

In honor of the prince's memory, the champions ceremonially wrapped his broken body and threw it into the infernal fires that raged all around them.

With Diablo's soulstone in their possession, the beleaguered heroes made their way back to the Hellforge and sundered the artifact upon the Anvil of Annihilation.

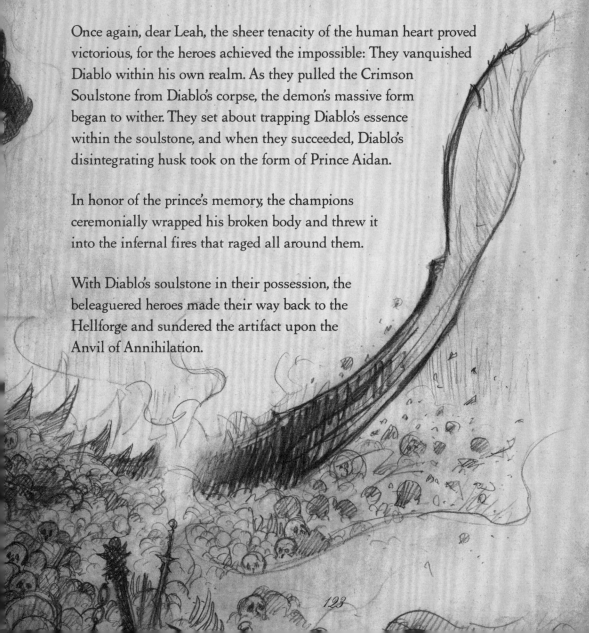

The firsthand accounts of the champions tell us that when both Mephisto's and Diablo's soulstones were shattered, a similar fate befell the Primes. A scream such as no human being had ever heard rent the air, followed by a black and intangible nothingness opening before the heroes. They averted their eyes as the wailing souls of Diablo and Mephisto were swallowed by the yawning darkness.

Upon hearing of this, I remembered the writings of my ancestor Jered Cain, who reported a theory held by Zoltun Kulle: that the spirits of angels and demons could be banished to a place beyond even Heaven and Hell—a place he called the Abyss. When I think back on the champions and their experience at the Hellforge, I know in my bones that Diablo and Mephisto were cast somewhere that would make even them feel fear.

And, though it is morbid, I must be honest and admit that this thought gives me some comfort.

Regardless, with the shattering of the soulstones, yet another chapter in the struggle of humankind against the agents of the Burning Hells had come to an end.

Questions, of course, remained. And years later I would glean the details concerning Aidan and his possession by the Lord of Terror.

It was revealed to me that upon defeating Diablo in the catacombs beneath Tristram, Aidan had thrust the Crimson Soulstone into his own forehead in an effort to trap the essence of Diablo within himself. Now I wonder whether, perhaps, it was Diablo's plan all along to lure the world's greatest champions down into the depths to test their strength and resolve and, in so doing, find the perfect host for his all-devouring evil.

How much of Aidan was in control when he left Tristram, striking out to the east? Was it truly his intention to exorcise the demon from within himself—or was it the voice of Diablo whispering deep in his mind, convincing him that these thoughts were his own? We may never know. But this I tell you, Leah, regarding the final battle with Diablo, when the champions fought him in the midst of the Burning Hells: I now believe, looking back on those events, that a small measure of Aidan remained, fighting the will of Diablo. Perhaps it was not only the heroes who overcame the Lord of Terror, but also Aidan, who contended with the demon from within.

As I say, this is not proven, but simply my belief. And it is beliefs like this which may provide some slim hope, even in the face of ultimate despair.

The Lord of Destruction

As my companions waged their battles against Mephisto and Diablo, Baal set out across the Twin Seas to corrupt the Worldstone, and thereby all of humankind. With the whole of humanity turned to darkness, he would possess an army with a power beyond even that of angels and demons—a fighting force capable of tipping the scales of the Eternal Conflict.

It appears, however, that in order to fulfill his plan, Baal required the Amber Soulstone shard that had been used to imprison him so long ago by the Horadrim. As you will remember from earlier in this tome, the shard had been taken by Marius, the Dark Wanderer's former companion.

Rather than follow Tyrael's orders to destroy the stone, Marius had fled to Westmarch. There, driven to the brink of madness, he had been arrested and confined to a sanitarium. It did not take long for Baal to track him down and acquire the soulstone shard. Reports say that a raging inferno swept through the sanitarium around this time. Sadly, Marius' charred corpse was later found in the remains of the building. I can only assume that this act of destruction was Baal's doing.

For quite some time, I wondered why the soulstone was so vital to Baal's plans, but I believe I now have an adequate explanation. Over the long centuries Baal was imprisoned, the stone became infused with his destructive essence. By melding this Shard of Destruction to the Worldstone, Baal knew that he could irrevocably corrupt the monolithic crystal.

Having secured the shard, Baal marched north from Westmarch, butchering entire villages en route to Mount Arreat. Those who died were not granted peace—they were possessed and transformed into hideous demonic soldiers. By the time Baal reached Arreat, his unholy legions had swelled to number in the thousands.

Some might question why Baal assaulted Arreat in force if he could have reached the Worldstone through stealth and deception. From what I have gathered, every act of mayhem and wanton chaos committed by the demon lord and his minions bolstered the shard's destructive power. Thus, Baal intended to wreak havoc along his journey to ensure that when he reached the Worldstone, the shard itself would be pulsing with untold corruptive energies.

Near Arreat's foothills, Baal contended with the barbarians. These fierce guardians had lived to protect Arreat for generations, believing that the holy "Heart of the World" existed within the mountain. The barbarians had long venerated Bul-Kathos and other nephalem, and they believed that the spirits of these ancients resided upon the lonely peaks of Arreat as a last line of defense against any who would threaten the sacred mount.

By all accounts, the barbarians fought ferociously, living up to their reputation as some of Sanctuary's hardiest warriors. Yet it was not enough to prevent the Lord of Destruction from storming across their lands and sacking their great capital of Sescheron. Eventually, all that stood between Baal and Arreat Summit was Harrogath, a fortress nestled in the mountain's foothills.

Reports suggest that the stronghold's Elders grew desperate at the sight of Baal's marauding armies. To stave off annihilation, they sacrificed themselves to cast an ancient (and forbidden) warding spell, creating a protective barrier around Harrogath.

It was then that Baal's forces laid siege to the bastion. With Tyrael's aid, my brave comrades who had defeated Diablo and Mephisto arrived at Harrogath amidst the chaos.

Over the course of their journey, the heroes' numbers had grown. One newcomer who had pledged herself to the cause was an assassin of the Viz-Jaq'taar, a secretive order created to hunt down and slay renegade sorcerers. Having foresworn the direct use of magic, the assassin donned exotic weapons and armor imbued with elemental energies.

Another newcomer was a druid who traveled far from the fabled woodlands of Scosglen. Prior to meeting this individual, I had read extensively from the ancient druidic tome Scéal Fada and knew much about the druids' abilities to command the forces of nature and assume the forms of various beasts.

The band of heroes did all they could to break Baal's demonic siege. Their efforts, however, were overshadowed by treachery. Nihlathak, the only Elder to have survived the warding ritual, believed that unless he made a pact with the Lord of Destruction, his people would be doomed. In exchange for the sparing of Harrogath, the Elder provided Baal with the Relic of the Ancients, one of the holiest artifacts in barbarian culture.

With the artifact in hand, Baal raced up the slopes of Arreat, bypassing the guardian nephalem spirits and breaching the Worldstone's secret chamber within the bowels of the mountain.

My allies followed in his tracks, clashing with the demon lord's minions and even proving themselves worthy against Arreat's spectral nephalem. Ultimately, they confronted Baal within the Worldstone's chamber and vanquished him in a ferocious battle that left them at the brink of death.

Yet, as the heroes were horrified to learn, Baal had fused the Shard of Destruction with the Worldstone. All of the strife and horror that had accumulated within the shard had already begun spreading throughout the gargantuan crystal.

When Tyrael arrived to assess the situation, he realized that these dark energies would soon echo through the hearts of all mankind, turning humans irrevocably evil and violent.

And so Tyrael did the unthinkable. He hurled his sword, El'druin, into the Worldstone itself. In that moment, the object over which the Eternal Conflict had been waged—that had created Sanctuary and all its myriad forms of life— was shattered in a horrific explosion.

The Worldstone's destruction was catastrophic. Baal's body was obliterated, and his spirit, I have come to believe, was flung into the Abyss, just like those of the other Primes. What remained of his demonic forces was utterly destroyed as well, and the surrounding area was devastated. To this day, toxic clouds of ash and choking arcane dust hang like a shroud over the land. The decimation was so utterly calamitous that this region is now known as the Dreadlands.

What became of Tyrael after this event is unknown to me, but it is clear that his physical form, like Baal's, was disintegrated. Some fragmented reports suggest that the Sword of Justice, El'druin, survived the explosion and was thrown across the lands of Sanctuary. Rumors tell of a young mortal named Jacob who later wielded the sword and used it to cleanse a curse that had taken hold around his home city of Staalbreak. I hope to confirm these rumors and perhaps write a more detailed account of this series of events in the future.

Think carefully on this, Leah, as recent events surrounding the fallen star have caused me to begin formulating theories which I dare not express here.

Suffice it to say, dear reader, that from the time of Diablo's awakening beneath Tristram to Tyrael's destruction of the Worldstone, the narrative of men, angels, and demons was altered forever. This conflict saw the defeat of five of the seven Lords of Hell. I cannot tell you how significant this is.

For the past twenty years, I have traveled the darkening world and witnessed many things come to pass, waiting to see when these troubles would erupt once again. To be clear, two of the Evils still live—Azmodan, the Lord of Sin, and Belial, the Lord of Lies. The End of Days is coming, and I believe these two will play principal roles in the annihilation of our world.

Also of great concern is a thought that has plagued me for some time: As we have seen, Tyrael is a noble being who has fought on the behalf of our kind time and time again. Yet I am afraid that he is alone in terms of how his fellow angels view humanity. We have witnessed numerous demons and their lords walk this world, but we have heard little of the High Heavens or of the Angiris Council that rules over them. There is something terribly unsettling about Heaven's silence and the unknown role that angels might play in the coming years.

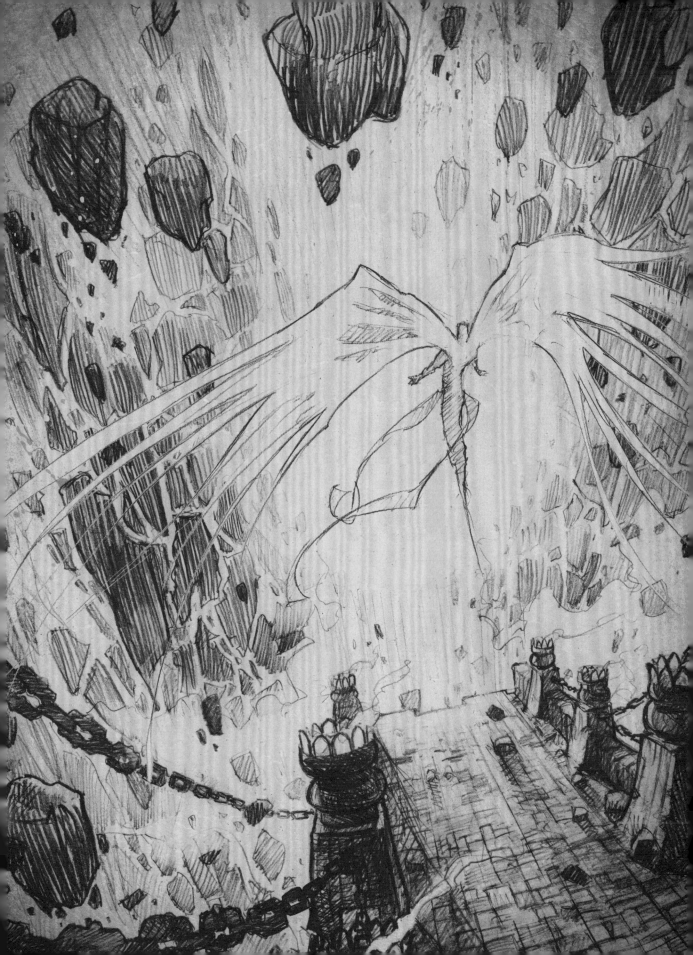

Sanctuary: Lands and Cultures
The Deserts of Aranoch

Since time immemorial, the vast sand-swept deserts of Aranoch have served as a natural barrier between the east and the west. Not until the Zakarum conqueror Rakkis' great crusade was the desert crossed in great numbers. Yet even after traversing and enduring, his forces still had to contend with the nearly impassable Tamoe mountain range that stretches across Aranoch's western border.

Despite the brutal environment, the desert boasts a surprising number of species and robust cultures. The lacuni, or "panther-men," as they are commonly called, are one such example. A number of nomadic human clans also inhabit Aranoch, either living as wandering traders or dwelling temporarily in vast subterranean caverns to escape the desert's oppressive sun.

It is written that the great nation of Ivgorod once controlled the northern reaches of Aranoch as well. The Valley of the Ancient Kings (the site of Tal Rasha's tomb, mentioned earlier in this tome) is said to be a sacred burial ground for some of the ancient Patriarchs who ruled the kingdom. It should be noted that this location was named by Aranoch's inhabitants, not the inhabitants of Ivgorod, and has also been referred to as the Canyon of the Magi (due to an erroneous belief that the mage clans had some part in its creation).

By far, the most important location in Aranoch is the port of Lut Gholein, the Jewel of the Desert. This city's influence throughout history cannot be overstated. Until Rakkis' conquest, much of what those in the east knew about the west was gleaned through Kehjistani merchants who traded in Lut Gholein.

The Dreadlands

This blasted region was once home to the many barbarian tribes and their beloved Mount Arreat, site of the Worldstone. In the course of the Worldstone's destruction, half of Mount Arreat's bulk exploded outward. Now, all that remains is a massive, smoldering crater in the earth.

The aftereffects of the Worldstone's destruction have left a terrible mark upon the realm. Demonic corruption now runs rampant, threatening both man and beast. Tales have spread of phantom horrors and infernal mutations stalking amidst the scarred forestlands, making the Dreadlands a destination shunned by all but the hardiest (or most foolish) of travelers.

No longer charged as caretakers of the sacred mountain,
some barbarians have left Arreat behind and struck
out to battle evil in atonement for failing in their
ancient stewardship. Other tribes have fallen into a
state of regression, becoming akin to unreasoning beasts
and, in some cases, even cannibals.

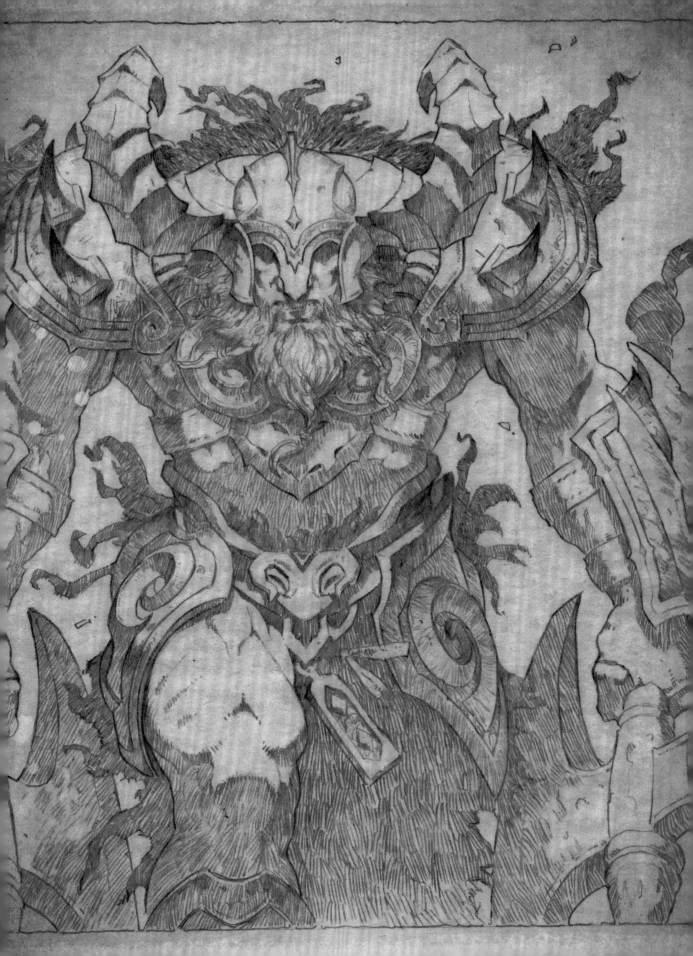

One of the only civilized sites left in the Dreadlands is the fortress known as Bastion's Keep. Built long ago by Korsikk, son of Rakkis (see the section on Westmarch), the keep now stands as a bulwark between the violent tribes in the north and the civilized lands to the south. The brave soldiers who guard its walls remain ready to confront any foes—human or otherwise—who might besiege them.

While not native to the region, the secretive cadre of warriors known as the demon hunters has chosen to make its home in the harsh and unforgiving Dreadlands. The abundance of demonic creatures and mutated beasts provides a wealth of training opportunities for the demon hunters to hone their deadly skills.

Entsteig

Located north of the densely forested Sharval Wilds, Entsteig is a proud kingdom that has pledged its loyalties to the Zakarum faith. When Rakkis' army first marched into the western lands centuries ago, he met violent resistance from the peoples of Ivgorod, who viewed his new beliefs as sacrilege. Entsteig, however, opened its gates to Rakkis and embraced his teachings.

Because of its peaceful acceptance of foreign rule, Entsteig quickly modernized and became an important Zakarum territory in the region, much like Westmarch and Khanduras would become. In recent times, many of the most devout Zakarum paladins have hailed from Entsteig.

Due to the thick, mountainous forests that blanket this region, Entsteig developed a culture highly distinct from nearby Ivgorod and the barbarian civilization to the north. The kingdom's inhabitants believe the Sharval Wilds to be an enchanted place of fey spirits, and many old customs and pagan rituals are still practiced there. Even so, these ancient rites have not conflicted with the observance of the Zakarum faith. Rather, Entsteig's people have managed to meld their own esoteric beliefs with their adopted religion.

Ivgorod

Ivgorod is a land steeped in tradition and mystery. It is known as the City of the Patriarchs, and the religious oligarchy rules with an iron fist. The religion of Ivgorod is known as Sahptev and is devoted to the worship of a thousand and one gods and goddesses. This rigidly complex system controls and informs every aspect of Ivgorod's society.

The exotic civilization of Ivgorod once held sway over surrounding lands (such as portions of Entsteig) and the northern deserts of Aranoch. I find it fascinating that some of the ancient rulers of Ivgorod are interred beneath the Valley of the Ancient Kings. But due to Rakkis' crusade, the power of this land was broken. Now, all that remains of this once-great civilization is its snow-capped capital.

The monks of Ivgorod are rarely seen outside of their predominantly isolationist kingdom. Secretive and reclusive, these holy warriors undergo intense mental and physical training to hone their minds and bodies into living instruments of divine justice.

Kehjistan

Perhaps no other region in the world has been so important to shaping human civilization as Kehjistan (known in ancient times as Kehjan). It was here where the mage clans formed and rose to prominence, and where some of the most profound discoveries in science, philosophy, magic, and religion have been made. Following the Sin War millennia ago, Kehjan was renamed Kehjistan to distance itself from that terrible and costly conflict.

The terrain of present-day Kehjistan has changed little over the millennia. Emerald rainforests teeming with life form the bulk of the region. A vast desert known as the Borderlands denotes Kehjistan's northern border, while swamplands lie at its eastern edge.

Kehjistan's capital has changed more than once over the course of its history, due in large part to war and upheaval. By the end of the Mage Clan Wars, the ancient capital of Viz-jun had been reduced to rubble. The city was later rebuilt and, for a time, remained Kehjistan's seat of power. However, the rise of the Zakarum saw the capital move to the church's religious center in Kurast. The capital shifted again more recently after the fall of Travincal (see the previous chapter for my writings on the Dark Wanderer), as the remnants of the Zakarum fled to the trade city of Caldeum.

Known as the Jewel of the East, Caldeum now stands as the center of Kehjistani life and governance. Together with Lut Gholein, it forms what some refer to as "the jewel cities." The Great Library of Caldeum is perhaps the single most important repository of knowledge in the world, and it has been invaluable to me in creating this tome. Despite the decadence and corruption that have befallen the city in recent years, I intend to return there one day and further my studies.

I have heard reports of an underground movement spreading amongst the young pupils of Caldeum's Yshari Sanctum, a legendary facility where many of the present-day mage clans hone their skills. Dissatisfied with their rigid instructors, these rebellious students have taken on the title of wizard (ironic, as it is considered a derogatory term by mages) and sought out dangerous and forbidden magics. They are said to possess the ability to manipulate the primal forces from which reality itself is constructed.

Khanduras

Khanduras is a land bordered by the Gulf of Westmarch to the west and the Tamoe mountain range to the east. It was in these mountains that Rakkis built Eastgate Keep to defend his holdings against the opposing armies of Ivgorod.

The lands of Khanduras are perhaps best known for the events surrounding Diablo's return and the Darkening of Tristram.

In the years following these terrible acts, merchants slowly began to return to the region, looking to profit from adventurers who plumbed the depths beneath Tristram's cathedral. The town of New Tristram arose, but in recent years it has once again fallen to decline.

You know this area well, Leah, but it is important that you know some of the old names and chronology, for these are things that will figure prominently in decoding the end times to come.

Scosglen

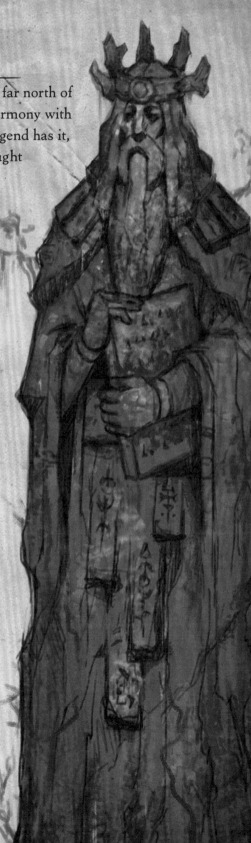

Scosglen is an untamed verdant wilderness located in the far north of the eastern lands. Here, the druidic culture has lived in harmony with nature since the days of the immortal ancient Vasily. As legend has it, the nephalem led his mortal followers to Scosglen and taught them the Caoi Dúlra, a way of life that allowed the druids to bond with their environment.

While the druids have shunned traditional magic, they possess other miraculous skills. Apart from communing with plants and animals, they can take on the forms of certain beasts and, in some rare instances, even bend the forces of nature to their will. Even at the height of their powers, the sorcerers of the mage clans never dared enter Scosglen for fear of the wild and savage powers its inhabitants wielded.

What passes as civilization in Scosglen might seem crude to some, but the druids do not value sprawling urban centers as do Kehjistan's inhabitants. The dwellings of Scosglen consist of ancient stone towers known as druid colleges scattered throughout the region's dense forests.

The greatest of these structures is Túr Dúlra, considered the heart of druidic culture. There, it is said that the druids have perfected their synergy with nature for ages beneath the boughs of a magnificent oak tree called Glór-an-Fháidha.

The Skovos Isles

Located south of the Western Kingdoms in the Twin Seas, the Skovos Isles consist of four main islands: Philios, Skovos, Lycander, and Skartara. The isles are home to the Askari civilization. Since ancient times, the Askari have espoused a matriarchal form of government, one in which men have a lesser voice and are prohibited from holding the highest offices. In truth, political power is shared between two castes—the warrior amazons and the mystic oracles. Each caste is represented by a queen; thus both queens rule the Skovos Isles in tandem.

The isles are also the origin point of the Sisterhood of the Sightless Eye, exiled rogues who struck out across the world years ago. (I have written more on this group in the chapter concerning the Dark Wanderer.)

The core of Askari mythology revolves around Philios, a first-generation nephalem, and his lover, Lycander, an angelic follower of Inarius. These doomed lovers communicated through an artifact known as the Sightless Eye—which even today is held as one of the most sacred objects in Askari culture.

Legend holds that Philios was a bold and powerful nephalem. The angel Lycander felt drawn to Philios, and the two fell in love. When the demoness Lilith massacred Sanctuary's renegade angels and demons, Lycander fled back to the Heavens. She maintained contact with Philios through an artifact in his possession called the Sightless Eye. In time, however, Lycander's fellow angels discovered she was communing with someone outside the Heavens, though they knew not who it was. Lycander ended the romance and insisted that Philios hide the Eye so that the Heavens would not learn of Sanctuary's existence.

Philios grieved but continued to adventure throughout Sanctuary, and in time met the mortal woman Askarra. The two fell in love, and soon Askarra gave birth to twin girls. The girls grew, hearing tales of the Sightless Eye . . . and they vowed to recover it.

The sisters found the Eye on the island of Skovos, and it was there that they made their home. Though the twins did not use the Eye to communicate with Heaven, they found that they were able to see the future through its mirrored surface. So it was that their culture grew with the Sightless Eye at the heart of their society.

From the more stalwart sister, the amazon caste descended. And from the more ethereal sister, the oracle caste evolved.

The Torajan Jungles

The immense, teeming jungles of Torajan span most of the southwestern expanse of the eastern lands. Even to nearby Kehjistan, this region is a strange and mysterious place, filled with vibrant and dangerous flora and fauna that cannot be found anywhere else on Sanctuary. The Zakarum discovered as much when they first explored this land, giving Torajan the name we know of today.

Westmarch

Founded by Rakkis, Westmarch was named in honor of the Zakarum warlord's great crusade and marks the farthest western point of his conquest.

Rakkis was loved by the peoples of the west and did much to bring civilization to the surrounding lands, including the building of roads and churches and necessary infrastructure for the burgeoning territories there. In time, Rakkis' heir, Korsikk, continued his father's rule and built Westmarch into a bastion of the Zakarum faith.

Ever wary of attack from the northern barbarians, Korsikk founded the impregnable Bastion's Keep to safeguard all that his father had thought to build.

In the present day, Westmarch is a kingdom that thrives on commerce and maritime trade. Influence from the Zakarum faith has waned of late, and Westmarch is now a forward-looking civilization. Indeed, one might say that it remains one of the healthiest, most vibrant kingdoms left in our troubled world.

Xiansai

Xiansai is a mountainous island nation found in the Frozen Sea at the roof of the world. Due to the isle's insular nature, the Xian have developed a highly distinct culture devoid of major foreign influence. The kingdom distanced itself from the Sin War, the Mage Clan Wars, and other notable conflicts, but it has seen its own share of civil strife.

Historically, many of Xiansai's internal wars have originated from the political maneuvering of the Great Families that hold sway on the island. These wealthy trade groups are said to be constantly competing with one another for influence and power. Each one of these families controls a specific aspect of the kingdom's economy, from its robust fishing industry to the mining of precious metals and gems in the towering Guozhi mountain range.

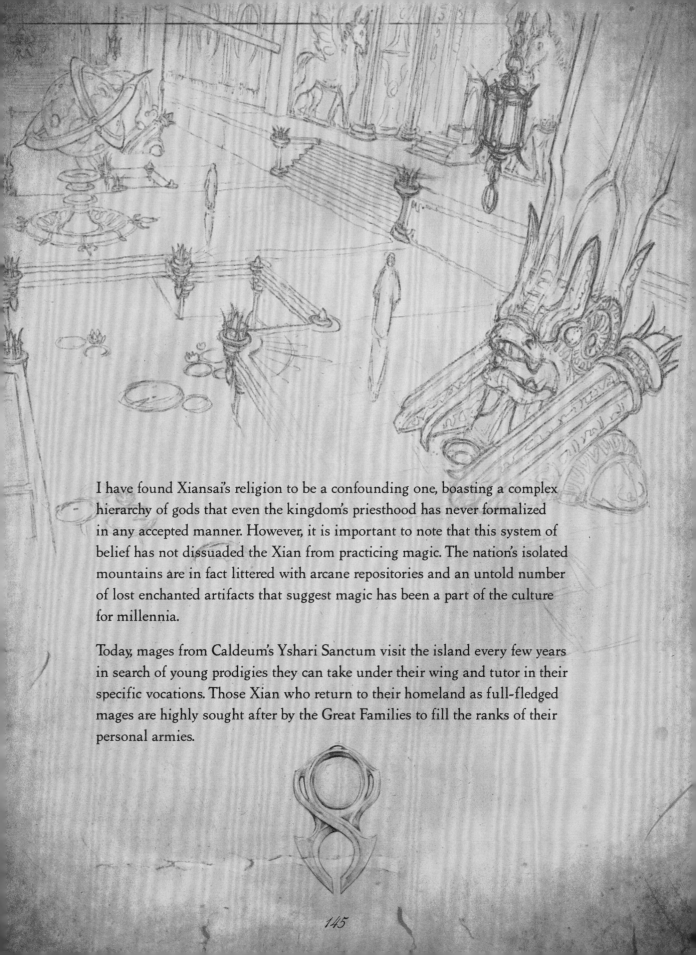

I have found Xiansai's religion to be a confounding one, boasting a complex hierarchy of gods that even the kingdom's priesthood has never formalized in any accepted manner. However, it is important to note that this system of belief has not dissuaded the Xian from practicing magic. The nation's isolated mountains are in fact littered with arcane repositories and an untold number of lost enchanted artifacts that suggest magic has been a part of the culture for millennia.

Today, mages from Caldeum's Yshari Sanctum visit the island every few years in search of young prodigies they can take under their wing and tutor in their specific vocations. Those Xian who return to their homeland as full-fledged mages are highly sought after by the Great Families to fill the ranks of their personal armies.

Dearest Leah,

By now you've no doubt perused this manuscript and gleaned from it at least a cursory knowledge of the dangers that lie in store for our troubled world. Believe me, I know how difficult it is to weigh the balance of these incredible mythologies, how hard it is to believe they could paint a picture of a world even more real and more terrible than the one we now perceive.

I must confess that in the wake of recent events, I have struggled to hold on to hope. When the falling star crashed down and blasted me into the darkened depths of that damned cathedral, I saw my long life flash before my eyes. All at once, I felt the totality of my experience: the unprecedented sights I'd seen, the knowledge I'd accumulated, the pain and loss I'd lived through. And though I was saved from certain death, I feel there was a part of me left behind, still buried beneath that cursed ground.

You would chide me for being morbid, but I cannot shake the feeling that my time is drawing to a close—that death, after all these long years, will finally catch up to me. And thus I hope that my life has had some impact for good in this world, that my work will continue should anything happen to me.

My great desire in leaving this tattered old journal in your possession is that you will take up the challenge of my work when I am gone. It is tedious, to be sure, but like all great works, it may inform the hearts and minds of men in the face of the apocalypse to come. It falls to you now, dear one, to draw your own conclusions regarding these apocryphal texts—and to warn the world of the perils that draw nearer with every passing day.

Oh, Leah, I never wanted any of this for you. I never wanted you to be drawn into the cycle of terror and violence that has hounded me these past twenty years. But fate, it seems, is cruelly fickle.

I'm sorry that you must now bear this burden. I console myself by remembering that you are so much stronger than I ever was—and that your great heart is young and true.

I'm sorry for so many things, Leah. Sorry that this befuddled old fool is the closest thing you've ever known for a father. Sorry that you've never had the quiet life you deserve. sorry that you are forced to sacrifice a carefree youth and the simple joys of home and friends, all on account of my life's work—my life's obsession. In all the ways that truly matter, the needs of my life have always overshadowed your own.

And now, as I sense my life drawing to a close, I am overwhelmed by regret.

Be that as it may, the one thing I want to make absolutely clear to you, dear one, is that for all the things I've seen and learned while trekking across this strange, dangerous world, there is only one truth I hold with complete certainty: that you are the single greatest joy of my life.

For all the darkness and fear we have come through together, you were always the light of hope and promise that kept me going. My child. My sweet daughter—if not by blood, then certainly through love and devotion.

I could not be any prouder of you, Leah—of the woman you've become.

Come what may, dear one, always hold fast to hope. For far beyond the crash of worlds and the unending struggle within our own frail hearts, I believe that something better lies in store for us.

A new beginning. A clean slate. A paradise . . .

. . . where we might meet again.

Love,

Uncle Deckard

BOOK OF CAIN

Written by: Flint Dille • Illustrated by: Brom: 34, 44, 107, 109, 133, 135, 136, 139, 143 • Mark Gibbons: 8, 18, 20 (top), 21, 23, 26, 29 (top), 31, 32, 35, 37 (middle), 39, 40, 42, 45, 47, 54, 61, 62 (right), 63 (left), 68, 83, 97, 100, 130, 132, 134, 137, 138, 142 • James Gurney: 17, 52, 53, 55, 56, 57, 60, 70, 71 (bottom), 88 • John Howe: 2 • Joseph Lacroix: 127, 128 • Alan Lee: 4 • Victor Lee: 140, 145 • Christian Lichtner: Cover • Iain McCaig: 27, 58, 62 (left), 76, 89, 98—99, 110 • Petar Meseldzija: 93, 102, 117 • Jean-Baptiste Monge: 10, 12, 24, 28, 36, 38, 46, 49, 64—65, 73, 74, 78, 90, 91, 104, 105, 113, 114, 120, 122—123, 129 • John Polidora & Glenn Rane: 3 • Adrian Smith: 14, 22, 30, 43, 50, 63 (right), 66, 80, 115, 118, 119 • Mac Smith: 33 • Additional Art: Trent Kaniuga

Additional Writings: Chris Metzen, Micky Neilson, Matt Burns

Edited by: Eric Geron • Design by: Corey Peterschmidt, Jessica Rodriguez • Produced by: Brianne Messina, Amber Thibodeau • Lore Consultation: Justin Parker • Game Team Consultation: Jon Dawson, Rod Fergusson, John Mueller, Rafał Praszczalek, Ashton Sanderson, Joe Shely, Mac Smith

Director, Consumer Products, Publishing: BYRON PARNELL
Associate Publishing Manager: DEREK ROSENBERG
Director, Manufacturing: ANNA WAN
Senior Director, Story & Franchise Development: DAVID SEEHOLZER
Senior Producer, Books: BRIANNE MESSINA
Associate Producer, Books: AMBER THIBODEAU
Editorial Supervisor: CHLOE FRABONI
Senior Editor: ERIC GERON
Book Art & Design Manager: COREY PETERSCHMIDT
Historian Supervisor: SEAN COPELAND
Department Producer, Lore: JAMIE ORTIZ
Associate Producer, Lore: ED FOX
Associate Historians: MADI BUCKINGHAM, COURTNEY CHAVEZ, DAMIEN JAHRSDOERFER, IAN LANDA-BEAVERS

ORIGINAL EDITION:

Justin Allen, Jason Babler, Matthew Beecher, Skye Chandler, Jane Chinn, Sean Copeland, Jeremy Cranford, Evelyn Fredericksen, Cate Gary, Jake Gerli, Raoul Goff, Doug Gregory, Joshua Horst, George Hsieh, Jan Hughes, Chrissy Kwasnik, Binh Matthews, Mark Nichol, Justin Parker, Glenn Rane, Anna Wan, Kyle Williams

Published by Blizzard Entertainment.

This book is a work of fiction. Names, characters, places, and incidents are either products of the author's imagination or are used fictitiously, and any resemblance to actual persons, living or dead, business establishments, events, or locales is entirely coincidental.

Blizzard Entertainment does not have any control over and does not assume any responsibility for author or third-party websites or their content.

Library of Congress Cataloging-in-Publication Data available.

ISBN: 978-1-956916-40-9

Manufactured in China

Print run 10 9 8 7 6 5 4 3 2